Preface and Acknowledgements

The present work and its planned continuations, two further volumes covering the Ming and Ch'ing periods, represent the latest in a succession of efforts to organize and index the great body of surviving Chinese paintings. Arthur Waley's *An Index of Chinese Artists* (London, 1922) was the first attempt in any language to provide students of Chinese art not only with a convenient guide to the painters, but also with lists of their published works. Waley's book was brief, covering only the limited number of reproduction books and other publications that had appeared by that date and were accessible to him. Corrections to it were published by Paul Pelliot in the same year (review in *Toung-pao*, XXI, 1922, pp. 322-62), and two supplements by Werner Speiser in 1931 and 1938 ("Ergänzungen zu Waley's Index," *Ostasiatische Zeitschrift*, N.F. VII, 1931, pp. 124-29; and "Weitere Ergänzungen zu Waley's Index," *Ibid.* XIV, 1938, pp. 230-39). In the meantime, Osvald Sirén had begun his great work of gathering and organizing which, flawed in some respects though it was, laid a foundation for all later studies. His *History of Later Chinese Painting* (2 vols., London, 1938) contained "Lists of Paintings and Reproductions" arranged by artists, which were the forerunners of the far more extensive and ambitious "Annotated Lists of Chinese Paintings," published in 1956 and 1958 in Sirén's seven-volume *Chinese Painting: Leading Masters and Principles*. Occupying the last third of volume II and the whole of volume VII, the Annotated Lists gave basic biographical information, with references to Chinese sources, and lists of published and known works, for some 1,250 artists from the Six Dynasties through the Ch'ing period.

The principal work on the Annotated Lists was done, according to Sirén's preface, by Mr. Huang Tsu-yü in the period 1950-1955. Others also took part in the project, including, in the last stages, myself. I had begun a similar index in card-file form while a graduate student, but discontinued it after meeting

Sirén in Kyoto in the autumn of 1954, when I learned of his far more comprehensive work. Instead, I began to concentrate on organizing my notes on U.S. and Japanese collections so as to be able to incorporate these with Sirén's material. This was done during three months in Stockholm in the winter of 1955-6, and a number of important publications and collections were added at that time.

The resulting Lists have served us ever since as an invaluable tool in the study of our subject; we turn to them continually to find information quickly on an artist, or ascertain the period of his acivity, or to begin an investigation of a painter's *oeuvre,* or track down a reproduction of a painting.

The usefulness of the Lists as a work somewhat independent of Sirén's *Chinese Painting* suggested that they should be published separately, and Sirén and his editor (the late Bruno Schindler of Lund Humphries, Ltd., London) agreed to that plan. I assumed responsibility for soliciting corrections and additions from scholars and collectors and incorporating them into the Lists, as well as adding newly-published material, to make them more accurate and complete. These improvements were to be finished in a year or so, after which the new Lists would be published. Twenty years have passed since then, and the first volume is just now appearing. It was not simply that the revision and augmentation of Sirén's index proved to be a much larger task than I had anticipated; the index has grown to nearly twice its original size, and changed in character until it is now an essentially new work. It has accordingly been given a new title, one that by intent echoes Waley's.

An important supplement to Sirén's work, and an aid to mine, was Ellen Johnston Laing's *Chinese Paintings in Chinese Publications, 1956-1965* (Ann Arbor, 1969). The great collections in the People's Republic of China had begun to be accessible for study through illustrated catalogs during the 1950's and early 1960's, and new publications of the National Palace Museum in Taiwan had revealed more of the wealth of little-known masterworks in that incomparable treasury. Serving as a guide to all this unfamiliar material, Laing's book performed a major service. I am grateful to her for allowing me to use freely the product of her industry and research.

The present *Index of Chinese Painters and Paintings,* then, is in considerable part a product of accretion. But it aspires to a higher state than that of a simple combination, with additions and corrections, of the Sirén and Laing indexes. It is an effort, to which many people have contributed, to organize more clearly and accurately than before the vast corpus of known Chinese paintings, or as many of them as we have been able to see and learn of, and present them in a form that will facilitate future studies. Hundreds of small and large problems have had to be dealt with: the relationship of different versions of a composition; the identification of subjects; the determination of probable authorship from signatures, inscriptions, and seals; questions of dating and authenticity; the proper placing of misattributed works; the periods of activity of artists; and others. Many of the solutions offered must be tentative and open to correction by future research. No one can be more aware than myself that hundreds of errors and omissions remain; but it seemed best to get the book into print as it stands, absolute perfection being an ultimately unattainable

goal. I shall be grateful for any corrections and additions that users may be willing to send; these will be kept for use when a revised edition is prepared.

Among those who have worked on this index, three who have been my principal assistants in the project deserve special recognition and thanks: Elizabeth Fulder Wilson, Howard Rogers, and Richard Vinograd. Colleagues who read over parts of the manuscript and suggested corrections, or helped on particular artists or paintings, include: John Ayers, Margaret Bickford, Karen Brock, Susan Bush, I-han Chiang, Richard Edwards, Jan Fontein, Herbert Franke, Marilyn Fu, Shen Fu, Roger Goepper, Wai-kam Ho, Hironobu Kohara, Thomas Lawton, Chu-tsing Li, Li Lin-ts'an, James Robinson, Michael Sullivan, Kei Suzuki, Teisuke Toda, T. W. Weng, Roderick Whitfield, Marc Wilson, Tung Wu. Deserving special mention for extensive and very useful comments and corrections is Richard Barnhart.

The staff of the Peking Palace Museum also supplied some corrections, for which I am grateful. I want to express special thanks also to the Chinese Scientific and Technical Association, which was host to the U.S. Chinese Archaeology Delegation in 1973, and the Bureau of Cultural Relics, which hosted the U.S. Chinese Painting Delegation of 1977, as well as the Committee on Scholarly Communications with the P.R.C, which sponsored both delegations. These two trips to China, and especially the second, allowed me to see and study hundreds of paintings in collections there, and to make this Index accordingly more complete and accurate. The collections in China are still, however, largely unpublished and unknown to outsiders; it is there that the major discoveries will be made in the future, enlarging substantially any future edition of this work.

Support for the project has come from a number of individuals and funding sources, over the years, and its eventual completion is owing to their generosity. The Harvard-Yenching Institute provided a grant to allow Professors Kei Kawakami and Kei Suzuki to work on completing the coverage for paintings in Japan. An appeal for funds to pay the salaries of research assistants was sent to collectors of Chinese paintings in 1974, and generous contributions were received from the following: Dr. and Mrs. Frederick Baekeland, Mr. C. D. Carter, Mr. John M. Crawford, Jr., Mr. Charles Drenowatz, Mrs. Jeannette Stein Elliot, Professor Wen C. Fong, Mr. Mitchell Hutchinson, the Earl and Irene Morse Foundation, Inc. The Committee on Studies of Chinese Civilization of the American Council of Learned Societies has given both financial and moral support at crucial moments over the years, and for the later stages of the project a fund established under the China Institute, New York, by Mr. C. C. Wang gave us two much-needed grants.

Secretarial and other assistance was provided by the staff of the Freer Gallery of Art during my years there, and by the Department of the History of Art, University of California, Berkeley, in more recent years; among the latter, I want to thank especially Nancy Grimsley, Wanda Mar, and Jill Moak. Dr. Shen Fu of the Freer Gallery of Art wrote the title for the cover and the title page in his distinguished calligraphy; the book is honored by these "traces of his brush." Anita Joplin mastered the electronic labyrinth of a computer editing

program to type the entire text into the terminal and make the subsequent corrections and additions; hers was a crucial contribution. She was succeeded by Edith Ng, who brought this phase of the project to completion. Finally, Lorna Price served as general text editor and oversaw the planning and production of the finished pages, applying skills that no computer will ever replace to turn a messy manuscript into a neat and useful book. To all of these, I and other future users of the Index owe a great debt of gratitude.

Preface to the Reprinted Edition

I am pleased to see my *Index of Early Chinese Painters and Paintings* back in print, since the issuing of the new printing indicates a continuing demand for this twenty-three year old reference work. All the advances made in Chinese painting studies over these two decades, impressive as they have been, were not of the kind that would render it obsolescent; connoisseurship and judgments of authenticity, attempts at constructing an early artist's reliable *oeuvre,* have not been popular pursuits in recent times. To the expected question, "Why, then, didn't you update it yourself, instead of simply reprinting the old one?" I can only respond that the foundation grants and other funding, high-level graduate student help, and library and research facilities needed for such an updating are no longer available to me, in my situation of retirement. The augmenting and updating of the *Index,* needed as that is, must be left to some future specialist willing to take on the task.

A great many picture catalogs and reproduction books containing Yüan and earlier paintings have appeared since the old *Index* was published, most importantly the 24-volume *Chung-kuo li-tai shu-hua t'u-mu,* an ambitious attempt to identify, catalog, and reproduce in small size most of the important paintings in P.R. Chinese collections.[1] Picture-catalogs of paintings in museums and other institutions in China and elsewhere have appeared in some number, along with numerous auction catalogs and publications of other kinds, many of them containing Chinese paintings ascribed to the early periods. All of these together, to be sure, have not really added very many Yüan and earlier works to our corpus; the great majority of the paintings newly published have been works of Ming and Ch'ing date. Perhaps we cannot reasonably expect our known body of extant early Chinese painting to be greatly augmented in the future.

ix

I have, of course, changed my mind on some of the datings and judgments of authenticity offered in the old *Index*, but again, it has not proved practical to make changes in this new printing. Fortunately, I still feel comfortable with most of them. A few that were controversial back then have since come to be widely accepted. An example is the pair of "Li T'ang" landscapes in the Kōtōin, Kyoto (p. 123), which once were taken to be genuine works by most specialists in the field—a whole book could be compiled of the passionate defenses published over the years of these paintings as truly by Li T'ang, attempts to extend unnaturally the artist's period of activity, or see their thirteenth century style as somehow possible in Li's (early twelfth century) time. But even the principal defender of the pictures has now quietly, in a footnote to an article. acknowledged their late Sung dating. It is equally true that I now recognize mistakes I myself made. Examples include the landscape handscroll "Serried Hills Over a Misty River" by the late Northern Sung master Wang Shen in the Shanghai Museum (p. 184), which I wrongly dismissed but now provisionally accept, in part through the convincing studies by Richard Barnhart; and the handscroll "Clearing After Sudden Snow" by Huang Kung-wang in the Palace Museum, Beijing (pp. 282–83), which I now believe to be genuine and important[2]

A few mistakes in the book can be noted here, out of many that could doubtless be found in a more thorough perusal. On page 33: the painting of "Bamboo, Old Trees and Rocks" in the Shanghai Museum, ascribed to Hsü Hsi is not, as stated there, "inscribed with the artist's name"; the inscription (written upside down on a bamboo stalk!) reads "This bamboo is worth more than a hundred *liang* of gold." On page 111: the date for the Li An-chung album leaf in the Cleveland Museum of Art is 1117, not 1177. On page 150: the Ma Lin "Evening Landscape" in the Nezu Museum is now recognized to be two separate album leaves, poetic inscription and painting, originally facing leaves but remounted (in Japan) one above the other to make a small hanging scroll that has deceived us all into seeing it as a single composition with an oddly large-character inscription in the sky. On page 389: the catalog *Chinese Art Under the Mongols; The Yüan Dynasty* by Sherman Lee and Wai-kam Ho (Cleveland Museum of Art, 1968) was unaccountably left out of the Bibliography, although references to it (as "Yüan Exhib. Cat.") appear in the main text.

There were a few cases in which I was deliberately indecisive in my datings and judgments, out of deference to others' opinions or respect for the owners of the paintings, and wrote "Important early work? or modern fabrication?" when I was already convinced that it was clearly the latter. An example is the *Ch'i-an t'u* ("Riverbank") landscape purportedly by Tung Yüan, now in the

Metropolitan Museum, New York (p. 48). I might have inserted, as an appendix to the *Index,* a list of "early" paintings that I strongly suspected of being forgeries by the late Chang Ta-ch'ien (1899–1983), and would probably do so now, in the hope of excluding these mischievous works from our attempts to chart the development of Chinese painting in the early periods.

A great deal of work was done under my direction on an *Index of Ming Paintings,* intended to follow on this one, but it remains unfinished and only on disk; a few institutions acquired copies of it in database form on disks, but even those are no longer available. The plan, so far unrealized, is to make the whole work as a database accessible on line both for users and for specialist scholars, including myself, who would continue to work on it. It is unlikely that it will ever be published in book form.

There has, as one might expect, been talk of adding digitalized images both to this old *Index* and to the *Ming Index,* perhaps extending the coverage through the Ch'ing, and making it all available on disk or on line. That, while technically feasible, is another project for the future and for someone of a younger generation to carry out. The work would be facilitated by the existence of two great photographic archives for Chinese painting, and a potential third. The first is the archive kept under the Asian Art Photographic Distribution at the University of Michigan, which includes most of the old and important paintings in the National Palace Museum, Taipei, as well as materials from many exhibitions and collections. The second is what is known as the Suzuki Archive, begun under the direction of Suzuki Kei and continued under Toda Teisuke and Ogawa Hiromitsu, kept at the Tōyō Bunka Kenkyūjo at Tokyo University; this is the product of their extensive travels with a photographer around collections in Japan, the U.S., Europe, Taiwan, and Southeast Asia. The third is an archive that could in principle be made from the photos taken by the Cultural Relics Publishing Co. in Beijing for the *Chung-kuo li-tai shu-hua t'u-mu* series, covering most of the important collections in P.R. China (only the great collection of the Palace Museum in Beijing remains only partially published, by their choice.) These three could ideally be combined into a vast digital archive, or database, to which much more could be added from other sources, eventually to comprehend the majority of significant extant Chinese painting. The obstacles to actually doing so are of course formidable, for reasons technological, monetary, and political; I offer it only as a vision.

Visions can be infinitely extended: the digital archive could then be computer-indexed thematically, allowing researchers to locate all representations of a particular subject; fields could be included for seals, writers of

colophons, earlier owners, and other research criteria. The hard-won mastery of how to attack the great corpus of Chinese painting that was expected of my generation would give way to easy access; where I used to subject my graduate students to long sessions on the bibliography of Chinese painting reproduction books and photographic archives, and on how to locate what they needed within them, more or less everything would become available to everybody. Oldsters like myself would grumble that much of the fun of pursuit and discovery had been lost; younger specialists would recognize the dawn of a new age in Chinese painting scholarship. Both would be right.

In any case, all this is for now only a dream (and one that I have presented, ineffectually, to rich foundations and individuals over the years.) Meanwhile, in our real world, this *Index of Early Chinese Painters and Paintings* continues to serve a purpose, and I am grateful to Weatherhill, Inc., and to its editorial director Ray Furse, for making it available once more.

James Cahill
Honolulu, January, 2003

[1] *Chung-kuo li-tai shu-hua t'u-mu* ("Illustrated Catalogue of Selected Works of Ancient Chinese Painting and Calligraphy"), Beijing, Cultural Relics Publishing Co., 24 vols., 1986–2001.

[2] See *Three Thousand Years of Chinese Painting*, New Haven, Yale University Press, 1997, p. 125 and Fig. 117, Wang Shen, and pp. 168–69 and Fig. 157, Huang Kung-wang.

Contents

Contents

Introduction

General Plan. This first volume of the Index includes all the Chinese paintings known to me, excluding only obvious forgeries and minor imitations, by or attributed to artists active in the early periods, down to the end of the Yüan dynasty. It provides information on present ownership and on sources where reproductions of the paintings can be found. Many paintings have, of course, changed hands since they were published, but wherever possible, they are located by present collection. Anonymous paintings follow those with attributions for each period, and are arranged by subject. Wall paintings and archaeological materials have generally been excluded.

Traditional attributions have been retained, even when they are virtually meaningless, since they are often the only "identity" that the painting has: we continue to speak of "the Boston M.F.A. Tung Yüan" even though there is general agreement now that the painting has nothing to do with Tung Yüan in date or in style. Discarding the traditional attributions would leave us with an unmanageable mass of anonymous pictures.

Artist Entries. The artist's names *(hsing* or family name, *ming* or given name, *tzu* or style abbreviated as "t.", *hao* or sobriquet abbreviated as "h.") are followed by some or all of the following information: the artist's birthplace; his birth and death dates if known, or period of activity; the subjects in which he specialized, and the tradition he followed; brief biographical notes; sources for his biography, listed mostly under letter abbreviations (see Part II of the Bibliography).

Painting Entries. Paintings are listed by collection, for museum and other public collections, when the present whereabouts are known; otherwise, by publication, with private collections identified if known. For paintings with specific well-established titles, these titles are sometimes given in transliterated Chinese form, and always in translation; for others, descriptive titles (e.g., "Landscape with travelers approaching a temple") are provided. Unless the form is specified ("album leaf," "handscroll," etc.) the paintings are assumed to be hanging scrolls. Other information—materials such as "ink and colors on silk," signature, inscription, seals, etc.—are given selectively, not consistently.

1

Terms such as "signed" or "inscription by so-and-so" should not be understood as necessarily endorsing the authenticity of the signature or inscription; it seemed too ponderous and space-consuming to write "inscription purportedly by..." or some similar phrase to indicate each doubtful case.

In place of the letter grades of Sirén's Annotated Lists, brief assessments are added: "Genuine work," "Copy or imitation," "Ming work of the Che School," and so forth. With the exception of a very few cases in which Sirén's opinions have been retained (for unpublished works which I have not seen), these represent my own opinions. They are not, of course, to be understood as final judgements; far more research will have to be carried out before the great number of early and purportedly early paintings can be attributed and dated by anyone with reasonable assurance. The attempt seemed nonetheless worth making, as a guide to students and beginning collectors; others can disregard my judgements and make their own. Asterisks before painting entries indicate those works that seem to me likely to be genuine, or of special value to an understanding of the artist, or otherwise of particular importance; these are the works to which a student might pay special attention in beginning an investigation of an artist or a school. They cannot be taken as firm indications of authenticity, although they are mostly intended to approach that ideal as closely as my present understanding allows; I have discovered myself in error too many times to have any illusions on that score.

Order of Painting Entries. For the Yüan period, dated works are listed by dates; otherwise, the order of the listings for each artist is as follows:

1. Paintings in collections in the People's Republic of China.

2. Paintings in the National Palace Museum, Taiwan.

3. Paintings in other Chinese collections in Taiwan and Hong Kong, or reproduced in old Chinese publications.

4. Paintings in Japanese collections and publications.

5. Paintings in U.S. public collections, followed by those in private collections.

6. Paintings in European collections, and collections in other countries.

Bibliography. The main body of the Bibliography is devoted to reproduction books; these are divided into Chinese, Japanese, and Western publications, and arranged alphabetically within each of these categories. The entry for each reproduction book begins with the abbreviation under which it is referred to in the Index, followed by a full bibliographical citation. Such abbreviations are used for reproduction books containing numbers of paintings by different artists, and for art journals, etc. Publications containing single paintings (handscrolls and albums, chiefly) and those containing works by a single artist are cited only in the individual painting entries, or in the artist entry, and are not included in the Bibliography. A second, shorter section of the Bibliography contains biographical sources, listed under the letter designations or abbreviations used for them in the artist entries.

I.

Painters of the T'ang Period and Earlier

CHAN TZU-CH'IEN 展子虔
From Po-hai in Shantung. Active from the Northern Ch'i into the Sui dynasty (581-609). Painted Buddhist figures, men and horses, landscapes. Sometimes characterized as the "originator of T'ang painting." A, 8. G, 1. H, 2. M, p. 300. Z, p. 14. See also Wang Po-min, *Chan Tzu-ch'ien* (Shanghai, 1958, in CKHCTS series.) (Chan Tzu-ch'ien.)

* Peking, Palace Museum. *Yu-ch'un t'u:* Traveling in Spring. Landscape with blossoming trees on the shore; men in white robes on the paths, a ferry boat on the river. Short handscroll. Artist's name and title written by Hui-tsung; also an inscription by Ch'ien-lung. Important early work; good copy, ca. 10th-11th century, after T'ang original? See I-shu ch'uan-t'ung IV; Chan Tzu-ch'ien 1-3; Chung-kuo hua I, 1-2; CK ku-tai 8; KKPWY ts'ang-hua II, 1-4; Siren CP III, 79-80; Kokyu hakubutsuin, 16; CK li-tai hui-hua 1, 33-35. See also article by Fu Hsi-nien in Wen-wu, 1978 no. 11, in which he presents evidence for considering it a Northern Sung copy after a mid-T'ang original.
Taipei, Palace Museum (VA1b). Studying the Classics: two men seated on the ground reading; a third advancing with a scroll, followed by a small boy.

3

Album leaf, ink and colors on silk. Attributed. Seals of Liang Ch'ing-piao. Copy of a Sung picture? See CKLTMHC II, 71; Three Hundred M., 34; Nanking Exh. Cat. 389.

Chan Tzu-ch'ien 4. Landscape. Handscroll? Copy purportedly by Hui-tsung. Late archaistic picture.

CHANG HSÜAN 張萱

A native of Ch'ang-an. Active in the K'ai-yüan era (714-42) as a painter of palace ladies and other palace scenes. A, 9. B. G, 5. H, 2. I, 46. L, 24. M, p. 455. Y, p. 241.

Chung-kuo I, 7 (Ti P'ing-tzu Coll.). Lady Kuo-kuo's Spring Garden Party. Late work. May be a free imitation after a picture with the same title recorded in the *Hsüan-ho hua-p'u.* See also Chung-kuo ming-hua 31.

Taipei, Palace Museum (VA2d). Emperor Ming-huang Playing a Flute. Album leaf, attributed. Late, free copy of early composition. See Three Hundred M., p. 15; KK ming-hua II, 3.

* Liaoning Provincial Museum. Lady Kuo-kuo and her Sisters on a Spring Outing. Copy, purportedly by Hui-tsung. Handscroll. See Liaoning I, 36-38; Chao Chi (see under Hui-tsung) 12-13; Li-tai jen-wu 20; T'ang-tai jen-wu 32-33; Wen-wu 1955, 5.10; and 1961, 12; and 1963.4. A version in the Taipei Palace Museum, earlier and better, is attributed to Li Kung-lin. See Skira 20. Another is in the Bibliothèque de l'Arsenal, Paris (Inv. 604).

Cheng Chi Coll., Tokyo. Emperor Ming-huang Enjoying a Cool Breeze. Handscroll, colors on silk. Attributed. Published as a portfolio of plates with accompanying booklet of text by Tohobunka Kankokai, Kyoto, 1966.

* Boston Museum of Fine Arts (12.886). Ladies Preparing Newly Woven Silk. According to the inscription by the emperor Chang-tsung of Chin (d. 1209) it was copied by Hui-tsung after a painting by Chang Hsüan. Colophons by Chang Shen (ca. 1350-1400), Kao Shih-chi (1645-1704), and others. Handscroll, colors on silk. See BMFA Portfolio I, 46 and 52-55; Chao Chi (see under Hui-tsung) 9-11; Li-tai jen-wu 21; T'ang-tai jen-wu 28-30; Skira 21; Siren CP III, 105-106; Bijutsu kenkyu 41; BMFA Bulletin vol. LIX, 1961; Kodansha Ca in West I, 42; Kodansha BMFA I, 71-72. See also article by Mitsuko Gomi in Bijutsushi no. 81, 1971.

Siren CP III, 107 (Frank Caro, N. Y.). A T'ang Empress and her Retinue Returning from a Journey. Said to be a portion of a larger ensemble consisting of five pictures representing the "Travels of a T'ang Empress" as mentioned in the *Hsüan-ho hua-p'u.* Colors on silk. Copy. See also Kwen Cat. 3; Bunjin Gasen II, 5; Chugoku I; Yün-hui chai 1; Liu 6; T'ang-tai jen-wu 31.

Chugoku I (C. C. Wang Coll., N. Y.). *Wen-hui t'u:* two ladies sitting on a couch writing; a maid standing and grinding ink. Album leaf. Attributed. Seals of Ch'ien-lung and Chia-ch'ing. Later work.

CHANG SENG-YU　張僧繇

From Wu (Kiangsu). Active 500-550. Painted wall paintings in Buddhist and Taoist temples, religious and figural subjects; also said to have painted landscapes. Used the *mo-ku* ("boneless") manner. A, 7, G, 1. H, 2. I, 45. L, 24. M, p. 454. Z, p. 29. See also Wu Shih-ch'u, *Chang Seng-yu* (Shanghai, 1963, in CKHCTS series) (Chang Seng-yu).

Taipei, Palace Museum (SV129). Autumn Landscape. Said to be a Sung paint-
　ing after a design by Chang Seng-yu. Late Ming or early Ch'ing, school of
　Lan Ying. See KK shu-hua chi 24; London Exh. Chinese Cat. p. 110.
Ibid. (TV1). Snowy Mountains and Red-leaved Trees. Inscribed with the
　painter's name. 17th century. See Li-ch'ao pao-hui, I/1. Same composi-
　tion as "Yang Sheng" landscape in Yale University Art Gallery.
* Osaka Municipal Museum (Abe Coll.). The Five Planets and Twenty-eight
　Constellations. The present picture contains only twelve constellations;
　the other sixteen were probably represented in an accompanying scroll.
　May be a close copy of a T'ang composition. The inscriptions in seal
　characters reproduce, according to the adjoining note, texts by Liang
　Ling-tsan of the 8th century, but date from the time of the execution of
　the picture. Colophons by Tung Ch'i-ch'ang and Ch'en Chi-ju. See
　Soraikan II, 1-17; Chang Seng-yu 1-14; T'ang-tai jen-wu 39-40; Skira 17;
　Siren CP III, 16-17 ; Osaka cat. 1; Chugoku I.
Freer Gallery (16.520). The Brushing of the Elephant. Attributed. Probably
　by Ts'ui Tzu-chung of the late Ming period. See his rendering of the sub-
　ject in KK shu-hua chi 35. Other versions of the same composition are
　preserved; see Chung-kuo I, 56; Toso 134; etc.

CH'ANG PIEN　暢𤲵

Note: The wall-paintings in the tomb of Prince I-te are signed with a similar name; Jan Fontein and Wu T'ung *(Han and T'ang Murals,* 1976, pp. 104-106) have proposed that the artist of these paintings is probably to be identified with Ch'ang Pien (the character for his given name probably miswritten) who is recorded in *Li-tai ming-hua chi* ch. IX (Acker trans., vol. II, p. 248) with the terse comment: "Excelled in [painting] landscapes, which resemble those of General Li [Ssu-hsün]."

CH'ANG TS'AN　常粲

A native of Ch'ang-an. Active in the Hsien-t'ung era (860-874). Went to Szechwan in his late years. Painted figures, especially antique subjects. Y. p. 203.

Fujii Yurinkan, Kyoto. Visiting Immortals on the Wei River. Handscroll.
　Attributed in a title purportedly written by Hui-tsung. Ch'ien-lung colo-
　phon. Late copy of earlier work. See Yurintaikan III.

CHAO KUNG-YU 趙公祐
From Ch'ang-an, lived in Ch'eng-tu where he decorated several temples with wall-paintings. Moved later to Chekiang. Active c. 825-850. Buddhist and Taoist figures. C. 1. F, 2. H, 2. I, 47. L, 46. M, p. 605. Y, p. 305.

British Museum. Demons attacking the bowl in which Buddha had imprisoned Mara's son Pingala. Attributed. Portion of a handscroll in bad repair, possibly executed during late Sung or Yüan. See Ars Asiatica IX, p. 15.

CH'EN HUNG 陳閎
A native of K'uai-chi in Chekiang. He was introduced at court in the K'ai-yüan period (714-742). Painted portraits of the emperors Hsüan-tsung and Su-tsung (reigned 756-763) and illustrations of imperial hunting parties. A, 9. B. G, 5. H, 2. I, 47. M., p. 425. Y, p. 229.

* Nelson Gallery, Kansas City (49.40). Meritorious Military and Civil Officials. Originally eight figures of which only six are preserved. They are represented as isolated figures in their official costumes. Attributed. Handscroll, colors on silk. Colophons by Wen Chia (1579), Chang Feng-i (1596) and Juan Yüan (early 19th century). Seals of Liang Ch'ing-piao. See Archives IV, p. 68; Siren CP III, 103.
Frank Caro, N.Y. (1958). A horse. Formerly in Japanese collections. Hsüan-ho and other seals painted on. Attributed. A later picture. See Li-ch'ao pao-hui, I/2.

CHENG CH'IEN 鄭虔　　t. Jo-ch'i 弱齊
Native of Cheng-chou, Honan. Appointed to the Kuang-wen Kuan in 737. Famous as a calligrapher, landscape painter and musician. A friend of Tu Fu and Li Po, much appreciated by the emperor Hsüan-tsung. A, 9. B. H, 2. I, 47. M, p. 640. Y, p. 341.

Ming-pi chi-sheng I. The Long Cataract. Water falling from an overhanging rock, two men admiring it below. A later picture.

CHENG FA-SHIH 鄭法士
From Wu (Kiangsu). Active during the late 6th century. (Later Chou into Sui.) Held the rank of Chung-san Tai-fu in the Sui dynasty. Painted figures in the style of his teacher, Chang Seng-yu. A, VII p. 98. G, V p. 53. H, II p. 13. M, p. 639. Y, p. 41.

Taipei, Palace Museum (VA2a). Reading the Tablet. Album leaf. Attributed. Ming picture.

CHOU FANG 周昉　　t. Chung-lang 仲朗　　and Ching-yüan 景元　　.
A native of Ch'ang-an. Born c. 730, died c. 800. Executed wall-paintings in Buddhist temples in the capital, but became most famous for his portraits and pictures of court ladies, for which he created a standard type. A, 10. B. F, 5. G, 6. H, 2. I, 47. L, 36. M, p. 242. Y, p. 136. See also Wang Po-min, *Chou Fang* (Shanghai; 1958, in CKHCTS series). (Chou Fang.)

* Peking, Palace Museum. Ladies embroidering, resting, adjusting their garments and coiffures etc. Large handscroll traditionally attributed to the master. Early copy? Heavily repainted. See I-shu ch'uan-tung V; Chou Fang 5-10; KKPWY ts'ang-hua II, 9-15; T'ang-tai jen-wu 46-47; Wen-wu 1957.1.35-37; T'ang-jen Wan-shan shih-nü t'u (Peking: Wen-wu ch'u-pan-she 1958, 1961); Siren CP III, 108; Kokyu Hakubutsuin, 19; CK li-tai hui-hua 1, 38-43. A late complete version of this composition, likewise ascribed to Chou Fang, in the Moore Coll., Yale University Art Gallery. See Moore Cat. 31; London Exh. Cat. 974.

* Liaoning Provincial Museum. Palace ladies wearing flowered headdresses standing in a garden. Handscroll. Attributed. Oldest and finest of the paintings ascribed to Chou Fang. Seals of Shao-hsing era (1131-63), of Chia Ssu-tao (d. 1276), Liang Ch'ing-piao, etc. See Chou Fang 1-2; CK ku-tai 17 (sect.); Liaoning I, 13-15; T'ang-tai jen-wu 44-45; Wen-wu 1955.5.9, and 1958.6.26; *Tsan-hua shih-nü t'u yen-chiu* (Ch'ao Hua Art Publishing Co., 1962), in which the author, Yang Jen-K'ai, argues for a date in the Chen-yüan era (785-804).

Taipei, Palace Museum (VA6a). Barbarian envoy bringing a white antelope as tribute. Title and artist's name written by Hui-tsung. Seals of the emperors Chang-tsung of Chin and Ch'ien-lung. Large album leaf. Fragments of a very old painting inserted in a later copy? See Three Hundred M., 18; CCAT 90; KK ming-hua I, 4; Wen-wu chi-ch'eng 2; NPM Masterpieces II, 2 and III, 3.

Ibid. (VA1d). Two ladies seated on the ground writing a poem. Large album leaf. Attributed. Seals of Liang Ch'ing-piao. Ming? copy of earlier work. See CKLTMHC II, 70; Nanking Exh. Cat. 389.

Ibid. (TV10). Five scholars enjoying music under a pine tree. Attributed. Ming copy of older figure composition of which other versions exist. See KK shu-hua chi 24; KK chou-k'an 324.

Formerly National Museum, Peking. The fairy Ma Ku and other figures. Attributed. See Siren ECP I, 67.

Garland I, 3 (formerly Chang Ta-ch'ien Coll.). Seven Female Musicians. Two servants and a man with a bow accompanying them. Short handscroll. Copy of a work in the manner of the master.

Ibid. I, 2. Woman holding a fan. Interpolated signature. Seals of Hui-tsung and Kao-tsung. Ming work.

Freer Gallery (11.163a). An Old Man Playing a Ch'in. Large album leaf. Attributed. Late Ming, cf. the work of Cheng Chung.

Ibid. (16.50). Banana Plant, Rocks and Three Women. Possibly a copy after a design by the master. Much damaged and restored. See Siren CP in Am. Colls. 122.

Ibid. (16.75). A woman seated on the floor in front of an embroidery frame. Copy of an early painting. See Freer Figure Ptg. cat. 56.

Ibid. (16.405). *Liu-tu t'u:* Leaving Behind the Ox-calf. The Wei official Shih-miao moving to another district, bidding farewell, leaves behind the ox-calf born there. Handscroll in the pai-miao manner, ink on paper. Another version in the Taipei Palace Museum is attributed to Chao Meng-fu (YH35); still another in the same collection to Ch'ien Hsüan (SH 124, chien-mu).

Ibid. (16.524). Heavenly maidens scattering flowers over an assembly of Buddhist saints and worshippers including Vimalakirti and Manjusri; white elephant with sacred objects. Yüan period? No stylistic connection with Chou Fang.

* Ibid. (39.37 and 60.4). Ladies Playing Double Sixes. Handscroll, ink and colors on silk. Attributed. Early copy? See Skira 22; Siren CP III, 109; Kodansha Freer 36-37; Freer Figure Ptg. Cat. 51; Cahill, "The return of the absent servants: Chou Fang's Double Sixes restored," in Archives XV, 1961, pp. 26-28. A Ming copy in the Taipei Palace Museum with inscriptions purporting to be by Ch'ien Hsüan, Liu Hsiao-chi and Lu Shih-tao. See TWSY ming-chi 9; KK ming-hua II, 5.

* Nelson Gallery, Kansas City. Listening to Music. Two ladies are listening to a third who is playing the ch'in in a garden. A servant at each end. Short handscroll. Sung copy after earlier work? See Chou Fang 3-4; Siren CP III, 110. Later versions of this composition in the Ueno Collection (formerly Lo Chen-yu); see Siren ECP I, 68; Li-tai jen-wu 7; T'ang-tai jen-wu 44; Erh-shih-chia; Toso 2; Freer Gallery (16.231); Wang Shih-chieh Collection, Taipei, and other collections.

Metropolitan Museum, N. Y. (13.220.2). Ladies with Fans. Attributed. Copy of an old design.

* Ibid. (40.148). Five women seated on the ground washing and playing with babies. Copy of an old composition. See Alan Priest's article in their *Bulletin,* May 1942, pp. 128-32. Other versions in the Freer Gallery attributed to Chou Wen-chü (35.8); and in Liu 7 and Yün-hui-chai 2.

Ibid. (47.18.146). Lady and Children. Attributed. Copy of an old design.

FAN CH'IUNG　范瓊

Active in the middle of the 9th century in Ch'eng-tu, Szechwan. He was a prominent painter of religious images and executed a large number of wall-paintings after the restoration of Buddhism in 850. He is mentioned together with the painters Ch'en Hao　陳皓　and P'eng Chien　彭堅　whom he surpassed in the strength of his brushstrokes, which were said to be like iron wires. C, 1. F, 2. G, 2. H, 2. M, p. 278. Y, p. 153.

Taipei, Palace Museum (TV11). Thousand-armed Kuan-yin seated on the lotus throne. Colors on silk, in the kung-pi manner. An interpolated

inscription with the signature of Fan Ch'iung, according to which the picture was executed in the first month of the year 850 in the Sheng-hsing temple at Ch'eng-tu. Colophon by Chang Ch'ou (late Ming dynasty). Yüan or early Ming picture?

HAN HUANG 韓滉 t. T'ai-ch'ung 太沖
From Ch'ang-an. B. 723, d. 787. Governor of Chekiang, prime minister in the reign of the emperor Te-tsung. Figures and buffaloes. A, 10. B. G, 6. H, 2. I, 47. L, 17. M, p. 696. Y, p. 379.

* Peking, Palace Museum. *Wen-yüan t'u:* Four Scholars in a Garden. Handscroll, ink and colors on silk. Title and painter's name written by Hui-tsung in 1107. Also seals of the emperor. Post-Sung copy of early work, perhaps by Han Huang. See Chung-kuo hua I, 3-4; KKPWY ts'ang-hua II, 16-18; Li-tai jen-wu, 10; T'ang-tai jen-wu 50; Liu 8; Siren CP III, 102; Loehr Dated Inscriptions p. 240; I-yüan to-ying, 1979 no. 1; CK li-tai hui-hua 1, 44-45. Also article by Feng Ching-ch'ang in Wen-wu, 1969.7. The composition recurs as part of the so-called *Liu-li t'ang* scroll, ascribed to Chou Wen-chü, formerly Sir Percival David Collection, now Metropolitan Museum, N. Y. See Chung-kuo I, 23-24. See also article by Hsü Pang-ta in Mei-shu Yen-chiu 2, 1979, on the relationship and history of these two scrolls. A later copy in the Freer Gallery (16.183); See Freer Figure Ptg. cat. 14; another in Ise Senichiro, *Shina sanzui-ga shi,* Pl. 5.
* Ibid. *Wu-niu t'u:* Five oxen in varied postures. Handscroll, ink and colors on coarse yellow-toned hemp paper. Attributed to the artist in a colophon by Chao Meng-fu. Palace seal of the Shao-hsing era (1131-63) and of the Jui-ssu Tung-ko; also seals of Hsiang Yüan-pien and other later collectors. Copy of T'ang work? See CK ku-tai 12; CK shu-hua I, 1-5; KKPWY ts'ang-hua II, 19-21; T'ang-tai jen-wu 51; TWSY ming-chi 1; Wen-wu 1960, 1.4-5; *T'ang Han Huang Wu-niu t'u* (Peking: Wen-wu ch'u-pan-she, 1959); Kokyu hakubutsuin, 18; CK ku-tai hui-hua 1, 46-51. Another version in the Ohara Museum, Kurashiki; see Kodansha Suiboku I, colorplate 5 and pl. 46. This version, which is 30 per cent larger in size than the Peking version, is signed in tiny characters. The accompanying article by Yoshiho Yonezawa identifies this version with one recorded by Pien Yung-yü, and judges it to be a Sung copy, closer to the original than the Peking version. May in fact be modern fabrication.
* Liaoning Museum. The Divine Horse *(Shen-chün t'u).* A white horse, with boy rider, emerging from the water; scholar and Buddhist monk seated on stone platforms on shore; groom with hunting hawk. Title by Sung writer; various seals, including Ch'en Hung-shou. Sung or Yüan copy of T'ang work? See I-yüan to-ying, 1978 no. 3, 24-5.
Freer Gallery (16.184). Seven scholars going through the pass. Handscroll. Colophon by Chin Wen dated 1429. While this scroll is attributed to Li T'ang, the composition is similar to a scroll formerly in the Palace Museum, Peking, that was attributed to Han Huang. See Freer Figure Ptg. cat. 11.

Yale University Art Gallery (1955.38.1). Peasants moving. Handscroll. Attributed. Fine Southern Sung? copy of T'ang composition, perhaps by Han Huang. See George S. Lee, *Selected Far Eastern Art in the Yale University Art Gallery,* 1970, no. 70. Two later, poorer versions in the Freer Gallery: 16.583, and 19.175, the latter ascribed to Ch'iao Chung-ch'ang of the Sung period; see Siren CP III, 200.

British Museum. Two Bulls. A late imitation. See London Exh. Cat. 1056.

HAN KAN 韓幹

From Lan-t'ien in Shensi; lived in Ch'ang-an. Famous painter of horses. B. c. 715, d. after 781. Summoned by the emperor Hsüan-tsung to paint the imperial horses. A, 9. B. F, 5. G, 13. H, 2. I, 47. M, p. 695. See also Ho Tung-chih, *Han Kan-Tai Sung* (Shanghai, 1961, in CKHCTS series); and the article by Nagashima Ken in *Shikan* (Waseda University), no. 59.

* Taipei, Palace Museum (VA1c). A groom on horseback leading another saddled horse. Album leaf, ink and color on silk. Inscription by Hui-tsung dated 1107. Seals of Hui-tsung and later emperors. Northern Sung work? See Three Hundred M., 16; CAT 3; CKLTMHC I, 3; CK shu-hua I, 6; KK ming-hua II, 4; T'ang-tai jen-wu 34; Wen-wu 1955, 7.1 (33); Wen-wu chi-ch'eng 1; Siren CP III, 101; Han Kan-Tai Sung 3; Loehr Dated Inscriptions p. 239-40; NPM Masterpieces II, 1; III, 2. A free copy of this picture is in Laufer Cat. 5.
 Ibid. (TV8). Monkeys and Horses. Attributed. 10th century work? See Skira 71.
 Ibid. (TV9). Old Man Leading Horse to Water. Album leaf. Seals of the Cheng-ho and Hsüan-ho eras and an inscription by Ch'ien-lung. Sung copy of older picture? by Li Kung-lin follower?
 Shen-chou ta-kuan hsü II. A white elephant, a camel, a black stag, a white horse, and a small dark bull in a group, along with a pig and poultry. Hui-tsung writing and Ch'ien-lung inscription. A strange early design in late execution.
 Garland I, 4. Groom on horseback leading an unsaddled horse. Attributed. Seals of the Hsüan-ho and Cheng-ho eras. Copy? Not an early picture.
 Fujita Museum, Osaka. *Ma-hsing t'u:* The Nature of Horses. Short handscroll on silk. Signed. Seals of Sung Lo, Ch'ien-lung etc.; colophons by Wu K'uan and others. Important early horse painting.
 Freer Gallery (15.16). Envoys from the Western Countries with Three Caparisoned Tribute Horses. Handscroll, colors on silk. Inscription in the manner of Hui-tsung, dated 1114. Colophon by Mo Shih-lung. Possibly a copy after one of Han Kan's scrolls representing foreigners with tribute horses. See Han Kan-Tai Sung 4-5; Siren CP in Am Colls. 3; Freer Figure Ptg. cat. 47. The same composition is repeated with minor changes in a later picture in the same museum (19.11), in a version ascribed to Ch'ien Hsüan in the Fogg Museum (23.153), in a painting by Jen Po-wen of the Yüan period in the Asian Art Museum of S. F. (B60D100), etc.

Metropolitan Museum, N. Y. (47.18.93). Tartar Groom Leading a Horse. Title written in the manner of Hui-tsung. Long inscription by Ch'ien-lung. Short handscroll. Imitation.

* Ibid. (formerly Sir Percival David Coll., London). Shining Light of Night (Shao-yeh Po), the favorite steed of emperor T'ang Hsüan-tsung, tethered to a pole. Ink on paper. Attributed. Important early painting. Inscriptions by emperor Li Hou-chu (937-978), by Hsiang Tzu-yen dated 1138, and later men. Sung and later seals. See Siren CP III, 99-100; CK ku-tai 11; T'ang-tai jen-wu 36; Wen-wu 1958.6.27; Siren ECP I, 61-62; *Han Kan-Tai Sung* 1-2; Loehr Dated Inscriptions p. 251-52; Hills, 86.

British Museum, London (2). A White Horse. Small, fragmentary painting on silk. Attributed. Sung or Yüan?

Musée Cernuschi, Paris (196-1). Horses and groom. Handscroll, ink and colors on silk. Title and the painter's name written in the calligraphy of Li Yü or Li Hou-chu of the Southern T'ang dynasty. Attributed. See Vadime Elisseeff, "Une peinture retrouvée" in *Ars Asiatiques* III, 1958, pp. 221-227; Speiser Chinese Art III, 5; Kodansha CA in West I, 26.

See also the "Lion Piebald" *(Shih-tzu ts'ung)* painting by Li Kung-lin, said to be a copy after Han Kan. Ch'ien Hsüan's "Yang Kuei-fei Mounting a Horse" in the Freer Gallery may also be based on a composition of his.

HSIAO I 蕭繹 or Liang Yüan-ti 梁元帝

See the Tribute Bearers scroll in the Nanking Museum, under Anonymous Figure Paintings, T'ang and pre-T'ang periods; said to be a copy of his painting of this subject.

KU K'AI-CHIH 顧愷之 t. Ch'ang-k'ang 長康 , h. Hu-t'ou 虎頭

From Wu-hsi, Kiangsu. B. c. 344, d. c. 406. Famous for his portraits and figures, but painted also landscapes. A, 5. G, 1. H, 2. L, 52. M, p. 734. Z, p. 54. See also P'an T'ien-shou, *Ku K'ai-chih* (Shanghai, 1958, in CKHCTS series) (Ku K'ai-chih); Yü Chien-hua et al., *Ku K'ai-chih yen-chiu tzu-liao* (Peking: Jen-min mei-shu ch'u-pan-she, 1962) (KK-c tzu-liao); and Ma Ts'ai, *Ku K'ai-chih yen-chiu* (Shanghai: Jen-min mei-shu ch'u-pan-she, 1958) (KK-c yen-chiu). See also Ch'en Shih-hsiang, *Biography of Ku K'ai-chih* (Berkeley: Univ. of Calif. Press, 1961); and biography by John Ayers in EWA VIII, 1038-1041. Translations of the poems illustrated in the "Nymph of the Lo River" and "Admonitions" scrolls listed below were published by Hsio-yen Shih in *Renditions* no. 6, Spring, 1976, pp. 6-29.

* Peking, Palace Museum. The Nymph of the Lo River. Illustrations to a *fu* poem by Ts'ao Chih of the 3rd century. Long handscroll, colors on silk. Copy of the Sung period after archaic original. See CK ku-tai 5; Ku K'ai-chih 25-26; KK-c tzu-liao 10-26; KK-c yen-chiu 1; Li-tai jen-wu 2; Wen-wu 1958.6.21; Siren CP III, 9. Kokyu hakubutsuin, 15; CK li-tai hui-hua 1, 2-19. Various other versions of the composition, or portions of it,

exist:

*1. Freer Gallery (14.53). An incomplete version corresponding in part to the picture above. Sung copy. Formerly in the Tuan Fang Coll.; colophon by Tung Ch'i-ch'ang. See KK-c yen-chiu 3; Skira 27; Siren CP III, 9-10; Kodansha Freer cat. 34; Kodansha CA in West I, 36-37; Freer Figure Ptg. cat. 1.

*2. Liaoning Provincial Museum. Nymph of the Lo River. Handscroll. The text written in the calligraphic style of Sung Kao-tsung. Seals of Hsiang Yüan-pien; seals and title of Liang Ch'ing-piao. Perhaps the most faithful copy of the archaic original. Much damaged and repaired. Sung period. See KK-c tzu-liao 27-29; KK-c yen-chiu 2; Liaoning I, 1-12; Wen-wu 1961.6 cover.

3. Taipei, Palace Museum (VA1a). Nymph of the Lo River. Album leaf. A late copy of a section of the design. See Three Hundred M., 33; CKLTMHC I, 5; KK ming-hua I, 9.

4. Bunjin Gasen II, 3-4. Nymph of the Lo River. Formerly called Anonymous T'ang. A free adaptation of the design, Ming period?

5. Chugoku I. Nymph of the Lo River. Fragment.

6. British Museum. Nymph of the Lo River. A late, free version.

7. Formerly Agnes Meyer Coll., now Freer Gallery (68.12 and 68.22). Nymph of the Lo River. Handscroll, ink on paper, in the pai-miao manner. Yüan? Ming? copy of the entire composition. Old attribution to Lu T'an-wei. Corresponds generally in composition to the Liaoning version. See Meyer Cat. 23; Freer Figure Ptg. cat. 2.

* Peking, Palace Museum. *Lieh-nü t'u:* Four groups of famous women represented together with their parents. The title refers to a lost picture by Ku K'ai-chih which may have served as model for the present one. Handscroll, ink and colors on silk. Sung copy. See Ku K'ai-chih 11-24; KK-c tzu-liao 35-37; KK-c yen-chiu 6; Li-tai jen-wu 3; Wen-wu 1958.6.22-24; CK li-tai hui-hua 1, 20-32.

Ibid. Making a ch'in. Handscroll. Sung copy of a design traditionally attributed to Ku K'ai-chih. See KK-c tzu-liao 38; I-shu ch'uan-t'ung VII, 12.

Tofuku-ji, Kyoto. Portrait of Vimalakirti. Old attribution. See KK-c tzu-liao 30.

Metropolitan Museum, N. Y. (13.100.26). Hills of Kuei-chi. Handscroll. Attributed. Late archaistic work. See Ferguson 56.

* British Museum. Admonitions of the Instructress to the Ladies of the Palace. Handscroll, now containing nine illustrations to a text by Chang Hua (232-300), portions of which are copied between the successive scenes. Two long colophons; one considered to be by Hui-tsung, the other by Ch'ien-lung, with quotations from Ku K'ai-chih's biography, etc. Numerous seals; the earliest reads "Hung-wen," the name of a department in the Han-lin College, used in the 8th century. Possibly a heavily restored early T'ang picture based on an original perhaps by Ku K'ai-chih. See Ku K'ai-chih 1-10; KK-c tzu-liao 1-9; KK-c yen-chiu 4; Li-tai jen-wu 1; T'ang-tai jen-wu 4-5; Skira 14; Siren CP III, 11-15; Kokka 908-9 and accompanying article by Hironobu Kohara; Kodansha CA in West I, 33-35. Also Kazuchika Komai, in *Tohogaku* 43, Jan, 1972. For a later dating

(10th-early 11th century) see Michael Sullivan, "A Further Note on the Date of the Admonitions Scroll," in *Burlington Magazine,* Oct. 1954, pp. 307-309. Printed as a reproduction scroll by Benrido (Kyoto: 1966) and published by the British Museum.

Peking, Palace Museum. Admonitions of the Instructress. Another version in a copy ascribed to an anonymous Sung artist. See KK-c yen-chiu 5; Wen-wu 1961.6.8-9.

LI CHAO-TAO　李昭道

Son of Li Ssu-hsün. Called the Little General Li. Active c. 670-730. Landscapes with buildings and figures in the gold, blue and green manner. A, 9. B (under Li Ssu-hsün). G, 10. H, 2. I, 46. L, 42. M, p. 184. Y, p. 86.

Peking, Palace Museum. Dragon-Boat Race. Fan painting. Attributed. Yüan or later work. See Sung-jen hua-ts'e A, 100; B, VI, 3.

Taipei, Palace Museum (TV18). The Ch'u River. Wooded Mountains; extensive palaces along the winding waters. Poem by Ch'ien-lung. See Ku-kung 17; KK chou-k'an 203; Siren CP III, 81.

Ibid. (TV5). Travellers in the Mountains in Spring. Late Ming mannered copy of the Emperor Ming-huang's Journey to Shu composition; cf. the better-known version in the same collection (SV137), listed under Anon. T'ang. See Ku-kung 26; KK chou-k'an 320; Three Hundred M., 4; Siren CP III, 82; London Exh. Chinese Cat. p. 18.

Ibid. (TV6). The Lo-yang Tower. Album leaf. Colophon by Tung Ch'i-ch'ang. Yüan or early Ming work. See KK shu-hua chi 32; KK ming-hua I, 3; London Exh. Chinese Cat. p. 17.

Ibid. (TV4). Horsemen by a Lake. Ming archaistic picture. See Three Hundred M., 32; KK ming-hua II, 2.

Ibid. (VA11a). The Lien-ch'ang Palace. Album leaf. Attributed. Southern Sung?

Fujii Yurinkan, Kyoto. Mountains in Spring. Handscroll, gold and green colors. Colophon signed Hsi-ya (Li Tung-yang of the Ming period). Late imitation. See Yurintaikan II. The same? in Ise Senichiro, *Shina sanzui-ga shi,* and Naito 22.

Boston Museum of Fine Arts (20.1830). The Chiu-ch'eng Palace. Fragment of a late imitation. See Portfolio I, 143; *Ars Asiatica* vol. I (1913).

Freer Gallery (09.217). *Hai-t'ien hsü-jih t'u:* Dawn Over Islands in the Ocean. Handcroll in the blue and green manner on silk. Other versions of the composition exist, most of them ascribed to Li Chao-tao (cf. 11.175 in the same collection).

Metropolitan Museum, N. Y. (18.124.9 and 29.100.478). Two archaistic paintings. Handscrolls in the blue and green manner. Late imitations. See Alan Priest's article in their *Bulletin,* March 1951.

Laufer Cat. 2. River Landscape with Cottages and Mountains in Snow. Attributed. A late and darkened picture on silk.

LI CHEN 李眞 or Li Shen 李紳
Active c. 780-804. Not recorded in the Chinese books on painters. Mentioned in the *Ching-lo ssu-t'a chi* as having done wall paintings in Buddhist Temples. Y, p. 88. See also Wen-wu 1976.3 31-36.

* Toji, Kyoto. Portraits of five patriarchs of the Shingon sect of Buddhism: Pu-k'ung chin-kang 不空金剛 or Amoghavajra; Hui-kuo 惠果 ; Shan-wu-wei 善無畏; Chin-kang-chih 金剛智 ; and I-hsing 一行 . The pictures were brought to Japan by Kobo Daishi in 804. Only the first-named portrait is relatively well preserved; the others are much worn so that only minor portions of the figures remain. See T'ang-tai jen-wu 48; Siren CP III, 113; Toyo Bijutsu 6 (all Amoghavajra only); Toso 3-4; Kokka 198, 344-345.

LI SSU-HSÜN 李思訓 t. Chien-chien 建見
Member of the T'ang imperial family. Born 651, died 716. Became a general. Landscapes in a detailed, heavily colored manner. Considered to be the founder of the "Northern School." A, 9. B. G, 10. H, 2. I, 46. L, 42. M, p. 184. Y, p. 84. Also Chin Wei-no, "Li Ssu-hsün yü Li Chao-tao," Wen-wu 1961.6; and biog. by Michael Sullivan in EWA IX, p. 266 ff.

Peking, Palace Museum. Palaces in a landscape. Handscroll. Attributed. Spurious colophons of Ni Tsan, Wang Meng, etc. Archaistic Ming work. (Probably the same as the picture in KKPWY ts'ang-hua II, 24-25.)
* Taipei, Palace Museum (TV3). *Chiang-fan lou-ko t'u:* boats on the river, leafy trees along the shore, large red buildings and figures on the opposite side. Attributed. Seals of the Sung period (Chi-hsi T'ien-pao) and of An I-chou. Sung copy after an earlier painting? See Three Hundred M., 3; CKLTMHC I, 2; KK ming-hua I, 2; Wen-wu 1961.6.14.
Fujii Yurinkan, Kyoto. River Landscape. Steep mountains with trees; fishing boats on the water. Handscroll, colors on silk. Attributed to Li Ssu-hsün in an inscription by the collector P'ei Ching-fu. A strange picture, probably of the early Ming period, cf. Shih Jui. See Yurintaikan II.
Freer Gallery (11.170). Palaces and gardens on Fang-hu, one of the three Islands of the Immortals. Fantastic buildings, brightly colored trees, blue mountains and white clouds. Handscroll. Late imitation.
Ibid. (17.99). Palaces Among Green Hills. Attributed. Ming, school of Ch'iu Ying.

LIANG LING-TSAN 梁令瓚
From Szechwan. Active during the K'ai-yüan era (714-742). Calligrapher, figure painter. M, p. 391. The handscroll depicting the "Five Planets and Twenty-eight Constellations" in the Osaka Municipal Museum, originally attributed to Chang Seng-yu, is sometimes ascribed to him; see under CHANG SENG-YU.

LIANG YÜAN-TI
See Hsiao I.

LIU SHANG 劉商　t. Tzu-hsia 子夏 .
From P'eng-ch'eng, Kiangsu. Chin-shih during the reign Ta-li of the emperor
Su-tsung (766-779). Pupil Of Chang Tsao 張藻 . Pine trees and rocks;
also figures. A, 10. B. H, 2. M, p. 655. Y, p. 345.

Ars Asiatica I, p. 2-3. A full-length portrait of a tall official with folded hands.
According to J. C. Ferguson, *Chinese Painting,* p. 66-7, the picture
represents Kuo Tzu-i, the T'ang general, who is also represented in a
similar painting in the St. Louis Museum. The inscription at the top, in
which the picture is said to represent Lü Tung-pin, was probably written
for another picture. Yüan period?

LU HUNG 盧鴻　or Lu Hung-i 盧鴻一 , t. Hao-jan 顥然 or
浩然
From Yu-chou, Hopei. Active in Loyang in the K'ai-yüan era (713-742); later
retired to his country home on Mt. Sung, which he described in poems and
represented in a series of pictures. A, 9. G, 10. H, 2. M, p. 676. Y, p. 369.

* Taipei, Palace Museum (TH3). *Ts'ao-t'ang shih-chih:* Ten Views from a
 Thatched Lodge. Ten pictures representing scenes of the region on Mt.
 Sung where Lu Hung's residence was situated. Not executed before the
 Yüan or early Ming period, but probably based on originals by Lu Hung.
 Colophons by Yang Ning-shih (947), Chou Pi-ta (1199), Kao Shih-ch'i
 and Ch'ien-lung. See KK chou-k'an, special volume 1930; CAT 4; Three
 Hundred M., 5-14; CH mei-shu I; CKLTMHC I, 4; also published as an
 album by Yen-kuang-shih, 1929. See also the article by Chuang Shen on
 this scroll in the *Bulletin* of the Inst. of History and Philology, Academia
 Sinica, XXX, 1960; Siren, *Chinese Gardens,* Pl. 83. Other versions of
 these pictures, sometimes ascribed to Li Kung-lin, in the Abe Collection
 of the Osaka Municipal Museum, possibly by the Yüan period artist Li
 Sheng, q. v. See Soraikan II, 26; Osaka Cat. 70; Kokka 585; Chugoku I.
 A copy of the first scene in the Freer Gallery (17.109).
Freer Gallery (16.401). Moonlit Landscape with Arriving Scholar. Fine work
 of late 15th or early 16th century date, Che school; unrelated to Lu Hung.
 See Cahill, *Parting at the Shore, pl. 63.*
Note: The composition of the Anonymous "Immortals' Dwellings on Pine-hung
 Cliffs" *(Sung-yen hsien-kuan)* in the Taipei Palace Museum (SV136) has
 been associated with Lu Hung by Li Lin-ts'an; see his article in *Ta-lu tsa-chih* XXII, no. 2, Jan. 1961.

LU LENG-CHIA 盧稜伽　or 楞伽
A native of Ch'ang-an. Often mentioned as Wu Tao-tzu's most important

pupil. Active c. 730-760. Executed wall-paintings in Buddhist temples in Ch'ang-an, Loyang, and later Ch'eng-tu. Also painted other religious pictures. A, 9. B. C, 1. G, 2. H, 2. I, 46. L, 9. M, p. 675. Y, p. 368.

* Peking, Palace Museum. Buddhist Arhats with Attendants and Worshippers. Six large album leaves from an original album of sixteen. Signed. Fine Southern Sung works, cf. paintings ascribed to Liu Sung-nien. See I-shu ch'uan-t'ung V; KKPWY ts'ang-hua II, 26-31; Wen-wu 1960.1.2; Siren CP III, 89; CK li-tai hui-hua 1, 58-69.
Chung-kuo MHC 40. Buddha with an attendant. Imitation.
Osaka Muncipal Museum (Abe Coll.). A holy man in monk's garments and Taoist tiara standing on a billowing stream. The painter's name inscribed in the manner of Hui-tsung. Possibly a Ming painting. See Soraikan I, 2; Osaka Cat. 4.
Yale University Art Gallery (Moore Coll.). Emperor Wu with Three Attendants. Copy. See Moore Cat. 20.

PIEN LUAN　邊鸞
Worked at the court in Ch'ang-an c. 785-802. The most important bird painter of the period. A, 10. B. G, 15. H, 2. I, 47. L, 18. M, p. 720. Y, p. 388.

Chang Ta-ch'ien Collection. A dove on a branch. Album leaf. Imitation.
Toso 6 (Ts'ai Shih-an Coll.). Sparrows among bamboo, camelia and plum blossoms. Inscription in the manner of Hui-tsung. A late imitation.

TAI I　戴嶧
Younger brother of Tai Sung. 8th century. Famous also for pictures of buffaloes. A, 10. G, 13. H, 2. I, 47. L, 54. M, p. 714. Y, p. 387.

Taipei, Palace Museum (VA2c). Two fighting water-buffaloes. Album leaf. Copy of the same composition as the painting ascribed to Tai Sung in the same collection. See KK ming-hua I, 5.
Kyoto National Museum (Ueno Coll.). One Hundred Buffaloes in a Landscape. Handscroll, color on silk. Attributed. Ming work by a Che school artist.
Hikkoen 11. Herd-boys and buffaloes on a reedy shore under a willow. Album leaf. Attributed. Late Sung picture?

TAI SUNG　戴嵩
Eighth century. Served as an official under Han Huang when Han was governor of Chekiang, and became his pupil in painting. Specialized in pictures of buffaloes. A, 10. B. G, 13. H, 2. I, 47. L, 54. M, p. 714. Y, p. 385. See also Ho Tung-chih, *Han Kan-Tai Sung* (Shanghai; 1961, CKHCTS series). (Han Kan-Tai Sung.)

Wen-wu, 1978.5.89 and pl. 6. One hundred buffalo in a landscape. Hand scroll. Fragmentary signature reading "Tai"; colophon (spurious?) by Tung Ch'i-ch'ang attributing it to Tai Sung. Late Sung work?

Taipei, Palace Museum (TH17). Two Fighting Water-buffaloes. Short handscroll, ink and light brown color on paper. Spurious signature. Poem by Ch'ien-lung, seals of Hsiang Yüan-pien and Ch'ien-lung. Late copy. See Li-tai I; Three Hundred M, 19; Siren CP III, 104; Han Kan-Tai Sung 7. A still later version of the same picture, ascribed to Tai I, is in the same collection (VA2c).

Ibid. (VA1e). Buffalo cow and calf grazing. Large album leaf. Possibly a Sung copy after a picture by the master. Seals of Liang Ch'ing-piao.

* Boston Museum of Fine Arts. Herd-boy mounting a water-buffalo. Fan painting. Old attribution to Tai Sung; fine work of the 12th or 13th century. See BMFA Portfolio I, 140.

Metropolitan Museum, N. Y. (47.18.118). One Hundred Buffaloes. Dated 763. Copy.

Berlin Museum. Two buffaloes by a grove of windswept trees. Fan painting. Signed. Possibly a late Sung picture. See London Exh. Cat. 920; Berlin Cat. 1970, no. 26; Bunjinga suihen II, 43.

Cheng Te-k'un Coll., Cambridge. Two buffaloes and a herd-boy in winter. Album leaf. Attributed in a title purportedly by Hui-tsung.

WANG WEI 王維　t. Mo-ch'i　摩詰
From T'ai-yüan. B. 699, d. 759. Often alluded to by official title, Yu-ch'eng. Best known as a poet and a landscape painter, but also did Buddhist and Taoist pictures. A, 10. B. F, 5. G, 10. H, 2. I, 47. L, 27. M, p. 28. Y, p. 13. See also Ho Lo-chih, *Wang Wei* (Shanghai, 1959, in CKHCTS series) (Wang Wei); Umezawa Waken, *Nanso Gaso O Makitsu* (Kyoto: 1929); Chuang Shen, *Wang Wei yen-chiu,* Hong Kong, 1971; biog. by Wai-kam Ho in EWA XIV, 825-828; and Hironobu Kohara et. al., *O I* (Wang Wei, Bunjinga suihen vol. I), 1975.

Taipei, Palace Museum (TH5). *Shan-yin t'u:* a man and his servant on a river shore, another man in a boat; willows and other trees. Short handscroll, ink and heavy colors on silk. Attributed. Colophon purportedly by Mi Fu with the date 1102. Archaistic picture of Yüan or later date, perhaps after an earlier design.

* Ibid. (TH6). Snow over the Mountain Stream. Handscroll. Attributed. Colophons by Shen Chou, Wang Ao and Tung Ch'i-ch'ang. Fine Sung work of Chao Ling-jang school; probably the source for the composition of the last half of the scroll now in the Honolulu Academy of Arts, see below. See Bunjinga suihen I, 64.

Ibid. (TV13). Sharply outlined mountains and bare trees by a river in snow. Attributed to Wang Wei in a poem by Ch'ien-lung, but probably not executed before the late Ming period. See London Exh. Chinese Cat., p. 19; Three Hundred M., 31; Siren CP III, 98; KK chou-k'an 288.

Ibid. (TH14, chien-mu). A Thousand Cliffs and Myriad Valleys. Handscroll. Signed. Interesting work of late Ming date, cf. Wu Pin.

Chung-kuo I, 2. (Formerly Manchu Household Coll.). River Scenery with cottages and a boat in snow. The inscription in the manner of Hui-tsung may have been transferred from another picture. Colophons by Tung Ch'i-ch'ang and Ch'ien-lung. Much later work. See also Wang Wei 9; Siren CP III, 97; Chung-kuo MHC 23.

* Ibid. I, 3. (Formerly Manchu Household Coll.). Two Scholars Playing Chess. Inscription in the manner of Hui-tsung. Important early work? The attribution of this picture to Wang Wei may be an error for Wang Ch'i-han, since the composition is related to paintings ascribed to him. See also Chung-kuo MHC 31.

I-yüan Album (T'ung-yin-kuan Coll.). *Kuan-shan chi-hsüeh t'u:* Clearing after Snowfall on the Mountains. Deeply creviced mountains and large trees along a river in winter. Possibly after a design by Wang Wei, but not executed before the Ming period.

S. H. Hwa Collection, Taipei. Buildings and figures among hills. Fragmentary handscroll on very dark silk. Attributed. Early picture?

Garland I, 5. Pines and Mountains after Snow. Handscroll. Old attribution.

* Osaka Municipal Museum (Abe Coll.). Fu Sheng Expounding the Classic. Short handscroll. Inscription by Emperor Kao-tsung (1133). Seals of Hui-tsung, Kao-tsung and later collectors; *ssu-yin* half-seal. Fine early work (9th-10th century?) probably unrelated to Wang Wei. See Soraikan I; Bunjin Gasen II, 1; Li-tai jen-wu 6; T'ang-tai jen-wu 37; Wang Wei 7-8; Skira 18; Siren CP III, 90; Chugoku meigashu I, 4-7; Bijutsu kenkyu 100; Loehr Dated Inscription p. 248; Osaka Cat. 2; Kokka 588.

Ogawa Collection, Kyoto. Clearing after snowfall on hills by a river. Copy of the first part of the same composition as the scroll now in the Honolulu Academy of Arts, see below. 16th or 17th century in date. See Wang Wei 1-6; Siren CP III, 92-3; Siren ECP I, 56; see also Chu-tsing Li, *Autumn Colors...* in Artibus Asiae Suppl. XXI, 1965, figure 4; Bunjinga suihen I, 63. See also the article on this scroll by Wen Fong in Archives XXX.

Fujii Yurinkan, Kyoto. Fishing in a Stream in Spring. Handscroll. Inscribed with the painter's name. Poems purportedly by Wu Chen, Ni Tsan, T'ang Yin, Wu K'uan and two by Wen Cheng-ming. Late imitation. See Yurin-taikan II.

Chishaku-in, Kyoto. Waterfall. Ink on silk. Attributed. Southern Sung painting by follower of Li T'ang. See Sogen no kaiga 101; Toso 25, etc.

Freer Gallery (16.74). Snow-covered mountains by a river; houses and figures. Attributed. Ming painting, loosely in his tradition. See Bachhofer 98. Another work of the same kind in the Metropolitan Museum, N. Y. (45.170.2).

Ibid. (17.332). Hsin-p'i tugging at the Emperor's robe. Attributed. Good work of Yüan date? (cf. Liu Kuan-tao) after older (10th century?) design. Inscription by Wang Wen-chih. See article by Thomas Lawton in NPM Quarterly XI, 1.

Ibid. (19.124). Snow-covered Mountains. Handscroll. Late copy of an old composition? Two other versions in the same collection ascribed to Yen Wen-kuei (11.233 and 15.6).

Honolulu Academy of Arts (formerly Lo Chen-yu Coll.). Clearing after Snowfall on Hills by the River. Handscroll, ink and light colors on silk. Ming copy, by an artist of Wen Cheng-ming school, after two different compositions, both probably Sung in origin; cf. Palace Museum, Taipei (TH5) and Ogawa paintings listed above. The association of these compositions with Wang Wei and with the pre-Sung period is very tenuous. See Siren CP III, 94-96; Siren ECP I, 53; Ecke, *Chinese Painting in Hawaii,* II, 41; Bunjinga Suihen I, 52-53.

For various other late archaistic works of the kind ascribed to Wang Wei, see Bunjinga Suihen I.

* For rubbings supposedly of late Ming stone engraving after Kuo Chung-shu's copy of Wang Wei's Wang-ch'uan Villa scroll, see Siren CP III, 91; Bunjinga suihen I, 10-19. Painted versions of the composition include:

1. Professor Kobayashi Taiichiro, Kyoto (formerly).
2. Professor Shigeki Kaizuka, Kyoto; signature of Kuo Chung-shu.
3. Seattle Art Museum; see Lee History of FE Art, Fig. 343; Bunjinga suihen I, 13-15.
4. Freer Gallery, four versions (09.207, 09.234, 11.205 and 11.198.).
5. British Museum (attributed to Chao Meng-fu). See Bunjinga suihen I, 28-30.
6. Metropolitan Museum, N. Y. (13.220.5 attributed to Chao Meng-fu). See Laufer article in *Ostasiatische Zeitschrift* 1912, p. 28ff; also Ferguson in Ibid. 1914-1915, p. 51.
7. Cheng Chi, Tokyo. Copy by Wen Po-jen dated 1558.
8. Ishiguro Collection, Kyoto (false signature of T'ang Ti with the date 1342). See Bunjinga suihen I, 9-11.
9. Tetsubayashi Collection, Osaka (false signature of Chao Ling-jang; title by Huang I, 1777).
10. Fujii Yurinkan, Kyoto.
11. Chicago Art Institute (1950.1369). Signature of Li Kung-lin. Catalogued as "Anonymous Sung"; probably Yüan in date. See Bunjinga suihen I, 47-50.
12. Attrib. to Shang Ch'i, Yüan period. See Bunjinga suihen I, 12, 22-23.

Others in Bunjinga suihen I.

WEI-CH'IH I-SENG　尉遲乙僧

Properly pronounced Yü-ch'ih I-seng. Called the Lesser Wei-ch'ih to distinguish him from his father Wei-ch'ih Po-chih-na　跋質那　called the Greater Wei-ch'ih. Said to have been a member of the royal family of Khotan. He lived in Ch'ang-an for many years during the second half of the 7th century (and possibly until 710). Executed a number of wall paintings in the Buddhist temples, and also icons, various objects and flowers in relief. A, 9. B. G, 1. H, 2. I, 46. L, 51. Y, p. 199. See Toshio Nagahiro, "Concerning the Painter

Wei-ch'ih I-seng," in *Jimbun Kagaku Kenkyusho,* Kyoto, 25th Anniversary Commemorative Volume, pp. 251-263 (in Japanese). See also Chuang Shen, "Wei-ch'ih Po-chih-na and his Son, Painters of Khotan Ancestry in the Sui-T'ang Period," Taipei, *Bulletin* of the Inst. of History and Philology, Academia Sinica, Extra Vol. No. 4, 1960, pp. 403-454 (in Chinese with English summary). Also Chin Wei-no, "Yen Li-pen yü Wei-chih I-seng," Wen-wu, 1960.4.

Boston Museum of Fine Arts (52.256). Sakyamuni in a red mantle, stepping out of a thicket of blossoming trees. Signed: Ch'en Yung-chih respectfully copied. The picture may be a copy, purportedly executed at the beginning of the 11th century but actually much later, of an original possibly by Wei-ch'ih I-seng. See Toronto Cat. I; Laufer 1; Siren CP III, 42; Kodansha BMFA 73; Tseng, "Loan Exh. of Ch. Ptg.," pl. 1.

* Freer Gallery (14.147). Lokapala Vaisravana enthroned between two Bodhisattvas and two officials under a canopy; two musicians and a dancing girl below. Colophons by Hsiang Yüan-pien, Chang Ch'ou and I Ping-shou (all of the Ming period) attributing the work to Wei-ch'ih I-seng. The execution probably not earlier than the Yüan period. See Chung-kuo I, 5; Siren CP III, 47b; also the article by Mueller in *Ostasiatische Zeitschrift* 1920, p. 300ff. Another version of the same composition in the Taipei Palace Museum (TV7) attributed to Wu Tao-tzu; still another in the same collection attributed to Wei-ch'ih I-seng (TV17, chien-mu), a late Ming copy.

* Formerly Berenson Collection, Settignano. Women admiring a baby; musicians and dancers performing before them. Handscroll, damaged in part. Attributed. Probably a Sung painting, possibly after Wei-ch'ih I-seng. See *Dedalo,* October 1928; Siren CP III, 43; La Pittura Cinese 76-78.

* Stoclet Collection, Brussels. A scene of grief in the tent of a Central Asian chieftain. One of the women is holding a baby in her arms. Portion of a handscroll. Probably executed in the Sung period after an original in the Wei-ch'ih I-seng style. See Siren CP III, 44-46. A copy in the Freer Gallery (11.517).

WEI YEN 韋偃 or 鷃
From Ch'ang-an; lived in Szechwan. Active in the late 7th-early 8th centuries. Painted horses, pine trees and rocks. A, 10. B. C, 3. G, 13. H, 2. I, 47. M, p. 270. Y, p. 149.

Peking, Palace Museum. A Hundred Horses. Handscroll. Attributed. Late Sung or Yüan copy of older work?
Taipei, Palace Museum (VA2b). Two Riders. Album leaf. *Ssu-yin* half-seal. Attributed. Late copy. See Three Hundred M., 17.
See also the scroll in the Peking Palace Museum by Li Kung-lin, representing pasturing horses; said to be copied after a work of Wei Yen.

WU TAO-TZU　吳道子　　also called Wu Tao-hsüan　吳道玄
From Yang-chai, Honan. Active c. 710-760. Entered service as a court painter
ca. 713; served at court during the reign of Hsüan-tsung. Travelled widely and
executed wall paintings in numerous Buddhist and Taoist temples in Ch'ang-an
and Lo-yang. Also famous as a landscape painter. A, 9. B. F, 5. G, 2. H,
2. I, 46. L, 6. M, p. 158; Y., 74. See also biog. by Benjamin Rowland in
EWA XIV, 871-874; and Wang Po-min *Wu Tao-tzu* (Shanghai; 1958, in
CKHCTS series) (Wu Tao-tzu).

Note: No authentic works by the painter are extant, but some features of his
style may be preserved in stone engravings, all executed much later.
Among them are:
1. Kuan-yin Standing on Waves. Versions of this engraving exist at
 various places, e.g. at the Pei-lin at Sian and at Lin-lo shan. See
 T'ang-tai jen-wu 22; Siren CP I, 114; Wu Tao-tzu 1, for rubbings of
 this subject.
2. The Black Warrior of the North (Tortoise and Snake). Engraving
 exists at Chengtu; see Siren CP I, 112.
3. Confucius and Yen-tzu. Engraved on a stone slab in Pei-lin, Sian.
4. A Soaring Devil. Engraved on two slabs (at different times) which
 are inserted in the terrace wall in front of Tung-yo miao in Chü-
 yang, Hopei. These copies seem to have been executed in the 18th
 and early 19th centuries after wall-paintings in the temple, which
 now are in a bad state of preservation. See T'ang-tai jen-wu 17.
Zeichnüngen nach Wu Tao-tzu aus der Gotter-und Sagen-Welt Chinas, F. R. Mar-
 tin, Munich, 1913 (Juncunc Col., Chicago). Album of fifty line drawings,
 ink on paper. The album is composed of two sets of pictures, by different
 hands: one of heavenly beings and hell scenes; the other a series of
 sketches for a *Sou-shan t'u:* Clearing the Mountain handscroll (see below).
 The attribution of both to Wu Tao-tzu is arbitrary and without
 significance. See Siren CP III, 86a.
T'ang-tai jen-wu 23-24. *Sou-shan t'u:* Clearing the Mountain. Demon servants
 of a taoist magician fighting animals, serpents, etc. Other versions of the
 subject in the album in the Juncunc Collection (see above); the Princeton
 Art Museum ("Anon. Sung"); the Freer Gallery ("Li Sung" handscroll,
 17.184), and other collections. See the article by Li Lin-ts'an in *Ta-lu
 tsa-chih* XXVI no. 11.
Osaka Municipal Museum (Abe Coll.). The Birth and Presentation of the Bud-
 dha. Handscroll, ink on paper. Attributed. Seal of Sung Emperor Kao-
 tsung. The design may be taken from some wall painting by the master,
 but the picture was not executed before the Ming period. See Soraikan I;
 CK ku-tai 10; Li-tai jen-wu 5; T'ang-tai jen-wu 18-19; Wu Tao-tzu 2-7;
 Siren CP III, 86-87; Toso 5; Osaka Cat. 3; Nanga Taisei VII.
Daitokuji, Kyoto. Kuan-yin seated at the shore in Lalitasana posture. Adoring
 figures on the waves. Probably of the Yüan period. A later Japanese ver-
 sion of the same figure in the same temple. See Sogen, Appendix 19.

Ibid. Koto-in. Kuan-yin with moustache and diadem. The two landscapes with which this now forms a triptych are ascribed to Li T'ang, q.v.

Freer Gallery (11.28). The Han Emperor Chao-lieh-ti. Attributed. Inscriptions by Wang Wen-chih. Based on a stone engraving after a work by Ch'en Hung-shou of the late Ming, purportedly based on Wu Tao-tzu's design.

Ibid. (16.521). Arhat and Attendant. Good work of late Sung or Yüan date, unrelated to Wu Tao-tzu.

YANG SHENG 楊昇

Active as a court painter in the K'ai-yüan period (714-742). Famous for his portraits of the emperors Hsüan-tsung and Su-tsung and also for his landscapes painted in the "boneless" manner of Chang Seng-yu. A, 9 (name mentioned). G, 5. H, 2. I, 46. L, 23. M, p. 580. Y, p. 292.

Peking, Palace Museum. Autumn landscape. Handscroll, colors on silk. Attributed. 16th century Soochow forgery?

Taipei, Palace Museum (TH4). Snow-covered mountains and pine trees along a broad river; fishing boats on the water. Handscroll, heavy color. Colophon by Yang Wan-li (1124-1206) dated 1191. Seals of the Sung (one of Ts'ai Ching) and Yüan periods are spurious, as well as the colophons, in which the picture is praised as an example of the *mo-ku* manner by Yang Sheng. Late Ming work? See Siren CP III, 85; Loehr Dated Inscriptions p. 259.

Nanking Exhib. Cat. 5. White Clouds and Green Mountains. Attributed in the title purportedly written by Hui-tsung and dated 1114. Late work. See Loehr Dated Inscriptions p. 242.

Liu 9 (Ogawa Coll, Kyoto). River Landscape in Snow. Late imitation. The same? in Ise Senichiro, *Shina sansui ga-shi.* See Chung-kuo MHC 1 and 39 for two more late, archaistic pictures of this kind; the first attributed to Yang Sheng, the second called "Sung copy after" him.

Nanshu ihatsu. Clearing after Snow in the Mountains. Travelers on muleback passing over a bridge and through a gorge. Ascribed to the painter in a spurious "imperial" inscription. Late imitation.

Freer Gallery (19.118). Landscape with white clouds and autumn trees. Attributed. Early Ch'ing, school of Lan Ying.

Metropolitan Museum, N. Y. (47.18.124). The Broken Tree. An old plum tree in a snowy landscape. Color on dark silk. Inscribed with the painter's name. See Siren Bahr Cat. III. Interesting archaistic picture of later (Ming?) date. Other pictures ascribed to him in the same collection: 13.220.103 (Snow Landscape) and 47.18.57 (Cloudy Landscape).

Yale University Art Gallery (Moore Coll.). Landscape after a snowstorm. The title of the picture and the painter's name are inscribed in the manner of Hui-tsung; also his seal and signature. Imitation. See Moore Cat 3. Same composition as "Chang Seng-yu" landscape in Palace Museum, Taipei (TV1).

Crawford Cat. 4 (John Crawford Coll., N. Y.). Light Snow on the Mountain
Pass. Album leaf. Attributed. Catalogued as "anonymous artist of the
Northern Sung"; may be later Sung in date.

YEN LI-PEN 閻立本
From Wan-nien, Shensi. Son of the painter Yen Pi and brother of Yen Li-te.
The leading figure painter of the 7th century. B. c. 600, d. 674. Served at
court under the emperors T'ai-tsung (627-649) and Kao-tsung (650-683),
President of the Board of Works in 657, and in 668 one of the two prime min-
isters. A, 9. B. F, 5. G, 1. H, 2. I, 46. L, 40. M, p. 672. Y, p. 363. See
also Toshio Nagahiro, "Yen Li-pen and Yen Li-te," in *Toho Gakuho* XXIX,
1959, pp. 1-50; biog. by Sherman Lee in EWA XIV, 880-882; and Chin Wei-
no, "Yen Li-pen yü Wei-ch'ih I-seng," Wen-wu 1960.4.

* Peking, Palace Museum. Emperor T'ai-tsung in a sedan chair greeting three
envoys from Tibet. Handscroll. Colophon by Chang Yu-chih in which he
ascribes the painting to Yen Li-pen and says it was mounted in 641.
Nineteen other colophons. Fine Sung copy? See KKPWY ts'ang-hua II,
5-8; Wen-wu 1959.7.3; *T'ang Yen Li-pen Pu-nien t'u* (Peking: Wen-wu
ch'u-pan-she, 1959); Kokyu hakubutsuin, 17; Smith and Weng, 118-19;
article by Chin Wei-no in Wen-wu 1962, 10; article by Su Ying-hui in
NPM Quarterly vol XI no. 1; CK li-tai hui-hua 1, 36-37.
Taipei, Palace Museum (TH2). Western barbarians bringing tribute of various
kinds, such as strange animals and stones, to the Emperor. Handscroll.
Copy of the Ming period after an early original. See Three Hundred M.,
1; KK ming-hua I, 1; Siren CP III, 76; NPM Masterpieces I, 1; also an
article by Li Lin-ts'an in *Ta-lu tsa-chih* XII, no. 2.
* Ibid. (TH1). Hsiao I obtaining the Lan-t'ing Manuscript by deceit from the
monk Pien-ts'ai. Short handscroll, ink and colors on silk. Five Dynasties
work? *Ssu-yin* half-seal. See I-shu ch'uan-t'ung IV; Three Hundred M.,
2; CKLTMHC I, 1; KK ming-hua II, 1; T'ang-tai jen-wu 13; Wen-wu
1965.12, p. 14; NPM Masterpieces III, 1. See article by "Han Chuang"
(John Hay) in NPM Bulletin, V, 3 and 6. Other versions of the composi-
tion attributed to Chao Lin, Chao Meng-fu, and Ch'ien Hsüan, q.v.
Ibid. (chien-mu TH11). Foreign Rulers Bringing Tribute. Handscroll. 24
figures. Sung or later copy of old and interesting composition. A later
copy, more complete (33 figures) attributed to Ku Te-ch'ien in the same
collection (WH12).
Ibid. (chien-mu TH10). The Eighteen Scholars. Handscroll. Dated 662. Ming
copy of early composition.
Ibid. (TV2). Five scholars in a Bamboo Grove. Copy of early composition.
Nanking Exh. Cat. 3. Portrait of Vimalakirti. Attributed.
Shen-chou 3. Playing wei-ch'i in the garden. Attributed. Late copy of old
composition.
Fujii Yurinkan, Kyoto. *Sheng-hsien t'u:* Portraits of Sages. Handscroll, colors
on silk. Late copy or imitation. See Yurintaikan III.

Toso (large edition) I, 3. Misty Landscape. Handscroll. Title and artist's name in the manner of Hui-tsung. Late archaistic picture.

* Boston Museum of Fine Arts (31.643). Portraits of thirteen emperors from the Han to the Sui dynasty, each accompanied by one or more attendants. Large handscroll. The first half (six portraits) is a later restoration. Attributed to the master in several colophons of the Sung period. See BMFA Portfolio I, 10-24; CK ku-tai 9; Li-tai jen-wu 4; T'ang-tai jen-wu 5, 6, 10-14; Siren CP III, 72-75; Toso I; also Tomita article in their *Bulletin* February 1932, also vol. LIX, 1961; Kodansha BMFA, pl. 67-69; Kodansha CA in West, I. 38; Unearthing China's Past, 116. See also article by Chin Wei-no in Mei-shu chia 8, June 1979, which argues that the scroll is probably a Sung copy after a work by another early T'ang master, Lang Yü-ling.

* Ibid. (31.123). Scholars of the Northern Ch'i Dynasty Collating Classical Texts. Handscroll, ink and light colors on silk. Five colophons of the 12th century and five of later date. Only five of the twelve scholars are represented. Fine early Sung work? Unrelated to Yen Li-pen. See BMFA Portfolio I, 46-51; Siren CP III, 76-78; BMFA Bulletin August 1931; Kodansha BMFA pl. 74; Speiser Chinese Art III, 13; Unearthing China's Past 117. See also the article by Wu T'ung in *Bukkyo Bijutsu*, no. 90, Feb. 1973.

Freer Gallery (11.235). Liu Ts'un (who by killing his brother became the ruler of the Han state in 318) threatening to have his minister Ch'en Yüan-ta (who had criticized the ruler) killed; the empress intercedes to save the minister. Handscroll, colors on silk. Probably a close copy of the Ming period. Colophons by Wang Ch'ih-teng and Han Feng-hsi dated 1613. See Freer Figure Ptg. cat. 10.

Ibid. (11.220). Drunken Poets. Handscroll. Ming copy of a famous composition attributed to both Yen Li-pen and Yen Li-te.

Ibid. (16.604). The Dragon King Reverencing the Buddha. Attributed. Probably by or after Ch'en Hung-shou of the late Ming.

Note: For the Eighteen Songs of Wen-chi, which have an old attribution to Yen Li-pen, see under Anonymous Sung Figures, Horsemen and Tartar Scenes.

II.

Painters of the Five Dynasties

CHANG YÜAN 張元 (Chang Hsüan 玄)
From Chin-shui, Szechwan. Active c. 890-930. Famous for his pictures of Arhats, hence called Chang Lo-han. Imitated Wu Tao-tzu's drawing of drapery. C, 2. F, 2. G, 3. H, 2. I, 49. L, 24. M, p. 458. Y, p. 247.

Osaka Municipal Museum (Abe Coll.). The Fifth Arhat, Fa-yeh-she. According to an inscription, presented by Chang Yüan and his wife Fang to the Lung-ts'ang temple. Ming picture. See Soraikan I, 3; Osaka Cat. 7.
Metropolitan Museum, N. Y. (47.18.46). Seven Buddhist Patriarchs, accompanied by servants and acolytes in a landscape. Signed: Chin-shui shan-jen Chang Yüan hui. A colophon referring to the vicissitudes of the picture by Su Shih was originally attached, but has been replaced by a copy written by T'ai Pu-hua (1304-1352); the picture may be of the same period. See Siren Bahr Cat. 5.

CHAO KAN 趙幹
From Nanking. Member of the Academy of Painting in the reign of the South-

ern T'ang Emperor Li Yü or Li Hou-chu (reigned 961-975). Landscapes, especially scenery of the Chiang-nan region. G, 11. H, 3, p. 7. M, p. 605. Y, p. 307.

* Taipei, Palace Museum (WH4). Early Snow on the River. Landscape with fishermen and travelers. Handscroll. Title written by Emperor Chang-tsung of the Chin Dynasty (reigned 1190-1209) who, according to the colophon, received the picture from his officials. Colophons by K'o Chiu-ssu (dated 1330) and other Yüan writers. Yüan palace seal *T'ien-li chih-pao,* used ca. 1330; also *Ssu-yin* half-seal. Work of the period, probably as attributed. See Three Hundred M., 50; CAT 12; CCAT pl. 93; CK ku-tai 22; CKLTMHC I, 12; NPM Quarterly I, 2; Nanking Exh. Cat. 14; KK chou-k'an 157-163; Skira 58; NPM Masterpieces I, 3; Soga I, 4; Bunjinga suihen II, 11; also published as a scroll reproduction by the Palace Museum in 1932. See also article by John Hay in *Burlington Magazine,* May, 1972.
Ibid. (WV37, chien-mu). Misty autumn landscape. Attributed. Ming copy of old (Northern Sung?) work.
Ibid. (VA7g). Landscape. Double album leaf. "Signature." Much later work.

CHAO YEN 趙巖 . Original name Chao Lin 趙霖 , t. Lu-chan 魯瞻
Son-in-law of the emperor T'ai-tsu of the Posterior Liang dynasty (907-912). Killed by Wen T'ao when the Posterior T'ang dynasty overthrew the Liang in 923. A collector and connoisseur of paintings as well as a painter of figures and horses. F, 2. G, 6. H, 2. M, p. 605. Y, p. 306.

* Taipei, Palace Museum (WV1). *Pa-ta ch'un-yu t'u:* Eight Gentlemen on a Spring Outing. A palace courtyard, with tall trees and a rock in the background. Attributed. Fine early painting; of the period or a bit later. See Three Hundred M., 53; CAT 11; CKLTMHC I, 9; KK ming-hua II, 8; Skira 56; Wen-wu chi-ch'eng 5; NPM Masterpieces III, 4.

CHING HAO 荆浩 t. Hao-jan 浩然 , h. Hung-ku-tzu 洪谷子
From Ch'in-shui, Honan. Active at the end of the 9th and first half of the 10th centuries. Landscapes. The treatise on landscape painting *Pi-fa chi* is ascribed to him; see Kiyohiko Munakata, *Ching Hao's "Pi-fa-chi* 筆法記*: A Note on the Art of the Brush* (Ascona, 1974), Artibus Asiae Supplementum XXXI. E. F, 2. G, 10. H, 2. I, 49. L, 34. M, p. 301. Y, p. 164. Also biog. by Richard Barnhart in Sung Biiog. 24-27.

* Taipei, Palace Museum (WV2). Mt. K'uang-lu. Title written by Kao-tsung. Inscriptions on the picture by Han Yü and K'o Chiu-ssu of the Yüan period. Probably a late Sung (Chin?) work, perhaps after an old

composition. See Three Hundred M., 37; CCAT pl. 91; CK ku-tai 20; CKLTMHC I, 6; KK ming-hua I, 10; Nanking Exh. Cat. 8; Wen-wu chi-ch'eng 6; KK chou-k'an 186; Siren CP III, 144; KK shu-hua chi IV: also Fu Shen, "Two Anonymous Sung Dynasty Paintings and the Lu Shan Landscape", NPM Bulletin II, 6 (Jan.-Feb. 1968) and III, 3 (July-Aug. 1968).

Ibid. (WV3). The Joys of Fishing. Attributed. Late Sung or Yüan copy of old composition. *Ssu-yin* half-seal.

Nanshu ihatsu V (Huang Po-yu Coll.). Auspicious Mist over Mountains and Rivers. Much later work. See also Naito 29.

Lin Nan-hai Collection, Kobe. Landscape with travelers on steep cliffs. Ink on dark silk. Attributed to Ching Hao in a "Hui-tsung" inscription. Seal of Tuan Fang. Old and interesting picture.

Freer Gallery (09.168). Chung-ni Visiting the Hermit. Steep mountain gorges and travellers. Inscription by Tung Ch'i-ch'ang. Ming archaistic work by an artist in the Li T'ang tradition. See Siren ECP I, 89; CP in Am. Colls. 38.

Ibid. (09.235). Autumn landscape with two scholars seated on the shore. Signed. Good work in the tradition of Li T'ang; 14-15th century.

Nelson Gallery, Kansas City. Winter Landscape. Deeply creviced mountains with a temple and other buildings. Travellers on the winding roads; slight snow on the ground. Ink on silk with additions of white and reddish pigments; very fragmentary—reportedly recovered by excavation. Probably after an early design. The signature, reading Hung-ku-tzu, is of later date. See Kodansha CA in West, I, 1; Bunjinga suihen II, 13-14. The upper part of the composition is based on the same design as one of the pair of "Anonymous Sung" paintings in the Taipei Palace Museum sometimes connected with Ching Hao (SV150 and SV 153); see Fu Shen's article above.

CH'IU WEN-PO 丘文播 also named Ch'iu Ch'ien 丘潛 .
From Kuang-han in Szechwan. Active c. 933-965. Buddhist and Taoist figures, landscapes and buffaloes. C, 2. F, 2. G, 6. H, 2. I, 49. L, 37. M, p. 73. Y, p. 41.

Taipei, Palace Museum (WV23). A Literary Gathering: Scholars in a landscape. The figure group copied from a section of the "Yen Li-pen" Scholars of the Northern Ch'i Collating Classical Texts scroll in the Boston Museum of Fine Arts. An archaistic landscape has been added. Ming period pastiche. See Ku-kung I; Three Hundred M., 56; CKLTMHC II, 35; KK ming-hua II, 18; KK chou-k'an 306; NPM Masterpieces III, 6.

Li-ch'ao pao-hui, 3. Arhat seated beneath banana palms reading a scroll. Signed.

CH'IU YÜ-CH'ING　丘餘慶
Son of Ch'iu Wen-po. Active c. 933-965. Flowers, bamboos, birds and insects. Followed T'eng Ch'ang-yu. C, 2 (under Ch'iu Wen-po). F, 4. G, 17. H, 2. I, 49. K, 20. L, 37. M, p. 73. Y, p. 42.

Chung-kuo I, 77 (Formerly Manchu Household Coll.). Birds on the branches of blossoming trees. Colored handscroll. Signed with the painter's name. Much later work. See Chung-kuo MHC 29.
Sogen 19 (Tan Mou-hsin Coll.). Two White Swans by a Rockery. Title written in the manner of Hui-tsung.
Freer Gallery (17.342). Flowers and insects in color. Inscribed with the painter's name. Fine work of early Ming date.

CHOU WEN-CHÜ　周文矩
From Chü-jung, Kiangsu. Served as tai-chao at the court of Li Hou-chu, ruler of the Southern T'ang dynasty (961-975). Very prominent figure painter; imitated Chou Fang. D, 1. F, 3. G, 7. H, 3. I, 49. K, 21. L, 36. M, p. 243. Y, p. 139. Also biog. by J. Cahill in Sung Biog., 28-31.

Peking, Palace Museum. A fairy riding on a phoenix. Fan painting. Attributed. Sung or later work. See Fourcade 23; Sung-hua shih-fu 4; Sung-jen hua-ts'e A, 1; B, I, 1.
Chung-kuo hua XI, 10-11 (Tso Hai Coll.). Yang Kuei-fei mounting a horse. Handscroll. Ming work.
* Taipei, Palace Museum (WH1). The parting of Su Wu and Li Ling in Mongolia where the former is tending sheep. Short handscroll. Several colophons in which the picture is attributed to Chou Wen-chü. Sung painting in Liao-Chin tradition. See CAT 9; KK ming-hua II, 14; NPM Masterpieces III, 7 (det.); also "The Freer 'Sheep and Goat'," fig. 16.
Ibid. (WH2). Ming-huang Playing Chess. Short handscroll, color on silk. Seal of Kao-tsung. Attributed. *Ssu-yin* half-seal. Crude, late version of early composition. See Three Hundred M., 51; CKLTMHC I, 10.
Taipei, Palace Museum (WH10, chien-mu). The Seven Sages Crossing the Barrier. Handscroll. Signed. Copy of early work?
Ibid. (chien-mu WH11). A Gathering of Immortals. Handscroll. Ch'ing copy of earlier work.
Ibid. (chien-mu WV30). Ladies in a pavilion by a lotus pond. Hanging scroll. Signed. Ming copy of earlier work.
Ibid. (VA3c). Ladies Playing Music. Fan painting. Attributed. Southern Sung or later. See NPM Masterpieces II, 6.
Ibid. (VA12b). Watching Ducks at the Pavilion. Fan painting. Attributed. Southern Sung or later.
Ibid. (WV8). Lady seated beneath a tree with a cat. Attributed. Ming period?
* *Note:* The "Palace Concert" in the same collection, YV145, is sometimes associated with Chou Wen-chü on the basis of style; see under Anonymous, pre-Sung.

Kwen Cat. 59, I. Two girls seated on a mat; one playing the harp, the other the flute. Album leaf. Imitation.

Osaka Municipal Museum (Abe coll.). Court Lady Walking. Hanging scroll, ink and color on silk. See Osaka Cat. 10; Soraikan I, 7.

Toso 19 (Kuan Mien-chün Coll.). Kuan-yin in a white robe seated on a rock. Later imitation. See also Chung-kuo MHC 28.

Boston Museum of Fine Arts (12.897). A child among rose-mallows. Fan painting. Southern Sung. See BMFA Portfolio I, 38; Siren CP III, 130.

* Chicago Art Institute (50.1370). *Ho-lo t'u:* concert by an orchestra of ladies. The central person in the audience, a bearded man, is placed on a dais at the opposite end of the picture. Short handscroll, attributed to Chou Wen-chü in an inscription written in the manner of Hui-tsung. Fine later version of an early composition. See Siren CP III, 126-128; Artibus Asiae XXXI, 1, 1969.

* Fogg Museum (1945.28); Cleveland Museum (76.1, formerly University Museum, Philadelphia); former Berenson Collection; Metropolitan Museum of Art, New York (former Sir Percival David Collection, London). Four sections of a handscroll, ink and touches of color on silk, depicting Court Ladies. Attributed. Colophon (on Cleveland section) by Chang Ch'eng dated 1140. Late Northern Sung copy of earlier composition? See Bijutsu kenkyu 25 and 56 for the whole, with articles by Yashiro Yukio; Loehr Dated Inscriptions p. 252; Siren CP III, 131 (2 sects. of the Fogg section); Munich Exh. Cat. 7 (detail of David section); Cleveland Mus. Bulletin, Feb. 1977 (detail of Cleveland section). A Japanese copy of the whole in the Metropolitan Museum, N. Y. (42.61).

Freer Gallery (11.486). A scholar seated by a table in his study occupied in cleaning his ear. A boy is bringing tea. The composition is a simplified version of Wang Ch'i-han's illustration of this motif, Yüan-Ming in date. See Kodansha CA in West, I, 62; Freer Figure Ptg. cat. 13.

* Ibid. (35.8 and 9). Two fan paintings: three women washing children in tubs; and two women, each attended by a maid. Southern Sung works. See Freer Album Leaves, frontispiece and pl. 1; Kodansha Freer, p. 160; Freer Figure Ptg. cat. 52-53. TWSY ming-chi 91 (first leaf). The first picture exists also in a version in the Metropolitan Museum (40.148) ascribed to Chou Fang, q.v.; the second in a number of versions with palace or garden setting; see Shen-chou 5 (att. Chou Wen-chü); T'ien-lai-ko; Erh-shih chia; etc.

* Ibid. (11.195). *Chung-p'ing t'u:* Emperor Li Yü and his brothers playing chess in front of a "double screen." Handscroll. Attributed. Early copy? See Freer Figure Ptg. cat. 3. Another version, of later date (late Sung or Yüan?), in the Peking Palace Museum; see Chung-kuo hua VII, 14; CK ku-tai 26; Li-tai jen-wu 14; NPM Bulletin I, 2, 4; Gugong Bowuyuan Yuankan 2, 1979, pl. 3; CK li-tai hui-hua 1, 96-97.

Philadelphia, University Museum. A lady beneath tall bamboo. Fan painting. Attributed. Southern Sung period. See Southern Sung Cat. 24. Another version in the Yale University Art Gallery (1952.52.25d). See Yale Cat. no. 74.

* Worcester Art Museum (1936.4). Palace Musicians. Women musicians playing before the emperor. Short handscroll. Poem and colophon by Shen Chou, dated 1507, who attributes the picture to Chou Wen-chü. Two poems by Li Po are copied by Wu Yung-kuang (1773-1843). Ming work. See George Rowley, "A Chinese Scroll of the Ming Dynasty: 'Ming Huang and Yang Kuei-fei Listening to Music,'" Worcester Art Museum *Bulletin* II, 1936 and 1937. (Reprinted with illustrations in Artibus Asiae XXXI, 1, 1969.)

British Museum. Ladies and children on a terrace. Handscroll. Copy or imitation. See Siren ECP I, 82; Cohn Chinese Ptg. 48; La Pittura Cinese 122.

Ibid. (Formerly J. D. Ch'en Coll., H. K.). Resting from Embroidery Work. One woman is resting in bed, while two are seated by the embroidery frame and two servants are standing by. Handscroll. Copy. The composition is sometimes ascribed to Chou Fang. See Siren CP III, 129; Artibus Asiae XXVII, 1965, p. 263, fig. 18. Other versions exist.

* Metropolitan Museum, New York (Formerly Sir Percival David Coll., London). Men assembled in the Liu-li Hall. A group of seven scholars and a monk; some are seated at a table, others on a stone bench by a tree. Handscroll. The latter part of the picture is a free version of the composition attributed to Han Huang now in the Peking Palace Museum. The painter's name and the title of the picture written in the style of Hui-tsung. Yüan-Ming copy. See also Chung-kuo MHC 33; Chung-Kuo I, 23.

CHÜ-JAN 巨然

A monk of the K'ai-yüan temple in Nanking. Active c. 960-980. Went with Li Hou-chu, the last ruler of the Southern T'ang dynasty, to pay his respects to the Sung emperor in K'aifeng, and settled there as a monk in the K'ai-pao temple. Landscapes, followed Tung Yüan. D, 2. F, 4. G, 12. H, 3. I, 52. K, 36. L, 64. M, p. 67. Y, p. 37. See also Fu Shen's article in NPM Quarterly II/2, p. 51ff; and biog. by S. Ueda in Sung Biog., 31-33.

* Shanghai Museum. *Wan-ho sung-feng t'u:* A Myriad Ravines, Wind in the Pines. Mountain landscape with men in elaborate pavilions along the rapids. Yüan-Ming work, after early original. See Chung-kuo hua XV, 9; Shang-hai 1; TSYMC hua-hsüan 4; Wen-wu 1961.1.39; Chugoku Bijutsu p. 79. Another, later version of the composition in the British Museum; see Oriental Art, Autumn 1962, p. 116 and Michael Sullivan's article in *Apollo,* June 1962.

* Taipei, Palace Museum (WV12). Snow Landscape. Painter's name and the title written by Tung Ch'i-ch'ang. Yüan period or later, copy of earlier composition? *Ssu-yin* half-seal. See KK shu-hua chi IV; Three Hundred M., 133; CH mei-shu I; CKLTMHC I, 19; KK ming-hua II, 13; Nanking Exh. Cat. 13; Soga I, 24; Wen-wu chi-ch'eng 15; KK chou-k'an 183; also Richard Barnhart, "The 'Snowscape' Attributed to Chu-jan," Archives XXIV pp. 6-22, where it is tentatively ascribed to a Southern Sung artist named Feng Ch'in, q.v.

Ibid. (WV13). Autumn Mountains. River landscape in autumn with a central mountain peak. Colophon by Tung Ch'i-ch'ang, in which he refers to a copy of the picture by Yao Shou. Seal of Wu Chen, and in his style; probably his copy of an older composition. See KK shu-hua chi 43; Three Hundred M., 45; CKLTMHC III, 46; KK ming-hua II, 11; Nanking Exh. Cat. 12; Wen-wu chi-ch'eng 16.

* Ibid. (WV14). Asking about the Tao in the Autumn Mountains. Hills covered by grass and leafy trees; a path leads from a homestead at their foot, in which two men are talking, to a temple seen dimly in the upper left. *Ssu-yin* half-seal. Yüan work in the Chü-jan tradition? See KK shu-hua chi 6; Bunjin Gasen II, 1; Three Hundred M., 44; CAT 15; CCAT, pl. 92; CKLTMHC I, 18; CKLTSHH; CH mei-shu I; KK ming-hua I, 14; Wen-wu chi-ch'eng 14; KK chou-k'an 44; Siren CP III, 168; Soga I, 1-2.

* Ibid. (WV15). Mountain Stream between Wooded Shores. Seal of the Hsüan-ho era; *ssu-yin* half-seal. Poem by Ch'ien-lung. Colophon by Chu I-tsun (17th century). Yüan period? Cf. paintings ascribed to Chiang Ts'an. See KK shu-hua chi 5; Three Hundred M., 48; CKLTMHC II, 25; KK ming-hua II, 12; KK chou-k'an 184.

Ibid. (WV16). Wintry Grove at Dusk. Poems and colophons by writers of Yüan and later times. Probably a Yüan painting. See KK shu-hua chi 21; KK chou-k'an 302; London Exh. Chinese Cat. p. 35.

* Ibid. (WV17). Layered Mountains and Dense Trees. Two mountain peaks with a path through a tree-covered valley. *Ssu-yin* half-seal. Inscriptions by Tung Ch'i-ch'ang and Wang To. Attributed. Fine Southern Sung work? See Three Hundred M, 46; CH mei-shu I; CK ku-tai 28; CKLTMHC I, 17; KK ming-hua I, 15; Wen-wu 1955.7.2 (34); NPM Masterpieces V, 3; Bunjinga suihen II, 9.

Ibid. (WV18). Cherished Companions: Lute and Crane. Pavilions under pine trees by a mountain stream. Probably by Wu Chen or some closely related Yüan artist. See KK shu-hua chi 44; Three Hundred M., 49; CKLTMHC III, 39; Siren CP III, 88.

Ibid. (WV36, chien-mu). The Fu-ch'un Mountains. Attributed. Yüan or early Ming work of good quality. *Ssu-yin* half-seal.

* Ibid. (SV172). Hsiao I Searching for the Lan-t'ing Manuscript. Mountain landscape with a temple in a gully; a man on horseback approaches the temple. Traditionally attributed to Chü-jan. Southern Sung? See Ku-kung 38; Three Hundred M., 47; CKLTMHC II, 69; KK ming-hua I, 16; Soga I, 3; Bunjinga suihen II, 4.

Ibid. (WH3). Pine Cliffs and Temples. Handscroll. Attributed. Highly mannered, much later work.

Ibid. (WH16, chien-mu). Dwelling in the Mountains. Handscroll. Attributed.

Ibid. (VA7a). Landscape. Double album leaf. 17th or 18th century picture, related to Wang Shih-min.

Ibid. (VA3d). Carrying the Staff in Autumn. Album leaf. Ming, in Southern Sung style?

Ibid. (VA13b). Asking the Way at the Mountain Pavilion. Album leaf. Fragment of a Yüan or early Ming painting.

Pao-yün 2 (Formerly Peking National Museum). The Mountain Abode. Short handscroll. Signed.

Chin-k'uei I, 3 (Formerly J. D. Ch'en Coll., H. K.). Towering mountains with rich growth, temples and houses. A very large, damaged picture. Probably a modern fabrication based on another version of the composition in the Freer Gallery (19.137) attributed to Tung Yüan but actually Yüan or Ming dynasty in date. See also Wen-wu 1964.3.18.

Ibid. I, 4 (Formerly J. D. Ch'en Coll., H. K.). River Scenery in Evening. Thickly wooded high mountains with buildings in the clefts and on the flat shore. Long handscroll. *Ssu-yin* half-seal. Imitation. See also TWSY ming-chi 4-7; Siren CP III, 170.

Formerly J. D. Ch'en Collection, Hong Kong. Wooded hills, a path winding into the distance. Ink and light colors on silk. Attributed. Good Yüan or early Ming work in this tradition?

Garland I, 9. Temple in the Mountains. Inscription by Wang To. Late imitation.

Fujii Yurinkan, Kyoto. Trees in a valley; hills above. Ink on silk. Inscription in the manner of Hui-tsung. Cheng-ho and other seals. Early Ch'ing work? Probably the original of the "Wang Hui" copy in the Earl Morse Collection, N. Y. (See *In Pursuit of Antiquity,* no. 15). See Yurintaikan III.

Ibid. A returning boat on a river with high banks. Fragment of an interesting composition. *Ssu-yin* half-seal; colophons by Tung Ch'i-ch'ang and Ch'en Chi-ju, attributing it to Chü-jan. See Nanshu ihatsu 5; Toso 32.

* Osaka Municipal Museum. Distant Peak over Floating Clouds; an inn in a river valley at the foot of high mountains. Possibly a Sung picture, but not in the style of Chü-jan. Hanging scroll, ink and light color on silk. Signed. See Osaka Cat. 15; Nanshu ihatsu 5; Soraikan II, 7.

Nanshu ihatsu 1. Cloudy Peaks and Winding Streams. Large pavilions on the misty slopes. Illustration to a T'ang poem. Imitation.

Ibid. 5. Low hills and tall trees by a stream. Inscription by Wu Chen, dated 1350. Possibly a Yüan picture.

Shoman (Hashimoto Coll.). River landscape with large pine trees on the shore. Part of a long handscroll. Minor Ming work, not in Chü-jan style.

Toan 5 (Formerly Saito Col., now Cheng Chi, Tokyo). High wooded mountains, temples in the gully, buildings on the riverbank. Signed. Seal of the Yüan period. *Ssu-yin* half-seal (spurious?). See also Nanshu ihatsu 5; Siren CP III, 169.

Kikuchi Collection, Tokyo. Wooded Mountains with Streams. A winding river below. Long handscroll, ink on silk. Ming work. Reproduced in scroll form by Otsuka Kogeisha, Tokyo.

* Cleveland Museum of Art (59.348). Buddhist Monastery by Stream and Mountains. Ink on silk. Attributed. Southern Sung work? See Siren ECP I, 97; Lee Landscape Painting 13; Lee Colors of Ink cat. 1; Bunjinga suihen II, 10, Contag, Chinese Masters, pl. 1.

* Freer Gallery (11.168). A Panorama of the Yangtse River *(Ch'ang-chiang wan-li t'u)*. Long handscroll. Colophons by Lu Shen and Tung Ch'i-ch'ang, who says that the picture once formed part of the Hsüan-ho collection. Late Sung painting, arbitrarily ascribed to Chü-jan. See Kokka 252; Pageant 49-51; Siren CP in Am. Colls. 82.

HSÜ HSI 徐熙

From Nanking. Member of a prominent family. He was active under the Southern T'ang dynasty and died before 975. Famous flower and bird painter. Rival of Huang Ch'üan. D, 3. F, 4. G, 17. H, 3. I, 49. K, 2. L, 5. M, p. 354. Y, p. 190. See also Benjamin Rowland, "Early Chinese Paintings in Japan: The Problem of Hsü Hsi," Artibus Asiae XV, 1952; biog. by Richard Barnhart in Sung Biog., 41-45; and Teng Pai, *Hsü Hsi yü Huang Ch'üan* (Shanghai, 1958, in CKHCTS series) (HH/HC).

Peking, Palace Museum. Dragonfly and bean flower. Fan painting. Seal with the artist's name. See Sung-jen hua-ts'e A, 2; B, VI, 8.
* Shanghai Museum. Winter scene: bamboo and old trees growing by a rock. Inscribed with the artist's name. Superb Five Dynasties or early Northern Sung picture. See TWSY ming-chi 3; TSYMC hua-hsüan 11; Sullivan Introduction (1st ed.) pl. 96.
Taipei, Palace Museum (WV7). A pheasant among peonies and magnolia flowers. Signed. Later work. See KK shu-hua chi 45; Three Hundred M., 54; Wen-wu chi-ch'eng 8; Siren CP III, 138; NPM Masterpieces V, 4.
Ibid. (VA17e). A bird on a gardenia branch. Album leaf. Attributed. Copy.
Ibid. (VA11b). Birds on a lichee branch. Album leaf. Attributed. Copy.
Ch'ing kung ts'ang 106 (formerly Manchu Household Coll.). A large lotus flower and a bud. Album leaf. Attributed. Imitation.
Chung-kuo I, 14 (Ti P'ing-tzu Coll.). A Hundred Birds. White herons and other water-fowl along a river shore. Handscroll. Post-Sung picture. See also Chung-kuo MHC 11.
Nanga taisei XVI, 1-2. A rich composition of flowering shrubs and trees. Handscroll. Possibly late Sung or Yüan. See also HH/HC 2-3.
Osaka Municipal Museum (Abe Coll.). Three pigeons and herb shoots. Album leaf, ink and colors on silk. Attributed. See Osaka Cat. 11; HH/HC 1. Soraikan II, 4.
Fujita Museum, Osaka. Lotus and herons. Pair of hanging scrolls. Attributed. Ming works.
Fujii Yurinkan, Kyoto. Birds, insects and rabbits in a landscape. Handscroll. Title in the manner of Hui-tsung. Ming work.
Kokka 88 (Ogiwara Coll., Tokyo). Bird on a branch. Interpolated signature and seal. Yüan painting?
Nelson Gallery, Kansas City. A peony flower. Album leaf; signed with the painter's name. Sung painting? much repainted. Seals of Keng Chao-chung. See China Institute Album Leaves, 13.

HU KUEI 胡瓌 (the second character properly written 瑰) The name is sometimes read Hu Huai.
A Khitan painter active during the Posterior T'ang dynasty (923-935). Lived at Fan-yang in Hopei. Horses and nomadic scenes . E. F, 2. G, 8. H, 2. I, 49. L, 10. M, p. 292. Y, p. 157.

* Peking, Palace Museum. Banquet scene in a Khitan camp. Handscroll. Attributed. Fine early painting in Liao tradition. See also CK ku-tai 19; Li-tai jen-wu 12; Wen-wu 1959.6.34; T'ang-tai jen-wu pp. 52-3; CK li-tai hui-hua 1, 76-79.
* Ibid. (exhibited Fall, 1977). Khitan horsemen, with laden camels. Handscroll, ink and colors on silk. Title with attribution in the manner of Hui-tsung. Good Chin work?
* Taipei, Palace Museum (chien-mu WH6). Barbarians Herding Horses. Handscroll. Attributed. Colophon by Kuo Yung dated 1145; palace seal of the 13th century (Ch'i-hsi Hall), as well as Liang Ch'ing-piao and many other seals. Important early painting in Liao tradition. See Loehr Dated Inscriptions p. 253.
* Ibid. (VA1f, VA4b). Pair of large album leaves, ink and colors on silk.
 A. Khitans with greyhounds on horseback on a plain;
 B. Four Khitans with falcons on horseback. Attributed. The latter with seal of Liang Ch'ing-piao. Fine Sung paintings in the Liao tradition.
 For A, see Three Hundred M., 30; CAT 7; KK ming-hua I, 6; NPM Masterpieces III, 5. For B, see CAT 8; CKLTMHC II, 80; KK ming-hua II, 7; NPM Masterpieces II, 3.
 Ch'ing kung ts'ang III (formerly Manchu Household Coll.). Three men on galloping horses. Album leaf. Attributed. Much later work.
* Boston Museum of Fine Arts (12.895). Khitan horseman with a hawk and a quarry. Fan painting. Old attribution. Fine Southern Sung work in Liao tradition. See BMFA Portfolio I, 37; Siren CP III, 135; Siren CP in Am. Colls. 9.
 Freer Gallery (11.191). Many animals (real and imaginary) in a landscape. Handscroll. Attributed. Interesting pastiche of the Ming period.

HUANG CHÜ-TS'AI 黃居寀 t. Po-luan 伯鸞
Son of Huang Ch'üan. B. 933, d. after 993. Served as a tai-chao under the Later Shu dynasty (929-966) and also under the emperor T'ai-tsu of Sung. Flowers, birds and landscapes. C, 2. D, 3. F, 4. G, 17. H, 3. I, 50. K, 17. K, 31. M, p. 540. Y, p. 275. Also biography by Ellen Laing in Sung Biog. 47-50.

Peking, Palace Museum. Sparrows fighting among reeds. Fan painting. Attributed. See Sung-jen hua-ts'e A, 39; B, III, 9.
Ibid. Crab and fading lotus. Fan painting. Attributed. See Sung-hua shih-fu 9; Sung-jen hua-ts'e A, 4; B I, 5.

Taipei, Palace Museum (VA1h). Ten doves on a large branch stretching over the water from a rocky shore. Large album leaf. Southern Sung period? Seals of Liang Ch'ing-piao. See CKLTMHC II, 74; Soga I, 13.

* Ibid. (SV10). A pheasant and small birds by dry jujube shrubs. Painter's name written in the manner of Hui-tsung. *Ssu-yin* half-seal. Poem by Ch'ien-lung. Northern Sung work? Somewhat cut down in size. See KK shu-hua chi 10; Three Hundred M., 57; CAT 16; KK ming-hua I, 20; CK ku-tai 33; CKLTMHC I, 27; HH/HC 10; Wen-wu 1955.7.4 (36); Wen-wu chi-ch'eng 22; KK chou-k'an 147; Soga I, 12; Hills, 94; article in NPM Quarterly XI/4 (Summer 1977), pp. 1-21.

Ibid. (SV11). Wild geese among reeds. Attributed. Ming work. See KK shu-hua chi 33; Siren CP III, 137; NPM Masterpieces V, 6.

Ibid. (SV232 chien-mu). Shellfish and Butterflies. Interesting work in mo-ku manner, 15th century?

Ch'ing kung ts'ang 17. (Formerly Manchu Household Coll.). A purple peony flower. Album leaf. Signed. Reproduction indistinct.

T'ien-yin-tang II, 1. (Chang Pe-chin Coll, Taipei). Flower and butterfly. Fan painting. Attributed.

Shina kacho gasatsu 47. Mandarin ducks. Attributed. Imitation.

Boston Museum of Fine Arts (30.461). A parakeet and a wasp on a blossoming pear branch. Album leaf. Ming work? See BMFA Portfolio I, 139.

Freer Gallery (19.113). A Goose. Attributed. Good painting, of Yüan date?

Metropolitan Museum, N. Y. (13.100.115). Two white camelia flowers and a small bird on a branch. Fan painting. Inscribed with the painter's name. Imitation.

HUANG CH'ÜAN 黃筌　　t. Yao-shu 要叔　　.

From Ch'eng-tu, Szechwan. B. 903, d. 968. Served as tai-chao in the Hanlin Academy already at age 17 under Wang Yen of the Later Shu dynasty (reigned 917-925); still serving during the reign of Meng Ch'ang (935-965). Painted flowers and birds in the mo-ku manner, also Buddhist and Taoist subjects. C, 1. D, 3. F, 2. G, 16. H, 2. I, 49. L, 31. M, p. 539. Y, p. 272. See also biography by Richard Barnhart in Sung Biog. 50-55; and Teng Pai, *Hsü Hsi yü Huang Ch'üan* (Shanghai, 1958 in CKHCTS series) (HH/HC).

* Peking, Palace Museum. Studies from nature: birds and insects. Short handscroll, ink and colors on silk. According to the inscription, purport-edly by Huang Ch'üan, presented by him to his son, Chü-pao. Fine work of middle Sung date (time of Hui-tsung)? Or earlier? See CK ku-tai 23; HH/HC 6-8; KKPWY hua-niao 1; Siren CP III, 134; Kokyu hakubutsuin, 27; CK li-tai hui-hua 1, 74-75.

Ibid. Ducks among reeds. Album leaf. Attributed. See Sung-jen hua-ts'e A, 3; B II, 4.

HH/HC 4-5. A deer under a gnarled tree. Attributed.

Taipei, Palace Museum (WV21). Examining Texts. Attributed. Ming period copy of old composition. See NPM Masterpieces I, 4.

Ibid. (VA1g). Winter scene: four crows in a bare willow; two ducks on the water. Album leaf. Attributed. Southern Sung period? See KK shu-hua chi 40; CKLTMHC II, 79; KK ming-hua II, 17; NPM Masterpieces II, 7; Soga I, 11.

Ibid. (WV22). Birds on a river shore; flowers and bamboo. Attributed. Later copy of old painting.

Ibid. (VA15c). Bird and Red Leaves. Fan painting. Attributed. Copy.

Ibid. (VA12c). Oriole on an apple branch. Fan painting. Attributed. Copy of the painting by the Sung master Lin Ch'un in the Peking Palace Museum, q.v. See NPM Bulletin I, 2 cover.

Ibid. (VA11c). The Autumn-river Hibiscus. Album leaf. Attributed. Fragment of a Southern Sung or later painting.

Ibid. (VA17c). Auspicious Birds and Rich Grain. Fan painting. Attributed. Copy of Sung work.

Ibid. (VA13a). Spring Birds at the Flowering Bank. Album leaf. Attributed.

Ibid. (VA15d). Peach Blossoms and a Mountain Bird. Album leaf. Late copy of Sung work.

Taipei, Palace Museum. Ducks on a snowy bank under bamboo and plum. Attributed. See CKLTMHC II, 24.

Ch'ing kung ts'ang 83 (Formerly Manchu Household Coll.). A lotus bud and a large leaf. Album leaf. Attributed.

Chung-kuo I, 12. (Formerly Manchu Household Coll.). Chrysanthemum Flowers. Album leaf. Seal of the painter and later seals. Imitation. See also Chung-kuo MHC 31; Ferguson, p. 86.

Kwen Cat. 7. Doves gathering around a bowl at the foot of a rockery. Imitation. See also Garland I, 10 (same?).

Ta-feng t'ang IV. A cat eating fish. Large album leaf. Inscribed: Huang Ch'üan shih yü mao. Interesting early work.

Nanga taisei VI, 1. A small bird on the branch of lichee. Album leaf. Attributed. Inscription by Wang Ao (1450-1524).

Toso 7 (Formerly Kuan Mien-chun Coll.). River scene in autumn with boats. Handscroll. Late archaistic picture.

Osaka Municipal Museum (Abe Coll.). Two cranes under bamboo. Inscription in the manner of Hui-tsung. Ming work. See Soraikan I, 6; HH/HC 9. Osaka Cat. 12.

Ibid. Water Fowl and Small Birds on a Plum Tree. Hanging scroll, ink and colors on silk. Attributed. See Osaka Cat. 13; Soraikan II, 28.

Nezu Museum, Tokyo. A goose by lotus plants. Fan painting. Southern Sung or Yüan. See Nezu Cat. 7.

Princeton Art Museum (Former J. D. Ch'en Coll., H. K.). Bird on a blossoming pear branch. Yüan period? style of Ch'ien Hsüan. See Chin K'uei I, 1.

Yale University Art Gallery (1953.27.4; Moore Coll.). Birds gathering by a willow pool. Long handscroll, heavy colors on paper. Title and painter's name written in the manner of Hui-tsung. Numerous seals and inscriptions. Colophon dated 1032. Late archaistic work. See Siren CP III, 136; Siren ECP I, 76; Loehr Dated Inscriptions pp. 230-231; Yale Cat. 71.

Other pictures ascribed to him in the Metropolitan Museum, N. Y.: 47.18.98 (Chickens, handscroll); 47.18.143 (Lotus, album leaf); 13.220.88 (Flowers, hanging scroll); 18.124.3 (Landscape; see their *Bulletin,* Jan. 1950, p. 171).

British Museum, London (Add. 230). Swans and other birds beneath trees. Attributed. Ming.

JUAN KAO 阮郜

Painted illustrations, figures, ladies. Served in the Wu-Yüeh state in the Five Dynasties period. G, 6. H, 2. I, 49. M, p. 117. Y, p. 64.

* Wen-wu ching-hua II, 17-23. Female immortals in Elysium. Handscroll, three inscriptions. Attributed. Sung archaistic picture? See also I-lin YK 25/9; Kokyu hakubutsuin, 21-22; CK li-tai hui-hua 1, 80-83.

KU HUNG-CHUNG 顧閎中

From Chiang-nan. Served as a tai-chao at the court of Hsüan-tsung of the Southern T'ang dynasty (943-960). Contemporary with Chou Wen-chü. Figures. G, 7. H, 3. I, 49. K, 29 (same as H, 3). L, 52. M, p. 736. Y, p. 399.

* Peking, Palace Museum. Han Hsi-tsai's Night Revels. Long handscroll, ink and colors on silk. Colophons by Pan Wei-chih (dated 1326) and others. Attributed. Late Sung copy after an original by Ku Hung-chung or some other 10th century artist; the true date of the scroll is revealed by paintings on screens within the picture. The composition is sometimes associated also with Chou Wen-chü. Portions of it have been copied by later painters, such as Wang Chen-p'eng (Pageant, 292). See article by Hironobu Kohara in Kokka 884, 888; and by Chang An-chih in Mei-shu chia #3, Aug. 78, pp. 2-11; also Chung-kuo hua XVI, 6-7, 10-13, 16-17, 19; XVII, 8, 10-11, 14-15, 18-19; CK ku-tai 18; Li-tai jen-wu 13; NPM Bulletin I, 2, 1-2; Wen-wu 1958.6.31; Siren CP III, 120-123; Chugoku Bijutsu 23-24; Ta-feng t'ang I, 5; Kokyu hakubutsuin, 23-25; CK li-tai hui-hua 1, 84-93; also published as a handscroll by Benrido, Kyoto, 1952.

Taipei, Palace Museum (chien-mu WH9). Han Hsi-tsai's Night Revels. Handscroll. Colophon by Chang Ch'eng, dated 1141. Last section of the same composition as the Peking scroll. See KK ming-hua I, 17; Loehr Dated Inscriptions p. 252.

Chung-kuo I, 13 (Ti Pao-hsien Coll.). A cock-fight in the presence of numerous onlookers in a garden. See also Toso 18; Chung-kuo MHC 27.

Metropolitan Museum, N. Y. (13.220.9). Returning from a banquet. Late copy.

KU TE-CH'IEN　顧德謙
From Nanking. Favorite of Li Hou-chu of the Southern T'ang dynasty (961-975). Figures, flowers and birds. F, 3. G, 4. H, 3. I, 49. K, 29 (same as H, 3). L, 52. M, p. 736. Y, p. 400.

Taipei, Palace Museum (chien-mu WH12). *Fan-k'o ju-ch'ao t'u:* Foreign Emissaries Bringing Tribute. Handscroll, ink on paper. Signed, as a "copy after Emperor Yüan-ti of Liang." Later (Ming) but more complete version of same composition as the scroll attributed to Yen Li-pen in the same collection (TH11).

Ibid. (chien-mu WH13). A man on a couch playing the flute. Attributed in a "Hui-tsung" inscription. Ming copy.

Tokyo National Museum. Pair of hanging scrolls: two mandarin ducks among lotuses; two herons among lotuses. Probably 13th century. See Sogen bijutsu 43; Sogen no kaiga 63; Kokka 297; Tokyo NM Cat. 14; Artibus Asiae XV, 1952, p. 229. Cf. the large pictures of lotus flowers and birds in the Chion-in, Kyoto (see under Yü Ch'ing-yen, Sung).

* Boston Museum of Fine Arts (12.898). Wen Chi's Return to China. Album leaf. Attributed to the master but later—12th-13th century? See BMFA Portfolio I, 102; Kokka 257; Siren CP in Am. Colls. 40; BMFA Bulletin Dec. 1912; I-lin YK 25.1.

KUAN-HSIU　貫休　. Family name Chiang　姜, personal name Hsiu 休　t. Te-yin　德隱, and Te-yüan　德遠. h. Ch'an-yüeh　禪月.
From Chin-hua, Chekiang. B. 832, d. 912. A Ch'an monk, famous also as a poet. Travelled in various provinces, painted in several temples and settled finally in Chengtu, where he was received with great honors. Mainly Buddhist figures. C, 3. F, 2. G, 3. H, 2. I, 49 (same as C, 3). L, 64. M, p. 370. Y, p. 197. See also Kobayashi Taiichiro, *Zengetsu daishi no shogai to geijutsu,* Tokyo, 1947; and biography by Richard Barnhart in Sung Biog. 55-61.

Taipei, Palace Museum (WV19). Arhat with attendant. Yüan or Ming painting, after an older design?
Ibid. (WV39, chien-mu). An Arhat with a landscape design on his robe. Attributed. Good early Ming work?
Chung-kuo MHC 31. An Arhat. Attributed. Late imitation.
Garland I, 7 (George Yeh Coll., Taipei). Arhat seated on a stone holding a sutra. Inscriptions. Later work.
* Toso 8-13 (Imperial Household Coll., Tokyo). The Sixteen Arhats. Attributed. One of the pictures with inscription by the artist and the date 880-894. Early copies? See also Toyo VIII, pl. 10-11; Che-chiang 3; T'ang-tai jen-wu p. 56; Li-tai jen-wu 11; Sogen no kaiga 4-5; Genshoku 29, pl. 35; Siren CP III, 114-115. See also copies of this series ascribed to Li Kung-lin in Toso 43; other versions of the set, in paintings or stone engravings, found in other collections.
* Kodai-ji, Kyoto. The Sixteen Arhats. Hanging scrolls, ink and color on silk. Attributed; Sung paintings. Brought to Japan by the priest Shinjo in 1211.

See Kokka 253; Sogen Bijutsu 95; Shimbi VI; Loehr Dated Inscriptions pp. 264-265.

Kokka 406 (formerly Asano Coll., now Tokyo National Museum). An Arhat. Ink on silk. Attributed. Yüan period. From the same series as the two following. For all five paintings, see also Doshaku, 64-66.

Ibid. 456 (Fujita Art Museum, Osaka). An Arhat with a tiger; an Arhat reading a sutra; an arhat with an incense-burner. Three paintings from the same series as the previous one. They have been "reidentified," by the addition of a broom to one of them, as Han-shan, Shih-te, and Feng-kan, and made into a triptych. See Boston Zen Catalog 2; Kodansha Suiboku III, pl. 28-29.

Nezu Museum, Tokyo. An Arhat seated under a twisted tree. Belongs to the same series as the paintings listed in the two previous entries. See Nezu Cat. 10; Kodansha Suiboku III, pl. 21; Genshoku 29, pl. 36. Another version, formerly Muto collection: see Muto Cat. 12, Siren CP III, 116. Still another in the collection of Bunzo Nakanishi, Kyoto.

Freer Gallery (16.35). An Arhat seated under a tree, served by a tortoise. Attributed. Ming period.

Luboshez Coll., Falls Church, Va. White-robed Kuan-yin. Signed. Good Ming painting.

KUAN T'UNG 關同　or　仝　.

From Ch'ang-an. Active in Ch'ang-an and Loyang during the Posterior Liang dynasty (907-923). Pupil of Pi Hung and a younger rival of Ching Hao. Landscapes. E. F, 2. G, 10. H, 2. I, 49. L, 14. M. p. 720. Y, p. 388. Also biography by Richard Barnhart in Sung Biog. 61-64.

Peking, Palace Museum. The western mountains at sunset. Fan painting. Attributed. Early Ming work by follower of Li T'ang. See Sung-jen hua-ts'e B, XV.

Taipei, Palace Museum (WV4). Waiting for the Ferry. Steep mountains with a waterfall; man with a donkey approaching the ford at the foot of the mountain. No signature, but a seal of the emperor Li Hou-chu (mid-10th century). Sung painting, by follower of Fan K'uan. See KK shu-hua chi 8; Three Hundred M., 38; CKLTMHC I, 8; KK ming-hua I, 11; Nanking Exh. Cat. 9; Wen-wu chi-ch'eng 7; KK chou-k'an 116; Siren CP III, 145; NPM Masterpieces V, 1.

* Ibid. (WV5). Autumnal Mountains at Dusk. Attributed. *Ssu-yin* half-seal. Fine work of late 11th century? perhaps originally a panel of a screen. See Three Hundred M., 40.

* Ibid. (WV6). Travellers at the Mountain Pass. Attributed. Yüan palace seal *T'ien-li chih-pao*, used ca. 1330; also *Ssu-yin* half-seal. Sung work, but preserving important elements of older tradition. See Three Hundred M., 39; KK ming-hua II, 9; CAT. 13.; Bunjinga suihen II, 22.

Ibid. (chien-mu WV28). The Road to Shu. Attributed. Ming, in the tradition of Fan K'uan and Li T'ang.

Ibid. (VA3b). Waiting for the Ferry. Album leaf. Southern Sung or later, unrelated to him.

Ibid. (VA5a). Two Peaks Pierce the Clouds. Album leaf. Attributed. Late archaistic work. See T'ang-Sung ming-hui chi-ts'e, Yen-kuang album.

Liu 10. A stream at the foot of overhanging mountains. Attributed. Imitation. See also Nanking Exh. Cat. 10.

Toan I (Agata Coll., Osaka). Mountain landscape with a ferry. Signed. Title and painter's name inscribed by Prince Yü in the year 1111. Yüan work? in Kuo Hsi manner, made up of parts of the two separate compositions? See also Nanshu ihatsu; Siren CP III, 146; Loehr Dated Inscriptions, p. 241.

Fujii Yurinkan, Kyoto. Mountain ridge rising over a river; pavilions at its foot. Painter's name inscribed in the manner of Hui-tsung. Colophons attached by Tsou Ti-kuang (1617) and others. Ch'ing dynasty work, school of Yüan Chiang. See Yurintaikan III.

Boston Museum of Fine Arts (57.194). Drinking and Singing at the Foot of a Precipitous Mountain. Inscription attributing the painting to Kuan T'ung. See Archives XII, 1958, p. 76; BMFA *Bulletin,* v. LIX, 1961; NPM Quarterly II, 2. p. 300. Modern forgery, copy after older composition. Another version, attributed to a follower of Tung Yüan named Liu Tao-shih (q.v.) formerly in the collection of the late J. D. Ch'en, Hong Kong; presently C. C. Wang, New York; see Three Patriarchs, 1, Pl. 6.

KUO CH'IEN-YU 郭乾祐

From Ch'ing-chou, Shantung. Active during the Southern T'ang period (937-975). Brother of the painter Kuo Ch'ien-hui. Flowers, birds, and cats. G, 15. H, 2. I, 49 (same as G, 15). L, 60. M, p. 396. Y, p. 216.

Freer Gallery (16.518). Two eagles in a tree over a waterfall. Attributed. Ming period, tradition of Li Ti. See Siren CP in AM. Colls. 100.

KUO CHUNG-SHU 郭忠恕 . t. Shu-hsien 恕先

From Loyang. B. c. 910, d. 977. Scholar, served in the Confucian temple during the Posterior Chou dynasty (951-959) and the Sung dynasty. Banished by the emperor T'ai-tsu; died in exile. Boundary paintings, landscapes and figures. D, 3. F, 3. G, 8. H, 3. I, 50. L, 60. M, p. 396. Y, p. 217. Also biography by Hsio-yeh Shih in Sung Biog. 69-76.

Peking, Palace Museum. A hostel in the mountains; travellers with bullock carts approaching and leaving. Fan painting. Sung work? See KK chou-k'an 488; Sung-jen hua-ts'e A, 82; B, VII, 6.

* Nanking Museum. The Yüeh-yang Tower: a boat on the river; buildings on the distant shore. Attributed. Fine late Sung or early Yüan work. See Gems I, 4; Nanking Cat. I, 5; I-lin YK 70/1.

* Taipei, Palace Museum (SV12). River Travel after Snowfall. Two large junks with high masts and tackles loaded with freight and men. Ink on silk.

Inscription in the manner of Hui-tsung with a seal. Very dark and damaged, but may be of the period; Sung work in any case. See Three Hundred M., 52; CK ku-tai 29; CKLTMHC I, 20; KK ming-hua II, 16; Soga I, 5; Bunjinga suihen II, 84; Wen-wu 1955.7.3 (35). Another version in the Nelson Gallery, Kansas City.

KK shu-hua chi 29. An old man dipping a scroll in the elixir of immortality, served by a fairy. Attributed. Seals of the Sung period and later. Imitation.

Taipei, Palace Museum (SH40, chien-mu). The Lan-t'ing Gathering, "after Ku K'ai-chih." Long handscroll. Attributed. Colophon of the 15th century; the painting may be of that date, good in quality.

Taipei, Palace Museum (VA3f). Flying herons and a riverside pavilion. Fan painting. Attributed. Southern Sung work. See KK ming-hua I, 18.

Ibid. (VA16a). Palace Pleasures: Emperor Ming-huang and Yang Kuei-fei mounting horses to set off on an outing. Fan painting. Attributed. Southern Sung academy work, 12th century. See NPM Masterpieces II, 5. Also see article by Li Lin-ts'an in Ta-lu tsa-chih, XIX/9.

Ibid. (VA12d). The Lan-t'ing Gathering. Album leaf. Attributed. Southern Sung, in archaistic style?

Ibid. (VA15b). The Three Moves of Mencius' Mother. Album leaf. Attributed. Late, crude copy.

Osaka Municipal Museum (Abe Coll.). The summer palace of Emperor Ming-huang of T'ang. Inscribed with the painter's name and possibly after his design, but not executed before the Ming period. See Soraikan I, 9; Siren CP III, 147; Kodansha Suiboku IV, 25; Osaka Cat. 17; Kokka 955.

Hikkoen 15 (Formerly Kuroda Coll.). A waterwheel under willows. Fan painting. Late Sung period.

Freer Gallery (19.128). Mountains and high pavilions by a river. Attributed. Yüan or early Ming.

Princeton Art Museum (68.207). Summer Pavilion. Fan painting.

Note: Various versions of Wang Wei's Wang-ch'uan Villa composition are attributed to Kuo Chung-shu: the late Ming stone engraving; three handscrolls in the Palace Museum, Taipei (SH38, SH41, SH42); another published in a reproduction album by Commercial Press, 1926; another in the Metropolitan Museum, N. Y. (13.220.5), etc. Some of these published in Bunjinga suihen I. See also Ferguson's article in *Ostasiatische Zeitschrift* April-June 1941, p. 51ff.

LI AI-CHIH　　李靄之　　　　. h. Chin-p'o ch'u-shih　金波處士
From Hua-yin, Shensi. Active during the Posterior Liang dynasty (910-925). Specialized in cats; painted also landscapes. F, 2. G, 14. H, 2. I, 49. L, 42. M. p. 186. Y, p. 91.

Chugoku I. Two cats playing on a rock; two small birds on a bamboo stalk. The painter's name inscribed in the manner of Hui-tsung. Imitation.

Laufer 10. A black "lion-cat." Album leaf. Large seal of the Hsüan-ho period. Attributed. Imitation.

LI CH'ENG 李成 , t. Hsien-hsi 咸熙 .
B. 919, d. 967. Born in Ying-ch'iu (Ching-chou) in Shantung; lived in Kaifeng.
Received Confucian education and took *chin-shih* degree, but never held office.
Landscapes. D, 2. F, 3. G, 11. H, 3. I, 50. M, p. 188. Y, p. 98. See also
Ho Wai-Kam's article in NPM Quarterly, V, 3.

* Liaoning Provincial Museum. Small Wintry Grove. Short handscroll, dark, damaged. Attributed. Kao-tsung, *Ssu-yin* seals. Remains of fine Sung work, in his tradition. See Liaoning I, 22.

Taipei, Palace Museum (SV1). Clearing after Snow on Distant Peaks *(Chün-feng chi-hsüeh t'u)*. Colophon by Kao Shih-ch'i. Ming-Ch'ing, school of Lan Ying. See KK shu-hua chi 19.

Ibid. (SV3). Old pine trees on a low shore in winter. Inscription in the manner of Hui-tsung. Ming copy of Sung work? See KK shu-hua chi 22; Three Hundred M., 63.

Ibid. (chien-mu SV228). A high mountain pass with travellers over a stream in autumn. Inscription of the Ming period. See KK shu-hua chi 27. Late Ming?

Ibid. (chien-mu SV229). Autumn landscape with fishing boat. Interesting Ming archaistic work.

Ibid. (SV4). Fishing on a Wintry River. Attributed. Two inscriptions, probably Yüan period. The painting appears to be Yüan in date; cf. the works of Chu Te-jun. See KK shu-hua chi 31; CAT 17; CKLTMHC II, 9; Nanking Exh. Cat. 15; Siren CP III, 148; Soga I, 7.

* Ibid. (SV2). A Wintry Grove: old cedar trees by a swirling stream. The painter's name inscribed by Wang To. Fine 12th century work? The rocks in the manner of Li T'ang. See KK shu-hua chi 37; Three Hundred M., 61; CKLTMHC II, 10; KK ming-hua II, 21; Wen-wu chi-ch'eng 18; Siren CP III, 150; Soga I, 6.

Ibid. (chien-mu SH37). Landscape with figures. Handscroll. Probably a work of Lu Yüan, early Ch'ing.

Ibid. (VA8a). Beautiful Trees and Mountains: bare trees by a snowy cliff. Attributed. Accompanying writing by Tung Ch'i-ch'ang probably transferred from a different painting. For all its damage and superficial look of age, probably a work by Wang Hui of the early Ch'ing. See London Exh. Chinese Cat. p. 100; Three Hundred M., 62; KK ming-hua I, 25; KK shu-hua chi 19; Wen-wu chi-ch'eng 17; KK chou-k'an 241; Soga I, 8.

Ibid. (VA5c). Fishing: pine trees on the shore; fishermen in boats. Fan painting. Attributed. A largely obliterated signature may read "Yün-hsi," i.e. Ts'ao Chih-po of the Yüan dynasty. The picture appears to be of that date. See KK ming-hua I, 26.

Ibid. (VA10a). Forest Pavilion. Large double album leaf. Probably by Wang Hui or follower, Ch'ing period.

Chung-kuo I, 21 (Ti P'ing-tzu Coll.). Trees and pavilions by an inlet of water. Album leaf. Attributed. Poem by Hsien-yü Shu (1257-1302). Imitation. See also Nanga taisei XI, 3; Chung-kuo MHC 18.

Li Mo-ch'ao. High mountains by a river; a man with an umbrella crossing a bridge. Fan painting. Attributed. Imitation.

Nanga taisei XI, 2. Snow-covered creviced rocks by a river which is spanned by a bridge; a small homestead under bare trees. Album leaf. Imitation.

* Osaka Municipal Museum (Abe Coll.). Reading the Stone Tablet: Emperor Wu of the Wei Dynasty and his attendant Yang Hsiu reading the stele of Ts'ao O. Figures in a wintry landscape. Hanging scroll, ink on silk. Inscribed with the painter's name. The figures are supposed to be by Li Ch'eng's contemporary Wang Hsiao. Probably a copy, Yüan dynasty in date, of an earlier work. See Soraikan I, 8; Hokuga shinden; Bunjin gasen II, 4; CK ku-tai 27; Siren CP III, 149; Osaka Cat. 16; Chugoku I; Bunjinga suihen II, 16.

Toan 2 (Saito Coll.). High mountains and winding waters on a clear summer day. Long handscroll. Title and painter's name written in the manner of Hui-tsung. Colophons by several prominent painters and critics of the Ming period. Late work, unrelated to Li Ch'eng.

* Toso 28 (formerly Yamamoto Teijiro, now Inokuma Coll.). Two pine trees by a stream; a vista over a river valley beyond. Fine Sung or early Yüan work in his tradition. See also Toyo bijutsu 13; Genshoku 29, pl. 1-2; Kodansha Suiboku II, 30; Bunjinga suihen II, 18.

Fujii Yurinkan, Kyoto. Pine trees and snowy mountains. Inscribed with the painter's name. Handscroll. Ming copy of the same composition as Li Shan's handscroll in the Freer Gallery. See Kohansha II; Yurintaikan I.

* Boston Museum of Fine Arts (12.879). Travellers on snowy hills by a stream. Hanging scroll, ink and light colors on silk. Painter's name and title of the picture written in the manner of Hui-tsung; seal of Chao Meng-fu. Late Sung or early Yüan. See BMFA Portfolio I, 32; Siren CP in Am. Colls. 10; Siren CP III, 152; BMFA *Bulletin,* Dec., 1912, also v. LIX, 1961; Bunjinga suihen II, 19.

Freer Gallery (15.21). Herb-gatherer in the Mountains. Attributed. Ming copy of old composition, of which two other versions are in the same collection (13.64 and 19.111); still another in the Taipei Palace Museum, see KK shu-hua chi 42.

Ibid. (11.287). A scholar beneath tall trees; low hills beyond. Attributed. Fine Ming work, perhaps by Chu Tuan.

Ibid. (15.122). River Landscape. Attributed. Work of minor artist of Yüan or early Ming period.

Ibid. (17.122). Winter Landscape. Probably by Wang Hui of the 17th century.

Metropolitan Museum, N. Y. Landscape with pine trees and rocks; a black-hatted rider below. Large hanging scroll, ink and colors on silk. Attributed. See Garland I, 11; Barnhart Wintry Forests cat. 1; Li-ch'ao pao-hui, 1/4; Bunjinga suihen II, 17.

Laufer, 11. River landscape with a village in the foreground, a Buddhist temple above. Attributed. Interesting Yüan-Ming imitation, based on some model similar to the Nelson Gallery work (see below).

* Nelson Gallery, Kansas City (47.71). Buddhist Temple Amid Clearing Mountain Peaks. Seals of the Sung and later periods; *ssu-yin* half-seal. Fine 11th century work? See Skira 30; Siren CP III, 151; Kodansha CA in

West I, 2; Summer mts., 16,17,19; Kodansha Suiboku II, 1; Bunjinga suihen II, 14-15.

* *Note:* The anonymous Sung "Small Wintry Grove" *(hsiao han-lin t'u)* picture in the Taipei Palace Museum (SV149) has sometimes been ascribed to him, and is a fine early (11th century?) work in his tradition.

LI P'O 李頗 or 坡 or 波 .
From Nan-ch'ang. Worked during the Southern T'ang dynasty (937-975). Painted bamboo. F, 2. G, 20. H, 2. I, 49. M, p. 188. Y, p. 95.

Taipei, Palace Museum (WV9). Bamboo in the Wind. Attributed. Yüan work? See Three Hundred M., 41; KK chu-p'u I, 1; KK ming-hua I, 12; NPM Quarterly I.4, pl. 15; KK bamboo II, 1. See article by Li Lin-ts'an in Ta-lu tsa-chih, XXI/6; article by Kao Mu-shen in NPM Quarterly, vol. XII no. 3.

LI SHENG 李昇 . t. Chin-nu 錦奴 .
From Chengtu. Active under the Former Shu dynasty (908-925). Known also as "The Little General Li from Shu." Said to have followed the style of Wang Wei. C, 2. F, 2. G, 3. H, 2. I, 49. L, 42. M. p. 188. Y, p. 96.

For entries formerly listed under this artist, see the Yüan dynasty artist Li Sheng (name written differently).

LI TSAN-HUA 李贊華 known as Prince of Tung-tan 東丹王 . Original name: Yeh-lü T'u-yü 耶律突欲
B. 899, d. 936. He was the eldest son of the first Liao emperor, T'ai-tsu (907-926), and brother of the second emperor, T'ai-tsung (926-947). In 931 he emigrated from the Liao realm to China and was given by the emperor Ming-tsung, of the Posterior T'ang dynasty (926-933), the family name Li and the personal name Tsan-hua. He painted Khitan chieftains and their horses. F, 2. G, 2. H, 2. M, p. 187. Y, p. 92. Also Liao History *(Liao shih).*

Taipei, Palace Museum (VA4c). A Khitan soldier standing before his horse carrying a bow and a long arrow. Inscription by K'o Chiu-ssu. Large album leaf. Good copy? See Three Hundred M., 36; CKLTMHC II, 96; NPM Masterpieces II, 4.
Ibid. (VA4d). The King of Liao on horseback, preceded by a mounted soldier. Large album leaf, ink and light colors on silk. Attributed. Part of the same composition as the Boston Museum of Fine Arts handscroll listed below.
* Princeton Art Museum (L258.70). Man on horseback shooting deer, both in "flying gallop." Short handscroll, ink and colors on paper. Colophon by Chu Te-jun includes attribution. Sung copy? See Garland I, 8.

Boston Museum of Fine Arts (52.1380). A Khitan chieftain and his entourage on horseback. Three colophons of the Ming period, the first dated 1560. Inscription at the end of the painting attributed it to Li Tsan-hua. Yüan copy of older composition, with interpolated inscription and seals? See Archives VII, 1953, opp. p. 86, fig. 1; Paine *Figure Compositions of China and Japan,* II, 1-4; Smith and Weng, 154-5 (bottom). Same composition as the Freer Gallery handscroll by Chao Lin (40.1); both presumably based on an early composition, perhaps by Li Tsan-hua. Another copy in the Freer Gallery (68.46), Meyer cat. 22, attributed to Ch'en Chü-chung in colophons.

C. C. Wang Collection, N. Y. A Horse and Groom. Handscroll. Attributed.

LIU TAO-SHIH 劉道士
Mentioned as a pupil of Tung Yüan by Mi Fu in his *Hua-shih;* otherwise unrecorded(?). Y, p. 348. See also J. D. Ch'en, *Three Patriarchs,* 50-51.

Chin-k'uei I, 4. (C. C. Wang, N. Y, formerly J. D. Ch'en Coll., H. K.). A Clear Morning over Lakes and Mountains. Hanging scroll, ink and light colors on silk. Attributed. *Ssu-yin* half-seal. Same composition as the landscape in the Boston Museum of Fine Arts attributed to Kuan T'ung. See *Three Patriarchs* 6; TWSY ming-chi 8. The "Chü-jan" handscroll in the Taipei Palace Museum (WH3) is related in style.

LU HUANG 陸晃 t. T'ing-shu 庭曙
From Chia-ho. Active during the Southern T'ang period (937-975). Landscapes and pictures illustrating old legends and fairy tales. E. G, 3. H, 1. M, p. 416. Y, p. 227.

Fujii Yurinkan, Kyoto. The Lan-t'ing Gathering: Wang Hsi-chih and an assemblage of poets gathered at the Orchid Pavilion, occupied in poetry competition and drinking wine from floated cups. Handscroll. Colophons purporting to be by K'o Chiu-ssu (dated 1339), Hsiang Yüan-pien (1587), Kao Shih-ch'i, and Ch'ien-lung. A rubbing of the engraved Lan-t'ing manuscript is attached to the picture. Ming painting. See Yurintaikan III.

SHIH K'O 石恪 t. Tzu-chuan 子專
From Chengtu. Went to Kaifeng c. 965, where he was ordered by the emperor to execute wall paintings in the Hsiang-kuo ssu. Buddhist and Taoist figures. C, 2. D, 3. F, 3. G, 7. I, 50. K, 3. L, 60. M, p. 75. Y, p. 44.

Chin-k'uei II, 1. (Formerly J. D. Ch'en Coll., H. K.). The Wedding Feast of Chung-k'uei for his Sister. Handscroll. Early Ming?
* Tokyo National Museum (formerly Shoho-ji, Kyoto). "Two Patriarchs with their Minds in Harmony." Two pictures of monks, one leaning on a tiger. Ink on paper. May have formed parts of a handscroll; cut out, provided

with seals of the Sung period and an inscription perhaps copied from else-where in the scroll. A detached colophon by Yü Chi of the Yüan period; seals of Sung emperor Kao-tsung, probably spurious. The correct render-ing of the title may be "The Second Patriarch (Hui-k'o) Harmonizing His Mind," in which case the figure with the tiger represents Feng-kan. "Sig-nature" with a date corresponding either to 919 or 963. See Shimada Shujiro, "Concerning the I-p'in Style of Painting," II, Oriental Art VIII, 3, pp. 1-6; Loehr Dated Inscriptions, p. 229; Toyo bijutsu 55-56; Siren CP III, 118; Boston Zen Catalog, 3; Kokka 95; Kodansha Suiboku III, 26-27; Genshoku 29, 37-38.

Fujii Yurinkan, Kyoto. The sixteen arhats with their servants and acolytes. Handscroll. Signed with the painter's name. See Yurintaikan.

C. C. Wang Collection, N. Y. Arhat seated on the ground with a staff. Signed. Much later painting. A set of six other figure paintings of the same kind, Ming? works in the stylistic tradition of the Tokyo National Museum pic-tures, in Strehlneek Cat., 168.

SUN WEI 孫位 (also called Yü 遇)
From K'uai-chi in Chekiang. Active for some time in the capital, and went as a refugee with the imperial court to Shu in 880; settled in Ch'eng-tu, where he decorated many temples with wall paintings and became very famous for his paintings of dragons and water. C, 1. G, 2. H, 2. I. M, p. 344. Y, p. 185.

Shanghai Museum. *Kao-i t'u:* Four scholars seated on mats by trees and garden rocks, each served by a boy who brings some implement, scrolls or refreshments. Large handscroll, ink and light colors on silk. The artist's name and the title written by Hui-tsung. Colophon signed Ssu-ma T'ung-po, dated 1489. Important early work? or modern fabrication? See I-shu ch'uan-t'ung V; Che-chiang 1-2; CK ku-tai 13; Li-tai jen-wu 9; T'ang-tai jen-wu pp. 54-55; TSYMC hua-hsüan 1; Wen-wu 1965.8 p. 1; also published as a scroll reproduction, *T'ang Sun Wei Kao-i t'u chuan* (n.p., n.d.).

T'ANG HSI-YA 唐希雅
From Hopei; moved to Chia-hsing in late T'ang. Active during the Southern T'ang dynasty (961-975). A calligrapher; painted bamboo and trees, birds, animals, grasses and insects. F, 4. G, 17. H, 3. I, 49. M, p. 325. Y, p. 172.

Taipei, Palace Museum (VA17f). Dove in an old tree. Fan painting. Signed. Hard, late copy of "Hui-tsung" dove, formerly Inoue Collection.

T'ENG CH'ANG-YU 滕昌祐 t. Sheng-hua 勝華
From Kiangsu. Followed the emperor Hsi-tsung of T'ang to Shu in 880, where he remained. Died after 930 at the age of 85. Specialized in flowers and birds,

served as a model for Huang Ch'üan. C, 3. F, 2. G, 16. H, 2. I, 49. L, 34. M, p. 627. Y, p. 336.

Taipei, Palace Museum (WV20). Peonies. Colors on silk. The painter's name is written at the top of the picture. Ming-Ch'ing decorative work. See KK shu-hua chi 24; CKLTSHH; CH mei-shu I; KK ming-hua I, 21; Wen-wu chi-ch'eng 9; KK chou-k'an 315.

Ibid. (VA13j). Fruit. Album leaf. Attributed.

Osaka Municipal Museum (Abe Coll.). Two white gulls under a willow and a peach tree. Inscription with the painter's name. Seals of the Sung statesman Han Ch'i (1008-1075) and the emperor Chang-tsung of the Chin dynasty. Imitation. See Osaka Cat. 6.

TIAO KUANG-YIN 刁光胤

From Ch'ang-an, moved to Shu in the T'ien-fu era (901-903) where he was active for 30 years and died at the age of 80 (c. 855-935). Flowers, birds and animals. Teacher of Huang Ch'üan. C, 2. F, 2. G, 15. H, 2. I, 48. L, 19. M, p. 2. Y, p. 1.

Taipei, Palace Museum (TA1). Butterflies, animals, etc. Album of fan paintings, ink and colors on paper; ten leaves. Signed. Poems purporting to be written by emperor Hsiao-tsung (reigned 1163-1169); colophon by Kao Shih-ch'i. Later works. See London Exh. Chinese Cat. pp. 20-31; Three Hundred M., 20-29; KK ming-hua II, 6 (1-10).

Ferguson p. 84. Peonies. Attributed. Much later work.

TUNG YÜAN 董源 or 元 t. Shu-ta 叔達 h. Pei-yüan 北苑

From Nanking. Served as an assistant director of the imperial parks under the Southern T'ang dynasty (937-975). Later hailed as the leading master of the Southern School of landscape painting. F, 3. G, 11. H, 3. I, 50. K, 23. L, 40. M, p. 570. Y, p. 288. Also biography by Richard Barnhart in Sung Biog. 139-142.

* Peking, Palace Museum. *Hsiao Hsiang t'u:* river landscape with fishermen drawing their nets, people in boats and waiting for a ferry. *Ssu-yin* half-seal. Two colophons by Tung Ch'i-ch'ang. Section of a large handscroll, ink and some color on silk. Attributed. Close copy, Sung period? See Chung-kuo hua XII, 12-13, 15; CK ku-tai 24; Siren CP III, 163-165; Sickman and Soper 89; Barnhart Marriage 1, 2, 5, 6; Ta-feng t'ang I, 4; Kokyu hakubutsuin, 26; Bunjinga suihen II, 5; CK li-tai hui-hua 1, 98-100; article by Wang I-k'un in Wen-wu 1960, 1; reproduction and article by Wang I-shen in I-yüan to-ying, 1979 no. 1.

* Liaoning Provincial Museum. Awaiting a crossing at the foot of mountains in summer. Handscroll. Attributed. Yüan palace seal *T'ien-li chih-pao*, used ca. 1330. According to the research of Richard Barnhart, this and the Peking picture originally formed parts of a single handscroll composition,

but now exist in versions of different date. Close early copy? See Liaoning I, 16-21; Chugoku bijutsu p. 78; Barnhart Marriage 4-5.

* Shanghai Museum (formerly P'ang Yüan-chi Coll.). *Hsia-shan t'u:* Summer Mountains. Large handscroll, ink and colors on silk. Later work— Yüan period? Published as a handscroll color reproduction, full-size, Shanghai 1959; Barnhart Marriage 3.

Taipei, Palace Museum (WV10). *Tung-t'ien shan-t'ang:* pavilions on the mountain of the immortals. Inscription by Wang To dated 1630. Ink and color on silk. *Ssu-yin* half-seal. Fourteenth century, by follower of Kao K'o-kung. See KK shu-hua chi I; Three Hundred M, 43; CAT 14; CH mei-chu I; CKLTMHC II, 18; CKLTSHH; KK ming- hua II, 10; Nanking Exh. Cat. 11; Wen-wu chi-ch'eng 12; KK chou-k'an 87; Siren CP III, 161.

Ibid. (WV11). *Lung-su chiao-min t'u:* mountain landscape with winding waters, boats and figures. Colophons by Tung Ch'i-ch'ang and Ch'ien-lung. Color and ink on silk. Yüan period, school of Chao Meng-fu. See London Exh. Chinese Cat. p. 34; Three Hundred M., 42; CH mei-shu I; CKLTMHC I, 11; KK ming-hua I, 13; TSYMC hua-hsüan 3; Wen-wu chi-ch'eng 13; KK chou-k'an 495; Siren CP III, 160; NPM Masterpieces V, 2; Bunjinga suihen II, 1; Hills, 91. See also article by Ch'i Kung in *Mei-shu chia* no. 5.

Taipei, Palace Museum (chien-mu WV32). Summer mountains before rain. Attributed. Interesting Ming work in his tradition.

Ibid. (chien-mu WV33). Deep Distance Beyond Summer Mountains. Early Ch'ing, cf. Wang Shih-min etc.

Chung-kuo I, 20 (Ti P'ing-tzu Coll.). Cottages by a mountain stream. Album leaf. Late imitation. See also Chung-kuo MHC 31.

Chung-kuo MHC 30 (formerly Manchu Household Coll.). *Yü-i t'u:* Hills before Rain. Short handscroll. Yüan dynasty?

Chin-k'uei I, 2 (formerly J. D. Ch'en Coll., H. K.). Travelling in Autumn Mountains. Houses and boats at the foot of high mountains. Colors on silk; much damaged. *Ssu-yin* half-seal. Late imitation. A version of the composition by Wu Li, now in the Princeton Art Museum, may in fact be the model.

Ibid. II, 3 (formerly J. D. Ch'en Coll., H. K.). River and Mountains in Snow. Long handscroll, ink on silk. *Ssu-yin* half-seal. Colophons of modern date. Late imitation.

Ta-feng t'ang I. River view; high mountains at the side, tall trees in the foreground and travellers on the road. Colors on silk. Attributed. Late imitation.

* Ibid. IV (C. C. Wang, N. Y.). *Ch'i-an t'u:* man in a pavilion overlooking a river; mountains beyond. Important early work? or modern fabrication? See also TWSY ming-chi 2; Barnhart Marriage 21; Bunjinga suihen II, 3.

Nanga taisei XV, 1. River valley in mist with fishermen in two boats. Ch'ien-lung and other seals. Ming painting.

Nanshu ihatsu I (Ogawa Coll.). Travellers' inn by a stream in the mountains. Colophon by Tung Ch'i-ch'ang dated 1601. Ming work? In the manner of the master. See also Pageant, 45; CK shu-hua I, 7. Another version attributed to Kuan T'ung in the Freer Gallery (19.134) with inscription by

Wang Wen-chih.

Ibid. I (Ueno Coll.). A ch'in player seated under pine trees at the foot of a hill. Inscription in the manner Hui-tsung. Imitation.

Osaka Municipal Museum (Abe Coll.). Cloudy valley, pine trees in wind; a wanderer on a river bank. Inscription in the manner of Hui-tsung, dated 1124; another by Wang Shih-chen (1526-1590). Imitation. See Nanshu ihatsu I; Toso 29; Soraikan II, 6; Loehr Dated Inscriptions pp. 246-247; Osaka Cat. 14.

* Kurokawa Institute of Ancient Culture, Ashiya. *Han-lin ch'ung-t'ing t'u:* Winter landscape, cottages and bare trees on a promontory, a vista over marshy ground beyond. Inscription by Tung Ch'i-ch'ang. Imperial seals of the Sung and Yüan periods. Important early (Southern Sung?) work in Tung Yüan tradition. See Nanshu ihatsu V; Bunjin gasen II, 2; Pageant, 44; Toyo bijutsu 11-12; Chung-kuo MHC 6; Genshoku 29/8; Barnhart Marriage 13-14; Summer Mts., 7; Bunjinga suihen II, I; Hills, 90.

Ibid. V. Summer landscape with trees; a man seated on the river bank. Inscription in the manner of Hui-tsung. Late imitation.

Ibid. V. Floating mist over distant mountains and knotty pine trees. Late imitation.

Toan 4 (Saito Coll.). River scenery with high mountains after snowfall. Handscroll, ink and light colors on silk. Colophons by Tung Ch'i-ch'ang and Ch'en Chi-ju. Ming work. See also Siren CP III, 162.

* Boston Museum of Fine Arts (12.903). A Clear Day in the Valley. Handscroll, ink and light colors on paper. Signed. Colophons by Tung Ch'i-ch'ang (1633), Wang Shih-min (1633), Mei Lei (17th century), and Tuan Fang (1911). A fine work of the 13th century, not in Tung Yüan's manner. See BMFA Portfolio I, 33-36; Siren CP III, 167; BMFA Bulletin, Dec. 1912; Kodansha, BMFA, pl. 79; Bunjinga suihen II, 6; Unearthing China's Past 121.

Ibid. (14.65). Waterfall among Pine-clad Rocks. Fan painting, ink on silk. Old attribution. Later (Sung?) work. BMFA Portfolio I, 137; Siren CP in Am. Colls. 92.

Freer Gallery (11.200) Landscape with rounded hills and marshes. Handscroll. Attributed. Yuan or early Ming. See Bunjinga suihen II, 7.

Ibid. (19.137). Houses among Hills. Ming work of the type usually ascribed to Chü-jan; a copy in the former J. D. Ch'en collection is attributed to that master.

Honolulu Academy of Arts. View over a misty river valley; a small homestead and two figures under trees. Poem by Ch'ien-lung. Attributed. Ming? Photo by the Yen Kuang Co., Peking; Ferguson, p. 94.

Philadelphia Museum. Landscape. Hanging scroll, ink and colors on silk. Attributed. See Bunjinga suihen II, 8.

WANG CH'I-HAN　王齊翰
From Nanking. Served as a tai-chao at the court of Li Hou-chu (961-975). Buddhist and Taoist figures. D, 1. F, 3. G, 4. H, 3. I, 49. L, 27. M, p. 29. Y, p. 18.

* Nanking University Dept. of History (formerly Ferguson Coll.). *K'an-shu t'u:* Examining Books. A man seated at a small table in front of a large screen cleaning his ear. Handscroll, ink and color on silk. The title and the painter's name written in the manner of Hui-tsung. Seals and colophons of the Sung period. Colophon by Su Shih dated 1091. Further colophons by Su Che, Wang Shen, Tung Ch'i-ch'ang and others. See also Ferguson, p. 82; TSYMC hua-hsüan 2; Chung-kuo MHC 3; Chung-kuo I, 15; Loehr Dated Inscriptions pp. 235-236; article by Han Ko in Wen-wu, 1960, 10.

Chin-k'uei II, 2 (formerly J. D. Ch'en Coll., H. K.). A man seated on a dais lifting a cup to drink. Album leaf. Signed: Ch'i-han. Copy.

Sung-jen hua ts'e B, 14. A midsummer rest under a locust tree. Album leaf. Attributed.

Boston Museum of Fine Arts (28.842). Lady on a terrace by a lotus pond; children playing in the garden. Fan painting. Old attribution; Southern Sung work. See BMFA Portfolio I, 39; Siren CP III, 133; BMFA Bulletin Feb. 1932.

Metropolitan Museum, N. Y. (47.18.49). A scholar at his desk; a servant bringing tea. Short handscroll. Attributed. Early copy?

Note: The attribution of the picture of two men playing chess, Chung-kuo ming-hua 31, to Wang Wei may be an error for Wang Ch'i-han, since the composition is related to the first two listed above.

WEI HSIEN 衛賢

A court painter in Nanking in the time of the Southern T'ang dynasty; held rank of Kung-feng under Li Hou-chu. Specialized in houses, trees and figures. G. H. M, p. 671. Y, p. 362.

* Peking, Palace Museum, *Kao-shih t'u:* the first century A.D. scholar Liang Hung and his wife in an open house at the foot of a mountain. Ink and colors on silk. Title and attribution written on adjoining silk by Emperor Hui-tsung. The painting is one of six of similar subjects by the artist recorded in *Hsüan-ho hua-p'u.* Seals of Wang Yung-ning (early Ming), Liang Ch'ing-piao, An Ch'i, and others. See notes by Hsü Pang-ta in Chung-kuo hua II, p. 59. See Chung-kuo hua II, 1; CK ku-tai 21; Kokyu Hakubutsuin, 161; CK li-tai hui-hua, 1, 94-5. Important early work, quite possibly as attributed.

* Shanghai Museum. The Water Wheel: buildings with figures; a waterwheel powering a flour mill. Large handscroll. Signed, signature partly cut off. Imperial seals of Hsüan-ho and Cheng-ho eras; also Liang Ch'ing-piao, etc. Colophons by Wang Shou-jen (dated 1510), Wang To, and others. Important early work. See Wen-wu 1966.2.3; I-yüan to-ying 1978 no. 2. An accompanying article in the latter notes the discovery during remounting of another signature, of Chang (? personal name illegible), and suggests that the Wei Hsien signature is an interpolation.

Ibid. The Kuang-han Palace. Signed. Good Yüan work. See Shanghai, 27; Chugoku bijutsu III, p. 100; Arts of China III, p. 52.

III.

Anonymous Paintings Ascribed to Periods before the Sung

Buddhist and Taoist Subjects

Shanghai Museum. Buddhist images and donors. See Wen-wu 1962.12.3.
Taipei, Palace Museum. Arhat with a tiger. See CKLTMHC I, 13.
* Boston Museum of Fine Arts (11.6120). The Sermon on Vulture Peak: Sak-
 yamuni and other figures in a landscape setting. Known as the "Hokke
 Mandara." Inscription by Kanshin (1084-1153). Sometimes said to be a
 Japanese painting. See BMFA Portfolio I, 30; Bijutsu kenkyu 58.186.192;
 Siren CP in Am. Colls. 4; Kodansha, BMFA, pl. 10.

Landscapes

* Taipei, Palace Museum (SV137). Emperor Ming-huang's Journey to Shu.
 Mountain landscape with travellers. Poem by Ch'ien-lung. Ming(?) copy
 of an important T'ang composition. See Pageant 13; Three Hundred M.,
 35; CAT 2; CKLTMHC II, 1; KK ming-hua I, 7; NPM Quarterly I, 2, pl.
 28; Wen-wu 1961.6.15; NPM Masterpieces I, 2. Wen-wu chi-ch'eng 4;
 Siren CP III, 83; Siren CP III, 83; Skira 28, 57. See also Li Lin-ts'an arti-
 cles in *Ta-lu tsa-chih,* VI/3, and Ars Orientalis IV, 1961. Other versions

of the composition include a late Ming mannered copy ascribed to Li Chao-tao in the same collection (V5); a version in hadscroll form in the Freer Gallery (09.224); a fragment of the upper left section only reproduced in Sogen (large edition only) pl. 20; a copy of the left half only, perhaps earlier than the Palace Museum version, now in the Yamato Bun-kakan, Nara see Etoh Shun's article in Yamato Bunka 49; "Chao Po-chü" picture in Chung-kuo MHC 25.

* Liaoning Museum. A villa in the mountains; men playing wei-ch'i on a terrace; another man with his servants approaching. Hanging scroll, ink and colors on silk. Found in a Liao dynasty tomb datable to the period 959-986. See Wen-wu, 1975 no. 12, pl. 1 and pp. 30-31.

Li-tai II (Formerly National Museum, Peking). A stream in autumn with red-leafed trees on the shores. Handscroll. Poem by Ch'ien-lung. Much later work.

Chung-kuo MHC 5. Winter Landscape. Imitation.

Nanshu ihatsu I. Sharply cut mountains in snow by a river. Possibly a work by Li Yin of the early Ch'ing period.

* John Crawford Collection, N. Y. (Cat., 3). *Pieh-yüan ch'un-shan t'u:* Retreats in the Spring Hills. Handscroll, painted in ink and colors. Colophon by Chao Yen. 12th century work in older style?

Peking, Palace Museum. Palaces and gardens. Yüan or later copy of an old composition? See KKPWY ts'ang-hua II, 22-23; Wen-wu 1961.6, inside front cover; CK li-tai hui-hua 1, 55-57.

Ibid. Figures in palace and garden complex. Handscroll. Archaistic picture of Ming date? See KKPWY ts'ang-hua II, 24-25; CK li-tai hui-hua 1, 52-54.

Figure, animal, and other subjects

* Peking, Palace Museum. Gentlemen riders on an outing. Handscroll. Fine work of Northern Sung date? See KKPWY ts'ang-hua II, 32-35; Pageant 17-19; CK li-tai hui-hua 1, 70-71; also handscroll reproduction (n.p., n.d.).

Ibid. One hundred horses. Handscroll. Copy of early composition? Repertory study scroll for specialists in horse painting? See KKPWY ts'ang-hua II, 36-38; I-yüan to-ying 1979 no. 1; CK li-tai hui-hua 1, 72-73.

* Nanking Museum. Tribute Bearers. Handscroll. Believed to be a Northern Sung copy, executed c. 1077, of an original by Hsiao I, or Emperor Yüan-ti of Liang, painted c. 539. See Wen-wu 1960.7.1; Chugoku bijutsu I, pl. 17, p. 114 and pl. 38-43, pp. 124-6; Arts of China pl. 198 and 218; see note pp. 224-226.

* Liaoning Museum. Two rabbits eating plaintain; lilies; sparrows in bamboo. Hanging scroll, ink and colors on silk. Found in a Liao dynasty tomb datable to the period 959-986. See Wen-wu, 1975 no. 12, pl. 2 and pp. 30-31.

Taipei, Palace Museum (TV14). *Yu-ch'i t'u:* seven men on horseback riding through a landscape. Possibly a T'ang design but later execution. See KK ming-hua I, 8; Wen-wu chi-ch'eng IV, 3; KK shu-hua chi 47.

* Ibid. (YV145). Palace Concert. Palace ladies seated around a table drinking; others making music to entertain an empress. Color on silk. Five Dynasties work? in the tradition of Chou Fang. See Three Hundred M., 204; CAT 10; CCAT pl. 12; CKLTMHC II, 15; KK ming-hua I, 22; Wen-wu 1955.7.8 (40); Skira 46; NPM Masterpieces III, 8.

Ibid. (TV12). The Great Yü Controlling the Flood; numerous men cutting rocks. Colophon by Ch'ien-lung. Late copy of older picture? See KK shu-hua chi 44.

Ibid. (WV25). A lady accompanied by three servants "Washing the Moon" in a garden well. Later Sung copy of 10th century composition? See KK shu-hua chi 13; CH mei-shu I; CKLTMHC I, 14; CKLTSHH; KK ming-hua I, 23; London Exh. Chinese cat. p. 113; KK chou-k'an 175.

Ibid. (WV24). A fisherman in a straw mantle standing among snow-covered reeds. Ming period. See KK shu-hua chi I; London Exh. Chinese Cat. p. 33; Three Hundred M., 60; KK ming-hua II, 19; Wen-wu chi-ch'eng 10; KK chou-k'an 493; NPM Masterpieces III, 9.

* Ibid. (WV26 and WV27). Deer in an Autumn Forest; Deer in Red Maples. Pair of hanging scrolls, colors on silk. Probably originally parts of a screen; may be Liao dynasty works, 10-11th century in date. Yüan palace seals, T'ien-li and K'uei-chang, used ca. 1330. For the first see Wen-wu chi-ch'eng 11; KK chou-k'an 308; Siren CP III, 142; Skira 68; KK shu-hua chi 22; Three Hundred M., 59; CAT 6; CH mei-shu I; CK ku-tai 25; CKLTMHC I, 15; CKLTSHH; KK ming-hua I, 24. For the second see KK chou-k'an 5; Siren CP III, 143; Three Hundred M., 58; CAT 5; CKLTMHC I, 16; KK ming-hua II, 20; KK shu-hua chi 22.

Mei-shu chia, no. 1. The Eight Ministers of the K'ai-yüan era (713-742). Handscroll. Colophon by Chao Meng-fu dated 1301; Cheng-ho (1111-1118) seal. Attributed to an anonymous master of the T'ang period, but judged by the author of the article, Li Wei-lo, to be a Sung copy.

Chiang Er-shih III, 2. Banquet of Literati. Handscroll, colors on silk. Hsüan-ho seal. Same composition as the hanging scroll "A Literary Gathering" ascribed to Hui-tsung. Late copy?

Freer Gallery (70.33). Wintry trees and sheep. Hanging scroll, ink on silk. 13th-14th century copy of early composition. See Meyer Cat. 21; Kodansha CA in West I, 25.

For the Boston Museum of Fine Arts picture "Scholars of the Northern Ch'i Dynasty Collating Classical Texts" see under Yen Li-pen.

* C. C. Wang, New York. A palace scene, with court ladies preparing a feast. See Smith and Wang, 156-7. Early copy?

IV.

Painters of the Sung Dynasty

AI HSÜAN 艾宣

From Nanking. Member of the Academy of Painting during the reign of the emperor Shen-tsung (1068-1085). Flowers and birds. F, 4. G, 18. H, 3. I, 50. K, 30. L, 54. M, p. 83. Y, p. 54.

Taipei, Palace Museum (VA17g). Two flowering poppy plants. Fan painting. Attributed. See KK chou-k'an I, 7; KK ming-hua II, 35.
Ibid. (VA11f). Mountain Bird on Autumn Reed. Album leaf. Attributed. Much later work.
Formerly National Museum, Peking. Eggplants and Cabbages. Signed. Imitation.
Shina kacho gasatsu 44. Four magpies attacking a grasshopper. Attributed. Yüan?
Laufer Cat. 23. Fading lotus and two herons. Attributed. Imitation.

CHANG CHI 張激

Nephew of Li Kung-lin. Active in the early 12th century.

* Liaoning Provincial Museum. *Pai-lien-she t'u:* The White Lotus Society Meet-

ing. Handscroll, ink on paper. Formerly ascribed to Li Kung-lin. The colophons by Li Chieh, Chang Chi and Chao Ling-shih were all inscribed by Fan Tun in 1161. Chang Chi's contains the date 1109, indicating his period of activity. The attribution of the painting to him is, however, somewhat speculative. See Liao-ning I, 24-35.

CHANG HSÜN-LI　張訓禮
See Chang Tun-li　張敦禮　　the Younger.

CHANG I　張翼　t. Hsing-chih　性之 h. Chu-lin　竹林
From Nanking. Active in the reign of the emperor Li-tsung (1225-1264). Figures. H, 4. Y, p. 255.

Liang Chang-chü Cat. 11. Portrait of a T'ang princess seated by a table. Attributed.

CHANG K'UEI　張珪
Chin dynasty, active in the Cheng-lung era (1156-1161). Figures in a lifelike manner in the "trembling brush" style. Y, p. 257.

* Peking, Palace Museum. A Sacred Tortoise on a Bank. Short handscroll, ink and colors on silk, with some use of "blown" (or spattered?) ink. Signed: *Sui-chia Chung Kuei,* indicating Chang's position as a court attendant. Two seals of the Chin palace collection. Colophon, unsigned, dated 1485. Seal of Ch'ien Hsüan, perhaps interpolated. Genuine work.

CHANG MAO　張茂　t. Ju-sung　如松
Native of Hang-chou. Member of the Academy of Painting in Kuang-tsung reign (1190-1193). Landscapes, birds and flowers. H, 4. I, 5. M, p. 462. Y, p. 255.

Peking, Palace Museum. Two ducks in water. Fan painting. Signed. See Sung-jen hua-ts'e A, 30; B VI, 9.
Taipei, Palace Museum (VA18j). Wagtail on a Lotus Leaf. Album leaf. Attributed. Copy of Yüan period work? See KK chou-k'an 14.

CHANG SHENG-WEN　張勝溫
Active in the 12th century in Yün-nan. Not recorded.

* Taipei, Palace Museum (SH28). Buddhist Images. Long handscroll representing Buddhas and Bodhisattvas (such as various forms of Kuan-yin), Arhats, etc. Ink, colors and gold on paper. Originally an album, remounted as a handscroll. The attribution to Chang Sheng-wen of the Ta-li Kingdom (in present Yünnan province) is contained in a colophon by the monk Miao-kuang, dated 1180; but the area of the date has been altered. Colophons by Sung Lien (1310-1381) and others. See Three Hundred M., 124-126; CAT 45; CKLTMHC I, 76; NPM Quarterly I, 2, pl. 25; Skira 51; Kokka 895, 898; NPM Masterpieces III, 24; Loehr Dated Inscriptions pp. 256-257; also an article by Helen Chapin in the *Journal of the Indian Society of Oriental Arts,* June 1936, Dec. 1936, June 1938; also articles by Masayuki Sekiguchi in Kokka 895 and 898; and Li Lin-ts'an, "A Study of the Nan-chao and Ta-li Kingdom in the Light of Art Materials Found in Various Museums," Academia Sinica, Institute of Ethnology, Monograph no. 9, Taipei, 1967; also a revision of Chapin's article by Alexander Soper, in *Artibus Asiae,* vol. 32/1-4 (1970), and vol. 33/1 (1971). The scroll is the subject of an unpublished doctoral dissertation for Princeton University by Moritaka Matsumoto; see his article in *Bukkyo Bijutsu,* no. 112, April, 1977.

CHANG SSU-HSÜN　張思訓
Unrecorded.

Saikyo-ji, Shiga. Portrait of Tendai Daishi. Signed. See Genshoku 29/81; Doshaku, 72.

CHANG SSU-KUNG　張思恭
Unrecorded in Chinese books, but mentioned in *Kundaikan Sayuchoki* (no. 14), where he is placed in the Northern Sung period. Said to have followed Li Kung-lin but painted mainly Buddhist figures.

Jison-in, Kyoto. Triptych: Sakyamuni; Manjusri; Samantabhadra. Attributed. See Kokka 149.
Senshu-ji, Mie. Amitabha and two Bodhisattvas. Attributed. See Kokka 489.
* Kozan-ji, Kyoto. Portrait of the Priest Pu-k'ung. Attributed. A fine work of the 12th or 13th century. See Kokka 278; Shimbi 14; Toyo 8; Toso 127; Siren CP III, 209.
* Ninna-ji, Kyoto. Mayura-vidyaraja (K'ung-ch'üeh Ming-wang) riding on a peacock. Attributed. See Shimbi 3; Toyo 8; Skira 50; Sogen no kaiga 1; Toyo bijutsu 1; Genshoku 29/76.
Doshaku, 82 (Private collection, Japan). Kuan-yin with willow branch. Attributed. Korean painting?

Matsuno-o-dera, Tango. Samantabhadra on the elephant. Attributed. See Shimbi 8.

Zenrin-ji, Kyoto. Sakyamuni and his ten disciples. Ten hanging scrolls. Attributed. See Sogen bijutsu 74 (Sakyamuni only).

Ibid. Amitabha triad. Signed. See Doshaku 80.

Kencho-ji, Kanagawa. Sakyamuni, Manjusri and Samantabhadra. Attributed. See Bijutsu kenkyu 56; Sogen bijutsu 72.

Atami Art Museum, Shizuoka. Amitabha triad. Attributed. See Doshaku, 83.

Sogen 73 (Okazaki Coll.). Sakyamuni standing on lotus flowers with one hand in varada-mudra. Attributed.

Kawasaki Cat. 45. Amitabha escorted by eight Bodhisattvas. Attributed. Also in Choshunkaku, 19.

Ibid. 49. Kshitigarbha (Ti-tsang) Bodhisattva. Attributed. Also in Choshunkaku, 20.

Fujita Museum, Osaka. Sixteen Arhats. Attributed. Ming copy.

Boston Museum of Fine Arts (68.145). Manjusri on the lion attended by a groom. In the style of the master. See Portfolio I, 125.

Ibid. (11.4002). Manjusri seated on a lion. Style of the master. See Portfolio II, 22; Siren CP in Am. Colls. 179.

Ibid. (11.6121). Bodhisattva with paper and brush; monkey holding ink-stone. Style of the master. See Portfolio I, 126; Siren CP in Am. Colls. 98.

Ibid. (09.86). Amitabha Trinity Descending on Clouds. Southern Sung painting; not attributed to Chang but in the style associated with him. See Portfolio II, 1.

Cleveland Museum of Art (formerly Marquis Inouye Coll.). Amitabha, Avalokitesvara and Mahastanaprapta(?). Attributed. See Kokka 249; Southern Sung Cat. 14.

University Art Museum, Berkeley. Manjusri on a lion. Late Sung, 13th cent.?

CHANG TSE-TUAN　張擇端　　t. Cheng-tao　正道　and Wen-yu　文友
From Tung-wu in Shantung. Active at the beginning of the 12th century in Kaifeng and Hangchou. Painted landscapes, boats, carriages, bridges, etc. H. K, 12. M, p. 461. V, p. 970. Y, p. 252.

* Peking, Palace Museum. *Ch'ing-ming shang-ho t'u:* Spring Festival on the River. Panorama of the city of Kaifeng. Handscroll, ink and colors on silk. Attributed in early (12th century) colophons. See Kokka 807, 809, 955; CK ku-tai 39; Wen-wu ching-hua I, pp. 9-28; Kokyu hakubutsuin, 28; Wen-wu, 1975, 4; also *Sung Chang Tse-tuan Ch'ing-ming shang-ho t'u chüan* (Shanghai: Chung-kuo ku-tien i-shu ch'u-pan-she, 1958). Also Chang An-chih, *Chang Tse-tuan Ch'ing-ming shang-ho t'u* (hereafter CMSHT) *Yen-chiu,* Peking, 1962; and article by Yang Hsin in Mei-shu yen-chiu 2, 1979. A study of this scroll by Roderick Whitfield, "Chang Tse-tuan's Ch'ing-ming Shang-ho t'u," Proceedings of the International Symposium on Chinese Painting, Taipei, 1972, pp. 351-388. Many later, free versions of the composition exist, all Ming period or later in date:

1. A version by Chao Che, Ming, dated 1577; see Kokka 567.
2. Taipei, Palace Museum (SH11), with spurious Sung colophons; see Loehr Dated Inscriptions pp. 243-244.
3. Taipei, Palace Museum (SH 75), Ming version with some variations in composition.
4. Two versions in the Metropolitan Museum, N. Y.
5. Two versions in the Freer Gallery (15.1 and 15.2); etc. For studies of some of these other scrolls, and (unconvincing) arguments for their authenticity, see Tung Tso-pin, *CMSHT* (Taipei, 1953); Hsü Chao, *CMSHT Kao* (Taipei, n.d., 1960s); and Liu Yüan-liu, *CMSHT chih ts'ung-ho yen-chiu* (Taipei, 1969).

Tientsin Art Museum. The Dragon-boat Festival; boat race on the Chin-ming lake. Large album leaf. Signed. Southern Sung painting? See I-yüan chi-chin I; Liang sung 16; Sung-jen hua-ts'e B, XVI; Wen-wu 1960.7.5.

Taipei, Palace Museum (SV264). Mountains in Spring. People on a dike approaching a palace on an island. Attributed. Seals of Liang Ch'ing-piao. Early Ming? or earlier? Work of good quality.

Kokka 681 (Atsushi Misaki Coll., Tokyo). The Bird-seller. Signed. Yüan-Ming work?

CHANG-TSUNG 章宗

Emperor Chang-tsung of Chin 金 (reigned 1190-1208). B. 1168, d. 1208. Collector and patron of art.

I-shu ts'ung-pien 19. A young woman holding a dog in her arms standing by a curtain, which she lifts with her hand. Attributed. Much later work.

CHANG TUN-LI 張敦禮

Later changed his name to Chang Hsün-li 張訓禮 when, in the reign of the emperor Kuang-tsung (1190-1194), the character *tun* became taboo. Followed Li T'ang as a painter of landscapes and figures. See *Hua-chi pu-i,* 13; also H, 4, p. 14. M, p. 460. Y, p. 255. Writers beginning with T'ang Hou and Hsia Wen-yen in the Yüan dynasty confused him with a man of the same name who was a son-in-law of the emperor Ying-tsung (reigned 1068-1077) or Che-tsung (reigned 1086-1100), and the mistake is repeated in later books (H, 3. M, p. 459. V, p. 955. Y, p. 250), but there is no evidence that this man was ever a painter.

Peking, Palace Museum. Fishing boat in a spring landscape. Fan painting. Attributed. See Sung-jen hua-ts'e A, 31; B IX, 2.

Ibid. Enjoying the scenery from a river pavilion. Fan painting. Attributed. See *Sung Chang Hsün-li Chiang-t'ing lan-sheng* (Peking: Jung-pao chai hsin-chi, 1956). The composition is identical to the painting in the Liaoning Provincial Museum ascribed to Chu Huai-chin.

Taipei, Palace Museum (SV84). Scholars drinking wine and examining pictures in a garden. Poem by Ch'ien-lung. Attributed. Ming copy of Sung work.

See KK shu-hua chi 35; CKLTMHC I, 53.
* Ibid. (VA11g). Landscape with villas on a river shore. Fan painting. Attributed. Fine 12th century work, possibly by him.
Ibid. (VA12g). Playing Football in the Garden. Fan painting. Attributed.
KK chou-k'an 480. A palace on the shore of a lake at the foot of cliff. Album leaf. Attributed. A colophon by the emperor Kao-tsung on the opposite leaf.
Freer Gallery (17.108). A traveller in a moonlit landscape. Fine painting of Ming date, close in style to Chou Ch'en, perhaps his work.
Boston Museum of Fine Arts (34.1460). Illustrations to the Nine Songs of Ch'ü Yüan. Handscroll, ink and colors on silk. A colophon attached to the scroll, essentially the same as one recorded in Pei Ch'iung's collected works, *Ch'ing-chiang shih-chi,* attributes the paintings to Chang Wu; but neither record refers to the present scroll, and it is clear that the colophon was copied onto the scroll on the basis of Pei's entry by a later owner. The earlier title label attributed the scroll to Chang Tun-li, and two recent publications have accepted that attribution (Barnhart, "Survivals," p. 166; Kodansha CA in West, I, 57, pp. 241-2). But some elements of the style suggest a dating as late as Ming. See Boston MFA Portfolio I, 148-151; MFA Bulletin, Oct. 1937; Kodansha suiboku IV, 58-9.

CHANG YÜ　張瑀
Unrecorded. According to the signature on the following picture, active under the Chin dynasty during the early 13th century.

* Kirin Provincial Museum. Lady Wen-chi's Return to China. Handscroll. Kuo Mo-jo, in Wen-wu 1964, no. 7, reads the signature as Chang Yü; not clear in reproduction. Signature preceded by Chih-ying ssu 祇應司 , a bureau(?) founded in 1201 under Chang-tsung. See Wen-wu 1964, no. 3; NPM Quarterly XI/1, pl. 4. Practically identical in composition to the scroll in the former Abe collection attributed to Kung Su-jan, which, however, is said to represent Wang Chao-chün leaving China.

CHAO CH'ANG　趙昌　t. Ch'ang-chih　昌之
From Kuang-han, Szechwan. B. c. 960, d. after 1016. Flowers and birds, followed T'eng Ch'ang-yu and became particularly famous for his close studies of nature. D, 3. F, 4. G, 18. H, 3. I, 50. K, 26. L, 47. M, p. 609. Y, p. 311. Biog. by S. Ueda in Sung Biog., 1.

* Peking, Palace Museum. Butterflies, grasshoppers and water plants. Short handscroll, ink and light colors on paper. Attributed. See *Sung Chao Ch'ang Chieh-tieh t'u chüan* (Peking: Wen-wu ch'u-pan she, 1960). A later Sung painting? Colophons by Feng Tzu-chen and Chao Yen of the early Yüan period, also by Tung Ch'i-ch'ang. See also I-yüan to-ying, 1979 no. 1, with article by Hsü Pang-ta arguing that the painting represents the tradition of Hsü Hsi.

Taipei, Palace Museum (SV21). Flowers of the New Year's Day. Plum blossoms, camelias, narcissus, and others by a rockery. Two spurious signatures. Ming decorative work. See Ku-kung 21; London Exh. Chinese Cat., p. 38; Three Hundred M., 55; KK chou-k'an 174; Siren CP III, 141.

Ibid. (SV22). Four magpies in a blossoming tree. Colophon, possibly spurious, signed Tung Ch'i-ch'ang. Ming work, perhaps by Pien Wen-chin. See KK shu-hua chi 20; Wen-wu chi-ch'eng 24; NPM Masterpieces V, 8.

Ibid. (SV23). Peonies, epidendrums, and fungi by a rockery. Inscribed with the painter's name. Late decorative work. See London Exh. Chinese Cat. p. 39; KK shu-hua chi 26; KK chou-k'an 354.

Ibid. (VA11d). Bird on a cherry-apple branch. Album leaf. Attributed. Ruin of a good painting, Southern Sung or Yüan.

Ibid. (VA15e). A mountain bird on the branch of a cherry tree. Fan painting. Attributed. Hard copy.

Ibid. (VA17d). A branch of blossoming apricot. Fan painting. Copy of Sung work? See KK chou-k'an I, 6; Soga I, 28.

Ch'ing kung ts'ang 34 (Formerly Manchu Household Coll.). A pair of wild geese standing by some rushes. Fan painting. Signed. Later work.

Chung-kuo MHC 6. White flowers on a tall stalk. Painter's name written by Hui-tsung. Poem by Ch'ien-lung. Reproduction indistinct.

Shen-chou ta-kuan hsü 10. Plover and flowers. A fragment. Attributed. Later work.

Chang Ta-ch'ien Cat. IV. Orchid, bamboo, chrysanthemum and insects. Large album leaf. Later work.

* Toyo 8 (Sugahara Coll., Kamakura). A branch of white jasmine. Fan painting. Attributed. Fine Southern Sung work. See also Kokka 241; NPM Quarterly I.2, pl. XIIb; Skira 75; Siren CP III, 139; Sogen MGS II, 12.

* Kokka 395 (Asano Coll.). A branch of a blossoming apple tree. Fan painting. Attributed. Fine Southern Sung work. See also Sogen no kaiga 51; Siren CP III, 140; Toyo bijutsu 49; Sogen MGS II, 2.

Sogen meigashu 5 (Baron Dan Coll.). A lotus bud and a split seed case. Album leaf. Attributed.

Ibid. 62 (Magoshi Coll.). An orange and two peaches. Painter's seal, interpolated. Later work.

Hikkoen pl. 35. Chrysanthemums and peonies in a basket. Album leaf. Later work.

Hatakeyama Art Museum, Tokyo (former Inouye). Bamboo and insects. Short handscroll. Attributed. See Sogen meigashu 16; Kokka 243.

Kyoto National Museum. A lotus pond with two mandarin ducks. Ink and colors on silk. Attributed. See Sogen no kaiga 63.

Nezu Museum, Tokyo. Basket of flowers. Album leaf. Attributed. Yüan-Ming painting. See Nezu Cat. I, 28.

Takamizawa Collection, Tokyo (1973; formerly Asano Coll.). Melon with flowers, beetle, and dragonfly. Fan-shaped painting, ink and color on silk. Fine Sung painting, in bad condition.

Sogen shasei gasen 12. Quail by peonies. Album leaf. Attributed. Sung-Yüan work, repainted?

Ibid. 10. Bird on a peach branch. Seal of Chao Ch'ang, a Japanese interpolation. Yüan-Ming work.

Nelson Gallery, Kansas City (31.135/32d). A basket of flowers. Album leaf, ink and colors on silk. Signed. Southern Sung work.

British Museum. Two white geese resting on the shore. Signed. Ming picture.

Note: Other works attributed to Chao Ch'ang in the Metropolitan Museum, N. Y.: 13.100.114 (Melon, album leaf); 26.115.1 (Herons in a lotus pond); 47.18.5 (Bees and flowers, handscroll; see Priest article in their *Bulletin,* Feb. 1952, p. 176ff.; also Siren Bahr Cat. pl. XIV.).

For the painting of bamboo, melons, insects, etc. formerly in the Asano Collection, sometimes ascribed to him, see under Hsü Ch'ung-ssu.

CHAO CH'IUNG 趙璚

Lived in Ningpo at the end of the Southern Sung period. Painted Buddhist icons. See Bijutsu kenkyu 46.

* Hokkekyo-ji, Chiba-ken. Series of paintings of sixteen arhats mounted on two screens. Signed. See Bijutsu kenkyu 46; Doshaku, 78.

* Boston Museum of Fine Arts (54.1423). The Arhat Kanakaratsa, from the above series. Signed. See Archives IX, 1955, p. 78.

CHAO FU 趙黻 or 芾

Native of Chen-chiang, Kiangsu. Active in the Shao-hsing era (1131-1162). Became famous for his pictures of the Chin and Chiao Islands and other scenes of the Yangtze River area. H 4. K, 26. M, p. 613. Y, p. 331.

Peking, Palace Museum. Ten Thousand Li of River and Mountains. Long handscroll, ink on paper. Signed. (Siren: genuine work.)

Metropolitan Museum, N. Y. (13.220.99). A man floating on a lotus leaf. Album leaf. Signed. Imitation.

CHAO K'O-HSIUNG 趙克夐

A member of the royal house of Sung who became a general. Northern Sung period. Fishes. H, 3. G, 9. M, p. 607. Y, p. 314.

* Metropolitan Museum, N. Y. (13.100.110). Fish at play among waterplants. Album leaf. Old attribution. Fine Sung work. See Siren CP III, 361a; Suiboku 3/92; Kodansha CA in West I, 27.

CHAO KUANG-FU 趙光輔

From Hua-yüan, Shensi. Member of the Academy of Painting in the reign of T'ai-tsu (960-975). Figures and horses. F. H, 3, p. 17. M. p. 608. Y, p. 310.

* Cleveland Museum of Art (57.358). *Man-wang li-fo t'u:* Barbarian Chieftains Worshipping Buddha. Handscroll, ink and colors on silk. Signed. Colophons by Chao Meng-fu, Kuo Pi (dated 1325), and others. Yüan palace seal *T'ien-li chih-pao,* used ca. 1330. Later Sung work? See their *Bulletin,* March 1958; Munich Exh. Cat. 8; Archives 12 (1958) p. 78; Lee History of F. E. Art fig. 202.

CHAO K'UEI　趙葵　t. Nan-chung　南仲 , h. Hsin-an　信庵
From Heng-shan, Hunan. B. 1186, d. 1266. Known as a poet and a prominent official; held the title of Duke of Chi　冀國公　. Specialized in plumblossoms. M, p. 613. Y, p. 331; also biography in *Sung-shih.*

* Shanghai Museum. *Tu Fu shih-i t'u.* Bamboo groves along a river; small figures travelling on foot and on horseback, and a scholar in his study. Handscroll, ink on silk. Colophon by Chang Chu (Yüan dynasty) attributing the picture to Chao K'uei; others by Cheng Yüan-yu, Yang Wei-chen, etc. Genuine work? See Gems II, 5; I-yüan to-ying, 1978, no. 2.

CHAO LIN　趙霖
Active as a painter in the reign of emperor Hsi-tsung of the Chin dynasty (1135-1148). M, p. 614. Y, 332.

* Peking, Palace Museum. The six horses of Emperor T'ang T'ai-tsung, painted versions of the stone reliefs (after a painting by Yen Li-pen?) which were placed at the emperor's tomb near Ch'ang-an. Each horse accompanied by an inscription. Attributed in a colophon by Chao Ping-wen dated 1160. Handscroll, colors on silk. See Kokyu hakubutsuin, 30-31.

CHAO LING-CHÜN　趙令畯　, t. Ching-sheng　景升
Brother of Chao Ling-jang. Held title of Duke of Chia　嘉國公　. Active at the end of the 11th century. Horses in the manner of Li Kung-lin; figures and landscapes. M, p. 610. V, p. 1392. Y, p. 317.

Freer Gallery (17.113). The Brushing of the White Elephant. Attributed. Late Ming, cf. Ting Yün-p'eng.

CHAO LING-JANG　趙令穰　t. Ta-nien　大年
Active c. 1070-1100. Member of the imperial Sung family; high official. Landscapes, particularly misty river scenes. G, 20. H, 3. I, 50. K, 26. L, 47. M, p. 609. Y, p. 314. Also Robert Maeda, "The Chao Ta-nien Tradition," Ars Orientalis VIII, 1970.

Peking, Palace Museum. A village by the water in mist. Fan painting. Attributed. Southern Sung painting. See Sung-jen hua-ts'e A, 78; B. VI, 2;

Maeda, Ars Orientalis VIII, fig. 4.

Taipei, Palace Museum (VA17b). Orange grove and birds. Fan painting. Fine Southern Sung? work in his tradition. See KK ming-hua I, 39; NPM Masterpieces II, 15.

Ibid. (VA3j). A broad view over a river; a traveller approaching a pavilion among willows on the shore. Fan painting. Attributed. Southern Sung? See Maeda, Ars Orientalis VIII, fig. 1; NPM Bulletin 3/1 (1968).

Shen-chou III. Village by the river at the foot of high mountains. Inscribed with the painter's name. Imitation.

Ming-jen shu-hua 24. An open bay with fishing boats; willows on the shore. Imitation.

Pao-yün II. A village by a river. Large hanging scroll. Signed. Much later work.

Chin-k'uei II, 9 (formerly J. D. Ch'en Coll., H. K.). Broken bridge in the harbor; houses among pines near a river. Handscroll. School work.

Toso 38 (S. H. Hwa Coll., Taipei). High mountains and trees by a river in snow. Inscribed with the painter's name. See also Mei-chan.

Fujii Yurinkan, Kyoto. T'ao Yüan-ming and a friend seated in a pavilion on a promontory surrounded by flowering chrysanthemums. Handscroll. Colophons by Chan T'ung-wen and other writers of the Yüan period. Inscription (perhaps spurious) by Tung Ch'i-ch'ang with attribution to the painter. Refined old imitation. See Yurintaikan III; Toso 37. Another version of the composition, in vertical form: Pageant 448.

Fujita Museum, Osaka. A river scene with willows and geese. Handscroll, ink and colors on silk. Attributed. Ch'ien-lung and other imperial seals. Colophons by Yüan dynasty writers, beginning with one by Ch'ien Hsüan dated 1297. See Homma Sogen, 13.

* Yamato Bunkakan, Nara (formerly Hara Coll.). River landscape in mist with geese and flocking crows. Album leaf. Genuine? or fine work of early Southern Sung follower? See Toyo VIII, pl. 27; Kokka 41; Shimbi 19; Sogen no kaiga 98; Siren CP III, 225; Toyo bijutsu 28; Genshoku 29/12; Sogen MGS III, 1; Yamato Bunka, 26; Yamato Bunkakan Cat. 2/107; Bunjinga suihen II, 74; Kokka 942.

Toyo VIII, pl. 26 (Akaboshi Coll.). A farmhouse among trees by a bay. Horizontal album leaf. Late Sung or Yüan, not in his style. See also Kokka 224; Bachhofer pl. 100.

Toso 36 (formerly Hayasaki Coll.). River scenery with mountains in snow and flocking crows. Album leaf. Early Ming?

Choshunkaku 26-27. Willows on a riverbank, ducks on a river. House among trees by a stream. Pair of fan paintings. Attributed. Good early school work.

Agata Collection, Osaka (formerly Moriya Coll., Kyoto). Mist and rain over the stream in spring. Handscroll. Colophons by Wen Cheng-ming, Tung Ch'i-ch'ang and others. Copy of Ming date?

Homma Sogen, 14. Geese and lotus. Fan painting. Attributed.

* Boston Museum of Fine Arts (57.724, formerly Manchu Household Coll.). River scenery with floating mist; cottages among trees. Handscroll, ink and color on silk. Signed and dated 1100. Ssu-yin half-seal. Genuine

work. Poems and colophons by Tung Ch'i-ch'ang and others. See Kokka 494; Sogen p. 7; CK ku-tai 35; Siren CP III, 226; Cohn Ch. Ptg. 60; Loehr Dated Inscriptions pp. 236-237; Kodansha BMFA 96; Bunjinga suihen II, 73.

Freer Gallery (14.62). River landscape with bare trees and crows. Handscroll, ink on silk. Spurious signature of Chao Po-chü; actually a fine work in the Chao Ling-jang tradition, Yüan or early Ming in date.

Ibid. (60.3, formerly Chang Ts'ung-yü Coll.). The Autumn Pond. Landscape with aquatic birds. Handscroll, ink and colors on silk. A later (early 16th century?) painting in his tradition.

* Metropolitan Museum, N. Y. (1973.121.12). River Village in Autumn Dawn. Farmhouse by a river on an autumn morning; a flock of wild geese alighting. Handscroll, ink on silk. Attributed. Colophons by Chao Meng-fu, Kung Hsiao and others. Early work in this style, perhaps genuine. See TWSY ming-chi 21-22.; Met. Cat. 1973, no. 5.

British Museum. Landscape with trees by a river. Portion of a handscroll? Yüan-Ming work in his tradition. See La Pittura Cinese, 156.

Note: See also the "Wang Wei" handscroll in the Taipei Palace Museum (TH6), a fine early work in his style; and works attributed to Hui-ch'ung in the Palace Museum, Taipei (VA5j) and the Liaoning Provincial Museum. See also the fan painting in the Liaoning Museum listed under Chao Ta-heng, the signature on which may read "Chao Ta-nien."

CHAO MENG-CHIEN 趙孟堅 t. Tzu-ku 子固 , h. I-chai 彝齋
B. 1199, d. c. 1267. A relative of the imperial Sung family; lived near Hai-yen, Chekiang. Han-lin Academy member. Specialized in narcissi; painted also plum blossoms, orchids, and bamboo. H, 4. I, 52. K, 26. L, 47. M, p. 612. Y, p. 329. See also the article by Hsü Pang-ta in Wen-wu 1958.10, pp. 17-18; biog. by Chu-tsing Li in Sung Biog., 2-7.

Peking, Palace Museum. Two tufts of orchids with gracefully spreading leaves. Inscription by the painter. Short handscroll. (Siren: genuine work.)

* Tientsin Art Museum. Narcissi. Handscroll. Inscription, signed and dated to an explanatory note by the editor of the last publication below, the inscription at the beginning containing the date is spurious, but the scroll, and the artist's seal at the end, are genuine. See T'ien-ching I, 1-5; Wen-wu 1958.10.19; and Sung Chao Meng-chien Shui-hsien t'u chüan (Peking: Wen-wu ch'u-pan-she, 1961).

* Shanghai Museum. Three friends of winter: pine, bamboo and plum. Fan painting. Artist's seal. See Liang sung 47; Sung-jen hua-ts'e B, 17.

Sung-jen hua-ts'e, A, 97. A narcissus. Fan painting, colors on silk. Attributed.

* Taipei, Palace Museum (chien-mu SH122). Narcissi. Long handscroll. Seals of the painter. Seals of Ch'ien-lung, Hsiang Yüan-pien, and An Ch'i (1683-1750). Colophons by K'o Chiu-ssu and others.

* Ibid. (VA2f). "Three friends of the cold winter": pine, bamboo and blossoming plum. Seals of the painter. Album leaf. See KK shu-hua chi 33;

Three Hundred M., 131; CAT 67; CKLTMHC I, 75; KK ming-hua III, 27; KK chou-k'an 31; NPM Masterpieces II, 34.

* Bunjin Gasen II, 2-4 (formerly Manchu Household Coll.). Narcissi. Long handscroll. The whole scroll reproduced in photographs by the Yen Kuang Co., Peking. See also Bijutsu kenkyu 15; Siren CP III, 363; Nanga Taisei I, 16, pls. 11-15.

Shen-chou album, 1909: *Chao Tzu-ku shui-hsien chüan.* Narcissus and rocks. Handscroll. Inscription by the artist. Colophons by Weng Fang-kang and Sung Pao-chün. Copy or imitation.

I-yüan Album, n.d. (Sung Chao Tzu-ku lan-p'u chüan). Orchids and rocks. Handscroll. Painted as a guide for students. An essay on painting orchids follows, written and signed by the artist. Copy? Colophon by Wang Ch'ih-teng, dated 1531.

Liang Chang-chü Cat. 12. Two tufts of orchids and fungi.

Wu P'u-hsin Collection, Taipei (1968). Narcissus. Handscroll, ink on paper. No signature or seal. Attributed. Colophons by Chou Mi and Ch'iu Yüan; seals of Hsiang Yüan-pien. Old and good painting.

Nanzen-ji, Kyoto. Bamboo. Probably a Yüan picture. See Shimbi III.

Freer Gallery (33.8). Narcissi. Handscroll, ink on paper. Signed. See Siren CP III, 362b; Shen-chou, 2. Similar pictures with the same poem also in Toso 99; Che-chiang 18; Chung-kuo MHC 23.

* Metropolitan Museum of Art, N. Y. (1973.120.4). Narcissi. Handscroll, ink on paper. Attributed. Colophons by Chou Mi (1232-aft. 1308), Ch'iu Yüan (1247-aft. 1327), Lin Chung (late Yüan), and four others; seals of Hsiang Yüan-pien and others. See Met. Cat., 1973, no. 12; Bunjinga suihen II, 80. Another version in the collection of C. T. Loo, Paris.

Ibid. Narcissus. Album leaf, ink on silk. Style of Chao Meng-chien. See China Institute Album Leaves #46.

Ralph M. Chait, N. Y. (1956). Flowering Narcissi (a portion in the center is missing). Long handscroll.

Chugoku, I, pl. 81-83 (Juncunc Coll., Chicago). Spring flowers. Handscroll. Signed and dated 1257. See Loehr Dated Inscriptions p. 275.

Note: There are doubtless some duplications and omissions in the above listing of narcissus scrolls ascribed to Chao Meng-chien.

CHAO PO-CHÜ　趙伯駒　　t. Ch'ien-li　千里

A descendant of the first Sung emperor. D. c. 1162. Active in the 1120's at the Academy in Kaifeng and during the reign of the emperor Kao-tsung at the Academy in Hangchou. Well known and highly appreciated as a painter in the "gold-and-green" manner, particularly of landscapes with architectural motifs. Followed Li Ssu-hsün. H, 4. I, 51. K, 26. (same as I, 51). L, 47. M, p. 614. Y, p. 324. See also Trousdale article in Ars Orientalis IV, 1961; biog. by Ellen Laing in Sung Biog. 8-15 (with Chao Po-su).

* Peking, Palace Museum. *Chiang-shan ch'iu-se t'u:* Autumn Colors on Rivers and Mountains. Large handscroll, ink and colors on silk. Attributed to the painter in a colophon by the Hung-wu Emperor dated 1375. Superb

painting of the period; most likely to be Chao Po-chü among the many ascribed to him. See Chung-kuo hua XIII, 10-11, 14-15, 18-19, 21; CK ku-tai 47; Trousdale pl. 66; Siren CP III, 271.

Taipei, Palace Museum (SV55). Mountains in spring; pleasure boats on the river at their foot. Poem and colophon by Ch'ien-lung. Interesting Ming work; cf. Ch'iu Ying's paintings in the blue and green manner. See Ku-kung 13; London Exh. Chinese Cat. p. 70; KK chou-k'an 199; CKLTMHC II, 39; NPM Masterpieces V, 9.

Ibid. (SV56). The A-fang Palace in a Rock Garden. Yüan work, cf. Hsia Yung. See KK shu-hua chi 26; London Exhib. Chinese cat. p. 71; CKLTMHC II, 4; CH mei-shu I; KK chou-k'an 403; Wen-wu chi-ch'eng 38; Trousdale pl. 5b.

* Ibid. (SV57). The Han Palace: the Mid-Autumn Festival. Fan painting. Attributed to Chao Po-chü in a note by Tung Ch'i-ch'ang. Probably by a contemporary of Ma Yüan. See KK shu-hua chi 3; KK chou-k'an 180; Skira 81; Trousdale pl. 5a; Siren CP III, 272; CAT 42; CKLTMHC I, 52; KK ming-hua III, 9; NPM Quarterly I.2, pl. 29.

Ibid. (SV58). The Han Palace on a Spring Morning. Attributed. Ming period, Che School. See KK shu-hua chi 47.

Ibid. (SV59). Resting the Ch'in and Playing the Yüan. Ming copy.

Ibid. (SV60). A sea deity listening to a discourse. Copy of Sung work? See Three Hundred M., 107; CKLTMHC II, 37.

Ibid. (chien-mu SV265). A fairy riding on a dragon which is floating on a cloud over the sea. Later work. See Ku-kung 32; CKLTMHC II, 38.

Ibid. (VA3k). A guest arriving in evening at a pavilion near tall pines. Fan painting. Attributed. Copy of Southern Sung work.

Ibid. (VA4e). Resting in the River Pavilion. Attributed. Copy.

Ibid. (VA13g). Seated on the veranda of a water-side pavilion. Album leaf. Attributed. Southern Sung in style, later execution? See NPM Masterpieces II, 23.

Ibid. (VA16d). Waiting for the Ch'in in the Willow Shade. Fan painting. Attributed. Copy of Yüan work?

Ibid. (VA22i). Elegant Gathering in the Western Garden. Album leaf. Attributed. Copy.

Ibid. (VA21a). Landscape with palaces. Fan painting. Attributed. Archaistic style, Ming execution?

Ch'ing kung ts'ang 46 (Formerly Manchu Household Coll.). Pavilion behind two pine trees under a cliff by a river. Fan painting. Signed. Reproduction indistinct.

Shen-chou 9. Fairy palaces amid clouds in the mountains. Gold and green style. Imitation.

Shen-chou 16. Imperial summer palaces; fantastic buildings and boats on lakes surrounded by craggy mountains and colored trees. Poem by K'o Chiu-ssu. Imitation.

Chung-kuo I, 30 (Ti P'ing-tzu Coll.). Pavilions at the foot of high mountains by a lotus lake. Crudely colored reproduction. See also Chung-kuo MHC 30.

Ibid. I, 31 (Ti P'ing-tzu Coll.). Travellers on a steep mountain path by a river in Shu. Signed. Inscription by a Yüan writer dated 1342. A copy of the left half of "Emperor Ming-huang's Journey to Shu" composition listed under Anon. Pre-Sung. See also Chung-kuo MHC 25.

Li-tai 4. (Formerly National Museum, Peking). Fairy Palaces on the mountain of the immortals. Gold and green. Signature and seals of the painter. Imitation.

C. P. Huang Collection, Taipei. Palace pavilion on a terrace rising above a river. Blue and green mountains, white clouds. Seal of the painter. Ming work.

Toso 66 (Ch'en Pao-ch'en Coll.). The Chiu-ch'eng Palace of the T'ang emperor T'ai-tsung. Signed. A T'ang poem copied by Wen Cheng-ming; other poems by Leng Ch'ien and T'ang Yin. Imitation.

Fujii Yurinkan, Kyoto. The Palaces of the Immortals. Colors on silk. Poem written by Wang Ch'ung. Imitation. See Yurintaikan III; Toso 65; Trousdale pl. 6a.

Ibid. Spring light on the jade pond. Handscroll. Gold and green on silk. Signed. Imitation. A better version of the composition is in the Nelson Gallery, Kansas City, ascribed to Chiu Ying. See Yurintaikan II.

Ibid. River landscape with cottages. River landscape with palaces. Two fan paintings. Attributed. Yüan or early Ming.

Seikasha Sogen, 6. Travellers with mules resting beneath rocky cliffs. Fan painting. Attributed. Ming? copy of central portion of "Emperor Ming-huang's Journey to Shu" composition (listed under Anon. Pre-Sung).

Kumamoto 2. Landscape with a temple on a cliff. Attributed. Later painting.

Takamizawa Collection, Tokyo (1973). Hawk attacking pheasant. Album leaf, ink and colors on paper. Signature, Ch'ien-li, interpolated. Good Southern Sung painting, cf. Ch'en Chü-chung.

Boston Museum of Fine Arts. Entry of the first Emperor of the Han dynasty into Kuan-chung. Handscroll, colors on silk, in the "gold and green" manner. Signed. Colophons dated in the Yüan and Ming periods. Ming work. See Portfolio I, 66-69; Siren CP III, 273-274; Trousdale pl. 1-3; Siren CP in Am. Coll. 24; Pageant 107; Kodansha BMFA 76.

Ibid. Palaces and pavilions among the mountains. Attributed. See Trousdale pl. 7.

Freer Gallery (14.62). Handscroll in Chao Ling-jang's style; spurious signature of Chao Po-chü.

John Crawford Collection, N. Y. (Cat. 13). Tartars and Horses. Handscroll, colors on paper. Signed. A work in the Liao tradition, unrelated to Chao. The first half of the picture is older than the latter half, which is a replacement. See also Chang Ta-ch'ien Cat. I, 2.

C. D. Carter Collection, Scarsdale, N. Y. A pavilion in the mountains with a man approaching. Fan painting. Attributed. Yüan-Ming?

Museum of Far Eastern Art, Stockholm. Temple in the Mountains. Two men watching a waterfall. Attributed. See La Pittura Cinese 170.

University of Michigan Art Museum. Buildings on cliffs among trees. Attributed. Good fourteenth century work.

Other works ascribed to the artist in the Metropolitan Museum, N. Y.:
13.100.122 (Sage by a stream, album leaf); 13.220.106 (The Lan-t'ing
Gathering); 23.117 (Palace); 27.24 (Contest between Hariti and Buddha);
38.31.2 (Landscape of palaces of Ch'in, see Priest article in their *Bulletin*,
Dec. 1939, pp. 277-279); 47.18.4 (Spring morning in the Palaces of Han,
small handscroll, see Priest article in their *Bulletin*, March 1951, pp. 173-
174 and Trousdale pl. 8); 29.100.478 (Sea and sky at sunrise, see Priest
article in their *Bulletin*, March 1951, pp. 176-177).

CHAO PO-SU　趙伯驌　　t. Hsi-yüan　希遠
Younger brother of Chao Po-chü, whom he followed in painting. B. 1124, d.
1182. H, 4. I, 51. L, 47. M, p. 611. Y, p. 326. Also Ellen Laing biog. in
Sung Biog. 8-15.

* Peking, Palace Museum. Pines and other trees on a river shore; cranes and
 other birds; a Taoist temple? beyond. Handscroll, ink and colors on silk.
 Attributed. Fine work of the period, in a poetically archaistic manner.
 Ibid. A warrior returning from the hunt. Album leaf. Attributed. Copy of old
 composition? See Sung-jen hua-ts'e A, 19; B. V, 1.
 Taipei, Palace Museum (VA12h). Reading in the Open Pavilion. Fan painting.
 Attributed. Southern Sung work of high quality. See NPM Masterpieces
 II, 24.
 C. M. Lewis Collection, Pittsburgh. A palace with figures; tall pine trees.
 Round fan painting. Attributed. Late Sung work?

CHAO SHIH-LEI　趙士雷　　t. Kung-chen　公震
Member of the imperial house of Sung. Served as a high official at Lien-chou,
Kwangtung. Painted river scenery, flowers and bamboo. G, 16. H, 3. M, p.
610. Y, p. 321.

 Taipei, Palace Museum (chien-mu SH74). *Chiang-hsiang nung-tso t'u:* the
 Farmers' Life along the River. Handscroll. Attributed. Ming work.
* Ibid. (VA16c). A villa by the water; a visitor approaching. Fan painting.
 Attributed. Southern Sung work of high quality. See NPM Masterpieces
 II, 14.

CHAO TA-HENG　趙大亨
Was for many years the servant of Chao Po-chü whom he imitated so closely,
particularly in the gold and green manner, that his pictures often were taken for
the master's works. H, 2. I, 52. M, p. 613. Y, p. 328.

* Liaoning Provincial Museum. Resting in a pavilion under fruit trees. Fan
 painting. Signed, but the signature may read Chao Ta-nien, i.e. Chao
 Ling-jang. See Liang Sung 14; Liao-ning I, 41; Sung-jen hua-ts'e B,
 XVIII; Sung Yüan shan-shui 5; Liaoning Album 5.

Taipei, Palace Museum (SV124). Immortals on the P'eng-lai Island. Palaces and figures among the mountains. Late Yüan or early Ming work. See KK shu-hua chi 28; CKLTMHC II, 54; KK chou-k'an 431.

CHAO TSUNG-HAN　趙宗漢　　t. Hsien-fu　獻甫
A brother of the emperor Ying-tsung of Sung (reigned 1064-1067). Died in 1109. Specialized in wild geese; also landscapes. G, 16. H, 3. M, p. 606.

Taipei, Palace Museum (chien-mu SV235). The Yen Mountain with pavilions and figures. Signed. Colophon by the painter dated 1057. Poem by Ch'ien-lung. Early Ch'ing Academy work? See Ku-kung 5; Loehr Dated Inscriptions p. 232.

CHAO TZU-HOU　趙子厚
From Shih(?)-hsien　　　in Hopei. Member of the Sung imperial family. H, 4. M, p. 612. Y, p. 331; also *Hua-shih hui-yao*.

Toso 118-119 (Inoue Katsunosuke Coll.). Hawk pursuing a hare; a hawk stalking a pheasant. A pair of hanging scrolls. Attributed. See also Pageant 182, 183.

CHAO YUAN-CHANG　趙元長　　t. Lü-shan　廬山
Active late 10th century. From Szechwan. Also signed his name Chang-yüan. Specialized in astrological diagrams. H, 3, p. 61. M, p. 608. Y, p. 309.

Taipei, Palace Museum (VA28d). Mountain bird on a branch of blossoming plum. Signed. Much later work.

CH'AO PU-CHIH　晁補之　　t. Wu-chiu　无咎　h. Kuei-lai-tzu　歸來子
From Chü-yeh, Shantung. B. 1053, d. 1110. Literary writer, poet and official. Figures, trees and animals. H, 3. I, 50. L, 19. M, p. 301. Y, p. 166.

Taipei, Palace Museum (SV53). Lao-tzu Riding a Buffalo. Signature and seal of the painter. Poem by Chin-ch'ing (Wang Shen?). Ming picture. See KK shu-hua chi I; Chung-kuo I, 34; Three Hundred M., 87; CH mei-shu I; Chung-kuo MHC 35; NPM Masterpieces III, 15.
Garland I, 15. Fisherman straightening his line between his toe and his teeth. Inscription. Late imitation. See "The Busy Loafer" ascribed to Ma Ho-chih for another depiction of the same subject.

CH'AO YÜEH-CHIH　晁說之　　t. I-tao　以道 , h. Ching-yü　景迂
Brother of Ch'ao Pu-chih. B. 1059, d. 1129. Landscapes and wild geese. H, 3. I, 50. L, 19. M, p. 302. Y, p. 167.

Taipei, Palace Museum (chien-mu SH146). Birds in an autumn landscape. Handscroll. (Same as former National Museum picture listed below?) Ming work of good quality, cf. Lü Chi.

Li-tai V (Formerly National Museum, Peking). Herons and geese gathering on a river in autumn. Handscroll. Attributed. Three inscriptions attached to the picture dated 1132, 1313 and 1342. See also Loehr Dated Inscriptions, p. 248.

CH'EN CHIH-KUNG　陳直躬

Active in the 11th century. Son of the painter Ch'en Hsieh. Painted wild geese and reeds. H, 3, p. 74. M, p. 427.

Taipei, Palace Museum (VA28c). Two wagtails on rocks with bamboo. Signed. Yüan or early Ming.

CH'EN CH'ING-PO　陳清波

From Ch'ien-t'ang, Chekiang. Tai-chao in the Painting Academy in the Pao-yu period (1253-1258). Landscapes, especially views of the West Lake. H, 4. M, p. 428.

Peking, Palace Museum. A Spring Morning. Landscape with buildings and figures. Fan painting. Signed and dated 1235 (or 1295). Yüan or later work. See Che-chiang 15; Sung-jen hua-ts'e A, 62; B. X, 3.

CH'EN CHÜ-CHUNG　陳居中

Served as a tai-chao in the Academy at Hangchou in the Chia-t'ai era (1201-1204). Specialized in horses and camp scenes. H, 4. J, 5. M, p. 428.

Peking, Palace Museum. Tending horses by the willow stream. Fan painting. Attributed. Copy? See Sung-jen hua-ts'e A, 27; B. I, 8.

Ibid. Four Goats. Album leaf. Artist's seal. Copy. See Sung-jen hua-tse A, 26; B. IV, 4; also *Sung Ch'en Chü-chung Ssu-yang t'u* (Peking, Jung-pao chai hsin-chi, 1958).

Liaoning Provincial Museum. A large herd of horses bathing in a stream. Handscroll. Signed. See Liao-ning II, 64-65.

* Taipei, Palace Museum (SH21). Horse and Groom. Short handscroll, ink and colors on paper. Signed, dated 1209. Genuine? or Yüan work? See Loehr Dated Inscriptions p. 263.

* Ibid. (SV120). Wen-chi Returning to China. A scene in the Mongol camp. Attributed. Fine work of the period, perhaps by Ch'en. See KK shu-hua chi 6; Three Hundred M., 116; CAT 48; CKLTMHC I, 60; KK ming-hua IV, 19; Wen-wu 1959.6.33; Nanking Exh. Cat. 37; Wen-wu chi-ch'eng 50; KK chou-k'an 181; Siren CP III, 315.

Ibid. (SV119). Illustration to a poem by Wang Chien: ladies in a palace watching a servant sweeping. Attributed. Fragment of a handscroll, school of

Ch'iu Ying.

Ibid. (SV121). Horse and groom. Signed. Copy. See NPM Masterpieces II, 31.

Ibid. (chien-mu SV298). The Buddha of Immeasurable Age (Amitabha). He is seated on a lotus flower, which rests on the back of a buffalo. Painter's signature and seal. Later work. See Ku-kung 30.

Ibid. (SH20). The Parting of Su Wu and Li Ling. Short handscroll, ink and colors on silk. Yüan-Ming copy of older work in the Liao-Chin tradition.

Ibid. (chien-mu SH118). Wen-chi Watching the Hunt. Handscroll. Attributed. Copy of old composition.

* Ibid. (VA1p). Deer-hunting on the plain. Album leaf. Attributed. Good early work in the Liao tradition. See CKLTMHC II, 72.

Ibid. (VA5i). A man on horseback leading another horse by a rope. Album leaf. Attributed. Good Sung work? See also NPM Bulletin I, 3 cover.

Ibid. (VA11o). Hunting on the Autumn Plains. Album leaf. Attributed. Copy of a work in the Liao tradition. (Cf. Hu Huai etc.)

Ibid. (VA13c). Hunter examining his arrow, with horse. Album leaf. Attributed. Late copy.

Ibid. (VA16h). The Plainsman Pats his Horse. Album leaf. Signed. Copy.

Li-tai V (Formerly National Museum, Peking). Eggplants, cabbages and butterflies. Handscroll. Signed. Seals of Yüan and Ming collectors. Later work.

I-Lin YK 19/16. Herd of horses in river and on bank. Handscroll. Reproduction indistinct.

Ibid. 20/1-2; 21/1-2; 22/3; 22/4; 23/5-6; 24/9. Ladies' Classic of Filial Piety. Handscroll in 9 sections, each with calligraphy by Kao-tsung copying the Classic. Ming copy of a Sung work? See also Wen-ming album, 1913. Cf. the scroll of this subject attributed to Ma Yüan in the Palace Museum, Taipei (SH35).

* Cleveland Museum of Art (30.314). Tartars Hunting. Fan painting. Attributed. Work of the period and style, probably by him. See Munich Exh. Cat. 20; China Institute Album Leaves #15; also Sherman Lee, Scattered Pearls Beyond the Ocean #4.

Freer Gallery (16.96). Ladies in a garden. Late Ming work; cf. Ch'en Hung-shou and Ts'ui Tzu-chung.

* Metropolitan Museum, N. Y. (47.18.32). Shooting Sea Eagles. Fan painting. Attributed to Ch'en Chü-chung on the label, possibly by him. See China Institute Album leaves #14.

For handscroll paintings formerly attributed to Ch'en Chü-chung and dealing with the subject of Wen-chi's captivity and return to China, see entry under "Anonymous Sung Figure Painting, Horsemen, Tartar Scenes, etc." See also the painting attributed to Chao Po-chü in the Takamizawa collection, and the work attributed to Li Tsan-hua in the Freer Gallery (68.46).

CH'EN HENG 陳珩，桁 t. Hsing-yung 行用 (or Yung-hsing 用行), h. Tz'u-shan 此山

From Fukien. Younger brother or nephew of Ch'en Jung. Active mid-13th

century. Painted dragons, bamboo, birds, fish and insects. H, 4. I, 51. L, 12. M, p. 428. *Hua-chi pu-i*, 1.

Hikkoen, 14. Fruits in a basket. Signed *Tz'u-shan.* Yüan-Ming work.

CH'EN JUNG　陳容　t. Kung-ch'u　公儲　h. So-weng　所翁
From Fukien. Chin-shih in 1235. Died after 1262. Well known as a poet in the Pao-yu era (1253-1258). Specialized in painting dragons. H, 4. I, 51. L, 12. M, p. 428.

* Kuang-tung Provincial Museum. Dragon in Clouds. Signed. Genuine? or early imitation? See Wen-wu 1978 no. 2, pl. VIII and p. 81.
Ogawa Collection, Kyoto. Dragons Amid Rocks and Waves. Handscroll. Attributed. Old copy? Damage by burning, repaired. Ch'ien-lung seals.
Fujii Yurinkan, Kyoto. Dragon amid clouds. Signed. Imitation.
Fujita Museum, Osaka. Six dragons. Signed. Imitation.
Ibid. Bodhidharma. Seal of the artist, interpolated. Inscription by Yü-an, unidentified.
Toyo IX, 79 (Baron Yokoyama Coll.). Cavernous rocks and rushing torrents; dragons issuing from the clouds. Section of a handscroll. Poem with signature of the painter. Good Yüan-Ming work.
Ibid. 80-81 (Sakai Coll.). Dragons in Clouds. Two sections of a handscroll. Ming?
Tokugawa Museum, Nagoya. A dragon in clouds. Poem with signature of the painter. Imitation. See also Sogen no kaiga 76; Kokka 226; Tokugawa 166; Suiboku III, 88; Sogen MGS III, 38; Osaka Sogen 5-53.
Bunkacho. Five winding dragons amidst clouds. Attributed. Section of a handscroll, ink on paper. Different composition from the Nelson Gallery scroll below. See Osaka Sogen 5-54; Homma Sogen 41.
Kokka 550 (formerly Suzuki Coll.). Dragons in clouds and water. Two sections probably from the same picture as the minor handscroll in Boston, listed below (14.50). Imitation of Ming date.
Ibid. 568. A dragon in the clouds. Attributed. Imitation.
Osaka Sogen 5-55. Dragons in clouds and water. Handscroll, ink on paper. Later imitations.
Boston Museum of Fine Arts (14.50 and 14.423). Four dragons and gushing water among cavernous rocks. Sections of the same handscroll as the picture in Kokka 550 above. See Boston MFA Portfolio I, 134-135; Siren CP in Am. Colls. 47a and b.
* Ibid. (17.1697). Nine dragons appearing through clouds and waves. Long handscroll, ink and touches of color on paper, with two inscriptions by the painter, dated 1244; and several eulogies of the Yüan and later periods. See Boston MFA Portfolio I, 127-129; BMFA Bulletin Dec. 1917; Siren CP III, 356-359; Loehr Dated Inscriptions p. 273; Kodansha, BMFA, pl. 78; Suiboku III, 86-87; Bunjinga suihen II, 81; also Tseng Hsien-chi, "A Study of the Nine Dragons Scroll," in Archives XI, 1957. A copy in the Metropolitan Museum, N. Y. (47.18.86).

Metropolitan Museum, N. Y. (29.100.531). Two dragons clinging to rocks; trees and mist. Section of same composition as the minor picture in the Boston Museum of Fine Arts (14.50). Yüan dynasty? See Yüan Exh. Cat. 212.

Ibid. (18.124.7). Dragon in Clouds. Imitation. See their *Bulletin*, Jan. 1919.

Ibid. (23.142.1). Dragon in Clouds. Imitation.

Freer Gallery (19.173). Dragons in a landscape. Long handscroll, ink on paper, including the scene of entwined dragons also in the Nelson Gallery scroll (see below). A close copy. Same composition as the scroll in the Fujita Museum, Osaka, listed above.

* Nelson Gallery, Kansas City (4815). Five winding dragons interlaced in a knot. Attributed; old and fine painting. Corresponds to part of the composition of the scroll in the Freer Gallery (19.173). See Siren CP III, 360; Southern Sung Cat. 29.

Princeton Art Museum (Formerly Dubois Morris Coll.). Twelve dragons issuing from the mist in cavernous rocks and over rushing streams. Signed. Copy. See Rowley, Principles (old ed.), 47-48.

See also I-Lin YK 44/16: section of a handscroll representing dragons among clouds and rocks, of the kind usually ascribed to Ch'en Jung.

CH'EN K'O-CHIU 陳可久

Tai-chao in the Painting Academy during the Pao-yu era (1253-1258). Painted fish, flowers and trees of the four seasons. Imitated Hsü Hsi. H, 4.

Peking, Palace Museum. Fish swimming in spring stream. Album leaf. Attributed. Copy? See Sung-jen hua-ts'e A, 65; B. III, 10.

CH'EN TSUNG-HSÜN 陳宗訓

From Hangchou. Tai-chao in the Academy during the Shao-ting era (1228-1233). Figures, after Su Han-ch'en. H, 4.

Peking, Palace Museum. Three children playing in a courtyard. Fan painting. Attributed. Good Southern Sung work. See Sung-jen hua-ts'e A, 66; B. VIII, 5.

Mei-chan, 9. Lao-tzu seated on a terrace speaking to two high officials. Ming picture.

CH'EN YUNG-CHIH 陳用志

Native of Yen-ch'eng, Honan. Member of the Academy in the T'ien-sheng era (1023-1032), but returned to his home town. A skillful painter of Buddhist and Taoist figures as well as secular subjects, and much praised for his exactness of detail. F, 3. G, 11. H, 3. M, pp. 426-427.

Boston Museum of Fine Arts (56.256). Sakyamuni Buddha in a red mantle, beneath blossoming trees. Signed. Said to be a faithful copy after an

original by Wei-ch'ih I-seng of the T'ang period, q.v. Late archaistic work? See Siren CP III, 42; Archives XI (1957) p. 86; Kodansha BMFA pl. 73.

CH'I CHUNG　戚仲
From P'i-ling, Kiangsu. Active in the Pao-ch'ing era (1225-1227). Landscapes. H, 4, p. 15. M, p. 377.

Boston Museum of Fine Arts (37.115). A river view; bare trees on the shore in the foreground and a man riding over a bridge. Snow-covered mountain range in the distance. Fan painting. Old attribution. A seal reads Tzu-chao, i.e. Sheng Mou, and the painting is by either him or a follower. See Portfolio I, 147; Siren CP III, 311.

CH'I HSÜ　祁序　also named Ch'i Yü　祁嶼
From Chiang-nan. 10th century. Flowers, birds, water-buffaloes and cats. F, 4. G, 14. H, 3. I, 50. L, 4. M. p. 218.

Peking, Palace Museum. Landscape with buffalo and herdboys. Handscroll, ink and colors on silk. Attributed to the artist in a colophon by the Chin emperor Chang-tsung (reigned 1190-1208). Seals of Keng Chao-chung and Liang Ch'ing-piao. "Hui-tsung" title. Early Southern Sung? See Wen-wu, 1978, 1, p. 9 and p. 96.
Taipei, Palace Museum (SV13). A boy leading a water buffalo. Ink painting. Inscribed with the painter's name. Colophon by Wen Yüan dated 1325; the painting of that date or slightly earlier? See KK shu-hua chi 28; Three Hundred M., 70; KK ming-hua I, 31; KK chou-k'an 432.
I-lin YK 48/1. Water buffalo swimming in river. Fan-shaped album leaf. Signed. later work.

CHIA SHIH-KU　賈師古
From Kaifeng. Chih-hou in the Painting Academy in Hangchou. Active c. 1130-1160. Buddhist and Taoist figures, followed Li Kung-lin. H, 4. I, 51. J, 3. L, 48. M, p. 563.

Taipei, Palace Museum (SV80). Kuan-yin seated on a rock. Signed. Ming picture. See KK ming-hua III, 7; KK shu-hua chi 7; KK chou-k'an 121; NPM Masterpieces III, 25.
* Ibid. (VA14b). A pass in the mountains; a temple on a cliff; two pilgrims approaching. Album leaf. Signed. *Ssu-yin* half-seal. See KK chou-k'an 57; CAT 38; CKLTMHC II, 53; KK ming-hua IV, 4.
I-shu ts'ung-pien 8. A lady in a long trailing garment standing in profile. Misattributed.
Freer Gallery (16.112). A fisherman in a wintry landscape. Attributed. Good Ming picture.

CHIANG SHEN 江參 (usually mispronounced *Ts'an*) t. Kuan-tao 貫道
From Wu-hsing, Chekiang. B. c. 1090, d. 1138. Followed as a landscape painter the Tung Yüan and Chü-jan tradition. H, 4. I, 51. L, 3. M, p. 88. See also Fu Shen, "Notes on Chiang Shen," in NPM Bulletin I.3, July 1966, and "A Further Note on Chiang Shen," in Ibid., I, 6, Jan. 1967.

Taipei, Palace Museum (SV81). Mount Lu, after Fan K'uan. Inscribed with the painter's name. By Wang Hui or follower, 17th-18th century. See KK shu-hua chi 25; Three Hundred M, 101; CH mei-shu I; CKLTSHH; Wen-wu chi-ch'eng 43.

* Ibid. (SH15). *Ch'ien-li chiang-shan t'u:* Thousand Miles of Mountains and River. Long handscroll. Authenticating inscription by K'o Chiu-ssu, written ca. 1330. Unsigned colophon dated 1217; other colophons by Liu K'o-chuang, Lin Pu-i (dated 1249), and later men. Genuine? or Yüan work? See KK chou-k'an 339-356 (and special publication by Ku-kung); Three Hundred M., 100; CKLTMHC I, 42; NPM Bulletin I.3, figs. 3, 5, 8; Nanking Exh. Cat. 29; Loehr Dated Inscriptions p. 265-266.

* Ibid. (YV125). A richly wooded mountain in autumn; a homestead by a river. Catalogued as "Anonymous Yüan," but very similar in style to the handscroll noted above. Fragment of a handscroll by the same artist? See KK chou-k'an 215; KK shu-hua chi 17; CKLTMHC I, 43; NPM Bulletin I.3, figs 2, 4, 6, 7; KK ming-hua VI, 41.

Shen-chou 18. A grove in the mountains; cottages by the stream. Album leaf. Inscription by Wang To of the Ming period. Imitation. See also Nanga taisei XI, 9.

Boston Museum of Fine Arts (28.838). Mist over a valley and a traveller on a bridge. Fan painting. Attributed. Ming work, 15th cent.? See Portfolio I, 141; Siren CP III, 259.

Freer Gallery (16.194). Landscape with bare trees. Attributed. Fine work of early Ch'ing, Nanking School, perhaps by Fan Ch'i.

Metropolitan Museum, N. Y. (18.125.4). The Hundred Buffaloes: river scenery with grazing animals. Handscroll. Probably of the Yüan period. See London Exh. Cat. 1221; Siren ECP II, 49; Siren CP in Am. Colls. 111; Yüan Exh. Cat. 211.

* Nelson Gallery, Kansas City. *Lin-luan chi-ts'ui t'u:* Amassed Verdure of Wooded Peaks. Signed. Similar in style to the Taipei Palace Museum handscroll listed above. Inscription by Ch'ien-lung, dated 1785. Genuine? or Yüan work? See Siren CP III, 257-258; Lee Landscape Painting 18; Toronto Cat. 5; Kodansha CA in West, I, 14; Bunjinga suihen II, 75.

CH'IAO CHUNG-CH'ANG 喬仲常
From Ho-chung, Shansi. Active in the first half of the 12th century. Followed Li Kung-lin in his religious pictures, but painted also secular figures and landscapes. I, 51. M, p. 506.

Freer Gallery (19.175). Families moving their residence. Handscroll, ink and colors on silk. Copy of old composition; the attribution probably arbitrary. See Siren CP III, 200. Another version in the same collection ascribed to Han Huang (16.583); still another in the Yale Art Gallery (see under Han Huang).

* John Crawford Collection, N. Y. (Cat. 14). Illustrations to Su Shih's *Hou ch'ih-pi fu* (Later Red Cliff Ode). Long handscroll on paper. Attributed, in a colophon (by Chao Yen?) which is no longer attached to the scroll. Fine work of the period, probably by Ch'iao. Colophons by Chao Ling-chih, dated 1123, and later writers. Seals of Liang Shih-ch'eng (d. 1126); also Liang Ch'ing-piao (1620-91). See also TWSY ming-chi 23-33; Loehr Dated Inscriptions p. 244-245; Suiboku IV, 35-36; Kodansha CA in West, I, 18; Hills, 93.

CH'IEN I 錢易 t. Hsi-po
From Hangchou. Took his chin-chih degree during the reign of the emperor Chen-tsung (998-1022) and became a Han-lin Academy member. Arhats, landscapes and flowers. H, addenda. I, 50. K, 9. L, 18. M, p. 679.

I-shu ts'ung-pien 2. A cabbage plant. Signed, dated 1022. Poem by Yü-wen Kung-liang (Yüan dynasty). Seals of the Sung period. Much later work. See also Loehr Dated Inscriptions p. 230.

CHIH-WENG 直翁 , also called Jo-ching 若敬
A Ch'an Buddhist monk painter. Active in the early 13th century. Pupil of the famous Ch'an monk Ch'ih-ch'üeh 痴絕 . His seals have sometimes been misread as Tsu-weng 卒翁 and Shuai-weng 率翁 . See Sogen no kaiga p. 39 for a brief treatment of this problem. Mistakenly listed in *Kundaikan sayuchoki* under the name Tsu-weng.

* Goto Museum, Tokyo (formerly Ohara Coll.). The sixth patriarch of the Ch'an sect carrying a hoe. Seal of the painter. Poem by the monk Yen-ch'i Kuang-wen (1189-1263). See Sogen meigashu 44-45; Bijutsu kenkyu 40; Toyo Bijutsu 60: Sogen bijutsu 134; Choshunkaku, 4; Suiboku III, 24; Sogen no kaiga 29; Genshoku 29/53.
Sogen bijutsu 132 (Umezawa Kinenkan, Tokyo). Pu-tai. Seal of the artist. Inscription by Yen-ch'i Huang-wen. See also Suiboku III, 36; Sogen MGS II, 34; Homma Sogen 45.
Tokyo National Museum. Pu-tai walking with his bag. Attributed. See Kokka I/II.
Fujita Museum, Osaka. Pu-tai. Attributed. Colophon by the monk Ch'ih-chüeh.

CHIH-YUNG 智融 Originally named Hsing Ch'eng 邢澄 h. Lao-yung 老融 , Lao-niu chih-yung 老牛智融

Originally from Kaifeng, moved to Hangchou in the Southern Sung period. B. 1114, d. 1193. Born into a physician's family, and held office under the Southern Sung. He gave up his official career and family in 1163, and went to live as a monk in the Ling-yin 靈隱寺 temple. Painted "three friends of winter," figures, and specialized in paintings of oxen and water buffalo; known as the originator of the 'wang-liang' or 'ghost painting' style. Unrecorded in the standard sources; this account of his life and painting is based on an essay by Lou Yüeh 樓鑰 , who knew the artist late in life. See Shimada Shujiro, "On the Moryo-ga Style of Zen Painting," *Bijutsu kenkyu,* nos. 84 (Dec. 1938) and 86 (Feb. 1939).

* Yabumoto Kozo, Amagasaki. Herd-boy managing a water-buffalo. Hanging scroll, ink on paper. Seal of the artist reading 'Lao-niu chih-yung.' See Osaka Sogen 5-44; Homma Sogen 15.

CHIN TA-SHOU 金大受

Formerly known as Hsi-chin Chü-shih 西金居士 , a name which was based on a misreading of inscriptions on the paintings listed below. His real name, according to these inscriptions, was Chin Ta-shou. He lived at a place called Ch'e-ch'iao in the town of Ch'ing-yüan, Chekiang. Mentioned (under the mistaken name) in Kundaikan Sayuchoki 37. Active at the close of the Southern Sung period in Ningpo, Chekiang. Buddhist figures.

Osaka Municipal Museum (Abe Coll.). Arhats. Attributed. See Kokka 580.
* Tokyo National Museum. Ten pictures of Arhats from a series of sixteen. Color on silk. Signed. See Toso 120-124; Che-chiang 17; Doshaku, 70.
Nanzen-ji, Kyoto. An arhat. Attributed. See Kokka 203.
Inoue Collection, Gumma. Arhat. See Genshoku 29/79.
Kawasaki Cat. 19. The Priest T'ien-t'ai. Attributed. Japanese? Also in Choshunkaku, 55.
Ibid. 23. The Priest Shao-k'ang giving money to two children. Attributed. Yüan-Ming work. Also in Choshunkaku, 54.
Choshunkaku, 53. Seated portrait of T'ao Hung-ching. Attributed. Yüan-Ming work.
Boston Museum of Fine Arts. Four of the Ten Kings of Hell. Attributed; inscription with the artist's name. See Portfolio I, 106-109; Siren, CP in Am. Coll., 101-104.
Metropolitan Museum, N. Y. (30.76.290-294). Five pictures from the same series as the preceding four in the Boston Museum of Fine Arts. See Kodansha CA in West, I, 45. Another, presumably from the same series, owned by Yabumoto Sogoro, Osaka (1965).
Berlin Museum. Two pictures of Arhats from the same series as those in the Tokyo National Museum.

CHO TS'UNG　卓琮　t. T'ing-jui　廷瑞
From Yung-ch'un, Fukien. A friend of the philosopher Ch'en Ch'un of the Southern Sung period. V, p. 522.

Boston Museum of Fine Arts. Wild geese and reeds. Signature and seals of the painter.

CHOU CHI-CH'ANG　周季常　, and LIN T'ING-KUEI　林庭珪
Two artists active c. 1160-1180 in Ning-po. Known only through a series of 100 pictures representing the 500 Arhats, executed 1178-88. Eighty-two of them are in the Daitoku-ji, Kyoto, ten in the Boston Museum of Fine Arts, and two in the Freer Gallery. See Wen Fong, *The Lohans and a Bridge to Heaven* (Freer Gallery Occasional Papers, 1958); and Loehr Dated Inscriptions p. 256.

* The following of the Daitoku-ji pictures have been reproduced:
 1. Kokka 238. Five Arhats and two attendants with a lion, by Chou Chi-ch'ang. See also Shimbi 15.
 2. Ibid. 274. Five Arhats and three demons, by Chou Chi-ch'ang.
 3. Shimbi 15. Five Arhats watching dragons fighting in the clouds, by Chou Chi-ch'ang. See also Toyo 8.
 4. Toyo VIII, 50. Five Arhats by a mountain stream; a deva is descending from heaven with lotus flowers, by Lin Ting-kuei(?).
 5. Ibid. VIII, 51. Four Arhats watching a fifth, who is ascending on a cloud to heaven, by Lin T'ing-kuei(?).
 6. Toyo bijutsu 5. Examining sutras. Seven figures.
* All of the Boston Museum of Fine Arts pictures have been reproduced:
 1. Portfolio I, 75. (06.291). Five Arhats crossing the sea, by Chou Chi-ch'ang. Signed, dated 1188. See also Siren CP in Am. Colls. 58.
 2. Portfolio I, 76. (06.290). The victory over Taoist heretics, by Chou Chi-ch'ang. See also Siren CP III, 207.
 3. Portfolio I, 77. (95.2). Indian on a camel offering corals and jewels to Arhats, by Chou Chi-ch'ang. See also Siren CP in Am. Colls. 56.
 4. Portfolio I, 78. (95.3). Four Arhats and two attendants witnessing the transfiguration of an Arhat, by Chou Chi-ch'ang, dated 1178. See also Siren CP III, 206; Siren CP in Am. Colls. 60.
 5. Portfolio I, 79. (95.4). Arhats bestowing alms on beggars, by Chou Chi-ch'ang, dated 1184. See also Kodansha BMFA 77; Siren CP in Am. Colls 61; Southern Sung Cat. 12; Kodansha CA in America I.46; Paine Figure Compositions of China and Japan, V, 1.
 6. Portfolio I, 80. (95.5). Five Arhats in the bamboo grove, by Chou Chi-ch'ang, dated 1180. See also Siren CP in Am. Colls; Paine Figure Compositions of China and Japan, V, 2.
 7. Portfolio I, 81. (95.6). Five arhats watching demons carrying Buddha's bones to different parts of the world, by Chou Chi-ch'ang. See also Siren CP in Am. Colls. 63.

8. Portfolio I, 82. (06.288). An Arhat attended by a dragon in meditation on water, and four others standing on clouds above, by Chou Chi-ch'ang, dated 1178. See also Siren CP in Am. Colls. 64, Kokka 393; Paine Figure Compositions of China and Japan, V, 3.

9. Portfolio I, 83. One of five Arhats manifesting himself as the nine-headed Avalokitesvara before priests and laity, four standing at his side, by Lin T'ing-kuei. See also Paine Figure Compositions of China and Japan, V, 4.

10. Portfolio I, 84. (06.292). Arhats feeding a hungry Preta, by Lin T'ing- kuei, dated 1178. See also Siren CP in Am. Colls. 59, BMFA Bulletin, Feb. 1932; Paine Figure Compositions of China and Japan, V, 5.

* The two pictures from the series in the Freer Gallery are:

1. (02.224) Arhats Laundering, by Lin T'ing-kuei.
2. (07.139) Miracle on the rock bridge at T'ien-t'ai-shan, by Chou Chi-ch'ang.

Both are signed and dated 1178. See Wen Fong pl. 1-2; Freer Figure Ptg. Cat. 18-19; Kodansha Freer p. 160 and cat. 41.

Daitoku-ji, Kyoto. Images of the ten Kings. Series of ten hanging scrolls, ink and color on silk. One painting inscribed by the Priest I-shao, dated 1178. See Kokka 175; Daitakuji meihoshu 73; Loehr Dated Inscriptions p. 256.

CHOU I 周儀
Active in the Shao-hsing era (1131-1162). Tai-chao in the Academy of Painting. Figures. H, 4. M, p. 244.

Chugoku I. Portrait of lady playing the flute. Attributed. Later painting.

CHU HSI 朱羲 and CHU YING 朱瑩
Cousins, from Chiang-nan. Active at the beginning of the 12th century. Both famous for painting buffaloes in peaceful landscapes. G, 14. H, 3. M, p. 91.

Sung-jen hua-ts'e XVI. Oxcarts crossing a bridge and fording a stream. Album leaf. Signed: Chu Ying (? the second character not clearly legible). Late Sung or later work.

Taipei, Palace Museum (VA6b). Buffalo. Copy after Tai Sung. Album leaf. Late imitation. Signed: Chu Hsi.

Laufer Cat 21. A herdboy on a buffalo under two large willow trees. Imitation.

Osaka Sogen, 5-43. Buffalo and herdboy. Album leaf. Attributed. Minor late Sung or Yüan work.

CHU HSIANG-SHIEN 朱象先 t. Ching-ch'u 景初 h. Hsi-hu yin-shih 西湖隱士
From Sung-ling, Chekiang. Active c. 1095-1100. Landscapes, followed Tung

Yüan and Chü-jan. Mentioned by Su Tung-p'o as a good painter who did not seek recognition. H, 3. I, 50. K, 3. M, p. 91.

Kokka 280 (Marquis Inoue Coll.). Fishes swimming in deep water. Old attribution. Possibly of the period.

CHU HUAI-CHIN 朱懷瑾

From Ch'ien-t'ang, Chekiang. Tai-chao in the Academy of Painting during the Pao-yu era (1253-1258). Landscapes and figures, followed Hsia Kuei. H, 4. I, 51. J, 8. M, p. 92.

* Liaoning Provincial Museum. A pavilion by the river; a man gazing out. Fan painting. Signed (signature also read as Chu Wei-te 朱惟德, otherwise unrecorded). Late Sung? See Liang Sung 46; Liao-ning I, 63; Sung-jen hua-ts'e B. XVIII; Sung Yüan shan-shui 10; Liao-ning album 10.

Chung-kuo I, 48 (Ti P'ing-tzu Coll.). Boats on river in autumn; high rocky shores. Signed. 17th century? See also Toso 100; Chung-kuo MHC 31.

Freer Gallery (09. 174). A hermit seated on the bank of a stream. Fan painting. Attributed.

CHU JUI 朱鋭

From Hopei. Active first half twelfth century. Tai-chao in the Academy of Painting in Kaifeng and also in Hang-chou. In his landscapes he followed Wang Wei and in his figure paintings Chang Tun-li. M, 4. I, 51. J, 2. M, p. 92.

Shanghai Museum. An oxcart crossing a mountain stream. Album leaf. Signed. Ming work, after Sung design? See Liang Sung 5; Sung-jen hua-ts'e B. XIV; KK hsün-k'an 29.

Taipei, Palace Museum (VA19k). Oxcarts by the Winter Stream. Fan painting. Attributed. Ming period. See NPM Masterpieces II, 22.

Ibid. (VA21b). Mountain Temple and Bright Mists. Album leaf. Attributed. A pair with VA21e, attributed to Chu Tz'u-chung.

Ibid. (chien-mu SH97). Returning Drunk from the Spring Festival. Handscroll, color on silk. Signed and dated 1229. Ming work. See Loehr Dated Inscriptions p. 270.

Note: For the handscroll painting depicting the Red Cliff in the Taipei Palace Museum, once attributed to Chu Jui, see under Wu Yüan-chih.

Chin-k'uei II, 10 (Formerly J. D. Ch'en Coll., H. K.). Snow scene; boat, pavilions, trees and mountains. Fan painting. Attributed.

Chung-kuo I, 47 (Ti P'ing-tzu Coll.). The Spring Message from Feng-ch'eng. Ladies in a pavilion on a high terrace among clouds. Said to be after Wang Wei. Later work. See also Chung-kuo MHC 32.

Boston Museum of Fine Arts (08.115). Bullock carts travelling over a mountain path. Inscription with the painter's name. Good Yüan-Ming work in Li T'ang manner. See Portfolio I, 60; Siren CP in Am. Colls. 39.

CHU KUANG-P'U　朱光普　　　t. Tung-mei　東美
From Kaifeng, moved to Hangchou at the fall of the Northern Sung. Member of the Painting Academy in Hangchou. Painted farm scenes. H, 4. J, 3. I, 51. M, p. 92.

Liaoning Provincial Museum. A man in a pavilion by a river. Fan painting. Attributed. Late Sung or Yüan. See Liang Sung 36; Liao-ning I, 40; Sung-jen hua-ts'e B. XVIII; Sung Yüan shan-shui 3.
Taipei, Palace Museum (VA11i). Pavilion by the water. Fan painting. Attributed. Late Sung or Yüan.

CHU SHAO-TSUNG　朱紹宗
A member of the Painting Academy. Painted figures, flowers and birds; also cats and dogs. H, 4. J, 8. I, 51. M, p. 92.

Peking, Palace Museum. Butterflies among chrysanthemums. Fan painting. Signed Chu... (illegible). See Sung-jen hua-ts'e A, 69; B. V, 8.

CHU TZ'U-CHUNG　祝次仲　　　t. Hsiao-yu　孝友
Active in the 12th century. From T'ai-ping in Anhui. Good at draft (grass) script. Painted landscapes. H, 4, p. 117. M, p. 308.

Taipei, Palace Museum (VA21e). Green cliffs and Pure Trees. Fan painting. Attributed. A pair with VA21b, attributed to Chu Jui. Both late Sung? works by followers of Li T'ang.

CHU WEI-TE　朱惟德
See Chu Huai-chin.

CH'U TING　屈鼎
Academy painter during the reign of Jen-tsung (1023-56). Follower of the Yen Wen-kuei in landscape painting. The "Summer Mountains" scroll formerly attributed to Yen Wen-kuei, now in the Met. Mus., N. Y. (1973.120.1), has been loosely ascribed to Ch'u Ting. See Summer Mts.; Met. Cat., 1973, no. 1; Suiboku II, 5, 37-38; Bunjinga suihen II, 29.

CHUNG-JEN　仲仁　　　h. Hua-kuang chang-lao　華光長老
From K'uai-chi, Chekiang. A Buddhist monk who lived in the Hua-kuang temple in Heng-chou, Hunan, after which he was named. Died 1123. A close friend of Huang T'ing-chien, who wrote comments on some of his pictures. Plum blossoms. The Mei-p'u treatise ascribed to Chung-jen is a fabrication of a later period, based largely on the Sung-chai mei-p'u by Wu T'ai-su of the Yüan dynasty. See Shimada's article (noted under Wu T'ai-su) pp. 116-118; and H,

3. I, 52. M, p. 84. Also Hua-shih Hui-yao II, p. 142; also the article by Weng T'ung-wen in NPM Quarterly IX, 3.

Berlin Museum. River scenery in mist. The signature "Chung-jen" may refer to a later painter. Fan painting. See London Exhib. Cat 921; Berlin Cat. (1970) no. 25.

FAN AN-JEN 范安仁　(nickname Fan Lai-tzu 范賴子　, Scabby Fellow) From Ch'ien-t'ang, Chekiang. Tai-chao in the Academy of Painting c. 1253-1258. Speciaized in fishes. H, 4. I, 51. J, 8. M, p. 279.

Taipei, Palace Museum (SH22). Fish and water plants. Handscroll, ink on silk. Attributed. Ming copy?

Hakone Museum (Formerly Magoshi Coll.). Two fishes and seaweeds. Fan painting. Attributed. See Kokka 175; Sogen MGS II, 4.

Sogen MGS pp. 39-40 (Murayama Coll.). Swimming fishes and a crab. Attributed. See also Kokka 146.

Kokka 530 (Dan Coll.). A carp. Album leaf. Attributed.

Ibid. 571 (Dan Coll.). A fish among seaweeds. Attributed.

Sogen no kaiga 77. A carp among seaweeds. Hanging scroll, ink on paper. Attributed.

Homma Sogen 40. Carp and sheatfish. Pair of hanging scrolls. Attributed.

Boston Museum of Fine Arts (15.908). Two carp leaping among waves. No attribution, but stylistically related to some of the above-mentioned pictures.

FAN K'UAN 范寬　original name Fan Chung-cheng 范中正　t. Chung-li 仲立 From Hua-yüan, Shensi. C. 960-1030. Landscapes, followed Li Ch'eng and Ching Hao. D, 2. F, 4. G, 11. H, 3. I, 50. M, p. 278; also article by Li Lin-ts'an in NPM Bulletin, VI, 2; and biographies by Hsio-yen Shih and Richard Barnhart in Sung Biog. 33-41.

* Taipei, Palace Museum (SV5). Sitting Alone by a Stream. Houses at the foot of misty mountains. Poems and colophons of the Ming and Ch'ing periods. Late Sung work? See KK shu-hua chi 4; London Exh. Chinese Cat. p. 36; Three Hundred M., 67; CH mei-shu I; CKLTMHC I, 25; KK ming-hua II, 23; KK chou-k'an 496; Siren CP III, 153; NPM Masterpieces V, 5; Soga I, 16-17.

Ibid. (SV6). Snow-covered mountains, a temple in a valley. Inscription by Wang To dated 1649. Ming work. See KK shu-hua chi 10; Three Hundred M., 66; CKLTMHC I, 24; KK ming-hua II, 22; Wen-wu chi-ch'eng 19; KK chou-k'an 131; Siren CP III, 156; NPM Masterpieces I, 5; Bunjinga suihen II, 25.

Ibid. (SV7). A Waterfall in an Autumn Grove. Later work, 14th cent.? School of Li T'ang. See KK shu-kua chi 12; Three Hundred M., 68; CH mei-shu I; KK ming-hua I, 28; Wen-wu chi-ch'eng 20; Siren CP III, 248;

Soga I, 18-19.

* Ibid. (SV8). Travellers Among Mountains and Streams. Towering mountain with a waterfall, a temple below, and travellers with donkeys. Signed. *Ssu-yin* half-seal. Inscription by Tung Ch'i-ch'ang. See KK shu-hua chi 9; Three Hundred M., 64; CAT 18; CCAT pl. 94; CH mei-shu I; CK ku-tai 30; CKLTMHC I, 23; CKLTSHH; KK ming-hua I, 27; NPM Quarterly I.2, pl. 16-17; Nanking Exh. Cat. 16; Wen-wu chi-ch'eng 21; Soga I, 14-15; KK chou-k'an 133; Siren CP III, 154; Skira 31, 33; also article by Li Lin-ts'an in Ta-lu tsa-chih, XVII/10; Bunjinga suihen II, 23.

Ibid. (SV9). Men with donkeys approaching a stream at the foot of steep mountains. Poem by Ch'ien-lung. Colophons by Sung Chün-yeh and Wang Shih-min. Copy by a 17th century artist of the Orthodox School (Wang Hui?) of "Travellers Among Mountains and Streams" above. See KK shu-hua chi 2; Three Hundred M., 65; Siren CP III, 155.

Ibid. (VA3e). Fishing on a Winter River. Album leaf. Attributed. Ming work. Cf. Li Lin-ts'an's article in NPM Bulletin V, 4, where it is ascribed to Li Tung on the basis of a hidden signature.

Ibid. (VA9a). *Ch'un-feng hsüeh-chi t'u:* clearing after snow on the mountains. Large album leaf. Inscription in the manner of Hui-tsung and by Ch'ien-lung. *Ssu-yin* half-seal. 17th century picture. See Ming-hua lin-lang; KK chou-k'an II, 36; KK ming-hua II, 24.

Ch'ing-kung ts'ang 101 (Formerly Manchu Household Coll.). River in snow; travellers crossing a bridge. Fan painting. Signed. Imitation. See also T'ien-yin-tang II, 2.

Chung-kuo MHC 25. River landscape in snow, travellers on paths. Ch'ien-lung inscription. Attributed. Ming work.

Chung-kuo I, 28 (Ti P'ing-tzu Coll.). Travellers with mules in the mountains. Inscribed with the painter's name. Seals of Hui-tsung and later men. Colophon by Tung Ch'i-ch'ang. Poor copy of "Travellers Among Mountains and Streams" above. See also Chung-kuo MHC 29.

Ibid. I, 29 (Ti P'ing-tzu Coll.). Craggy mountains and a river in snow. Inscribed with the painter's name. Colophon by Yo Chün of the Yüan dynasty. Later work. See also Chung-kuo MHC 24.

I-yüan chen-shang 8. Landscape with travellers. Attributed. Late (17th century?) archaistic work.

Wang Shih-chieh Collection, Taipei. Scenery of the Yangtze River. Attributed. Southern Sung? Colophon by Tung Ch'i-ch'ang.

Osaka Municipal Museum (Abe Coll.). A man seated in comtemplation under large trees and circling clouds. Attributed; later work, not in his style. See Hokuga shinden.

Toan p. 3 (Formerly Saito Coll., now Agata Coll., Osaka). River view in autumn; temple in the mountains. Fragmentary handscroll. Colophon by Mi Yu-jen, poem by Kao Shih-ch'i. Ming work, after older composition. See also Bunjin gasen II, 1; Chung-kuo MHC 8.

Choshunkaku 32. A boy and a buffalo in a landscape. Attributed. Late Sung or Yüan, unrelated to Fan K'uan.

* Boston Museum of Fine Arts (12.889). River shore in snow with a lonely wanderer. Fan painting. Southern Sung work. Yüan palace seal *T'ien-li*

chih pao, used ca. 1330. See Portfolio I, 40; Siren CP III, 157; Kokka 267; Siren CP in Am. Colls. 12. See also the Anonymous fan painting in the Metropolitan Museum N. Y. (13.100.117) which is similar in some features.

Ibid. (14.53). Winter landscape with large trees. Fan painting. Yüan-Ming work, unrelated to him. See Portfolio I, 42; Siren CP in Am. Colls. 17; Bachhofer 101; Siren ECP I, 136; Barnhart Wintry Forests cat. 2.

* Ibid. (14.52). A deep mountain gorge in snow with pavilions and temples. Fine work of late Sung date. See Portfolio I, 43; Siren CP in Am. Colls. 20.

Freer Gallery (11.199). Landscape; open vista through a valley. Handscroll, ink on silk. Attributed. Good 15th-16th cent. painting, tradition of Fan K'uan and Li T'ang. See Siren CP in Am. Colls. 105.

Ibid. (19.161). Landscape with bare trees. Very dark, on silk. Early Ch'ing, Nanking school, artificially darkened.

Princeton Art Museum (L119.71). Landscape. Fan painting. Attributed. See Summer Mts. 34-35; Bunjinga suihen II, 40.

Juncunc Collection, Chicago. Pavilions by a waterfall; wooded mountains above. Inscription by Chang Hsiao-ssu. Fine Ming painting.

Note: Various other works in the tradition of Fan K'uan could be added: the "Travellers in Snowy Mountains" in the Shanghai Museum (Shanghai, 6); the Winter Landscape in the John M. Crawford Collection (Cat. 6); Bunjinga suihen II, 26; a landscape in the Freer Gallery (19.127) with an inscription by someone who saw it in 1340, probably not much earlier than that in date; a landscape in the Metropolitan Museum, N. Y. (56.151); a landscape in the Princeton Art Museum (46.186, Rowley, *Principles,* old ed. 17); an Anonymous Ming Winter Landscape in the Taipei Palace Museum (MV332); the Anonymous Sung Wang-ch'uan Villa handscroll in the Chicago Art Institute (50.1369, Munich Exh. Cat. 28); an attributed landscape with high mountains in the British Museum (Bunjinga suihen II, 24); etc.

FAN LUNG 梵隆 t. Mao-tsung 茂宗 h. Wu-chu 無住
From Wu-hsing, Chekiang. A monk active during the first half of the 12th century. His paintings were reportedly admired by Emperor Kao-tsung (reigned 1127-1163). Figures and landscapes in the manner of Li Kung-lin. H, 4. M, p. 374.

Freer Gallery (19.174). Arhats moving through forests and across the sea. Handscroll, ink on paper. Attributed. Ming work. See Siren CP in Am. Colls. 93.

* Ibid. (60.1). The 18 Arhats. Figures in a landscape setting. Long handscroll, ink on paper. Signed, although the signature may be added. A fine work of the period. Colophons by Chung-feng Ming-pen (1260-1323) and later writers, including Tung Ch'i-ch'ang. See Skira 94 (detail); Freer Figure Ptg. cat. 20; Suiboku III/appendix 39-46; Suiboku IV, 54-57. Many copies of all or part of the composition exist, e.g. a "Ma Ho-chih" scroll (Toso

61), a Ch'iu Ying scroll (formerly Tonying and Co., N. Y.), the "Liang K'ai" scroll in the Abe Collection, a "Li Kung-lin" Arhat in a Forest, Stoclet Collection (London 1936 exhibition), a leaf in the Hikkoen album (Arhat with boy and servant), etc.

FAN TZU-MIN 范子珉 (珉)
Taoist. Active in the 13th century. Painted oxen and birds. M, p. 279.

* Formerly Chicago Art Institute (41.38). Seven oxen and two herdboys relaxing by a stream. Handscroll, ink on paper. Signed. Stolen from the museum in 1969. See Sickman and Soper pl. 109; Munich Exh. Cat. 22.

FANG CH'UN-NIEN 方椿年
Active c. 1225-1264. From Chien-t'ang. Tai-chao in the Shao-ting era (1228-1233) and Chih-hou in the Chin-ting era (1260-1264). Landscapes, figures, Buddhist and Taoist immortals. J, 8, p. 175; M, p. 22.

Ferguson, p. 134. Benign fairies of the South Pole scattering flowers. Handscroll, color on silk. Dated 1229, according to the author. Late archiastic work. See also Loehr Dated Inscriptions p. 269.
Freer Gallery (16.588). Taoist immortals walking on the water. Old attribution. Probably by an early Ming follower of Yen Hui. See Siren CP in Am. Colls. 184.
Ibid (08.170). Land of the Immortals. Handscroll. Signed. See the same composition, attributed to Ch'iu Ying, in the Nelson Gallery, K. C. (72-39).

FENG CH'IN 馮覲 t. Yü-ch'ing 遇卿
Native of Kaifeng. A eunuch in the court of Emperor Hui-tsung. Landscapes, followed Li Ch'eng. See *Hsüan-ho hua-p'u,* Peking 1964 ed. p. 210.

The "Chu-jan" Snow Landscape in the Taipei Palace Museum (WV12) has been tentatively ascribed to this artist by Richard Barnhart; see "The Snow Landscape Attributed to Chü-jan" in Archives XXIV, pp. 6-22.

FENG TA-YU 馮大有 h. I-chai 怡齋
Lived in Suchou. Painted lotus flowers. H, 4. I, 51. M, p. 529.

* Taipei, Palace Museum (VA17i). Lotus and mandarin ducks. Fan paintings. Attributed. Lovely work of Southern Sung date. See KK ming-hua III, 26; NPM Masterpieces II, 32.

HAN JO-CHO 韓若拙
From Loyang. Active c. 1110-1125. Best known for his bird paintings but exe-
cuted also portraits. H, 3. I, 51. M, p. 697.

* Berlin Museum. Sparrows and rice stalks. Fan painting. Signed. See Munich
 Exh. Cat. 14; Berlin Cat. (1970) no. 27.

HAN YU 韓祐
Active c. 1131-1162. A native of Shih-ch'eng. Served as chih-hou in the
Painting Academy c. 1131. Painted flowers and birds in the style of Li Ch'un.
M, p. 696. H, 4. J, 3.

Taipei, Palace Museum (VA17m). Katydids on a Melon Vine. Album leaf.
 See KK chou-k'an 15.
Sogen shasei gasen 14. Dragonfly and other insects on flowering plant. Attri-
 buted. Fine Southern Sung or early Yüan painting.

HO CH'ENG 郝澄 t. Ch'ang-yüan 長源
From Chü-jung, Kiangsu. Active during the second half of the 10th century.
Buddhist and Taoist figures, and horses. D, 1. F, 3. G, 7. H, 3. M, pp. 307-
308.

Boston Museum of Fine Arts (17.741). A man trying to catch a horse.
 Inscription in the manner of Hui-tsung, dated 1107, attributing the picture
 to Ho Ch'eng. Album leaf. Old and good painting. See Portfolio I, 44;
 Siren CP III, 322; Loehr Dated Inscriptions p. 240; BMFA Bulletin, April
 1917, and v. LIX, 1961.
Freer Gallery (17.185). The Lords of the Four Directions on an outing with
 their attendants. Handscroll, ink on paper. Attributed. Ming work of
 good quality, perhaps a cartoon for a wall painting in a Taoist temple? See
 Freer Figure Ptg. cat. 38.
Metropolitan Museum, N. Y. (47.18.64). The Drunken General. Fan painting.
 Attributed.

HO CH'UAN 何荃
Unidentified.

Peking, Palace Museum. Visitors arriving at a country estate. Fan painting.
 Signed, dated *hsin-mao*. See Liang Sung 45; Sung-jen hua-ts'e B. XI.

HO CH'UNG 何充
From Suchou. Active c. 1078-1085. Painted mainly portraits. H, 3. I, 50. M,
p. 131.

Freer Gallery (17.114). Portrait of a lady in a white garment standing with a fly whisk in her hand. Old attribution; more likely Yüan or early Ming work. See Siren CP III, 203; Siren CP in Am. Colls. 94; Freer Figure Ptg. cat. 45.

HSI-CHIN CHÜ-SHIH
See Chin Ta-shou.

HSIA KUEI 夏珪　t. Yü-yü 禹玉

From Ch'ien-t'ang, Chekiang. Tai-chao in the Academy of Painting, active in the first half of the thirteenth century, into the reign of Emperor Li-tsung. Landscapes, followed Li T'ang. Equally famous with Ma Yüan and co-founder of the so-called Ma-Hsia School. H, 4. J, 6. M, p. 318. Biographies in EB, VIII, 1122-1124 (James Cahill) and EWA VI, 650-654 (Sherman Lee). See also Teng Pai and Wu Fu-chih, *Ma Yüan yü Hsia Kuei* (Shanghai, 1958, in CKHCTS series). (MY/HK).

Peking, Palace Museum (former Li Mo-ch'ao Coll.). A hamlet below mountain peaks. Fan painting. Signed. Early school work or copy. See Sung-jen hua-ts'e A, 47; B. VI, 10; Kokyu hakubutsuin, 166.

Ibid. Scholar's study by a pond. Album leaf. Signed. Ming copy of Sung work? Not style of Hsia Kuei. See Sung-jen Hua-ts'e A, 48; B. VIII, 1.

Ibid. (former Li Mo-ch'ao Coll.). A Ch'in player by a stream. Fan painting. Attributed. Ming copy. See Sung-jen hua-ts'e A, 49; B. IX, 1.

Ibid. A Ch'an monk and a Confucian scholar conversing on a ledge overlooking rooftops and a valley. Album leaf. Attributed. Work of a follower of Ma Yüan. See Liang Sung 28, Sung-jen hua-ts'e B. XI.

Ibid. Distant peaks, two scholars and servant looking across a misty valley. Album leaf. Attributed. Copy of work in the Ma Yüan style? See Fourcade 2; Sung-jen hua-ts'e A, 50; B. IX, 6.

* Ibid. Misty mountain landscape. Fan painting. Attributed. Genuine? Or good early work in his style? See Sung-jen hua-ts'e A, 51; B. VII, 1.

Ibid. Temples on a mountain. Fan painting. Attributed. Ming painting. See Liang Sung 30; Sung-jen hua-ts'e B. XI.

Shanghai Museum. *Chiang-shan kuei-shen t'u.* River landscape. Handscroll, ink and light color on paper. Signed; fragmentary date which may correspond to 1204. Imitation of Ming date. See Chang An-chih, Ma Yüan - Hsia Kuei (Peking, 1959), pl. 14-16.

Ibid. (Formerly Li Tzu-ch'ing Coll.). One hundred peaks competing for splendor. By Chou Ch'en of the Ming period, whose signature is on it. See Toso 98; Shanghai 51 (as Chou Ch'en).

I-yüan to-ying, 1979, no. 1, cover. Talking with a Guest in a House in the Snow. Album leaf. Signed. Good later Sung or Yüan work with interpolated signature, not style of Hsia Kuei.

* Taipei, Palace Museum (SH18). *Ch'i-shan ch'ing-yüan t'u:* A Pure and Remote View of Streams and Mountains. Long handscroll, ink on paper.

Colophon by Ch'en Ch'uan, dated 1378, in which Hsia Kuei is mentioned as the artist; another by a later man. The last section, which had the signature of the painter, is lost. See Three Hundred M., 115; CAT 57; CCAT pl. 101; CH mei-shu I; CKLTMHC I, 70; MY/HK 12-13; NPM Quarterly I.2, pl. VI; Wen-wu 1960.7, 32; Nanking Exh. Cat. 34; Siren CP III, 305-307; Skira 85; Hills, 87.

Many copies of the composition exist. One in the Freer Gallery (11.169), with a spurious signature of Ma Yüan, reproduces the first half of the scroll, including a section now missing from the original. The same is true of the copy in the Metropolitan Museum, N. Y. (14.220.18). Both are Ming Dynasty in date. See below, under Hatakeyama Museum and Genjo Collection, for two sections of a Japanese copy, Muromachi period?

Ibid. (SH17). *Ch'ang-chiang wan-li t'u:* Ten Thousand Li of the Yangtze River. Long handscroll, ink on silk. The attribution is made in a colophon dated 1340 and signed "K'o Chiu-ssu." Seal of the emperor Wen-tsung of Yüan reigned 1328-1329 and of later collectors. Colophons by Kao Shih-ch'i, dated 1698, and Liang Kuo-chih (18th century). Ming painting of mediocre quality, probably based on a Sung work. See London Exh. Chinese Cat., p. 96; Palace Museum Album, 1931; Ku-kung 8; KK chou-k'an 37-47. A copy of a portion in the Freer Gallery (11.182).

Ibid. (SH19). River landscape with figures. Signature interpolated. Ming painting, related in style to Chang Lu; perhaps his work. See KK chou-k'an 67-76.

Ibid. (SV113). The Willow Dike of the West Lake in Hangchou. The colophon, by the Yüan painter Kuo Pi, is probably a copy. Poem by Ch'ien-lung. Early Ming work? See Ku-kung 25; London Exh. Chinese Cat. p. 87; Three Hundred M., 114; Che-chiang 12; KK ming-hua III, 22; MY/HK 16; Wen-wu chi-ch'eng 47; KK chou-k'an 328.

Ibid. (SV114). Entertaining a guest in a mountain pavilion under a large tree. Ming work, by a poor follower of Chou Ch'en. See Ku-kung 18; Wen-wu chi-cheng 48; KK chou-k'an 151; KK ming-hua IV, 17.

Ibid. (SV115). Looking for plum blossoms. An old scholar with his servant on a snowy mountain path. Ming painting by Che School artist. See MY/HK 15; Ku-kung 14; KK chou-k'an 120.

Ibid. (SV116). The Returning Boat. River landscape with a steep mountain in the background. Hard Ming imitation. See KK shu-hua chi 25.

Ibid. (SV117). Landscape with two men approaching a village. Signed. Ming dynasty, close in style to Chiang Sung.

* Ibid. (SV118). High cliffs by a river; temples in the valley, houses below. Inscription by Wang To (about 1640), who attributes the picture to Hsia Kuei. Fine Southern Sung work. See KK shu-hua chi 38; CKLTMHC I, 68. The same composition exists in later versions attributed to Hsiao Chao (C. C. Wang Collection), and Kao K'o-ming (Taipei Palace Museum VA30a).

Ibid. (VA1o). Two men seated on a high riverbank under a projecting pine. Album leaf. Attributed. Signature, at left, illegible but apparently not that of Hsia Kuei. See KK shu-hua chi 40; CAT 58; CK ku-tai 51; CKLTMHC I, 69.

* Ibid. (VA3m). Gazing at a waterfall. Fan painting. Signed. Early work of the artist? See KK ming-hua III, 23; NPM Bulletin II.5, cover; NPM Masterpieces II, 30.

Ibid. (VA15l). Lofty Sage in the Autumn Grove. Album leaf. Signed. Work of another artist with interpolated signature.

Ibid. (VA19g). Man seated on a terrace under pines looking at clouds. Album leaf. See CKLTMHC II, 86.

Ibid. (VA22h). Man in pavilion beneath overhanging cliff and pine tree. Fan painting. Signed. Copy.

Ibid. (VA24e). Fishing on a cold stream. Fan painting. Signed. Copy. See KK ming-hua IV, 18.

Formerly National Museum, Peking. *Yüeh-ling ch'i-shih-erh hou:* The Seventy-two Periods of the Yüeh-ling. Four albums each comprising eighteen leaves, representing the four seasons. Attributed. Colophon by Chou Mi, dated 1277, and his seals. Colophons and seals of later men. Loehr Dated Inscriptions p. 277.

Ming-pi chi-sheng III. Snow storm over the Pa Bridge. Signed. Poem by Ch'ien-lung. Imitation.

T'ien-yin-tang II, 7 (Chang Pe-chin Coll., Taipei). Travellers on muleback. Fan painting. Signed.

Formerly J. D. Ch'en Collection, H. K. Two men on a ledge beneath a pine tree. Fan painting. Attributed. Copy.

Garland I, 28. Lofty and Remote Streams and Mountains. Trees by a river, a figure on a path approaching a house. Attributed. School work of early Ming date? Also in Li-ch'ao pao-hui, 8.

Chung-kuo MHC 39. Landscape with a man in a house, another approaching. Signed. Imitation.

* Tokyo National Museum. Houses on a river shore beneath trees; an anchored boat; a farmer returning. Attributed. A fine work of the period, quite possibly by Hsia Kuei. See Genshoku 29/22; Suiboku II, 14; Tokyo NM Cat. 7. A (Japanese?) copy formerly in the Seikado (Iwasaki Collection), Tokyo; see Toyo VIII, 56; Shimbi XI, Sogen meigashu 19; Toso 96; MY/HK 11. Still another version in the collection of Mr. and Mrs. Samuel H. Maslon, Minnesota, formerly Chang Pe-chin; see Far Eastern Art from Minnesota Collections, U. of Minnesota, 1970, no. 73.

Ibid. A ravine with waterfall and pines; a river valley with a house beyond pines. Attributed. Late 13th or 14th century, cf. Sun Chün-tse. See Kokka 48; Toyo VIII; Bijutsu kenkyu 213; Tokyo NM Cat. 30.

Hatakeyama Museum, Tokyo (formerly Asano Coll.). Landscape with a pavilion built on a bridge. Section of early Japanese copy of the "Pure and Remote View" in the Taipei Palace Museum. See Kokka, 385; Bijutsu kenkyu 21; Sogen no kaiga 102. Another section of the same copy, a river landscape with boats and a city in the distance, formerly Masao Genjo Coll.; see Toyo VIII, 60.

Kokka 158 (Formerly Kuroda Coll.). A promontory with a wind-swept tree, a boat by the shore. Fan painting. Signed, but the signature does not appear to be that of Hsia Kuei. School work. See also Hikkoen pl. 4; Siren CP III, 299; Sogen MGS III, 17.

Ibid. 165 (Formerly Kuroda Coll.). A herdboy with two buffaloes on a snowy beach. Fan painting. Signed.

Ibid. 193 (Formerly Akimoto Coll.). Dwelling among leafy trees on sharply cut cliffs by a stream. Ming work? See also Shimbi 16; Bunjinga suihen II, 83.

Ibid. 203 (Formerly Yamamoto Coll.). A man and a crane under a pine tree. Attributed. Not in his style.

Ibid. 247 (Inoue Coll.). Playing Chess in a Bamboo Grove. The inscription on top of the picture probably by the emperor Ning-tsung (1195-1224). Attributed. Fine work of the period, not in the style of Hsia Kuei.

Ibid. 432 (Prince Matsukata Coll.). A man playing the ch'in on a terrace in moonlight. Tall bamboo growing from the steep mountain wall. Attributed. Yüan-Ming work.

Ibid. 452 (Fujita Coll.). A man walking with a staff along a precipice under pine trees. Signed. Early school work? See also Siren CP III, 301b; Sogen MGS III, 16.

Shimbi 15 (Iwasaki Coll.). A windswept tree on a promontory; a buffalo. Album leaf. Copy.

Toyo VIII, 55 (Formerly Kawasaki Coll.). Rainstorm over a pavilion among trees by a river. Signed. Copy or school work. See also MY/HK 14; Siren CP III, 301a; Choshunkaku, 33; Sogen MGS II, 13.

* Ibid. VIII, 57 (J. Nakamura, Tokyo; formerly Kuroda Coll.). A pavilion on a rocky promontory among leafy trees. Signed. Probably genuine. See also Hikkoen pl. 31; Sogen meigashu 10; Kokka 34; Siren CP III, 300; Sogen no kaiga 103.

Ibid. VIII, 58 (Akaboshi Coll.). A man seated by a waterfall. Fan painting. Signed. School work.

Ibid. VIII, 59 (Akaboshi Coll.). A man seated under a pine tree looking over a winding stream. Fan painting. Signed. Copy or imitation. See also Siren CP III, 302.

Ibid. VIII, 61 (Formerly Kuroda Coll.). Two herons by a cliff in a stream. Fan painting. Attributed; somewhat later in date. See also Shimbi 20; Hikkoen pl. 5.

Ibid. VIII, 62-64 (Formerly Maeda Coll.). Old pine trees and craggy rocks. Three landscapes forming a set. Probably of the Ming period.

Toso 93 (Shimizu Coll., Tokyo; formerly Akimoto Coll.). A misty river valley; a man followed by his servant walking along the steep bank. Fine Yüan? work in his tradition. See also Toyo bijutsu 35; Suiboku II, 49.

Ibid. 94, 95 (Formerly Kuroda Coll.). Two landscapes: river valleys with towering mountains and pavilions. One representing Spring, the other Summer. Ming period Che School works. See also Osaka Sogen 5-19.

Ibid. 97 (M. Ogawa Coll.). View over a distant river with boats. Mountain silhouettes in the mist. Good Ming work.

Former Okihara Collection. Cliff and waterfall. Short handscroll. Signed. Dated kuei-ssu, or 1233? Japanese copy?

Seikasha Sogen, 8. A man leaning on a pine tree and gazing into the water. Album leaf. Attributed. Later work, not in his style.

Kumamoto 3 (Formerly Hongan-ji, Kyoto). A house beneath trees on the shore. Fan painting. Attributed. Work of a follower.

Sogen no kaiga 104 (Asano Coll.). A man on a donkey followed by his servant proceeding along a riverbank toward a bamboo grove. Signed. Copy? See also Siren CP III, 297-298.

* Osaka Catalogue 39.5. A cottage in the mountains; a man setting out on a stroll. Fan painting. Signature, which may read Hsia Kuei. Good Sung work. See Kokka, 564; Soraikan II, 20(3).

Ibid. 39.12. A man and his servant in a garden. Signed. Album leaf. Late, poor work.

Kohansha 2 (Formerly Kawai Coll., Kyoto). Landscape with a man crossing a bridge. Album leaf. Seal reading "Hsia Kuei." Later work.

* Boston Museum of Fine Arts (12.891). River landscape in wind and rain; a windblown tree and house on the shore, a sailboat on the river. Fan painting. Signed. Accompanying inscription by the emperor Hsiao-tsung (reigned 1163-1189). Genuine? or early school work with interpolated signature? See Portfolio I, 85-86; Kokka 255; Southern Sung Cat. 16; Siren CP in Am. Colls. 14; BMFA Bulletin, Dec. 1912, Kodansha CA in West I, 15; Suiboku II, 12.

Ibid. (14.54). Landscape with fishing nets and a group of large trees on the riverbank. A much retouched early painting in the manner of the master. See Portfolio I, 87; Siren CP in Am. Colls. 54; Toronto Cat. 3. Several other versions exist, including the "Li T'ang" in Chung-kuo I, 18, q.v.

Freer Gallery (06.228). Long landscape handscroll, ink and colors on silk. The attribution is by a Japanese writer. 15th century work? based on older composition.

Ibid. (11.26). The hundred water-buffaloes. River landscape. Handscroll, ink on silk. A Ming picture not in the manner of Hsia Kuei.

Ibid. (11.229). Landscape with flying birds. Handscroll, ink on paper. Two signatures, both spurious. Good Ming work, school of Tai Chin.

* Ibid (11.254). A misty gorge. Signed, but signature (on left margin, reading "Yü-yü") apparently lost in remounting. Fine work in his style, and probably of his period. See Siren CP in Am. Colls. 137; Bachhofer 109; La Pittura Cinese 186.

Ibid. (11.296). The Emperor Wen of the Chou Dynasty Meets the Sage Chiang Tzu-ya. Attributed. Good work of Ming date, Che School, close to Chou Wen-ching. See Siren CP in Am. Colls. 110; Bachhofer 121.

Ibid. (19.121). Seashore landscape. Handscroll. Good Ming work.

Ibid. (19.126). Autumn Moon on Lake Tung-t'ing. Large hanging scroll. Attributed. Title and poem at top. Work of Yüan dynasty follower?

Ibid. (68.44, formerly Mrs. Eugene Meyer Coll.). Landscape with figures. Signed. Ming work; cf. Wang Wen. See Meyer cat. 26.

Indianapolis Art Institute (61.80). Morning on the River. Album leaf. Signed. Early copy? or school work? See Bachhofer 107; Art News, May 1, 1937, pp. 127-129.

Kimball Art Museum, Fort Worth. Landscape with traveller on a donkey; servant. Small hanging scroll, ink on silk. Inscription by Ching-shan Yün-feng (died in the 1270's). Good 13th century painting, not by Hsia Kuei.

See their *Catalogue of the Collection,* 1972, pp. 250-251.

Metropolitan Museum, N. Y. (13.100.102). Landscape. Album leaf. Attributed. Later work. See Priest article in their *Bulletin,* April 1950, p. 243. Other paintings in the same museum ascribed to Hsia Kuei: 47.18.40 (River Landscape with Boatman, album leaf); 47.18.110 (River Landscape; see Siren Bahr Cat. pl. 16); 47.18.138 (Boatman in Rocky Cove); 47.18.128 (Landscape with Scholar and Servant; see Priest article in their *Bulletin,* Jan. 1950, p. 168); 13.220.1 (River Landscape); Lakeside Scene with Trees and Boat (see Priest article in their *Bulletin,* Jan. 1950, p. 174); 47.18.30 (Landscape, fan painting of good quality and possibly Sung date); and 49.6.11 (The Ch'ien-t'ang Estuary, album leaf).

* Nelson Gallery, Kansas City (32.159/2). Twelve Views from a Thatched Hut. (This subject and title may not be the original.) Portion of a handscroll, comprising four of the views. Ink on silk. Signed. Possibly an early, close copy. Titles to the four views written in the script of the emperor Li-tsung (reigned 1225-1264). Colophons by Shao Heng-cheng (Hung-wu period), Wang Ku-hsiang (1562), Tung Ch'i-ch'ang (1627), and others. See London Exh. Cat. 1074; Che-chiang 13; MY/HK 8-10; Siren CP III, 303-304; Kodansha CA in West I.16; Suiboku II, 45, 46. Other versions of the composition are in the Yale University Art Gallery and the Wang Shih-chieh Collection, Taipei. Both reproduce the complete composition. The latter is now mounted in two scrolls, is signed, and has seals of Hsiang Yüan-pien, Huang Lin and Liang Ch'ing-piao. See Garland I, 27.

Cleveland Museum of Art (78.1). A gibbon hanging from a tree over the water. Fan painting. Signed, but the signature appears to read "Hsia Lin." Fine Sung work, not in the style of Hsia Kuei. See Archives XXXII, 1979, p. 79.

Ernest Erickson Collection, N. Y. River landscape with willows and a man in a boat. Round fan painting. Attributed. Later work.

H. T. Lee, San Francisco. Fisherman in a landscape. Signed. Ming painting. See I-lin YK 9/1.

Metropolitan Museum, N. Y. (1973.121.11; formerly C. C. Wang Coll.). Evening Return; a man disembarking from a boat. Fan painting. Attributed, and in his style, but somewhat later in date. See Met. Cat. 1973, no. 10. Note: See also the fan painting in the Cleveland Museum ascribed to Hsia Sen.

HSIA SHEN (SEN) 夏森
Active in the mid 13th century. Son of Hsia Kuei. Landscapes. H, 4. J, 6. M, p. 318.

Taipei, Palace Museum (VA19o). Watching the Tide from the High Pavilion (The Hangchou Bore). Album leaf. Signed. Copy. See KK hsün-k'an 32.

* Cleveland Museum. Hills in Mist, People in Boat. Fan-shaped album leaf. Signed "Hsia Sheng" 夏生 . Fine early painting, close to Hsia Kuei in style.

HSIAO CHAO　蕭照

From Hu-tse, Shansi. Tai-chao in the Academy of Painting in Hangchou, c. 1130-1160. Landscapes and figures. Pupil of Li T'ang. H, 4. I, 51. J, 3. K, 10. M, p. 699-700.

* Liaoning Provincial Museum. Red trees in autumn mountains. Fan painting. Attributed. Fine late Sung work? See Liang Sung 20; Liao-ning I, 39; Sung-jen hua-ts'e B. XVIII; Sung Yüan shan-shui 4; Liaoning Album 4: *Sung Hsiao Chao Ch'iu-shan hung-shu* (Peking: Jung-pao chai hsin-chi, 1956).
* Tientsin Art Museum. Three scenes illustrating events in the reign of T'ai-tsu (Sung Emperor Kao-tsung). Three paintings mounted in handscroll with sections of text. Attributed. See Tien-ching II, 1-6.
* TWSY Ming-chi 65-81. *Chung-hsing chen-ying t'u:* Auspicious Omens during the Reign of T'ai-tsu (Sung Emperor Kao-tsung). Handscroll in 12 sections (possibly part of the preceding painting). Attributed. Good Southern Sung work. See also I-Lin YK 13/16, 14/16.

Sung-jen hua-ts'e A, 73. A study by a river. Fan painting. Attributed. Southern Sung, in style associated with Liu Sung-nien.

Chung-kuo ming-hua 24. Willows. Later imitation.

* Taipei, Palace Museum (SV70). Tall cliffs by the river; travellers climbing to a temple, others gazing over the river. Signed. *Ssu-yin* half-seal. The work of a later (post-Sung) follower of Li T'ang? See Three Hundred M., 103; CKLTMHC I, 54; KK ming-hua III, 6.

Ibid. (VA19j). Travellers in the Mountain Pass. Album leaf. Attributed. Ming work. See KK hsün-k'an 30; NPM Bulletin IV.1, cover. NPM Masterpieces II, 18.

Toso 56 (Chu I-fan Coll.). The Tiger Hill near Suchou. Short handscroll. Signed. Ming picture? See Chugoku I, Siren CP III, 261.

Ibid. 57 (Fang-jo Coll.). Mountain Dwellers: pavilions among winding waters and rugged cliffs. Handscroll, ink on silk. Inscribed with the painter's name, dated 1134. Ming work. See also Siren CP III, 260; Loehr Dated Inscriptions p. 249.

Ogawa Collection, Kyoto. The Waterfall on Mt. Lu. Large hanging scroll, ink on dark silk. Said to have a hidden signature of Hsiao Chao; also attributed to a Northern Sung artist named Sung Hsieh.

Seikasha Sogen, 3. Hills by the river, houses among trees. Fan painting. Attributed. Yüan-Ming work.

Boston Musem of Fine Arts (14.65). A waterfall among pine-clad rocks. Fan painting. Attributed. See Portfolio I, 137; Siren, CP in Am. Coll., 92.

Metropolitan Museum, N. Y. (26.114.5). The Red Cliff. Imitation.

Ibid. (47.18.119). Pavilions with figures. Handscroll. Attributed.

C. C. Wang Collection, N. Y. A wine shop in a bamboo grove at the foot of snow-covered mountains. Large album leaf. Signed. The same composition in versions attributed to Hsia Kuei and Kao K'o-ming, both in the Taipei Palace Museum (SV118 and VA30a). The "Hsia Kuei" is the oldest and best.

HSIAO YUNG　蕭瀜
Served as a high official at the court of the emperor Hsing-tsung of the Liao dynasty (1030-1055). Imitated Pien Luan as a painter of birds. I, 52. M, p. 700.

Taipei, Palace Museum (SV71). Pheasants on a rock by a stream. Signed. Ming work. See KK shu-hua chi 3; Three Hundred M., 94; CH mei-shu I; CKLTSHH; KK ming-hua I, 43; Wen-wu chi-ch'eng 36; KK chou-k'an 99.

HSIEH YÜAN　謝元
Unrecorded. Probably an academician in the Sung period.

Sogen 21 (Chang Hsüeh-liang Coll.). A branch of peach blossoms. Short handscroll. Signed. See also Garland I, 34.

HSÜ CH'UNG CHÜ　徐崇矩
From Nanking. Grandson of Hsü Hsi. 11th century. Flowers and birds. D, 3. F, 4. G, 17. H, 3. I, 50. M, p. 355.

Peking, Palace Museum. Bird on smartweed. Fan painting. Attributed. Seals of Hsiang Yüan-pien and others. See KKPWY hua-niao 4; Sung-jen hua-ts'e A, 5; B.I, 2.

HSÜ CH'UNG-SSU　徐崇嗣
From Nanking. Grandson of Hsü Hsi. 11th century. Flowers and birds. D, 3. F, 4. G, 17. H, 3. I, 50. M, p. 355.

Taipei, Palace Museum (VA12e). Long-tailed bird on a branch of loquat tree. Fan painting. Attributed. Sung work, badly repainted? See CKLTMHC II, 73.
Chung-kuo MHC 40. Two ducks by rock and flowering tree. Attributed. Good Ming work.
Fujii Yurinkan, Kyoto. Two rabbits and melons. Part of a handscroll. Ming work. See Naito pl. 38.
Tokyo National Museum (former Hatakeyama Museum, Tokyo; former Asano Coll.). Butterflies, dragonflies, grasshoppers, bamboo, cockscomb and melon. Sometimes attributed to Chao Ch'ang. Yüan painting? See also Sogen no kaiga 64; Sogen MGS II, 9-10; Kokka 388; Tokyo NM Cat. 13.
Tokyo National Museum. Egrets and lotuses. Pair of hanging scrolls. Sung-Yüan works. See Suiboku III, 82-83; Tokyo NM Cat. 28.
Shina kacho gasatsu. Four quails under maize. Attributed. Imitation.

HSÜ SHIH-CH'ANG　徐世昌
For the painting in the Freer Gallery formerly attributed to him (16.95) see Wang Shih-ch'ang of the Ming period.

HSÜ TAO-NING　許道寧
From Ho-chien, Hopei. Born c. 1000, died after 1066. Lived first as a vendor of medicine in Ch'ang-an, but became gradually known and highly appreciated as a painter. Landscapes, followed Li Ch'eng. D, 2. F, 4. G, 11. H, 3. L, 44. M, p. 409. Also biography by T. W. Weng in Sung Biog. 45-47.

Peking, Palace Museum. A returning boat in a storm. Fan painting. Attributed. Yüan-Ming work. See Sung-jen hua-ts'e A, 94; B.III, 8.

Ibid. Blue mountains and white clouds. Fan painting. Attributed. Ming work. See Sung-jen hua-ts'e A, 95; B.III, 1.

Taipei, Palace Museum (SV18). Heavy Snow on a Mountain Pass. "After Li Ch'eng," according to the interpolated "artist's" inscription. The upper section replaced, probably when original inscription was removed. Spurious seals of Hui-tsung, Chang-tsung of Chin, Shen Chou and others of the Ming period. A work by Wang Hui of the early Ch'ing period. See Ku-kung 9; Three Hundred M., 75; KK ming-hua I, 34; Nanking Exh. Cat. 26; Wen-wu chi-ch'eng 23; KK chou-k'an 54.

Ibid. (SV19). Fishing on a Snowy River. Inscribed with the painter's name and the date chia-shen of the Ching-yu era, a date that did not exist. Late Sung or Yüan work. See Ku-kung 12; CAT 19; KK ming-hua II, 30; KK chou-k'an 61; Soga I, 23.

Ibid. (SV20). Old leafless trees on bare cliffs. Attributed. Yüan work? See KK shu-hua chi 29; CKLTMHC II, 11; KK chou-k'an 448; NPM Masterpieces, V, 7.

Ibid. (chien-mu SV237). Winter Landscape. Good Ming work in his tradition.

Tien-yin-tang II, 3 (Chang Pe-chin Coll., Taipei). A homeward-bound boat; a man seated on the shore. Fan painting. Attributed.

* Fujii Yurinkan, Kyoto. River view with bare hills and leafless trees. Handscroll, ink and light color on silk. Attributed; perhaps a slightly later work in his tradition. See Toso 31a; Yurintaikan III; Sogen no kaiga 91; Siren CP III, 159; Toyo Bujutsu 14-16; and a scroll reproduction by Hakubundo; also Suiboku II, 31-32; Bunjinga suihen II, 21, 27.

Osaka Municipal Museum (Abe Coll.). Snow covered mountains with travellers on the bridge below. Attributed in an inscription in the manner of Hui-tsung, dated 1108. Minor 17th century work. See Soraikan II, 9; London Exh. Cat. 1114; Loehr Dated Inscriptions p. 240; Osaka Cat. 21.

Ibid. A philosopher's abode in the mountains. Poem signed Hu Ning. Mediocre Ming work. See Soraikan II, 2; Osaka Cat. 20.

Toso 30 (Formerly Wang Heng-yung Coll.). High mountain ridges with pine trees; travellers on a bridge. Seal of the emperor Chang-tsung of Chin (reigned 1190-1195). Poem by the emperor Hsiao-tsung, dated 1185(?). Late Ming work. See also Loehr Dated Inscriptions, p. 257-258.

Boston Musem of Fine Arts (17.733). Man in a pavilion watching the tide on the Ch'ien-t'ang River. Fan painting. Signed "Tao-ning"; perhaps the work of another artist who had that name. Southern Sung picture, style of Ma Lin. See Portfolio I, 59; BMFA Bulletin, v. LIX, 1961; Siren CP in Am. Colls. 91. Another version in the Metropolitan Museum, N. Y. (47.18.70) with a wave only.

Freer Gallery (16.32). Looking for the first plum blossoms of spring; man on a donkey with servant in wintry landscape. Attributed. Good work of Ming date, Che School.

Ibid. (16.571b). Landscape with bare trees. Large album leaf. 17th century, perhaps by Liu Tu.

Ibid. (70.36). Listening to the Pines in a Riverside Pavilion. 16th century, Che school painting. See Meyer cat. 25.

Metropolitan Museum, N. Y. (49.6.12). Snowy Mountains. Album leaf. Attributed.

* Nelson Gallery, Kansas City (33.1559). Fishing in a Mountain Stream. Weathered cliffs rising from a glacial valley; fishermen in boats, travellers on paths. Large handscroll, ink and light colors on silk. Unsigned; of the period, may be by the master. See Siren CP III, 158; Kodansha CA in West I.3; Suiboku II, 6; Summer Mts., 22-24; Bunjinga suihen II, 28.

Frank Caro, N. Y. (1958). Temples in the Mountains. Small hanging scroll, ink on dark silk. Signed. Good work in his tradition, Yüan date?

C. M. Lewis Collection, Pittsburgh. Travellers in a winter landscape. Fan painting. Attributed. A work of a follower of Sheng Mou.

British Museum, London (Add.228; former Oppenheim Coll.). Mountain landscape with a sage crossing a bridge. Reattributed by Whitfield to the Ming painter Chiang Sung in Burlington Mag., Mar. 1972, p. 290. See London Exh. Cat. 1207; Ars Asiatica IX, p. 25.

HSÜ TI　許迪

Active in the 11th century. A native of P'i-ling, Kiangsu. Flowers and birds in imitation of the Priest Chü-ning. M, p. 408.

Taipei, Palace Museum (VA17z). Cabbage and Insects. Album leaf. Attributed. See KK chou-k'an 4.

HSÜ TSU　徐祚

Unidentified; late Sung period? According to the signature on the painting below, from Kuang-ling (Yangchou).

Toso 125 (Setsu Gatodo Coll., Tokyo; formerly Inoue Coll.). An angler in a white cloak hunched up among reeds on a riverbank. Signed. Fine Sung work. See also Sogen meigashu.

HSÜ TSE 徐澤

Unidentified. Late Sung? Tzu? Yün-yen (from seal on the painting listed below). Not mentioned in Chinese books; according to Kundaikan Sayuchoki, a painter from Yün-chien who specialized in flowers and birds, especially hawks. See Yoshiho Yonezawa's article in Kokka 816.

Toyo bijutsu 51. A hawk tied to a perch. Attributed. See also Kokka 816.

HSÜ YÜ-KUNG 徐禹功

Unidentified.

Liaoning Provincial Museum. Plum blossoms and bamboo in snow. Handscroll. Signed; dated hsin-yu (1141?). Colophons by Yang Pu-chih, Chao Meng-chien (dated 1257), Chang Yü (dated 1349) and others. Hard work, of post-Sung date? See Liao-ning I, 55-56.

HU CHIH-FU 胡直夫

Probably 13th century. Figures and landscapes. Unrecorded except in *Kundaikan sayuchoki* 39. Cf. Bijutsu kenkyu 84, 86.

* Hatakeyama Museum (formerly Sakai Coll.). Sakyamuni as an ascetic returning from the wilderness. Poem by Ming-pen (1263-1323), a friend of Chao Meng-fu. Fine work of late Sung or Yüan. See Kokka 275.
Tokugawa Art Museum. Pu-tai seated on the ground. Inscription by Yen-ch'i huang-wen (1189-1263). See Suiboku III, 37; Sogen no Kaiga 28; Tokugawa 154, 156. Another picture of Pu-tai attributed to Hu Chih-fu with inscription by Yen-ch'i kuang-wen in the Asada Chohei collection.
Seikado, Tokyo (formerly Baron Iwasaki Coll.). Han-shan, the Ch'an monk. Attributed. Inscription by Ching-fu (fl. late 13th century). Good work of this period. See Kokka 372; Suiboku III, 58; Sogen no kaiga 40; Genshoku 29/62.
Ibid. 577 (Kato Coll.). Han-shan and Shih-te. Half-seal reading "Chih", perhaps that of the artist, although the painting seems post-Sung.
Idemitsu Art Museum, Tokyo. P'u-hua holding a bell. Inscription by Yen-ch'i Huang-wen. Attributed. Late Sung amateurish work.
Hikkoen (formerly Kuroda Coll.). A Buddhist monk seated on a mat sewing his garment. Album leaf. Attributed. Yüan-Ming?
Kawasaki Cat. 20. A boatman speaking to a woman who stands on the shore. Poem by the priest Chih-ming. Attributed. Late Sung work?
Kokka, 853 (Kanichiro Kagata Coll., Niigata City; deposited at Tokyo National Museum). Landscape, hanging scroll. Attributed. Yüan-Ming work, after Southern Sung original in Li T'ang manner? See Bunjinga suihen II, 82.
Akaba Untei, Tokyo. A crow on a branch. Small picture, ink on silk. Seal of the artist, interpolated.

Formerly Frank Caro, New York (1951). Ten Odes of Kuo, from the Mao Shih. Handscroll, attributed. Long inscription of Tung Ch'i-ch'ang. Yüan-Ming?

* Freer Gallery (65.9, formerly Yamaoka and Kawasaki Colls.). Sakyamuni as an ascetic returning from the wilderness. Inscription by Hsi-yen, 13th century. See Sogen 72; Choshukaku 9; Freer Figure Ptg. cat. 21; Kodansha CA in West I, 52; Suiboku III, 55; I-lin YK 58/1.

Note: The Summer Landscape in the Kuonji, one of the three Landscapes of the Seasons listed under Anonymous Sung, was formerly attributed to Hu Chih-fu.

HU SHUN-CH'EN 胡舜臣
From Chekiang. Flourished in the 12th century. Classified as a follower of Kuo Hsi. H. M, p. 292.

* Soraikan II, 16. High mountains and pine trees along a river. A much damaged and worn handscroll. Inscription, signed and dated 1122. Colophons by Ts'ai Ching (1046-1126) and by three writers who viewed the scroll in 1344; by Shen Chou, and by four 18th and 19th century writers. See Bijutsu kenkyu 104; Loehr Dated Inscriptions p. 244; Osaka Cat. 30; Bunjinga suihen II, 36.

Freer Gallery (16.137). Winter landscape with bare trees. Spurious inscription and signature. Fine work by follower of Sheng Mou.

HUANG CH'I 黄齊 t. Ssu-hsien 思賢
Active c. late 11th century. A native of Chien-yang, Fukien. Landscapes. G, 12, p. 131; H, 3, p. 51.

Taipei, Palace Museum (VA2e). Landscape in mist and rain. Album leaf. Attributed. Yüan dynasty?

HUI-CH'UNG 惠崇
From Chien-yang, Fukien. A monk-painter active at the beginning of the 11th century; born c. 965, died 1017. Water-fowl and small landscapes. Su Tung-p'o wrote a poem on a picture by him. Paintings in the Chao Ling-jang manner are commonly and misleadingly ascribed to him. F, 4. H, 3. I, 52. K, 36. L, 64. M, p. 503.

* Peking, Palace Museum (Formerly National Museum, Peking). Dawn over streams and mountains in spring. Handscroll. Poems by Ch'ien-lung. Colophons by Tung Ch'i-ch'ang and several other Ming writers. Attributed. Southern Sung painting? in the style of Chao Ling-jang. See Li-tai II, also Chung-kuo hua XXI, 16-19.

* Liaoning Provincial Museum. A river shore with misty trees and ducks on the water. Album leaf. Attributed. Fine early work in Chao Ling-jang style.

See Liang Sung 10; Liao-ning I, 23; Sung-jen hua-ts'e B.XVIII; Sung Yüan shan-shui I; also *Sung Hui-ch'ung Sha-t'ing yen-shu* (Peking: Jung-pao chai reproduction, 1957).

Taipei, Palace Museum (V8b). Two mandarin ducks on a beach in autumn. Album leaf. Yüan work? See Palace Museum Album 1932 (Li-ch'ao hua-fu chi-ts'e); London Exh. Chinese Cat. p. 101; Three Hundred M., 69; CAT 22; CH mei-shu I; CKLTMHC II, 101; CKLTSHH; KK ming-hua I, 29; Soga I, 25.

Ibid. (VA17h). Two geese on a river shore. Fan painting. Close copy of Sung work? See KK chou-k'an I, 2; KK ming-hua II, 25.

* Ibid. (VA12u). Four doves in a landscape, with bamboo and flowering tree. Album leaf. Attributed. Fine Southern Sung work. See KK ming-hua I, 30; Soga I, 27.

Ibid. (VA5j). Herding Ducks. Album leaf. Attributed. Work of Chao Ling-jang follower. See T'ang-Sung Ming-hui, Yen-kuang alb. 1927.

* Ibid. (VA15n). Mandarin ducks under winter trees. Album leaf. Attributed. Fine Southern Sung work, closer in style to Li Ti. See NPM Masterpieces II, 11; Soga I, 26.

S. H. Hwa Collection, Taipei. Birds gathering at a stream. Ink and colors on dark silk. Attributed. Inscription by Wang Shih-min. Seals of Hsiang Yüan-pien.

I-lin YK 27/11. Pair of ducks in reeds by river. Signed. Yüan or early Ming?

Mino Collection, Kamakura. Geese and Reeds. Probably a Japanese painting of the Muromachi period, perhaps after a Chinese original.

* Yabumoto Soshiro, Tokyo. Geese on Low Promontory by River. Album leaf, ink on silk. See Suiboku III, 79; Genshoku 29/69; Kokka 943.

Yabumoto Kozo, Amagasaki. Geese and reeds. Album leaf, ink on paper. At tributed. Japanese?

Hikkoen 60 (formerly Kuroda Coll.). Geese on a low promontory by a river. Album leaf. Sung work.

Muto Cat. 15. Wild geese among lotus plants and rushes. Fan painting. Later work.

HUI-TSUNG 徽宗

Emperor Hui-tsung of Sung. B. 1082, d. 1135. Reigned from 1101 to 1126. Reorganized the Academy of Painting and took an active part in supervising the artists. As a painter, specialized in birds and flowers. H, 3. I, 21. L, 1. M, p. 607; also Teng Pai, *Chao Chi* (Shanghai; 1958, in CKHCTS series: Chao Chi); Rowland, "The Problem of Hui Tsung," *Archives* V, 1951; forthcoming book by Tseng Yu-ho.

Peking, Palace Museum. A scholar seated under a large tree playing the ch'in for two friends. Colors on silk. Imperial signature and a poem written by Ts'ai Ching. Late copy. See I-shu ch'uan-t'ung VI; China Pictorial, 1962, no. 12; Chao Chi 14; Li-tai jen-wu 19; Fourcade 21; Wen-wu 1957.3.

* Ibid. A pheasant perched on the branch of a blossoming shrub. Colors on silk. Inscription by the emperor. Yüan palace seal *T'ien-li chih-pao*, used ca.

1330. Genuine? or Academy picture? See Chao Chi 3; Chung-kuo hua I, 12; CK ku-tai 45; KKPWY hua-niao 2; I-yüan to-ying, 1979 no. 1, p. 23.

Ibid. A white-eye on a blossoming plum branch. Album leaf. Signed. Copy? See Liang Sung 2; Sung-jen hua-ts'e B.XII.

Ibid. Loquats, bird and butterfly. Fan painting, ink on silk. Signed. Copy? See KKPWY hua-niao 3; Sung-jen hua-ts'e A, 8; B.I, 3.

Ibid. Wang Chi Examining a Horse. Short handscroll. Title in the manner of Hui-tsung; the painting ascribed to him. Interesting copy of old (Five Dynasties?) work.

Shanghai Museum. Four magpies in a bare willow and four ducks on the shore under bamboo. Handscroll, ink and colors on paper. Signature and seals of the emperor. Seals of Liang Ch'ing-piao and others. Later work. See Wen-wu 1963.10, 18; *Sung Hsüan-ho Liu-ya lu-yen* (Shanghai: Shanghai Museum, n.d.).

Liaoning Provincial Museum. Lady Kuo-kuo on a spring outing. After Chang Hsüan. Handscroll. See Chao Chi 12-13; Liao-ning I, 36-38; Li-tai Jen-wu 20; T'ang- tai jen-wu pl. 7; Wen-wu 1955.5, 10; 1961.12 inside back cover.

Ibid. Returning fishing boats on a snowy river. Handscroll, ink on silk. Seal and signature of the emperor. Colophons signed Ts'ai Ching dated 1110, Wang Shih-chen and Tung Ch'i-ch'ang. Ming work; after earlier composition? See also Chao Chi 4-8; Loehr Dated Inscriptions p. 241; Bunjinga suihen II, 35. A later version in the Yale Art Gallery; see Moore Cat. 14, Hakubundo scroll reproduction.

* Ibid. Auspicious Cranes: two cranes perched on the roof of a palace; eighteen others in flight above. Handscroll. Long inscription by the emperor, according to which the incident occurred in the year 1112. Genuine? Or work of academy master, executed on emperor's order? See TSYMC hua-hsüan 7; I-yüan cho-ying 1978 no. 3, where the emperor's inscription is also reproduced (p. 27). See also article by Tung Yen-ming (p. 29).

Szechwan Provincial Museum. Two birds on blossoming plum and cedar branches. Album leaf. Signed. Copy. See Liang Sung 1; Sung-jen hua-ts'e B. XVI.

Taipei, Palace Museum (SV47). Streams and Mountains in Autumn Hues. Signature and seal of the emperor. *Ssu-yin* half-seal. Poem by Ch'ien-lung. Ink on paper. Late Sung? See KK shu-hua chi 1; Three Hundred M., 91; CAT 32; CKLTMHC I, 35; KK ming-hua II, 37; Wen-wu chi-ch'eng 31; KK chou-k'an 505; Siren CP III, 240. A later, reversed rendering of this composition (also attributed to Hui-tsung) in the Osaka Municipal Museum (Abe Coll.). See Soraikan II, 15; Osaka Cat. 34; Chugoku I; Nanga Taisei XI.

Ibid. (SV48). A Literary Gathering: twelve scholars of the Sung period at a festival meal in a garden. Poem by the emperor and his signature. Another poem by his minister Ts'ai Ching. Colors on silk. Academy painting of Ming date? See Ku-kung 7; Three Hundred M., 92; CAT 31; CKLTMHC I, 34; KK ming-hua I, 41; Nanking Exhib. Cat. 23; NPM Masterpieces I, 8 and III, 12. Another version called "Anonymous T'ang," in the same collection (TV15).

Ibid. (SV49). A white goose resting on a shore and a red polygomum plant. Seal of the emperor. Colors on silk. Fine Yüan-Ming copy of an earlier work. See KK shu-hua chi 15; London Exh. Chinese Cat. p. 53; Three Hundred M., 90; CH mei-shu I; CKLTMHC II, 3; CKLTSHH; KK ming-hua I, 42; KK chou-k'an 169.

* Ibid. (SV50). Two small birds in a leafless blossoming wax tree. *(Ligustrum lucidum),* and two lilies below. Ink and colors on silk. Inscription and poem by the emperor. Yüan palace seal *T'ien-li chih-pao,* used ca. 1330. Genuine? See KK shu-hua chi 45; Three Hundred M., 89; CCAT pl. 98; Chao Chi 2; CH mei-shu I; CKLTMHC I, 36; KK ming-hua II, 38; Wen-wu chi-ch'eng 32; Siren CP III, 234.

* Ibid. (chien-mu SV253). A man seated on a rock; an ox. Hanging scroll, ink on silk. Inscription by Hui-tsung may be genuine; the painting is of his time or earlier, but by someone else. Seal of K'o Chiu-ssu. Important early work.

Ibid. (chien-mu SV255). Blossoming pear. Hanging scroll. Lovely work in the style of Wang Yüan, Yüan period?

* Ibid. (SH6). A white heron and two ducks with lotus and other plants at a lake shore. Handscroll, ink on paper. The emperor's seal and signature. Two colophons of the Southern Sung period; the first refers to the picture as existing in the Shao-hsing era (1131-1162); the second is dated 1177. Many seals. Poem by Ch'ien-lung. Late Sung painting? See Palace Museum scroll reproduction 1934; London Exh. Chinese Cat. pp. 54-62; CKLTMHC I, 37; Siren CP III, 232-233; Loehr Dated Inscriptions p. 248.

Ibid. (SH7). Handscroll containing two paintings: birds and butterflies in a lichee tree, signed with his cipher; and two mandarin ducks, attributed. The latter by far the finer work, but both are later than Hui-tsung.

Ibid. (chien-mu SH66 and SH 67). Two versions of the "Eighteen Scholars" composition, sometimes connected with Yen Li-pen. Handscrolls. Both Ming works. This series has been treated by Ellen Laing in an unpublished study.

Ibid. (VA12a). Chestnuts. Album leaf. Cipher. Copy?

Ibid. (VA26a). A Single Crane. Album leaf. Inscription in his style. Copy.

KK shu-hua chi 35. Two small birds on the branches of a lichee tree. Hsüan-ho seal. Ink and colors on paper. A later picture.

Formerly National Museum, Peking. A mother monkey with her baby; a tuft of dandelions and beetles. Signature and seal of the emperor. Old copy.

Chung-kuo I, 40 (Ti P'ing-tzu Coll.). A bird on the branch of a flowering tree-peony. Fan painting. Imitation.

Ibid. I, 41 (Ti P'ing-tzu Coll.). A mother sparrow feeding young birds perched on bamboo branches. Imitation. See also Chung-kuo MHC 32.

Ibid. I, 43 (Ti P'ing-tzu Coll.). Two fighting quails, bamboo and flowering plants. Inscribed with the emperor's signature. Imitation. See also Chung-kuo MHC 31.

Ibid. I, 45 (P'ang Yüan-chi Coll.). Three mynah birds fighting. Signature and seal of the emperor. Inscribed by Ch'ien-lung. Much later painting. See also London Exh. Cat. 1125; Toso 51; Chung-kuo MHC 37; Chao Chi 16; Bunjin gasen II, 5.

Ch'ing kung ts'ang 1. (Formerly Manchu Household Coll.). A white parakeet on the branch of a flowering plum tree. Album leaf. Seals and signature of the emperor. Imitation. See also Siren CP III, 231.

Ibid. 5 (Formerly Manchu Household Coll.). A bird on the branch of mulberry tree. Album leaf. Two seals of the emperor. Imitation.

Ibid. 6 (Formerly Manchu Household Coll.). Two squirrels on pine branches. Seal and signature of the emperor. Ming painting.

* TWSY ming-chi 35-39 (Formerly J. D. Ch'en Coll.). *Chin-ying ch'iu-chin t'u:* magpies and other birds in a garden. Handscroll, signed with his cipher. Dots of lacquer in the birds' eyes. Seals of emperor Chang-tsung of Chin, and Chia Ssu-tao (d. 1276). Important early painting.

Ibid. 34. Imperial white eagle on a roost. Inscription signed and dated 1114; inscription by a courtier dated 1122. Old, badly damaged work. See also Loehr Dated Inscriptions p. 252.

CK shu-hua I, 11-16. Rare Birds. Handscroll.

* Siren CP III, 235-236 (Cheng Chi Coll., Tokyo). Four small pictures mounted as a handscroll, ink on paper. Three of them represent pairs of birds perched on the slender branches of blossoming fruit trees; the fourth shows a single bird on bamboo branch. Seal and signature of the emperor; numerous other seals of Sung and later periods. Poems by Ch'ien-lung. Described in a colophon by Yü Sung, dated 1242, as a work by Hui-tsung of the highest class. See Loehr Dated Inscriptions p. 272; Siren CP III, 235-236. An exact modern copy of this scroll is in the Princeton Art Museum. Twelve other somewhat similar bird paintings form a scroll in the Fujii Yurinkan, Kyoto, which is likewise attributed to emperor Hui-tsung; see Yurintaikan I.

Hakone Museum. A bird on the branch of a fruit tree in bloom. Attributed. Imitation.

Nezu Museum, Tokyo. A small bird on a large pomegranate. Album leaf, colors on silk. Southern Sung work? See Toso 49, Nezu Cat. 1.

Ibid. Wagtail on garden rock. Signature and seal. Imitation. See Nezu Cat. I, 16.

Ibid. Small bird on loquat branch. Signature and seal. Sung work, by later artist? See Nezu Cat. I, 3.

Ibid. Two small birds on the branches of a shrub with large white flowers. Fan painting, colors on silk. Imperial seal. Copy of Southern Sung work? See Nezu Cat. I, 23; Toso 42.

Cheng Chi Collection, Tokyo. T'ang emperor Ming-huang teaching his son. Handscroll. Inscription; signed. Late copy of old composition, T'ang dynasty, according to the inscription. Another version, attributed to Liu Sung-nien, is in the Taipei Palace Museum (VA7d).

Chang Ta-ch'ien Cat., I, 78. *Hsiang-lung shih:* the Auspicious Dragon Rock. A strange-shaped rock with plants growing from the top. Short handscroll. Long inscription, signed. *Ssu-yin* half-seal.

Chugoku I, 53-67. Studies of small landscapes in the manner of various old masters. Seventeen album leaves mounted on a scroll. The inscription by the emperor on the last picture contains the dates 1105 and 1107. Late fabrications, of no value as evidence for early styles. Most of them also in

Ferguson. See also Loehr Dated Inscriptions p. 238.

* Sogen MGS I, 1. (Setsu Gatodo Coll., Tokyo; formerly Inoue Coll.). A dove on the branch of a blossoming peach tree. Seal and inscription of the emperor, dated 1107. Album leaf, colors on silk. Copy? See also Kokka 25; Bijutsu kenkyu 38; Sogen no kaiga 50; Siren CP III, 237; Toyo bijutsu 45; Loehr Dated Inscriptions pp. 238-239; Genshoku 29/25.

Ibid. I.2 (formerly Kuroda Coll.). A sparrow on the branch of a plum tree. Fan painting, colors on silk. Attributed. Southern Sung Academy. See also Hikkoen.

* Ibid. I.9 (Asano Coll.). A quail and flowering narcissus. Color on paper. Two painted seals of the emperor. Fine Sung work, probably unrelated to Hui-tsung. See also Kokka 386; Sogen no kaiga 49; Siren CP III, 238.

Ibid. II, 8 (formerly Murayama Coll., Osaka). Bird on gardenia branch. Album leaf. Signed. Imitation.

Toso 52 (Hayasaki Coll.). A shrike on a blossoming branch. Fan painting. Attributed.

Choshunkaku 43. Peonies and rock. Attributed. Yüan-Ming work.

Fujita Museum, Osaka. Sparrows and bamboo. Attributed.

Homma Sogen, 10. Bird on pomegranate branch, a seed in its beak. Album leaf. Attributed. Yüan work?

* Boston Museum of Fine Arts (33.364). A five-colored parakeet on the branch of a blossoming apricot tree. Handscroll, colors on silk. A poem and a colophon by the emperor; also seals of Hui-tsung and of the emperor Wen-tsung of Yüan, including Yüan palace seal T'ien-li chih-pao, used ca. 1330. Later Sung or early Yüan copy? See Kokka 472; Toso 48; Chao Chi I; Siren CP III, 238-239; BMFA Bulletin, Oct. 1933; Kodansha, BMFA, pl. 70.

* Ibid. (12.886). Ladies Preparing Newly Woven Silk. Handscroll, colors on silk. According to the inscription by the emperor Chang-tsung of Chin (d. 1209) it was copied by Hui-tsung after a picture by Chang Hsüan (c. 713-742). The picture is followed by colophons by Chang Shen (c. 1350-1400), Kao Shih-ch'i (1645-1704) and others. Fine Sung work, not by Hui-tsung? See Chao Chi 9-11; Li-tai jen-wu 21; Siren CP III, 105-106; Portfolio I, 46 and 52-55; T'ang-tai jen-wu 28-30; Skira 21; Bijutsu kenkyu 41; BMFA Bulletin, LIX, 1961; Kodansha, BMFA, pl. 71-2; Kodansha CA in West I, 42; Paine Figure Compositions of China and Japan, III, 1-4; Unearthing China's Past 119.

Ibid. (14.55). Bird on a flowering branch. Fan painting. Attributed. See Portfolio I, 138; Siren CP in Am. Colls. 83.

Metropolitan Museum, N. Y. Various works ascribed to him: 47.18.126 (White Falcon); 13.100.98, 13.100.107 and 13.100.113 (Birds on lichee branches, fan paintings); 13.220.89 (T'ang Hsüan-tsung Instructing his Heir Apparent); 47.18.82 (Children Playing, fan painting); 47.18.101 (Cranes and other birds with lotus and reeds).

* John Crawford Collection, N. Y. (Cat. 15). Two small finches on bamboo branches growing from a rock. Handscroll, ink and color on silk. Signature and seal of the emperor. Colophon by Chao Meng-fu. Sung Academy picture? See also Kokka 644; Chang Ta-ch'ien Cat. IV; TWSY

ming-chi 40; Skira 73; and scroll reproduction by Shurakusha.
Yu-cheng album, 1918. Copy of "Six Cranes" by Huang Ch'üan. Album
leaves, ink and color on silk. See Nanga taisei VI, 15-17; article by B.
Rowland in Artibus Asiae XVII (1954). pp. 131-133.

I YUAN-CHI　易元吉　t. Ch'ing-chih　慶之
From Ch'ang-sha, Hunan. Served as a teacher in the Confucian temple in his
native city. Summoned twice in the Chih-p'ing era (1064-1067) to the capital
where he executed some wall paintings in the palace. He died while occupied
in this work. Flowers, birds, and particularly monkeys. F, 4. G, 18. H, 3. I,
50. L, 61. M, p. 216.

Peking, Palace Museum. Monkey reaching for a spider. Fan painting. Attri-
　　buted. Southern Sung work? See Sung-hua shih-fu 6; Sung-jen hua-ts'e
　　A, 7; B. III, 2.
Ibid. Three gibbons on an old branch. Fan painting. Sung work. See Ch'ing
　　kung ts'ang 107; Sung-jen hua-ts'e A, 83.
* Taipei, Palace Museum (SH1). A monkey seated on the ground holding a kit-
　　ten to its bosom while another kitten watches. Fine *kung-pi* manner and
　　pale colors. Handscroll. Inscription by Hui-tsung; colophons by Chao
　　Meng-fu and Chang Hsi. Genuine? See Three Hundred M., 73; CAT 25;
　　CKLTMHC I, 30; KK ming-hua II, 27; NPM Quarterly I: 2, pl. 11a; Soga
　　I, 42.
Ibid. (VA15f). Gibbons and Deer. Fan painting. Attributed. Probably a pair
　　with the painting ascribed to Ma Shih-jung in the same collection
　　(VA11e); both appear to be careful Ming copies of Sung works. See NPM
　　Masterpieces II, 12.
Ibid. (VA12f). Three monkeys in a juniper tree. Fan painting. Yüan or later
　　work. See KK ming-hua I, 33; Soga I, 41.
Ibid. (VA26e). Bamboo and Rabbits. Album leaf. Signed. Late copy.
Ch'ing kung ts'ang 80 (Formerly Manchu Household Coll.). Monkeys snatch-
　　ing young herons from their nest. Fan painting. Attributed. See also
　　Siren CP III, 218.
* Yün-hui-chai. A monkey on a rock, reaching toward a tree; two deer.
　　Handscroll. Attributed. Fine early work.
Chang Ta-ch'ien Collection. A she-monkey with her baby in a tree; a deer with
　　two fawns below. Fan painting. Attributed.
Chin-k'uei II, 6 (Formerly J. D. Ch'en Coll., H. K.). Scowling monkey in an
　　old tree. Album leaf. Attributed.
T'ien-yin-tang II, 5 (Chang Pe-chin Col., Taipei). Three monkeys in an oak
　　tree. Fan painting. Attributed.
Bunjin Gasen II, 5 (Pao Tuan-ch'en Coll.). Small white-breasted birds gather-
　　ing in dry trees by a rock. Part of a handscroll? Signed. Ming-Ch'ing
　　work.
Osaka Municipal Museum (Formerly P'u Ju Coll.). Monkeys playing in trees
　　and on cliffs. Handscroll, ink on silk. Poem by Ch'ien-lung. Colophon
　　by Ch'ien Hsüan of the Yüan dynasty. Copy? See also Kokka 603; Siren

CP III, 217; Osaka Cat. 25; Soraikan II, 10; Bunjinga suihen II, 38.

Ibid. White goose on a riverbank. Hanging scroll, ink and color on silk. Attributed. See Osaka Cat. 24; Soraikan I, 12.

Freer Gallery (11.272). Two gibbons climbing in a tree. Inscribed with the painter's name. Ming work.

Metropolitan Museum, N. Y. Various paintings ascribed to him: 18.88 (Landscape with goats, handscroll); 13.100.36 (Birds and Flowers, handscroll); 13.220.100 (Album of paintings of various subjects); 13.100.104 (Monkeys attacking a nest of cranes, album leaf).

British Museum. Two gibbons playing in a loquat tree. Signed. Later work. See their *Quarterly* XXIV, 3-4, opp. p. 114.

Stockholm Museum of Far Eastern Antiquities. Two black gibbons in the branches of a tree. Inscribed with the painter's name. Seals of the Sung and Ming periods. Much later work. See Siren CP III, 219.

See also Sogen (large ed.) 16 for an old and fine painting of the kind commonly attributed to I Yüan-chi: a gibbon seated on a rock beside a bare tree. Album leaf. Sung work.

JIH-KUAN 日顴
See Wen. 溫

KAO HUAI-PAO 高懷寶
Possibly identical with Kao Yüan-heng 高元亨 . From Kaifeng. 10th-11th century.

Freer Gallery (16.48). Cabbage plant. Formerly attributed to Kao Huai-pao. Yüan work? See Siren CP in Am. Colls. 107.

KAO K'O-MING 高克明
From Chiang-chou, Shansi. Tai-chao in the Painting Academy from c. 1008 to 1053. Friend of Yen Wen-kuei. Landscapes and figures. D, 2. F, 4. G, 11. M, p. 331.

* Taipei, Palace Museum (VA19d). A hostel on a pine-covered knoll. Fan paint-ing. Attributed. Fine 12th century work; cf. Yen Tz'u-p'ing etc. See CKLTMHC II, 76; KK hsün-k'an 26; NPM Masterpieces II, 9; Soga I, 32.

Ibid. (VA30a). Snow on the Mountain Streams. Album leaf. Another ver-sion, post-Sung in date, of the composition of which other versions are ascribed to Hsiao Chao (C. C. Wang Coll.) and Hsia Kuei (Taipei, Palace Museum SV118). The last is oldest and best of the three.

Ibid. (VA5d). Autumn Grove and Water Birds. Fan painting. Attributed. Southern Sung or Yüan. See KK ming-hua II, 29; Yen Kuang Album 1927.

John Crawford Collection, N. Y. (Cat. 5). Streams and Hills under Fresh Snow: snow on hills along the river; buildings, bamboo groves and large

trees on the banks. Large handscroll, colors on silk. Signed and dated 1035. See also TWSY ming-chi 13-14; Skira 41; Loehr Dated Inscriptions p. 231.

KAO TAO 高燾 t. Kung-kuang 公廣 , h. San-yüeh Chü-shih 三樂居士
C. 12th century. From Mien-chou. Painted landscapes. H, 4. M, p. 331.

Cleveland Museum of Art (66.115). Birds in a grove in a mountainous winter landscape. Ink and colors on silk. Seal of the artist. See Archives XXI, 1967, p. 78. Another version of the same composition in the Freer Gallery (70.32); see Meyer cat. 28.

KAO-TSUNG 宋高宗
Emperor Kao-tsung of Sung. B. 1107, d. 1187. Son of the emperor Hui-tsung and the first emperor of the Southern Sung dynasty. Connoisseur of paintings. Figures, landscapes and flowers. J, 1. L, 1. M, p. 611.

Peking, Palace Museum. River landscape with fishing boat. Fan painting. Poem by the emperor. Academy work? See Sung-jen hua-ts'e A, 16; B.II, 8.
Taipei, Palace Museum (VA4a). Fisherman awaking in his boat. Album leaf. Poem. Seals of Liang Ch'ing-piao. Ming work. See KK ming-hua III, 1; NPM Masterpieces II, 16.

KAO WEN-CHIN 高文進
Son of Kao Ts'ung-yü 高從遇 . Specialist in Buddhist and Taoist painting; followed Wu Tao-tzu and Ts'ao Chung-ta. Came to Kaifeng from Szechwan in 965. Tai-chao in the Han-lin Academy under T'ai-tsung (976-997). D, 1. F, 3. H, 3. M, p. 330; see also Gregory Henderson and Leon Hurvitz, "The Buddha of Seiryoji: New Finds and New Theory", *Artibus Asiae,* XIX/1 (1956), 5:55; and Max Loehr, "Chinese Paintings with Sung Dated Inscriptions," p. 230.

Taipei, Palace Museum (SV236). Thousand-armed Kuan-yin. Signed. Later work.
Seiryoji, Kyoto. Maitreya. Woodblock print made by the monk Chih-li 知禮 after Kao's design. Dated 984. See Henderson-Hurvitz article listed above.

KOU-LUNG SHUANG 勾龍爽
From Szechwan. Chih-hou in the Painting Academy during the reign of the emperor Shen-tsung (1068-1085). Figures. D, 1. F, 3. G, 4. M, p. 66.

Taipei, Palace Museum (SV45). River landscape with sailing boats. Inscription purportedly by Su Che, younger brother of Su Tung-p'o, in which the

picture is ascribed to the painter. Late, minor work.

Chung-kuo I, 11 (Formerly Ti Pao-hsien Coll.). An emperor with his two consorts in a garden receiving a supplicant. Signed. Copy of earlier composition. See also Chung-kuo MHC 32.

KUNG SU-JAN　宮素然

Unrecorded in biographies of painters, but according to the Abe catalog, a Taoist nun from Chen-yang, Kueichou. Active at the beginning of the 12th century.

* Osaka Municipal Museum (Abe Coll.). Chao-chün on her way to Mongolia under the escort of Mongol horsemen. Handscroll, ink on paper. Signed. Seal of an imperial commissioner of the emperor Kao-tsung of Sung. Probably a copy of the Chin dynasty version in the Chi-lin Museum, by an artist surnamed Chang; see Wen-wu 1964.3. See also Soraikan I, 14; Sogen 18; Li-tai jen-wu 22; Osaka Cat. 44; Sogen no kaiga 17; Suiboku IV, 63-65; NPM Quarterly XI/1, pl. 3.

KUO HSI　郭熙　t. Shun-fu　淳夫

From Wen-hsien in Hoyang (Honan). B. ca. 1001, d. ca. 1090. Served as i-hsüeh in the Painting Academy. Landscapes, followed Li Ch'eng. Author of the *Lin-ch'üan kao-chih chi*　林泉高致集
. F, 4. G, 11. H, 3. M, p. 397; also Chang An-chih, *Kuo Hsi* (Shanghai, 1959, 1963 in CKHCTS/series Kuo Hsi).

Peking, Palace Museum. Eroded Rocks on a Plain: a broad river view with rocks and twisted trees. Large horizontal painting. Signed, dated 1078. Yüan or later work. See Chung-kuo hua XIV, 10-11; CK ku-tai 34; Kuo Hsi 4; Wen-wu ching-hua III, 14; Loehr Dated Inscriptions p. 233; Kokyu hakubutsuin, 162; I-yüan to-ying, 1979 no. 1, p. 11.

Ibid. Snowy hills; people approaching a pass. Signed. Exhibited Fall 1977 as "Anonymous Yüan"; more likely early Ming in date.

* Shanghai Museum. Yu-ku-t'u: snowy river gorge. Attributed. *Ssu-yin* half-seal. Yüan work? Or later Sung? Incomplete? See Chung-kuo hua XI, 13; Kuo Hsi 2-3; Shang-hai 2; TSYMC hua-hsüan 5; Wen-wu ching-hua III, 13.

Ibid. *Ku-mu yao-shan t'u:* a view over a river valley; a man in a house in the foreground. Good painting of Yüan date, close to T'ang Ti in style. See Kuo Hsi 14; Wen-wu ching-hua III, 11.

Liaoning Museum. Travellers among Streams and Mountains. Fan painting. Attributed. See under Anonymous Sung, Landscapes, Album Leaves.

Wen-wu ching-hua III, 12. A mountain village. Attributed. Excellent imitation of later (Yüan?) date.

Sung Kuo Hsi Ch'i-shan hsing-lü t'u (Peking: Jung-pao chai reproduction, 1956). Travellers among streams and mountains. Fan painting. Attributed.

Sung-jen hua-ts'e, A, 43. Junks sailing in spring. Fan painting. Attributed. Southern Sung?

* Taipei, Palace Museum (SV25). *Tsao-ch'un t'u:* Early Spring. Bare and leafy trees on eroded mountains; fishermen on the shore, travellers on paths, Buddhist temples above. Signed, dated 1072. Seal of the emperor Chang-tsung of the Chin dynasty. *Ssu-yin* half-seal. Genuine work. See Three Hundred M., 76; CAT 20; CCAT pl. 96; CKLTMHC I, 21; KK ming-hua I, 35; Kuo Hsi 1; NPM Quarterly I, 2, pl. XXI, XXIIIa, also XI/4, pl. 4, 20, 24; Wen-wu 1955.6, 14; Ku-kung 10; Nanking Exh. Cat. 25; KK chou-k'an 95; Siren CP III, 175; Skira 36; Loehr Dated Inscriptions p. 232; Summer mts., 25-27; Bunjinga suihen II, 30; Hills, 92. See also Chiang Chao-shen's article in NPM Quarterly XI/4.

* Ibid. (SV26). Twisted old cedar trees; snowy mountains in the distance. Fine work, late Sung or early Yüan in date. See KK shu-hua chi 21; CH mei-shu I; CKLTSHH; KK ming-hua II, 31; Wen-wu chi-ch'eng 27; KK chou-k'an 290; Siren CP III, 174.

Ibid. (SV27). Village in a mountain valley; travellers on the roads, fishermen in a boat. Signed. 16th century? Che School work. See Ku-kung 6; London Exh. Chinese Cat. p. 51; Three Hundred M., 77; KK ming-hua I, 36; Kuo Hsi 11; KK chou-k'an 57; Siren CP III, 176.

Ibid. (SV28). Mountain path in snow. Signed: painted on the order of the emperor in 1072. Yüan work? See KK shu-hua chi 18; London Exh. Chinese Cat. p. 49; Three Hundred M., 78; CH mei-shu I; CKLTMHC I, 22; KK ming-hua II, 32; Kuo Hsi 13; Wen-wu chi-ch'eng 26; KK chou-k'an 235; Loehr Dated Inscriptions p. 232-233; NPM Masterpieces I, 6.

Ibid. (SV29). A bay with rocky shores in autumn; old trees and travellers on the shores. Inscribed with the painter's name. Poor Ming work. See KK shu-hua chi 27; Kuo Hsi 12; KK chou-k'an 404.

Ibid. (SV30). Travellers in snowy mountains. Attributed. Bizarre work of the 16th century.

Ibid. (SV31). Propitious Snow on New Year's Day. Attributed. Ming work, 15th-16th century.

Ibid. (SV32). Fantastic hollow mountains and tortuous trees by a stream. Attributed. Fine "rococo" work of late Ming period. See KK shu-hua chi 30.

Ibid. (SV33). River landscape with mountains in snow. Horizontal composition. Ming work, 16th century, cf. Chu Tuan. See KK shu-hua 39.

Ibid. (SV34). River landscape in snow. Attributed. Ming work, perhaps by Chu Tuan.

Ibid. (SV35). A steep cliff, temple buildings and willows in mist by a bay. Signed. Poor Ming work. See KK shu-hua chi 26; London Exh. Chinese Cat. p. 50; Three Hundred M., 79; KK chou-k'an 353.

Ibid. (SV36). Landscape. Signed. Ming work, Che School.

Ibid. (SV37). Reading the Stele. Two men in a bleak landscape with servants and horses. Based loosely on the same compostition as "Li Ch'eng" in the Osaka Municipal Museum (Abe Coll.), q.v. Late imitation.

Ch'ing kung ts'ang 110 (Formerly Manchu Household Coll.). Pavilions under snowy trees on a river shore. Album leaf. Attributed.

Fujii Yurinkan, Kyoto. Mountain Landscape: travellers in a rest house by a bridge. Handscroll. Signed. Colophons by Ho Ching-ming, dated 1517, and by Chang Yeh, 18th century. Ch'ing work.

Nanshu ihatsu II. Crows in bare trees by a stream. Short handscroll. Painter's name added. Imitation.

Toso 34 (Kuo Tsung-hsi Coll.). High mountains and waterfall; boat on the stream below the bridge. Interesting late Ming picture.

Ibid. 35 (Hsü Shih-ch'ang Coll.). Old cedar trees on cliffs. Yüan or later work.

Chicago Art Institute (55.17). Landscape with temple and houses. A seal reading Lan-an chü-shih may be the artist's; he has not been identified. See Hokuga Shinden; Yüan Exhib. Cat. 216; Pageant 68.

* Freer Gallery (16.538). Clearing Autumn Skies over Mountains and Valleys. Handscroll, ink and light colors on silk. Attributed. Southern Sung work? Chin? See Kokka 250; Kuo Hsi 5-10; Kodansha CA in West, I, 4; Kodansha Freer Cat. 38; TWSY ming-chi 15-20; Skira 37; Siren CP III, 172-173; Bunjinga suihen II, 33; Summer Mts., 28-29; also article by Archibald Wenley in Archives, X, 956, pp. 30-41.

Ibid. (11.230). Landscape with strolling scholar. Handscroll, ink and light colors on silk. Spurious signature and the date 1079. Fine work of 15th-16th century, by follower of the Ma-Hsia tradition.

Metropolitan Museum, N. Y. Various paintings ascribed to him: 13.100.27 and 13.220.96 (two landscape handscrolls); also 47.18.3 for which see Priest article in their *Bulletin* March 1950, p. 199, and *Streams and Mountains Without End,* pl. xiii. The anonymous handscroll in the Cleveland Museum, subject of this volume, is another version of the same composition.

Toledo Museum of Art. River scenery with bare trees and craggy mountains in snow. Long handscroll, ink on silk. Yüan or Ming period. See London Exh. Cat. 1139; Bachhofer 99; Cohn Chinese Painting pl. 51; Suiboku II, 64-67; Bunjinga suihen II, 34.

* John Crawford Collection (Cat. 7). Lowlands with Trees. View over a river valley with bare trees; a pavilion on a hillock; two men approaching. Short handscroll, ink on silk. Attributed. Nine colophons by Chao Meng-fu, Yü Chi, K'o Chiu-ssu, Liu Kuan, and others. Late Sung work? See also Chang Ta-chien Cat. IV; Munich Exh. Cat. 9; Barnhart Wintry Forests cat. 3; Bunjinga suihen II, 31.

Ming-pi chi-sheng IV (Juncunc Coll., Chicago). Travellers in autumn mountains. Inscribed with the painter's name and perhaps after his design, but much later in date.

J. T. Tai Collection, N. Y. (formerly City Art Museum, St. Louis). Mountain Landscape After Snow. Attributed. Ming? For other versions, see under Anonymous Sung: also Loehr article in Arts Orientalis 9, where the painting is reproduced (fig.5) and the composition associated with the early period of Kuo Hsi.

KUO SSU　郭思　t. Te-chih　得之、
Son of Kuo Hsi. Became a chin-shih in 1082; entered the Academy of Painting c. 1100. Died after 1123. Painted horses in imitation of Han Kan. Edited his father's treatise on landscape painting. G, 11 (under Kuo Hsi). I, 51. L, 60. M, p. 397.

Taipei, Palace Museum (SV54). A boy in princely costume with a goat under a plum tree. Signed. Ming Academy picture; meaningless attribution. See KK shu-hua 42.

LI AN-CHUNG　李安忠
From Ch'ien-t'ang in Chekiang, Chih-hou in the Academy of Painting in Hangchou. According to *Hua-chi pu-i* active at the same time as Li Ti, i.e. second half of the twelfth century. (The information that he was already active in the Academy in Kaifeng is probably mistaken.) Flowers and birds, particularly quails. H, 4. J, 2. M, p. 194. Also biography by J. Cahill in Sung Biog. 76-78, where, however, the earlier dating for his activity is still accepted, probably wrongly.

Peking, Palace Museum. Butterflies. Fan painting. Attributed. See Sung-jen hua-ts'e A, 21; B.VI, 4; Sung-tai hua-niao.
Taipei, Palace Museum (VA1j). Two quails beside chrysanthemums and thorny shrubs. Album leaf, colors on silk. Copy. See NPM Masterpieces V, 13.
Ibid. (VA17x). Mallow. Fan painting. Signed. Copy. The picture is catalogued as by Li Tung, but the signature clearly reads "Li An-chung." See KK chou-k'an 12.
Ibid. (VA23h). Finches eating grain. Fan painting. Signed. Copy.
Ibid. (VA17p). Two quails and flowering autumn plants. Fan painting. Copy. See KK chou-k'an I, 9; NPM Masterpieces II, 19.
Ibid. (VA29c). Shrike on a branch. Fan painting. Close copy. See CAT 34; KK ming-hua III, 8; KK chou-k'an 130.
Ch'ing-kung ts'ang 44 (Formerly Manchu Household Coll.). Four sparrows picking grains on the stalks of a plant. Fan painting. Copy.
Garland I, 29. Four flying partridges. Signed.
Chung-kuo MHC 13. Two quail among chrysanthemums, one eating an insect. Good Sung-Yüan painting of the kind usually ascribed to him.
* Nezu Museum, Tokyo. A quail standing by a bush. Fan painting. Attributed. Fine Sung work, perhaps by Li An-chung. See Sogen meigashu 4 and 18; Toso 68; Nezu Cat. 4; London Exh. Cat. 970; Sogen no kaiga 52; Kokka 688; Genshoku 29/29.
Kokka 54 (Prince Konoye Coll.). Four quails by a stream. Horizontal album leaf? Attributed.
Ibid. 296 (Formerly Inoue, later Moriya Coll.). Two quails with their young. Seal of the painter, interpolated. Late Sung work? See also Bijutsu kenkyu 146. The same? Setsu Gatodo, Tokyo (1979).

Speiser et. al. Chinese Art, vol. III, pl. 40 (former Yamamoto, Tokyo). Three
quails. Attributed. Anachronistic seal of the Yüan-feng era (1078-1085).
See also Sogen MGS III, 15.

Hikkoen 3 (Formerly Kuroda Coll.). Two quails and plants. Attributed. Yüan
work.

* Sogen meigashu 17 (Magoshi Coll.). A quail pecking on the ground. Fan
painting. Attributed. Very similar to the painting in the Nezu Museum;
same hand?

Heizando, Tokyo (1973). Two Quail. Fan-shaped album leaf, ink and colors
on silk. Good Ming copy of Sung painting.

Yabumoto Kozo, Amagasaki. A quail. Album leaf. Attributed. Good early
work.

* Cleveland Museum of Art (63.588). A cottage under trees on a low river
shore. Style of Chao Ling-jang. Album leaf, ink and light color on silk.
Inscription, signed, with the date 1177. Genuine work. See Siren CP III,
228; China Institute Album Leaves #4, p. 32; Lee Landscape Painting 19;
Munich Exh. Cat. 13; Lee *Scattered Pearls Beyond the Ocean* 1; Loehr
Dated Inscriptions p. 243.

Metropolitan Museum (47.18.148). Two sparrows on stalks of millet. Fan
painting. Copy.

* Seattle Art Museum. An eagle chasing a pheasant. Album leaf, color on silk.
Signed and dated 1189. Genuine. See Kokka 36; Siren CP III, 229;
Loehr Dated Inscriptions p. 247.

Princeton Art Museum (68.210). Branch of Jasmine. Fan-shaped album leaf,
ink and colors on silk.

British Museum (Eumorfopolous Coll.). Dog and hawks pursuing a hare.
Album leaf. Attributed. See London Exh. Cat. 948.

LI CHAO-CH'ING 厲昭慶
Active c. 961-975. From Chien-kang, Kiangsu. Served as a Han-lin tai-chao
under the Southern T'ang Dynasty; later entered the Sung Academy of Paint-
ing. Painted Buddhist figures, specialized in representations of Kuan-yin. F,
III, p. 42; H, III, p. 61; M, p. 626.

Taipei, Palace Museum (VA28a). Searching for the Fungus of Immortality: a
Taoist Immortal accompanied by a lion and a monkey walking beside a
waterfall. Album leaf. Ming work.

LI CHI 李吉
From Kaifeng. Active in the Northern Sung period; served as i-hsüeh in the
Academy of Painting. Flowers and birds; followed Huang Ch'üan. F, 4. H, 3.
M, p. 190.

Former National Museum, Peking. Peaches, lichee, apricots, melon, beans and
eggplants. Handscroll. Signed. Colophon by T'ao Tsung-i, dated 1350.
Seals of the emperor Kao-tsung of Sung and later. Late copy.

LI CHIH 李植　t. Hua-kuang　化光
From Kaifeng. Active during the first half of the 11th century. Landscapes, flowers. H, 3. I, 50. L, 42. M, p. 191.

Freer Gallery of Art (54.126, formerly Count Date Coll.). A bird on the branch of an apricot tree. Album leaf. Seal of the painter. The picture has also been ascribed to Wang Yüan of the Yüan period, which is probably the real date. See Shimbi 17; Cahill Album Leaves I.

LI CHUNG-HSÜAN 李仲宣　　t. Hsiang-hsien　象賢
From Kaifeng. Active probably at the end of the 11th century. A eunuch attached as *kung-feng* to the Palace service. Flowers and birds. G, 19. H, 3. M, p. 192.

Ch'ing-kung ts'ang 48 (Formerly Manchu Household Coll.). Flowering plants and butterflies. Fan painting. Signed.

LI CHUNG-LÜEH 李仲略　　t. Chien-chih　簡之
From Kao-p'ing in Shansi Province, Chin-shih in 1179, d. 1206. Official under the Chin; follower of Mi Fu and Mi Yu-jen in landscape painting. H, IV, 40.

John Yeon Collection (kept at the Nelson Gallery, Kansas City). Misty river landscape. Horizontal hanging scroll, ink on paper. Signed, seal of the artist. Very amateurish work, difficult to accept as of the period.

LI CH'ÜAN 李權
From Ch'ien-t'ang, Chekiang. Served as chih-hou in the Painting Academy in Hangchou during the Hsien-ch'un era (1265-1274). Figures and landscapes, followed Liang K'ai. H, 4. J, 8. M, p. 195.

Chung-kuo I, 60 (Ti P'ing-tzu Coll.). Bare trees on cliffs by a waterfall. Ch'ing work of Nanking school? See also Chung-kuo MHC 28.

LI CH'ÜEH 李確
Middle of the 13th century. Member of the Sung Academy. Recorded as a pupil of Liang K'ai in *T'u-hui pao-chien*. H, 4. M, p. 195.

* Myoshin-ji, Kyoto. Feng-kan and Pu-tai. Two hanging scrolls. Signed. Poems by the monk Kuang-wen (1189-1236). These two pictures are combined with a third picture, representing Bodhidharma, into a triptych, but the last named picture is not the work of Li Ch'üeh; it is attributed to Men Wu-kuan. See Sogen no kaiga 26-27; Toyo bijutsu 59 (Pu-tai); Siren CP III, 351 (Feng-kan); Bijutsu kenkyu 15; Boston Zen Catalog, 15; Suiboku IV, 45-46; Sogen MGS III, 34-36.

LI KUNG-LIN 李公麟 t. Po-shih 伯時 , h. Lung-mien chü-shih 龍眠居士
From Shu-ch'eng, Anhui. B. c. 1049, d. 1106. The most famous figure painter
of the Sung period; also highly esteemed as a painter of horses and landscapes.
G, 7. H, 3. I, 50. L, 42. M, p. 190; also Chou Wu, *Li Kung-lin* (Shanghai:
1959, 1961 in CKHCTS series), (Li Kung-lin); biographies by James Cahill
(EWA IX, 248-251) and Hsio-yen Shih (Sung Biog. 78); and an unpublished
dissertation by Richard Barnhart.

* Peking, Palace Museum. Pasturing Horses: a herd of horses driven by grooms
 (1,286 horses, 143 men!). Long handscroll, colors on silk. According to
 the inscription, executed by Li Kung-lin on imperial order, after a picture
 by Wei Yen of the T'ang. Fine work, as attributed. See Li Kung-lin 15-
 16; Wen-wu 1961.6, 2; Siren CP III, 193; Kokyu hakubutsuin, 163.
 Ibid. Barbarian Kings Worshipping the Buddha. Handscroll, ink on paper in
 the pai-mao manner. Later work. Detail in *Chung-kuo ku-tai shih ta-hua-
 chia,* Hong Kong, 1962.
 Ibid. Wei Mo-ch'i (Vimalakirti) in conversation with Wen Shu (Manjusri).
 They are both accompanied by a number of kneeling attendants and guar-
 dians. Large handscroll, in pai-miao technique. Probably of the Ming
 period.
* Liaoning Museum. Four Old Recluses of Mt. Shang; Nine Old Men of Hui-
 ch'ang. Two paintings mounted together in a handscroll. Attributed.
 Seals of Ch'ien Shih-hung (Ming) and Mei Ch'ing (early Ch'ing). 13th
 century? by same hand as Freer Gallery *Realms of Immortals* (see below)?
 See Liaoning Cat. 67-70, 71-74.
 Shanghai Museum. *Lien-she t'u:* The Lotus Society Meeting. Handscroll.
 Later imitation or copy. See Li-tai jen-wu 18. For another version of the
 subject in the Liaoning Museum, formerly ascribed to Li Kung-lin, see
 under Chang Chi.
 Nanking Museum (Cat. 6). The Lotus Society Meeting. Attributed. Late
 Ming pastiche?
 Han Kan-Tai Sung (see under Han Kan) 6. *Shih-tzu ts'ung:* The Lion Piebald.
 Horse and rider. Handscroll. Inscription by Li Kung-lin, in which he says
 the painting is copied after a work of Han Kan. Signed, dated 1090.
 Li Kung-lin 14. The Three Tasters of Vinegar: Su Tung-p'o and two friends
 standing around a rock beneath a tree. Attributed. Later work.
* Taipei, Palace Museum (SH3). *Shan-chuang t'u* (properly *Lung-mien shan-
 chuang t'u):* Dwelling in the Lung-mien Mountains. Handscroll, ink on
 paper. Colophons by Yün-wu (1304), Liu Kuan (1337), and Tung Ch'i-
 ch'ang. Late Sung or Yüan copy, heavily repainted? See Siren CP III,
 195; CH mei-shu 1. Another version in the former Berenson collecton,
 Settignano, colors on silk, containing only ten of the original sixteen
 scenes. Colophon by Wang Hsing-chien dated 1453. See Siren CP II,
 opp. p. 44; Bunjinga suihen II, 61-63. A similar but reportedly better ver-
 sion, mentioned by Ch'ien-lung in his colophon on the above, is in the
 Peking Palace Museum; cf. Wen-wu, 1961.6, p. 39 (not reproduced).
 Seals of the artist; colophons by Wang Ao and Tung Ch'i-ch'ang. Still
 another version, colors on silk, published in album form by Otsuka

Kogeisha, Tokyo, 1937, with explanatory essay by Harada Bizan. Late, crude copy.

Ibid. (SH4). Kuo Tzu-i Receiving the Homage of the Uighurs. Handscroll, ink on paper. Signed. Colophon by Han Chun dated 1367. 14th-15th century work? See KK chou k'an 481-485; Three Hundred M., 85; CAT 29; CKLTMHC I, 33; Li Kung-lin 4-7; NPM Masterpieces III, 13.

Ibid. (SH5). Lady Kuo-kuo and her sister setting forth on an outing. Handscroll. Copy of a work ascribed to Chang Hsüan of the T'ang dynasty. See CCAT pl. 97; KK ming-hua II, 36; Skira 20.

Ibid. (chien-mu SH133). The Elegant Gathering in the Western Garden: Su Shih, Mi Fu and others meeting at the villa of Wang Shen. Handscroll, ink on paper. Fine 13th-14th century painting. Catalogued as "Anonymous Sung"; but the same composition is ascribed to Li Kung-lin in a handscroll owned by C. C. Wang, New York. Other versions of the composition in the Taipei Palace Museum (chien-mu SH56 and SH 133), in the Freer Gallery (11.523); and other collections. See the study by Ellen Laing in the *Journal of the American Oriental Society* LXXXCIII, no. 3, July-Sept. 1968.

Ibid. (chien-mu SH55). *Kuei-ch'ü-lai t'u:* Illustrations to T'ao Ch'ien's "Homecoming" Ode. Handscroll. Attributed. Good late Sung or Yüan work in Li Kung-lin tradition. Cf. the scroll in the Freer Gallery listed below.

Ibid. (chien-mu SH57). Illustrations to the Classic of Filial Piety. Handscroll. Attributed in an inscription dated 1085. 15th century? Copy of the Princeton painting listed below. See Loehr Dated Inscriptions p. 235.

Ibid. (chien-mu SH59). *Pai-fo lai-ch'ao t'u:* procession of warriors, arhats, etc. Handscroll. 16th century? copy of late Sung? work.

Ibid. (chien-mu SH137). Illustrations to the Chiu Ko, Nine Songs, of Ch'u Yüan. Handscroll. Ming period copies of the designs sometimes associated with Chao Meng-fu; cf. also the depictions of this subject by Chang Wu of the Yüan period. Other versions exist, all attributed to Li Kung-lin, as follows:

1. Palace Museum album 1934 (not the same as above). Long handscroll, ink on paper. Signed. The text copied on the painting by Ch'ien-lung; colophon by Mi Fu dated 1077; seals of the Emperor Hui-tsung, Chia Ssu-tao, and other collectors. At the end of the scroll is a portrait of Ch'u Yüan by Chang Jo-ai (18th century). Copy of late Sung or Yüan date? See Cheng Chen-to, *Ch'u-tz'u t'u* (Peking, 1963), pl. 5-14; also KK chou-k'an 357-377; Siren CP III, 298; Loehr Dated Inscriptions p. 233. This scroll is not presently in the Taipei Palace Museum.

2. Wen-ming Album 1940 (formerly Yamamoto Teijiro, presently Eda Bungado Coll., Tokyo). Handscroll, ink on paper. Colophon by Chao Yung, dated 1315. Yüan period? See Li Kung-lin 1-3.

3. Fujita Museum, Osaka. Handscroll in the pai-miao manner. Signed. Ming colophons. Yüan painting? See Bunjinga suihen II, 65.

4. Metropolitan Museum, N. Y. (47.18.120). Copy.

5. Wen-wu 1964.3, 7. Detail from another handscroll of the type, apparently pai-miao on paper. "Spurious signature of Li Kung-lin" according to the caption.

KK shu-hua 23 (SV249). A gentleman playing the ch'in to his friends on a gar den terrace. Inscribed with the painter' name. Yüan-Ming copy of older composition.

* Former National Museum Peking. *Chi-jang t'u:* Beating the Ground; peasants dancing and frolicking. Handscroll, ink on paper. Colophon by Chang I-chieh dated 1265. Seals of the Shao-hsing period (1094-1097) and later. Old, good work in this style. See Siren CP III, 194; Loehr Dated Inscriptions p. 275-276.

Ch'ing-kung ts'ang 27 (formerly Manchu Household Coll.). An old man seated on the ground striking a musical stone. Album leaf. Signed. Ming work, 16th century? (cf. Wang Wen). Another version, with the addition of a garden setting, in the Taipei Palace Museum (VA27a).

Ibid. 103 (formerly Manchu Household Coll.). The Morning Audience at Ta-ming kung. Palace courts with figures. Fan painting. Possibly a late Sung picture.

Former J. D. Ch'en, Hong Kong. A Taoist Immortal and his two attendants. Fragment of a handscroll? Attributed. Good middle Ming work.

Academy of Art, Tokyo. Two pictures of Arhats, each with an accompanying figure. Attributed. Late Sung, unrelated to Li Kung-lin. See Toyo VIII, p. 23-24; Kokka 30, 41; Toso 41-42. Another from the same set, former Okazaki Coll., in the Tokyo National Museum.

Fujita Museum, Osaka. *Shih-kao hui-men t'u:* Shih-kao's Gathering of the Tribes (?). Landscape with many horsemen and other figures. Handscroll, ink on paper. Liang Ch'ing-piao, Ch'ien-lung and other seals. Close copy of Sung work? See Bunjinga suihen II, 66.

Tofuku-ji, Kyoto. Vimalakirti seated on an elegant platform. Sung work, probably unrelated to Li Kung-lin. See Sogen no kaiga 8.

* Kokka 380 (formerly Manchu Household Coll., and later Kikuchi and Yamamoto Teijiro Coll., Tokyo). Five Tribute Horses; each led by a Western Asian groom. Handscroll. Colophons by Huang T'ing-chien, dated 1090, and by Tseng Yü, date 1131. Poems and seals of Ch'ien-lung. Said to have perished in a fire during the last war, but now believed to be still extant. Genuine work at least in part. See CK ku-tai 38; Li Kung-lin 9-13; Siren CP III, 191-192; Hills, 88. Copy in the John Herron Art Institute, Indianapolis (35.26); see their *Bulletin,* December 1935.

Ibid. 536. The God of Long Life. Attributed. A Southern Sung picture?

Toyo VIII, p. 22 (Count S. Tokugawa Coll.). Pu-tai falling asleep. Attributed. Japanese painting? See also Shimbi XIII.

Toan 6 (Formerly Saito Coll.). *Ling-shan shen-hui t'u:* A Sacred Gathering in the Spirit Mountains. Landscape with monks on roads, in temples, seated in caves, etc. Long handscroll. Two colophons by monks. Seals of the Yüan period. Good work of early 16th century? (cf. Chou Ch'en, T'ang Yin). Based on older composition?

Choshunkaku 34-35. Seated Sakyamuni; Sakyamuni Descending from the Mountains. Both paintings arbitrarily attributed to Li Kung-lin; both Yüan-Ming in date.

Freer Gallery (11.201). *Lien-she t'u:* The Lotus Club. Later imitation, with mounting and colophons transferred from an earlier version. Perhaps the work of Yu Ch'iu of the Ming period, much retouched.

Ibid. (11.187). The Lan-t'ing Gathering. Handscroll. Interesting late Ming picture.

Ibid. (11.245). The Lan-t'ing Gathering. Probably by Yu Ch'iu of the Ming period: cf. the version of the same subject by that master in the Stockholm Museum.

Ibid. (11.521). The Lan-t'ing Gathering. Handscroll, ink on silk. Interesting work of late Ming, ascribed in a colophon to Ting Yün-p'eng, but probably not by him.

* Ibid. (16.539). *Shu-ch'uan t'u:* panorama of the upper Yangtze River. Long handscroll, ink on paper. Colophons by Tung Ch'i-chang, Kao Shih-ch'i and Ch'ien-lung. Formerly in Tuan Fang Collection. Late Sung work, by minor master, unrelated to Li Kung-lin. See Kokka 273; Yu-cheng album, 1920; Bunjinga suihen II, 60, 69. Note that the anonymous 12th century "Dream Journey in the Hsiao-Hsiang Region," Tokyo National Museum, was once ascribed to Li Kung-lin.

* Ibid. (18.13). Realms of the Immortals. Deities and fairies in an imaginary landscape. Long handscroll, ink on paper. Fine 13th century work. See Siren CP III, 196-197; Freer Figure Ptg. cat. 34. Cf. the two anonymous handscrolls in the Liaoning Museum (Liaoning Cat. 67-70, 71-74), very similar in style, perhaps by the same hand.

Ibid. (19.119). Illustrations to T'ao Yüan-ming's *Kuei-ch'ü-lai tz'u.* Two consecutive handscrolls, ink and colors on silk. Attributed. Colophon by Li P'eng dated 1110, perhaps genuine but not originally attached to the scroll. Late Sung or Yüan. See Siren CP in Am. Colls., 50-52; Loehr Dated Inscriptions pp. 240-241; Freer Figure Ptg. cat. 4. An early Ming copy of a portion of the composition in the same collection (V68.78).

Ibid. (19.123). The Cassia Hall and Epidendrum Palace: pavilions and galleries along garden courts and canals. Handscroll, ink on paper. Ming period. See Siren CP III, 201; Siren CP in Am. Colls., 32-33.

Ibid. (57.15). Three Worthies of Wu-chung. Handscroll. Inscriptions by Yün-wang, a son of the emperor Hui-tsung. Attributed. Modern fabrication.

Ibid. (68.18, formerly Mrs. Agnes E. Meyer, Washington and P'ang Yüan-chi Colls.). The Drunken Priest: a priest seated on a stone under a pine tree writing on a scroll. Two servants are bringing pots of wine. Handscroll, ink and slight color on paper, inscribed with the painter's signature. Three poems by Ch'ien-lung and numerous seals of Ming and Ch'ing collectors. Copy. See Chung-kuo MHC 20; Meyer Cat. 30.

Ibid. (68.19). *A-lo hsien-hsiang.* Buddhist deities. Handscroll, in gold drawing on blue paper. Attributed. Fine work of early Ming? Unrelated to Li Kung-lin.

Ibid. (68.205). Tribute Bearers. Album of 8 leaves, ink on silk.

Ibid. (70.37, formerly Mrs. Agnes E. Meyer, Washington). Stories of Ancient Emperors, Princes and Worthies. Handscroll, ink on silk. Passages of text accompany the pictures. Ming copy of Li Kung-lin composition? See Freer Figure Ptg. cat. 5; Meyer Cat. no. 29.

Metropolitan Museum, N. Y. Various paintings ascribed to him: 13.220.130 (Album of arhats); 13.220.24 (Arhats); 18.1242 (Sages at Rest and Play); 18.25.1 (Taoists Crossing the Sea); 13.100.108 (The Lan-t'ing Gathering, fan painting); etc.

* Princeton Art Museum (L.28.65). Illustrations to the Hsiao-ching (Classic of Filial Piety). Handscroll, ink on silk. Signed; the calligraphy also by Li Kung-lin. Probably genuine. A complete study of the scroll has been written by Richard Barnhart, but is unpublished. See Kodansha CA in West I, 40- 41; Suiboku IV, 1, 31-34; Bunjinga suihen II, 67. A copy in the Taipei Palace Museum (SH57).

* John Crawford Collecton, N. Y. (Cat. 36). Illustrations to the Odes of Pin in the Shih-ching. Handscroll, ink on paper. Attributed. Good 13th century work. See Smith and Weng, 186-87.

Ferguson, Chinese Painting p. 110. Five hundred Arhats. Handscroll, ink on paper. Inscription signed and dated 1083. Ming-Ch'ing work. See also Loehr Dated Inscriptions p. 234.

* Toyo VIII, pl. 25 (formerly Kuroda Coll., now V. Hauge Coll., Washington). Vimalakirti seated on a platform attended by a servant girl. Attributed. Good Sung work, unrelated to Li Kung-lin. See also Toso 40; KK-c tzu-liao (see under Ku K'ai-chih) 31; Li Kung-lin 8; Li-tai jen-wu 17; Siren CP III, 199; Sogen no kaiga 9; Buddhist and Taoist Figures, 5; Suiboku IV, 12; Sogen MGS III, 41.

Li-ch'ao pao-hui, 5 (Alice Boney, New York). Immortal with deer. Large album leaf. Signed. Seal of Wu Wei of the Ming period; probably his work.

Indiana University Art Museum. The Washing of the Elephant. Attributed.

National Gallery of Canada, Ottawa. Three figures, from a set of seven immortals. Handscroll. Attributed. See Toronto Cat. 4.

British Museum. *Hua-yen lieh-hsiang t'u:* metamorphoses of various beings according to the Hua-yen Sutra. Handscroll in the pai-miao manner on paper. Yüan? See Basil Gray, "A Great Taoist Painting" in *Oriental Art* XI, no. 2, 1965, pp. 86-91; Sickman and Soper, pl. 96.

Musée Guimet, Paris. Buddha imprisoning the son of Hariti. Handscroll. Signed, dated 1081. Copy of old work. See La Pittura Cinese, 148.

London Exh. Cat. 813 (Formerly Sir Percival David Coll.). A Taoist deity riding on a unicorn. Attributed.

Ibid. 1036 (Stoclet Coll., Brussels). An Arhat in a forest with two deer. Album leaf. Copy of a section of the Sung handscroll, now in the Freer Gallery, with a signature of Fan-lung, q.v.

Formerly Dr. Karl Bone, Düsseldorf. Long handscroll representing Arhats and other Buddhist figures, demons, etc. in a landscape. Seals of the artist, also of Hui-tsung, Yang Wei-chen, and others. Interesting archaistic work in *pai-miao* manner. See *T'oung-pao,* ser. II, vol. VIII, no. 2 (1907), pp. 235-267.

LI KUNG-NIEN 李公年
Late 11th, early 12th century. Landscapes. G, XIII, p. 132. H, III, p. 51. M, p. 193.

Shimbi XX (Formerly Otto Kümmel Coll.). A man seated on a terrace gazing at a waterfall. Fan painting. Attributed. Signature at right partially missing. Southern Sung work, school of Li T'ang.
* Princeton Art Museum (46.191). A Mountain Valley; a fisherman in a boat; two travelers approaching a pavilion. Signed. See Southern Sung Cat. 1; Rowley Principles (old ed.), pl. 24; new ed. pl. 19; Barnhart Marriage fig. 17; Kodansha CA in West I.5; Suiboku II, 7; Bunjinga suihen II, 32.

LI SHAN 李山
From P'ing-yang, Shansi. Active at the beginning of the 13th century, under the Chin Dynasty. Landscapes. I, 52. M, p. 196.

* Freer Gallery (61.34). *Feng-hsüeh sung-shan t'u:* Wind and Snow in the Fir-pines. Handscroll. Signed. Genuine? or close copy? Colophons by Wang T'ing-yün (1151-1202), Wang Man-ch'ing (dated 1243), Wang Shih-chen (1526-1490), Wen Po-jen (1502-1575, dated 1568) and others. Seals of Huang Lin (c. 1400), Wang Shih-chen, Liang Ch'ing-piao (1620-1691), An Ch'i (1683-c. 1742), Ch'ien-lung and others. See Southern Sung Cat. 5; Oriental Art XI, no. 3, Autumn 1965, p. 166 and XV, no. 2, Summer 1969, p. 111; Meyer Cat. no. 20; Kodansha Freer cat. 44; Kodansha CA in West I, 19; Bunjinga suihen II , 45.
Ibid. (16.552). A mountain stream between rocky banks; tall pines in the foreground. Old attribution. Chin or early Yüan? See Siren CP III, 321; Kodansha Freer cat. 59; Kodansha CA in West I, 20; Bunjinga Suihen II, 47.
Yale Art Gallery (1952.52.25g). Winter landscape. Album leaf, ink and slight color on silk. Attributed. See Yale Catalogue (New Haven, 1970) no. 72; also Oriental Art, XI/3, Autumn 1965, p. 164; Bunjinga suihen II, 46.

LI SUNG 李嵩
From Hangchou. Started life as a carpenter but was adopted by the painter Li Ts'ung-hsün. Became tai-chao in the Academy of Painting c. 1190-1230. Followed Liu Sung-nien and Chao Po-chü. Famous for his boundary paintings but painted also figure compositions. H, 4. J, 5. M, p. 194; also see Ellen Johnston Laing, "Li Sung and Some Aspects of Southern Sung Figure Painting,"

Artibus Asiae, 27/1-2 (1975); and biography by same author in Sung Biog. 85-90.

* Peking, Palace Museum. Knick-knack peddler. Short handscroll. Signed and dated 1211. Colophon by Ch'ien-lung. see Wen-wu 1958.6, 3; Loehr Dated Inscriptions p. 264; I-shu ch'uan-t'ung VII, 8-9.
* Ibid. The Skeleton Puppet Master. Fan painting. Signed. Genuine. See Che-chiang 11; Sung-jen hua-ts'e A, 58; B. IV, 10. Poem on facing leaf composed by Huang Kung-wang and inscribed by his student Wang Hsüan-chen.
 Ibid. Three scholars in a pavilion over water under a misty mountain cliff. Fan painting. Signed. Hard Ming work. See Sung-jen hua-ts'e XV.
 Ibid. Flower basket. Album leaf. Signed. Yüan work, with interpolated signature? See KKPWY hua-niao 11; Sung-jen hua-ts'e A, 59; B.IV, 9.
* Shanghai Museum. A view over the West Lake in Hangchou. Handscroll, signed. Fine, genuine work. See Che-chiang 10; TSYMC hua-hsüan 8; Shen-chou ta-kuan 14; *Sung Li Sung Hsi-hu t'u* (Shanghai Museum, n.d.).
 Taipei, Palace Museum (SV92). Immortals calculating the fortunes of some inquirers. Figures in a pavilion. Attributed. Ming work. See KK chou-k'an 59; Ku-kung XII. Another version of the composition, ascribed to Liu Sung-nien, in the same collection (SV86); still another by Ch'en Hsien (1405-1496) is in the Tofukuji, Kyoto.
 Ibid. (SV93). A scholar listening to a lady playing the p'i-p'a in a garden; three maids in attendance. Close in style to the work of Tu Chin of the Ming period; probably by him. See KK shu-hua chi 13; CKLTMHC II, 50; KK ming-hua III, 15; Wen-wu chi-ch'eng 44; KK chou-k'an 165.
 Ibid. (SV94). The Lantern Festival. Ladies making music in a garden; children playing with their toys. Ming work, after old composition. See KK shu-hua chi 15; KK chou-k'an 173; CKLTMHC II, 51; KK ming-hua IV, 10.
 Ibid. (SV95). An Arhat seated on a bench with two acolytes. Probably a Yüan painting. See KK shu-hua chi 24; KK chou-k'an 330; London Exh. Chinese Cat. p. 84; CH mei-shu I; CKLTSHH.
* Ibid. (VA12o). Inviting the Guest at the Pine Bank. Fan painting. Attributed. Fine Southern Sung work.
* Ibid. (VA14c and d). Offering Incense to the Spirits; A Palace Among Willows. Fan paintings. Both bear partly cut-away signatures which probably read "Li Sung"; may be his works. See KK chou-k'an 60-61; CKLTMHC I, 63.
 Ibid. (VA16g). Sleeping in the Pine Breeze. Fan painting. Attributed. See under Liu Sung-nien, whose signature it bears.
 Ibid. (VA18k). Dragon Boat. Album leaf. Signed. See NPM Bulletin I/4, 7; NPM Masterpieces I, 11. See following entry.
 Ibid. (VA18l). Return from the Court: a palace with courtiers seen on verandahs. Signed. Companion to the previous picture; both probably cut from a handscroll, with signatures added (note vertical cracks in both). Yüan works? See NPM Bulletin I/4, 9.
 Ibid. (VA19m). Boating by plum trees and cliffs. Fan painting. Signed. Late copy. See CKLTMHC II, 89; KK hsün-k'an 31; KK chou-k'an NS 31.

Ibid. (VA26f). A Basket of Flowers. Album leaf. Signed. Copy. See NPM Bulletin I/4, 11; II.6 cover.

* Ibid. (VA27c). The Knick-knack Peddler. Fan painting. Signed; dated 1210. See CAT 50; KK ming-hua IV, 11; NPM Bulletin I, 4; 1, 10, 11; NPM Quarterly I, 2, XXIV; Loehr Dated Inscriptions p 264; Skira 53; NPM Masterpieces II, 28 and II, 19.

Ibid. (VA29a). The Hangchou Bore in Moonlight. Fan painting. Signed. Two lines of poetry. Seal of An Ch'i. Possibly genuine. See CAT 51; CKLTMHC I, 62; NPM Bulletin II/3, p. 8; KK chou-k'an 124; Artibus Asiae 33/4.

Ibid. (VA36p). The Red Cliff. Album leaf. Copy of the Nelson Gallery picture (see below).

Ibid. (SV 290, chien-mu). *Sui-ch'ao t'u:* Exchanging New Year's Greetings. Signed. Ming work? Indistinct reproduction in Wen-wu 1955.7, 7 (39); see also NPM Bulletin VI/1 (March-April 1971), p. 1.

* See also Ibid. (VA14a). Summer at Li-chüan. Style of Li Sung.

Fujita Museum, Osaka. Pu-tai. Attributed. Inscription by Wu-hsüeh Tsu-yüan.

Fujii Yurinkan, Kyoto. A drunken man returning on a buffalo from a spring festival. Handscroll. Signed. Poem by Chao Meng-fu. Copy. See Yurin-taikan III.

Hikkoen, pl. 20. A buffalo turning a waterwheel. Album leaf. Attributed.

Kohansha II. A bull seen through a round window. Inscription by Miao-sung, a Ch'an monk of the 13th century. Unrelated to Li Sung.

Yabumoto Kozo, Amagasaki. Two small paintings from the "Ten Oxherding Pictures" series. Attributed.

Ferguson, p. 130. A pavilion by the river, with figures. Fan painting. Attributed. Fine Southern Sung work.

Cleveland Museum of Art (63.582). Peddler with children. Fan painting. Signed; dated 1212. See China Institute Album Leaves 16, p. 42; Sherman Lee, *Scattered Pearls Beyond the Ocean #3.*

Fogg Museum (1924.20). A man and his servant beneath a willow. Fan painting. Attributed. Late Sung or Yüan. See China Institute Album Leaves 38.

Freer Gallery (17.184). *Sou-shan t'u:* demons fighting serpents and fantastic animals to "Clear the Mountain" on the command of a Taoist magician. Handscroll, ink on paper. Ming work of the Che school. A signature at the end has been altered; it may have read "Li Tsai." See Freer Figure Ptg. cat. 37; Siren CP in Am. Colls. 34-36. For other versions of the composition see under Wu Tao-tzu, T'ang period.

* Nelson Gallery, Kansas City (49.79). The Red Cliff. Four men in a boat on a stormy sea. Fan painting. Signed. Fine, genuine work. See Toso 73; Southern Sung Cat. 22; Siren CP III, 313; China Institute Album Leaves 17 (no ill.); Lee Landscape 21; Kodansha CA in West I, 17; Artibus Asiae 33/4.

Ibid. (59.17). Emperor Ming-huang Watching a Cockfight. Fan painting. Signed; but the signature may be an interpolation. See article by Sickman in their *Bulletin,* March 1959; Southern Sung Cat. 23. Another version of

the composition in Yüan-jen chi-ts'e, I. For other paintings in the same style, see the "Yen Hui" leaf in Hikkoen 38; an "Anonymous Sung" leaf in Sung Yüan pao-hui 5; and an "Anonymous Sung" fan in Chung-kuo MHC 38. (Formerly Ti Pao-hsien Coll.); This style is sometimes associated with Liu Kuan-tao of the Yüan dynasty.

* Ibid. (58.10). Chao Yü's Pacification of the Barbarians South of Lü. Handscroll. Formerly attributed to Li Sung; perhaps a Chin dynasty work. See Toronto Cat. 2; Southern Sung Cat. 6; Kodansha CA in West I, 12.

Metropolitan Museum, N. Y. (1973.121.10; former C. C. Wang Collection, N. Y.) A knick-knack peddler; a woman and two children. Fan painting. Much damaged. Attributed. See Munich Exh. Cat. 24a (no ill.); Met. Cat., 1973, no. 8.

LI T'ANG 李唐 t. Hsi-ku 晞古

From Ho-yang, Honan. Born in the 1050's, died after 1130. Tai-chao in the Academy of Painting in Kaifeng and later Director of the Academy in Hangchou. Most prominent as a landscape painter but also did figure compositions. H, 4. J, 2. M, p. 194. See also Richard Edwards, "The Landscape Art of Li T'ang" in Archives XII, 1958, 48-59; Richard Barnhart, "Li T'ang and the Kotoin Landscapes", *Burlington Magazine,* May 1972, 304-314; and biography by Ellen Laing in Sung Biog. 90-97.

* Peking, Palace Museum. The virtuous brothers Po I and Shu Ch'i in the wilderness picking herbs. Handscroll, ink and light colors. Signed. Early copy? See Chung-kuo hua I, 13; CK ku-tai 42; Li-tai jen-wu 24; Wen-wu 1960.7, 4; Siren CP III, 251; Chung-hua reproduction album. Another version in Garland I, 18; others in the Fujii Yurinkan, Kyoto and the Freer Gallery (11.208).

Ibid. The Long River in Summer. A dense composition of rocky mountains with trees and temple buildings. Long handscroll, ink and greenish color; much worn. Signed. Inscription by Emperor Kao-tsung of Sung. Siren: genuine work.

* Ibid. A buffalo and herdboy beneath autumn trees. Signed. Early school work. See KK shu-hua chi 46 (printed but not published; copy in Palace Museum, Taipei).

Ibid. Two boats passing dangerous rapids of swirling water beneath rocks. Album leaf. Signed. See Ku-kung 37. Good early work.

Ibid. Boats returning to shore in a storm. Fan painting. Signed. Yüan-Ming work by artist in the Kuo Hsi tradition. See Fourcade 3; Sung-jen hua-ts'e A.94.

Ibid. The Cowherd's Return: a boy on a buffalo crossing a stream. Fan painting. Attributed. Work of a minor Southern Sung artist? See Sung-jen hua-ts'e A.80; B.III, 4.

Ibid. Men conversing in a pavilion by the water. Album leaf. Attributed. Ming copy. See Sung-jen hua-ts'e A.90; B.X, 1.

* Ibid. Playing the Yüan and Drinking Wine in the Bamboo Grove. Fan painting. Attributed. Fine work of later Sung follower. See Sung-jen hua-ts'e A.88.

Liaoning Provincial Museum. Fishing under a Pine-covered Cliff. Fan painting. Attributed. Fine Southern Sung Academy work, cf. Yen Tz'u-p'ing. See Liang Sung 41; Liao-ning I, 79; Sung-jen hua-ts'e B.XIX; Sung Yüan shan-shui 11; also Sung Li T'ang Sung-hu tiao-yin (Peking: Jung-pao chai hsin-chi, 1957).

* Taipei, Palace Museum (SV64). Whispering Pines in the Mountains: pine trees in a rocky valley by a stream. Signed and dated 1124. Seals of the emperor Kao-tsung and Chia Ssu-tao; ssu-yin half-seal. Genuine? or exact Yüan-Ming copy? See KK shu-hua chi 27; Three Hundred M., 95; CAT 36; CCAT p. 99; CH mei-shu I; CKLTMHC I, 47; KK ming-hua III, 2; TSYMC hua-hsuan 6; Nanking Exh. Cat. 18; Wen-wu chi-ch'eng 33; KK chou-k'an 401; Siren CP III, 247; Bijutsu kenkyu 165; Loehr Dated Inscriptions pp. 245-246; Summer Mts., 30.

* Ibid. (SV65). Solitary Temple in the Mist: temple buildings and a pagoda in the mountains surrounded by floating mist. Ssu-yin half-seal. Fine work of the 13th century, tradition of Fan K'uan. See KK shu- hua chi 24; KK chou-k'an 314.

Ibid. (SV66). Snow Landscape: storm over snow-covered mountains by a river. Ming work of the Che School. See KK shu-hua chi I; CKLTMHC I, 48; KK chou-k'an 86.

Ibid. (SV67). River View in Snow. Colophon by Tung Ch'i-ch'ang, who attributes the painting to the master. Ming work. See Wen-wu chi-ch'eng 34; Three Hundred M., 97; CKLTMHC I, 49; KK ming-hua IV, 1.

Ibid. (SV68). The Village Doctor. Attributed. Ming picture, after Southern Sung Academy work? See Chung-kuo I; Three Hundred M., 99; CH mei-shu I; CKL TMHC II, 33; CKLTSHH; KK ming-hua III, 3; Wen-wu chi-ch'eng 35; KK chou-k'an 81; Chung-kuo MHC 34; NPM Masterpieces III, 17; Artibus Asiae 37/1-2.

Ibid. (SV69). A herd boy on a buffalo cow followed by its calf. Early Ming work. See KK shu-hua chi 26; London Exh. Chinese Cat. p. 68; KK chou-k'an 350; NPM Masterpieces I, 9.

* Ibid. (SH12). Mountains by the River. Rocky cliffs surmounted by trees; sailing boats on the water. Handscroll. Attributed. Two colophons by Tung Ch'i-ch'ang, dated 1613 and 1623; two poems by Ch'ien-lung. 12th century school work? See Palace Museum reproduction scroll, 1936; Three Hundred M., 98; CAT 37; CKLTMHC I, 50; NPM Masterpieces V, 10.

Ibid. (SH13). Hermit Fishing in a Clear Stream. Handscroll, ink on silk. Colophon by Yeh Fan dated 1237; colophon by Chao Meng-chien dated 1301. Mediocre Ming work. See KK chou-k'an 184-189; Three Hundred M., 96; CKLTMHC I, 51; Loehr Dated Inscriptions pp. 270-271.

Ibid. (SA1). Wen-chi returning to China. Album of 18 leaves. Southern Sung copies? much restored, of the designs sometimes ascribed to Ch'en Chü-chung. Colophon on a separate leaf by Han Shih-nung dated 1591. The attribution to Li T'ang is probably arbitrary. See CCAT pl. 132. For other versions of this subject see under Anonymous Sung Figure Painting,

Horsemen and Tartar Scenes section.

Ibid. (SA2). Landscapes of the four seasons. Short handscrolls mounted as an album. Attributed to the master in a colophon by Tung Ch'i-ch'ang. Ming works. See KK ming-hua IV, 2.

Ibid. (VA3g). An Herb Gatherer at the Cliffs of the Immortals. Fan painting. Attributed. School work, late Sung? or Ming copy? See NPM Masterpieces II, 17.

Ibid. (VA11h). Receiving the Guest. Fan painting. Yüan or later, by follower of Chao Meng-fu.

Ibid. (VA12j). Two men seated on rocks, watching the clouds. Album leaf. Attributed. School work, 13th century?

Ibid. (Va13d). Travellers at the Mountain Pass. Album leaf. Attributed. Copy.

Ibid. (VA16e). Carrying a staff, searching for plum blossoms. Album leaf. Attributed. Copy of a work in the Ma Yüan style.

Ibid. (VA18f). Water buffalo resting on the mountain path. Fan painting. Attributed. Yüan?

Ibid. (VA19i). Island peak with temples. Album leaf. Attributed. Fine Southern Sung? work in the Kuo Hsi tradition. See KK hsun-k'an 28; Soga I, 35.

* See also the album leaf "A Myriad Trees on Strange Peaks" in the Taipei Palace Museum (VA16b) attributed to Yen Wen-kuei; actually style of Li T'ang , possibly his work; so published in Skira 42.

KK shu-hua chi 46 (Printed but not published—copy in Palace Museum, Taipei). Snowy River Scene. Attributed. A Ming picture?

Ars Orientalis III, 1959, pl. 8. Landscape with waterfall and figures. Fan painting. Attributed. Southern Sung work, not in the Li T'ang style. See also Ch'ing-kung ts'ang 5 (formerly Ti Pao-hsien Coll.).

Ch'ing-kung ts'ang (formerly Manchu Household Coll.). The Four Old Men on Shang-shan. Wooded rocks and small figures. Album leaf. Signed. Inscriptions.

Chung-kuo MHC 26. Reading the Changes in a Mountain Hut. Attributed. See also Ferguson Ch. Ptg. 122. Also ascribed to Li Tsung-ch'eng, q.v. Later work.

Ibid. 28. Autumn landscape with cliffs; travellers on a bridge and on paths. Close to the work of Chou Ch'en of the Ming period.

Ibid. 40. Fisherman on a river bank. Imitation.

Shen-chou ta-kuan hsü 9. A sail boat passing a rocky shore with large leafy trees. Album leaf. Ming work.

Tien-yin-tang II, 4 (Chang Pe-chin Coll., Taipei). Herd boy leading water buffalo under willow trees. Fan painting. Attributed.

* Koto-in, Daitoku-ji, Kyoto. Pair of landscapes: (a) Autumn scene(?) with leafy trees by a stream, a traveller on a path; (b) Winter scene with two men on a ledge by a waterfall, a rocky cliff above. Ink on silk. Sometimes said to be Autumn and Winter from a set of landscapes of the Four Seasons. Once at tributed (through association with the Kuan-yin painting that formed the centerpiece of a triptych of which they are the side pieces) to Wu Tao-tzu of the T'ang period. More recently ascribed to Li T'ang on

the basis of a nearly obliterated signature on the Autumn scene; see S. Shimada's article in Bijutsu kenkyu 165, pp. 13-25. The "signature," however, is oddly placed and probably spurious. The paintings are post-Hsia Kuei, probably 13th century, the work of an artist affected by, but somewhat outside, Southern Sung Academy painting circles. See Toyo VIII, 6-7; Sogen no kaiga 94; Siren CP III, 249-250; Toyo bijutsu 31-32; Toso 26-27; Genshoku 29/7; Suiboku II, 33-34.

Kyoto National Museum (former Lo Chen-yü and Ueno Collections). Villager's Wedding Procession. Handscroll, ink and colors on silk. Signed. Ming painting. See Kokka 261; Artibus Asiae 37/1-2.

Hikkoen p. 33 (formerly Kuroda Coll.). Water buffaloes on a beach at the foot of high mountans. Fan painting. Southern Sung work? Style of Hsia Kuei.

Hokuga shinden (Ogawa Coll.). The Road to Shu. A mountain path along steep terraced cliffs. Figures on the bridge leading over a turbulent stream. Probably a Ming picture. See also Chung-kuo I, 38.

Toso 67 (Formerly Yamamoto Coll.). A scholar's garden at the foot of high mountains. Two men playing chess, a third approaches with his ch'in. Inscription by Tung Ch'i-ch'ang. Fine Ming work, cf. Chou Ch'en, possibly by him. See also Hokuga shinden 7; Pageant 120.

Artibus Asiae XIV, 1951, p. 208 (Japan Art Society Coll., Tokyo, formerly Akaboshi Coll.). Water buffalo and farmer. Imitation, with spurious signature and date 1084. Also two seals of the painter. See Teruo Akiyama article listed above; also Loehr Dated Inscriptions pp. 234-235.

Inokuma Collection, Yokkaichi (Former Yamamoto Teijiro Coll.). Landscape with buildings and figures. Ink on silk. Attributed. Early Ming?

Boston Museum of Fine Arts (12.893). Man on a water buffalo returning from a village feast in spring. Album leaf. Attributed. Ming work, unrelated to Li T'ang. See Portfolio I, 57; Kokka 255; Siren CP III, 252; NPM Quarterly II/4 (April 1968, pl. 3A.

Ibid. (14.49). Two boys herding two water buffaloes under willows. Poem by Ch'ien-lung. Kao Lien, a 16th century writer, attributes the picture to Chang Fu of the T'ang period. Copy of an earlier picture? See Portfolio I, 70: Siren CP in Am. Colls. 19.

Freer Gallery of Art (11.306). After the Rain: fishing nets drying on the shore. See Chung-kuo I, 18; Chung-kuo MHC 16. A late copy of the picture attributed to Hsia Kuei in the Boston Museum of Fine Arts (14.54).

* Nelson Gallery, Kansas City (34.267). A Solitary Temple in the Hills. Hanging scroll. Called "Anon. Yüan," but appears to be a fine Southern Sung work by a Li Tang follower.

Seattle Art Museum (CH32.18). Scholars in a house gazing at plum trees by moonlight. Inscription purportedly by P'u-ming of the Yüan period. Good Ming work of the Che School.

John Crawford Collection, N. Y. (Cat. 55, former Moriya Coll.). Mountain Landscape: The Four Seasons. Handscroll, ink and light colors on silk. Interpolated seal and signature of Li T'ang. Ming work, cf. Li Tsai. See also Kokka, 633 and 635.

Ibid. (Cat. 32). Two gentlemen gazing at a waterfall. Fan painting. Attributed. Southern Sung work?

* Metropolitan Museum, N. Y. (1973.120.2; former C. C. Wang Coll., N. Y.). The Return of Duke Wen of Chin: Six pictures illustrating episodes from this historical event of the late Chou period. The text between the pictures is attributed to the emperor Kao-tsung. Handscroll, ink and colors on silk. Traditional attribution. Early copy? See Met. Cat., 1973, no. 2; TWSY ming-chi 41-47; Suiboku II, 35-36.
* Metropolitan Museum, N. Y. (1973.121.12; former C. C. Wang Coll., N. Y.). A bluff by a river. Fan painting. Attributed to an anonymous follower of the 12th century. See Met. Cat., 1973, no. 7; Southern Sung Cat. 2.

Kunst des Ostens: Summlung Preetorius, 1955, pl. 3 (Preetorius Coll., Munich). Man on bank of a stream beneath pine with boy servant. Album leaf. Signed. Imitation.

LI TE-MAO 李德茂

Late 12th, early 13th century. Son of Li Ti. Tai-chao in the Academy of Painting during the Shun-yu era (1241-1253). Famous for paintings of flowers and birds. H, IV, p. 109; J, VIII, p. 169; M, p. 194.

Taipei, Palace Museum (VA17v). Butterflies and Grass. Fan painting. Attributed.

LI TI 李迪

From Ho-yang, Honan. According to the earliest source, the *Hua-chi pu-i* (1298), he was active in the Academy under emperors Hsiao, Kuang and Ning (1163-1225). The later statement in *T'u-hui pao-chien* that he was active under Hui-tsung is surely erroneous. He served as vice-director of the Academy. Famous for his flowers, bamboo, birds and dogs, but also painted landscapes. H, 3. I, 51. J, 2. M, p. 194; also see R. Edwards, *Li Ti* (Freer Gallery Occasional Papers III/3, 1967); and biography by same author in Sung Biog. 97-99.

* Peking, Palace Museum. A hawk chasing a pheasant. Large horizontal hanging scroll (originally a screen?) Signed, dated 1196. Genuine, fine work. See KKPWY hua-niao 8; Kokyu hakubutsuin, 174.
* Ibid. A large dog walking with lowered head. Album leaf. Signed, dated 1197. See Sung-jen hua-ts'e A, 57; B.II, 10; Loehr Dated Inscriptions p. 261. Another version of the picture, attributed to Mao I, is in the Boston M.F.A.
* Ibid. Two Chicks. Album leaf, color on silk. Signed, dated 1197. Seal of Hsiang Yüan-pien. See KKPWY hua-niao 9; Sung-hua shih-fu 2; Sung-jen hua-ts'e A, 56; B.II, 9; Loehr Dated Inscriptions pp. 260-261. Another version, in reverse, in Sogen Shasei gasen 2.

Ibid. Su Wu guarding sheep. Fan painting, color on silk. Copy.

Shanghai Museum. A winter bird in a snowy tree. Signed, dated 1187. Hard copy. See Shang-hai 3; Wen-wu 1963.10, 19; Loehr Dated Inscriptions p. 258.

Sung Li Ti shan-shui ts'e (Shanghai, 1915). Studies of whirling waters, cliffs, clouds and trees. Album of eight leaves. Last picture signed and dated 1136(?) Ch'ing work, cf. Tsai Chia. See Loehr Dated Inscriptions p. 260.

Chung-kuo I, 81 (Ti P'ing-tzu Coll.). Five wild geese and some reeds on the shore. Signed. Yüan-Ming work? See also Chung-kuo MHC 19.

Taipei, Palace Museum (SV72). Two herd boys on buffaloes returning home through a rain storm. Signed and dated 1174. Inscription by the emperor Li-tsung. *Ssu-yin* half-seal. Yüan or Ming copy. See Ku-kung 15; London Exh. Chinese Cat. p. 67; Three Hundred M., 104; CAT 40; CKLTMHC I, 55; KK ming-hua IV, 5; Wen-wu chi-ch'eng 37; KK chou-k'an 119; Loehr Dated Inscriptions p. 254.

Ibid. (SV73). A pigeon among some flowering plants at the foot of a tree; two smaller birds. Ink and colors, probably after an earlier design. Signature and seal of the painter. Late decorative work. See KK shu-hua chi 31; Siren CP III, 244.

Ibid. (chien-mu SH91). Herding Goats. Su Wu in a cave; horses, camels, goats etc. outside. Handscroll. Attributed. Painting of good quality, following a Liao Dynasty tradition.

Ibid. (VA1i). Spring Tide and Rain. Large album leaf. Attributed. Seals of Liang Ch'ing-piao. Later work, or copy.

Ibid. (VA11j). Hoopoe on a Myrtle Branch. Album leaf. Attributed. Ming work?

Ibid. (VA12k). Sparrows Eating Rice. Album leaf. Attributed. Work of later, lesser artist.

Ibid. (VA13e). Cowherd at the Willow Bank. Album leaf. Attributed. Ming work.

Ibid. (VA15i). A bird bathing. Album leaf. Attributed. Sung work? or Yüan? See NPM Bulletin II/3, cover.

Ibid. (VA15j). Two Cranes. Fan painting. Attributed. Yüan period?

Ibid. (VA17n). Autumn flowers and insects. Album leaf. Signed. Fine copy? See KK chou-k'an 16.

Ibid. (VA20a). Dog and cat in an autumn garden. Fan painting. Signed. Copy. See NPM Masterpieces II, 21.

* Ibid. (VA24j). Cat. Album leaf. Signed, dated 1174. See CAT 39; Loehr Dated Inscriptions p. 255. A companion picture, unsigned but apparently by the same artist, is in the same collection (VA36d). Both genuine.

Ibid. (VA26g). Morning Glory and Melon. Album leaf. Signed.

Mo-ch'ao pi-chi, I. Geese and reeds. Attributed. Ming painting.

I-lin YK 50/7. Dog and puppy. Album leaf. Attributed. Reproduction indistinct.

* Tokyo National Museum (Formerly Fukuoka Coll.). White and Red Hibiscus Flowers. Two album leaves. Signed and dated 1197. Genuine, fine works. See Kokka 26 and 134; Sogen meigashu 3, 14 and 15; Sogen no kaiga 53; Toyo bijutsu 47-48; Siren CP III, 245; Loehr Dated Inscriptions

p. 261; Genshoku 29/27-28.

* Yamato Bunkakan, Nara (Formerly Masuda Coll.). Hunters Returning through the Snow. One rides on a buffalo and carries a pheasant on a stick; the other is walking in front of the buffalo and carries a rabbit on a pole. Two album leaves. Signed; but some Japanese authorities believe the signature on one to be a later addition. Genuine. See Toyo 8; Kokka 71 and 180; Shimbi 8; Sogen no kaiga 99; Siren CP III, 253-254; Toyo Bijutsu 29; Genshoku 29/13; Yamato Bunka, 2; Sogen MGS III, 2, 14.

Soraikan II, 20 (6). Cat with a dragon-fly. Album leaf, color on silk. Signed, dated 1193. Seal of the artist. Probably later. See also Loehr Dated Inscriptions p. 260; Osaka Cat. 39 (8).

Nezu Museum, Tokyo. Aquatic plants and dragonfly. Album leaf. Attributed. Sung-Yüan work. See Nezu Cat. I, 38.

* Kokka 144 (Count Tsugaru Coll.). Five apples on a branch. Fan painting. Attributed. Fine Southern Sung painting. See also Sogen bijutsu 31; Sogen MGS II, 1.

Ibid. 355. Boys and Water Buffalo in Landscapes. Pair of Hanging scrolls. Attributed to Li Ti, but seal reads Po-ta; probably by Kuo Min of Yüan, q.v.

Sasaki Collection, Tokyo (Formerly Masuda Coll.). A white bitch and two puppies. Signed. Album leaf. Seal of Ashikaga Yoshimitsu. Good Sung work.

Toso 58 (Chin Yün-p'eng Coll.). Chickens and finches in a bamboo grove. Early Ming?

Eda Bungado Collection, Tokyo. Album of bird and flower pictures, colors on silk. Attributed. Yüan or early Ming?

Nakamura Katsugoro, Tokyo. Branch of peaches. Round fan, ink and colors on silk. Late Sung or early Yüan.

Boston Museum of Fine Arts (17.186). Bamboo and rock under a long branch of an old tree. Album leaf. Signed; but the signature weak, suspect. Seals of the emperor Kao-tsung and later collectors. Work of slightly later, lesser artist? See Portfolio I, 72.

Freer Gallery (16.533). Birds in trees by a stream. Attributed. Ming copy of fine work in his style.

Ibid. (70.32). Birds in wintry trees. Same composition as the Kao Tao in the Cleveland Museum. 17th c. See Meyer Cat. 28.

John Crawford Collection, N. Y. (Cat. 29). Birds on a Winter Tree. Fan painting. Attributed. See also Chang Ta-chien Cat. IV; China Institute Album Leaves 11, ill. p. 38.

Howard Hollis Collection, N. Y. Dog and Cat. Pair of hanging scrolls. Attributed.

* A. Dean Perry Collection, Cleveland (Formerly C. C. Wang Coll.). Birds in a tree above a cataract. Album leaf. Signed. Genuine. See Southern Sung Cat. 8; Munich Exh. Cat. 16; China Institute Album Leaves 12.

Siren ECP 45 (Formerly Henry Oppenheim Coll., London). A white heron alighting among reeds. Album leaf. Signed. Imitation.

See also the pair of "Anonymous Sung" album leaves in Sung-jen hua-ts'e A, 98-99. Copies after paintings in the Li Ti style.

LI TSUNG-CH'ENG　李宗成
Lived in Northern Sung period. Landscapes after Li Ch'eng. F. H, 3. M, p. 190.

Chugoku I. A man reading at a window of a cottage on a winter night. Ming work. See also Chung-kuo MHC 26 and Ferguson Ch. Ptg. p. 122, where the same picture is attributed to Li T'ang.

LI TS'UNG-HSÜN　李從訓
From Hangchou. Tai-chao in the Painting Academy both in Kaifeng and in Hangchou. Figures, flowers and birds. H, 4. J, 2. M, p. 194.

Kwen Cat. 59, 2. Two scholars and a monk seated on a platform playing chess. Album leaf. Signed.

LI TUNG　李東
Active during the reign of emperor Li-tsung (1225-1264). H, 4. M., p. 195.

* Peking, Palace Museum. A fisherman selling fish to a woman in a pavilion along a snowy river. Fan painting. Signed. See Fourcade 4; Sung-jen hua-ts'e A, 63; B. VII, 9; also *Sung Li Tung Hsueh-chiang mai-yü* (Peking: Jung-pao chai hsin-chi, 1958).
Taipei, Palace Museum (VA17x). Mallow. Fan painting. Attributed. A signature clearly reads "Li An-chung," q.v. See KK chou-k'an 12.
Cf. also the "Fan K'uan" leaf in the Taipei Palace Museum (VA3e) which bears a Li Tung signature, but appears to be later in date.

LI WEI　李瑋 t. Kung-chao　公炤
From Ch'ien-t'ang, Chekiang. Son-in-law of the emperor Jen-tsung (1032-1063). A high official who amused himself with calligraphy and painting but destroyed most of his works. Specialized in bamboo. G, 20. H, 3. I, 50. L, 42. M, p. 190.

* Boston Museum of Fine Arts (12.904). A bamboo garden with pavilions and figures. Signed; but part of the signature, including the family name, is missing. Seals of the emperor Kao-tsung (1107-1187) and of Liang Ch'ing-piao. Fine late Sung or Chin work? See Portfolio I, 45; Chechiang 5; Siren CP in Am. Colls. 84; Pageant 90. Kodansha CA in West I, 7; Suiboku IV, 26; Bunjinga suihen II, 56.

LI YEN-CHIH　李延之
An artist in the Hsuan-ho Academy of Painting. Fish, insects, grasses and trees. G, 20. M, p. 190.

Gems I, 1. Two perch swimming under a blossoming pear tree. Signed. Genuine?

LI YU-CHIH 李祐之
From Lo-yang (or Tung-ching). Lived in Hangchou during the Shao-hsing period. Painted Buddhist figures, ghosts, oxen and horses. H, IV, p. 35. M, p. 195.

Chung-kuo MHC 40. Landscape with buffaloes. Signed, dated 1138. A title purportedly written by the emperor Hsiao-tsung and dated 1172 attributes the painting to him. Imitation.

LIANG K'AI 梁楷 h. Feng-tzu 風子
From Tung-p'ing, Shantung. Tai-chao in the Painting Academy in Hangchou c. 1201-1204. Left the Academy and lived in a Ch'an Buddhist temple. Landscapes, Buddhist and Taoist figures. H, 4. J, 5. M, p. 391; also Bijutsu kenkyu 184; and Tanaka Ichimatsu, *RyoKai* (Kyoto: 1957). Also article by Kenyu Dotani in Kobijutsu no. 55, 1978; and biography by Sherman Lee in EWA IX, 239-244.

Peking, Palace Museum. A man sleeping under a pine tree. Album leaf, ink on silk. Signed. Formerly P'ang Yüan-chi Collection. Later work. See Sung-jen hua-ts'e A, 61.
* Ibid. The top of a bare willow tree; two birds in flight. Fan painting, ink and light colors on silk. Signed. Damaged and repaired; possibly genuine. See Sung-jen hua-ts'e A, 60; B.IX, 5; KKP WY hua-niao 10; Fourcade 30; I-yüan to-ying, 1979 no. 1, p. 14.
Ibid. *San-kao:* three old scholars under a pine tree. Album leaf, ink on silk. Signed. Ming work. See Sung-jen hua-ts'e A, 61; B.IX, 4.
Ibid. Four magpies: two flying and two seated on a tree stump. Fan painting. Signed. Imitation? See Wen-wu 1966.4, 39. Kokyu hakubutsuin, 173.
* Shanghai Museum. Illustrations to events in the lives of eight famous monks. Long handscroll: eight paintings, of which four are signed, separated by section of text. Odd, but genuine? or early copy? See CK ku-tai 52; *Sung Liang K'ai Pa kao-seng ku-shih t'u chüan* (Shanghai Museum: n.d.).
* Ibid. Pu-tai. Large album leaf, ink and colors on silk. Signed. Genuine work?
* Taipei, Palace Museum (SV122). Scholar of the Eastern Fence: T'ao Ch'ien walking with a staff beneath a pine tree. Signed. Fine early work; original, representing Liang K'ai's Academy period?
Ibid. (chien-mu SV299). A man standing between two old pines looking at a waterfall. Attributed to Liang in an inscription by Wang Tsuan of the Ch'ing period. Late Ming, cf. Li Shih-ta. See KK shu-hua chi 25.
Ibid. (VA9b). An old immortal in a loose open gown. Signed. Imitation. See Ming-hua lin-lang (Ku-kung album); Three Hundred M., 118; CAT 63; CCAT pl. 102; CKLTMHC I, 61; KK ming-hua IV, 23; Li-tai jen-wu 26; KK chou-k'an 28; NPM Masterpieces III, 22.

Ibid. (VA15m). Discussing the Tao. Album leaf. Attributed. Interesting Ming work by follower of Li T'ang, after older composition?

Ibid. (VA17j). Water birds and hibiscus. Fan painting. Late Sung or Yüan work with interpolated signature.

Chung-kuo I, 55 (Formerly Manchu Household Coll.). Wang Hsi-chih writing on a fan. Signed. Several colophons of the Yüan period, one dated 1323. Poem by Ch'ien-lung. Early imitation. See also Siren CP III, 327; Bukkyo bijutsu 16; Chung-kuo MHC 30. Another version in the Taipei Palace Museum (VA10b).

* Tokyo National Museum. The poet Li Po walking and chanting a poem. Signed. Genuine. Toyo IX, pl. 66; Shimbi III; Toso 81; Sogen meigashu 25; Southern Sung Cat. 14; Skira 90; Sogen no kaiga 19; Siren CP III, 330-331; Genshoku 29/18; Suiboku IV, 5.

* Ibid. The sixth Ch'an patriarch Hui-neng achieving enlightenment while cutting a bamboo pole. Signed. Genuine. See Kokka 229; Li-tai jen-wu 27; Toso 77; Toyo IX, pl. 68; Sogen no kaiga 21; Genshoku 29/17; Siren CP III, 328. The picture that once formed a pair with this, representing the Patriarch Hui-neng tearing up a sutra, is probably a Japanese copy, replacing a lost original. See Toso 76; Siren CP III, 329. Both in Boston Zen Catalog, 6; Suiboku IV, 4, 37; Sogen MGS II, 15-16. A copy of the "Chopping bamboo" picture, painted on silk, in the Fujii Yurinkan, Kyoto.

* Ibid. Sakyamuni Descending from the Mountains. Signed. See Toyo IX, 70-71; Kokka 227; Sogen no kaiga 20; Siren CP III, 325-326; Genshoku 29/15-16; Suiboku IV, 3; Sogen MGS III, 21, 22.

* Ibid. Winter Landscape; bare trees, two men on horseback approaching a pass. Signed. See Toyo IX, pl. 74; Kokka 220; Sogen no kaiga 100; Toyo bijutsu 34; Siren CP III, 332; Genshoku 29/14; Suiboku IV, 2; Sogen MGS III, 24.

Suiboku IV, 117 (Matsunaga Coll.). Pu-tai and Fighting Cocks. Attributed. Japanese imitation? See also Sogen MGS III, 30.

Nezu Museum, Tokyo. Seated Arhat. Attributed. Unrelated to Liang K'ai. See London Exh. Cat. 972.

Ibid. Seated figure of Bodhidharma. Attributed. Yüan-Ming work. See Nezu Cat., 5.

Fujita Museum, Osaka. Han-shan and Shih-te. Pair, ink on paper. Attributed. Curious and interesting early pictures, not by Liang K'ai. Another pair in the same collection with Liang K'ai signature; probably Japanese copies.

Masaki Art Museum. Han-shan and Shih-te. Seal of the artist. Inscriptions by the monks Wu-hsiang Ching-chao (1234-1306) and Tao-lien Tsu-fang (early Ming). See Masaki Cat. VI. Early Yüan work?

Hakone Museum (formerly Isogai Coll.). Han-shan and Shih-te. Old and fine painting with signature added. See Toyo IX, pl. 65; Sogen bijutsu 129; Suiboku IV, 39; Sogen MGS III, 25.

* Ibid. A pair of herons alighting on rocks. Signed. Fan painting. Good work, possibly genuine. See Toyo IX, 75; Shimbi XV; Suiboku IV, 43; Sogen MGS III, 28.

Osaka Municipal Museum (formerly Abe Coll.). The Sixteen Arhats. Long handscroll. Signature and seals of the painter. Colophons by Wang Wen-chih, dated 1789, and by later Korean and Japanese writers. Ming picture based in part on the composition of the Fan-lung scroll now in the Freer Gallery. See Soraikan I, 17; Osaka Cat. 38.

Kyoto Mingeikan. Han-shan and Shih-te. One is writing on the cliff, the other is holding a jar. Signed. Yüan paintings? See Kokka 40; Osaka Sogen 5-88; Suiboku IV, ref. pl. 10.

Kokka 114 (Masuda Coll.). A monk eating a pig's head; a monk holding a shrimp. Two pictures forming a pair. One signed. Japanese paintings of a later period.

Ibid. 402 (Asano Coll.). Two Taoists in attitudes of obeisance. Old attribution. Yüan work. See also Pageant 432.

Ibid. 688 (Yabumoto Coll., Amagasaki). Portrait of Hui-neng. Inscription by the Priest Tsu-yüan. Attributed. Late Sung, unrelated to Liang K'ai.

Ibid. 729 (Tokugawa Coll., Nagoya). Feng-kan. Attributed. Inscription by Shih-chiao K'o-hsüan, early 13th cent.; the painting of that period. Also in Suiboku, III, 22.

Sogen MGS 24 (Murayama Coll.). Pu-tai carrying a sack. Signed. Copy or imitation? See also Kokka 152; Bijutsu kenkyu 149; Sogen bijutsu 127; Suiboku IV, 38.

Shimbi 14 (Count Matsudaira Coll.). An old drunkard. Album leaf. Signed. Yüan? or Japanese? See also Kokka 145; Sogen MGS III, 26.

Choshunkaku 25. Tsai-sung Tao-che: The Planter of Pines. Man with a hoe. Attributed. Yüan work?

Toyo IX, pl. 69 (Magoshi Coll.). A man seated on a projecting cliff under a pine tree. Signed. Later work—Japanese? See also Osaka Sogen 5-87.

Ibid. pl. 72 (formerly Kuroda Coll.). A man reading and a grazing buffalo by a tree. Signed. Old (Yüan?), but minor painting. See also Toso 78; Suiboku III, appendix 19.

Sogen MGS III, 27 (formerly Count Date Coll.). A monk with a mallet(?). Signed. Old imitation.

Ibid. III, 29 (formerly Marquis Kuroda Coll.). Birds flying over bare trees at sunset. Attributed. Good Sung-Yüan work, unrelated to Liang K'ai. See also Hikkoen, 34.

Ibid. pl. 73 (formerly Count Sakai Coll., now Mrs. Sen Hinohara, Tokyo). Three old trees by a slope in snow. Attributed. Old work in his tradition. See also Kokka 227; Siren CP III, 333; Suiboku IV, 40; Sogen MGS III, 23.

Hinohara Coll., Tokyo. Winter landscape with bare trees. Fan painting. Attributed. Yüan copy or imitation?

Toso 79 (Tokugawa Coll.). Wild geese and reeds on the shore. Album leaf. Signed. Old painting, not by Liang K'ai; see Suiboku IV, 44.

T. Yanagi, Kyoto (1977). Chien-tzu, the shrimp catcher, by a rock with bamboo. Album leaf. Attributed. Yüan or later work.

Takamizawa Collection, Tokyo (1973). Han-shan and Shih-te. Pair of hanging scrolls, ink and heavy colors on silk. Seal of the artist on one, interpolated. Inscription by the monk Shan-k'ai. Yüan period?

* Fogg Art Museum (1924.88). Winter landscape with a dry tree and birds. Fan painting. Signed. Early imitation. See Southern Sung Cat. 25; Lee Landscape Painting 22; China Institute Album Leaves 43, ill. p. 55; Sui-boku IV, 42.

Boston Museum of Fine Arts (29.962). Two birds in a wintry tree. Album leaf. Signed. Copy or imitation, early Ming?

Freer Gallery (07.141). Bodhidharma Crossing the River on a Reed. Attributed. Perhaps Japanese, or Yüan period.

Ibid. (17.186). Landscape with buffalo. Handscroll. Attributed. Coarse work of late Ming? or Korean?

Ibid. (71.7, former Hayasaki and J. D. Ch'en collection). A fisherman with his nets returning home in snow. Fan painting. Signed. 14th cent.? imitation? See Toso 80; Chin-k'uei II, 12.

Honolulu Academy of Arts (2217.1). A gibbon sleeping on a rock. Signed. Identical in composition with one of the triptych attributed to Mu-ch'i in Kokka 425, and probably a modern copy after that picture. See Nanking Exh. Cat. 33; Ecke, Chinese Painting in Hawaii, pl. 52, fig. 2, 3, 64. Another version in a private collection, N. Y.

Metropolitan Museum, N. Y. (47.18.144). A fisherman returning on a winter evening. Signed. Early imitation?

Cleveland Museum of Art (77.5). Scenes of sericulture. Handscroll, ink and light colors on silk. Attributed. Not in his style. See Archives XXXI, 1977-8, p. 119.

* John Crawford Collection, N. Y. (Cat. 33). Strolling on a Marshy Bank. Fan painting. Signed. Genuine? or early imitation? See also China Institute Album Leaves 41, ill. p. 54; Chang Ta-ch'ien Cat. IV, 14; Suiboku IV, 41.

* H. C. Weng Coll., Lyme, N. H. *Tao-chün hsiang:* the supreme Taoist master Chang Tao-ling surrounded by attendants, watching the redemption of the good and the punishment of the evil. Short handscroll in neat pai-miao manner. Signed. Chao Meng-fu's copy of the Huang-t'ing sutra and a colophon by Wang Ch'ih-teng, dated 1568, are attached. Possibly an early work by Liang K'ai? See Southern Sung Cat. 30; Smith and Weng, 184-5.

LIANG SHIH-MIN 梁師閔 or 梁士閔 , t. Hsün-te 循德
Native of Kaifeng. Active in the reign of Hui-tsung; governor of Chung-chou. Started as a poet; but showed a great natural talent for painting. Specialized in flowers and bamboos, and painted also landscapes. G, 20. H, 3. M, p. 391.

* Peking, Palace Museum. River view in winter. Reeds along the snowy bank; mandarin ducks in the water and on the shore. Signed. Inscription by Hui-tsung. Handscroll, ink and colors on silk. See CK ku-tai 43; Kokyu hakubutsuin, 29.

LIEN FU 廉孚
Son of Lien Pu (see below). Painted in his father's style. H, 4. I, 51. M, p. 556.

Taipei, Palace Museum (VA19h). Travellers in Autumn Mountains. Signature. Appears to be the work of a Ma-Hsia follower. See KK hsün-k'an, 28.

LIEN PU 廉布 t . Hsüan-chung 宣仲 h. She-tse lao-nung 射澤老農
From Shang-yang, Honan. Son-in-law of Chang Pang-ch'ang, the last primeminister of the emperor Hui-tsung. Active at the beginning of the Southern Sung period. Landscapes. H, 4. I, 51. M, p. 556.

Taipei, Palace Museum (Va31h). Mountains in autumn. Album leaf. Signed. Late Ming or early Ch'ing picture. See KK shu-hua chi 33.
Muto Cat. 17. A branch of grape vine. Handscroll. Seal of the painter. Later work.
Museum of Far Eastern Antiquities, Stockholm. Autumn Landscape. Inscribed with the name of the painter and the date 1131, but not executed before the Ming period. See Loehr Dated Inscriptions p. 248.

LIN CH'UN 林椿
From Ch'ien-t'ang, Chekiang. Tai-chao in the Academy of Painting in Hangchou c. 1174-1189. Flowers and birds; followed Chao Ch'ang. H, 4. I, 51. J, 4. M, p. 229.

* Peking, Palace Museum. A bird on a branch of a peach tree. Album leaf. Signed. Genuine. See Ku-kung 27; Ch'ing-kung ts'ang 3; CK ku-tai 54; KKPWY hua-niao 7; Sung-hua shih-fu 1; Sung-jen hua-ts'e A, 23; B.VII, 2; Sung-tai hua-niao.
* Ibid. A grapevine, with mantis, dragonfly and other insects. Fan painting. Signed. Genuine. See KKPWY hua-niao 6; Sung-jen hua-ts'e A, 22; B. VIII, 4; Sung-tai hua-niao.
Ibid. Bird on snowy plum blossoms and bamboo. Fan painting. Signed. See Liang Sung 15; Sung-jen hua-ts'e B.XIII; Sung-tai hua-niao.
Che-chiang 7. Birds on hibiscus and bamboo. Handscroll.
Taipei, Palace Museum (SV83). Ten magpies on a cliff and in a pine. Signed: Hua-yüan tai-chao Lin Ch'un hua; only the "Ch'un" character seems altered, the rest genuine, indicating the work of an academy artist of the Ming period named Lin. See Ku-kung IV; London Exh. Chinese Cat. p. 78; Three Hundred M., 106; Wen-wu chi-ch'eng 42; KK chou-k'an 284.
Ibid. (VA8d). A pair of peacocks. Fan painting. Attributed. Yüan? See Palace Museum album Li-ch'ao hua-fu chi-ts'e, 1932; London Exh. Chinese Cat. p. 103; CKLTMHC II, 92.
Ibid. (Va12L). Chrysanthemums. Fan painting. Signed. Good early work.
Ibid. (VA12m). Camellia blossoms after snow. Fan painting. Attributed. Southern Sung work? NPM Bulletin I.6 cover.
Ibid. (VA16f). Spring bird and apricot blossoms. Album leaf. Attributed. Fine Sung work? See NPM Masterpieces II, 27.

Ibid. (VA17L). A branch of cherry-apple blossoms. Fan painting. Signed. Close copy? See KK chou-k'an 8.

Ibid. (VA17w). Lily. Fan painting. Signed. Copy.

Ibid. (VA29e). Oranges. Fan painting. Signed. Copy. See KK chou-k'an 126; CKLTMHC I, 64.

Princeton Art Museum (68.226). Geese on Sand Banks.

Cf. also the fan painting representing Birds and Blossoming Quince in the Nelson Gallery, Kansas City; similar in style to the works of Lin Ch'un. See Southern Sung Cat. 7; Ch'ing-kung-ts'ang 5 (formerly Ti Pao-hsien Coll.).

LIN HUANG　林璜

Unidentified. t. (?)Chung-yü　仲玉　.

Palace Museum, Taipei (SV227). A pair of cranes and blossoming plum in winter. Late Ming picture.

LIN T'ING-KUEI　林庭珪

See under Chou Chi-ch'ang.

LIU CHING　劉涇　t. Chü-chi　巨濟　.

From Chien-chou, Szechuan. B. 1043, d. 1100. Scholar, friend of Wang An-shih and Mi Fu. Bamboos. H, 3. I, 51. L, 35. M, p. 657.

Ch'ing-kung ts'ang 12 (formerly Manchu Household Coll.). A crab eating grains from a stalk. Signed. Seals of Hsiang Yüan-pien and Wang Shih-chen (1526-1590). See Siren CP III, 221.

I-lin YK 66/10. A crab among reeds. Album leaf. Signed.

LIU HSI　劉希

Concubine of Sung Kao-tsung.

Fujii Yurinkan, Kyoto. *Hsüan-chi t'u:* Preparing a Palindrome. Figure painting in the pai-miao manner. Handscroll, ink on paper. Attributed. Close copy? Similar pictures are ascribed to Kuan Tao-sheng of the Yüan period.

LIU SSU-I　劉思義　t. Ch'ing-yen　青巖　.

Tai-chao in the Painting Academy in Hangchou c. 1130-1160. Specalized in landscapes in blue and green. H, 4. I, 51. J, 3. M, p. 658.

Nelson Gallery, Kansas City. A man and two boys standing under a pine tree looking at the rising moon. Ming painting of the Che school. Partly effaced signature in upper left (?). See Toso 70.

LIU SUNG-NIEN　劉松年
From Ch'ien-t'ang, Chekiang. B. ca. 1150, d. after 1225. Entered the Painting
Academy in the Shun-hsi era (1174-1189), became a tai-chao in the Shao-hsi
period (1190-1194). Active in the reign of the emperor Ning-tsung (1195-
1224). Figures, landscapes. Pupil of Chang Tun-li. H, 4. J, 4. M, p. 658.
Also biography by Hsio-yen Shih in Sung Biog. 99-101.

Peking, Palace Museum. Landscapes of the four seasons. Four paintings
　　mounted in a handscroll. Attributed. Fine Ming copy or imitation, time
　　of Chou Ch'en? See Chung-kuo hua VIII, 15; CK ku-tai 46; Kokka, 617
　　and 619; Kokyu hakubutsuin, 172; also *Ssu-ching shan-shui t'u chüan Sung
　　Liu Sung-nien hui* (Peking, 1961).
Ibid. Three men (Confucian, Buddhist, and Taoist) discussing the Tao under
　　pine trees. Fan painting. Attributed. Copy. See Sung-jen hua-ts'e A,
　　89; B. VII, 4.
Liaoning Provincial Museum. Reading the I-ching by an autumn window. Fan
　　painting. Signed. Ming copy? See Liang Sung 40; Liao-ning I, 57;
　　Sung-jen hua-ts'e B. XVIII; Sung Yüan shan-shui 9; also *Sung Liu Sung-
　　nien Ch'iu-ch'uang tu-i* (Peking, 1957).
Tientsin Museum. A man sailing on a lake; a pine tree on the shore. Fan
　　painting. Signed. Copy. See Sung-jen hua-ts'e B.XVI; I-yüan chi-chin 4.
Taipei, Palace Museum (SV85). Guests Conversing in Streamside Pavilion.
　　Signed. Ming work, cf. Ch'iu Ying. See KK shu-hua chi 19; CKLTMHC
　　I, 59; KK chou-k'an 239; Siren CP III, 308.
Ibid. (SV86). Immortals in the Land of Immortality. Attributed. Ming work:
　　another version in the same collection ascribed to Li Sung (SV92); still
　　another by Ch'en Hsien (1405-1496) in the Tofukuji, Kyoto.
* Ibid. (SV87). Five T'ang Scholars. Five gentlemen seated on a garden terrace
　　examining books and writings. Attributed. Southern Sung Academy copy
　　of older (10th cent.) composition. See KK shu-hua chi 38; London Exh.
　　Chinese Cat. p. 77; CH mei-shu I; CKLTMHC II, 5; CKLTSHH; KK
　　ming-hua II, 14; Siren CP III, 309; NPM Quarterly XI/4, pl. 34, 36.
Ibid. (SV88). Two women on a terrace making silk thread. Signed. Colophon
　　by Wang Lo-yü dated 1642. Ming work, by follower of Ch'iu Ying; a seal
　　in lower left corner may be the artist's. See Ku-kung 16; London Exh.
　　Chinese Cat. p. 76; KK ming-hua III, 13; KK chou-k'an 211.
* Ibid. (SV89a,b,c.). An arhat leaning against a tree; an arhat before a rock; an
　　arhat before a screen. Three hanging scrolls, all three dated 1207 and
　　signed. Genuine. For (a) see KK shu-hua chi 45; CAT 49; Che-chiang
　　9; CKLTMHC I, 56; Wen-wu 1955.7, 6 (38); NPM Masterpieces III, 21;
　　NPM Masterpieces V, 15. For (b) see CKLTMHC I, 5-7. For the com-
　　plete set, see NPM Quarterly XI/4, pl. 28-30. An "Anonymous Sung"
　　painting of an arhat in the same collection (chien-mu SV326) may also
　　belong to the series, but the inscription is missing.
Ibid. (SV90). An arhat mending clothes before a screen, another walking; two
　　servants behind. Signed. Yüan or early Ming work, with interpolated sig-
　　nature. See KK ming-hua IV, 9.

* Ibid. (SV91). Drunken monk writing. Signed. Dated 1210. Genuine. See Three Hundred M., 109; CCAT pl. 100; CKLTMHC I, 58; KK ming-hua IV, 8; Loehr Dated Inscriptions p. 263; NPM Quarterly XI/4, pl. 29, 33.

Ibid. (chien-mu SV283). An imperial visit to the jade pond of Hsi-wang mu amidst hollow cliffs and tortuous pines. Good work of Ming date, cf. Chou Ch'en, after Sung composition? See KK shu-hua chi 43.

Ibid. (chien-mu SV286). Travellers on a path; a palace in a valley; a hermit living above. Ming work of Che School.

Ibid. (chien-mu SV288). Examining Antiquities. Good Ming copy of earlier work.

* Ibid. (SH16). The Eighteen Scholars of T'ang examining old books and writings. Handscroll, ink and colors on silk. Attributed to the painter in a colophon by Wang Lai; another by Tung Ch'i-ch'ang, who says it is based on a work of Chou Wen-chü. Yüan? copy after an old composition. Another handscroll painting of the same title, signed "Liu Sung-nien" and dated to the Shün-hsi era (1174-1189), was in the former National Museum, Peking; it bore colophons by Ch'en Te-hsin (dated 1225) and Yü Chi (dated 1361). It is unpublished, and its present whereabouts are unknown. See Loehr Dated Inscriptions p. 255.

Ibid. (chien-mu SH106). The Lan-t'ing Gathering. Handscroll. Ming copy.

Ibid. (chien-mu SH109). The Nine Elderly Gentlemen of Hsiang-shan. Handscroll. Ming copy. See NPM Quarterly XI/4, pl. 27. Note that Chiang Chao-shen, in the accompanying article, attributes a fan painting of this subject in the same collection to Liu Sung-nien or close follower.

* Ibid. (VA1L). A celestial girl offering flowers to a Bodhisattva and some monks. Album leaf. Attributed. Fine Southern Sung work, perhaps by him. See Ku-kung 40; Three Hundred M., 110; CKLTMHC II, 95; NPM Bulletin I.44; NPM Quarterly XI/4, pl. 16.

Ibid. (VA5f). In the Cool of the Pines. Album leaf. Attributed. Ming work. The figures are freely adapted from the "Double Screen" composition ascribed to Chou Wen-chü.

Ibid. (VA7d). Ming-huang Instructing the Prince. Album leaf. Signed. Later copy of old composition.

Ibid. (VA11m). Two Scholars Talking of Antiquity. Fan painting. Signed. Good painting, somewhat later in date, with interpolated signature.

Ibid. (VA12n). The Tea Peddlers. Album leaf. Attributed. Fine work, closer in style to Li Sung, although somewhat later (Yüan?). See Artibus Asiae 37/1-2.

Ibid. (VA13f). After a Wang Wei Poem. Scholar on a terrace gazing at the moon. Album leaf. Originally intended for a work of Ma Yüan, whose "signature" is at the left edge. Copy.

Ibid. (VA15k). Reading the I-ching in the Pine Shade. Fan painting. Attributed. Copy.

* Ibid. (VA16g). Sleeping in the Pine Breeze. Fan painting. Signed. Close early copy, if not original. Mistaken attribution to Li Sung.

Ibid. (VA18h-i). Lieh-tzu Standing in the Wind; A Quiet Talk in the Willow Pavilion. Two album leaves. Attributed. Copies.

Ibid. (Va191). Willow Bridge and Empty Pavilion. Fan painting. Yüan dynasty? See KK Hsün-k'an 30.

Ibid. (VA220). Landscape with sailing boat. Fan painting. Signature. Copy.

Ibid. (VA30b). Huang Ch'u-p'ing changing Stones into Sheep. Album leaf. Signed. Mannered but interesting Yüan-Ming work. See NPM Bulletin I.4, 2-3.

Ibid. (VA35c). Making Silk. Double album leaf. Attributed. Fine work of early Ming date?

Ku-kung VI. A pavilion built over a stream in snow. Fan painting. Signed and dated 1210. Later work—copy? See also Loehr Dated Inscriptions p. 263.

Ibid. XX. Mountain landscape with soldiers on horseback. Signed. Ming work by Che School artist.

KK shu-hua chi XXIII. Two shepherd boys tending four sheep. Yüan-Ming work?

Ch'ing-kung ts'ang 24 (formerly Manchu Household Coll.). Two men seated under pine trees by a waterfall, one playing the ch'in, and four servant boys. Album leaf. Imitation.

Chung-kuo I, 57 (Ti Pao-hsien Coll.). Receiving Good Luck on the New Year's Day; a boy catching a bird in a tree. Later work. See also Chung-kuo MHC 26.

I Yüan Album (Ch'in Ming-chang Coll.). The Four Old Men on Shang-shan. Short handscroll. Signed and followed by two colophons of the Yüan period.

Li Mo-ch'ao. Night scene: a pavilion built over the water under a cliff; an overhanging pine tree. Fan painting. Attributed. Style of the artist, later work.

Mo-ch'ao pi-chi I. Landscape with travellers. Handscroll. Attributed. Ming work.

I-lin YK 50/11. Two men on a ledge by the river beneath willows. Album leaf. Attributed. Early Ming? in Ma-Hsia tradition.

Fujii Yurinkan, Kyoto. A scholar seated under a pine tree. Album leaf. Yüan-Ming work? by follower of Ma Yüan. See Naito pl. 55.

Nanga taisei VIII, 14. A man resting by a mountain stream shaded by two trees. Fan painting. Attributed. Good work of Yüan-Ming date?

Hayashibara Coll., Okayama. Taoist Immortals. Long handscroll, signed. Later work.

Hikkoen 12-13 (formerly Kuroda Coll.). Two ladies by an embroidery table in the garden; a maid offering fruit to her mistress, with a boy playing by a marble bowl. Pair of fan paintings. Attributed. Yüan-Ming pastiches, based on old compositions. (Cf. the "Resting after Embroidery" ascribed to Chou Fang; the two fan paintings in the Freer Gallery ascribed to Chou Wen-chü.)

Choshunkaku 50. Landscape. Attributed. Ming work, Kuo Hsi school. See also Osaka Sogen 5-30.

Seikasha Sogen, 2. A man in a boat by a willow tree. Album leaf. Signed. Imitation.

Bunjin Gasen II, 1 (Ch'en Pao-ch'en Coll.). A man playing the ch'in on a promontory by a stream, high mountains in the background. Good Ming painting.

Toso 82 (Shen Jui-lin Coll.). A man seated under a pine tree by a waterfall. Signed. Seals of Hsiang Yüan-pien. Good Ming work, 16th century?

Ibid. 83 (Ku Ho-i Coll.). The Lan-t'ing Gathering. A number of men seated along the stream composing poems while the wine cups are floated. Short handscroll. Attributed. Ming painting. See also Che-chiang 8; Li-tai jen-wu 23.

Ibid. 84 (formerly Yamamoto Coll.). The Mountain Road to Shu. Signed. Poem by Sung Lien dated 1369. 17th-18th century work, cf. Li Yin.

Ibid. 85 (Okada Coll.). Lu T'ung Preparing Tea. Signed. Poem signed by Chang Yü of the Yüan period, dated to the *hsin-yu* year of the Chih-cheng era (an impossible date). Late copy of old composition, usually called the Tea Sellers, and variously attributed (e.g. to Chao Meng-fu).

Ibid. 92b (Ting Ch'eng-ju Coll.). A man in an oxcart, four servants walking behind with his luggage. Portion of a handscroll. Good painting, possibly after his design.

Nakanishi Collection, Kyoto. 24 scenes of filial piety. Album leaves, mounted on a pair of screens. Signed, dated 1209. Inscriptions by Shen Tu of the early Ming. Ch'ing imitations.

Boston Museum of Fine Arts. A cottage by a river in autumn, fishing boats on the water. Fan painting. Attributed. Fine Ming work, cf. Ch'iu Ying. See Portfolio I, 88; Siren CP III, 310.

* Ibid. (14.57). Two cranes under an overhanging pine tree by a stream. Fan painting. Attributed. Fine 12th century work, possibly as attributed. See Portfolio I, 89; Siren CP in Am. Colls. 85; Munich Exh. Cat. 19.

Freer Gallery (14.60-61.). Scenes from the Lives of Famous Men. Explanatory text between the scenes. Two colored handscrolls; one of them signed. Ming copies. Eight of the illustrations repeated in the same collection (09.221); another set in the Princeton Art Museum; see Rowley Principles, old ed., 3-4.

Ibid. (16.97). A visitor to a mountain retreat received by the host who carries a ch'in. A Ming work of good quality close to Ch'iu Ying in style. See Siren CP in Am. Colls. 132.

Seattle Art Museum (56ch32.25). A river shore with villa; a boat. Fan painting. Attributed. Seal of P'ang Yüan-chi. Early Ming work?

Metropolitan Museum, N. Y. (23.33.2). People gathered on a terrace invoking rain. Fan painting. Badly damaged. Attributed.

Princeton Art Museum (Dubois S. Morris Coll.). Two men playing chess under pine trees. Inscribed with the painter's name. See London Exh. Cat. 1115. Imitation.

John Crawford Collection, N. Y. (Cat. 35). Evening in the Spring Hills. A large knotty pine tree projecting from a cliff over a blossoming plum tree and a low pavilion. Fan painting. Attributed. See also China Institute Album Leaves 31, p. 51; Chang Ta-ch'ien Cat. IV.

British Museum (formerly Eumorfopoulos Coll.). The Three Incarnations of Yüan-tzu. Short handscroll. Imitation.

Vannotti Collection, Lugano. A scholar playing a ch'in beneath pines, with a boy servant. Fan painting. Signed.

LIU TS'AI　劉寀　t. Tao-yüan　道源　or Hung-tao　宏道
Lived in Kaifeng. Active in the reign of Shen-tsung (1068-1085); died after 1123. Specialized in fish. G, 9. H, 3. M, p. 656.

Peking, Palace Museum. Swimming fish and falling blossoms. Handscroll. Attributed. Seals of Wen P'eng of the 16th century, and Ch'ien-lung. See I-shu ch'uan-tung VI; CK ku-tai 36; Siren CP III, 361b.
Ibid. Fishes playing among aquatic plants. Fan painting. Attributed. See Sung-jen hua-ts'e A, 6; B. I, 4.
Taipei, Palace Museum (VA27b). A fish and a lobster. Large album leaf. Colophon by Yao Shou of the Ming period. Imitation. See KK shu-hua chi XII.
Ibid. (chien-mu SH142). Fish Playing Among Waterweeds. Handscroll. Copy.
Chung-kuo MHC 39. Fish Swimming Among Lotus. Attributed.
Chin-k'uei II, 7 (formerly J. D. Ch'en Coll., H. K.). Fishes Playing in a Stream in Spring; aquatic plants below. Album leaf. Attributed. Later work.
* St. Louis City Art Museum (97.26). Fishes swimming among aquatic plants and falling leaves. Handscroll. Attributed. Fine Sung work, perhaps as attributed. See their Bulletin April 1927; *Masterpieces of Asian Art in American Collections II* (Asia House Gallery, 1970), no. 37; Kodansha CA in West I, 28.

LIU TSUNG-KU　劉宗古
From K'aifeng. Tai-chao in the Painting Academy during the Hsüan-ho era (1119-1125). Still active during the Shao-hsing era (1131-1162). Figures. H, 4. I, 51. J, 2. M, p. 658.

Peking, Palace Museum. Ladies enjoying the moonlight on a terrace. Fan painting. Attributed. See Sung-jen hua ts'e A, 10; B. VIII, 8.

LIU YUNG-NIEN　劉永年　t. Chün-hsi　君錫　or Kung-hsi　公錫
From Kaifeng. Born 1030, died after 1088. A relative of the imperial Sung family. Became a high military officer. Figures, flowers and birds. F, 3. G, 19. H, 3. M, p. 656.

Taipei, Palace Museum (SH2). Jade Rabbits under the Flowers; small birds among shrubs, white rabbits, bamboos and roses. Handscroll, ink and bright colors on paper. Ming work.

KK shu-hua chi XLII. Peaks of the Shang Mountain rising over a misty field. Signed. Inscription in the manner of Hui-tsung, and his seals. Seals of Chao Meng-fu. Ch'ing painting, by mediocre Academy artist. See also Chung-kuo I, 39; Chung-kuo MHC 22.

Chin-k'uei II, 8 (formerly J. D. Ch'en Coll., H. K.). A black horse. Album leaf. Attributed.

Sogen 15 (Chin K'ai-fan Coll.). A goose among reeds. Painter's name inscribed in the manner of Hui-tsung. Imitation.

LO-CH'UANG　蘿窗

A priest who lived in the Liu-t'ung Ssu by the West Lake, Hangchou, the same temple where Mu-ch'i lived. Active probably at the end of the Southern Sung period. H, 4. M, p. 750.

Koto-in, Daitokuji, Kyoto. Wild geese and reeds on the shore; herons and wagtail by lotus. Pair of hanging scrolls, ink on silk. Attributed. Late Sung pictures? See Sogen Meigashu 60; Shimbi 20; Suiboku III, 78.

* Tokyo National Museum (formerly Marquis Asano Coll.). A white cock. Signed. Poem by the painter. Genuine. See Bijutsu kenkyu 13; Sogen no kaiga 74; Toyo bijutsu 69; Kokka 406; Suiboku III, 16; Genshoku 29/51; Sogen MGS III, 39.

Toyo IX (Asabuki Coll.). A wild goose alighting; lotus leaves below. Poem by Chu Pen. See also Suiboku III, appendix 26.

Homma Sogen 44. White-robed Kuan-yin seated by waterfall. Poem. Signed. Later work.

University Art Museum, Berkeley (formerly Otobe Coll.). Han-shan reading a scroll. Small hanging scroll, ink on paper. Seal of the artist, a Japanese interpolation. Sung-Yüan work? or early Japanese imitation? See Suiboku III, 33; Gumpo Seigan 6.

LOU KUAN　樓觀

From Ch'ien-t'ang, Chekiang. Chih-hou in the Academy of Painting in Hangchou c. 1265-1274. Followed Ma Yüan in his landscapes, but painted also flowers and birds. J, 8. M, p. 625.

Taipei, Palace Museum (VA17s). A branch of a loquat tree. Fan painting. Signed(?). Copy. See KK chou-k'an 10.

Ibid. (VA22f). Landscape with traveller on horseback. Fan painting. Signed. Copy.

Li-ch'ao pao-hui, 10. Clearing After Snowfall on Mountains and Rivers. Attributed.

* Tokyo National Museum. River landscape with two moored boats. Fan painting. Attributed. Fine late Sung work. See Toso 101; Che-chiang 16; Sogen MGS II, 37; Tokyo NM Cat. 32.

Fujita Museum. Osaka. Wild geese in reeds on a river shore. Attributed. Later work.

Kokka 84. A hibiscus flower. Album leaf. Signed.
* Hikkoen (formerly Kuroda Coll.). Winter landscape; high snow-covered peaks rising above an inlet of water. Fan painting. Signed. Genuine? See also Siren CP III, 296.
* C. C. Wang Collection, New York. A man accompanied by girl attendants coming to visit a hermit in the mountains. Signed. Genuine. See Li-ch'ao pao-hui, I/9.
National Museum, Stockholm. High mountains with leafy trees. Signed. Fine Ming painting, 15th-16th cent.
See also Dotani Kenyu's article in Bunka XX, no. 2, in which a painting of a branch of blossoming plum is reproduced.

LU CHUNG-CHIEN　陸仲潤
Unrecorded. Probably a specialist in Buddhist subjects working in Ningpo in the Southern Sung period.

Rokuoin, Japan. Sakyamuni, Samantabhadra and Manjusri represented as recluses in a landscape setting. Attributed. See Suiboku III, 15.

LU CHANG-YÜAN　陸仲淵
Unrecorded. Perhaps identical with Lu Hsin-chung.

Joshoko-ji, Kyoto. An Arhat. Signed. See Doshaku, 74.
Kokka 371 (Baron Morimura Collection, Tokyo). Three pictures from a series of the Ten Kings of Hell. Signed. See also Doshaku, 75.

LU HSIN-CHUNG　陸信忠
Unrecorded in Chinese books, but mentioned in *Kundaikan Sayuchoki* 127. Active at the end of the Southern Sung period in Ningpo, Chekiang. Buddhist figures.

* Shokoku-ji, Kyoto. Sixteen pictures representing the Sixteen Arhats. Each signed. Two reproduced in Kokka 255; two others in Shimbi V; one of these also in Toyo IX and in Bijutsu kenkyu 45; see also Doshaku, 79.
Honen-ji, Kagawa-ken. Ten pictures representing the Ten Kings of Hell. Signed. One in Kokka 322.
Daitoku-ji, Kyoto. Ten pictures representing the Ten Kings of Hell. Attributed. Two in Kokka 175, the same in Shimbi X. One in Toyo IX. According to Harada, *Nihon Genzai*, p. 41, an inscription on one of them contains the date 1178 and reveals the real artist to be Chou Chi-ch'ang, q.v.
Hoju-in, Aichi-ken. Buddha Entering Nirvana ("Death of the Buddha"). Signed. See Bijutsu kenkyu 45; Doshaku, 76; Osaka Sogen 5-116.
Masaki Museum, Osaka. One of the Kings of Hell. Signed. See Masaki Cat. VIII.

Jodo-ji, Hiroshima. Ten pictures representing the Ten Kings of Hell. Signed. See Doshaku, 77.

Kokka 878 (Choichi Tsukura Coll., Takamatsu). Ten Kings of Hell. Ten hanging scrolls. Signed.

Ibid. 1020 (Zendoji, Fukuoka City). Ten Kings of Hell. Ten hanging scrolls. Signed.

Boston Museum of Fine Arts. (06.317; 06.318; 07.1; 07.2). Four pictures representing four of the Kings of Hell. See Portfolio I, 106-109; CP in Am. Colls. 101-104.

Ibid. (07.8; 07.9). Arhats with attendants in a landscape. Pair of hanging scrolls. Attributed. Yüan works. See Pratapaditya Pal, *Lamaist Art,* Cat. 24a-b.

Ibid. (11.6123-11.6138). Sixteen pictures representing the Sixteen Arhats. One signed. The tenth is a Japanese substitute. See Portfolio I, 110-124; Siren CP in Am. Colls. 65-79; one also in Siren CP III, 208.

Metropolitan Museum, N. Y. (29.100.467). Arhats and attendants. Attributed.

LU SSU-LANG　陸四郎

Unrecorded. Perhaps identical with Lu Hsin-chung.

Fujita Art Museum, Osaka (former Baron Fujita Coll.). An arhat with an incense burner. Signed. See Kokka 459; Doshaku, 73.

LU TSUNG-KUEI　魯宗貴

From Ch'ien-t'ang, Chekiang. Tai-chao in the Academy of Painting in Hangchou c. 1228-1233. Flowers, bamboo, birds and animals. H, 4. J, 8. M, p. 631.

Peking, Palace Museum. Summer flowers. Fan painting. Attributed. Good Southern Sung painting. See Sung-jen hua-ts'e A, 64; B.X, 9; Sung-tai hua-niao.

Taipei, Palace Museum (SV123). A pheasant and a quail on a rock under blossoming trees in spring. Signed. Ming period, after Sung model. See London Exh. Chinese Cat. p. 99; KK shu-hua chi XVII; Che-chiang 14; KK ming-hua IV, 24; Ku-kung III; Wen-wu chi-ch'eng 49; KK chou-k'an 217. A copy of this painting is in the same collection (SV209) titled "Anonymous Sung; New Year's Day."

Ibid. (VA11p). Enjoying Spring; a man drinking wine on a terrace by a blossoming plum tree, with two servants. Album leaf. Attributed. Ming work.

Ibid. (VA12s). Hibiscus and butterfly. Fan painting. Attributed. Hard copy.

Chung-kuo I, 49 (Ti Pao-hsien Coll.). White swans under willows by a stream in spring. Attributed. Imitation. See also Chung-kuo MHC 37.

Shen-chou ta-kuan 10. Two geese on the shore; a third descending from the air. Fan painting. Signed. Neat copy.

Tien-yin-tang I, 2. (Chang Pe-chin Coll.). Birds in spring. Inscribed with the
two characters Ch'ao-hsü　. Ming work, cf. Lü Chi.

Sogen 17 (Hua Chien-ko Coll.). A mother swan carrying two goslings on her
back. Inscribed with the painter's name. Seal of the Ming emperor
Yung-lo. 17th-18th century, European influenced? See also Garland I,
30.

Cheng Chi, Tokyo. Chickens. Signed.

Boston Museum of Fine Arts. A pomegranate and grapes. Signed. Yüan
work?

Metropolitan Museum, New York (47.18.38). Playing cats. Attributed.

MA FEN (PEN)　馬賁

From Ho-chung, Shansi. Tai-chao in the Painting Academy in Kaifeng c.
1119-1125. The first painter of the Ma family to serve in the Academy. Bud-
dhist figures, animals and birds. H, 3. I, 50. M, p. 337.

Nanga Taisei VIII. Houses beneath willows; a visitor and his servant approach-
ing. Fan painting. Attributed. Good Sung work by follower of Ma
Yüan? Reproduction indistinct.

Honolulu Academy of Arts. The Hundred Geese. Handscroll. Inscribed with
the painter's name. Seal of an imperial prince of the Yung-lo period; also
seals of Hsiang Yüan-pien and later collectors. See Bijutsu kenkyu 64;
London Exh. Cat. 1387; Siren CP III, 220; Suiboku III, 80-81; and article
by Edgar Schenck in the Honolulu Academy of Arts *Annual Bulletin* I,
1939, 3-14, in which the painting is placed, probably correctly, as a work
of the Che School, 15th century. Another version on silk, signed and
dated 1087, in the collection of Mr. Chang Shu-t'ung (Cheung Sze-luk),
Hong Kong. Cf. also a related scroll in the Boston Museum of Fine Arts
(50.1455).

MA HO-CHIH　馬和之

From Ch'ien-t'ang, Chekiang. Chin-shih in the Shao-hsing era (1131-1162).
Became vice-minister of the Board of Works, and was still alive in the reign of
Hsiao-tsung, probably dying ca. 1190. Painted illustrations to the *Mao shih*
Odes, the texts of the poems being copied by the emperor Kao-tsung.
Landscapes and figures. H, 4. J, 3. *Ch'ing-ho shu-hua fang,* X. M, p. 337.
Also biography by J. Cahill in Sung Biog. 101-105.

* Peking, Palace Museum. Illustrations to Seven Odes of Pin in the Kuo-feng
section of the Shih-ching. Handscroll, ink and light colors on silk. The
text between the scenes is written in *hsiao-k'ai* script, possibly by the
emperor Kao-tsung. Genuine, excepting one section, *p'o-fu,* "The Broken
Axe," which is inserted from a different scroll. Another scroll with these
compositions in the Metropolitan Museum, N. Y. (1973.121.3; formerly
C. C. Wang). See Siren CP III, 279-280 and II, p. 110; Met. Cat., 1973,
no. 4; Barnhart Wintry Forests cat. 4; Bunjinga suihen II, 78.

* Ibid. The Red Cliff. Illustration to Su Tung-p'o's prose poem. Short handscroll. Unsigned; very fine work, probably as attributed. The poem in the calligraphy of Emperor Kao-tsung is attached. See I-shu ch'uan-t'ung VII; CK ku-tai 49; Fourcade 22; Wen-wu 1956, 1.

Liaoning Provincial Museum. Illustrations to the twelve Odes of T'ang. Handscroll with text between the paintings. Early copies? See Liao-ning I, 42-54.

Ibid. A man sitting on a tigerskin by a riverbank listening to autumn sounds in the moonlight. Fan painting. Inscription by Chao Meng-fu. Seal of Hsiang Yüan-pien. Imitation of Yüan date? See Liang Sung 8; Sung-jen hua-ts'e B.XVIII; Sung Yüan shan-shui 2.

Taipei, Palace Museum (SV62). Spring Boating on the Willow Stream. Signed. Good early copy or imitation? See KK shu-hua chi XXVII; London Exh. Chinese Cat. p. 74; Che-chiang 6; CKLTMHC I, 39; KK ming-hua III, 4; KK chou-k'an 402; NPM Masterpieces V, 11.

Ibid. (SV63). Spare-time Occupation: The Busy Idler; man sitting under a tree twisting a thread. Ming painting. Note, however, that the same motif occurs in the Freer Gallery scroll listed below; based on a design of Ma Ho-chih? See KK shu-hua chi VIII; London Exh. Chinese Cat. p. 75; Wen-wu chi-ch'eng 39; KK chou-k'an 122.

Ibid. (chien-mu SV267). Enjoying the Summer in a Pavilion by a Lotus Pond. Signed. Seals of Yang Wei-chen and others of the Yüan period. Copy of that date?

Ibid. (SH35). Ladies' Book of Filial Piety. Handscroll in 19 sections. Attributed. Good work by artist of Ma Yüan school, late Sung or slightly later. See CCAT 131 (one section).

Ibid. (SA6). Illustrations to the Book of Filial Piety. Album of 15 paintings and 17 leaves of calligraphy. Ink and color on silk. Calligraphy ascribed to the Emperor Kao-tsung, paintings to Ma Ho-chih. Earliest colophon dated 1235. Early Ming copies of Southern Sung compositions? The last leaf, a landscape with buildings and figures, is on different silk, and may be earlier than the rest—Southern Sung? See also Loehr Dated Inscriptions p. 270.

Ibid. (VA31). Sound of the River by the Grass Pavilion. Fan painting. Attributed. Fine Southern Sung work in his style. See NPM Bulletin II, 4, cover.

* Ibid. (8VA17e; VA7f). Old Tree by the Water; Cranes Crying by the Clear Spring. Two double album leaves, ink on paper. Signed. Good early works in his style. See CH mei-shu 1; KK ming-hua IV, 3 and III, 5; Three Hundred M., 102; CKLTMHC I, 40; NPM Masterpieces II, 25.

Ibid. (VA12i). Mandarin Ducks by Willow Banks. Fan painting. Attributed. Southern Sung, unrelated to Ma Ho-chih.

Cf. also Taipei, Palace Museum (VA25A). Riding a Donkey in the Autumn Grove. Album leaf. Style of Ma Ho-chih.

Pageant 115 (formerly National Museum, Peking). A man with a stick walking under a wind-swept tree. Signature and seal of the painter. Imitation. See also Siren ECP 44.

Photographs by Yen Kuang Co., Peking. Illustrations to Ten Odes of Ch'en in the Kuo-feng section of the Shih-ching. Formerly in the Manchu Household collection. Handscroll. Early copy? See Siren ECP II, 43. Another scroll with the same compositions in the British Museum, London (formerly C. T. Loo Coll.). See Bunjinga suihen II, 77. Note that a copy of these compositions by Hsiao Yün-tsung is in the Palace Museum, Taipei (CA40).

Chung-kuo MHC 17. Birds and a flowering tree. No relationship to Ma Ho-chih.

Garland I, 19. Illustrations to the Odes of Yung. Two sections of a handscroll. Attributed.

Ch'ing-kung ts'ang 91 (formerly Manchu Household Coll.). Four officials on horseback escorted by men on foot. Album leaf. Imitation.

* Fujii Yurinkan, Kyoto. Illustrations to Twelve Odes of T'ang in the Ta-ya section of the Shih-ching. Handscroll, ink and slight color on silk. The text written in hsiao-k'ai script. Genuine. See Yurintaikan I; Toso 60; Toyo bijutsu 30; Genshoku 29/11; Bunjinga suihen II, 76.

Kyoto National Museum (formerly Ueno Collection). Illustrations to Twelve Odes of T'ang in the Kuo-feng section of the Shih-ching. Handscroll, ink on paper. Seals of Hsiang Yüan-pien. Late copy of the scroll now in the Liao-ning Museum, see above. Published as a scroll reproduction by Hakubundo.

Toso 62 (Hayasaki Coll.). A butterfly and a cicada in a willow tree. Fan painting. Attributed. Southern Sung work, probably not by Ma Ho-chih. See also Pageant 114.

Ibid. 64 (Lu Hsiang-yeh Coll.). Spirits of the sea paying homage to Kuan-yin, who sits on a cliff by the water. Late Ming, cf. Ting Yün-p'eng etc.

* Soraikan II, 20. Two deer by a waterfall. Fan painting, ink and slight color on silk. Attributed. The work of a close follower? See also Kokka 570; Osaka Cat. 39(b).

Cheng Chi, Tokyo. Breaking the Axe: illustration to a poem in the Book of Odes. Two men on the bank of a river; a broken bridge. Short handscroll, ink and colors on silk. Interesting early painting.

* Boston Museum of Fine Arts (51.698). Illustrations to six (originally ten) of the so-called Odes of P'ei of the Hsiao-ya section. Handscroll, ink and slight color on silk. The accompanying text written in hsiao-k'ai script, possibly by the emperor Kao-tsung. Probably genuine. See Siren CP III, 275-278; Paine Figure Compositions of China and Japan, VI, 1-4; Kodansha BMFA 98-9; Bunjinga suihen II, 79; Unearthing China's Past 120.

* Freer Gallery (19.172). Eight illustrations to the Odes of Pin. Handscroll, ink on paper. Seals of the Chin Emperor Chang-tsung; title and colophon by Wen Cheng-ming. Attributed. Important early work, late Sung or Yüan? See Freer Figure Ptg. cat. 6.

* Cleveland Art Museum (78.68). Two boats moored below a city wall. Fan painting, ink, colors and gold on silk. Two lines of poetry written by Yang Mei-tzu, on a separate piece of silk, seal dated 1199. Attributed. Not in his style, but fine work of the twelfth century. See Toso 63; Kokka 537; Pageant 116; Loehr Dated Inscriptions p. 261.

Ibid. (19.136). Scholar sleeping in a house. Attributed. Ming work in Ma Ho-chih tradition.

Ibid. (16.100). Scholar sleeping in house, servants outside. Attributed. Ming work, close in style to Hsieh Shih-ch'en.

Ibid. (16.113). Lao-tzu riding the clouds in a cart. 17th century, follower of Ch'en Hung-shou.

* Princeton Art Museum (L118.71, formerly Chiang Ku-sun Coll., Taipei). Illustrations to Six Odes in the Hsiao-ya section of the Shih-ching. The paintings are much damaged and repaired and the early sections may be replacements; but parts of the scroll may be original.

C. D. Carter Collection, Scarsdale, N. Y. A man seated in a garden. Attributed. Ming work.

Ching Yüan Chai Collection, Berkeley. Illustrations to the Ode Ts'ai Ch'ih: the sister of Prince Wen of Wei addressing two noblemen. Fan painting. Late Sung or Yüan, in the style of Ma Ho-chih. See China Institute Album Leaves #10, p. 37.

C. C. Wang Collection, N. Y. A scholar approaching a pavilion. Fan painting. Attributed. Work of Southern Sung follower? See Wango Weng, Gardens in Chinese Art, China House Gallery, 1968, fig. 7.

W. Hochstadter Collection, Zurich (formerly John Herron Art Institute, Indianapolis). Six scenes from the Odes of Ch'i. Handscroll on silk. Copy.

MA HSING-TSU 馬興祖

Son of Ma Fen. Tai-chao in the Painting Academy in Hangchou in the Shao-hsing era (1131-1162). Acted as advisor to the emperor Kao-tsung. J, 3. M, p. 337.

I-shu ch'uan-t'ung VII, 2. A small bird on the stalk of a lotus plant, and a dragonfly. Album leaf. Yüan or later. See also Sung-jen hua-ts'e A, 18; B. IV, 2; Sung-tai hua-niao.

Hikkoen (formerly Kuroda Coll.). Waves. Fan painting. Attributed. Fine late Sung or Yüan work. See Artibus Asiae, vol. 33/4 (1971), p. 259, pl. 14.

Kawasaki Cat. 16. A pair of handscrolls illustrating Liu Pei's visit to Chu-ko Liang. Ming works. See also Choshunkaku 48-49.

MA K'UEI 馬逵

Son of Ma Shih-jung. Active c. 1180-1220. Landscapes, figures, flowers and birds. J, 6. M, p. 338.

Taipei, Palace Museum (VA12q). Leaving the Willow Bank. Fan painting. Attributed. Southern Sung work, by minor master. See KK ming-hua IV, 16.

Ibid. (Va17t). Butterfly and Rose Flower. Fan painting. Copy. See KK chou-k'an I, 11.

Ibid. (VA18p). Young Bird on a Cherry-apple Branch. Album leaf. Signed. Copy.

Ibid. (Va180). The Purple Hortensia. Fan painting. Signed. Copy.

* Ibid. (VA21f). Pure Summer in the Water Village. Fan painting. Signature indistinct: perhaps intended to read "Ma Yüan." Fine Southern Sung work.

KK chou-k'an 484. Watermill under willow trees. Album leaf. Attributed. Imitation.

Garland I, 26 (Wang Shih-chieh, Taipei). Landscape. Long handscroll, colors on paper. Signed. Ch'ien-lung and other seals. Brilliant work; of Ming period?

Chishaku-in, Kyoto. High peaks rising from a stream, large trees in the foreground. Probably a Yüan picture by a follower of Li T'ang. See Kokka 236; Shimbi XV.

Shimbi IX (Count Tokugawa Coll.). A man playing the ch'in under a pine by a river; a man on a promontory looking at plum trees. A pair of hanging scrolls. Attributed. Yüan or early Ming works. See also Kokka 196.

Ibid. XIII (Baron Iwasaki Coll.). Lin Pu admiring plum blossoms. Attributed. Early Ming work. See also Toyo VIII.

* Toyo VIII (K. Magoshi Coll.). A man and a boy in a boat on an evening lake. Fan painting. Attributed. Good Southern Sung work. See also Siren CP III, 283; Toso 87.

Soken'an kansho II, 53 (Matsumoto Coll.). Three men in a boat on a river under willows. Ming painting.

Fujita Museum, Osaka. Man admiring a blossoming plum tree. Attributed. Ming work.

Hikkoen, p. 10 (formerly Kuroda Coll.). A man in a house beneath trees; two porters arriving. Album leaf. Attributed. 14th cent.? by follower of Hsia Kuei.

Ibid. p. 59 (formerly Kuroda Coll.). Mountain landscape with three figure scenes, apparently illustrating successive events in a story. Late Sung work?

* Boston Museum of Fine Arts (14.58). Temple buildings near the seashore; a man approaching. Fan painting. Attributed. Good Southern Sung work. See Portfolio I, 91; Southern Sung Cat. 20; Siren CP III, 282.

Freer Gallery (11.225). Melons and Insects. Handscroll. Signed. Early Ming work of good quality.

Ibid. (70.34). Fisherman preparing food on riverbank. Signed. Ming work, cf. Wu Wei. See Meyer Cat. 27.

Ars Asiatica IX, p. 21 (Martin White Coll.). Misty morning, travellers wading in a mountain stream. Imitation.

MA K'UEI-CH'ING　馬騤卿
Unidentified; Sung period? See Y, p. 183, also *Shan-hu-wang hua-lu*, 19, 19, which may refer to the painting listed below.

* Seikasha Sogen, 9. A man and his servant in a boat among the reeds by moonlight. Fan painting. Signed.

MA KUNG-HSIEN　馬公顯

Son of Ma Hsing-tsu. Tai-chao in the Painting Academy in the Shao-hsing era (1131-1162). Landscapes, figures, flowers and birds. J, 3. M, p. 338. (Note: this is the information given in standard sources. However, *Hua-chi pu-i* states that he was the grandson of Ma Yüan; and the style of the painting listed below agrees better with the dating that this implies.)

* Nanzen-ji, Kyoto. The hermit Yao-shan talking with Li Ao on a terrace under a pine tree. Ink and slight colors. Signed. See Kokka 221; Shimbi I, Toyo VIII; Toso 86; Siren CP III, 281; Sogen no kaiga 41; Suiboku II, 39.

MA LIN　馬麟

Son of Ma Yüan. Active early to mid-13th century. Chih-hou in the Academy of Painting. Landscapes, flowers and birds. Followed the family tradition. J, 8. M, p. 338. Also biography by Robert Maeda in Sung Biog. 105-109.

* Peking, Palace Museum. Two branches of blossoming plum. Signed. Poem by Empress Yang; her seal dated 1216. Genuine. *Ssu-yin* half-seal. See KK shu-hua chi XI; KKPWY hua-niao 12; NPM Bulletin II, 2, p. 14; Nanking Exh. Cat. 35; Speiser, Ma Lin 1.
Ibid. Two men standing in front of a waterfall. Signed. Ming work of Che School, cf. Chang Lu. See Chung-kuo hua XII, 14; Fourcade 1.
Ibid. An Orchid plant. Fan painting. Attributed. See Sung-jen hua-ts'e A, 84; B. VII, 7.
Ibid. Green Oranges. Fan painting. Signed. Copy. See Sung-jen hua-ts'e A, 52; B. X, 2; Sung-tai hua-niao.
Ibid. Peacocks and red plum blossoms. Album leaf. Signed "Ma..." Attributed, but not in Ma Lin's style. See KKPWY hua-niao 5; Sung-jen hua-ts'e A, 53; B. IX, 7.
Shanghai Museum. Scholar with a staff and a servant in a landscape. Fan painting. Signed. Copy or imitation. See Liang Sung 23; Sung-jen hua-ts'e B. XIII.
Liaoning Provincial Museum. A willow-lined lake and river scene. Handscroll, colors on silk. Interpolated signature. Good Ming copy? See Liao-ning I, 58-62.
Taipei, Palace Museum (SV109). A traveller on muleback passing through a mountain gorge. Signed. Poem by Ch'ien-lung. Ming work. See KK shu-hua chi VIII; KK chou-k'an 112.
* Ibid (SV110). Listening to the Wind in the Pines. Signed. Inscription by the emperor Li-tsung and his seal, dated 1246. Genuine, fine work. See Three Hundred M., 117; CAT 60; CKLTMHC I, 71; KK ming-hua III, 24; Skira 64; Loehr Dated Inscriptions p. 273; KK shu-hua chi 36.
Ibid. (SV111). Three Taoist Divinities on an Excursion. Attributed. Fine Taoist temple painting, of 14th century date? Unrelated to Ma Lin. See CKLTMHC II, 47.
Ibid. (SV112). Three quails under a blossoming plum tree in snow. Signed. Ming picture. See KK shu-hua chi 11; London Exh. Chinese Cat. p. 98;

KK chou-k'an 159.

Ibid. (N1). Portraits of emperors Fu-hsi, Yao, Yü, T'ang, and Wu-wang of Chou. Copies? See KK chou-k'an V, 105-109; NPM Masterpieces IV, 1-5; Fu-hsi also in Li-tai III; NPM Quarterly VIII/4, pl. 1, p. 16.

Ibid. (SA4). Eight flower studies. Album leaves. Signed. Inscriptions purportedly by the empress Yang, dated 1216. Seals of post-Sung periods. Post-Sung works; copies? See KK chou-k'an II and III, 48-55; Loehr Dated Inscriptions p. 265.

* Ibid. (VA1n). Fragrant Spring after Rain; old trees by a mountain brook. Signed. Genuine. See CAT 59; KK ming-hua IV, 20; NPM Bulletin II, 2, p. 13; Skira 87.

Ibid. (VA4h). Two birds on the branch of a thorny shrub in front of a trunk in snow. Album leaf. Signed. Inscription by Yüan Mei-tzu. *Ssu-yin* half-seal. Copy? See KK ming-hua IV, 22; NPM Masterpieces I, 12.

Ibid. (VA8c). Branches of plum blossoms and bamboo. Album leaf. Attributed. His style, possibly his work. See Palace Museum Album 1932 (Li-ch'ao hua-fu chi-ts'e); London Exh. Chinese Cat. p. 102; CH mei-shu I; CCAT pl. 102; CKLTMHC II, 93; KK ming-hua IV, 21.

Ibid. (VA11n). Kingfishers on a Hibiscus. Album leaf. Attributed. Copy of work in style of Li Ti.

Ibid. (VA12r). Releasing the Tortoise. Album leaf. Attributed. Excellent work of late Sung or Yüan date, by follower of Liu Sung-nien?

Ibid. (VA13k). Watching the Stream. Album leaf. Signed. Copy.

* Ibid. (VA29b). Waiting for Guests by Lamplight. A nobleman in a garden pavilion gazing at blossoming trees by moonlight. Fan painting. Signed. Genuine. See KK chou-k'an VI, 125; CAT 61; CKLTMHC I, 72; KK ming-hua III, 25; NPM Quarterly I, 2, pl. XXX; Skira 74.

* Ch'ing kung ts'ang. A man seated on a projecting cliff contemplating the view between the cliffs. Fan painting. Signed. Inscription by Yang Mei-tzu. Genuine?

Shen-chou ta-kuan I. Plum tree and a rabbit in snow. Attributed. Imitation.

Chin-k'uei 7 (formerly J. D. Ch'en Coll., H. K.). High Mountains and Flowing Water. Scholar and servant on the bank; pine from the opposite shore overhanging. Ming copy or imitation.

Formerly J. D. Ch'en Collection, H. K. A scholar standing in the wind, his robe blowing. Signed. Copy or imitation.

Garland I, 31. (Wang Shih-chieh Coll., Taipei). Hibiscus at Dawn; reflection of the moon in the water. Signed.

Ibid. I, 32. Sakyamuni Leaving the Mountains. Signed. Imitation.

Tien Yin Tang II, 9 (Chang Pe-chin Coll., Taipei). Cottages under bare trees, snowy hills. Fan painting. Attributed. Late copy; cf. Anon. Sung leaf in Sung-jen hua-ts'e, A, 28.

Fujii Yurinkan, Kyoto. A rustic homestead at the foot of a steep cliff; drunken men fighting and being brought home. Signed. Copy. See Yurintaikan III.

Hakone Museum (formerly Kuroda Coll.). Fisherman seated under a shed by a river in winter. Possibly a Korean painting; unrelated to Ma Lin. See Kokka 162; Toso 91; Sogen meiga 25; Bijutsu shuei XIV; Sogen MGS III, 18.

* Nezu Museum, Tokyo. Evening landscape; swallows skimming over the river. Signed. Two lines of a poem written by the emperor Li-tsung and his seal, dated 1254. Genuine. See Kokka 677; Sogen meigashu 23; Sogen no kaiga 110; Nezu Cat. 2; Siren CP III, 294; Loehr Dated Inscriptions p. 274; Suiboku II, 43.

Osaka Municipal Museum (Abe Coll.). Pavilion among willows in rainstorm. Album leaf, ink on silk. Signed. (The reading "Ma Chao" is an error.) Imitation. Inscription opposite said to be by the emperor Ning-tsung (reigned 1195-1224). Seal of emperor Li-tsung dated 1255. See Soraikan II, 20, 8; Loehr Dated Inscriptions pp. 274-175; Osaka Cat. 39 (11).

Myoshin-ji, Kyoto. Samantabhadra in the shape of an old man seated on an elephant. Attributed. Probably of the Yüan period. See Kokka 116; Shimbi VII; Toyo VIII.

Shimbi XI (Iwasaki Coll.). Autumn and Spring. A man on a garden terrace under tall pines looking at the moon; a man in a pavilion by a stream looking at plum blossoms. A pair of hanging scrolls. Attributed. Early Ming works.

Kokka 25. The waves and the moon. Fan painting. Attributed. Yüan painting?

* Kokka 217 (Baron Yamamoto Coll.). Two sparrows in a blossoming plum tree. Album leaf. See also Sogen no kaiga 57; Sogen bijutsu 33. Another painting of a similar subject, probably originally a pair with the above, with the same zakka-shitsu seal, is in the Goto Art Museum, Tokyo. See Sogen no kaiga 56; Sogen bijutsu 34. Both attributed; of the period and school. See article by Takaaki Matsushita in Yamato Bunka, 13. Still another painting of this type, two birds in a blossoming plum tree, attributed, Zakka-shitsu seal, in Yamada Collection, Ashiya.

Hikkoen (formerly Kuroda Coll.). Lin Pu standing on a terrace looking at a crane. Fan painting. Imitation.

Toso 92a (Fan Jo Coll.). A plum tree bending over a stream in moonlight. Handscroll. Signed. Copy.

Ibid. 90 (Suenobu Coll.). Han-shan and Shih-te. Poem by the priest Ching-shan. Attributed. 14th century? Unrelated to Ma Lin. See also Sogen MGS III, 19.

J. Nakamura Collection, Tokyo (formerly Akaboshi Coll.). Pu-tai standing under willows singing; Pu-tai meeting a scholar under bamboo. Two small pictures. The latter signed.

Ibid. Spring Morning; sharply-cut rocks along a misty river, an old plum tree and ducks in the water. Signed.

Choshunkaku 23. Herdboy and buffalo returning homeward beneath bare trees. Attributed. Yüan-Ming picture.

Masaki Museum, Osaka. Landscape with two figures. Fan painting, accompanied by an inscription by Emperor Ning-tsung dated 1196. Copies?

Eda Bungado Collection, Tokyo. Sakyamuni Descending from the Mountains. Ink and light color on silk. Seal of Ma Lin.

Kobijutsu 48 (former Tokugawa Coll.). Herdboy astride a buffalo under bamboo. Hanging scroll, ink and color on silk. Attributed.

Boston Museum of Fine Arts. A nobleman on a stag viewing autumn foliage by a lake. Album leaf. Signed. Early imitation? See Portfolio I, 98; Siren CP III, 293.

Ibid. Ling-chao Nü standing in the snow. Album leaf. Seal of the painter. Fine Sung work; not by Ma Lin? See Siren CP III, 292; Portfolio I, 99.

Ibid. Two birds sleeping on a maple branch. Album leaf. Signed. Poor Ming imitation. See Portfolio I, 100.

Ibid. (14.59). Evening mist over a bay; two men walking along the shore. Fan painting. Attributed. Fine Southern Sung work. See Portfolio I, 101; Siren CP in Am. Colls. 87; Munich Exh. Cat. 23.

Cleveland Museum of Art (52.285). Landscape with flying geese. Album leaf, ink and green wash on silk. Copy or imitation. See China Institute Album Leaves 34, no ill.; S. E. Lee, *Scattered Pearls Beyond the Ocean* 7.

* Ibid. (61.421). Scholar reclining and watching rising clouds. Fan painting. Accompanied by facing calligraphy by Emperor Ning-tsung, dated 1256. Odd, but possibly genuine. See China Institute Album Leaves 35; S. E. Lee, *Scattered Pearls Beyond the Ocean* 6; Lee, Colors of Ink cat. 3.

Fogg Museum, Cambridge (1922.74). Fisherman under an overhanging rock. Album leaf. Attributed. 14th century?

Ibid. (1929.239). River scene with large overhanging rock; houses on the shore, a man and boy in a boat. Fan painting. Attributed. Good late Sung work?

Metropolitan Museum, N. Y. Houses on a hillside beneath a pine; a man walking below. Attributed. Sung work. See China Institute Album Leaves 36, ill. p. 53.

Ibid. (13.220.99b). Pomegranates. Album leaf. Signed. See China Institute Album Leaves 40, no ill.

Ibid. (47.18.28). Plum branch with snow. Signed. Copy?

Ibid. (1973.120.10; former C. C. Wang Coll., N. Y.). Orchid. Album leaf. Signed. Genuine. See Met. Cat., 1973, no 11; Southern Sung Cat. 21.

S. Juncunc Collection, Chicago. Four magpies in a pine tree. Signed. Ming picture.

C. C. Wang Collection, N. Y. Man on ledge beneath pine gazing at distant mountains. Signed. Copy, similar in composition to "Ma Yüan" in the Taipei Palace Museum, SV108.

Ibid. Landscape with buildings and figures. Handscroll, ink and colors on silk. Seals of the artist.

MA SHIH-JUNG　馬世榮

Son of Ma Hsing-tsu. *Tai-chao* in the Painting Academy in the Shao-hsing era (1131-1162). Landscapes, figures, flowers and birds. J, 3. M, p. 338.

Peking, Palace Museum. Landscape with high pavilions. Fan painting. Attributed. Minor 12th-13th century work. See Sung-jen hua-ts'e A, 32; B.X, 5.

Taipei, Palace Museum (VA11L). Monkey and Deer at the Cliffs of Immortality. Fan painting. Signed. Ming copy? Probably a pair with the fan painting ascribed to I Yüan-chi in the same collection (VA15f).

MA YUNG-CHUNG 馬永忠
Active c. 1253-1258. From Chien-t'ang, Chekiang. *Tai-chou* in the Academy of Painting c. 1253. Painted Buddhist figures in the style of Li Sung. H, 4, p. 107; J, 8, p. 170; M, p. 338; Hua-shih hui-yao.

Taipei, Palace Museum (VA21h). Fragrant Lotus at the Water Pavilion. Album leaf. Attributed. Early Ming? of good quality.

MA YÜAN 馬遠　　t. Ch'in-shan 欽山
From Ho-chung, Shansi. Son of Ma Shih-jung. Tai-chao in the Academy of Painting in the Shao-hsi era (1190-1194), still active at the beginning of the emperor Li-tsung's reign (1225-1264). Continued the family tradition and was strongly influenced by Li T'ang. Co-founder of the so-called Ma-Hsia School. J, 7. M, p. 338. See also biography by Richard Edwards in Sung Biog. 109-116; another by Michael Sullivan in EB XI, 723-725; another by Sherman Lee in EWA IX, 590-594; and Teng Pai and Wu Fu-chih, *Ma Yüan yü Hsia Kuei* [MY/HK], (Shanghai; 1958, in CKHCTS series.)

Peking, Palace Museum. *Ta ko t'u:* Dancing and Singing, peasants returning from work. Signed. Ming work? Perhaps after a Sung original. See Chung-kuo hua X, 12; CK ku-tai 50; MY/HK 1; Wen-wu 1960.7, 3; CK ming-hua 26; Kokyu hakubutsuin, 166. Another version in KK shu-hua chi 40 called "Anonymous Sung"; still another, attributed to Tai Chin, in the collection of J. S. Lee, Hong Kong.

* Ibid. Twelve Scenes of Water. Handscroll, consisting of twelve separate paintings, all but one with descriptive titles. Seals of Liang Ch'ing-piao, Keng Chao-chung and others; colophons by ten Ming dynasty writers, dated between 1548 and 1577. Attributed. Fine late Sung work, probably as attributed. See Chung-kuo hua I, 14; II, 3; and *Sung Ma Yüan Shui t'u* (Peking, 1958); also the article by Robert J. Maeda in Artibus Asiae, vol. 33/4 (1971).

* Ibid. Ducks on the water below a blossoming tree growing from high rocks. Album leaf. Signed. Fine, genuine work. See Sung-jen hua-ts'e A, 44; B. IV, 7; Siren CP III, 288.

 Ibid. Burning incense by a mountain brook. Fan painting. Attributed. Ming copy or imitation. See CK shu-hua I, cover; Sung-jen hua-ts'e A, 46; B. VII, 10.

* Ibid. White Roses. Album leaf. Signed. Genuine? See Sung-jen hua-ts'e A, 45; B. IV, 8.

 Ibid. Scholar and servant on a terrace, a flying crane. Fan painting. Signed. Ming copy or imitation. See Sung-jen hua-ts'e B, XIII.

Ibid. A fishing boat on a river in spring. Fan painting. Attributed. Later work, not in his style. See Sung-jen hua-ts'e A, 79.

* Shanghai Museum. A palace among willow trees on a moonlit night. Fan painting. Signed (the signature partly cut away). Genuine. See Liang Sung 22; Sung-jen hua-ts'e B, XIV; Sung-jen hua-hsüan 1.

Ibid. Scholar leaning on a pine over a pool, a servant with a ch'in. Large album leaf. Signed. Ming imitation. See Shang-hai 4; TSYMC hua-hsüan 9.

Ibid. The Three Old Men on the Mountainside. Horizontal composition. Attributed. Ming dynasty, 15th-16th century. See MY/HK 3; Gems I, 3.

Ibid. Mountains along a river in snow and mist; a high temple pavilion. Handscroll. Inscriptions by Empress Yang, wife of the emperor Ning-tsung. Ming, 16th century? See MY/HK 4-5; Gems II, 4.

Tientsin Museum. Two men meeting on a terrace, with their servants; a boy bringing a p'i-p'a. Album leaf. Two lines of verse written by Li-tsung(?). Early work in the style. See I-yüan chi-chin 3; Sung-jen hua-ts'e B, XVI. The same painting(?) published in Suchou 7 and Liang Sung 60 as Anonymous Sung.

Li-tai jen-wu 25. Man and boy in a pavilion by a lotus pond. Album leaf. Signed. Copy?

Taipei, Palace Museum (SV96). Immortals looking at a waterfall. Attributed. Hard Ming work.

Ibid. (SV97). A man on a projecting cliff drinking wine and enjoying the moon. Attributed. Ming work by Chung Li, whose signature and seal are in the lower left corner. See KK shu-hua chi 28; KK ming-hua IV, 12; KK chou-k'an 471.

Ibid. (SV98). Playing the lute in the moonlight. Attributed. Ming imitation or copy. See CAT 55; KK ming-hua III, 17.

Ibid. (SV99). Fisherman Returning along Autumn Banks. Signed. Ming period, 15th-16th century; cf. Shih Chung, Chiang Sung, etc. See KK chou-k'an 99.

Ibid. (SV100). Crossing the Wooden Bridge in Snow. Signed. Ming copy or imitation.

Ibid. (SV101). Solitary Fisherman on an Autumn River. Seal of the painter. Poem by Ch'ien-lung. Ming, 15th century? See Ku-kung XI; London Exh. Chinese Cat. p. 86; Three Hundred M., 112; MY/HK 6; Wen-wu chi-ch'eng 46; KK chou-k'an 22.

* Ibid. (SV102). Egrets in a Snow Landscape. Signed. Genuine? See KK shu-hua chi 9; CKLTMHC I, 66; KK chou-k'an 142; NPM Masterpieces V, 16.

* Ibid. (SV177). A Banquet by Lantern Light: a large hall, with servants seen inside, in a palace garden at evening; dancers in the courtyard, seen through plum trees. Poem composed by Emperor Ning-tsung and inscribed by Yang Mei-tzu (cf. Chiang Shao-shen article in their *Bulletin* May 1967). Not presently ascribed to Ma Yüan, but a superb work of his time and style, further associated with him by the "signed" version noted below. See Ku-kung XIX; London Exh. Chinese Cat. p. 123; CAT 56; KK ming-hua III, 18; NPM Bulletin II, 2, inside cover; Hills, 89.

Another version of the composition in the same collection (SV103), with a spurious signature of Ma Yüan, is a Ming copy, 15th century? See KK shu-hua chi 3; Three Hundred M., 111; CH mei-shu I; CKLTMHC I, 65; KK ming-hua IV, 13; Wen-wu 1960.7, 30; KK chou-k'an 106.

Ibid. (SV104). Facing the Moon; a man seated under leafy trees on a cliff projecting over a gully. Ming work, perhaps by Chung Li (cf. SV97). See KK shu-hua chi 19; London Exh. Chinese Cat. p. 85; CH mei-shu I; CKLTSHH; Wen-wu chi-ch'eng 45; KK chou-k'an 238.

Ibid. (SV105). Snow Landscape; mountains and tall pines by a cottage in snow. Signed. Interesting Ming work, 16th century. See Ku-kung VIII; CKLTMHC II, 44; Siren CP III, 286.

Ibid. (SV106). Snow Landscape. Attributed. Ming period, Che School work of fairly good quality.

Ibid. (SV107). Landscape; a cottage among bare trees in a winter landscape. Horizontal composition. Attributed. A meaningless "Li Ch'eng" signature in lower right. Ming work.

Ibid. (SV108). Landscape and Figures; two men under pine trees on a terrace overlooking a misty valley. Horizontal composition. Attributed. Good early Ming(?) work in his style. See Ku-kung VI; CKLTMHC II, 42.

Ibid. (chien-mu SV292). Cold Cliff and Piled Snow; two men in a pavilion under tall pine trees. Signed. Ming work of Che School.

Ibid. (chien-mu SV293). Contemplating the Moon under Pines. Signed. Good Ming work of Che School. See Ku-kung 31.

* Ibid. (chien-mu SV294). Riding the Dragon; an immortal on a dragon descending through clouds and mist. Signed. Genuine work. See Ku-kung 24.

Ibid. (chien-mu SV295). Wang Hsi-chih Gazing at Geese. Ming work of good quality.

Ibid. (chien-mu SV296). Bamboo and Crane. Attributed. *Ssu-yin* seal; also seal of Liang Ch'ing-piao. Early copy? or imitation?

Ibid. (chien-mu SV297). Pear Flowers and Mountain Bird. Attributed. Fine Ming Academy work? See KK shu-hua chi 41.

Ibid. (chien-mu SH116). Twenty Views of Water. Handscroll, ink and light colors on silk. The scenes form a continuous composition, beginning with the Red Cliff; descriptive titles are written above. Inscription at the end with the date 1141, interpolated. Attributed. Yüan or early Ming period. See KK chou-k'an, Special Number, October 10, 1930; Loehr Dated Inscriptions p. 253.

Ibid. (SA3). Collection of Small Paintings. Album of 14 leaves, consisting of six paintings of plum branches, all signed; eight small paintings of unusual shape, four of flowers and four landscapes with figures, attributed.

* Ibid. (VA1m). On a Mountain Path in Spring; a scholar standing under a bare willow followed by a servant with his ch'in. Album leaf. Signed. Genuine. Couplet written by Yang Mei-tzu. See Nanking Exh. Cat. 389; Three Hundred M., 113; CAT 52; CKLTMHC I, 67; KK ming-hua III, 19; NPM Bulletin II, 2, p. 11; Skira 82.

* Ibid. (VA4f). Through Snowy Mountains at Dawn; a man returning over a snow-covered field carrying a pheasant over a pole and driving two pack-mules in front of him. Large album leaf in the Ming-hua chi-chen album.

Signed. Genuine. See CAT 53; CCAT pl. 101; KK ming-hua IV, 15; NPM Masterpieces II, 29.

Ibid. (VA4g). Two Birds at the Pine Spring. Double album leaf. *Ssu-yin* half-seal. Attributed. Work of a follower.

Ibid. (VA5g). Geese Over Autumn Mountains. Fan painting. Copy. See Yen Kuang album 1927; KK ming-hua III, 21.

* Ibid. (VA5h). Pine Winds at the Temple. Album leaf. Signed. Good work, possibly genuine. See Yen-kuang album 1927; KK ming-hua III, 20.

Ibid. (VA12p). Empty Pavilion at the River Bank. Fan painting. Attributed.

Ibid. (VA17u). Pheasants, Plum and Bamboo. Fan painting. Copy. See NPM Masterpieces I, 10.

Ibid. (VA18m). Plum and Pine. Album leaf. Signed. Imitation.

Ibid. (VA19n). Plum Branches in the Snow. Album leaf. Copy.

Ibid. (VA21d). Watching the Stream in the Pine Valley; a man seated beneath a pine gazing over a stream; a boy servant beside him. Fan painting. Signed. Copy. Another copy in the same collection (VA20g).

Ibid. (VA23e). Crows Perched on the Young Willow. Fan painting. Signed. Copy?

Ibid. (VA23f). Two Crows on the Winter Willow. Fan painting. Signed. Copy?

* Ibid. (VA26h and 27d). Apricot Blossoms and Peach Blossoms. A pair of album leaves, ink and colors on silk. The first is signed. Genuine. See NPM Bulletin, II, 2, fig. 4-5; KK ming-hua IV, 14; CAT 54 (Peaches).

Ibid. (VA36i). Snow Landscape; two men in a hut. Album leaf. Signed. Good work, possibly genuine.

Ibid. (VA36q). The Peach and Plum Garden. Album leaf. Attributed. Imitation.

Ibid. (VA36x). Plucking the Lute. Album leaf. Attributed. Seals of Hsiang Yüan-pien, An Ch'i. Work of a close follower?

Ibid. Man in a pavilion in snow, servant walking along the river-side under plum tree. Album leaf. Attributed. Copy. See CKLTMHC II, 85.

KK chou-k'an 431. A man and his servant on a terrace beneath pines. Signed. Early Ming Academy work.

Ibid. 482. A man crossing a bridge; behind him, a house with two figures in an upstairs window. Album leaf. Attributed. Ming work.

Ch'ing-kung ts'ang 2 (formerly Manchu Household Coll.). A man seated under a pine by a stream attended by a boy. Fan painting. Imitation.

Ibid. 97 (formerly Manchu Household Coll.). Early Spring; bare willows by a stream, a man with his servant approaching a bridge. Fan painting. Signed. A later version of a painting in the Boston Museum of Fine Arts (14.61).

Chin-shih shu-hua, 28. Portrait of Chuang-tzu. Signed. Seals of Hsiang Yüan-pien; inscription by him mounted above. Reproduction indistinct.

Shen-chou II. A man on a terrace gazing over a pond. Album leaf. Signed. Early imitation?

CK ming-hua XII (formerly P'ang Yüan-chi Coll.). Asking the Way; a man approaching a terrace with a tall pine, speaking with another man; the moon in the sky. Copy?

* Ibid. 31 (formerly Manchu Household Coll.). Two monks playing chess in a bamboo grove, a visitor approaching. Horizontal album leaf. Poem. Signed. Genuine? See also Ferguson 128; Chung-kuo I, 50.

Ibid. 18 (formerly Ti P'ing-tzu Coll.). A man seated in contemplation under a pine tree. Album leaf. Imitation. See also Chung-kuo I, 51.

Peking Palace Museum (formerly Ti P'ing-tzu Coll.). Portrait of Confucius. Album leaf. Interpolated signature. Copy? See Chung-kuo Ming-hua 32; Chung-kuo I, 52; Liang Sung 21; Sung-jen hua-ts'e B, XIX.

Ming-pi chi-sheng II. A man seated at a table in a pavilion by a stream. Signed. Copy or imitation.

Garland I, 21 (Wang Shih-chieh Coll., Taipei). *Sung-lu fang-yu t'u:* Visiting a Friend. Signed. Inscription by Emperor Li-tsung dated 1229. Ming work of Che School. See also Naito 57; Loehr Dated Inscriptions p. 269.

Ibid. I, 22. Summer Landscape. Handscroll. Signed. Ming, 16th century; related in style to T'ang Yin.

Ibid. I, 23. Gazing into the Distance by River and Pine. Colophons by Wang Chuan and Tai Pen-hsiao, etc. Late imitation.

Ibid. I, 24. (Huang Chün-pi Coll, Taipei). Wang Hung Presenting Wine to T'ao Yüan-ming on a terrace. Album leaf. Perhaps originally a pair with the album leaf in the Tientsin Museum listed above.

Ibid. I, 25. Picking Plum Blossoms; scholar and servant walking beneath large trees and rocks. Good Yüan-Ming work. See also Li-ch'ao pao-hui, I/7.

Chang Ta-chien Collection. A scholar and a boy in a pavilion by a lotus pond. Album leaf. Signed. Early copy or imitation.

Tien yin tang II, 6 (Chang Pe-chin Coll., Taipei). Scholar and servant approaching a bridge, a homestead among bamboo. Fan painting. Signed. Good copy or early imitation.

Ibid. A man on a terrace by the river gazing at a waterfall, his servant behind. Attributed. Good school work, Yüan or early Ming.

Ibid. A house in a misty valley among pine trees. Good work of 14th or early 15th century.

I-lin YK 64/1. A man standing beneath blossoming plum trees, about to cross a bridge. Attributed. Yüan-Ming work?

Ibid. 27/1. Li T'ieh-kuai. Attributed; seals of the Ch'eng-hua emperor of Ming. 18th-19th cent., Western influenced.

Chung-hua Shu-chü album, Shanghai, 1920. *Nü hsiao-ching t'u:* Ladies classic of filial piety. Album of nine leaves. Yüan-Ming copies after Southern Sung composition? See also the handscroll and album of similar subjects ascribed to Ma Ho-chih, works close to Ma Yüan in style.

* Tokyo National Museum. The Ch'an Monk Tung-shan Wading a Stream. Poem by Yang Mei-tzu. Attributed. See Shimbi XVII; Sogen no kaiga 43; Sogen bijutsu 116. The picture belongs to the same series as the two following. See also Suiboku II, 40.

* Tenryu-ji, Kyoto. The Ch'an Monk Yün-men Wen-yen and his teacher Hsüeh-feng I-ts'un; the Ch'an Monk Fa-yen Wen-i and his teacher Lo-han Kuei-ch'en. A pair of hanging scrolls, ink and colors on silk. Attributed. These two pictures and the preceding formed a series representing the founders of the Five Schools of Ch'an Buddhism. Fine Southern

Sung works. See Bijutsu kenkyu 43; Kokka 838; Sogen no kaiga 42-44; Toyo bijutsu 9; Sogen bijutsu 107; Boston Zen Cat. 4; Suiboku II, 41-2.

* Tokyo National Museum. An Angler on a Lake. Fragment from a larger painting? Attributed. Imperial seal of the reign of Ning-tsung (1195-1225). Fine Sung work, perhaps by him. See Sogen meigashu 21; Kokka 23; Shimbi 13; Toyo VIII; Bijutsu kenkyu 32; MY/HK 2; Sogen no kaiga 107-108; Siren CP III, 290; Toyo bijutsu 37; Kobijutsu 40.

* Seikado Collection. Landscape with rainstorm: a temple among trees on a rocky shore, a man with an umbrella climbing the path. Attributed. Fine Sung work by Li T'ang follower; not in the style of Ma Yüan? See Sogen Meigashu 22; Kokka 234; Shimbi XI; Toyo VIII, 42; Toso 88; Sogen no kaiga 105; Siren CP III, 285; Toyo bijutsu 36; Genshoku 29/20; Seikado Kansho III, 2.

Hakone Museum. A scholar seated under a projecting pine gazing at the moon; a servant standing to the right. Attributed. Yüan-Ming work in Ma Yüan style. See Toyo VIII, 44; Kokka 160; Shimbi VIII; Toso 89; Sogen no kaiga 106; Siren CP III, 284; Suiboku II, 13.

Ibid. (formerly Honden-ji, Okayama). Travellers ascending to a temple under a mountain ledge. Signed. Yüan work? See Sogen no kaiga 109; Suiboku II, 44.

Osaka Municipal Museum (formerly Abe Coll.). Tall pines by a strange cliff, a wanderer approaching. Inscribed with Ma Yüan's name, and a poem by Yang Mei-tzu. Crude Ming-Ch'ing work. See Soraikan I, 16; Osaka Cat. 37.

Ibid. A temple on a cliff, a tall pine tree. Attributed. Good early work in Ma Yüan style. See Soraikan II, 20; Kokka 553; Osaka Cat. 39 (10).

Fujii Yurinkan, Kyoto. A scholar and servant on a mountain ledge gazing at a waterfall; a plum tree behind. Signed. Ming imitation. See Yurintaikan III.

Ibid. A garden scene in winter, a scholar seated in a pavilion. Album leaf. Signed. Good early work.

Ibid. A man with his servant looking at peach blossoms. Inscribed with the painter's name. Imitation.

Nezu Museum, Tokyo. Scholar seated at table, with servant, beneath pine. Seal of artist. Good work of Yüan-Ming date. See Nezu Cat. I, 33.

Ibid. Lin Pu by plum-tree. Album leaf. Attributed. Good work by Yüan-Ming follower. See Nezu Cat. I, 62.

Fujita Museum, Osaka. The God of Old Age. Signed. Imitation of Ming period.

Ibid. A man gazing at a waterfall. Signed. Yüan work?

* Yamato Bunkakan, Nara. Swallows in bamboo growing beside a rock by a stream. Signed. Genuine? See Homma Sogen, 21.

Kokka 660. A winter scene; a man in a house. Attributed. Yüan-Ming work.

Toyo VIII, 43 (Viscount Tanaka Coll.). A scholar seated by a stone table under a large pine. Yüan-Ming work. See also Kokka 202.

Ibid. VIII, 46 (formerly Magoshi Coll.). A man on a promontory under a pine looking at distant peaks in mist. Album leaf. Ming imitation. See also Kokka 147; Sogen MGS II, 14.

Muto Cat. 9. River View; a man in a boat, pavilions among bamboo on the opposite shore. Fan painting. Seal of the painter. Imitation.

Hikkoen (formerly Kuroda Coll.). The poet Lin Pu seated by a plum tree looking at the moon. Horizontal album leaf. Early and good work in the style; Yüan period? See also Sogen MGS II, 3.

Ibid. 9. A man in a boat. Fan painting. Attributed. Fine Southern Sung painting, unrelated to Ma Yüan.

Bijutsu shi, January 1954, p. 99 (formerly Asano Coll.). Picking Fungus; a scholar and two servants in a landscape. Album leaf? Signed.

Seikasha Sogen, 4. A man seated on a terrace by the river. Album leaf. Signed. Good early imitation?

Ibid. 12. A man by a stream in moonlight; tall bamboo. Fan painting. Attributed. Imitation.

Kumamoto 4. The T'ang official Wei Cheng leaving as an envoy; landscape with figures on horses. Attributed. Ming work.

Nakamura Tomijiro Collection, Tokyo. A man and a boy in a boat under an old willow by a river shore; mountains in the distance. Attributed. Good early work.

Kawasaki Cat. 9 (Noda Coll.). Two men examining a picture under a blossoming plum tree. Yüan-Ming work. See also Choshunkaku 12.

Domoto Coll., Kyoto. Chou Tun-i Gazing at Lotus Blossoms. Seal of the artist. Copy or imitation.

Former Asano Coll. Picking Mushrooms. Signed. Seal of Yoshimasa. Japanese copy?

* Setsu Gatodo, Tokyo (formerly Akaboshi and Okura Colls.). Landscape with a man gazing at a waterfall. Fan painting. Attributed. Good early work in the Ma Yüan style.

Ryo Hosomi Collection, Izumi-Otsu. Landscape with travellers beneath willows. Attributed. Ming work of Che School.

* Cheng Chi Collection, Tokyo. Branches of blossoming plum, some with clouds, rocks, etc. Album of eight leaves. Signed. Seals of Hsiang Yüan-pien. Three of the leaves identical in composition to leaves in the Taipei Palace Museum album (SA3). The Cheng album is older and better in quality, perhaps genuine.

Boston Museum of Fine Arts (14.60). A boat near a pavilion built over the water by a wooded riverbank; steep mountains behind. Signed. Badly worn and retouched. Ming work, early 16th century. See Portfolio I, 92.

Ibid. (15.909). Winter Scene. A man and a boy in a pavilion by a stream. tall tree in front strewn with snow. Attributed. Ming work. See Portfolio I, 93; MY/HK 7; Siren CP in Am. Colls. 109.

* Ibid. (14.61). Early Spring. Bare willows and distant hills, a farmer returning at evening. Fan painting. Signed. Seal of Hsiang Yüan-pien. Genuine. See Portfolio I, 94; Kodansha BMFA 80; Siren CP III, 289. The composition is repeated in painting attributed to Ma Fen in Nanga taisei VIII.

* Ibid. (14.62). Two old men in conversation beneath a plum tree with an attendant. Fan painting. Signed. Genuine. See Southern Sung Cat. 17; Portfolio I, 95; Artibus Asiae 37/1-2.

Ibid. (14.63). Hsiao Ssu-hua seated under a tree playing the ch'in. The emperor Wen-ti is approaching. Fan painting. Attributed. Fine Southern Sung work. See Portfolio I, 96; Siren CP in Am. Colls. 90.

Ibid. (28.850). A man viewing clouds from a palace terrace. Album leaf. Early Ming imitation. See Portfolio I, 97; Siren CP III, 291.

Ibid. (08.61). A man resting under a projecting branch of a leafy tree; two boys behind him. Fan painting. Sung work?

Ibid. A man lying in a boat; a few reeds along the shore. Album leaf. Follower of Ma Yüan. See Siren CP III, 295.

Cincinnati Art Museum (1950.77). *Ssu hao:* the Four Old Recluses in the Shang Mountains at the close of the reign of Ch'in Shih Huang-ti. Two of them are playing chess under the pines, another is looking on. Handscroll. Signed. Numerous seals and forty colophons, some of the Sung period. Good early Ming work? See TWSY ming-chi 83-85; Siren CP III, 287; Lee Landscape Painting, 22.

* Cleveland Museum of Art (67.145). Ducks by the River. Signed. Seals of An Kuo (early Ming), Hsiang Yüan-pien, Liang Ch'ing-piao, and An Ch'i. Perhaps originally a companion to the winter scene with egrets in Taipei Palace Museum listed above (SV102). See Archives XXII (1968-69), p. 109; Cleveland *Bulletin* (Dec. 1967) F16.162.

Fogg Museum (1923.207). Houses by a river; a visitor approaching over a bridge; a sailing boat. Attributed. Fragment of a handscroll. Early Ming copy of Sung composition?

Freer Gallery (09.245c). A pavilion under the pines by a stream. Fan painting. Signed. Probably by a close follower in the Southern Sung period. See Cahill Album Leaves X.

Ibid. (11.169). Views of high mountains and tall pines along a river. Long handscroll. Inscribed with the painter's name and dated 1192. Copy after Hsia Kuei's "Pure and Remote View." See Siren CP in Am. Colls. 134-136; Loehr Dated Inscriptions pp. 259-260.

Ibid. (12.4). Men in a pavilion beneath pines. Ming work in his tradition.

Ibid. (15.36j). Pavilions on the hillside, tall pines. Album leaf. Signed. Later copy. See Cahill Album Leaves XI. Another version in Contag, *Zwei Meister,* fig. 2.

Ibid. (16.44). Mountain landscape; two men on a mountain terrace beneath a large tree. Fine work of Yüan or early Ming date. See Siren CP in Am. Colls. 133.

Ibid. (16.132). A mountain retreat under pines by a river. Old attribution. Ming work. See Siren CP in Am. Colls. 48.

Ibid. (17.340). River landscape; a scholar in a pavilion, fishermen. Good work of Ming date, Che School.

Ibid. (18.5). Pavilion built over the water under tall pines. See Bachhofer 119; Siren LCP (as style of Wang E).

Ibid. (19.125). A scholar walking by a river; misty trees. Attributed. Fine work of 15th century, Che School.

Ibid. (19.144). Scholar and servant walking in early spring. Inscription by a contemporary with the date 1185. Close copy of Ming date?

Ibid. (68.43). Scholar's dwelling in the mountains. Attributed. Ming work, 15th c. See Meyer Cat. 24.

Yale University Art Gallery (1953.27.9). Two fishermen on bank beneath pines. Signed. Ming academy work. See Yale Cat. no. 423; Moore Cat. no. 15.

Honolulu Academy of Arts. A scholar standing by a bridge gazing at plum blossoms. Album leaf. Early work in Ma Yüan style. See China Institute Album Leaves 37 (not reproduced).

* Nelson Gallery, Kansas City (63.19). Composing poetry on a spring outing. Handscroll. Attributed. Fine early work in the style, perhaps genuine; may be Ma Yüan's depiction of a famous garden in the vicinity of Hangchow. See TWSY ming-chi 86-90; Kodansha CA in West I, 47-49; Suiboku II, 10-16.

Metropolitan Museum, N. Y. (23.33.5). A sage under a pine tree. Album leaf. Attributed. Good early work. See China Institute Album Leaves 23, ill. p. 46.

* Ibid. (1973.120.9; former C. C. Wang). Scholar gazing at waterfall. Album leaf. Signed. See So. Sung cat. 19; China Institute Album Leaves no. 19; Met. Cat., 1973, no. 9. Old, good work, perhaps by close follower.

* Cleveland Museum of Art (Perry Collection). A scholar and his servant watching deer drinking from a stream. Album leaf; forms a pair with the previous. See Skira 83; China Institute Album Leaves no. 18; So. Sung cat. 18.

* Ching Yüan Chai collection (formerly Matsunaga Kinenkan). A plum tree growing from a rock by a stream; ducks on the marshy shore; hills beyond. Hanging scroll. Signed. Genuine.

Ars Asiatica IX, pl. 17 (Formerly Eumorfopoulos Coll.). Boating on a lake by moonlight. Imitation. See London Exh. Cat. 1163.

Frank Caro, N. Y. (1958). Illustrations to the Pin-feng Ode of the Shih-ching. Handscroll, colors on silk. Attributed. Copy?

* John Crawford Collection, N. Y. (Cat. 30). Looking for plum blossoms in a moonlit night. Fan painting. Signed. Genuine? or early imitation? See also China Institute Album Leaves 21, cover illustration; Chang Ta-ch'ien Cat. IV, 11; Barnhart Wintry Forests cat. 5.

Ibid. (Cat. 31). Watching a Waterfall. Fan painting. Attributed. See also China Institute Album Leaves 29, ill. p. 49.

Juncunc Collection, Chicago. A man on a terrace by the water. Signed. Ming work.

Ibid. A palace among pines by moonlight. Signed. Copy.

C. M. Lewis Collection, Pittsburgh. Two men in a pavilion beneath pine trees looking across to tall peaks. Fan painting. Attributed. Later work.

C. C. Wang Collection, N. Y. Scholar in a boat looking at plum trees. Fan painting. Attributed.

Ibid. Pavilion by the water. Fan painting. Attributed.

Frank Seiberling Collection, Iowa City. Men on a mountain terrace beneath pines gazing at the moon. Attributed. Fine work of Yüan or early Ming period.

Museum of Far Eastern Antiquities, Stockholm. Shooting Oriioles. Signed, Title and seal of Sung Lo (1634-1713). School work. See *Bulletin of the M. F. E. A.,* no. 49, pp. 17-29, article by Per-Olov Leijon.

Strehlneek Cat. 211. Album of twelve leaves by Ma Yüan and other artists, some signed. Four leaves owned by C. C. Wang, New York; six owned by John Crawford, New York; two others(?) by J. T. Tai, New York. (Note: some of these are noted elsewhere in the list.)

See also, under Anonymous Sung, the paintings listed as "Landscape with figures, of the Ma Yüan type and tradition," for many more works of followers.

MAO I 毛益

From K'un-shan, Kiangsu. Son of the painter Mao Sung. Tai-chao in the Academy of Painting in the Ch'ien-tao era (1165-1173). Flowers, birds and animals, especially cats and dogs. H, 4. J, 4. M, p. 20.

Sung-jen hua-ts'e A, 75. A golden oriole on a pomegranate branch. Album leaf. Attributed. Copy. See also Sung-tai hua-niao.

Taipei, Palace Museum (VA17k). A pair of ducks and smartweed. Fan painting. Attributed. Copy. See KK chou-k'an 5.

Formerly Manchu Household Collection (Yen Kuang Shih photo). Cat and dog in a garden. Fan painting. Attributed. Copy. See also Ch'ing-kung-ts'ang 15.

* Yamato Bunkakan, Nara (formerly Fukuoka Coll.). Bitch and four puppies by a rockery with lilies. Album leaf. Attributed. Fine Southern Sung work. See Kokka 27; Toyo VIII, pl. 49; Sogen no kaiga 58; Genshoku 29/32; Yamato Bunka, 26 (with the following two pictures).

* Ibid. Cat and four kittens in a garden with hollyhocks. Album leaf, forming a pair with the preceding picture. Attributed. Fine Southern Sung work. See Kokka 69; Skira 77; Sogen no kaiga 59.

Chugoku meiga, II (Arai Tsunekichi). Dog and puppies by hollyhocks. Attributed.

Hikkoen 22 (formerly Kuroda Coll.). A cat with three kittens; hollyhocks by a rockery. Fan painting. Attributed. Copy after the Yamato Bunkakan painting listed above.

Ibid. 36. Cock and hen with chickens; hollyhocks and a garden rock. Forming a pair with the preceding picture. Attributed.

Toso 71 (Noda Coll., Kyoto). Wild ducks under a flowering tree and peony flowers. Ming work, cf. Lü Chi.

Shimbi Shoin Shina Meigashu. A cat with two kittens at the foot of a rockery with flowering plants. Imitation.

Kohansha III (Howard Hollis Coll., N. Y.). A dog. Album leaf. Attributed. Early Ming?

* Boston Museum of Fine Arts (11.6143). A dog. Album leaf. Attributed. Copy, reversed, of the Li Ti painting in the Peking Palace Museum. See Portfolio II, 24; Siren CP in Am. Colls. 115.

* Freer Gallery (44.51). Swallows in a willow tree. Fan painting. Signed. Genuine. Cahill Album Leaves, cover; Kodansha Freer Cat. 40.

Sogen MGS III, 46 (Japanese Imperial Household). A cat watching an insect. Attributed. Yüan or later work.

Ibid. III, 44. A cat and chrysanthemums; a dog beneath a flowering tree. Pair of hanging scrolls. Attributed. Late Sung or Yüan works.

MAO SUNG 毛松
From K'un-shan, Kiangsu. Active during the reign of emperor Hui-tsung. Flowers and birds; famous for his pictures of monkeys. H, 4. J, 4. M, p. 20.

* Tokyo National Museum (formerly Manju-in, Kyoto). A Monkey. Old attribution. Fine Sung work. See Kokka 340; Bijutsu kenkyu XVII; Sogen no kaiga 60; Siren CP III, 246; Toyo bijutsu 46; Genshoku 29/30.

Note: The painting of a cat and kittens in the Hikkoen album listed above under Mao I is also sometimes ascribed to Mao Sung.

MI FU 米芾 (Usually mispronounced "Fei"). Originally written 黻 t. Yüan-chang 元章, h. Nan-kung 南宮, Lu-men chü-shih 鹿門居士, Hsiang-yang man-shih 襄陽漫士, Hai-yüeh wai-shih 海嶽外史.

From Hsiang-yang, Hupeh. Born in 1051, died 1107. Calligrapher, painter and writer on art. Author of *Hua-shih* 畫史. Served as secretary of Board of Rites and Military Governor of Huai-yang, Kiangsu. Landscapes. H, 3. I, 51. L, 45. M, p. 82. See also biography by Lothar Ledderose in Sung Biog. 116-127; another by Wai-kam Ho in EWA X, 84-90; and Sun Tsu-pai, Mi Fei yü Mi Yu-jen (Shanghai: CKHCTS). (MF/MY-j.)

Taipei, Palace Museum (SV133). Verdant Mountains Rising through the Mist; with pine trees and a pavilion in the foreground. Signed. Above the picture is mounted a poem by an imperial writer (possibly intended for Kao-tsung). *Ssu-yin* half-seal. Ink and colors on paper. Yüan or later work, by follower of Kao K'o-kung; much overrated. See Ku-kung I; Chung-kuo I, 33; London Exh. Chinese Cat., p. 52; Three Hundred M., 88; CAT 28; CH mei-shu I; KK ming-hua I, 40; Wen-wu chi-ch'eng 30; KK chou-k'an 306; Siren CP III, 186; Chung-kuo MHC 35.

Ibid. (VA25b). Clouds and Mist on the Frosted Peak. Album leaf. Signed. Late imitation.

Ibid. (SH72, chien-mu). Cloudy mountains. Handscroll. See the fifth entry under Mi Yu-jen.

Formerly National Museum, Peking. Cloudy Mountains and Trees in Mist. Handscroll. Signature and seal of the painter. Seals of Yüan collectors, and of Hsiang Yüan-pien and Ch'ien-lung. Late imitation. See Siren CP III, 187.

Shen-chou XX. Peaks rising through clouds over a misty valley. Late imitation.

Shen-chou ta-kuan hsü IV. A pine tree in front of mountain peaks in mist. Probably a fragment. Late Ming or later.

Garland I, 14. Misty landscape. Album leaf. Artist's inscription.

S. H. Hwa Collection, Taipei. Landscape. Handscroll, ink on silk. Signed. Good Ming picture.

Toso 44 (Formerly F, Nakamura, Tokyo). River valley; mountains rising through clouds. Album leaf. Signed and dated 1102. 17th century work? See also London Exh. Cat. 918; Cohn Chinese Ptg. 56; Sickman and Soper 91a; Loehr Dated Inscriptions p. 237.

Nanshu ihatsu V (Ogawa Coll., Kyoto). A valley in mist between verdant mountains. Ascribed to the painter by Ku Kuang-hsü of the Ch'ing period. Ming imitation. See also Naito 48.

Osaka Municipal Museum. Cloudy Mountains; pine trees below. Ink on silk. False inscriptions signed by K'o Chiu-ssu and Yü Chi of the Yüan period. Ming work, by follower of Kao K'o-kung. See Soraikan II, 14; Osaka Cat. 32.

Fujii Yurinkan, Kyoto. Landscape. Ink on paper. Signed and dated 1088. Yüan period?

Boston Museum of Fine Arts (50.1456). Misty Landscape. Wide hanging scroll. Ming work. See Portfolio II, pl. 26.

* Freer Gallery (08.171). Wooded hills rising above mist; leafy trees below. Ink on silk. Inscription (couplet) supposed to be written by Emperor Hui-tsung: "Heaven sends down timely rain; hills and rivers exude mists." The picture, which is worn and retouched, may be part of a triptych or a larger composition. Attributed; early and fine work in his tradition. See Siren CP III, 188; Bunjinga suihen II, 57.

Ibid. (11.260). River Valley in the Mountains; cottages along the shore and dry trees. Ink on paper. Inscription with the name of the painter. Korean painting?

Ibid. (16.404). Misty hills, houses on a river shore. Ink on silk; very dark. 17th century. Nanking school?

Ibid. (16.408). Landscape with misty peaks. Small hanging scroll, ink on paper. Spurious inscription and signature, with the date 1080. Imitation.

John Herron Art Institute, Indianapolis. Mountain Landscape. Inscription by Chen Tsui. Attributed. A 17th or 18th century work.

Metropolitan Museum, N. Y. Various works ascribed to the artist: 26.115.2 (dated 1089); 29.100.465 (dated 1087); 47.18.48 (handscroll, dated 1103); 47.18.109 (hanging scroll—see Priest article in their *Bulletin* , March 1950, p. 170).

Yale University Art Museum (formerly Ada S. Moore Coll.). River landscape with trees in mist. Handscroll, ink on paper. Signed. Colophon signed Mi Fu dated 1104. Other inscriptions by the poet Yüan Hao-wen (1190-1257), dated 1225, Yang Wei-chen (14th century), Li Shih-feng, dated 1381, and two by later men. Imitation. See Kwen Cat. 52; Loehr Dated Inscriptions p. 238.

Ibid. Landscape with returning boat. Ink on silk. Inscription signed and dated 1079. Another inscription by Kao-tsung. Imitation. See Moore Cat. 9; Loehr Dated Inscriptions p. 234.

Cheng Te-k'un Collection, Cambridge. Landscape. Handscroll, ink on paper. Title by Wen P'eng, colophon by Tung Ch'i-ch'ang, attributing the painting to Mi. Yüan work?

MI YU-JEN 米友仁　　t. Yüan-hui　元暉
Known also by his boyhood name Hu-erh 虎兒. Son of Mi Fu. Born 1075, died 1151. Vice-president of the Board of War. Landscapes, followed his father. H, 4. I, 51. L, 45. M, p. 82. See also biography by Hsio-yen Shih in Sung Biog. 127-134; and Mi Fei yü Mi Yu-jen [MF/MY-j], (Shanghai: CKHCTS).

* Peking, Palace Museum. Yün-shan mo-hsi t'u: Cloudy Mountains: Ink Play. Handscroll, ink on paper. Signed. Inscription by the artist. Colophon by Tung Ch'i-ch'ang. Seals of Chao Meng-fu, Liang Ch'ing-piao, An Ch'i, Ch'ien-lung and others. Old, fine work, possibly genuine. See MF/MY-j 7-8; Wen-wu 1961.6, 21.
* Ibid. *Hsiao-Hsiang ch'i-kuan t'u:* Rare Views of the Hsiao and Hsiang; trees on a shore, low mountains in the background. Handscroll. Attributed. An inscription by the artist follows, with colophons by Sung and later writers. Early work in the style, heavily restored. See CK ku-tai 41; MF/MY-j 3-6; Wen-wu 1961.6, 3; Kokyu hakubutsuin, 168-171.
* TWSY ming-chi 59-61. *Shih-i t'u:* fishermen in a mountain river. Handscroll. Inscription by the artist(?). Mounted in a handscroll with a painting by Ssu-ma Huai. Genuine? Important early work. Cf. the entry for Ssu-ma Huai.
* Shanghai Museum. White Clouds on the Hsiao and the Hsiang Rivers. Handscroll. Signed. Similar in composition to the Taipei Palace Museum scroll listed below, but incomplete. Inscriptions on the painting by Ch'ien-lung; long colophon by the artist. See Gems II, 2; also Chugoku bijutsu III, p. 82-83.

Taipei, Palace Museum (SH9). *Yün-shan te-i t'u:* Cloudy Mountains. Handscroll, ink on paper. An unsigned inscription, purportedly by Mi Yu-jen, dated 1135, states that he painted it when a youth. Colophon by Tseng Ti dated 1162 ascribing the work to Mi Fu; other colophons dating from the 12th century on. 14th century seals. Yüan-Ming work, probably based on the Shanghai Museum painting listed above. See CAT 35; CKLTMHC I, 38; Loehr Dated Inscriptions p. 250. Another version of the composition in the same collection (SH72, chien-mu), probably older and better, with the same two early colophons (1135 and 1162), but attributed to Mi Fu. Early copy?

Ibid. (chien-mu SV262). Mist and Rain on Streams and Mountains. Hanging scroll. Good work by minor Yüan or Ming artist, follower of Kao K'o-kung.

* Nanking Exh. Cat. 27 (former P'u Ju Collection). Mountains in Ch'u on a Clear Autumn Day. Handscroll. Signed. Genuine? or early imitation? See also Sogen 16.

Shen-chou 12. Mountains rising through layers of mist. Signed and dated 1141. Late, poor imitation. See also Loehr Dated Inscriptions, p. 253.

Shen-chou ta-kuan 9 (formerly Huo Chih-p'ai Coll.). Mountains rising into the clouds. Two lines of poetry by the painter. Late Ming? See Siren CP III, 190.

Shen-chou ta-kuan hsü 4. Cloudy Mountains. Attributed.

Chin-k'uei I, 6 (formerly J. D. Ch'en Coll., H. K.). Mountains in clouds. Ming dynasty work, in tradition of Kao K'o-kung.

* Osaka Municipal Museum (Abe Coll.). Misty Trees by a River; mountains beyond. Ink on paper. Signed: Playfully painted by Yüan-hui. Inscription mounted above, dated 1134, may not have belonged originally with the picture. Heavily worn and retouched, but early and important work in the style, possibly by him. See Soraikan II, 17; MF/MY-j 10; Skira 92; Loehr Dated Inscriptions p. 249; Suiboku III, 114; Osaka Cat. 36; Bunjinga suihen II, 58.

Nanshu ihatsu II. Cloudy Mountains. Inscribed with the artist's name and the date 1138. Ming picture. See Chung-kuo MHC 39; Loehr Dated Inscriptions p. 251; and Loehr "Apropos of Two Paintings..." plate 1.

Hikkoen 47. An inlet, old trees on the shore, mountains in the distance. Fan painting. Ming work, unrelated to Mi Yu-jen.

* Cleveland Museum of Art (33.220). Hills in clouds; trailing mist between the ridges along a river shore. Handscroll, ink and light colors on silk. Poem by the painter, dated 1130. Colophon by Wang To (17th century). Probably genuine. See London Exh. Cat. 1140; Siren CP III, 189; Lee Landscape Painting 17; Toso 56a; Loehr Dated Inscriptions p. 247; Kodansha CA in West I, 10.

Fogg Museum, Cambridge (1923.208). Misty Mountains. Double album leaf mounted as a hanging scroll. Signed. Ming work?

Ibid. (Hofer Collection). Misty hills. Handscroll, ink on paper. Signed. Colophon by Liu Lien, dated 1366; the painting of that period? Seals and colophon of Tuan-fang.

Yale University Art Gallery. Cloudy Mountains. Handscroll. Attributed. Minor Yüan work? See Moore Cat. 12; George Lee, Yale Cat. 76.

Freer Gallery (35.17). Mountains in Ch'u on a Clear Autumn Day: river landscape with cloudy hills. Handscroll, ink on paper. Signature and seals of Mi Yu-jen and also of several prominent collectors in the Southern Sung, Yüan, and Ming periods; colophon by Chu Hsi(!). Late copy of the painting listed above in Nanking Exh. Cat. 27.

* Metropolitan Museum, N. Y. (1973.121.1; former C. C. Wang Coll., N. Y.). A mountain ridge and clump of trees appearing through light mist. Short handscroll, ink on paper. Colophons by Wang Shen-yu (Sung), Kuo Yu-chih and Hsien-yü Shu (Yüan) and several men of the Ming period. Genuine? See Garland I, 20; MF/MY-j 9; TWSY ming-chi 58; Met. Cat., 1973, no. 6; Southern Sung Cat. 4; Bunjinga suihen II, 59.

H. C. Weng Collection, N. Y. A mountain ridge with peaks rising through the mist of a river valley. Ten colophons, but no inscription by the painter. Miniature handscroll.

Strehlneek Cat. 183. River Landscape. Ink on silk. Inscription dated 1138. Ming work? See also Loehr Dated Inscriptions p. 251 and Loehr "Apropos of two Paintings...," plate 2.

MOU CHUNG-FU　牟仲甫
From Sui-chou, Hupei. Birds and animals. M., p. 81.

Palace Museum, Taipei (VA17y). Pine, Fungus and Deer. Fan painting. Attributed. Fine work of 14th century(?). See NPM Masterpieces II, 33.

MOU I　牟益　t. Te-hsin　德新　　and Te-ts'ai　德彩
Born 1178, died after 1242. Figures. H, 4. M, p. 81.

Formerly Manchu Household Collection (Yen Kuang collotype). An old Taoist holding a scroll. Seals of K'o Chiu-ssu, Hsü Lin and T'ang Yin.
* Taipei, Palace Museum (SH23). *Tao-i t'u:* Beating the Clothes. An illustration to a poem by Hsieh Hui-lien (394-430) which describes how ladies are preparing clothes for the husbands away in the war. The poem is copied by Tung Shih. The picture, executed in the manner of Chou Wen-chü, may be based on an earlier composition. Long handscroll. According to the colophon by the artist, dated 1240, it was begun in 1238, and completed two years later. Beside the poem by Tung Shih, there are fifteen poems and colophons by connoisseurs and collectors of the Ming and Ch'ing periods. Genuine. See Palace Museum Scroll reproduction, 1936; Three Hundred M., 119; CAT 62; CKLTMHC I, 73; NPM Masterpieces III, 23; Nanking Exh. Cat. 138; Siren CP III, 312; Loehr Dated Inscriptions pp. 271-272; see also Richard Edwards, "Mou I's Colophon to his Pictorial Interpretation of 'Beating the Clothes,'" in Archives, XVIII, 1964.
Ibid. (VA12t). Crickets. Fan. Attributed. Good Southern Sung work, unrelated to Mou I.

MU CH'I　牧谿　　or 牧溪 *hao* of the monk Fa-ch'ang　法常
From Szechuan. Lived first in the Ching-shan temple and later in the Liu-t'ung temple near Hangchou. Born in the early part of the 13th century, still active in 1279. Pupil of the priest Wu-chun (d. 1249). Landscapes, figures, flowers, birds and animals. His few authentic works have been preserved in Japanese collections. H, 4. L, 64. M, p. 218. V, p. 496. Also *Hua-chi pu-i* (1298), I, 6-7. See also biography by Sherman Lee in EWA X, 371-374.

Peking, Palace Museum. Fruits, birds and fish. Handscroll. Colophon by Shen Chou. Poor Ming or later imitation. See Wen-wu 1964.3, 4-6; Suiboku III, 6-11.
Taipei, Palace Museum (SH10). Drawings from Life: birds, vegetables and flowers. Handscroll, ink on paper. Signed and dated 1265. Colophons of

Ming writers. *Ssu-yin* half-seal. Ming copy or imitation. See Nanking Exh. Cat. 31; Three Hundred M., 120-123; CKLTMHC I, 74; Suiboku III, appendix 2-5.

Chung-kuo I, 35 (Ti P'ing-tzu Coll.). The poet Lu Yu walking with a staff. Seals of the painter and of the Yüan emperor Wen-tsung. Much later work. See also Chung-kuo MHC 34.

Garland I, 33. Mynah bird on a branch. Signed. Seal of the artist. Late imitation.

Japanese Imperial Household Collection, Tokyo. Two short handscrolls forming a pair; one representing a radish plant, the other a turnip plant. Attributed, but with no firm basis; probably by another hand. See Kokka 486, 489; Sogen bijutsu 38-9; Suiboku III, 69-70.

* Seikado, Tokyo. An arhat in meditation encircled by a snake. Seal of the painter. Genuine. See Sogen meigashu 26; Kokka 233; Shimbi X; Toyo IX, 87-88; Toso 105; Bijutsu kenkyu 28; Li-tai jen-wu 28; Sogen no kaiga 23; Siren CP III, 335; Toyo bijutsu 65; Suiboku III, 8; Seikado kansho III, 1.

Ibid. Two swallows in a willow tree. 14th-15th century? by a lesser artist. See Shimbi XVII.

* Daitoku-ji, Kyoto. A set of three pictures: the white-robed Kuan-yin seated on a ledge by the water; a mother gibbon with her baby on a pine branch; a crane walking through a misty bamboo grove. All signed over the seal of the painter. Genuine works. See Sogen meigashu 30-33; Kokka 185, 265; Shimbi I; Toyo IX, 84-86; Sogen, appendix 9-11; Toyo bijutsu 62-64; Wen-wu 1965.8, 5-6; Southern Sung Cat. 12; Sogen no kaiga 24-25, 69-71; Siren CP III, 336-339; Skira 97; Suiboku III, 1-3; Genshoku 29/40-42.

* Ibid. Two pictures forming a pair: the head of a dragon; a tiger. Signatures and the date 1269. Genuine? or Yüan works with interpolated signatures? See Toyo IX, 90-91; Kokka 190; Sogen, appendix 12-13; Sogen no kaiga 72; Siren CP III, 342; Boston Zen Cat. 10; Suiboku III, 71-72; I-lin YK 92/1; Sogen MGS II, 19-20. Other versions of the compositions, dated 1267, in the Eda Collection, Tokyo. See Suiboku III, appendix 31-32.

Ibid. Two pictures forming a pair: one representing the head of a dragon; the other a tiger. Both different from the two preceding ones, but the dragon is based on the same composition. Japanese copies? See Suiboku III, appendix 23-24.

Ibid. Hibiscus. Album leaf, ink on paper. Attributed. Fine late Sung work. See Toyo bijutsu 67; Sogen no kaiga 75.

Ryuko-in, Kyoto. Chestnuts. Album leaf. Attributed. See Sogen, appendix 14; Kokka 493; Suiboku III, 68; Sogen MGS II, 23. See below.

Ibid. Persimmons. Album leaf. Attributed. See Sogen, appendix 15; Kokka 493; Suiboku III, 67; Sogen MGS II, 22; Genshoku 29/48. See below.

Soken-in, Kyoto. Rose mallows in rain. Album leaf. Attributed. See Sogen, appendix 16; Sogen meigashu 36; Suiboku III, 10. This and the above two pictures probably formed parts of a handscroll. Fine early paintings, but the attribution to Mu-ch'i is not secure. Note however, the recurrence of the persimmons (in greatly debased form, perhaps there understood as apples) in the Palace Museum scroll listed above, which

may be a copy after Mu-ch'i; this gives some weight to the attribution.

Tennei-ji, Kyoto. The Discussion Between Ma-tsu Tao-i and the Recluse P'ang. Inscription by Yü-chi Chih-hui (ca. 1215-1300). Yüan period. See Boston Zen Cat. 17; Suiboku III, 31; Doshaku, 32.

Formerly Fujii Collection, Osaka (kept in the Kyoto National Museum). The Discussion Between Hsüeh-feng and Hsüan-sha. Inscription by Yü-chi Chih-hui (ca. 1215-1300). Yüan period. This and the Tennei-ji painting above are by the same hand. See Suiboku III, 30; Doshaku, 33.

Nezu Museum, Tokyo. Two sparrows on a bare branch. Old and fine picture, though probably not by Mu-ch'i. See Sogen meigashu 37; Bijutsu kenkyu 22; London Exh. Cat. 1117; Siren CP III, 344; Boston Zen Cat. 11; Nezu Cat. 29; Suiboku III, 76.

Ibid. A dragon on rocks by the water. Fragment of a handscroll? Attributed. Good Sung-Yüan work, related in style to Mu-ch'i. See Toso 103; Nezu Cat. 32.

Ibid. Two Lohans and attendant. Japanese copy of Yüan work? See Nezu Cat. I, 50.

Ibid. Shih-te. Attributed. Inscription by I-hsün. Japanese painting of Muromachi period? See Nezu Cat. I, 6.

Ibid. Kuan-yin. Seal of the artist (unclear). Japanese work of Muromachi period? See Nezu Cat. I, 9.

Ibid. Kuan-yin on a rock by the sea. Attributed. Inscription by the priest Ch'ing-yü (d. 1363). Fine work of Yüan period. See Nezu Cat. I, 15.

Ibid. Tu Fu on a donkey. Seal of the artist. Japanese copy? See Nezu Cat. I, 17. Another version of this subject, with an inscription by Chien-weng Chü-ching, is in the Matsunaga Kinenkan; see Osaka Sogen 5-92.

Ibid. Monkey. Seal of the artist. Yüan work? See Nezu Cat. I, 20.

Ibid. Reeds and a crab. Seal of the artist (?). Late Sung or Yüan work. See Nezu Cat. I, 22.

Ibid. Dove. Attributed. Japanese painting of Muromachi period. See Nezu Cat. I, 24.

Ibid. Monk reading sutra in the moonlight. Japanese painting of late Muromachi, perhaps after an earlier work? See Nezu Cat. I, 26.

Ibid. Priest riding an ox. Inscription by the Southern Sung priest Pei-chien. Crude work of late Sung. See Nezu Cat I, 34.

Ibid. Lotus. Album leaf. Sung-Yüan painting by lesser artist, with interpolated seal of Mu-ch'i. See Nezu Cat. I, 37.

Ibid. White-robed Kuan-yin. Japanese work, late Muromachi or later. See Nezu Cat. I, 47.

Tokugawa Museum, Nagoya. A tiger. Signed. Japanese copy or imitation? See Kokka 268; Tokugawa 167; Homma Sogen 32.

Ibid. Swallows and a spray of willow. Attributed. Fine work, unrelated to Mu-ch'i. See Kokka 242; Toyo bijutsu 68; Suiboku III, 75; Genshoku 29/50; Tokugawa 160,161; Sogen MGS II, 27; Homma Sogen 31.

Atami Art Museum. Two small pictures forming a pair: a wagtail; a kingfisher. Seals of the painter. Probably Japanese. Seals of Zen'ami, Muromachi period. See Bijutsu kenkyu 26, p. 78; Choshunkaku 13-14; Suiboku III, 84-85; Sogen MGS 17-18.

Osaka Municipal Museum (Abe Coll.). Bodhidharma, head and shoulders only. Seal of the painter interpolated. Probably Japanese. See Soraikan I, 15; Sogen meigashu 29; Suiboku III/appendix 30; Osaka Cat. 43.

Ibid. Han-shan, the Ch'an monk. Inscription by Tao-lung (c. 1245). Attributed. Late Sung work, by a different hand. See Soraikan II, 18; Osaka Cat. 42.

Fujita Musem, Osaka. Magpies in a pine tree. Seal of the artist.

Ibid. Heron. Seal of the artist. Japanese copy.

Ibid. White-robed Kuan-yin. Attributed. Inscription by Hsü-t'ang Chih-yü. Japanese copy.

Itsuo Art Museum, Osaka (formerly H. Mayeyama coll.). A lotus root on a lotus leaf. Album leaf. Attributed. Minor Japanese work. See Toso 112; Sogen bijutsu 37.

Matsunaga Kinenkan Museum, Kanagawa (formerly H. Mayeyama Coll.). The fifth Ch'an patriarch carrying a hoe. Poem by Ch'iao-yin Wu-i (?-1334). Late Sung work by lesser master. See Toso I, 11; Sogen no kaiga 30; Sogen Bijutsu 135; Suiboku III, 23; Doshaku, 37.

Engaku-ji. Kuan-yin. Attributed. Yüan painting? See Suiboku III, 61.

* Two sets of the Eight Views of the Hsiao and Hsiang, both originally in handscroll form, are attributed to Mu-ch'i. There is no basis other than old attributions for connecting either with Mu-ch'i; the larger set appears to be older and better. For reproductions of both see Takagi Bun, *Mokkei Gyokkan meibutsu Shoso hakke-e no denrai to kosai* (Tokyo: 1935). The entire large set is reproduced in a Kano School copy in the Nezu Museum. Of the originals, fine late Sung works, five have survived into modern times:

1. Sogen meigashu 34 (Hinohara Collection; former Count Matsudaira Coll.). Returning Sails off a Distant Coast. See Takagi 2; Sogen no kaiga 116; Siren CP III, 345; Toyo bijutsu 39; Suiboku III, 5; Genshoku 29/45.

2. Nezu Museum. Sunset over a Fishing Village. See Takagi 4; Southern Sung Cat. 6; Skira 93; Sogen no kaiga 114, 119; Siren CP III, 340-341; Toyo bijutsu 42, 44; Sogen meigashu 35; Toso 102; Nezu Cat. 11; Suiboku III, 4; Genshoku 29/44.

3. Idemitsu Art Museum, Tokyo (formerly Sasaki Coll., Tokyo, and Matsudaira Coll.). Wild Geese Alighting. See Kokka, 410; Sogen no kaiga 115; Siren CP III, 348-349; Toyo bijutsu 41, 43; Takagi 5; Suiboku III, 6.

4. Hatakeyama Museum, Tokyo (formerly Yada Coll., Katayamazu; and Maeda Coll.). Evening Bell from a Distant Temple. See Sogen Meigashu II; Takagi 3; Sogen no kaiga 117-118; Siren CP III, 340-341; Toyo bijutsu 40; Suiboku III, 7; Genshoku 29/43; Sogen MGS II, 24.

5. Sogen MGS II. (formerly Tokugawa and Suenobu Colls., destroyed in 1945). Evening Snow on the Hills. See also Takagi 6.

Of the small set, three survive:

1. Shimbi V (Hatakeyama Coll.; formerly Matsudaira Coll.). The Evening Bell from a Distant Temple. See also Takagi 10.
2. Tokugawa Museum. The Autumn Moon over Tung-t'ing Lake. See Takagi 8; Siren CP III, 348-349; Tokugawa 158; Sogen MGS II, 25.
3. Former Baron Masuda Collection. The Night Rain. See Takagi 9.

Kokka 481 (Viscount Akimoto Coll.). Misty river in spring with a ferry. Album leaf. Attributed. Related to the "Eight Views" scrolls, but looser in execution, by another hand.

Shimbi XI (Count Sakai Coll.). Monkeys playing among trees and rocks by a stream. Handscroll. Seal of the painter. Japanese painting of later date. See also Sogen MGS II, 26.

Ibid. XIV (Marquis Inouye Coll.). Hen, Chickens and Puppies. Handscroll. Seal of the painter. Interesting work of later date.

Toyo IX, 89 (Baron Masuda Coll.). The Priest Chien-tzu playing with shrimp. Seal of the painter. Inscription by Yen An (c. 1260). Good work of the period; the seal appears to be a Japanese interpolation. See also Kokka 122; Toyo bijutsu 61; Sogen no kaiga 22; Siren CP III, 334; Loehr Dated Inscriptions p. 275; Suiboku III, 9; Genshoku 29/39; Sogen MGS II, 21.

Ibid. IX, 93 (Ooka Coll., Tokyo). A shrike standing on a rock. Imitation, Japanese?

Kokka 87 (Ueno Coll.). A monk reading a scroll in the moonlight. Inscription by an unidentified monk (seals illegible). Ming period? or Japanese?

Ibid. 177 (Yabumoto Kozo, Amagasaki). Two doves on an old tree trunk. Japanese imitation? See also Suiboku III, 12.

Ibid. 209 (Viscount Akimoto Coll.). A dragon among vaporous clouds. Seal of the painter. Painting of quality, Yüan date?

Ibid. 293 (Marquis Inouye Coll.). A heron by a faded lotus leaf. Inscription by the monk Shukyu (1323-1409). Japanese painting.

Ibid. 314 (Count Date Coll.). Ch'ao-yang t'u: Morning Sun. A priest sewing his mantle. Inscription by the Monk Tung-sou Yüan-k'ai. Probably a Yüan painting. See also Toyo bijutsu 70; Sogen MGS III, 32; Suiboku III, 32; Genshoku 29/56; Doshaku, 34.

Ibid. 425 (Noda Coll., Kyoto; formerly Dan and Matsudaira colls.). A set of three pictures: Wei-t'o in the guise of a rugged old man; a gibbon resting on a projecting rock; a gibbon with her baby hanging from a bamboo branch. The last picture bears the painter's seal. Old and fine, close to Mu-ch'i in style. The first gibbon picture was copied as the "Liang K'ai" in the Honolulu Academy of Arts.

Ibid. 802. Pu-tai Slapping his Belly. Inscription by the late Sung monk Chien-weng Chü-ching. Late Sung painting by a lesser artist. See also Suiboku II, 48.

Sogen meigashu 27 (Setsu Gatodo Coll., Tokyo; formerly Matsudaira Coll.). Shrike on the trunk of a pine tree. Seal of the painter interpolated. Fine Japanese painting? See also Kokka 218; Shimbi VII; Toyo IX, 92; Siren CP III, 343; Sogen no kaiga 73; Toyo bijutsu 66; Suiboku III, 11; Genshoku 29/49. A similar painting of the same subject in Suiboku III, appendix 27.

Sogen meigashu 28 (Suenobu Coll.). Portrait of Lao-tzu. Seal of the painter. Seal of Ashikaga Yoshimitsu. Destroyed in 1945. Later imitation, with interpolated seal. See also Toso 106; Suiboku III, appendix 12.

Toso 107 (Matsudaira Coll.). A turtle-dove on a bamboo stalk. Seal, interpolated; signature? on right edge. Yüan-Ming work by lesser master.

Ibid. 108-110 (formerly Kuroda Coll.). A set of three pictures: Feng-kan with a tiger; sparrows on a bamboo branch; sparrows on a willow branch. Seals of the painter, interpolated. Yüan period? by lesser master. See also Homma Sogen, 35.

Sogen 25 (Tanaka Buhei Coll.; formerly Yamaoka Coll.). The white robed Kuan-yin. Old Japanese copy after the picture in the Daitoku-ji. See also Suiboku III, appendix 20.

Hikkoen 32 (Nakamura Tomijiro Coll.). A monkey on a rock. Album leaf. Attributed. See also Suiboku III, 74.

Choshunkaku 15. Squirrel and Bamboo. Attributed. Late Sung or Yüan work.

Muto Cat. 3. A turtle-dove resting on a leafless branch. Probably Japanese.

Sogen MGS III, 33. Reclining tiger. Attributed. Japanese?

Sogen bijutsu 128 (Takano Tokitsugu Coll., Aichi). Priest riding an ox. Attributed. Inscription by Shih-hsi Hsin-yüeh, of the mid 13th century. Work of lesser, and later? master. See also Sogen no kaiga 31; Suiboku III, 47; Genshoku 29/55.

* Former Fujii Collection, Osaka (kept at Kyoto Nat. Mus.). Pu-tai sleeping on his bag. Attributed. Very fine late Sung painting. Ink on paper. See Suiboku III, 43.

Inoue Collection, Gunma. Geese and Reeds. Attributed. Inscription by Ching-t'ang Ssu-ku (active early 14th c.) Sung-Yüan work by minor artist. See Suiboku III, 13; Genshoku 29/68; Osaka Sogen 5-57.

Nakamura Katsugoro, Aomori. Gibbon and baby in tree. Two seals of the artist, interpolated. Late Sung, close to Mu-ch'i. See Genshoku 29/52; Suiboku III, 17.

Yabumoto Soshiro (1973). Kuan-yin in ragged robes. Attributed. Inscription by a priest active in the early 14th century; work of that age.

Yabumoto Kozo, Amagasaki. Dove on a rock; bamboo. Ink on silk. Seal of the artist, probably interpolated. The work of a lesser master, perhaps late Sung.

Suiboku III, 14. Feng-kan, Han-shan, and Shih-te. Attributed. Late Sung? by follower of Mu-ch'i.

Ibid. III, 63. White-robed Kuan-yin. Attributed. Yüan work?

Ibid. III, appendix 1. Evening snow on the river. Handscroll. Attributed. Similar to the Hsiao-Hsiang series ascribed to Mu-ch'i, but inferior and by a different hand—copy? See also Sogen MGS III, 31.

Ibid. III, appendix 21. White-robed Kuan-yin. Attributed.

Ibid. II, appendix 25. Han-shan and Shih-te. Attributed. See also Osaka Sogen 5-94.

Moriya Coll., Kyoto. The Ch'an Monk Hsüan-cho. Probably a Yüan painting by a close follower.

Osaka Sogen 5-59. Doves on a pine branch; swallows on a willow branch. Pair of hanging scrolls, ink on paper. Later imitations, Japanese?

Ibid. 5-60. Mynah on a rock. Hanging scroll, ink on paper. Later imitation, Japanese?

Homma Sogen, 33. Dove on branch of bamboo. Attributed. Late Sung or Yüan.

Idemitsu Art Museum, Tokyo. Mynah on Branch. Small hanging scroll, ink on paper. Interpolated seal; later work.

* Cheng Chi, Tokyo, Lotus and Swallow. Seal. Old, fine painting, possibly genuine.

Freer Gallery (07.650). The Water-moon Kuan-yin. Japanese copy of a Chinese picture.

Cleveland Museum of Art (formerly Sakai Coll. 58.427-8). Tiger and Dragon. A pair of hanging scrolls. Later works, based loosely on the Daitoku-ji pair? See Southern Sung Cat. 27-28; Lee, *Japanese Decorative Style,* pp. 6-7; Lee Colors of Ink cat. 4-5; Suiboku III, appendix 28-29.

Indianapolis Museum of Art (60.46, formerly Kuroda Coll.). Tiger. Attributed. Imitation, based loosely on the Daitoku-ji painting.

Ching Yüan Chai Collection, Berkeley. A gibbon. Seal, interpolated. Late Sung or early Yüan.

Ibid. Mother gibbon and child. Seal, interpolated. Late Sung or early Yüan, heavily damaged.

George Schlenker, Piedmont, Calif. White-robed Kuan-yin. Attributed. Inscriptions by two late Sung priests, dubious. Early Muromachi Japanese, cf. Mokuan?

Berlin Museum. Two pictures representing Geese and Reeds. Seal of the painter. Japanese? unrelated to Mu-ch'i. See Berlin Cat. 90.

PI LIANG-SHIH　畢良史　　　t. Shao-tung　少董
From Ts'ai-chou, Honan (also recorded as being from Tai-chou, Shansi). Took *chin-shih* degree; active during the Shao-hsing era (1131-1162). Painted landscapes and dragons. H, IV, p. 97; M, p. 383.

Taipei Palace Museum (VA18e). Carrying the Staff on the Rustic Bridge. Album leaf. Attributed. A work by a follower of the Ma Yüan tradition, Yüan or early Ming in date. See KK chou-k'an 14; NPM Masterpieces V, 12.

PO LIANG-YÜ　白良玉
From Ch'ien-t'ang, Chekiang. *Tai-chao* in the Painting Academy in the reign of the emperor Ning-tsung (1195-1224). Taoist and Buddhist figures. H, 4. J, 8.

Kokka 463 (Kawasaki Coll.). Kuan-yin. Ink on paper. Seals of the artist. See also Choshunkaku 21.

Okazaki Collection, Kyoto. Cranes among Bamboo. Fan painting. Attributed.

Tokyo National Museum (16.132). *Chao-yang tui-yüeh t'u:* Monk mending robe. Attributed.

P'U-AN 樸菴
Unidentified.

Shanghai Museum. Two men running from a boat toward trees in rain. Album leaf. Signed. Work of later follower of Hsia Kuei. See Liang Sung 38; Sung-jen hua-ts'e B, XVII.

P'U-YÜEH 普悅
A specialist in Buddhist subjects who worked in Ning-p'o. From Ssu-ming (Ning-p'o) in Chekiang. Listed as a painter of Buddhist subjects in *Kundaikan sayu choki.*

Shojoke-in, Kyoto. Amitabha Triad. Triptych. Each panel signed. See Kokka, 678; Cahill, *Chinese Paintings, XI-XIV Centuries,* 14; Toyo bijutsu 2; Sogen bijutsu 77; Genshoku 29/87; Suiboku IV, 6, 47-49.

SHUAI-WENG 率翁
See Chih-weng.

SSU-CHING 思淨
Family name Yü 喻 , called Yü Fa-shih 喻法師 or Yü Mi-t'o 喻彌陀 , the latter because he specialized in images of Amitabha Buddha. A Buddhist monk. Died 1137. Native of Ch'ien-t'ang, Chekiang. Followed Wu Tao-tzu in figure painting. Unrecorded in books on painters. See S. Shimada article in *Bukkyo shigaku ronshu* (Commemorative Volume for Professor Tsukamoto), 1961.

Konren-ji, Kyoto. Standing figure of Amitabha Buddha. Attributed to the artist in an inscription on the reverse, dated 1359, by Teizan Sozen, in which he states that the painting was brought to Japan in the Chia-ting era (1208-1225). Reproduced in the Shimada article cited above.

SSU-MA HUAI 司馬槐 t. Tuan-heng 端衡
Native of Shen-chou, Honan. Active during the Shao-hsing era (1131-1162). Son of Ssu-ma Kuang, friend of Mi Yu-jen. M, p. 70; V, p. 186.

* TWSY ming-chi 62-64. *Shih-i t'u:* Bare Trees on a Shore. Mounted as a handscroll with a landscape by Mi Yu-jen under the collective title, *Shih-i t'u.* Seals of An Ch'i, Liang Ch'ing-piao and others. According to the description of this scroll in Wang K'o-yü, *Shan-hu-wang hua-lu* (IV, 16), the attribution to the two artists is made in a colophon by T'ien Ju-ao, dated 1148. Another colophon by Wang Min, dated 1149, also mentions the two artists.

SU HAN-CH'EN 蘇漢臣
From Kaifeng. Tai-chao in the Academy of Painting in the reign of the
Emperor Hui-tsung (1101-1125), still active at the beginning of Hsiao-tsung's
reign (c. 1163). Figures, followed Liu Tsung-ku, particularly famous for his
pictures of children. H, 4. J, 2. M, p. 731. Also biography by J. Cahill in
Sung Biog. 134-136.

Peking, Palace Museum. Ladies looking at the moon under Wu-t'ung trees.
 Fan painting. Attributed. Copy of Southern Sung work? See Sung-jen
 hua-ts'e A, 76; B, VIII, 6.
Ibid. The Hundred Children Enjoying Spring. Fan painting. Signed. Ming
 work. See I-shu ch'uan-t'ung VII; Sung-jen hua-ts'e A, 85; B, I, 7.
* Ibid. Fifteen Children Playing Around a Garden Rock and Plantain Trees. Fan
 painting. Attributed. Fine Southern Sung painting. See Liang Sung 4;
 Sung-jen hua-ts'e B, XIX; Chung-kuo MHC 35; Ch'ing-kung ts'ang IV.
Ibid. Children playing. Large handscroll, colors on silk. Signed. Mediocre
 late copy.
Tientsin Art Museum. Children playing; one chasing butterflies, one holding a
 fan. Album leaf. Signed. Copy or imitation. See I-yüan Chi-chin 2;
 Liang Sung 7; Sung-jen hua-ts'e B, XVI.
Sung-jen hua-ts'e 67. Children at play, a woman and a maid watching. Fan
 painting. Attributed. Good Southern Sung work?
Ibid. 68. Children playing in a courtyard. Album leaf. School work or copy.
Taipei, Palace Museum (SV74). Double Fifth Festival. Twenty-five children
 playing along the terraces and galleries of a garden. Good Ming painting.
 See KK shu-hua chi XII; KK chou-k'an 153.
* Ibid. (SV75). Children at Play. Two small children in a garden playing with
 toys. Poem by Ch'ien-lung. Fine Sung work, perhaps by Su Han-ch'en.
 See KK shu-hua chi XVI; London Exh. Chinese Cat. p. 72; Three Hun-
 dred M., 108; CAT pl. 14; CH mei-shu I; CK ku-tai 40; CKLTMHC I, 44;
 CKLTSHH; KK ming-hua IV, 6; KK chou-k'an 212; Siren CP III, 269;
 NPM Masterpieces III, 18.
Ibid. (SV76). Three Children Playing with Crickets. Attributed. Much later
 work.
Ibid. (SV77). Five Auspicious Things: five children with masks at play. Good
 Ming painting, cf. Lü Chi for rocks and plants. See KK shu-hua chi VII;
 CKLTMHC I, 46; Nanking Exh. Cat. 30; KK chou-k'an 113.
Ibid. (SV78). Toy Peddler: peddler with a wheelbarrow and six children play-
 ing. Attributed. Good Ming Academy work. See KK shu-hua chi VI;
 London Exh. Chinese Cat. p. 73; CKLTMHC I, 45; KK ming-hua III, 10;
 KK chou-k'an 500. Similar painting in KK shu-hua chi 47.
Ibid. (SV79). New Year's Greetings: boy riding a goat with 100 sheep and
 goats around him. Attributed. Poor work of late date.
Ibid. (SV275, chien-mu). Eight children playing with toys and masks in front
 of a pavilion. Seal of T'ang Yin; perhaps a study copy by him? A Ming
 painting, in any case. See KK shu-hua chi XXXIX; Siren CP III, 268.
* See also Ibid. (SV196). Anonymous Sung, Two Children Playing with a Cat in
 a Garden (Winter Play). Not ascribed to Su Han-ch'en, but very close in

style to SV75 above. See NPM Masterpieces I, 15; KK shu-hua chi XXXVII; CKLTMHC II, 27.

Ibid. (VA5e). A toy seller with two children. Album leaf. Attributed. Yüan-Ming work. See NPM Masterpieces II, 20.

Ibid. (VA11k). Six gentlemen playing football (Emperor T'ang Tai-tsu and his courtiers?). Fan painting. Attributed. Late Sung or Yüan painting? See KK ming-hua IV, 7; Smith and Weng, 182. Cf. the "Ch'ien Hsüan" painting of this subject in Toso 144.

Ibid. (VA13i). Music in the Palace. Album leaf. Attributed. Fine work, probably early Ming period.

Ibid. (VA20L). Herding Sheep. Fan painting. Signed. Late copy of Sung picture. See KK chou-k'an 128.

Shen-chou 12. Itinerant Toy Peddler. Attributed. Similar painting in Kokka 181, not attributed to him.

Tien-yin-tang II, 8 (Chang Pe-chin Coll., Taipei). Children playing with hobby horse and lotus leaf. Fan painting. Attributed. Fragment of Yüan-Ming date?

Nezu Museum. Toy peddler and nine children playing. Ming work, cf. Lü Wen-ying. See Toso 69, Nezu Cat. 51.

Ibid. Sakyamuni preaching. One of a set of four hanging scrolls. Attributed. Odd painting of late Ming date(?). See Nezu Cat. I, 46.

Hikkoen 42. Small boys playing by a rockery. Album leaf. Signed.

Kawasaki Cat. 18. Two pictures, each representing four children playing in a garden. Ming works. See also Choshunkaku 30-31.

Osaka Sogen 5-81. Lohan watching the brewing of tea by attendants. Pair of pictures, ink and light colors on silk. Attributed.

* Boston Museum of Fine Arts (29.960). A lady at her dressing table on a garden terrace. Fan painting. Signed. Fine Sung painting, probably genuine. See Siren CP III, 270; Portfolio I, 74; Kodansha CA in West I, 44.

Ibid. (56.98). Two boys playing with a balance toy. Attributed. Sung work? or close copy?

Cleveland Museum of Art (61.261). One Hundred Children at Play. Fan Painting. Attributed. See Southern Sung Cat. 11; China Institute Album Leaves #30, ill. p. 40; Lee, *Scattered Pearls Beyond the Ocean* 8, and cover; Edward Schafer, "Playing Grownup" in *Horizon* XIII, Winter 1971.

Freer Gallery (16.64). Amitabha welcoming souls to the Western Paradise. Inscribed with the painter's name and the date 1164. Oldest colophon impossibly dated 1032 by Pao Ch'eng (d. 1062). See Loehr Dated Inscriptions p. 253.

Ibid. (11.161F). Children playing in a garden. Fan painting. Copy after a Southern Sung work, perhaps by Su Han-ch'en. See Freer Figure Ptg. cat. 57.

Formerly Hoyt Collection, Cambridge, Mass. Sweetmeat vendor with a child. Portion of a larger painting, possibly after a work by the master. See Siren CP III, 267.

Stockholm, Museum of Far Eastern Antiquities. Toy peddler under a tree, six children playing around his stall. Later execution. Seals of Chao Meng-fu and the emperor Chang-tsung of Chin dynasty. Imitation.

SU HSIEN-TSU　蘇顯祖
From Ch'ien-t'ang, Chekiang. Figures and landscapes. Contemporary of Ma Yüan.

Nezu Museum, Tokyo. Landscapes. Pair of hanging scrolls, ink on silk. Attributed. Odd works of Yüan-Ming date. See Nezu Cat. I, 52.

SU KUO　蘇過　t. Shu-tang　叔黨　h. Hsieh-ch'uan chü-shih　斜川居士
Son of Su Shih. B. 1072, d. 1123. Bamboo and stones. H, 3. I, 50. L, 9. M, p. 731.

Kokka 200 (Kosaku Uchida Coll.). A mynah bird on a bamboo stalk. Seal of the painter. Probably a Ming picture.

SU SHIH　蘇軾　t. Tzu-chan　子瞻　h. Tung-p'o chü-shih　東坡居士
From Mei-shan, Szechwan. Born 1036, died 1101. Chin-shih 1057. Served as magistrate at various places 1071-1079. Banished to Huang-shou in 1080, where he built his study on the Eastern Slope (Tung-p'o). In 1086 he was summoned to the court and served between this year and 1094, partly in the government and partly as a magistrate of Ying-shou. Exiled 1094 to Hui-chou in Kwangtung and 1097 to the Island of Hai-nan. Recalled 1101 by the emperor Hui-tsung, but died before he reached the capital. Poet, calligrapher, painter and critic of art. H, 3. I, 50. L, 9. M, p. 730. See also Yü Feng, *Wen T'ung-Su Shih* [WT/SS], (Shanghai: CKHCTS).

Peking, Palace Museum. Two dessicated trees growing from overhanging rocks; white herons soaring above. Large album leaf on silk. Ascribed to the painter in the adjoining inscription. Yüan period? See Ch'ing kung ts'ang; Sung Yüan pao-hui 4; Ferguson p. 100.
* Shanghai Museum. Dry tree, bamboo and stone. Handscroll, ink on paper. Mounted together with a painting of bamboo with a signature of Wen T'ung. Attributed to Su Shih in a colophon dated 1301 by Hsien-yü Shu. See Wen-wu, 1965.8, pl. 3.
* China Pictorial, 1962, no. 6. Bamboo and rock by a river; a distant shore. Handscroll, ink on silk. Signed and dedicated to "Hsin-lao," perhaps Sung Chüeh. Inscription dated 1334. Old and important work.
* Anonymous collotype reproduction in the form of a handscroll. (No indication of owner.) A twisted old tree and bamboo shoots by a stone. Ink on paper. Accompanied by three colophons and a poem, one written by Mi Fu, another by Liu Liang-tso, who mentions Su Tung-p'o as the artist. Interesting early work of the kind associated with Su Shih. See also CK ku-tai, 37; WT/SS 2; Siren CP III, 180.
Formerly Lo Chia-lun Collection, Taipei. A branch of bamboo. Small painting, mounted as a handscroll. Signed. Inscription by Ch'in Kuan.
Garland I, 13. Bamboo in the Rain. Truncated bamboo branch. Inscription by the artist dated 1080. Imitation.

I-t'an (Fine Arts Magazine) no. 1, January 1968, pl. 4.(Ting Nien-hsien Coll., Taipei). Tall bamboo growing by a stream. Signed. Fine work, 13th century in date? An article by the owner in the following issue.

Fujita Museum, Osaka. Bamboo. Inscription, signed. Later work.

Toso 39 (Ku Ho-i Coll.). A stalk of bamboo. Signed. Three poems by later writers. Old attribution, but probably not executed before the Ming period.

Suchiku 1. Branch of bamboo. Ink on silk. Signed, dated 1080.

Homma Sogen, 8 (Yabumoto Kozo, Amagasaki). Branches of bamboo. Pair of hanging scrolls, ink on paper. Signatures, interpolated. Yüan works?

Boston Museum of Fine Arts (29.946). A broken branch of bamboo. Album leaf. Old attribution. Probably 14th century. See Portfolio II, 25.

Freer Gallery (09.177). Bamboo. Round fan painting. Attributed. Ming picture.

Indianapolis Museum of Art. Bamboo. Handscroll, ink on silk. Colophon by Mi Fu. Later imitation.

Metropolitan Museum, N. Y. (47.18.11). Bamboo. Handscroll. Dated 1095. Later work.

Crawford Cat. 9 (John M. Crawford Coll., N. Y.). A branch of bamboo. Signed, dated 1094. Yüan work? See also Chung-kuo MHC 37; Loehr Dated Inscriptions p. 236.

Laufer, XIV. Bamboo by moonlight. Signed, dated 1075. Imitation.

SUN CHIH-WEI　孫知微　t. T'ai-ku　太古
From P'eng-shan, Szechwan. Died c. 1020. Buddhist figures. D, 1. F, 3. G, 4. H, 3. I, 50. L, 16. M, p. 345.

Chung-kuo I, 17 (Joseph Seo, N. Y., 1958). Bodhidharma seated in a cave. Inscription at the top of the picture by the poet Lu Yi (1125-1210) impossibly dated 1032. Inscription also by Chang Chu (1287-1368). Attributed. Late imitation. See also Chung-kuo MHC 4; Loehr Dated Inscriptions p. 231.

* Nelson Gallery (F74.35, formerly J. D. Ch'en Coll., Hong Kong). Travelling Among Rivers and Mountains. Handscroll, ink on paper. Signed T'ai-ku i-min. Fine painting of 13th century date, Chin? See Chin-k'uei, II, 5.; Bunjinga suihen II, 51.

Osaka Municipal Museum (Abe Coll.). Fu Hsi, one of the "Three Emperors." Inscription in the manner of Hui-tsung. Attributed. Late painting. See Soraikan I, 11; Toso 33; Osaka Cat. 18.

See also the rubbing of a stone engraving in the British Museum (no. 69), representing a Taoist immortal seated beneath a gnarled evergreen, accompanied by two women, a crane, and a tortoise; signature of the artist.

SUNG CH'U 宋處
From Hsing-chou, Hopei. 11th century. Landscapes, imitated Kuo Hsi. H, 3.
M, p. 127.

Chung-kuo I, 58 (Ti P'ing-tzu Coll.). Lofty Mountains in Snow; a man walking
along the road followed by his servant. Attributed. Work of Lan Ying
school. See also Chung-kuo MHC 28.

SUNG HSIEH 宋澥
Northern Sung. For a landscape ascribed to him, see the painting in the Ogawa
Collection, Kyoto, listed under Hsiao Chao.

SUNG JU-CHIH 宋汝志　　h. Pi-yün 碧雲
From Ch'ien-t'ang, Chekiang. Tai-chao in the Painting Academy in the
Ching-ting era (1260-1264). Became a Taoist monk in the Yüan period.
Landscapes, figures, flowers and birds. Followed Lou Kuan. H, 4-5. M, p.
127.

* Sogen Meigashu 43 (Marquis Asano Coll.). Young sparrows in a basket.
Album leaf. Attributed. Fine Southern Sung work. See also Kokka 385;
Bijutsu kenkyu 11; Sogen no kaiga 54; Siren CP III, 314; Toyo bijutsu 50;
Genshoku 29/31.
* Formerly Charles Bignier, Paris (photo in Fogg Museum archive). Cicadas on
an oak branch. Album leaf. Signed. Genuine?

SUNG LIANG-CH'EN 宋良臣
Active probably during the Southern Sung period (1127-1276). Flowers and birds.
Little known; name mentioned only in H, 4.

Ch'ing kung ts'ang 42 (Formerly Manchu Household Coll.). Five small birds on
the twigs of a shrub. Fan painting. Signed. later work.
Chin-k'uei 8 (Formerly J. D. Ch'en Coll., Hong Kong). Bird on the branch of a
gingko tree. Signed. Ming-Ch'ing work.

SUNG TI 宋迪　t. Fu-ku 復古
From Loyang. 11th century. Chin-shih. Landscapes, followed Li Ch'eng. Said
to have been the first to represent the famous "Eight Views of Hsiao and Hsiang."
F, 3. G, 12. H, 3. I, 50. M, p. 126.

Taipei, Palace Museum (VA19e). Streams, Mountains and Level Distance.
Album leaf. Attributed. A work of Sheng Mou or close follower. See KK
hsün-k'an 26.
Ibid. (VA31i). Peony. Album leaf. Signed. Much later painting, turned side-
ways when false signature and seals were added.

Kwen Cat. 19. Tall willows and a pavilion by a mountain stream. Attributed. Imitation.

Metropolitan Museum, N. Y. (26.114.1). Pines. Copy of early painting? Another version in the Indianapolis Art Museum.

TAI WAN (YÜAN) 戴琬
From Kaifeng. Member of the Han-lin Academy c. 1110-1125. Favorite of the emperor Hui-tsung. Flowers and birds. I, 51. M, p. 714.

Tai Wan Hua-niao ts'e (1918). Eight leaves representing flowers and birds. Colophon by Lo Chen-yü who writes that the album, according to the old label, contains pictures by Tai Wan. Late paintings.

Toso 59 (Prince Kung Coll.). Two birds on the branches of a cherry-apple tree. Album leaf. Attributed. Another version of the same design, possibly of the Sung period, in the Nelson Gallery, Kansas City.

Metropolitan Museum, N. Y. (47.18.6). The Hundred Birds. Handscroll. Attributed in an inscription by Hsiang Yüan-pien. Later work.

T'ANG CHENG-CHUNG 湯正仲 t. Shu-ya 叔雅 , h. Hsien-an 閒庵
Nephew of Yang Pu-chih, whom he followed in painting plum-blossoms, representing them against a darkened background. H, IV, 66. M, p. 525.

Nanking Exh. Cat. 36 (formerly Wu Hu-fan Coll.). Magpies on a Plum Tree. Signed and dated 1207. Inscriptions by Han Hsing (Yüan Dynasty) and by Ch'ien-lung. Later work. See also Loehr Dated Inscriptions pp. 262-263.

T'ANG SU 唐宿
From Chia-hsing, Chekiang. Active in the Northern Sung period. Flowers and birds. H, 3, p. 13; M, p. 325.

Freer Gallery (19.159). Bamboo and sparrows. Attributed. Ink and colors on silk. Fine work of the Yüan period, close in style to Li K'an.

TS'AI CHAO 蔡肇 t. T'ien-ch'i 天啟
Active second half of the 11th century. From Cheng-chiang, Kiangsu. Chin-shih in 1082. Painted old trees and strange rocks. H, III, p. 77. M, p. 632.

Taipei, Palace Museum (SV52). Grasses and Rocks. Signed. Late Ming, cf. Kao Yang etc.

TSU-WENG 卒翁
A mistaken reading; see CHIH-WENG.

TS'UI CH'ÜEH　崔慤　t. Tsu-chung　子中
Brother of Ts'ui Po. Active during the second half of the 11th century. Flowers and birds. F, 4. G, 18. H, 3. M, p. 387.

Taipei, Palace Museum (VA11e). Quail and beetle by an aspen tree. Album leaf. Attributed. Good painting, of Yüan date?

TS'UI PO　崔白　t. Tsu-hsi　子西
From Hao-liang, Anhui. Became an i-hsüeh in the Academy of Painting at the beginning of the Hsi-ning era (1068-1077) and particularly favored by the emperor Shen-tsung. Executed many wall paintings in the palace and the temples at Kaifeng. Specialized in flowers and birds. F, 4. G, 18. H, 3. M, p. 387. Also biography by J. Cahill in Sung. Biog. 136-139.

*　Peking, Palace Museum. Seven sparrows on a dry branch, one alighting. Handscroll., ink and colors on silk. Signed, but the signature is unconvincing. Good Sung work. See Chung-kuo hua XIV, 12-13; CK ku-tai 32; Wen-wu 1956, 1; *Han-ch'üeh t'u chüan Sung Ts'ui Po hui* (Peking, 1959).
Taipei, Palace Museum (SV38). Peacocks and other birds by a loquat tree. Attributed. Yüan dynasty? copy of earlier work.
Ibid. (SV39). Two flying geese, lotuses and peonies. Inscribed with the painter's name. Ming painting. See KK shu-hua chi 36.
Ibid. (SV40). A swan standing on the shore crying with a lifted head. Attributed. Yüan or early Ming. See KK chou-k'an 4; KK shu-hua chi 14.
Ibid. (SV41). A wild goose resting on a shore beneath reeds. Attributed. Yüan or early Ming. See KK shu-hua chi 20; London Exh. Chinese Cat. p. 40; CKLTMHC II, 21; KK ming-hua I, 37; Wen-wu chi-ch'eng 25; KK chou-k'an 280.
*　Ibid. (SV42). Two Jays and a Hare. Signed and dated 1061. Genuine. *Ssu-yin* half-seal. See KK shu-hua chi 7; Three Hundred M., 81; CAT 23; CCAT pl. 13; CKLTMHC I, 29; KK ming-hua II, 33; Wen-wu 1955.6, 13; Nanking Exh. Cat. 21; KK shou-k'an 114; Skira 72; Siren CP III, 214; Sickman and Soper 98a; Loehr Dated Inscriptions, p. 232; Soga I, 45-46.
Ibid. (SV43). A goose and reeds on a riverbank. Signed. *Ssu-yin* half-seal. Yüan-Ming copy of earlier work? See KK shu-hua chi 1; Three Hundred M., 80; CKLTMHC II, 22; KK chou-k'an 85; Soga I, 47.
Ibid. (SV44). A heron and bamboo in wind. Inscribed with the painter's name. 14th cent. copy of earlier work? See KK shu-hua chi 31; CH mei-shu I; CKLTMHC I, 28; CKLTSHH; KK Bamboo II, 2; Siren CP III, 213; NPM Masterpieces I, 7.
Ibid. (VA15g). Four Rabbits. Album leaf. Attributed. Minor Ming work.
Ibid. (VA28b). Gold Beauty in the Autumn Wind: a flowering branch. Album leaf. Signed. Yüan or later.
Shen Chou 4. A Rabbit. Attributed. Much later work.
Chang Ta-ch'ien Cat. IV. An autumn hare seated under a projecting cliff. Imitation.

I-lin YK 62/1. Bamboo and plum in snow: two birds on a rock. Title by Hui-tsung; seals of Chang-tsung of Chin. Reproduction indistinct. Imitation?

Toso 46 (Ting Shih-yüan Coll.). Two wild geese on the shore; a small bird alighting. Later work.

Sogen 5 (Ihachi Doi Coll.). Two turtle-doves by a rosebush. Attributed. Imitation.

Freer Gallery (19.154). Birds in Autumn Trees. Attributed. Fine work of Yüan or early Ming.

Ibid. (15.25). Geese on the shore, with bare trees. Ming picture.

Ibid. (16.33). Geese and Willow. Ming period, cf. Pien Wen-chin.

Ibid. (16.187). Herons and Willow by Moonlight. Fine Ming work, cf. Lin Liang.

Ibid. (16.196). Ducklings. Ming academic work.

Metropolitan Museum, N. Y. Several paintings ascribed to him: (21.17) Eagle on a rock in the sea; (47.18.34) Wild duck on the shore; (47.18.94) Geese, handscroll.

Asian Art Museum of San Francisco. Two birds on a blossoming branch. Attributed. Ming imitation.

Nelson Gallery, Kansas City. A goose standing on the shore. Attributed.

* Rudolph Schaeffer, San Francisco. Two Geese and Reeds. Attributed. Fine painting of late Sung or Yüan date.

WAN-YEN T'AO 完顏璹 t. Chung-pao 仲寶 and Tzu-yü 子瑜 , h. Ch'u-hsien chü-shih 樗軒居士

A cousin of emperor Chang-tsung (1190-1208) of the Chin dynasty; Duke of Mi-kuo 密國公 . Scholar and collector. B. 1172, d. 1232. M, p. 113.

Mei-chan 12. Two farmers with a water buffalo on the shore of a stream. Two scholars reading in a pavilion built over the water. Signed. Ming work.

WANG CHÜ-CHENG 王居正 also known by the name Han-ko 憨哥
Active in the 11th cent. From Ho-tung, Shansi. Figures. F, 3, p. 17. H, 3, p. 19. M, p. 31.

* Peking Palace Museum. Woman spinning thread assisted by a man-servant. Short handscroll, colors on silk. Signed. Good painting of Sung date. See Chang Ta-ch'ien Cat. I; Li-tai jen-wu 16; Wen-wu 1961.2, 3.

* Boston Museum of Fine Arts (37.302). A lady seated on a terrace looking at a parakeet held by a servant. Old attribution. Good Southern Sung work. See Portfolio I, 145; Southern Sung Cat. 10; Siren CP III, 266.

WANG HSI-MENG 王希孟
Not mentioned in the literature, but the following historical data are found on the picture. Active in the Hsüan-ho era in the Imperial Academy. Born 1096, died 1119. The present picture was painted when he was only eighteen years old.

* Peking, Palace Museum. A Thousand Li of Rivers and Mountains. Mountain ridges with buildings, bridges, boats, trees and numerous figures. A long handscroll painted in archaistic style with heavy green and blue color on silk. Signed. Colophon by Ts'ai Ching dated 1113 . Fine Sung work, probably genuine. See CK ku-tai 44; Chung-kuo hua-pao 1957, no. 6 (section reproduction in color); Loehr Dated Inscriptions p. 242; article by Shu-hua in *Mei-shu,* 1977 no. 3; and articles by Fu Hsi-nien and Yang Hsin in Gugong Bowuyuan Yuankan no. 2, 1979.

WANG HSIAO 王曉
From Ssu-chou, Anhui. Active during the second half of the 10th century. Figures, flowers and birds. D, 3. F, 4. G, 19. H, 3. M, p. 30.

Ch'ing kung ts'ang 23 (Formerly Manchu Household Coll.). Two small birds on a jujube branch. Album leaf. Inscribed with the painter's name. Imitation.
Osaka Municipal Museum (Abe Coll.). Reading the Tablet. The figures in Li Cheng's famous landscape supposedly painted by Wang Hsiao. Copy. See Soraikan I, 8; CK ku-tai 27.
Freer Gallery (16.532). Eagles on Rocks. Attributed. Vigorous work of Ming academic painter.
Ibid. (19.170). Two eagles. Ming work.

WANG HUI 王輝
From Ch'ien-t'ang, Chekiang. Chih-hou in the Painting Academy in the reign of Li-tsung (1225-1264) and that of Tu-tsung (1265-1274). Buddhist and Taoist figures. Worked also with his left hand. H, 4. J, 8. M, p. 34.

Toyo IX (Tanaka Shinzo Coll.). A pair of pictures representing pavilions with figures at the foot of high mountains. Signed. Good Yüan or early Ming works, with interpolated signature.
Hikkoen, 45. Landscape. Album leaf. Attributed. Yüan work, cf. Sheng Mou.

WANG HUNG 王洪
Native of Szechwan . Active in the Shao-hsing period (1131-1162). Imitated Fan K'uan in landscapes. H. M, p. 33.

Princeton Art Museum. (L117.71a-h). Eight Views of the Hsiao and Hsiang. Handscroll, ink and light colors on silk. Signature on the first picture. Colophons by Mo Shih-lung and later writers. Late Sung work? Published as a folio of plates by Lo Yüan-chüeh, Hong Kong, 1956?; Kodansha CA in West I, 8-9; Suiboku II, 8-9; Bunjinga suihen II, 71-72; Kokka 955.

WANG I-MIN 王逸民
A Buddhist monk from Yung-k'ang, Chekiang, who returned to secular life. Active in the Cheng-ho era (1110-1114). Figures and landscapes. H, I, 51, p. 11. M, pp. 32-33.

Chung-kuo I, 37 (Ti P'ing-tzu Coll.). Two shepherd boys playing under leafy trees in autumn. Attributed. Later work. See also CK ming-hua 34.

WANG KUAN 王瓘 t. Kuo-ch'i 國器
From Loyang. Active c. 963-975. Buddhist and Taoist figures. Studied Wu Tao-tzu's wall paintings in the temples at Loyang and imitated their style with so much success that he became known as "the Little Wu." D, 1. F, 3. H, 3. M, p. 30.

Stockholm, Museum of Far Eastern Antiquities. The three Bodhisattvas Avaloki-tesvara, Manjusri, and Samantabhadra in the guise of old bearded men. The attribution is based on a temple tradition and reported in an inscription by Weng T'ung-ho. Cruder versions of the two side figures are reproduced in the Laufer Cat., 7-8 under the name of Kuan Hsiu. Late imitations.

WANG LI-YUNG 王利用 t. Pin-wang 賓王
From T'ung-ch'uan, Shensi. Active under the reign of Sung Kao-tsung. Took the chin-shih degree. Calligrapher and painter. Landscapes and figures. *Hua chi* IV, p. 6. M, p. 33.

Nelson Gallery, Kansas City. Ten manifestations of T'ai-shang Lao-chün. Handscroll, colors on silk. Signed. Inscriptions attributed to emperor Kao-tsung. Seals and colophon of Hsiang Yüan-pien.

WANG NING 王凝
From Chiang-nan. 11th century. Tai-chao in the Painting Academy. Birds and flowers. G, 14. H, 3. M, p. 30.

Taipei, Palace Museum (VA6c). A mother hen walking with chickens on her back. Signed. Seals of Yüan, Ming and later times. Ming picture with inter-polated signature. See KK shu-hua chi 34; Three Hundred M., 74; KK ming-hua II, 28.

WANG SHEN 王詵 t. Chin-ch'ing 晉卿
From T'ai-yüan, Shansi. Born c. 1046; died after 1100. Son-in-law of the emperor Ying-tsung; friend of Su Shih. Connoisseur and collector. Landscapes after Li Ssu-hsün and Li Ch'eng. G, 12. H, 3. I, 40. L, 27. M, p. 32. See also biography by T. W. Weng in Sung Biog. 142-147; and Shen Mai-shih, *Wang Shen* [WS], (Shanghai: CKHCTS, 1961).

* Peking, Palace Museum. Fishermen's village under snow. Handscroll. Attributed. Inscription by Ch'ien-lung. Fine work of late Sung date(?) in Kuo Hsi manner. See I-shu ts'ung-pien IV; Chung-kuo hua I, 5-11; Wen-wu 1961, 6, 2-3; Siren CP III, 222-3; WS 2-4; Yonezawa, Chugoku Bijutsu III, 80; Bunjinga suihen II, 37. A late, exact copy in the Taipei Palace Museum *(Chien-mu, SH145)* has colophons by Chao Meng-fu, Sung K'o and Wen Cheng-ming.

Ibid. Boating on a lotus lake. Fan painting. Attributed. Southern Sung? or later? See Sung-jen hua-ts'e B, XV.

Liaoning Provincial Museum. A man in a pavilion on a riverbank. Fan painting. Attributed. Fine Southern Sung work by follower of Chao Ling-jang? See Liang Sung 17; Liao-ning I, 76; Sung-jen hua-ts'e B, XVIII; Sung Yüan shan-shui 6.

Shanghai Museum. Dense fog over the river. Handscroll. Attributed. Colophon by Sung Lien of the fourteenth century. Late Sung? mannered work in the Yen Wen-kuei-Fan K'uan tradition; copy? See Gems II, 1; Wen-wu, 1962, 12, 5; WS 1; Yonezawa, Chugoku Bijutsu III, pp. 27, 80.

Taipei, Palace Museum (SV51). A white eagle in an old tree. Signed. Ming academic picture, unrelated to Wang. See KK shu-hua chi 18.

Ibid. (SH8). The Land of the Immortals. Said to illustrate a dream of the painter's. Short handscroll in blue and green colors on silk. Signed and dated 1124. Inscriptions by T'ien Yüan-mao, Ch'en Chang-han and Tung Ch'i-ch'ang. Seal of Chia Ssu-tao. Yüan or Ming work. See KK shu-hua lu IV, 31; Three Hundred M., 86; CAT 30; CKLTMHC I, 32; Loehr Dated Inscriptions p. 245.

Ibid. (VA3i). Land of the Immortals: landscape with palace. Album leaf. Attributed. Fragment of a Ming painting.

Ibid. (VA15h). Morning Mirror in the Embroidered Cage. Fan painting. Another version, Southern Sung in date? of one of the two compositions sometimes ascribed to Chou Wen-chü. See NPM Masterpieces II, 13. Cf. Cahill Album Leaves, opp. p. 7; and T'ien-lai-ko for other versions.

Ibid. (VA19f). Garden and two-storeyed pavilion; two ladies on the balcony. Album leaf. Attributed. Ming work. See CKLTMHC II, 90; KK hsün-k'an 27.

Chin-k'uei 5 (Formerly J. D. Ch'en Coll.). The Late Ferry by the Ford. Inscriptions by Wang Ch'ung (dated 1531) and Wang To. Later work.

Chang Pe-chin, Taipei. The Three Whites: a white hawk attacking a white goose in a snowy sky. Attributed. Good Yüan-Ming work, unrelated to Wang.

Shen-chou XX. A man in a boat by a mountain cave on a river. Archaistic decorative style. Attributed. Late Ming?

Toso 31b (Kuan Mien-chün Coll.). Autumn Clouds over Myriad Valleys; deeply creviced mountains and old trees along the river. Handscroll. Attributed. Interesting late Ming work.

Seikasha Sogen, 5. Travelers in a winter landscape. Fan painting. Signed. Imitation.

* Crawford Cat. 8 (John Crawford Coll., N. Y.). Fishing boats on a broad river at the foot of the Hsi-sai Mountain. Section of a handscroll; colors on silk. Ten colophons by Fan Ch'eng-ta (dated 1185), Hung Ching-lu (dated 1188),

Chou Pi-ta (dated 1190?), Tung Ch'i-ch'ang and others. Attributed. Important early painting. See also Loehr Dated Inscriptions p. 258; Ta-feng t'ang IV; Bunjinga suihen II, 42.

WANG TING-KUO 王定國

From Kaifeng. Moved to Hangchou and became a court official. Flowers and birds after Li An-chung.

Taipei, Palace Museum (VA17o). Two birds on a branch in snow. Fan painting. Hard, late copy. See KK chou-k'an I, 13; NPM Masterpieces V, 14; NPM Quarterly V/3, pl. 13A.

WANG T'ING-YÜN 王庭筠 t. Tzu-tuan 子端 h. Huang-hua shan-jen 黃華山人

From Ho-tung, Shansi. Born 1151, died 1202. Said to be a nephew of Mi Fu, but this is not certain. A Han-lin member under the Chin dynasty. Landscapes, bamboo and old trees. H, 4. I, 52. M, p. 34.

Shen-chou ta-kuan 11. A branch of bamboo. Inscription by the artist, signed. Copy or imitation. See also Chiang Er-shih I.
Mo-ch'ao pi-chi I. A house by a stream among leafy trees. Poem, Signed. Inscription by Wang Lo-yü. Imitation.
* Fujii Yurinkan, Kyoto. Old Tree and Bamboo. Short handscroll. Inscription by the painter; colophons by several prominent men of the Yüan period such as Hsien-yü Shu, Chao Meng-fu and T'ang Hou. Genuine. See Kokka 523; NPM Quarterly I, 4, pl. 3; Skira 96; Sogen no kaiga 78; Siren CP III, 320; Toyo bijutsu 75; Bunjinga suihen II, 44.
National Museum, Stockholm (OM99/70). Bamboo in Moonlight. Attributed.

WANG TSAO 王藻 t. Sung-nien 嵩年

Active in the Shao-hsing era (1131-1162). Buffaloes and horses. H, 3. M, p. 33.

Kwen Cat. 56. Three Hundred Buffaloes. Attributed. Imitation. A slightly different verson of this picture, formerly ascribed to Li T'ang, is in the Detroit Institute of Arts.
Fujii Yurinkan, Kyoto. Boy driving a buffalo over snowy ground. Signed. Late, crude copy.

WEI SHENG 衛昇

Active 12th century. Flowers and birds. M, p. 671. H, IV, p. 112.

Taipei, Palace Museum (VA17r). A branch of crepe-myrtle. Fan painting. Attributed. Copy of Sung work.

WEN 溫 , usually called TZU WEN 子溫 t. Chung-yen 仲言 , h. Jih-kuan 日觀 and Chih-kuei-tzu 知歸子
From Hua-t'ing, Kiangsu. Died c. 1295. He lived as a monk in the Ma-nao temple near Hangchou. Specialized in painting grape vines. H, 4. L, 64. M, p. 6. Also biography by Chu-tsing Li in Sung Biog. 147-150.

Nezu Museum. Branches of climbing vine. Two seals of the painter and his inscription dated 1288. Old imitation. See Toso 114; Loehr Dated Inscriptions p. 268-9; Seizanso seisho I, 21; Nezu Cat. 21.
Tenryu-ji, Kyoto. Grape vines. Two sections of a handscroll. Imitation. See Siren ECP 93.
Fujii Yurinkan, Kyoto. Grape vines. Handscroll, ink on paper. Colophon by Sung Lien. Imitation. See Yurintaikan III.
Bunjin gasen II, 4 (Chu Ai-ch'ing Coll.). Grape vines. Short handscroll, ink on paper. Signed and dated 1289. Poem by the painter with two seals. Imitation. See also Loehr Dated Inscriptions, p. 269.
* Kokka 230 (Marquis Inouye Coll.). Grape vines. Signed and dated 1291. Poem by the painter. Genuine. See also Sogen no kaiga 90; Sogen MGS II, 39; Sogen Meiga 24-5; Loehr Dated Inscriptions, p. 270; Siren CP III, 368; Genshoku 29/71. A free copy with the same inscriptions in I-lin YK 99/4.
Nakamura Katsugoro, Japan. Grapes. Ink on paper. Inscription above with artist's seal. Probably based on the former Inouye Coll. painting. See Osaka Sogen 5-66 (same?).
Sogen meigashu 59 (Marquis Kuroda Coll.). A branch of grapes. Album leaf. Old imitation. See also Hikkoen pl. 54.
Fujita Museum, Osaka. Grape vines. Signed. Ming copy.
* Homma Sogen, 54. Grapes. Short handscroll. Poem, signed. Good early work.
Heisando, Tokyo (1979). Grape vines and moon. Horizontal hanging scroll. Attributed. Fine Yüan(?) work.
Shiga Coll. (formerly Viscount Hisamatsu). Grape vines. Signed. Early imitation.
Professor Ando Collection, Kyoto. Grapes. One seal of the artist. Ink on paper.
Agata Collection, Osaka (Formerly Konoe Coll.). Grapes. Ink on paper. Inscription, signed and dated 1281. Imitation.
Yuji Eda, Tokyo. Grapes. Horizontal hanging scroll, ink on paper. Inscription and 2 seals of artist. Old and good painting, probably slightly later than his time.
Freer Gallery (60.2). Grape vines. Hanging scroll, ink on silk. Two seals of the artist; inscription by Chao Meng-fu. Early work; the seals and inscription probably interpolated.

WEN TUNG 文同 t. Yü-k'o 與可 h. Chin-chiang tao-jen 錦江道人 , Hsiao-hsiao hsien-sheng 笑笑先生 and Shih-shih Hsien-sheng 石室先生
From Tzu-t'ung, Szechwan. Born 1019; chin-shih 1049; died 1079. Served as magistrate of Hu-chou, Chekiang, hence known as Wen Hu-chou 文湖洲
Distant cousin and friend of Su Shih. Poet, calligraphist and painter of bamboo.

F, 3. G, 20. H, 3. I, 50. L, 15. M, p. 16. See also biography by S. Ueda in Sung Biog. 150-151; and Yü Feng-pien *Wen T'ung Su Shih* [WTSS] (Shanghai: CKHCTS).

* Shanghai Museum. A branch of bamboo. Ink on silk. Mounted in a handscroll with a painting attributed to Su Shih. Signed Yü-k'o. Early work, possibly genuine, although the signature is unconvincing. See Wen-wu 1965.8, pl. 4.
* Taipei, Palace Museum (SV46). Branch of bamboo. Seals of the painter. Colophons by Wang Chih and Ch'en Hsün of the Ming period. Genuine? or old and faithful copy? See Ku-kung XI; Three Hundred M., 83; CAT 27; CKLTMHC I, 31; KK ming-hua I, 38; NPM Quarterly I, 4, pl. 2; WTSS 1; KK ming-jen hua-chu chi II, 1; Siren CP III, 182.
* Ibid. (VA7b). Bamboo branch; the top bent at a sharp angle. Double album leaf, in ink on heavily sized (Ch'eng-hsin t'ang?) paper. Fine early work; the signature is a later interpolation. Seals of Hsiang Yüan-pien and others. See Nanking Exh. Cat. 391; Chung-hua wen-wu chi-ch'eng IV, p. 318; Wen-wu chi-ch'eng 28; Three Hundred M., 84; KK ming-hua II, 34; Siren CP III, 183; NPM Masterpieces II, 10.

Hsü Hsiao-pu Collection, Taipei. *Wan-ai t'u:* Evening Clouds over the Bay. Handscroll. Title and signature. Copy.

Chang Ta-ch'ien Cat. I. Bamboo branch. Ink on silk. Inscription said to be by Su Shih. Imitation. See also Garland I, 12.

Chin-shih shu-hua, 41. Bamboo branch in snow. Signed? Much later work.

Chung-kuo I, 27 (Ti P'ing-tzu Coll.). Bamboo by a rock in wind. Inscribed with the painter's name and dated 1070. Four poems. Imitation. See also Loehr Dated Inscriptions, p. 232; Chung-kuo MHC 22.

I-lin YK 35/1. Bamboo in Snow. Signed "Hsiao-hsiao hsien-sheng tso." Yüan work?

Osaka Municipal Museum. Bamboo branches in the wind. Imitation. See Soraikan II, pl. 13; Osaka Cat. 27.

Fujita Museum, Osaka. Bamboo. Signed. Ming copy or imitation.

Masaki Art Museum, Osaka. Branch of bamboo. Inscribed, signed. Another inscription by Su Shih. See Masaki Cat. IV. Good Yüan painting.

Metropolitan Museum, N. Y. (19.165). Autumn in the River Valley. Short handscroll; inscribed with the painter's name. Later work in Kuo Hsi style. See Siren CP in Am. Colls. 112; Siren CP III, 184; Priest article in their *Bulletin* 1950, p. 206.

WU-CHUN HO-SHANG　無準和尚　　　Family name Yung　雍, personal name Shih-fan　師範
From Tzu-t'ung, Szechwan. Born c. 1178, died 1249. A priest of the Ching-shan temple and the teacher of Mu-ch'i. The emperor Li-tsung (1225-1264) bestowed on him the hao Fo-chien ch'an-shih　佛鑒禪師　. Cf. *Kundaikan Sayuchoki* 17. For an example of his calligraphy, see his portrait under "Anonymous Sung, Portraits of Priests."

* Kokka 243 (Tokugawa Coll.). Set of three paintings: Bodhidharma crossing the Yangtse on a reed, seals of the painter with a poem by a student of his; Yu-shan-chu on a donkey, poem and seals of the painter; Chen-huan-ning on a buffalo, poem and seals of the painter. Works of the period; perhaps by him. See also Suiboku III, 44-46; Tokugawa 150-153; Sogen MGS II, 30-32.

Fujita Museum, Osaka. Pu-tai. Inscription, signed.

Crawford Cat. 38 (John Crawford Coll., N. Y.). Monk riding a mule. Ink on paper. Poem signed with his name; the painting may be by a different artist.

WU CHÜN-CH'EN 吳俊臣

Active c. 1241-1252. From the Chiang-nan (Kiangsu-Chekiang) region. Tai-chao in the Academy of Painting c. 1241. Painted figures and landscapes; notably snow scenes after Chu Jui. See M, p. 159; H. IV, p. 119; J, VIII, p. 169.

Taipei, Palace Museum (VA21g). The Goddess of the Lo River. Fan painting. Later work.

WU PING 吳炳

From P'i-ling (Wu-chin), Kiangsu. Tai-chao in the Painting Academy in the reign of Kuang-tsung (1190-1194). Flowers and birds. H, 4. J, 5. M, p. 159.

Peking, Palace Museum. Lotus blossom on the water. Fan painting. Attributed. Fine Sung work. See KKPWY hua-niao 13; Fourcade 36; Sung-jen hua-ts'e A, 20; B.I, 9; Sung-tai hua-niao.

Taipei, Palace Museum (VA1k). Butterflies and other insects on rice stalks. Attributed. Fragment of a later work. See CKLTMHC II, 103.

Ibid. (VA17a). A bird on a pomegranate branch. Fan painting. Signed. Copy.

Ibid. (VA23a-b). Mountain bird and oak leaves; bulbul on a bamboo branch. Pair of fan paintings. Each signed, dated 1199. Copies of Sung works.

Ch'ing-kung ts'ang 33 (Formerly Manchu Household Coll.). A bird on a branch of a leafy tree. Album leaf. Inscribed with the painter's name. Imitation.

Chung-kuo MHC XVII. A large white water bird with a blue crest soaring. Fan painting. Inscribed with the painter's name. Imitation.

Chin-k'uei II, 11 (Formerly J. D. Ch'en Coll.). Cherry-apple and a purple bird. Album leaf. Copy.

Metropolitan Museum, N. Y. (13.100.99 and 13.100.103). Birds on the branches of fruit trees. Two album leaves. Attributed. Late works.

Philadelphia Museum. Ducks and hibiscus. Inscribed with the painter's name. Later work.

China Institute Album Leaves #33 (Mrs. A. Dean Perry Coll., Cleveland). Bamboo and insects. Album leaf. Signed.

WU SHU-MING 吳叔明

Unrecorded; probably a court painter of the Southern Sung period, 12th century. Follower of Li T'ang.

* Toso 116 (Umezawa Memorial Hall, Tokyo). Temple among rocks and trees. Signed. Fan painting. Genuine, fine work. See also Shimada and Yonezawa, *Chinese Painting of Sung and Yüan.*

WU TSUNG-YÜAN 武宗元 originally Tsung-tao 宗道 h. Tsung-chih 總之
From Pai-po, Honan. Active at the beginning of the 11th century, died 1050. Buddhist and Taiost figures; imitated Wu Tao-tzu and Wang Kuan. D, 1. F, 3. G, 4. H, 3. M, p. 222.

Toso 136 (Liang I-ming Coll.). A heavenly king. Inscription in the manner of Hui-tsung. Ming work.
* C. C. Wang Collection, N. Y. The Celestial Rulers of Taoism and their attendants in a long procession. Handscroll, ink on silk. Attributed to the artist in a colophon by Chao Meng-fu dated 1304; an earlier colophon by Chang Tzu-hao(?) dated 1172 attributes it to Wu Tao-tzu. Published in Japan in complete scroll reproduction; also in Siren CP III, 119; CK ku-tai 31; T'ang-tai jen-wu p. 25; Wen-wu 1956.2, p. 54-55; Kodansha CA in West I, 39; Sui-boku IV, 27-30. Another version formerly in the possession of the painter Hsü Pei-hung, now in the Hsü Pei-hung Memorial Hall, Peking; reproduced in scroll form by Yu-cheng Book Co. in Shanghai, also in Li-tai jen-wu 15 (three sections). Still another version in the Metropolitan Museum, N. Y. (18.124.1 and 21.18); see London Exh. Cat. 1141. The C. C. Wang version appears to be the oldest. Probably originated as a design for a wall painting. See Hsü Pang-ta's article in Wen-wu 1956 no. 2, p. 57; he considers the C. C. Wang version to be early Sung, the Hsü Pei-hung version later Sung in date.

WU TUNG-CH'ING 吳洞清
From Ch'ang-sha. Flourished in the 11th century. Famous for his paintings of Buddhist and Taoist figures.

Osaka Municipal Museum. Fairy with an attendant. Dated 1175 in upper left corner; 1376 in lower right. Late imitation. See Soraikan II, 11; Loehr Dated Inscriptions pp. 255-6; Osaka Cat. 35.

WU YÜAN-CHIH 武元直 t. Shan-fu 善夫
From Peking. Active during the Ming-ch'ang era (1190-1196) of the Chin dynasty. Painted landscapes. H, 4. I, 42. M, p. 223.

* Taipei, Palace Museum (SH14). The Red Cliff; illustration to Su Shih's fu poem. Handscroll, ink on paper. The text of the poem in the calligraphy of Chao Ping-wen, signed and dated 1228, accompanies the painting. The scroll appears to correspond with a painting by Wu Yüan-chih recorded in the collected literary works of the Chin writer Yüan Hao-wen; hence the attribution, which was first made by Chuang Yen. Formerly attributed to Chu Jui.

See Ku-kung XIX; Three Hundred M., 132; CAT 46; CKLTMHC II, 2; Nanking Exh. Cat. 28; KK chou-k'an 145-6; Siren CP III, 262-3; Loehr Dated Inscriptions pp. 267-8; Bunjinga suihen II, 50; entire scroll and colophon discussed and reproduced in Susan Bush, "Literati Culture under the Chin" in *Oriental Art* XV, no. 2, Summer 1969.

WU YÜAN-YÜ 吳元瑜　　　t. Kung-ch'i　公器
From Kaifeng. Active c. 1080-1104. Pupil of Ts'ui Po. Flowers and birds. G, 19. H, 3. M, p. 159.

Osaka Municipal Museum. Two golden orioles on the branches of a blossoming pear tree. Inscription in the style of Hui-tsung and his seals. *Ssu-yin* half-seal. Ming copy of older work. See Soraikan II, 12; Toso 47; Osaka Cat. 28.
Minneapolis Institute of Arts (62.70.7-.8). Pair of paintings representing a gander and a goose; the latter floating on the water with goslings on her back, the former standing on the shore. Inscribed, in a label mounted on the framing silk, with the painter's name and the date 1103. Ming period. For the latter, see Siren CP III, 216; both in their *Bulletin* LIII, no. 2, June 1964.

YANG FEI 楊朏 (or 裴　　)
From Kaifeng. Active in the Northern Sung period. Buddhist and Taoist figures, particularly pictures of Kuan-yin. f, 3. H, 3. M, p. 582.

I-shu ts'ung-pien 4. Kuan-yin descending on clouds; long fluttering garments laid in fine folds. Attributed. Sung work in archaistic style?

YANG MEI-TZU (EMPRESS YANG)　楊后　　　(楊妹子)
Born 1162; died 1232. Consort of Emperor Ning-tsung. See Chiang Chao-shen, "The Identity of Yang Mei-tzu and the Paintings of Ma Yüan" in NPM Bulletin II, no. 2, May 1967, pp. 1-15; no. 3, July 1967, pp. 8-13.

TSYMC hua-hsüan 10 (Formerly Wu Hu-fan Coll.). Two orioles on branches of a cherry tree. Horizontal album leaf; seal dated 1213. Inscription by Empress Yang; the painting probably by an Academy master of that time.
Note: The anonymous Sung painting of weeping willow in Sung-jen hua-ts'e A, 55 etc. which is inscribed by her, has also sometimes been attributed to her, although without reason.

YANG PU-CHIH 楊補之 t. Wu-chiu 無咎 h. T'ao-ch'an lao-jen 逃禪老人　　and Ch'ing-i chang-che　清夷長者
From Nan-ch'ang, Kiangsi. Born 1098, died 1169. Followed the plum-blossom painter Hua-kuang, and is the purported editor and part-author of the spurious *Hua-kuang mei-p'u* 華光梅譜　　　. H, 4. I, 51. L, 32. M, p. 499.

Peking, Palace Museum. Plum blossoms and bamboo in snow. Handscroll. Numerous colophons from the Yüan dynasty and later. Attributed in an inscription by his contemporary Tseng Ti. Published as a folio of plates by Wen-wu Pub. Co., Peking, 1960. Hard, dry work; later Sung or Yüan copy or imitation? See also the article by Hsü Shu-ch'eng in Wen-wu, 1973, no. 1, pp. 15-18, and I-yüan to-ying, 1979 no. 1, pp. 12-13.

* Ibid. Four Stages of Blossoming Plum. Four paintings mounted in a handscroll, followed by an inscription by the artist dated 1165. Seals of Wu Chen, Shen Chou, Hsiang Yüan-pien Wen Cheng-ming, etc. Fine early painting, probably genuine. See CK ku-tai, 48; Kokyu hakubutsuin, 164-5.

Tientsin Art Museum. Ink plum blossoms. Fan painting. Signed Ch'ing-i. See Liang Sung 6; Sung-jen hua-ts'e B, XIX.

Taipei, Palace Museum (SV61). A ch'in player on a misty mountain. Four poems by writers of the Ming period. Late Sung? or Yüan? See KK shu-hua chi XXIX; KK chou-k'an 428.

* Ibid. (VA7c). A spray of bamboo. Album leaf. Colophon. Attributed to the artist in an inscription by Yeh-weng, or Yeh-she, a contemporary? Fine early work, perhaps as attributed. See Nanking Exh. Cat. 391; Three Hundred M., 93; CKLTMHC I, 41; KK ming-hua II, 39.

Ibid. (VA31a). A branch of blossoming plum. Album leaf. Signed. Inscriptions by Liu Yin and other Yüan dynasty scholars. Yüan work, with interpolated signature?

KK shu-hua chi XXXIV. The upper section of an old plum tree in bloom. Signed. Poem by the painter. Late, minor work. See also KK ming-hua mei-chi I, 1.

I-lin YK 107/14. Branch of blossoming plum. Signed, dated 1260. Much later work.

Fujita Museum, Osaka. Branch of blossoming plum. Seal. Ming copy?

Umezawa Memorial Museum, Tokyo. Blossoming plum and moon. Seal of the artist. Colophons by Fan-ch'i, Ch'u-shih, and Ou-chü, unidentified. See Homma Sogen 39.

Mayuyama and Co., Tokyo (1970, formerly Shorin-ji, Kyoto). Blossoming plum. Pair of hanging scrolls, ink on silk. Attributed. Yüan period works?

Freer Gallery (18.2). Branches of blossoming plum in snow. Inscription, signed and dated 1135. Early Ming?

YANG SHIH-HSIEN　楊士賢
Tai-chao in the Painting Academy during the Hsüan-ho and Shao-hsing eras (c. 1120-1160). Landscapes, followed Kuo Hsi. H, 3. M, p. 583.

Boston Museum of Fine Arts (59.960). The Red Cliff. Handscroll. Signed. Good Yüan-Ming work, 14th century? See their *Bulletin* LIX, no. 317, pp. 86-7; Kodansha CA in West I.6; Bunjinga suihen II, 52.

YANG WEI　楊威
From Chiang-chou, Szechwan. 11th century. Painted farm scenes. G, 3. I, 51. M, p. 582.

Peking, Palace Museum. Peasants at work. Attributed. 14th-15th century? See Sung-jen hua-ts'e A, 9; B.VI, 1.

YAO YÜEH-HUA　姚月華
A woman painter. Painted flowers, birds and animals. I, 52.

Peking, Palace Museum. Chrysanthemums in a vase. Fan painting. Attributed. Poem by Emperor Ning-tsung (reigned 1195-1224). Copy? See Sung-jen Hua-ts'e A, 54; B.IX, 10.

YEH HSIAO-YEN　葉肖巖
From Hung-chou, Chekiang. Active c. 1253-58. Painted figures, mostly in album leaves. Imitated Ma Yüan. H, IV, p. 107. M, p. 575.

Taipei, Palace Museum (SA5). Ten Views of the West Lake. Album of 10 leaves. Signed. Ming paintings?

YEH NIEN-TSU　葉念祖　　　t. Po-hsien　栢仙
Probably late Sung dynasty. Unrecorded.

Chin-k'uei 9 (Formerly J. D. Ch'en Coll., H. K.). A hanging grapevine. Signed. Formerly in the T'ing-fan-lou Collection, Shanghai. Late Sung or Yüan?

YEN-SOU　嚴叟
Probably active in the Southern Sung period as a specialist in plum blossoms. Not identical with Wang Yen-sou　王嚴叟　t. Yen-lin　彥霖　who served as a censor in the reign of the Emperor Che-tsung (1086-1100).

* Freer Gallery (31.2). Plum blossoms; long branches of a tree and a section of its trunk. Handscroll. Signed. Fine work of Southern Sung date. See Toso 117a; Siren CP III, 366-7. Also Hin-cheung Lovell's article in Archives XXIX, 1975-6, pp. 59-79.

YEN SU　燕肅　t. Mu-chih　穆之
From I-tu, Shantung. Also known as Yen Lung-t'u because of his service in the Lung-t'u Pavilion. Passed his chin-shih degree and served as President of the Board of Rites in the reign of the emperor Chen-tsung (998-1022). Born 961; died 1040. Landscapes. F, 3. G, 11. H, 3. I, 40. L, 18. M, p. 668.

Taipei, Palace Museum (SV24). Mountains in snow along a river; pavilions under some bare trees. Inscription by Li Jih-hua who attributed the picture to Yen Su; but the execution is not earlier than the middle Ming period, post-Shen Chou. See Three Hundred M., 82.

Ibid. (VA 19c). Fishing Net on the Cold Shore. Fan painting. Late copy. See KK hsün-k'an 24.

Metropolitan Museum, N. Y. (47.18.45). Walking with a Staff in the Autumn Mountains. Album leaf. Later work. See Priest article in their Bulletin, April 1950, p. 250.

YEN TZ'U-P'ING　閻次平

Son of the painter Yen Chung　閻仲　. Entered the Painting Academy c. 1164; became a chih-hou, and was still active in 1181. Specialized in water buffaloes; influenced by Li T'ang as a landscapist. H, 4. J, 4. M, p. 673. See the article by Richard Edwards in *Ars Orientalis* X (1975).

* Nanking Museum. Herding Buffalo. Four horizontal paintings, corresponding to the four seasons. Attributed. Fine Southern Sung works, possibly by him. See Chung-kuo hua XIX, 16-17; Gems II, 3; Nanking Mus. Cat., I, 1.

Taipei, Palace Museum (SV82). Landscape with water and pavilion, known as The Four Contentments (wood-cutter, fisherman, farmer and scholar). Probably a work of the 18th century artist Yüan Yao. See KK shu-hua chi XIII; London Exh. Cat. p. 51; Three Hundred M., 105; Wen-wu chi-ch'eng 40; KK chou-k'an 166; Siren CP III, 264.

* Ibid. (VA14f). A temple on a rocky shore among large pine trees. Fan painting. Signed. Genuine. See KK shou-k'an III, 64; CKLTMHC II, 77; KK ming-hua III, 11; NPM Masterpieces II, 26.

Chin-k'uei 10 (Formerly J. D. Ch'en Coll.). Hermitage by the Lake in Late Spring; palace and rocks. Attributed. School of Yüan Chiang.

Li Mo-ch'ao. Three goats under willows. Album leaf. Attributed. Copy.

Tokyo National Museum (formerly Daitoku-ji). A pair of paintings: fishing boats on the river, the river in snow with a ferry. Interesting works by a Kuo Hsi follower; Yüan period? See Shimbi XII, Suiboku II, 56-57; Tokyo NM Cat. 31.

* Kokka 191 (Sumitomo Coll.). Two herd-boys and water buffaloes by a river. Attributed. Good Southern Sung work? See also Toyo VIII; Sogen no kaiga 111; Toyo bijutsu 33; Genshoku 29/19; Sogen MGS III, 20.

Cleveland Museum of Art (72.41; former T. Inouye Coll.). Bodhidharma seated in meditation facing a cliff. Seal of the painter interpolated; Yüan work? See Toso 72; Pageant 136; Suiboku III, 102; Lee Colors of Ink Cat. 9.

Freer Gallery (16.99). Fisherman returning through winter landscape. Attributed. Good Ming work; cf. Chiang Sung.

Ibid. (11.161a). River scene with fisherman. Album leaf. Attributed. An illegible signature at left is not Yen's. 14th century? See Cahill Album Leaves XXV.

Juncunc Collection, Chicago. Landscape. Signed, dated 1187. Copy.

YEN TZ'U-YÜ　閻次于

Younger brother of Yen Tz'u-p'ing. Chih-hou in the Painting Academy c. 1164. Landscapes. H, 4. M, p. 673. See the article by Richard Edwards in Ars Orientalis X (1975).

Sung-jen hua-ts'e 86. Ducks on a pond. Attributed. Later, unrelated to Yen.

Taipei, Palace Museum (VA19h). Travellers in Autumn Mountains; a man and his servant approaching a promontory with leafy trees. Album leaf. Catalogued as "Lien Fou," but this name is based on a misreading of a signature which appears to read: Yen Tz'u-yü. Genuine? or early imitation? See Ars Orientalis X (1975), p. 86, pl. 5.

Ibid. (VA21c). Rowing Home over Mirror Lake. Album leaf. Signed. Ming copy? See Ars Orientalis X (1975), p. 88, pl. 9.

* Freer Gallery (35.10). A hostel in the mountains; travellers. Album leaf. Signed. Genuine. See TWSY ming-chi 82; Siren CP III, 265; Kodansha Freer cat. 39; Kodansha CA in West I, 11; Suiboku II, 50; Cahill Album Leaves, V.

Metropolitan Museum, N. Y. (47.18.134). Landscape. Album leaf. Signed, but the signature probably is interpolated, and the painting later.

* John M. Crawford, Jr., N. Y. A rocky bay and pines in wind and rain. Fan painting. Attributed. Good Southern Sung work. See Crawford Cat. 34; Ta-feng t'ang IV; China Institute Album Leaves no. 32.

YEN WEN-KUEI　燕文貴　　or Yen Kuei　燕貴

From Wu-hsing, Chekiang. Served first as a soldier, retired in the reign of T'ai-tsung (976-997). Became later a tai-chao in the Academy of Painting. Landscapes and figures. D, 2. F, 4. H, 3. I, 50. L, 18. M, p. 668. Y, p. 258. See also Wen Fong's study of this artist in Summer Mountains (New York, 1975); and biography by Hsio-yen Shih in Sung Biog. 151-154.

TWSY ming-chi 10-12. Yen-lan shui-tien t'u: river landscape, palaces by the river, men in boats, mountains beyond. Handscroll. Indistinct reproduction; appears to be similar in style to the painting in the Osaka Municipal Museum listed below.

* Taipei, Palace Museum (SV14). Ch'i-shan lou-kuan t'u: towering mountains rising over a river; temples in the valleys, houses and travellers below. Signed. Genuine work. Ssu-yin half-seal. See KK shu-hua chi 2; Three Hundred M., 71; CCAT pl. 95; CKLTMHC I, 26; KK ming-hua II, 26; KK chou-k'an 506; Siren CP III, 171; Soga I, 20-21; Summer Mts. 45.

Ibid. (SV15). Temple among autumn peaks. Signed. Inscription by Kuo Pi of the Yüan dynasty. Probably a work of some 17th century master such as

194

Lü Huan-ch'eng or Liu Tu. See KK shu-hua chi 43; Che-chiang 4; KK ming-hua I, 32.

Ibid. (SV17). Three immortals seated in a cave. Strange painting of the Ming period, cf. Chou Ch'en and T'ang Yin. See KK shu-hua chi 28; Three Hundred M., 72; KK chou-k'an 402; London Exh. Chinese Cat., p. 37; NPM Masterpieces III, 11.

Ibid. (SV16). Fishing with a Net along Wintry Banks. Attributed. Later copy of a Southern Sung work?

Ibid. (chien-mu SH43). Temple in autumn hills. Handscroll 17th century?

Ibid. (SH44). Mountains and rivers after snow. Handscroll, ink and colors on silk. Dull, late imitation of a type commonly attributed to Yen.

Ibid. (VA16b). A Myriad Trees on Strange Peaks. Fan painting. Attributed. Style of Li T'ang; possibly his work. See Skira 42; NPM Masterpieces II, 8; Soga I, 34.

Ibid. (VA19b). Travelling on the Winter Stream. Fan painting. Attributed. Late Sung or Yüan? See KK hsün-k'an 23.

Ibid. (VA3h). The visit. River landscape: a house on the shore, a visitor arriving by boat. Album leaf. Yüan or later painting.

Tien-yin-tang I, 1 (Chang Pe-chin Coll., Taipei). Travellers in autumn mountains; returning boats. Handscroll. Signed. Ming work.

Yu Cheng album (Formerly Manchu Household Coll.). A river winding among heavily eroded hills; gnarled trees, houses in valleys, travellers. Long handscroll. Attributed. Chin or early Yüan work? in the Northern Sung tradition. Colophons by Ni Tsan, Lu Kuang and many others. See also Chugoku I; Liu 19.

* Osaka Municipal Museum (Abe Coll.). River landscape with high mountains and temple buildings. Handscroll, ink on paper. Signed. Early 12th century work? in the tradition of Yen Wen-kuei. See Soraikan I, 10; Toyo bijutsu 17-19; Chugoku I; Genshoku vol. 29, pl. 10; Suiboku, II, 4; Osaka Cat. 19; Summer Mts. 9; Bunjinga suihen II, 20.

Tokyo National Museum (49.295). Pair of landscapes. Attributed. Yüan works?

Fujii Yurinkan, Kyoto. Clearing after snowfall on a river. Free version of Wang Wei's composition. Inscribed with painter's name. Colophons purporting to be by Lu Kuang, Sung K'o, and Shen Chou (dtd. 1502). Seals of Hsiang Yüan-pien. See Yurintaikan II; cf. the picture in the TWSY ming-chi listed above. Imitation.

Cheng Chi Collection, Tokyo. Wind on the River: hills by a river with temples and figures. Handscroll on dark silk. Ch'ien-lung and other seals. Attributed. Later work. See Summer Mts. 31-2. The colophons originally with this scroll are now attached to the version of the composition in the Juncunc Collection, see below.

Freer Gallery (11.223). Winter Landscape. Handscroll on silk. Signed. Supposed to be after Wang Wei's "Clearing after Snow." Copy. Another late copy in the same collection (15.6); still another ascribed to Wang Wei (19.124).

* Metropolitan Museum, N. Y. (1973.120.1). *Hsia-shan t'u:* Summer Mountains. Handscroll, ink on silk. Attributed. Seals of Liang Ch'ing-piao, Ch'ien-lung and others. Early (12th-13th cent?) and fine painting. See Met. Cat., 1973, no. 1 and Summer Mts., where it is loosely ascribed to a follower of Yen named Ch'ü Ting, q.v.

Juncunc Collection, Chicago. *Ch'i-feng t'u:* Wind on the River. Handscroll, on paper. Attributed. Seals of Liang Ch'ing-piao, Ch'ien-lung and others. Later work. Same composition as scroll in Cheng Chi Collection, see above.

Crawford Cat. 34 (John Crawford Coll., N. Y.). A rocky bay and pine trees in wind and rain. Fan painting. Attributed. Good Southern Sung work. See also Chang Ta-ch'ien Cat. IV; China Institute Album Leaves #32, ill. p. 52.

Other album leaves loosely attributed to Yen Wen-kuei in the Metropolitan Museum, N. Y. (13.100.116 and 13.100.118—for the former see Alan Priest article in their *Bulletin,* April 1950, p. 246); and the Crawford Collection (Cat. #28.).

YÜ-CHIEN 玉澗

The name has been used by two monk-painters, both active around or shortly before the middle of the 13th century.

A. Ying Yü-chien 瑩玉澗 who lived in Ch'ing-tz'u ssu at the West Lake in Hangchou and is said to have been a follower of Hui-ch'ung as a landscape painter.

B. Jo-fen 若芬 . Family name Ts'ao 曹 , t. Chung-shih 仲石 , h. Fu-jung shan-chu 芙蓉山主 and Yü-chien, who lived in Shang-chu ssu in Yangchou and later in Wu-chou, Chekiang. H. 4. M, p. 259. The latter is probably the painter of the works listed below; he was not a Ch'an priest, but a priest of the T'ien-t'ai sect. See Kei Suzuki, "A Study of Yü-chien Jo-fen" in *Bijutsu kenkyu* 236, Sept. 1964, pp. 1-14.

Fujii Yurinkan, Kyoto. Arhats in a landscape. Handscroll, ink on paper. Ming work with interpolated "Yü-chien" signature. See Yurintaikan II, 10.

* Daiun-in Temple (kept at Kyoto National Museum). Misty river landscape; fisherman in a boat. Ink on silk. Poem, signed. Related in style to the Mount Lu painting listed below; possibly genuine. See Suiboku II, 100.

* Toso 113 (Yoshikawa Eiji Coll., Tokyo). Waterfall on Mount Lu. Handscroll, now divided into two pieces. Poem by the artist; signed. See also Sogen no kaiga 124-5; Siren CP III, 347; Toyo bijutsu 38; Kokka 691; Suiboku II, 18-19; Genshoku 29/46; Sogen MGS II, 29. An early complete copy of the original is in the Nezu Museum; see Nezu Cat. 12; Suiboku III, appendix 37.

* Idemitsu Art Museum, Tokyo (Formerly Matsudaira Coll., and Yoshikawa Eiji Coll., Tokyo). Mountain Village in Clearing Mist. One of the Eight Views of Hsiao and Hsiang. Attributed. Fine late Sung work. See Kokka 429; Toyo X; Sogen p. 38; Sogen no kaiga 121 and 123; Siren CP III, 346 bottom; Suiboku III, 20; Genshoku 29/47.

* Ibid. 498 (Formerly Maeda Coll., now Matsutaro Yada, Katayamazu). Harvest Moon over Tung-t'ing Lake. From the same series as the preceding picture. See also Sogen no kaiga 122; Siren CP III, 346 top; Suiboku III, 99. Sogen MGS II, 28.
* Reimeikai, Tokyo (Tokugawa Coll.). Returning Sails on a Distant Inlet. See Suzuki article plate V; Sogen no kaiga 120; Suiboku III, 98; Tokugawa 159; Sogen MGS III, 37.

Muto Cat. II, 2. A beach at the foot of undulating hills. Short handscroll. Poor condition, but may be of the period.

Suiboku II, appendix 15. Epidendrum. Short handscroll, mounted as hanging scroll. Attributed. Fine late Sung or early Yüan work.

Hosomi Collection, Izumi Otsu (kept at Kyoto National Museum). A house among trees; a returning farmer. Inscription; seal which is illegible, but may be the artist's. Horizontal hanging scroll, ink on silk. Of the period. Badly damaged, but with inscription resembling that on the painting of Mt. Lu listed above.

Sogen meigashu 11.46 (Murayama Coll.). Mountains rising over a low beach with dark trees. A later picture, Korean? Cf. the works attributed to Kao Jan-hui, Yüan dynasty.

Homma Sogen, 38 (T. Yanagi, Kyoto). River landscape: Ox in water, man on shore. Ink on silk. Attributed. Accompanying letter by Sen-no Rikyu, who once owned the painting. Late Sung or Yüan.

Ibid. 37. A man walking by a stream in rain; tall bamboo. Attributed. Interesting Sung-Yüan work.

Ching Yüan Chai Collection. Landscape with boats and travellers. Badly damaged, retouched. Fragment of old painting with interpolated Yü-chien seal? See Suiboku III, 101.

YÜ CH'ING-YEN　於青言　　　or　于青言　　　, or Ch'ing-nien　青年
Native of P'i-ling (Ch'ang-chou), Kiangsu. Active in the Chia-ting era (1208-1222). Specialized in lotus and was called Ho Yü, i.e. "Lotus Yü." Younger members of the family continued the same tradition: Yü Tzu-ming 於子明 was probably his son, and Yü Wu-tao 於務道 , Wu Yen 務言 , who was active in the Yüan period, was probably his grandson. H, 4. M, pp. 7, 215.

* Chion-in, Kyoto. A pair of pictures: Lotus and Ducks; Lotus and White Herons. Attributed. Seals reading *P'i-ling Yü shih* (Yü Family of P'i-ling), and *Yü-shih Tzu-ming.* The paintings were once ascribed to Hsü Hsi. See Sogen no kaiga 62; Toyo bijutsu 52-3; Siren CP III, 369-70; SBZ V, XIV; Genshoku 29/33; Yamato Bunka, 31. Two similar pictures are in the Tokyo National Museum, ascribed to Ku Te-ch'ien. See Sogen bijutsu 43; Sogen no kaiga 63; Sogen MGS III, 11-12. Two others, lotuses and other plants only, in the Kyoto National Museum (not a pair).

YÜ CHUNG-WEN　虞仲文　　t. Chih-fu　質夫
From Ting-yüan, Shansi. Born ca. 1069, probably d. 1123. *Chin-shih* and Han-lin member under the Chin dynasty. Bamboos after Wen T'ung. Figures and horses. H, 4. I, 52. L, 6. M, p. 562. *Chin shih* ch. 75.

Chung-kuo MHC 26 (Ti P'ing-tzu Coll.). A flying horse running through the air. Signed. Colophon by the painter, dated 1186. Impossible date; imitation. See also Chung-kuo I, 83; Loehr Dated Inscriptions p. 258.

YÜ TZU-MING
See Yü Ch'ing-yen.

V.

Anonymous Sung Paintings

Note: We have separated this section into many more subject categories than were used by Siren in the old Annotated Lists, and hope that this new arrangement will make it easier to locate particular pictures and representations of particular subjects. Obviously, the distinctions between categories are not always sharp; we have made them according to sometimes subjective judgements of the prominence of figures or buildings in the landscape, etc. Within each category, album leaves (including fan paintings) are listed after the works in the larger forms.

The subject categories now are:

Landscapes
Palaces and Temples
Landscapes with Buildings and Figures
Landscapes with Figures
Landscapes with Figures, of the Ma Yüan Type and Tradition
Fishing and Boating Scenes

Horsemen, Tartar Scenes, Etc.
Scholarly Gatherings
Narrative, Historical and Legendary Scenes
Palace Ladies and Children
Miscellaneous Figures
Portraits
Portraits of Priests
Buddhas and Boddhisattvas
Other Buddhist Figures
Arhats
Ch'an Buddhist Subjects
Taoist Scenes
Buffalo and Herd-boy Pictures
Monkeys and Gibbons
Dogs and Cats
Goats and Sheep
Other Animals and Fish
Birds, and Birds-in-landscape Compositions
Flowers, Fruit and Insects

Landscapes

* Peking, Palace Museum (this and the following three works exhibited Fall 1977). Winter landscape with travellers. Hanging scroll, ink and light colors on darkened silk. Two inscriptions by Wang To, dated 1616 and 1642, ascribed the work to Wang Wei of the T'ang period. Southern Sung work, in older manner.
* Ibid. Geese alighting on a wintry bank. Hanging scroll, ink and light colors on silk. *Ssu-yin* half-seal; also seals of Liang Ch'ing-piao. Fine work of the late Northern Sung period?
* Ibid. Rocky landscape with travellers. Hanging scroll, ink and colors on silk. Manner of Li T'ang. Fine Southern Sung or Yüan work.

Ibid. Travellers in snowy mountains. School of Kuo Hsi, Yüan period?

Shanghai Museum. Travellers in snowy mountains, watermills and pagodas. Ming? or earlier? copy of monumental landscape in Fan K'uan tradition. See Shang-hai 6.

Taipei, Palace Museum (SV129). Creviced mountains with old trees in snow. Late Ming or early Ch'ing work, School of Lan Ying, in a manner loosely associated with Chang Seng-yu of the 6th century. See KK shu-hua chi XXIV; London Exh. Chinese Cat. p. 110; CH mei-shu I; KK chou-k'an 327.

* Ibid. (SV130). Countless Peaks and Valleys. A fine Chin or early Yüan work in the Kuo Hsi tradition. See KK shu-hua chi XVI; CKLTMHC III, 97;

KK ming-hua III, 30; KK chou-k'an 193.

Ibid. (SV131). Steep Mountains and Gushing Waterfalls. Probably by the Ming artist Wu Pin. See KK shu-hua chi XXXIV.

Ibid. (SV134). Pine trees and rocks by a waterfall. Yüan period or later. See KK shu-hua chi II; Three Hundred M., 144; CKLTMHC II, 23; KK ming-hua IV, 27; KK chou-k'an 497; Soga I, 10.

Ibid. (SV138). Winter scenery with travellers; village by a river spanned by a high bridge. Hard Ming painting, 15th-16th century, by follower of Sheng Mou. See KK shu-hua chi XXIII.

Ibid. (SV141). Seasonable Snow on Streams and Mountains. Yüan or early Ming.

Ibid. (SV142). Snow-covered mountains by a river. Poem by Ch'ien-lung. Fine painting, probably of Ming date. See KK shu-hua chi V; London Exh. Chinese Cat., p. 108; Three Hundred M., 143; CAT 43; CKLTMHC II, 57; KK ming-hua IV, 28; KK chou-k'an 502; NPM Masterpieces V, 19.

Ibid. (SV140 and SV143). See below, under Freer Gallery (15.20).

* Ibid. (SV144). Clearing after Snow in the Min Mountains. Fine Chin painting? Or Yüan? in tradition of Kuo Hsi. See KK shu-hua chi XI; CAT 47; CKLTMHC II, 58; KK ming-hua III, 32; NPM Bulletin II, 6, fig. 6; NPM Quarterly I.2, pls XXII, XXIII.B; Nanking Exh. Cat. 46; KK chou-k'an 155; Siren CP III, 224; see also Susan Bush, "Clearing after Snow in the Min Mountains" in *Oriental Art* XI (Autumn 1965), no. 3.

Ibid. (SV146). Playing the lute in a pavilion among pines. Ming archaistic work.

* Ibid. (SV148). Secluded Fishing in a Clear River. Important early composition (10th century?) in somewhat later execution (Yüan dynasty?). See KK shu-hua chi XLV.

* Ibid. (SV149). *Hsiao han-lin t'u:* Small Wintry Grove. Fine work of Sung period, school of Kuo Hsi. Formerly associated with Li Ch'eng. *Ssu-yin* half-seal. See KK shu-hua chi XLIV; CKLTMHC II, 8; KK ming-hua III, 33; Nanking Exh. Ct. 44; Yüan Exh. Cat. 44; Soga I, 9; Bunjinga suihen II, 39.

* Ibid. (SV150 and SV153). Deeply creviced mountains in autumn; river valley with building at the foot of deeply creviced mountains. Pair of hanging scrolls. Late Sung or Chin works? in the tradition of Ching Hao. See SV150 in KK chou-k'an 104; CKLTMHC II, 6; KK ming-hua IV, 30; NPM Bulletin II, 6 and 7. See SV153 in KK shu-hua chi 12; CKLTMHC II, 7; KK ming-hua II, 34; NPM Bulletin II, 6. Both works are discussed in Fu Shen, "Two Anonymous Sung Dynasty Landscapes and the Lu Shan Landscape" in NPM Bulletin II, no. 6 and II, no. 1 (1968).

Ibid. (SV154). Fishing boats on the river at the foot of high mountains. Ming work, with elements of Kao K'o-kung style. See KK shu-hua chi XVIII; CKLTMHC II, 40; KK chou-k'an 235.

Ibid. (SV172). Hsiao-i Stealing the Lan T'ing Manuscript. See under Chü-jan.

Ibid. (SV182). *Ch'iu-shan wen-hui t'u:* Scholars Meeting in Autumn Mountains. Ming work, cf. Yu Ch'iu, after older composition? See KK shu-hua chi XLIII.

* Ibid. (SV345, chien-mu). *Han-lin tai-tu t'u:* A clump of knotty old trees on a riverbank, men stepping onto a ferry. Fine Chin or early Yüan work in the Kuo Hsi tradition. See KK shu-hua chi XLIII; CKLTMHC II, 67.

Ibid. (SV346, chien-mu). Visiting a Recluse in the Shade of Pines. Late Ming work, related to Hsiang Sheng-mo.

Ibid. (SV347, chien-mu). A house among trees by a bridge. Seals of Hsiang Yüan-pien. Ming work, 15th century?

I-shu ts'ung-pien 13. Reading the I-ching in a pavilion under pine trees. Inscriptions on the mounting by Tung Ch'i-ch'ang and others. Late imitation of Tung Yüan manner.

Garland I, 16. Snowy Landscape. Old attribution to Li Ch'eng. Ming painting.

Formerly Chang Ta-ch'ien Collection. Autumn Morning on the Ch'u River. Handscroll. Copy of Sung composition?

Chung-kuo MHC 23. Mountain landscape with temples and houses. Ming work, based on an early composition of the tradition associated with Kuan T'ung.

* Tokyo National Museum. A Dream Journey on the Hsiao and Hsiang Rivers. Handscroll, ink on paper. Wrongly ascribed to Li Kung-lin, and bears a spurious signature of that artist. One of the Sung colophons (the earliest dated 1170) mentions a "Master Li" as the artist. A fine 12th century work, probably done in the 1160's. Published in scroll form by Haku-bundo; see also Shimada and Yonezawa; Sogen no kaiga 92-3; Toyo bijutsu 20-23; Loehr Dated Inscriptions pp. 253-4; Genshoku 29/3; Bunjinga suihen II, 64, 70; Tokyo NM Cat. 1.

Toso 133 (K'uai Shou-shu Coll.). High snow-clad mountains by a river, pavilions and boats. Ming work in Li T'ang tradition.

Nanshu ihatsu I. Cliffs by a river in snow. Late 17th century, cf. Li Yin; see Cahill "Yüan Chiang and His School" I in Ars Orientalis V, pl. 2.

Ibid. Travelling at Morning in Snowy Mountains. Spurious "Hui-tsung" inscription. Late forgery.

Ibid. A villa in the mountains, with an old tree. 17th century, cf. Lu Wei. See also Chung-kuo I, 70; Chung-kuo MHC 24.

Osaka Cat., 22. River Landscape with Travellers. Old attribution to Kuan T'ung. Inscription by Tung Ch'i-ch'ang mounted above. Later Sung archaistic work? See also Soraikan II, 24.

* Ibid. 23. Fishing on the River in Autumn. Important early work, 11th century? Seals of Teng Wen-yüan, Ch'en Wei-yün, and other Yüan and later people. See also Soraikan II, 27; Kokka 645; Bijutsu Kenkyu 126.

Ibid. 26. A man seated by a stream; mists around the base of a bluff. Title by Lo Chen-yü calling it "Anon. T'ang." Ming work? See also Soraikan II, 23.

Ibid. 33. A man washing his feet in the stream; misty trees. Ming work? perhaps after an older and more complete composition. See also Soraikan II, 21; Nanshu ihatsu I.

Ibid. 71. A river landscape in autumn. Old composition in Ming rendering. See also Soraikan II, 22.

Suiboku III, 104. Travellers in a misty landscape. Inscription by Hsü-chou P'u-tu (1199-1280), written after 1277. Amateurish work by Ch'an priest-artist of the 13th century.

Kagata Kanichiro, Niigata. Landscape. Attributed to the Southern Sung, but more likely Yüan. Manner of Li T'ang.

Chicago Art Institute (50.1369). A version of Wang Wei's Wang-ch'uan landscape scroll. Unsigned. Called "Anonymous Sung"; more likely Yüan in date, tradition of Fan K'uan. See Munich Exh. Cat. 28 (detail); Art Institute Quarterly XLV, no. 4, pp. 68-70.

* Cleveland Museum of Art (53.126). Streams and Mountains Without End. Handscroll, ink and light color on silk. Ascribed to the late Northern Sung period. Chin dynasty work? Dated before 1205 on the basis of nine colophons of the Chin, Yüan and Ming dynasties. See Lee and Fong, "Streams and Mountains Without End," Artibus Asiae Supplementum XIV; Loehr Dated Inscriptions p. 262; Kodansha CA in West I, 13; Summer Mts., 36-37; Bunjinga suihen II, 49. Another version of the same composition in the Metropolitan Museum is attributed to Kuo Hsi, but probably not executed before the Ming dynasty.

Ibid. (72.157). A waterfall. Old attribution to Chiang Shen, to whom it is unrelated. Late Sung or early Yüan? See Lee, Colors of Ink Cat. 8.

Freer Gallery (15.20). Early Snow on Myriad Peaks. Formerly attributed to Kuo Hsi, and with a spurious signature. 17th century? copy of old composition. Other versions include two in the Palace Museum, Taipei: SV140, very close to the Freer painting; and SV143, later and cruder, reproduced in KK shu-hua chi XXIV. Another version attributed to Kuo Hsi, is in the collection of J. T. Tai, New York. Still another, attributed to Li Ch'eng, in the F. S. Kwen Catalog. A relatively early (early Ming?) and good version in the Worcester Art Museum. See Loehr's article on this composition in Ars Orientalis, IX, 1973.

Metropolitan Museum, N. Y. (13.100.117). A lake scene in winter; two figures on the shore, a man in a boat. Sung painting? in poor condition.

Nelson Gallery, Kansas City (35.262). Winding river with fishing boats, groves of trees and travellers along the shore; mountains beyond. Long handscroll, light color. 14th century? See Sogen 10 (section).

* Ibid. (34.267). Solitary Temple in the Hills. A man in a boat below. Fine work in Li T'ang tradition. 13th cent.?

Ibid. (F74.35). Traveling Among Rivers and Mountains. Handscroll. See under Sun Chih-wei.

Crawford Cat. 6 (formerly John Crawford Coll., N. Y., now Nelson Gallery, K. C.). Winter Mountains. Tradition of Fan K'uan; late Sung (or Chin) in date?

Album Leaves

* Peking, Palace Museum. A boat returning on an autumn evening. Fan painting. Fine 12th century work by Li T'ang follower. See Sung-jen hua-ts'e A, 17; B.II, 7.

Ibid. Snow covered mountain pass. Fan painting. Late Sung, in Fan K'uan tradition. See Sung-jen hua-ts'e A, 28; B.III, 5.

Ibid. Long bridge across a river. Fan painting. Late Sung? See Sung hua shih-fu 5; Sung-jen hua-ts'e A, 35; B.IV, 5.

Ibid. Riding through snowy mountains. Ming work in archaistic style, cf. "Yang Sheng" (T'ang) handscroll etc. See Sung-jen hua-ts'e A, 37; B. II, 1.

Ibid. Autumn reeds along the lake. Fan painting. Southern Sung, follower of Chao Ling-jang. See Sung-jen hua-ts'e A, 81; B. III, 7.

Ibid. Willows by the stream in spring. Fan painting. Late Sung or Yüan, in blue-green manner. Sung-jen hua-ts'e A, 96; B. X, 10.

Ibid. Two men playing chess in a hut on a promontory. Fan painting. Southern Sung, by Li T'ang follower. See Liang Sung 31; Sung-jen hua-ts'e B. XII.

Shanghai Museum. Two boats at anchor and a hut in snowy mountains. Fan painting. Crude Ming work. See Liang Sung 44; Sung-jen hua-hsüan 7; Sung-jen hua-ts'e B. XV.

Ibid. A man with a staff on a bridge in the mountains. Fan painting. Good Yüan-Ming work in blue-green manner. See Sung-jen hua-ts'e B. XVII.

Ibid. River scene: two men in a boat, two others seated on the shore. Late Sung work? See I-yüan to-ying, 1978, no. 1.

Ibid. A fisherman returning beneath an overhanging cliff. Fan painting. Late Sung or Yüan? See I-yüan to-ying, 1978 no. 2, cover.

* Ibid. A man in a boat, another on the shore, beneath pines. Fan painting. Fine 12th-13th century work by follower of Li T'ang, close to Liu Sung-nien. See I-yüan to-ying, 1978 no. 1.

Liaoning Provincial Museum. Ranges of mountains, streams and bridges. Album leaf. Late Sung? Yüan? Cf. "Chü-jan" panoramic handscroll in the Freer Gallery. See Liao-ning I, 80; Sung-jen hua-ts'e B.XVIII; Sung Yüan shan-shui 12.

* Ibid. Travelers among streams and mountains. Album leaf. Kuo Hsi style work of Southern Sung date? See Liang Sung 18; Liao-ning I, 78; Sung-jen hua-ts'e B. XVIII; Sung Yüan shan-shui 7.

Sung-jen hua-hsüan 10. Returning fisherman crossing a rustic bridge. Odd Ming imitation of Southern Sung work.

Taipei, Palace Museum (VA20d). Old temple in the autumn mountains. Fan painting. Ming copy.

Ibid. (VA20j and VA20n). Traveling in the Cold Mountains. Snow landscape. Two album leaves. Ming works in the Kuo Hsi tradition.

Ibid. (VA24b). Jade on Mountains and Streams; a winter landscape. Album leaf. Ming work.

Ibid. (VA36c). Landscape; river scene with large grove of leafy trees sheltering two groups of small figures and a boat. Double album leaf. Late Sung or Yüan.

Ibid. Watching geese by the lake. Fan painting. 12th-13th century, by follower of Li T'ang. See CKLTMHC II, 84.

Ibid. A flock of magpies over a snowy river. Album leaf. Hard early Ming work. See CKLTMHC II, 104.

* Ibid. Watching the tidal bore on the Ch'ien-t'ang river. Fine Southern Sung work of the Ma Yüan school; the best surviving depiction of this subject? See CKLTMHC II, 82.

Ibid. Watching the tide bore at sunrise. Fan painting. Southern Sung. See CKLTMHC II, 81.

* Ibid. (VA35e). Scholar walking on a path toward a pavilion on a river cliff. Album leaf. Fine Southern Sung work by Li T'ang follower. See CKLTMHC II, 75.

Tien-yin-tang II, 10 (Chang Pe-chin Coll., Taipei). Travelers returning on a snowy day. Fan painting. Ming copy or imitation.

Ibid. II, 11. Mountains and woods, temple on a cliff, waterside pavilion, and sailing boats. Fan painting. Yüan-Ming copy of earlier work.

Ibid. II, 16. Fisherman under pines returning home. Fan painting. Copy of Sung work in Hsia Kuei style.

T'ien-lai ko (Li Pa-k'o Coll.). The Ch'ien-t'ang Bore. Fan painting. Ming copy.

Ibid. Pavilion among trees by a bay, gathering crows. Fan painting. Good Ming copy of late 12th century work, cf. Hsia Kuei.

Osaka Catalogue, 39, 1. Traveler in a river landscape. Album leaf. Archaistic Ming work. (Note: this and the following two pictures are from an album titled Ming-hsien pao-hui; see also Soraikan II, 20, for this and other leaves.)

Ibid. 39, 2. River landscape with two men leaving a house. Fan painting. Hsüan-ho seal. Late Sung or Yüan.

Ibid. 39, 3. Autumn landscape. Late, poor work.

Cheng Chi, Tokyo. A temple on a mountainside among pines. Fan painting, ink and light colors on paper. Good twelfth century work by Li T'ang follower.

* Boston Museum of Fine Arts (14.51). A house among trees by a river; flowering trees and willows. Fan painting. Good Southern Sung work.

* Ibid. (20.754). Houses among bare trees; flocks of birds alighting at evening. Fan painting. Fine 13th or early 14th cent. work, cf. Sheng Mou? or slightly earlier?

* Ibid. (29.2). A man and his servant in a boat; autumn trees on the shore. Album leaf. Fine late 12th-early 13th cent. work. See Portfolio I, 142.

* Nelson Gallery, Kansas City (R70-2). Landscape. Album leaf. Fine late 12th cent. work by Li T'ang follower. See their *Handbook*, vol. II, 1973, p. 53.

Nelson Gallery, Kansas City (46.52). Landscape. Fan painting. Yüan period? in Kuo Hsi tradition.

Metropolitan Museum, N. Y. (13.100.17). Winter Landscape. Fan painting. Old attribution to Hsü Ching of the 11th century. Late Sung work, by

minor master. See Siren CP in Am. Colls, 106.

Crawford Cat. 4 (John Crawford Coll., N. Y.). Light Snow on the Mountain Pass. Album leaf. Formerly attributed to Yang Sheng, fl. 713-741. Sung? or later? See also Musee Cernuschi, *Dix Siecles de Peinture Chinoise,* 1966.

Ibid. 28. River Hamlet. Fan painting. Old attribution to Yen Wen-kuei. Late Sung? See also China Institute Album Leaves 3.

Palaces and Temples

Taipei, Palace Museum (SV173). Imperial palaces and figures in the mountains. Illustration to a poem by Tu Fu, "Ballad of a Lovely Woman." Ming work, fragment of a larger picture. See Ku-kung XVII; London Exh. Chinese Cat., p. 124; KK chou-k'an 200.

Chung-kuo I, 66 (Ti P'ing-tzu Coll.). Pavilions and gateways in a garden: T'ai-ku Composing Poems. See also Chung-kuo MHC 34.

Ibid. I, 79. Spring Morning at the Palaces of Han. Later work. See also Chung-kuo MHC 31.

Shen-chou ta-kuan XII. Palaces. Ming work.

Album Leaves

Peking, Palace Museum. Avoiding the heat in the Chiu-ch'eng Palace. Fan painting. Ming archaistic work. See Sung-jen hua-ts'e B, XV.

Ibid. Palace and gardens by a river. Fan painting. Fine 14th century work? See Sung-jen hua-ts'e B, XV.

Shanghai Museum. Elaborate palace, ladies in corridors and halls, two cranes in the garden. Fan painting. Ming archaistic work. See Sung-jen hua-t'se B, XIV.

Ibid. Halls and pavilions in cloudy mountains. Fan painting. Ming archaistic work. See Sung-jen hua-ts'e B, XVII.

Taipei, Palace Museum (SV139). Pavilions of the Shang-lin park in snow. Fan painting. Routine Ming work. See Ku-kung XXIX; London Exh. Chinese Cat., p. 125; CKLTMHC II, 78; KK chou-k'an 276.

* Ibid. (VA14a). Summer at Li-ch'uan: the summer retreat of T'ang T'ai-tsung. Elaborate palace complex and courtyard with figures. Fragment of a larger composition. Album leaf. Fine work, late Sung or Yüan. See CKLTMHC II, 94.

Ibid. (VA20k and VA20m). Two album leaves, each representing sections of a palace compound, with courtyards and trees. Fragments of a handscroll? Southern Sung.

T'ien-lai ko (Li Pa-k'o Coll.). The Yellow Crane Tower; The Pavilion of Prince Teng. Two album leaves. Ming copies of earlier works. See Wen-wu 1957, 11.49-50.

Sung Yüan Pao-hui V.4. A palace by a misty river. Fan painting. Yüan work?

* Boston Museum of Fine Arts (29.1). The garden terrace in front of a palace. Fine Southern Sung work; fragment of a larger painting? Album leaf. See Portfolio I, 71.

 Crawford Collection, N. Y. Palaces in a landscape. Fan painting. Yüan or early Ming? See China Institute Album Leaves #45, ill. p. 56.

Landscapes with Buildings and Figures

* Peking, Palace Museum. Landscape with thatched house and figures: Women weaving thread. Small hanging scroll, ink on silk. Poem written above, probably by some Southern Sung imperial hand. Fine work of the 13th century?

 Ibid. An inn in the mountains; ox carts approaching. Late Sung or Yüan, tradition of Kuo Hsi. See Mei-shu yen-chiu, 1959 no. 4, colorplate.

* Shanghai Museum. A palace by a river. Large, impressive composition, Northern Sung in date? See Shang-hai 5.

 Ibid. Paying New Year's visits, guests in and arriving at a pavilion. Southern Sung? or close copy? See Shang-hai 7.

* Nanking Museum. The Yüeh-yang Tower. A palace on the river shore: a ferry boat on the water. Also attributed to Kuo Chung-shu. Fine work of late Sung or Yüan. See Nanking Cat. I, 5; Gems I, 4; I-lin YK 70/1.

 Ibid. Peasants' Occupations: ladies spinning and weaving, men working in fields. Good Southern Sung painting. See Ku-hua pa-chung , folio of plates published by the Nanking Museum.

* Taipei, Palace Museum (SV136). Immortals' Dwellings on Pine-hung Cliffs (Sung-yen hsien-kuan). Early Ming? Close copy of early (9-10th c.?) composition. See NPM Masterpieces I, 13; KK ming-hua II, 31. See also the article by Li Lin-ts'an in Ta-lu tsa-chih, 22/2, January 1961, where the painting is associated with the T'ang period master Lu Hung.

 Ibid. (SV145). A Mansion in a Wintry Grove: palace pavilions and tall trees a the foot of a snow-covered slope. Inscription by Tung Ch'i-ch'ang. Fine work of the early Ming, after Southern Sung original? See KK shu-hua chi VII; London Exh. Chinese Cat., p. 109; CKLTMHC II, 43; KK ming-hua IV, 29; KK chou-k'an 499.

 Ibid. (SV168). The Fairy Terrace on the Island of the Immortals. Ming work. See KK shu-hua chi IV; KK chou-k'an 181.

 Ibid. (SV183). Reading by the window after a snowfall. Ming copy of the "Reading the Changes" composition (Chung-kuo ming-hua 26 etc.) sometimes ascribed to Li T'ang.

 Ibid. (SV185). A roadside inn and traveling carts in snowy mountains. Poem by Ch'ien-lung. Ming dynasty, tradition of Li T'ang. See KK shu-hua chi XLII; CKLTMHC II, 29; KK ming-hua III, 35.

 Ibid. (SV191). A lady in a pavilion contemplating the moon. Ming copy. See Ku-kung XXIII; London Exh. Chinese Cat. p. 113; CKLTMHC II, 61; KK chou-k'an 215.

 Ibid. (SV226). High pavilions along a mountain river. Painted on hemp cloth. Poems by Ch'ien-lung and eleven of his officials. Ming follower of Wang

Chen-p'eng tradition. See KK shu-hua chi II; CKLTMHC II, 55; KK ming-hua IV, 52; London Exh. Cat. p. 122; KK chou-k'an 494.

* Ibid. (SH29). Market Village by the River: sailing boats entering a harbor at the foot of verdant mountains. Short handscroll. 11th or 12th century? Tradition of Yen Wen-kuei. *Ssu-yin* half-seal. See KK shu-hua chi IX; London Exh. Chinese Cat., p. 120; CAT 21; CH mei-shu I; CKLTMHC II, 12; KK ming-hua IV, 31; KK chou-k'an 160; Skira 39; NPM Masterpieces V, 18; Soga I, 22; Summer Mts., 33.

Chung-kuo I, 71 (Ti Pao-hsien Coll.). Pavilions with scholars at the foot of high mountains in autumn. Ming archaistic work. See also Chung-kuo MHC 33.

Chung-kuo MHC 40 (Ti Pao-hsien Coll.). A procession of court ladies and their attendants visiting a Buddhist temple on the river. Copy of Southern Sung work?

Album Leaves

Peking, Palace Museum. Pavilion in a willow grove, junks on the river. Fan painting. Southern Sung. See Sung-jen hua-ts'e A, 36; B.I, 10.

Ibid. Pavilions by the river. Fan painting. Yüan-Ming work. See Sung-jen hua-ts'e A, 41; B.II, 2.

Ibid. A study by the river. Fan painting. Southern Sung, in style associated with Liu Sung-nien. See Sung-jen hua-ts'e A, 73; B. VIII, 7.

Ibid. Preparations for dawn departure. Fan painting. Yüan-Ming copy of earlier work? See Sung-jen hua-ts'e A, 87; B. V, 10.

Ibid. A waterwheel under willow trees. Album leaf. Yüan-Ming copy? See Sung-jen hua-ts'e A, 93; B, VII, 5.

Ibid. Ladies on a pavilion terrace by a tree-lined river in spring. Album leaf. Yüan-Ming work; a fragment? See Sung-jen hua-ts'e B, XII.

Ibid. A servant sweeping the courtyard of a pavilion on a promontory. Fan painting. Yüan-Ming copy of Southern Sung. See Liang Sung 29; Sung-jen hua-ts'e B, XIX.

* Shanghai Museum. Two scholars, servant with ch'in walking toward a pavilion hidden behind pines and rocks. Album leaf. Fine Southern Sung work, in style associated with Liu Sung-nien. See Liang Sung 12; Sung-jen hua-ts'e B, XIII.

* Ibid. A house under pine, servant at the gate, river view. Fan painting. Fine Southern Sung work by a Li T'ang follower. See Sung-jen hua-ts'e B., XIX.

Ibid. A man sleeping in a pavilion over a lotus pool. Fan painting. Ming copy of earlier work. See Sung-jen hua-ts'e B, XIX.

* Shanghai Museum. Scholar and a servant on a path going toward a pavilion in a pine grove high in the mountains. Fan painting. Fine Southern Sung work by a follower of Li T'ang. See Sung-jen hua-ts'e B, XIV.

* Liaoning Provincial Museum. Pavilions of the immortals, an immortal on a phoenix. Fan painting. Old attribution to Chao Po-chü. Archaistic Yüan work? See Liang Sung 43; Liao-ning I, 77; Sung-jen hua-ts'e V, XIX;

Sung Yüan shan-shui 8.

Tientsin Art Museum. A snow landscape, a servant bringing an umbrella to a man on a horse. Hard Ming work. See I-yüan chi-chin 5.

Sung-jen hua-ts'e B, XIII. A man in his house gazing out at a lotus pond; two servants beyond picking mulberry leaves. Album leaf. Late Sung? or later? See also Sung-jen hua-hsüan 2.

Ibid. B, XV. Boating on the lotus pond; a woman and her servant in a pavilion above. Fan painting. Late Sung work?

* Taipei, Palace Museum (VA14e). Whiling away the summer in a lotus pavilion. Album leaf. Fine 12th century work by a follower of Li T'ang. *Ssu-yin* half-seal. See KK ming-hua IV, 33; NPM Bulletin I, 4, cover; KK chou-k'an 63; Soga I, 36.

Ibid. (VA14g). Clearing after snow on a lake; a pavilion and bare trees on the shore. Fan painting. Southern Sung? or Yüan? See CKLTMHC II, 83; KK chou-k'an 62.

Ibid. (VA20f). The Donkey Rider: river scene with houses and trees. Fan painting. Badly damaged, but fine work, late Sung?

Ibid. (VA24g). Temples at the Pine Cliff. Fan painting. Early Ming.

* Ibid. (VA34b). Waiting for the ferry by an autumn river. Album leaf. Fine 13th century? work with elements of Kuo Hsi tradition; Chin? See KK ming-hua III, 38; Soga I, 37.

* Ibid. (VA36L). Fishing on a Willow Bank: a man in a boat; houses among willows across the river. Album leaf. Fine Southern Sung work. See KK ming-hua III, 37.

Ibid. (VA37c). Enjoying the Cool at the Lotus Pavilion: four figures on the second storey of a building, visitors arriving below. Fan painting. Yüan-Ming work.

Ibid. (VA37e). Woman fishing from a pavilion on a lotus pond; a friend and servant alongside. Fan painting. Yüan?

Ibid. (VA37f). Retirement in the Pine Pavilion; a gentleman seated, a servant entering. Fan painting. Yüan.

* Ibid. (VA37g). Gathering Lotus: four people in a boats, four in a pavilion over a lotus pond, bamboo. Fan painting. Fine Southern Sung work.

Ibid. (VA37j). Thick with Flowers at the Immortals' Palace: two wings of a palace each with ladies inside. Fan painting. Early Ming, after Sung design?

* Ibid. (VA37q). Pine Shaded Palace Courtyard. Fan painting. Good Southern Sung work. See NPM Masterpieces II, 36.

Ibid. (VA37r). Scholars meeting in a house; wall enclosed garden with tethered horses; servant arriving at the gate. Fan painting. Fine Ming work.

Ibid. An illustration to the book of poetry, silk manufacture. Album leaf. Southern Sung? See CKLTMHC II, 98.

Ibid. Courtyard with shady pines; three servants approach a room where a woman sleeps. Fan painting. See KK ming-hua III, 36.

Ibid. A Literary Gathering: three men eating at a table; servants outside. Fan painting. See KK ming-hua III, 41.

Tien-yin-tang II, 13 (Chang Pe-chin Coll., Taipei). Three people reading in a pavilion in a bamboo grove. Fan painting. Ming copy.

Ibid. II, 18. Four people gathered in a pavilion under pines; a servant entering the gate. Fan painting. Yüan-Ming copy of Sung work?

Sung Yüan pao-hui IV, 8. Scholar and servant in garden; woman in house. Fan painting. Ming academy work of 15th century.

Ibid. V, 3. Figures in a garden; houses within walls. Fan painting. Copy of Southern Sung composition.

Ibid. V, 6. Woman and 3 attendants worshipping statues of Buddha in garden. Fan painting. Crude copy of interesting Southern Sung composition.

Sogen (large ed.) I, 17. A house in the mountains; visitors approaching (emissaries of ruler with invitation to court?). Album leaf. Fine early Ming work of Academy tradition.

Ibid. (large ed) I, 18. Pines by the river; a traveller; houses on the further shore. Fan painting. Late Sung or Yüan, tradition of Kuo Hsi.

Ibid. (large ed.) I, 21. Wintry landscape with temples and houses; travellers approaching a gate. Album leaf. Sung-Yüan work in tradition of Li T'ang.

Osaka catalogue 39, 9. Han Wu-ti Meets Hsi-wang-mu: Two figures on the verandah of a palace; phoenixes in clouds above. Late Sung work? See also Soraikan, II, 20.

Freer Gallery (11.155b). River Landscape: a lady welcoming an arriving guest at the shore. Fan painting. Southern Sung. See Cahill Album Leaves IX.

Ibid. (11.155D). A Lakeside Pavilion. Fan painting. Southern Sung. See Cahill Album Leaves VIII.

China Institute Album Leaves #7, ill. p. 34. Peasants irrigating the fields; buffalo pushing wheel; large trees around hut; four figures. Fan painting. Post-Sung, copy or pastiche.

Landscapes with Figures

Taipei, Palace Museum (SV327, chien-mu). Two travelers, one with a staff, and a boy servant, in a landscape. Catalogued as "Arhats" but probably not painted as that. Interesting Western-influenced work of late Ming or early Ch'ing date?

KK shu-hua chi XLII. An herb-collector in the mountains. Ming work. A composition sometimes ascribed to Li Ch'eng, q.v.; three versions in the Freer Gallery (15.21; 13.64; 19.111).

(For the three landscapes with figures from a set of Four Seasons, Konchiin and Kuonji, once ascribed to Hui-tsang, see below under "Landscapes with Figures, Ma Yüan Type and Tradition.")

Album Leaves

Peking, Palace Museum. Man resting under a willow. Album leaf. Yüan or early Ming? See Sung-jen hua-ts'e A, 13; B, III, 3.

Ibid. The shepherd Huang Ch'u-p'ing. Fan painting. Ming copy of earlier work? See Sung-jen hua-ts'e A, 42; B, IV, 3.

* Ibid. Returning from a spring outing. Fan painting. Fine Southern Sung work? See Sung-jen hua-ts'e A, 71; B, V, 6.

Ibid. Playing the *yüan* in a bamboo grove. Fan painting. Fine early Ming work? See Sung-jen hua-ts'e A, 88; B, IX, 8.

Ibid. The Three Laughers of Hu Stream. Fan painting. Ming copy of Sung work. See Sung-jen hua-ts'e B, XI.

Ibid. Scholar and two servants picking chrysanthemums. Fan painting. Late Sung work? See Sung-jen hua-ts'e B, XV.

Ibid. Evening scene; a boat at the shore, flights of birds, tall cliffs. Fan painting. Early Ming, in hardened derivative of Li T'ang manner. See Sung-jen hua-ts'e XV.

Shanghai Museum. Travelers approaching a bridge. Folding fan painting. Ming work. See Liang Sung 27; Sung-jen hua-hsüan 4; Sung-jen hua-ts'e B, XIV.

Ibid. A tipsy scholar on a donkey returning home. Fan painting. Yüan-Ming work in Li T'ang tradition. See Liang Sung 48; Sung-jen hua-ts'e B, XIV.

Ibid. Oxcarts crossing the river. Album leaf. Signed Chu... Late Sung work? See Liang Sung 9; Sung-jen hua-ts'e B, XVI.

Ibid. Figures at the entrance to a valley between steep cliffs. Fan painting. Late Sung work? See Sung-jen hua-ts'e B, XVII.

Ibid. Wind and rain in mountains and streams. Fan painting. Yüan or early Ming. See Liang Sung 42; Sung-jen hua-ts'e B, XVII.

Shanghai Museum. Scholar on a donkey in a wintry grove. Fan painting. Ming copy of Sung painting? See Sung-jen hua-hsüan 9; Sung-jen hua-ts'e B, XIV.

* Sung-jen hua-ts'e B, XIII. A fisherman in a boat conversing with a man on the shore; a tall pine above. Southern Sung, in a style associated with Liu Sung-nien. See also Sung-jen hua-hsüan 5.

Taipei, Palace Museum (VA20b). Sitting Alone by the Stream's Edge. Fan painting. Hard Ming copy of work of Li T'ang school.

* Ibid. (VA20e). Streamside Conversation: one gentleman on the shore, another in a boat. Fan painting. 13th century? Fine work in tradition of Li T'ang.

Ibid. (VA20h). Scholar in the Autumn Grove. Album leaf. By a follower of Sheng Mou, Yüan or Ming period.

Ibid. (VA24a). Travellers in Snowy Mountains. Fan painting. Ming copy. See KK ming-hua III, 39.

* Ibid. (VA33f). Conversation about the Tao by a pine cliff; two men seated in a cave. Fan painting. Good Southern Sung work, by a follower of Li T'ang.

Ibid. (VA37b). Bringing the lute; looking at the mountain. Album leaf. Ming copy.

Ibid. (VA37h). Riding Through the Cold Grove: a man on a donkey, a servant walking behind. Fan painting. Late Sung?

Ibid. (VA25a). Travelling on muleback in the autumn woods. Album leaf. Yüan? by follower of Ma Ho-chih. See KK ming-hua IV, 35.

Ibid. (VA36j). Travelling amid Streams and Mountains. Album leaf. Late Sung? or copy? See KK ming-hua IV, 34.

Sung Yüan pao-hui V, 9. Two goats at shore with fishermen and their families. Album leaf. Ming work.

Chung-kuo I, 19 (Ti P'ing-tzu Coll.). Oxcarts travelling through snowy mountains. Fan painting. Copy of Sung work. See also Chung-kuo MHC 19.

Ch'ing Kung ts'ang 14 (former Manchu Household). Scholar on a donkey with two servants crossing a bridge. Album leaf. Yüan or early Ming work of the Kuo Hsi School.

Li Mo-ch'ao. A man seated in a pavilion under two pines by a river. Fan painting. Yüan or later, archaistic work.

Li Pa-k'o. Fairies crossing the Hsiao and Hsiang river; woman dancing on terrace below. Album leaf. 13th-14th century, after older composition. See T'ien lai ko 6.

Tien-yin-tang II, 14 (Chang Pe-chin Coll., Taipei). Two men under a pine viewing sharp cliffs and a waterfall. Fan painting. Ming imitation.

Chu Hsing-chai, Hong Kong. Fishing on the shore. Fan painting. Yüan or early Ming painting in the tradition of Chao Meng-fu. Reproduction folio, N.P., N.D.

Freer Gallery (09.244j). Two travellers on donkeys in a winter landscape. Fan painting. Late Sung or Yüan. See Cahill Album Leaves XII. Based freely on Liang K'ai's painting in the Tokyo National Museum.

Ibid. (11.155g). A mule train on a mountain road. Album leaf. Yüan dynasty? See Cahill Album Leaves XIII.

Philadelphia Museum of Art. A lady standing beneath tall bamboo. Fan painting. Late Sung? See Southern Sung Cat. 24.

Landscapes with Figures, of the Ma Yüan Type and Tradition

Shanghai Museum. A phoenix flying over pavilions in a misty valley; two scholars and a servant on a bridge. Ming work of Ma Yüan School. See Shang-hai 8.

Taipei, Palace Museum (SV147). Enjoying the Ch'in in a Waterside Pavilion. Ming work in Ma Yüan manner.

Ibid. (SV151). The poet under pine trees looking at the moon. Ming work, by follower of Ma Yüan. See KK shu-hua chi XIV; Ku-kung XXXI; CKLTMHC II, 41.

* Ibid. (SV177). Banquet by Lantern-Light. The original of the "Ma Yüan" painting of the same subject (SV18), and perhaps a work of Ma Yüan. See Ku-kung XIX; London Exh. Cat., p. 123; CAT 56. See also under Ma Yüan.

Ibid. (SV184). Welcoming Guests at A Mountain Studio: the visitor arriving at the scholar's pavilion in the mountains. Ming painting in the Ma Yüan manner; a spurious Ma Yüan signature in lower left.

Ibid. (SV190). A man in a snow-covered pavilion looking at plum blossoms. Ming, manner of Ma Yüan. See KK shu-hua chi XXI; London Exh. Chinese Cat. 112; CH mei-shu I; CKLTSHH; KK chou-k'an 301.

Ibid. (SV352, chien-mu). *Sung-feng chiu-yün t'u:* Playing the Ch'in Beneath Pines. Ming work in the Ma Yüan tradition; interesting in suggesting

prototype for some features of Japanese painting of the Muromachi period.

Ibid. Sharp cliffs in mist; men walking along the dike. A Ming version of the *Ta-ko t'u* composition ascribed to Ma Yüan, q.v. (first entry). See KK shu-hua chi XL.

Tien-yin-tang I, 3 (Chang Pe-chin Coll., Taipei). A man sitting alone by a willow tree. Ming work in Ma Yüan tradition.

Ibid. I, 4. Admiring plum blossoms on a moonlit night. Ming version of Ma Yüan manner; cf. Chang Lu etc.

Garland I, 35. Spring travellers returning to a remote valley; rider approaching a bridge; pavilions, willows and plum trees in the foreground; outlined peaks beyond. Yüan or later, School of Ma Yüan.

* Konchi-in, Kyoto. Two landscapes from a set of four representing the four seasons: a man beneath a pine tree gazing at flying cranes (Autumn), and a man walking on a path listening to gibbons above a waterfall (Winter). A third of the series, representing a man walking with a staff in a rainstorm (Summer) in the Kuon-ji; the fourth is lost. Once attributed to Emperor Hui-tsung. 13th century works, by a master related to but outside the Hangchou Academy circle. See Toyo VIII; Kokka 155; Shimbi II; Toso 53-55; Sogen no kaiga 94-97; Siren CP III, 241-243; Toyo bijutsu 24-27; Genshoku 29/4-6; also Kei Suzuki's article in Yamato Bunka 32; Suiboku II, 47-48, Sogen MGS II, 6-7, III, 9.

Kokka 528 (Fujii Collection). A scholar under a pine tree. Early Ming imitation of the Ma Yüan manner.

Album Leaves

* Peking, Palace Museum. Playing the ch'in in a secluded mountain dwelling. Fan painting. Fine late Sung work of Ma Yüan school. See CK shu-hua I, 19; Sung-jen hua-ts'e A, 72; B, VIII, 10.

Shanghai Museum. Enjoying music by a lotus pool. Album leaf. Fragment of a larger work in the Ma Yüan manner, 14th century? See Liang Sung 32; Sung-jen hua-ts'e B, XIV.

* Tientsin Art Museum. Drinking on a hilltop in the moonlight. Album leaf. Poem inscribed by Empress Yang. Good Sung work in the style of Ma Yüan. See I-yüan chi-chin 3; Liang Sung 25; Sung-jen hua-ts'e B, XVI; T'ien-ching II, 7-8.

Taipei, Palace Museum (VA37t). Palace in the moonlight; large pine tree above. Fan painting. Early Ming, in Ma Yüan style.

* Osaka Municipal Museum (former Abe Coll.). Man and servant on mountain path gazing across ravine at waterfall. Fan painting. Good Southern Sung work by Li T'ang follower, time of Ma Yüan? See Osaka Cat. 39 (7); Soraikan II, 20 (5).

Sung-jen hua-hsüan 8. A lady and two servants on a terrace under blossoming trees enjoying the moon. Album leaf. Early Ming? work in Ma Yüan manner.

Taipei, Palace Museum (VA24c). A grass-thatched pavilion beneath pines. Fan painting. Early Ming.

Sogen 11 (Ts'ao Jun-t'ien Coll.). A man seated by a waterfall. Fan painting. Early Ming imitation of Ma Yüan manner.

Metropolitan Museum of Art, N. Y. Two men in a cave beneath a pine tree; a servant outside. Fan painting. Yüan work? in Ma Yüan manner. See China Institute Album Leaves #22, ill. p. 45.

Berlin Museum (Inv. 1780). Man on ledge beneath pine looking at crane. Fan painting. 14th century?

Fishing and Boating Scenes

Taipei, Palace Museum (SV132). Enjoying the Moonlight in Deserted Mountains. Ming work, School of Chang Lu. See London Exh. Cat. 46, p. 111.

Ibid. (SV152). Transporting Grain. Ming picture, dull rendering of interesting composition.

Ibid. (SV192). The Old Fisherman. Good copy of an older composition. Inscription by Chou Po-wen; seal of Hsiang Sheng-mo.

Ibid. (SV193). Fishermen in two boats on the river. Ming work. See KK shu-hua chi XXII; CKLTMHC II, 17; KK chou-k'an 296.

Ibid. (SV194). The Joys of Fishing. Ming work.

Chung-kuo I, 62 (Ti P'ing-tzu Coll.). Boats anchored along the rocky shore of a river in winter. 17th century, Orthodox School. See also Chung-kuo MHC 30.

Ibid. I, 16. A man in a boat by a cliff under a plum tree in bloom . Crude color reproduction of late work. See also Chung-kuo MHC 21.

* Bijutsu kenkyu 4 (Sugahara Coll., Kamakura). Parting at the Shore. Presented to a Japanese priest, perhaps Eisai, on his return to Japan. Colophons by Chung-t'ang-chieh and Tou Tsung-chou, (d. 1196), the latter a pupil of Chu Hsi. Late 12th century work, probably by an artist working in Ning-p'o. See Miyeko Murase, "Farewell Paintings of China," *Artibus Asiae* XXXII, 2/3, 1970.

Album Leaves

Peking, Palace Museum. Fishing boat on the river in spring. Fan painting. Attributed to Ma Yüan. Late Sung? See Sung-hua shih-fu 10; Sung-jen hua-ts'e A, 79; B, V, 4.

Ibid. Boating on the West Lake. Fan painting. Copy of Southern Sung work. See Liang Sung 55; Sung-jen hua-ts'e B, XI.

Ibid. Sailing boats on the Yangtse, with sharp peaks on shore. Fan painting. Work in blue-green manner. See Sung-jen hua-ts'e B, XI; Liang Sung 49.

Ibid. Gentleman and three servants in a boat on a lotus pond enjoying the new moon. Late Sung, by minor master? See Liang Sung 52; Sung-jen hua-ts'e B, XI.

Ibid. Sunrise behind clouds and high waves. Fan painting. Ming copy of Southern Sung original? See Liang Sung 35; Sung-jen hua-ts'e B, XII; also R. Maeda, "The Water Theme in Chinese Painting" in *Artibus Asiae* XXIII, no. 4, pl. 13.

Ibid. Boating under blossoming plum. Fan painting. Ming copy. See Sung-jen hua-ts'e B, XII.

Ibid. Fishermen in boats under pines. Fan painting. Copy of Southern Sung work. See Sung-jen hua-ts'e B, XII.

Ibid. Scholar in a boat gazing at misty peaks. Fan painting. Yüan-Ming copy of earlier work? See Sung-jen hua-ts'e B, XV.

Shanghai Museum. Three boats on a river; sharp peaks and low distant hills. Fan painting. Yüan work? in blue-green style. See Liang Sung 50; Sung-jen hua-ts'e B, XVII; I-yüan to-ying, 1978 no. 1.

Shanghai Wen-wu pao-kuan wei-yüan-hui (Committee for the Protection of Cultural Relics). Fishermen in a boat raising a net; willows on the shore. Copy of a Sung work? See Sung-jen hua-ts'e B, XIV.

Tientsin Art Museum. Boat race on the Chin-ming lake. Album leaf. Signed Chang Tse-tuan. See I-yüan chi-chin I; Liang Sung 16; Sung-jen hua-ts'e B, XVI; Wen-wu 1970, 7.5. (See also under Chang Tse-tuan above).

Suchou Museum. Autumn tide bore on the Ch'ien-t'ang river. Fan painting. Signed Hsia... Early Ming copy? See Liang Sung 39; Su-chou 1; Sung-jen hua-ts'e B, XIX.

Sung-jen hua-ts'e B, XIII. A man in a boat poled by his servant on a windy river; two other men on the shore. Late Sung work?

Taipei, Palace museum (VA24f). A Fisherman at Evening. Album leaf. Ming painting.

Ibid. (VA35e). Sails on Distant Water: pavilion in a grove with two approaching figures at the left. Double album leaf. School of Li T'ang. Yüan or early Ming. See Soga I, 38.

Ibid. (VA37a). Fishing in the moonlight. Album leaf. Ming copy of Sung work. See KK ming-hua IV, 36.

Metropolitan Museum, N. Y. Landscape with fishermen. Fan painting. Late Sung work? See China Institute Album Leaves #5, ill. p. 33.

Horsemen, Tartar Scenes, Etc.

Note: For the handscroll in the Kirin Museum depicting Chao Chün on her way to Mongolia, first published as an Anon. Chin work, see above under Chang Yü.

Taipei, Palace Museum (SV200). Washing the Horse. Yüan or later.

Shen-chou ta-kuan hsü V. Four polo players. Silk fragment reportedly found at Chü-lu hsien, which was inundated and abandoned in 1108. Another version in Stockholm Museum of Far Eastern Antiquities. See Gyllensvard article in their Bulletin XLI, 1969, pl. 1-2.

* Metropolitan Museum, N. Y. (41.138). The Tribute Horse. (The Emperor Ming-huang's Journey to Shu?) Eight men riding through a mountainous country conducting a white saddled horse without a rider. Fragment of

larger picture. Ink and colors on silk. Fine Sung work. See Skira 61.

* Boston Museum of Fine Arts (28.62-65). Four pictures, formerly parts of
handscroll, illustrating four of the "Eighteen Songs" traditionally attributed
to the Lady Ts'ai Wen-chi, which tell of her marriage to a Hunnish chief-
tain, her grief on leaving him, and her return to China. Fine 11th or early
12th century works; the oldest and finest version of the subject. See Port-
folio I, 61-64; Siren CP III, 316-318; Kodansha CA in West I, 50-51;
Unearthing China's Past 118; Paine Figure Compositions of China and
Japan, IV, 1-4; Kodansha BMFA 75. Other, complete versions of this set
of compositions exist, all later, as follows:
1. Taipei, Palace Museum (SA1). Album of paintings. Attributed to
Li T'ang, q.v.
2. Metropolitan Museum, N. Y. (1973.120.3; former C. C. Wang Col-
lection, N. Y.). Handscroll. Inscriptions between the paintings in
the manner of the Emperor Kao-tsung, See Garland I, 36; Met.
Cat., 1973, no. 3; and Robert Rorex, *Eighteen Songs of a Nomad
Flute,* N. Y., 1974.
3. Yamato Bunkakan, Nara. See Shujiro Shimada's article in Yamato
Bunka 37.
4. Nanking Museum. Published in color as *Hu-chia shih-pa po* (Eigh-
teen Songs for a Barbarian Flute) Shanghai, 1961; introductory text
by Hsü Hsin-nung. The same with an English translation of the
Songs by Rewi Alley published as *The Eighteen Laments,* Shanghai
1963.
5. I-lin yüeh-k'an 1-6, 31-43; perhaps identical with one of the above.
For studies of the poems and the paintings, reproducing parts of some of
the above versions, see John Haskins, "The Pazyryk Felt Screen and the
Barbarian Captivity of Ts'ai Wen-chi" in BMFEA XXXV, 1963, pp. 141-
160; also articles by Liu Ling-ts'ang in Wen-wu 1959, no. 5. p. 3ff. and by
Shen Tsung-wen in Wen-wu 1959, no. 6, p. 135ff.

Album Leaves

Taipei, Palace Museum (VA35g). Testing the Horses: three gentlemen on
horseback. Double album leaf. Ming, after earlier composition.
Ibid. (VA14j). Mongol camp scene. Album leaf. Appears to be a fragment
from the latter part of a free version of the "Herding Horses" handscroll
attributed to Hu Kuei in the same collection (WH6, chien-mu). See
CKLTMHC II, 88; KK ming-hua VI, 48; KK chou-k'an 58.
T'ien-lai ko 6. Fairies crossing the Hsiao and Hsiang rivers; a woman dancing
on a terrace below. Album leaf. Southern Sung or slightly later.
Ibid. 13. Chao-chun's journey to Mongolia. Fan painting. Copy of the Sung
version of this composition now in the Stockholm Museum of Far Eastern
Antiquities. See NPM Quarterly, XI/1, pl. 5.
Ibid. 14. Ts'ai Wen-chi Returning to China. Fan painting. Early Ming? copy
of earlier work. See also Wen-wu 1959, 5, 3.

Seikasha Sogen, 11. Dancers performing before a tartar chieftain. Album leaf. Yüan work? in tradition of Wei-ch'ih I-seng.

* National Museum, Stockholm. Crossing the Stream: a scene from Wen-chi's Return to China? Fan painting. Artist's signature on left edge, partly cut away and illegible; the family name may be Yen. Fine Sung, or Chin? See Smith and Weng, 188-9; NPM Quarterly XI/1, pl. 6.

* Boston Museum of Fine Arts (12.898). A Chinese woman—Ts'ai Wen-chi?—and her two children escorted by a Tartar soldier. Album leaf. Fine Sung work, perhaps by a Chin painter. See Portfolio I, 102; Siren CP III, 319.

Scholarly Gatherings

Taipei, Palace Museum (SV135). Two gentlemen studying in a house under a pine tree. Minor Ming work.

Ibid. (SV175). The Loyang Septuagenarian Society: Wen Yen-po and twelve of his friends meeting in a pavilion at Loyang. Close in style to Ch'iu Ying, e.g. the Chion-in paintings. See Ku-kung XXVI; KK chou-k'an 326.

Ibid. (SV176a/b/c/d). Four pictures representing the famous Eighteen Scholars of the T'ang dynasty. The gentlemen are meeting on garden terraces and are occupied with the Four Arts (Calligraphy, Painting, Playing the Ch'in, and Chess). Good Ming Academy copies of Southern Sung works. See KK shu-hua chi XXV, XXVI, XXXIV, XLIV; CKLTMHC II, 63-66; KK chou-k'an 400.

Ibid. (SV178). Two scholars conversing in a bamboo grove. Ming work. See CKLTMHCII, 46; KK ming-jen hua-chu chi II, 4.

Ibid. (SV179). Pure Leisure Under Wu-t'ung Trees: scholars occupied at their writing-desks on a garden terrace. Yüan dynasty? See Ku-kung II; CKLTMHC II, 34; KK ming-hua IV, 32.

Ibid. (SV188). Collating the Texts: a gathering of scholars in a garden. Yüan-Ming copy of an earlier work. See KK ming-hua IV, 40.

Ibid. (SV189). Listening to the Ch'in: five men dancing to music played by a gentleman in a pavilion. Fine early Ming(?) work, probably after an older composition. See CKLTMHC II, 19; KK ming-hua III, 43.

Ibid. (SV350, chien-mu). Scholars in a garden on the riverbank enjoying paintings. Crude Ming copy of earlier composition.

* Ibid. (SH35). The Loyang Septuagenarian Society: Ssu-ma Kuang and eight of his friends seated at a meeting with servants attending. Handscroll, ink and colors on paper. Colophons by Ssu-ma Kuang (dated 1082), Chao Meng-fu and others are probably copies, but the painting may be late Northern or early Southern Sung in date although heavily restored.

Album Leaves

Peking, Palace Museum. Scholars and ladies clustered around a table in front of a lotus pool. Album leaf. Probably a fragment of an "Elegant

Gathering in the Western Garden" scene. Early Ming? See Sung-jen hua-ts'e B, XV.

Suchou Museum. Hsiao-hsia t'u: scholars examining paintings in a garden. Fine work in style associated with Liu Kuan-tao of the Yüan period. See Liang Sung 60; Suchou 2.

Taipei, Palace Museum (VA37s). The Nine Old Men of Hsiang-shan. Fan painting. Fine Sung-Yüan work. See NPM Quarterly XI/4, pl. 25, 32.

T'ien-lai ko 5. Watching a game of chess. Album leaf. Late Sung? copy of the "Wang Wei" composition, q.v., with figures etc. added.

Narrative, Historical and Legendary Scenes

* Shanghai Museum (Formerly P'ang Yüan-chi Coll.). Greeting the Emperor at Wang-hsien Village. Said to represent the Emperor T'ang Hsüan-tsung returning from exile and being met by his son. An alternative explanation is that it represents Han Kao-tsu taking his old father to visit his native village which has been transplanted to the capital. A Southern Sung Academy work of high quality. See Chung-kuo hua I, 15; TSYMC hua-hsüan 13; also published in a color reproduction by the Shanghai Museum 1959. See also Li Lin-ts'an, Chung-kuo ming-hua yen-chiu pp. 103-106; Artibus Asiae 37/1-2.

* TSYMC hua-hsüan 12. Historical subject: Ts'ao Hsün meeting the imperial carriages carrying the coffins of Hui-tsung and his empress. Handscroll. Good 12th century work. See Wen-wu, 1972 no. 8. Also published in color, in scroll form, Shanghai, 1969.

* Liaoning Provincial Museum. The Four Greybeards of Mount Shang. Handscroll. Formerly ascribed to Li Kung-lin, q.v. Fine 13th century? work of Li Kung-lin School; cf. the "Realms of the Immortals" handscroll in the Freer Gallery, which may be by the same hand. See Liao-ning I, 67-70.

* Ibid. The Nine Ancients of Hui-ch'ang. Handscroll. Very close in style to the previous picture. See Liao-ning I, 71-74; NPM Bulletin, I, 2.5 (detail).

* Taipei, Palace Museum (SV174). Emperor Yüan-tsung of the Southern T'ang Dynasty with his court ladies assembled in a pavilion where a Taoist is boiling snow. Early Ming work, after older composition. See Ku-kung XVI; CKLTMHC II, 36; KK chou-k'an 213.

* Ibid. (SV186). Breaking the Balustrade: the Emperor Ch'eng-ti of Han condemning the duke Chang Yü. Poem by Ch'ien-lung. Fine Southern Sung Academy work. See KK shu-hua chi XV; Three Hundred M., 134; CAT 44; CCAT pl. 104; CKLTMHC II, 31; KK ming-hua IV, 39; Wen-wu 1955.7.19 (41); KK chou-k'an 171; Skira 60; NPM Masterpieces III, 20; NPM Quarterly XI/1, pl. 9.

* Ibid. (SV187). Refusing the Seat. A high official saluting an emperor and the empress in a garden. Southern Sung? or fine copy of slightly later period? See KK shu-hua chi XVII; London Exh. Chinese Cat., p. 114; Three Hundred M, 135; CH mei-shu I; CKLTMHC II, 32; CKLTSHH; KK ming-hua III, 42; KK chou-k'an 220; NPM Masterpieces I, 14; NPM

Quarterly XI/1, pl. 8.

Ibid. (SV371, chien-mu). The Peach-Blossom Spring. Good 16th century? depiction of the subject. See KK shu-hua chi XLII.

Ibid. (SH30). Ssu-ma Kuang's Garden of Solitary Pleasure. Handscroll, ink on paper. Colophon dated 1257. Yüan period? See Nanking Exh. Cat. 42; Loehr Dated Inscriptions p. 275. See below for other representations of the subject.

Ibid. (SH31). Four Events in the Ching-te Era (1004-1008). Handscroll. Yüan-Ming copies of older compositions? See CH mei-shu I.

Ibid. (SH32). Pien Chuang-tzu Killing a Tiger. Handscroll. Ming copy of earlier (pre-Sung?) composition.

Ibid. (SH33). Inquiring about the Panting Buffalo. Handscroll. Early Ming copy of Sung composition?

Chung-kuo I, 67 (Ti P'ing-tzu Coll.). The Tu-lo Yüan, or Garden of Solitary Pleasure, of Ssu-ma Kuang. The poet is resting in the bamboo grove; servants work nearby. Ming painting. See also Chung-kuo MHC 34. A fragment of a similar picture in the Indianapolis Art Institute (69.80.3); a superior version of the scene in handscroll form, attributed to Ch'iu Ying, in the Cleveland Art Museum.

* Chin-k'uei 16 (Formerly J. D. Ch'en Coll., now Princeton Art Museum). Envoys of Chin. Handscroll. A Chin work, 13th century? Attributed by J. D. Chen, without foundation, to the Chin artist Yang Pang-chi.

Fujii Yurinkan, Kyoto. Three Legends of the Nan-chao Kingdom. A colophon by Chang Chao, dated 1727, says that the scroll was painted in 899; the present scroll is a copy. See Li Lin-ts'an, *A Study of the Nan-chao and Ta-i Kingdoms,* Monograph #9 of the Institute of Ethnology, Taipei, 1967.

Cleveland Museum of Art (72.26). The football players. Good late Sung work in Academy style. See Archives, XXVI, 1972-73, p. 79.

Scenes from the Life of T'ao Yüan-ming. For references to handscroll versions of this subject, some of them called "Anonymous Sung," see under Chao Meng-fu, Yüan.

Album Leaves

Taipei, Palace Museum (VA20i). Chou Ch'u Slays the Dragon: man sharpening his sword. Fan painting. Ming work.

Ibid. (VA34a). The Three Laughers at Hu-ch'i. Double album leaf. Good work by a follower of Li T'ang. 14th century? See NPM Masterpieces II, 35.

T'ien-lai ko 7. Liu Pei Paying his Visit to Chu-ko Liang. Album leaf. Good Sung-Yüan painting.

Ibid. 15. Cheng K'ang-ch'eng and his poet-maids. Fan painting. Early Ming copy? A later and stiffer version now in the Boston Museum of Fine Arts; see Toso 13.

* Boston Museum of Fine Arts (12.896). Yang Kuei-fei Mounting a Horse in the Presence of Emperor Ming-huang. Fan painting. Fine Southern Sung work. See Portfolio I, 73; Siren CP in Am. Colls., 16.

* Ibid. (14.63). An emissary of the emperor comes to invite a hermit, who plays the *ch'in*. Fan painting. Fine work of Li T'ang follower, late 12th century?

Palace Ladies and Children

Taipei, Palace Museum (SV181). Enjoying the Cool by the Palace Pool: a court lady seated on a terrace by a pond, attended by two servants. Ming Academy work. See Ku-kung XXXV; KK chou-k'an 465.

Ibid. (SV195). Seven small children picking dates. Good Ming Academy work. See KK shu-hua chi XIV; CKLTMHC II, 26; KK chou-k'an 163.

* Ibid. (SV196). Two children playing with a cat in a garden. Southern Sung work, very close in style to the picture of a similar subject ascribed to Su Han-ch'en (SV75). See KK shu-hua chi XXXVII; CKLTMHC II, 27.

Ibid. (SV323, chien-mu). An itinerant peddler and some children. Ming work. See KK shu-hua chi XXXVIII.

Ibid. Three children playing with small boats in a stone basin. Copy of Southern Sung work. See Ku-kung XXXIII.

I-shu ts'ung-pien 18. Two ladies calling a white bird which is tied to a tree. Yüan or Ming.

Erh-shih chia (Lo Chen-yü). Testing the baby on its Birthday. Pai-miao copy of earlier composition, or pastiche?

Chung-kuo MHC 5. A palace lady walking on a garden path; trees with snow above. Late Ming copy of old composition?

Toso 132 (K'uai Shou-chu Coll.). A bird peddler accompanied by some children. Handscroll. Good 14th century work?

Album Leaves

* Peking, Palace Museum. Children at play in a garden, with a lady. Fan painting. Southern Sung? See Sung-jen hua-ts'e A, 67; B, X, 4.

Ibid. Four children playing in a small courtyard. Album leaf. Ming copy of Southern Sung? See Sung-jen hua-ts'e A, 68; B. III, 6.

Taipei, Palace Museum (VA37d). Cold Weather and the Blue-green Sleeve. Lady in a bamboo, plum and pine garden enclosed by a fence. Late Sung work?

T'ien-lai ko 3 (Li Pa-k'o Coll.). The Village School: children misbehaving while their teacher sleeps. Album leaf. Good Sung-Yüan work. A later version, time and school of Chou Ch'en, in the Boston Museum of Fine Arts; see Toso 130.

Ibid. 4. Mencius' mother leading him to school. A companion to the previous leaf. Album leaf.

Ibid. 9. Three boys watching crickets fight. Album leaf. Copy of Sung work of the kind associated with Su Han-ch'en.

Ibid. 10. Three boys performing a puppet play. Album leaf. Companion to the previous picture.

Ibid. 16. Threading a needle on the 7th day of the 7th moon; a lady on a garden terrace. Fan painting. Good Yüan-Ming painting.

Ibid. 17. A lady standing before her dressing table, two maids bringing a tray. Fan painting. This and the following picture reproduce, with additions, two well-known compositions; cf. the earlier and finer versions in the Freer Gallery attributed to Chou Wen-chü.

Ibid. 18. An Imperial concubine bathing a baby. Fan painting. Copy; see previous entry.

Yale University Art Gallery (1952.52.25m). Lady playing flute in garden. Album leaf. See Yale Cat. no. 414.

Note: For other pictures of this type see Su Han-ch'en.

Miscellaneous Figures

* Taipei, Palace Museum (SV180). Noble Scholar (T'ao Yüan-ming?) under a Willow. Fine Sung work. See CAT 26; CKLTMHC III, 87; KK ming-hua III, 40; Skira 63; also Li Lin-ts'an's article in NPM Bulletin IV, no. 1, Autumn 1970; NPM Masterpieces III, 26.

Album Leaves

Peking, Palace Museum. Two entertainers. Illustration of an opera scene. Album leaf. Late Sung or Yüan. See Liang Sung 59; Sung-jen hua-ts'e B, XI; Wen-wu ching-hua I, p. 31.

Ibid. Illustration to the play "The Eye-Medicine Vendor". Album leaf. Ming. See Liang Sung 58; Sung-jen hua-ts'e B, XII; Wen-wu ching-hua I, p. 29.

Ibid. Mid-summer rest under a locust tree; a man lying on a bed in the garden. Album leaf. Early Ming, after earlier design? See Sung-jen hua-ts'e A, 14; B, II, 3.

Taipei, Palace Museum (VA36a). A gentleman and his portrait. Album leaf. Not earlier than Ming, as is indicated by the style in which the portrait is mounted. See CAT 64; KK ming-hua IV, 38; NPM Bulletin I, 2.3. Another version, also Ming, in T'ien-lai-ko, 8.

Metropolitan Museum, N. Y. A man sleeping on a bamboo couch. Album leaf. Copy of older work.

Portraits

Liaoning Provincial Museum. Portraits of Chu Hsi and another scholar (the older figure on the left is Chu Hsi). Frontispiece to a collection of Chu's letters, in a handscroll. See Liao-ning I, 75.

Taipei, Palace Museum (SH34). Portrait of Lu Chih (754-805). Inscription by Wen Yen-po. Mediocre work, but perhaps of Sung date. See Ku-kung IX; KK ming-hua IV, 37; NPM Masterpieces IV, 15.

Ibid. (N76H). Portrait of Ssu-ma Kuang (1019-1086). Short handscroll. Good Sung work? See KK shu-hua-chi VI; NPM Masterpieces IV, 24.

London Exh. Chinese Cat. p. 79, no. 33. Portrait of the philosopher Chu Hsi (1130-1200). The portrait accompanies a collection of letters written by Chu. Ming? See also NPM Masterpieces IV, 28; NPM Quarterly V/1 (Autumn 1970), pl. 6.

Toso 136 (K'o Cheng-hsien Coll.). Portrait of Kuei Hsün. From an album of portraits of sages and worthies. Copy.

Ibid. 136 (Hsü Hui Coll.). Portraits of three members of the Chiang Family, from a handscroll. Ming work?

Kokka 572 (K. Muto Coll., Hyogo). Portrait of Po Chü-i. A long eulogy above the picture signed by the Ch'an priest Tsu-yüan (1226-1286), the founder of the Engaku-ji and Kamakura, and dated 1284. See Loehr Dated Inscriptions p. 277.

* Freer Gallery (48.10 and 48.11). Portraits of Wang Huan and Feng P'ing. Two of the "Five Old Men of Sui-yang". See Cahill Album Leaves II and III; Siren III, 202; CK ku-tai 53; Kodansha Freer Cat. 43; Freer Figure Ptg Cat. 41-42; Kodansha CA in West, I, 61. Two more from the same set in the Yale University Art Gallery (1953.27.11-12). See Yale Univ. Art Museum cat. 68-69; China Institute Album Leaves no. 2 for an entry on one of these. The last portrait of the set in the Metropolitan Museum, N. Y. (17.170.1), a portrait of Pi Shih-ch'ang. See China Institute Album Leaves #1, ill. p. 31. All five were originally mounted together as a handscroll. 11th century works. The colophons are in the Metropolitan Museum. See Li Lin-ts'an's article on the set in NPM Bulletin VIII, 5, Nov.-Dec. 1973.

Portraits of Priests

* Tofuku-ji, Kyoto. Portrait of the Ch'an priest Wu-chun. Inscription by Wu-chun, dated 1238. Genuine, fine work. See Shimbi VI; Toyo IX; Sogen no kaiga 10-11; Kokka 163; Siren CP III, 210; Skira 48; Genshoku 29/82.

Shofuku-ji, Fukuoka. Priest Ching-cho Cheng-teng. Half-length portrait, inscribed and dated 1198. See Sogen bijutsu 106.

* Nison-in, Kyoto. The five Patriarchs of the Jodo Sect of Buddhism, with their disciples. Southern Sung. See Sogen bijutsu 108.

* Nezu Museum, Tokyo. Portrait of the Ch'an priest Huan-wu (d. 1135). Attributed to Chin Ta-shou. Fine 12th century work. See Nezu Cat. I, 49.

Atami Art Museum. Portrait of Priest Mu-an Fa-chung (1084-1149). Inscriptions by Chih-kung, dated 1150, and by Chao-i. See Suiboku IV, 103.

Toyo VIII (T. Hara Coll.). The priest Hsüan-chuang returning to China. See also Kokka 96.

Todai-ji, Nara. The priest Hsiang-hsiang Ta-shih. Inscription dated 1185. Southern Sung painting. See Toyo VIII; Loehr Dated Inscriptions p. 258.

Muraguchi Collection, Tokyo (1965, formerly Muto Coll.). Portrait of a priest. Ink and color on silk. Ascribed to the late Northern Sung period by Tani Shinichi in an article in *Zen to bijutsu*.

Mitako Collection, Tokyo. Portrait of the priest Hsien-tsu. Inscription by Chien-weng Chü-ching, late Sung.

Yamato Bunkakan, Nara. Portrait of Wu-hsiang Chü-shih. Inscription by the Southern Sung priest Ta-hui.

Cleveland Museum (74.29). Portrait of the Priest Ta-chih. Chin dynasty, early 12th century. See their Bulletin, April 1977, p. 127; Archives XXXI, 1977-8, article by Susan Bush and Victor Mair.

Buddhas and Bodhisattvas

* Liaoning Museum. Sakyamuni Buddha attended by bodhisattvas, monks, guardian kings, etc. Handscroll. Seals and collection mark of Hsiang Yüan-pien; others. Fine Sung work, after T'ang model?

Taipei, Palace Museum (SV156). Sakyamuni Buddha on a pedestal; below two Lokapalas, two Bhikshus and two Bodhisattvas. Late Sung or Yüan, after earlier composition? See KK shu-hua chi XXXV; CAT 66; CKLTMHC II, 48; NPM Masterpieces III, 10.

Ibid. (SV157). Buddhist Assembly: Sakyamuni and assembled deities, kings, etc. Yüan or early Ming painting, after earlier design.

Ibid. (SV158). Thousand-armed Kuan-yin. Yüan period? See CAT 65; NPM Masterpieces V, 20.

Ibid. (SV159). Kuan-yin with a fishing creel. Mediocre Ming work.

Ibid. (SV160). White-robed Kuan-yin seatd on a bench before a screen. Good Ming work, period of Ch'iu Ying? See KK shu-hua chi III; CKLTMHC II, 68; KK chou-k'an 185.

Ibid. (SV161). Manjusri wearing a mantle of plaited straw. Half-length figure. Poem by Ch'ien-lung. Late Sung or Yüan. See KK shu-hua chi IV. Another version of the subject in the same collection, SV362, chien-mu; related paintings are in the Marquis Asano and other Japanese collections, some of them ascribed to the Yüan period artist Hsüeh-chien, q.v. See Ahn Hwi-joon's article on this theme in Archives XXIV, pp. 36-59.

Tien-yin-tang I, 7 (Chang Pe-chin Coll., Taipei). Bodhisattva. Yüan or early Ming?

Tofuku-ji, Kyoto. Triptych: Sakyamuni, Manjusri and Kuan-yin. Yüan or Japanese copies? See Toso 21-23; Sogen bijutsu 73 (Manjusri only); Doshaku, 54.

* Eiho-ji. Thousand-armed Kuan-yin. Southern Sung work of superlative quality. See Toso 126; Sogen no kaiga 2-3; Siren CP III, 211.

Chion-in, Kyoto. Amitabha's Paradise. Dated 1184. Southern Sung. See Sogen bijutsu 78.

Kokka 421. The Bodhisattva Ti-tsang (Ksitigarbha), with two attendants and a lion. Late Sung or Yüan.

Domoto Collection, Kyoto. White-robed Kuan-yin. Inscription by the monk Hsi-yen Liao-hui.

Suiboku IV, 89. White-robed Kuan-yin. Inscription by Hsiao-weng Miao-k'an (1177-1248).

Jobodai-in, Shiga. Sakyamuni Mandala. See Doshaku, 71.

Choko-ji, Kyoto. One of the Sixteen Meditations of Amitabha. Southern Sung. See Sogen bijutsu 79.

* Shinchogoku-ji, Kyoto. Samantabhadra Bodhisattva riding an elephant chariot. See Toyo bijutsu 3; Genshoku 29/80; Sekai bijutsu zenshu (old ed.) XIV, 64 (detail). Copies in the Kyoto National Museum, see Siren CP VI, 13; and a private collection in Stockholm.

* Nakamura Katsugoro. Kuan-yin in the form called Ma-lang-fu. Inscription by Cho-weng Ju-yen (1151-1225); title by Soami. See Suiboku IV, 52.

* Yabumoto Kozo, Amagasaki. White-robed Kuan-yin. Small painting, round in shape, ink and colors on silk. Fine work of the 12th century. See Kokka 946; Doshaku, 1; Suiboku IV, 8.

* S. Yabumoto, Tokyo (1979). Kuan-yin. Inscription by Wu-chun Shih-fan (1178-1249). See Suiboku IV, 50; Doshaku, 2.

Komoyoji Temple. Kuan-yin. Inscription by Ch'ih-chüeh Tao-ch'ung (d. 1250). See Suiboku IV, 51.

Museum of Fine Arts, Boston (11.6142). Sakyamuni expounding the law to an assembly. Late Sung period? See BMFA Portfolio, II, 2-3.

Princeton Art Museum. White-robed Kuan-yin. Inscription by Shih-ch'iao K'o-hsüan, dated 1208. 14th century Japanese copy? See the article by Tayama Honan in Kobijutsu No. 29 (March, 1970), pp. 109-110.

* Freer Gallery (26.1). The Buddha Addressing Yamaraja at Kusinagara: The Buddha enthroned, surrounded by Bodhisattvas, guardian kings, etc., with two donors. Frontispiece to sutra of which opening passages, describing this assembly, are mounted after the painting. Colophons by Weng Fang-kang (1733-1818) and other Ch'ing period writers. Early 12th century, probably painted in the Ta-li kingdom in Yünnan. See Freer Figure Ptg. 17.

* Cleveland Museum (62.161). Samantabhadra and Attendant. See Cahill Southern Sung Cat. 13. Originally the left panel of a triptych; for a Yüan dynasty copy of the whole, see Yüan Cat. 194. Copy or another version of the complete triptych in the Nison-in, Kyoto; see Sogen bijutsu 75.

Ibid. (70.2). Sakyamuni coming down from the mountains. Inscription by Ch'ih-chüeh Tao-ch'ung dated 1244. See Cleveland Bulletin (Feb., 1971), fig. 174; Lee Colors in Ink Cat. 6; Suiboku III, appendix 16. A similar painting, formerly Ogiwara Yasunosuke, Tokyo, also with an inscription by Tao-ch'ung, dated 1246.

Other Buddhist Figures

Taipei, Palace Museum (SV162). Vimalakirti and an attendant. Good Yüan or early Ming work. See Three Hundred M., 141.

Chung-kuo MHC 32. Vimalakirti Delivering a Sermon. Late Ming work of Suchou School.

Eda Bungado, Tokyo. The Ten Kings of Hell. Ten hanging scrolls. Late Sung or Yüan.

* Ninna-ji, Kyoto. The Peacock King. See under Chang Ssu-kung, to whom it is attributed.
* Freer Gallery (11.313). Deva Kings. Ink on silk. Fine painting of late Sung date? or Yüan? Sketch for wall painting?

Seikado, Tokyo. Thirteen paintings of Kings of Hell. See Seikado Kansho, III, 11-12 (three paintings).

Arhats

Taipei, Palace Museum (SV163). Quietly Studying the Sutras Written on Palm Leaves: Arhat and attendant. Ming copy of older work.

Ibid. (SV164). Arhat with attendants under pine. Early Ming copy of older work.

Ibid. (SV328-331, chien-mu). Sixteen hanging scrolls representing the Sixteen Arhats. Yüan or early Ming, copied after earlier series.

Ibid. (SV359, chien-mu). Arhat. Copy of work in Kuan-hsiu tradition. Yüan-Ming date.

Ibid. (SV363, chien-mu). Arhat and attendant. Early Ming work?

Engaku-ji, Kanagawa. Arhats on the terrace of a palace hanging a painting of Sakyamuni. Late Sung or Yüan. See Kokka 421.

Shoryo-ji. The Seventh and Eighth Arhats. See Shimbi IV; Toyo VIII. Four more of the same series in Sogen appendix 1-4. Early Sung.

* Seiryo-ji, Kyoto. The Sixteen Arhats. Set of sixteen hanging scrolls. Probably (at least in part) to be identified with the series recorded as having been brought to Japan in 987 by the Todaiji priest Chonen; they were probably rescued from a fire, perhaps in damaged condition, in 1218. The oldest parts appear to be Northern Sung, but there is much restoration and repainting. See the article by Yonezawa Yoshiho in Kokka 754, where two of the set and a detail of a third are reproduced; see also Toyo 4; Sogen bijutsu 91; Bijutsu kenkyu 7; Genshoku 29/77-78.

* Egawa Art Museum, Hyogo. Two arhats and an attendant. Short handscroll, ink on paper. Inscription by the priest Tao-chung (1169-1250). See Toyo Bijutsu 71; Kokka 816; Suiboku III, 40; Genshoku 29/54. This and the picture of Yao-shan and Li Ao listed below (under Ch'an Buddhist subjects, Princeton Art Museum) may originally have belonged to a single handscroll.

Osaka Catalogue, 53. A series of sixteen paintings of Arhats with attendants. Post-Sung works, much damaged. See Soraikan I, 19.

Eda Bungado, Tokyo. An arhat seated on rocks by a stream; warrior and demon attendants beyond, two birds. Yüan period?

Ibid. Arhat and attendants. Ink and colors on silk. Fine work of the period.

Nelson Gallery, Kansas City (50.11). The Sixteen Arhats. Handscroll, ink on paper. Called "Anonymous T'ang"; possibly late Sung or Yüan in date. Ch'ien-lung seals and inscription.

Cleveland Museum (76.91). Arhat and two attendants. See their *Bulletin*, Feb. 1977.

Kokka, 790 and 798 (Kobayashi Kazuya, Tokyo). Seven arhat paintings from a set of sixteen. Late Sung or Yüan.

Note: Hundreds of other arhat paintings dating from the Sung and Yüan periods are preserved in Japanese temple collections; for a partial list, see Suzuki Kei et. al., Sogen butsuga: Shuchu Rakan-zu Juo-zu no kenkyu (Tokyo, 1970).

Ch'an Buddhist Subjects

Palace Museum, Taipei (SV321, chien-mu). Bodhidharma seated beneath a tree. Strange, woodblock-like work, late Ming.

Ibid. (SV320, chien-mu). Bodhidharma. Ming work.

Nezu Museum. Bodhidharma. Half-length figure. Poem by Te-kuang, dated 1189. See Toso 129; Nezu Cat. I, 8.

Idemitsu Art Museum, Tokyo. Dancing Pu-tai. Inscription by T'ien-chang Nü-chih, 13th cent.

Kogoku-ji. Bodhidharma seated on rocks. Inscription by Lan-ch'i Tao-lung (1231-1278). Painted circa 1271. See Toso 128; Boston Zen Cat. 20; Kokka 468.

Tokugawa Museum, Nagoya. A monk sewing; a monk reading. Inscriptions by Wu-chu-tzu, one dated 1295. See Tokugawa, 155, 157.

Myoshin-ji, Kyoto. Bodhidharma. Ink on paper. Inscription by the priest Mieh-weng Wen-li (1167?-1250?). Sometimes attributed to P'u-men of the Yüan period, q.v. See Boston Zen Cat. 7; Sogen MGS III, 36.

Kokka 729 (Tokugawa Coll., Nagoya). The priest Feng-kan. Inscription by Chih-chiao K'o-hsüan, early 13th c. Old attribution to Liang K'ai. See also Suiboku III, 22; Oriental Art, Spring, 1964, X, no. 1, p. 24.

Kokka 557 (Kozo Moriya coll.). The poet Tu Fu on a donkey. Good 13th century painting by a follower of Liang K'ai.

Suiboku III, 35. Han-shan Laughing. Inscription by Tai-ch'ien Hui-chao (1286-1373). Yüan painting. See also Sogen no kaiga 39; Doshaku, 36.

Ibid. III, 50. Bodhidharma with clasped hands. Inscription by Wu-chun Shih-fan (1177-1249), but the authenticity is questioned, and the painting may be somewhat later.

Ibid. III, 52. Pu-tai with bag and staff. Inscription by Shih-ch'i Hsin-yüeh (d. 1254); painting of that period.

Ibid. III, 65. Patriarch Picking his Nose. Inscription by Hsiao-ts'ung, unidentified. Yüan work?

Ibid. III, appendix 13 (Count Hisamatsu). Shan-tsai, the Good Boy. Old attribution to Yen Hui, but has inscription by the monk Pei-chien (1214-1246). Another figure—Kuan-yin?—has been removed, only the hand remaining. See also Toyo IX.

Ibid. III, appendix 17. Han-shan holding a scroll. Inscription above, but the signature illegible in reproduction. Amateurish Yüan work?

Ibid. III, appendix 18. Han-shan holding a scroll. No inscription or seal. Fine Sung-Yüan work.

Ibid. III, appendix 25. Han-shan pointing at the moon; Shih-te with a broom. Sung-Yüan work.

Takahashi Coll., Tokyo. Pu-tai. Inscription by No-t'ang Ching-pien. Late Sung period.

Tokiwayama Bunko, Kamakura (Sugahara Coll.): Shih-te holding a scroll. Seikado, Tokyo: Han-shan holding a brush. Pair of hanging scrolls, ink on paper. Inscriptions on both by the late Sung-early Yüan monk Hu-yen Ching-fu; the paintings of that period. See Suiboku III, 57-58; Doshaku, 18; Seikado kansho III, 8.

Freer Gallery. Bodhidharma crossing the Yangtze on a reed. Inscription by Tung-ku Miao-kuang (d. 1253). Painting of that period? Or Yüan-Ming with interpolated inscription? See Suiboku III, 56.

* Ibid. (64.9). Chien-tzu with a shrimp net. Inscription by Chien-weng. 13th century. See Sherman Lee, *Tea Taste in Japanese Art,* 1963, no. 2; Freer Figure Ptg. Cat. 22; Suiboku III, 54; Kodansha CA in West I, 53.

* Princeton Art Museum. Yao-shan and Li Ao in Conversation. Handscroll, ink on paper. Inscription by the priest Yen-hsi (1228-1260). See Kobijutsu 27, September 1969; Kokka 859; Suiboku III, 41.

Ibid. (L150.70). Monk reading sutra by Moonlight. Inscription by Yü-ch'i Ssu-mien (d. 1337). Yüan work. See Suiboku III, 34; Kodansha CA in West I, 54.

Note: Many of the paintings attributed to Mu-ch'i and other Ch'an Buddhist masters are in fact Anonymous Sung or Yüan works.

Taoist Scenes

Taipei, Palace Museum (SV165). A Taoist sage, painted in the p'o-mo (splashed ink) technique. Yüan-Ming work.

Ibid. (SV166). A fairy with the White Stag of Longevity. Poor Ming work. See KK shu-hua chi XXXI.

Ibid. (SV167). The Immortal Chang Kuo-lao seated in a garden under a peach tree with two attendants. Ming academic work, 15th century.

Ibid. (SV169). A Taoist Immortal carrying a basket with fungi of immortality. Yüan or early Ming, school of Yen Hui. See KK shu-hua chi XXVIII; London Exh. Chinese Cat., p. 115; KK chou-k'an 451.

Ibid. (SV170). Two Taoist Immortals gathering flowers and herbs. Mediocre Ming work.

Li-ch'ao pao-hui, 11-12. Sun and Moon: the sun with two deer, the moon with two cranes. Pair of hanging scrolls. According to the label, a date in the Hsi-hsia era Kuang-ting, corresponding to 1214, is written on the paintings.

Kokka 558 (Baron H. Fujita Coll.). A Taoist Divinity. Southern Sung? or Yüan?

Sogen 29 (Fan Yao-yü Coll.). The King of Heaven and other Taoist deities. Yüan-Ming temple painting.

Osaka catalogue 40. Taoist deities and legendary figures. Handscroll. Spurious signature of Wang Wei. Good Yüan-Ming work.

* Boston Museum of Fine Arts (12.880). Taoist pantheon in three pictures: Deities of Heaven; Deities of Earth; Deities of Water. Old Attribution to Wu Tao-tzu. Southern Sung or Yüan. See Portfolio I, 103-105; Siren CP in Am. Colls., 95-97; Siren CP v. 1, 12; *Artibus Asiae* , vol. 33/4 (1971), p. 260, pl. 20.

* Ibid. (17.185). Lü Tung-pin crossing Lake Tung-t'ing. Fan painting. Fine 13th century work.

Princeton Art Museum. *Sou-shan t'u:* Clearing the Mountain. Demon servants of a Taoist magician fighting animals etc. Handscroll. Yüan work? For other versions of the composition, see under Wu Tao-tzu, T'ang.

Album Leaves

Peking, Palace Museum. An immortal flying on a lotus petal. Fan painting. Illegible signature. Yüan? See Sung-jen hua-ts'e A, 11; B, IX, 3.

Shanghai Museum. A Taoist resting beneath a pine. Album leaf. 14th century? in a style associated with Liang K'ai. See Liang Sung 34; Sung-jen hua-ts'e XVII.

* Taipei, Palace Museum (Va34c). Fairy Presenting the Peach of Immortality. Double album leaf. Fine Sung work, 11th-12th century.

Metropolitan Museum, N. Y. (17.170.2). The Sage Lü Tung-pin Appearing in air above the Yoyang Tower. Fan painting. An old attribution to the Northern Sung master Lü Cho may be discounted; the signature has been mostly cut away, and cannot be read. The cyclical date that accompanies it, ting-ssu, may correspond to 1197 or 1257. See China Institute Album Leaves #27, ill. p. 48.

Buffalo and Herd-boy Pictures

Taipei, Palace Museum (SV197). A herd-boy leading home two buffaloes. Ming work, after Sung design? See KK shu-hua chi XI; CKLTMHC II, 59.

Ibid. (SV198). A buffalo with its calf. Ming painting. *Ssu-yin* half-seal. See KK shu-hua chi XXXIX; Three Hundred M., p. 140; CKLTMHC II, 45; KK ming-hua IV, 41.

Ibid. (SV199). Water Buffaloes and herd-boys by a river. Hanging scroll, horizontal shape. Mediocre Ming picture. See KK shu-hua chi XLI; CKLTMHC II, 52.

Osaka Municipal Museum. Thirteen water buffaloes grazing in a landscape with dry trees. Handscroll. Ch'ien-lung inscription dated 1758. Various seals among which is a small seal of Ch'en Shun of the 16th century. See Osaka Cat. 41; Soraikan II, 29; Kokka 591.

Ogiwara Collecton, Tokyo. Boy on a buffalo in a landscape. Ink on silk. Inscription signed "Yüan-miao", possibly Kao-feng Yüan-miao (1238-1295). Amateurish Sung-Yüan work. See Suiboku III, 105.

Eda Bungado, Tokyo. Two herd-boys and buffalo under pine. Horizontal hanging scroll, ink on silk. Yüan work? See Suiboku III, 116.

Kokka 470. Two water buffaloes and a herd-boy under a willow. Yüan-Ming? or Japanese?

Ibid. 601 (Harada Coll., Tokyo). Two herd-boys on buffaloes crossing a river. Late Sung?

Detroit Institute of Arts. Water buffaloes on a spring pasture. Handscroll. Ming painting. See Siren CP III, 256.

University of Michigan Art Museum (1961/2.12). Herd-boy and buffalo returning home by moonlight. Mysterious work; Yüan-Ming provincial style? Japanese?

Album Leaves

Peking, Palace Museum. A water-buffalo and herd-boy in an autumn landscape. Fan painting. Late Sung? in Li T'ang tradition. See Sung-jen hua-ts'e A, 29; B, IV, 6.

* Shanghai Museum. Water-buffalo and calf under a willow; a farmer in a paddy. Fan painting. Fine Southern Sung work. See Liang Sung 56; Sung-jen hua-ts'e B, XVII. A copy in the Taipei Palace Museum (VA37o).

Taipei, Palace Museum (Va14h). A herd-boy on a buffalo; a buffalo calf. Album leaf. Yüan-Ming? See CKLTMHC II, 99; KK chou-k'an 58.

Ibid. (Va29d). Flute-playing herd-boy riding on a water-buffalo; another buffalo accompanying. Fan painting. "Hui-tsung" cipher; originally intended as a forgery of his work? Ming imitation.

Ibid. (VA37k). A buffalo and calf; a herd-boy seated beneath leafy trees. Fan painting. Ming copy of Sung picture.

Ibid. (VA37n). Herdsman returning in the snow riding on a buffalo and holding a pheasant on a pole. Fan painting. Ming copy of Sung picture.

* Ibid. (VA37p). Buffalo calling its calf at the willow bank; herdsman standing under willow tree leaning on a stick. Fan painting. Good Southern Sung work. See NPM Quarterly, VI/4 (Summer 1972), pl 7A.

Ibid. A herd-boy riding on a water-buffalo. Fan painting. Late Sung? Yüan? See CKLTMHC II, 100.

Chin-k'uei II, 14 (Formerly J. D. Ch'en Coll.). Herdboy riding a buffalo across a stream; young buffalo on shore. Album leaf. Poor Ming work.

* Osaka Catalogue, 39.4. A buffalo and calf; herd-boy sleeping beneath willow trees. Fan painting. Fine Southern Sung work. See also Soraikan II, 20, 2.

* Freer Gallery (11.155a). River landscape with buffalo, calf and herd-boy. Album leaf. Fine Southern Sung work. See Cahill Album Leaves IV.

Ibid. (44.53). A boy with a pheasant on a pole riding a water-buffalo through a wintry landscape. Album leaf. Southern Sung? or fine early Ming copy? See Cahill Album Leaves VII.

* Ibid. (15.8). A herd-boy asleep beneath a willow; a buffalo wandering away. Fan painting. Fine Southern Sung work. See Cahill Album Leaves VI.

* Seattle Art Museum. Buffalo and boy with a bird on a pole walking behind. Fan painting. Fine Southern Sung work. See Southern Sung Cat. 3; Siren CP III, 255; Munich Exh. Cat. 21; also Sherman Lee, "A Probable Sung Buffalo Painting" in Artibus Asiae XII, 1949, pp. 293-301; NPM Quarterly II/4 (April 1968), pl. 4B.

Cleveland Museum of Art (60.41). Boy, buffalo and calf. Fan painting. Signed "Li...," dated 1265? Late Sung work? See Southern Sung Cat. 26; S. E. Lee, "Scattered Pearls Beyond the Ocean," no. 9.

* University of Michigan Art Museum. Buffalo and herdboy in a landscape. Album leaf. Good Southern Sung work.

Monkeys and Gibbons

* Taipei, Palace Museum (SV201). Two gibbons in a loquat tree. Fine early Sung work. See KK shu-hua chi XIII; London Exh. Chinese Cat. p. 116; Three Hundred M., 138; CAT 24; CH mei-shu I; CKLTMHC II, 14; CKLTSHH; KK ming-hua III, 45; KK chou-k'an 174; Kokka 826; Soga I, 39-40.

Nezu Museum, Tokyo. Monkey. Seal of Huang Ch'üan. Good Yüan painting with meaningless attribution. See Nezu Cat. I, 30; Suiboku III, 77.

Suiboku III, 73. Gibbon. Inscription by Ching-t'ang Chüeh-yüan, who came to Japan in 1279 and died in 1306. Japanese painting of that period?

Album Leaves

Peking, Palace Museum. Monkeys picking fruit. Fan painting. Poor Ming imitation. See Sung-jen hua-ts'e A, 83; B, II, 5.

Shanghai Museum. A monkey at the base of a pine tree holding a crane chick; adult crane above. 14th century? See Liang Sung 53; Sung-jen hua-ts'e B, XIII.

* Sogen 12 (Ts'ao Jun-t'ien Coll.). A monkey on a rock by a bare tree. Album leaf. Good Southern Sung work.

Taipei, Palace Museum. A monkey on a rock by a bare tree. Album leaf. Good Southern Sung work.

Taipei, Palace Museum. A monkey swinging on a tall pine. Fan painting. Late Sung? or later? See CKLTMHC II, 87.

Chin-k'uei I, 12 (Formerly J. D. Ch'en Coll.). Two monkeys, mother and child. Odd post-Sung work.

Metropolitan Museum, N. Y. The Moaning of the Gibbon. Album leaf. China Institute Album Leaves #42.

Ibid. Gibbons attacking a nest of cranes. Album leaf. China Institute Album Leaves #39.

Dogs and Cats

* Taipei, Palace Museum (SV203). A cat under peony plants. Fine work of late
 Sung or early Yüan period. See KK shu-hua chi XXXIII; London Exh.
 Chinese Cat., p. 119; CKLTMHC II, 28; KK ming-hua III, 46.
 Ibid. (SV204). Seven kittens playing on a garden terrace. Ming, 16th century.
 See KK shu-hua chi X; KK chou-k'an 140.
 Sogen shasei gasen 5. Three dogs, two of which are fighting. Short handscroll.
 Old attribution to Wan Shan, unidentified.

Album Leaves

 Shanghai Museum. Three puppies and a bitch by stones and flowers. Fan
 painting. Southern Sung? or copy? Cf. paintings attributed to Mao I. See
 Sung-jen hua-hsüan 3; Sung-jen hua-ts'e B, XIV.
 Liaoning Provincial Museum. A dog and butterflies in a garden. Fan painting.
 Probably post-Sung copy of a work similar in style to paintings in the
 Yamato Bunkakan attributed to Mao I. See Liang Sung 11; Liao-ning I,
 81; Sung-jen hua-ts'e B, XIX.
* Taipei, Palace Museum (VA36d). A kitten. Album leaf. Close in style to the
 painting of a kitten by Li Ti in the same collection (VA24j); a pair? See
 KK ming-hua IV, 42; NPM Bulletin II, no. 1, cover; Soga I, 43.
 Sogen Meiga 21 (Tsunekichi Arai, Tokyo). Bitch and puppies with rock and
 flowers. Album leaf. Southern Sung or Yüan work.
 Sogen MGS III, 60. Cat licking its paw. Good Sung work.
* Setsu Gatodo, Tokyo (Formerly Masuda Coll.). A cat. Album leaf in oval
 shape. Southern Sung work of good quality. See Sogen MGS II, 35.

Goats and Sheep

 Taipei, Palace Museum (SV353, chien-mu). The Nine Blessings to dispel the
 Cold: return of spring with grazing goats. Yüan-Ming work. See KK
 shu-hua chi XXVIII.
 Ibid. (SV354, chien-mu). The Return of Spring: a boy with eightyone goats.
 Yüan-Ming? work of routine quality. See KK shu-hua chi XXVII.
 Another similar picture in the same collection (SV343). See under
 Anonymous Yüan for still others.
 Ibid. (SV367, chien-mu). The Return of Spring: a boy with nine goats. Crude
 Ming painting. See KK shu-hua chi XXXII.
 Sogen 23 (Yen Chih-k'ai Coll.). Pasturing goats and sheep. Handscroll. Ming
 painting.

Album Leaves

Taipei, Palace Museum (VA37L). Herding sheep. Fan painting. Early Ming? See NPM Bulletin II, 2, cover.
Formerly Manchu Imperial Household Collection (Yen Kuang Shih Photo). Two goats beneath trees. Fan painting. Yüan-Ming copy.

Other Animals and Fish

Taipei, Palace Museum (SV171). The Deer of Longevity: white stag and a doe under a peach tree. Good early Ming painting. See KK shu-hua chi XXXVI.
Ibid. (SV202). A black rabbit. Album leaf. 15th century? See KK shu-hua chi VIII; Three Hundred M., 142; KK ming-hua IV, 43; Soga I, 44.
Chung-kuo MHC 37. A tiger drinking from a rushing stream; a white hawk in a pine tree. Fan painting. Interesting Ming work.
Toso 24 (Kawai Gyokudo Coll.). Lion. Old picture, post-Sung; fragment of Buddhist composition?
Boston Museum of Fine Arts (15.908). Two carp leaping among the waves. Yüan period? See Portfolio I, 136; Siren CP in Am Colls., 89; Artibus Asiae, 33/4 (1971), p. 259, pl. 15.
Nelson Gallery, Kansas City. A white hare by a river under a leafy tree. A darkened Sung painting?
Worcester Art Museum (1937.10). Fish in a stream. Handscroll. Colophon purportedly by Yang Pu-chih. Ming or later painting.

Album Leaves

I-yüan to-ying, 1979 no. 1, p. 26. A crab clinging to a lotus leaf on the shore of a pond. Album leaf. Good Sung-Yüan work.

Birds, and Birds-in-landscape Compositions

Peking, Palace Museum. A hawk with a captured duck on the ground; another duck flying away. Yüan or early Ming, after earlier composition? See KKPWY hua-niao 20.
Liaoning Provincial Musem. Magpies on a wintry bank. Handscroll. Colophons by Chao Meng-fu and others, including one by Ch'iu Yüan dated 1314. Mannered work, of late Sung date? See Liao-ning I, 64-66.
Nanking Museum. Pairs of mandarin ducks beneath blossoming peach tree. Late Sung or Yüan work. See Nanking Mus. Cat. I, 7.
Taipei, Palace Museum (SV205). An eagle sitting on a branch. Inscriptions by Yüan writers. Mediocre Yüan work?
Ibid. (SV206). A falcon chasing a mynah and other birds. Late Ming period? See KK shu-hua chi XIV; KK chou-k'an 179.

Ibid. (SV207). Swimming goose; other birds in a tree above. Ming, style of Lü Chi.

Ibid. (SV208). A white hen and five chicks against a dark background. An inscription mounted above is dated 1486. Fine Yüan painting? See KK shu-hua chi XXXV; Three Hundred M., 139; KK ming-hua IV, 44; Soga I, 57.

* Ibid. (SV210). Finches in stalks of wheat; quail below. Late Sung or Yüan, good quality. See KK shu-hua chi IX; London Exh. Chinese Cat., p. 117; KK ming-hua III, 47; KK chou-k'an 143.

Ibid. (SV211). Mandarin ducks under an apricot tree in a wintry landscape. Large album leaf, mounted as a hanging scroll. Close copy of early Southern Sung work?

* Ibid. (SV212). Birds in a Thicket of Plum and Bamboo. Superb work of some master in the Hui-tsung Academy. *Ssu-yin* half-seal; also Yüan palace seals, *T'ien-li chih pao* and *K'uei-chang-ko pao,* used ca. 1330. See KK shu-hua chi XLII; Three Hundred M., 136; CAT 33; CKLTMHC II, 13; KK ming-hua IV, 45; Nanking Exh. Cat. 43; Skira 69 (detail); Soga I, 58-59.

Ibid. (SV213). A bird on a branch of a Wu-t'ung tree. Yüan-Ming work, post Ch'ien Hsüan; perhaps a copy. See KK ming-hua IV, 46; Soga I, 51; NPM Quarterly, VI/4.

Ibid. (SV214). Birds in a flowering tree and bamboo; quail below. Hard decorative copy.

Ibid. (SV215). A pair of ducks swimming under bamboo and peach blossoms. Fine painting, Yüan period?

Ibid. (SV216). A wild goose standing by some lotus plants. Late Sung or Yüan. See Ku-kung XXII; CKLTMHC II, 60; KK ming-hua III, 49; KK chou-k'an 184; Soga I, 48.

Ibid. (SV217). Cooing turtle-doves, mynahs, bamboo, and peach branch. Ming, probably a copy.

* Ibid. (SV218). Turtle-doves, bamboo, and rocks. Related in style to the "Birds in a Thicket of Plum and Bamboo" in the same collection (SV212); fine Hui-tsung Academy work? See KK shu-hua chi XX; CKLTMHC II, 56; KK ming-hua IV, 49; KK chou-k'an 273.

Ibid. (SV219). Five wild geese on a wintry bank; one more flying above. Spurious Sung imperial seals. Close copy of early Southern Sung work.

Ibid. (SV220). Two wild geese standing by reeds in winter. Hard Ming copy. See KK shu-hua chi XV; CKLTMHC II, 20; KK ming-hua III, 52; KK chou-k'an 190; Soga I, 49.

Ibid. (SV221). Four magpies and other birds in a flowering tree. Ming period. See KK shu-hua chi XII; KK ming-hua IV, 50; KK chou-k'an 162.

Ibid. (SV336, chien-mu). Two birds and blossoming trees; a New Year composition. Late, decorative work; part of a screen? See KK shu-hua chi XXV.

* Ibid. (SV338, chien-mu). Two sparrows in a blossoming peach tree. Fine painting of late Sung or early Yüan date; cf. Ch'ien Hsüan. See KK shu-hua chi XVI.

Ibid. (SV339, chien-mu). Small birds among blossoming camellias and plum tree. Probably by Ch'en Hung-shou of the late Ming period. See KK shu-hua chi XXXII.

* Ibid. (YV163). Two pheasants and mynah birds among bamboo in winter. Probably a Southern Sung work, time and style of Li Ti. *Ssu-yin* half-seal. See KK shu-hua chi XXX; Three Hundred M., 137; CCAT pl. 105; CKLTMHC II, 16; KK ming-hua III, 48; Wen-wu 1955, 7.10 (44).

Garland I, 17. A pair of ducks swimming below reeds. Sung-Yüan? or later copy?

Tien-yin-tang I, 5 (Chang Pe-chin Coll., Taipei). Ducks and lotus flowers. Yüan-Ming painting.

Ibid. I, 6. Lotus, cassia and three egrets. 15th century work.

Ogiwara Collection, Tokyo. Lotuses with herons and kingfishers. Hanging scroll, colors on coarse silk. Late Sung or Yüan, by provincial, specialist artist.

Eda Bungado, Tokyo. Five birds eating insects. Horizontal shape, ink and colors on silk. Yüan period?

Yabumoto Kozo, Amagasaki. Geese on a wintry river shore beneath bare trees. Hanging scroll, ink on silk. Old attribution to Yang Tzu-hsien, unidentified. Good Sung work. See Homma Sogen, 25.

Freer Gallery (09.192). Two mandarin ducks under a blossoming shrub. Good early Ming painting. See Siren CP III, 215; Siren CP in Am. Colls., 118.

Chicago Art Institute (53.439). Landscape with flight of geese. 15th century? See Lee Landscape Painting 26.

Berlin Museum. Ducks and lotus. Good late Sung work. See their catalogue, 1970, no. 32.

Album Leaves

Peking, Palace Museum. Mynah on a withering tree. Fan painting. Post-Sung; copy? See KKPWY hua-niao 19; Sung-jen hua-ts'e A, 12; B, V, 5.

* Ibid. Loquats and white-eye bird. Album leaf. Fine Southern Sung work. See Sung-jen hua-ts'e A, 24; B, VII, 3; Sung-tai hua-niao.

Ibid. Five sparrows on a dry autumn branch. Album leaf. Southern Sung? or meticulous copy? See Sung-jen hua-ts'e A, 25; B, VIII, 3; Sung-tai hua-niao.

Ibid. A white-head on bamboo. Fan painting. Copy of fine Sung work. See KKPWY hua-niao 16; Sung-jen hua-ts'e A, 40; B, VI, 7.

Ibid. Peacocks and red plum blossoms. Album leaf. Signed "Ma...". Sung-Yüan decorative work. See KKPWY hua-niao 5; Sung-jen hua-ts'e A, 53; B, IX, 7.

Ibid. Bamboo, plum blossoms and two birds. Album leaf. Hard copy of Sung work. See Sung-hua shih-fu 8; Sung-jen hua-ts'e A, 70; B, VII, 8; Sung-tai hua-niao.

Ibid. Birds and pine trees in a narrow gorge. Album leaf. Copy of Southern Sung work, cf. Li Ti. A better version, with a companion leaf, in T'ien-lai-ko. See Sung-jen hua-ts'e A, 74; B, VI, 6.

Ibid. Golden oriole on a pomegranate tree. Album leaf. Copy of Sung work. See Sung-jen hua-ts'e A, 75; B, V, 7; Sung-tai hua-niao.

Ibid. Two ducks on a pond, plum blossoms, narcissi and camellias. Album leaf. Close copy of Southern Sung work? See Sung-jen hua-ts'e A, 86; B, IX, 9.

Ibid. Bamboo and five sparrows. Album leaf. Hard copy of Sung work. See Sung-jen hua-ts'e A, 91; B, VIII, 2; Sung-tai hua-niao.

Ibid. A wagtail on a fading lotus leaf. Album leaf. Late Sung or Yüan. See KKPWY hua-niao 17; Sung-jen hua-ts'e A, 92; B, IV, 1.

Ibid. Two birds on bare branches in a frost-covered gorge. Two birds in a tallow tree above a snowy stream. Pair of album leaves. Copies of Southern Sung Academy paintings. See Sung-jen hua-ts'e A, 98-99; B, X, 7-8.

Ibid. Pied wagtail on a rock. Album leaf. Southern Sung? or copy? See Sung-jen hua-ts'e B, XI.

Ibid. Two ducks, flight of cranes in river scenery. Album leaf. Yüan-Ming work in Chao Ling-jang tradition. See Liang Sung 51; Sung-jen hua-ts'e B, XI; Sung-tai hua-niao.

Ibid. Four ducks on a wintry spit of land. Fan painting. Late Sung or Yüan. See Liang Sung 13; Sung-jen hua-ts'e B, XII.

Ibid. A large bird perched on the edge of a bowl. Album leaf. Southern Sung? See Sung-jen hua-ts'e B, XII.

Shanghai Museum. Pied wagtail eyeing an insect from a lotus stalk. Yüan? or later? See Liang Sung 37; Sung-jen hua-ts'e B, XIII.

Ibid. A quail on a grassy bank. Album leaf. Good copy of Sung painting of the kind associated with Li An-chung. See Liang Sung 3; Sung-jen hua-hsüan 6; Sung-jen hua-ts'e B, XV.

Szechwan Provincial Museum. Three ducks swimming in a lotus pond. Album leaf. Good, although highly rarefied, late Sung work. See Liang Sung 26; Sung-jen hua-ts'e B, XVI.

Taipei, Palace Museum (VA23c and VA23d). Feeding the young sparrows on a bamboo branch. Feeding the young sparrows on a willow branch. A pair of fan paintings. Copies of Sung works. See Soga I, 53.

Ibid. (VA23g). Two small finches on rice stalks. Fan painting. Good copy of Sung work.

Ibid. (VA23i). Three cold birds on snowy bamboo. Fan painting. Hard copy of Sung work.

Ibid. (VA23j). Bird on a camellia branch. Fan painting. Sung painting, somewhat retouched?

Ibid. (VA36k). Egrets on the river shore. Album leaf. Yüan or later, by mediocre artist.

Ibid. (VA37i). Geese by an autumn pond. Fan painting. Late Sung work? or later? See KK ming-hua IV, 47.

* Ibid. (VA37m). Rooster, hen, chicks and large rock and grasses. Fan painting. Yüan palace seal *T'ien-li chih pao,* used ca. 1330. Good Sung-Yüan work. See Soga I, 55.

* Ibid. (VA36g). A Duckling. Album leaf. Good late Sung work. See KK ming-hua IV, 48; NPM Bulletin I, 5, cover; Soga I, 56.

Ibid. (VA36f). Egrets, bamboo and rock. Album leaf. Yüan period. See KK ming-hua III, 50.

Ibid. (VA36h). Two birds on a branch of blossoming plum. Album leaf. Late Sung or Yüan. See KK ming-hua III, 51.

Chung-kuo I, 59 (Ti P'ing-tzu Coll.). Seascape with mountain silhouettes and a bird. Fan painting.

Li Mo-ch'ao. Two geese, rushes and lotus leaves. Fan painting. Mannered copy.

Ibid. Cock, hen and chickens on a garden terrace. Album leaf. Minor Yüan-Ming work.

* Ibid. Two mandarin ducks resting under bamboos and a plum tree. Album leaf. good late Sung work?

T'ien-lai ko (Li Pa-k'o Coll.). Magpies by a stream under pine trees. Mynah birds in a blossoming plum tree over a stream. Pair of album leaves. Good Ming copies of Southern Sung works. The former in another version in Sung-jen hua-ts'e A, 74.

Tien-yin-tang II, 12. Rice plant and bird. Fan painting. Good Yüan picture.

Ibid. II, 17. Two birds flying toward a bank, four birds on a cliff under pines. Fan painting. Hard copy.

Chung-kuo MHC 36. Birds in a blossoming plum tree over a cataract. Album leaf. Reproduction unclear. By follower of Li T'ang.

Ibid. 32. Quail and Orchids. Horizontal picture—fragment of handscroll? Fine Sung-Yüan work.

* Sogen no kaiga 55 (formerly Asano Coll., Kanagawa). A bird on a branch of blossoming white peach flowers. Album leaf, ink and colors on silk. Fine work of early Southern Sung, Hui-tsung tradition. See also Sogen meiga 7; Sogen MGS III, 10. Old attribution to Hsü Hsi.

Kokka 459. A wagtail on a rock. Fan painting. Late Sung or Yüan. See also Sogen MGS II, 36.

Seikasha Sogen, 18. A small bird on a peach branch. Fan painting. Unsigned. Meaningless attribution to "Huang Yao-chai," unidentified. Fine Sung-Yüan work.

Cleveland Museum of Art (61.260). Birds and ducks on a snowy islet. Fan painting. Late Sung? or later? China Institute Album Leaves #6; Southern Sung Cat. 9; Sherman Lee, *Scattered Pearls Beyond the Ocean* #2.

Ibid. (69.305). Returning birds and old cypress. Fan painting. Yüan painting? See Lee, Colors of Ink, cat. 7.

Boston M.F.A (14.55). Bird on peach branch. Fine early Yüan painting, close in style to Ch'ien Hsüan. See Portfolio I, 138.

Metropolitan Museum, N. Y. Landscape with egrets. Fan painting. Late Sung work? See China Institute Album Leaves #9, ill. p. 36.

Honolulu Academy of Arts. Tit inspecting loquat. Fan painting. Sung-Yüan painting. See China Institute Album Leaves #25, ill. p. 47.

Earl Morse Collection. Bird on an apple branch. Fan painting. Good copy of Sung work. China Institute Album Leaves #8, ill. p. 35.

Flowers, Fruit and Insects

* Peking, Palace Museum. The Hundred Flowers. A long handscroll of flowers, fruits and insects. Ink on paper. Important late Sung or early Yüan work, probably by a scholar-amateur painter, cf. Chao Meng-chien. For a related work, see "Hui-tsung" Autumn Pond scroll in the Taipei Palace Museum (SH6); for a later version of the style see Chao Chung scroll in Cleveland Museum of Art dated 1361. For reproductions of the Hundred Flowers scroll see Wen-wu 1959, 2, inside back cover; also reproduced in 46 sections by Wen-wu Publishing Co., 1958. See also article by Tan Kuo-ch'iang in *Mei-shu* , 1978 no. 2

Taipei, Palace Museum (SV222). Peonies and other flowers in an ornamental vase. Ch'ing period. See KK shu-hua chi XXIX; KK chou-k'an 455.

Ibid. (SV223). Peonies. Yüan? by minor, specialist artist. See Nanking Exh. Cat. 45; CKLTMHC II, 30.

Ibid. (SV224). A branch of camellia blossoms. Hard copy of a painting in the style of Ch'ien Hsüan. See Ku-kung XXXVI; KK ming-hua IV, 51.

* Ibid. (SV225). Three Melons. Double album leaf, mounted as a hanging scroll; ink and colors on paper. Lovely decorative work. Yüan? by follower of Ch'ien Hsüan? See KK shu-hua chi V; London Exh. Chinese Cat. p. 121; CH mei-shu I; CKLTMHC II, 62; KK ming-hua III, 53; Wen-wu chi-ch'eng 53; KK chou-k'an 186; NPM Quarterly, VI/4, p. 56, pl. 1A.

Ibid. (SV338). Sparrows in Flowering Tree. Fine work of Yüan period of the kind often attributed to Ch'ien Hsüan.

Ibid. (SV339, chien-mu). Sparrows in flowering plum tree. Late Ming, cf. Ch'en Hung-shou.

Ibid. (SV340, chien-mu). An evergreen plant in a pot on a pedestal. Poor Ming picture. See KK shu-hua chi, XXXVI.

Museum für Ostasiatische Kunst, Cologne. Lotus blossoms. Late Sung work of P'i-ling School. See Speiser, Chinese Art, III, pl. 10.

Album Leaves

Peking, Palace Museum. Crabapple blossoms and butterflies. Album leaf. Copy of good Southern Sung work? See Sung-hua shih-fu 7; Sung-jen hua-ts'e A, 15; B, I, 6; Sung-tai hua-niao.

* Ibid. White camellias. Fan painting. Fine Southern Sung work. Cf. "Chao Ch'ang" fan paintings in the Asano and Sugahara collections. See Sung-jen hua-ts'e A, 33; B, V, 9; Sung-tai hua-niao.

* Ibid. Peach blossoms. Fan painting. Fine Southern Sung painting. See KKPWY hua-niao 15; Sung-hua shih-fu 3; Sung-jen hua-ts'e A, 34; B, V, 3; Sung-tai hua-niao.

Ibid. Insects and wild grasses. Album leaf. Good late Sung work? or Yüan? See Sung-jen hua-ts'e A, 38; B, X, 6.

* Ibid. Branch of weeping willow. Album leaf. Fine 12th-13th century work. Inscription and seal of Empress Yang. See Sung-jen hua-ts'e A, 55; B, VI, 5.

 Ibid. Prometheus moth and maple bough. Fan painting. Late Sung? or good copy? See Sung-jen hua-ts'e A, 77; B, V, 2; Sung-tai hua-niao.

* Ibid. Narcissi. Fan painting. Fine Southern Sung Academy work, cf. Ma Lin. See Sung-jen hua-ts'e A, 97; B, VIII, 9.

* Ibid. Cluster of chrysanthemums. Fan painting. Good Sung work. See Sung-jen hua-ts'e B, XII.

 Sung-jen hua-ts'e B, XIII. Pink hollyhocks. Fan painting. Southern Sung Academy work, cf. Li Ti, with outlines redrawn? or copy?

* Shanghai Museum. Butterfly and camellia. Fan painting. Fine Southern Sung work, cf. "Chao Ch'ang" fan paintings in the Asano and Sugahara collections. See Liang Sung 19; Sung-jen hua-ts'e B, XVI.

* Ibid. Pink lotus. Fan painting. Fine Southern Sung painting. See Liang Sung 33; Sung-jen hua-ts'e B, XVI.

* Szechwan Provincial Museum. White hibiscus flowers. Fan painting. Fine Southern Sung painting. See Liang Sung 24; Sung-jen hua-ts'e B, XVI.

 Shanghai Museum. Flower basket. Fan painting. Good Sung-Yüan work. See Sung-jen hua-ts'e B, XVII.

* Taipei, Palace Museum (VA14i). A branch of oranges. Album leaf. Good Sung-Yüan painting, cf. Ch'ien Hsüan. See CKLTMHC II, 91; KK chou-k'an 65.

 Ibid. (VA20c). Hibiscus. Fan painting. Good copy of Sung work? See Soga I, 29.

* Ibid. (VA36aa). Camellias. Album leaf. Good painting of Southern Sung date or slightly later. See KK ming-hua III, 54.

 Li Mo-ch'ao. A large lotus flower. Fan painting. Copy.

 Ibid. A blossoming shrub and some insects. Fan painting. Late Sung? or neat copy?

 Chin-k'uei II, 15 (Formerly J. D. Ch'en Coll.). Loquats. Fan painting. Hard copy.

 Tien-yin-tang II, 15. (Chang Pe-chin Coll., Taipei). Plum blossoms and the reflection of the moon. Fan painting. Crude copy of Southern Sung work.

 Chung-kuo MHC 14. Branch of blossoming plum. Fan painting. Reproduction indistinct; Southern Sung?

 Ch'ing kung ts'ang 11 (Former Manchu Household). Two lichee fruits on a branch. Fan painting.

 Ibid. 13 (Former Manchu Household). Three eggplants. Square fan.

 Sung Yüan pao-hui IV, 4 (Former Manchu Household). Flowers with tendrils curling around bamboo stalks. Square fan painting. Southern Sung.

 Fogg Art Museum. Peony. Album leaf. See China Institute Album leaf #44 (no illustration).

* Ching Yüan Chai collection. Geranium flowers and butterfly. Fan painting. Old attribution to Huang Chuan. Fine Southern Sung work.

VI.

Painters of the Yüan Dynasty

A-CHIA-CHIA　阿加加
Probably a nun; active in the Yüan period. Unrecorded in Chinese sources, but see *Kundaikan Sayuchoki* (No. 185).

Shimbi XI (Count Sakai). Kuan-yin seated on a rock by a stream; the boy Shan-ts'ai standing on a lotus petal. Attributed. See also Toyo IX; Toso 141.

CH'AI CHEN　柴楨　　t. Chün-cheng　君正　　, h. Shih-an　適菴　or Shih-chai　適齋
From Tung-p'ing, Shantung. Active in the 14th century. H, 4. M, p. 265.

Osaka Municipal Museum. Autumn Landscape. Signed. Poems by Wang Shih-tien, Chen Yüan-yü (1292-1364) and Ch'en Ju-yen (dated 1378). See Soraikan II, 41; Toso, 222; Osaka Cat. 62.

CHANG CHUNG　張中
See Chang Shou-chung.

CHANG FANG-JU　張芳汝

Yüan period. Landscape and figures. Unrecorded in Chinese books but mentioned in *Kundaikan Sayuchoki* (No. 40).

Kokka 246 (Ueno Collection). Misty river landscape. Album leaf. Attributed.

Kawasaki Cat. 27. A buffalo eating leaves from the branches of a tree. Attributed. See also Choshunkaku, 24.

Muto cat. 23. A winding stream in mist and rain; large trees on the banks. Album leaf. Attributed.

Atami Art Museum (Former Baron Dan). A pair of hanging scrolls each representing a herd-boy with a buffalo in a sketchy landscape. Attributed. See Shimbi, VIII; Suiboku III, 106-107; Sogen Meigashu 49-50.

Sogen MHS III, 42-43 (Baron Mitsui coll.). Herd-boys riding buffalo in sketchy landscape. Pair of hanging scrolls, ink on paper. Attributed.

Note: The small set of Eight Views of the Hsiao and Hsiang attributed to Mu-ch'i (q.v.) has also been attributed, on the basis of style, to Chang Fang-ju.

CHANG HSÜN　張遜　t. Chung-min　仲敏　, h. Ch'i-yün　溪雲

From Suchou. Studied bamboo with Li K'an; also painted landscapes after Chü-jan. H,5. M, p. 463.

Formerly Frank Caro, N.Y. Bamboo painted in outline, pine and rocks. Handscroll. Signed and dated 1341.

* Peking, Palace Museum. Bamboo, rocks and pines. Handscroll. Signed and dated 1349, done for Wang Yü. See *Yüan Chang Hsün Shuang-kou-chu t'u-chuan,* Peking, 1964.

Garland II, 36 (Formerly Chiang Ku-sun, Taipei). Bamboo, drawn in outline, and rock. Ink on paper. Early Ming inscriptions. Attributed.

See also the painting listed under Ni Tsan, dated 1346, which bears an inscription by Chang Hsün and may be his work.

CHANG KUAN　張觀　t. K'o-kuan　可觀

From Sung-chiang, Kiangsu. Active at the end of Yüan and beginning of Ming dynasty. Followed the Ma-Hsia tradition. N, 6, p. 2. H, 5, p. 11. M, p. 464.

Peking, Palace Museum. Landscape, ink on paper. Mounted together with paintings by Shen Hsüan, Liu Tzu-yü and Chao Chung.

Shen-chou ta-kuan hsü V. High mountains, winding road and stream. In the style of Ma Yüan. Signed.

* Cheng Chi, Tokyo. A man approaching a house by tall bamboo. Fan painting. Signed. Probably genuine.

Metropolitan Museum, N. Y. (13.100.106). A man on a terrace. Album leaf, in the style of Ma Yüan. Attributed.

Freer Gallery (16.36). A man with his servant in a small boat at the foot of a cliff under an overhanging willow tree. Attributed.

CHANG K'UNG-SUN　張孔孫　　t. Meng-fu　夢符
From Lung-an, Chi-lin. B. 1233, d. 1307. Served as a censor in the reign of
Kublai Khan. Landscapes. I, 37, 53. L, 24. M, p. 463.

Sogen 75 (former J. D. Ch'en collection). Two men in a straw-covered hut at
the foot of misty mountains. Signed and dated 1306. Later picture—
Ch'ing period. See also Chin-k'uei 15. Another version, by Hua Yen of
the 18th century, owned by Cheng Chi, Tokyo.

CHANG MENG-K'UEI　張夢奎
Unrecorded. According to the label on the following picture, active in the
Yüan period.

Princeton University (Du Bois-Morris collection). Nine egrets, reeds and lotus
plant. Signed.

CHANG PO-HUNG　張伯洪　　(or 洪)
Yüan period. Unrecorded in Chinese sources, but mentioned in *Kundaikan
Sayuchoki* as a painter of figures, Kuan-yin, etc.

Hikkoen, 49. Arhat and Attendant. Attributed. Fragment of strange, good
Sung work.

CHANG SHEN　張紳　t. Shih-hsing　士行　and Chung-shen　仲紳　, h.
Yün-men shan-ch'iao　雲門山樵
From Chi-nan; served as Governor of Chekiang in the Hung-wu period (1368-
1398). Painted bamboo. I, 54. L, 25. M, p. 465.

* Taipei, Palace Museum (YV172). An old tree and bamboo by a rock, painted
together with Ni Tsan and Ku An. Poems by Ni Tsan (dated 1373) and
Yang Wei-chen. See KK shu-hua chi V; CH mei-shu, II; CKLTMHC, III,
74; KK ming-hua VI, 38.

CHANG　SHOU-CHUNG　張守忠　　, or　張守中　　also named
CHANG CHUNG　張中　t. Tzu-cheng　子政　or 正 and Yü-cheng　于政
From Sung-chiang, Kiangsu. Active in the middle of the 14th century. Painted
landscapes, flowers and birds. H, 5. M, p. 464.

H. C. Weng, N. Y. Lotuses, sea-grass and crabs. Signed and dated 1347.
Handscroll. Ming work?
Shen-chou ta-kuan hsü III. Man fishing by a waterfall. Signed and dated 1350.
Taipei, Palace Museum (YV102). A cock under flowers. Signed and dated
1351. See KK shu-hua chi XX; London Exh. Chinese Cat., p. 162.

Osaka Municipal Museum. Two swallows on a willowbranch. Signed and dated 1352. Inscriptions by Yang Wei-chen (1296-1370) and others. See Soraikan, II, 39; Osaka Cat. 59. Another version(?) in the collection of Yabumoto Soshiro, Tokyo (1973).

* Shanghai Museum. Two ducks swimming under a camellia bush. Inscribed, signed, dated 1353. See TSYMC hua-hsüan, 28.

Shen-chou ta-kuan, II. Two wagtails by a rockery. Handscroll. Signed and dated 1360.

* Taipei, Palace Museum (YV101). A bird on the branch of a blossoming peach tree. Signed. Several poems by contemporaries. See KK shu-hua chi, II; CKLTMHC, III, 33; KK ming-hua, VI, 4.

* Ibid. (YV100). A pair of mandarin ducks among rushes. Signed. See KK shu-hua chi, XLV; Three Hundred M., 182; CKLTMHC, III, 32; NPM Masterpieces V, 27.

Sogen 68 (Yeh Fan-yüan collection). A flowering rose bush, birds and butterflies. Handscroll. Later work.

CHANG SHUN-TZU 張舜咨, also named Chang I-shang 張義上 or Chang Hsi-shang 張羲上 t. Shih-k'uei 師夔, h. Li-li-tzu 櫟里子
From Hangchou. Active ca. 1330-1350. Painted landscapes. H, 5. M, p. 463.

* Taipei, Palace Museum (YV35). Old trees and rocks by a stream. Signed and dated 1347. Poem by the painter Yang I (Yen-ch'ang). See Ku-kung, XIV; Three Hundred M., 170; CKLTMHC, III, 69; KK ming-hua, V, 37; Mei-shu t'u-chi 2; KK chou-k'an 126.

* Ibid. (YV36). A small cypress tree and rocks. Signed and dated 1349. Poems by two contemporaries and three later writers. See KK shu-hua chi, VII; London Exh. Chinese Cat., p. 166; CH mei-shu, II; CKLTMHC, III, 68; KK chou-k'an, 125; NPM Masterpieces V, 25.

* Peking, Palace Museum. An eagle in a juniper tree. Signed; done with Hsüeh-chieh, unidentified, who painted the eagle. See Chung-kuo hua, XIII, 20.

CHANG T'UNG
For the painting of a lily in the Musée Guimet formerly ascribed to this master, see under Chang Heng-t'ang of the early Ming period.

CHANG WU 張渥 t. Shu-hou 叔厚 , h. Chen-hsien-sheng 眞閒生 and Chen-ch'i-sheng 眞期生
From Huai-nan; active in Hangchou and Suchou. Active ca. 1336-ca. 1364. Figures, followed Li Kung-lin. H, 5. I, 54. L, 24. M, p. 464. See the article by Hsieh Yung-nien in *Wen-wu,* 1975, no. 11, pp. 64-68.

Taipei, Palace Museum (YV107). Amitabha in a garden with two attendants. Signed and dated 1336.

Ibid. (YV108). Peach festival at the lake of gems. Signed and dated 1341. See Three Hundred M., 183.

* Shanghai Museum. *Chiu-ko t'u:* Illustrations to the Nine Songs of Ch'ü Yüan. Handscroll, ink on paper. Signed. Dated to the sixth lunar month of 1346 in a colophon by Wu Jui, who wrote the text. Also colophons by Chang Yü and others.

* Kirin Provincial Musem. *Chiu-ko t'u:* Illustrations to the Nine Songs of Ch'ü Yüan. Handscroll, ink on paper. Signed. Dated to the tenth lunar month of 1346 in a colophon by Wu Jui, who wrote the text in *li shu.* Painted for Yen Shih-hsien (Ssu-chai). Colophon by Ni Tsan, dated 1372. Seals of Liang Ch'ing-piao, An Ch'i and three Ch'ing emperors. See *Wen-wu,* 1977, no. 11, pl. 6-9.

* Cleveland Museum of Art (59.138). *Chiu-ko t'u:* Illustrations to the Nine Songs of Ch'ü Yüan. Handscroll, ink on paper. Dated 1360; text written in *li shu* by Ch'u Huan. See Yüan Exh. Cat. 187, Venice Exh. Cat 785; CK ku-tai, 63; Siren CP VI, 44-45, Munich Exh. Cat. 36; Lee Colors of Ink cat. 15; Hills 70.

Toso p. 161 (Huang Chih collection). The Dragon King issuing from waves saluting Kuan-yin, who is seated on clouds. Handscroll. Signed and dated 1360. Sutra copied by a Ming calligrapher.

* Sogen, large ed., 33-34 (Chang Hsüeh-liang collection). The Eight Immortals of the Wine Cup: illustrations to the poem by Tu Fu, which is copied on the picture. Signed and dated 1363. According to the artist's inscription, copied after a work by Chao Meng-fu. See also Sogen, 53 (section).

* Shanghai Museum. Wang Hui-chih on his way to visit Tai K'uei on a snowy night. Signed. Probably genuine, although not first-class work. Poem by Ch'ien-lung. See Sogen 54; Che-chiang, 41; Li-tai jen-wu, 38; Shang-hai 25; Chugoku bijutsu III, p. 85.

* Liaoning Provincial Museum. A grass hut across the river from a bamboo grove. Handscroll. Seal of artist. Poem by Yang Yü; colophons by Yang Wei-chen, Chang Yü, Ma Wan, T'ao Tsung-i and others. See Liao-ning, I, 87.

Peng Hsi (Chen-ku chai) collection, Hongkong. Chung-k'uei hunting, attended by demon servants. Handscroll, ink on gold-sprinkled paper. Signed.

Note: Cf. the scroll in the Museum of Fine Arts, Boston, ascribed to Chang Tun-li, which is also sometimes attributed to Chang Wu.

CHANG YEN-FU 張彥輔　　t. Liu-i 六一

A Taoist, active in Peking in the 1340's; probably died ca. 1350. Painter-in-attendance at the Yüan court. Landscapes and horses. H, 5. I, 54. M, p. 464.

* Nelson Gallery, K. C. (49.19; former Chang Ts'ung-yü). Two birds, briars, and bamboo. Painted as a present for Sheng Mou; another friend of the

painter, Wu Jui, telling of their meeting at a Taoist temple in 1343. Seven other inscriptions by contemporaries. See Yüan Exh. Cat. 243; Siren CP VI, 55; Yün-hui-chai, 52.

CHANG YÜ 張雨 , also named CHANG T'IEN-YÜ 張天雨 t. Po-yü 伯雨 , h. Chü-ch'ü wai-shih 句曲外史
B. 1283, d. 1350. From Ch'ien-t'ang, Chekiang. A Taoist monk. Painted landscapes. I, 54. L, 24. M, p. 464. See the article by Chang Kuang-pin in NPM *Bulletin* X/5 (Nov.-Dec. 1975).

Taipei, Palace Museum (VA251). Streams and Mountains in Winter. Album leaf. Signed and dated 1329. Poor work of much later date.
Chang Pe-chin, Taipei. Fungus, bamboo and rock. Signed and dated 1336. Colophons by K'o Chiu-ssu and Wang Tzu-fan. See Tien-Yin-Tang, I, 9; I-lin YK 83/7.
Sogen 55 (Chou Chih-ch'eng collection). A leafless tree, bamboo and a rock. Signed and dated 1338. Later work. See also Pageant, 395.
Taipei, Palace Museum (YV300, chien-mu). Pavilions under trees on a river shore in autumn, after Cheng Ch'ien. Signed and dated 1344 (at age 70). Poem by the painter. Early Ch'ing work. See KK shu-hua chi, XXX.
Cheng Te-k'un, Hong Kong. *T'ing-yü lou:* Pavilion for Listening to the Rain. River scenery in the mountains. Poem by the painter, dated 1348. Another inscription, signed by Ni Tsan, dated 1365.
Nanga Taisei Introd. 4. *Te-ch'ang ts'ao-t'ang:* a wooded hill; a village by the water. Signed and dated, but the second character of the cyclical date illegible. Inscription by Wang Sung dated 1459.

CHANG YÜ 張羽 t. Lai-i 來儀 , Fu-feng 附鳳
B. 1333, d. 1385. From Hsün-yang, later moved to Wu-hsing. Friend of Kao Ch'i. See biography by T. W. Weng in DMB I, 106-7.

Garland, II, 40 (Private coll., N. Y.). Clearing after rain at the Pine Studio. Signed and dated 1366. Inscriptions by Wu Kuei and Ch'ien-lung.

CHANG YÜ-TS'AI 張羽材 t. Kuo-liang 國梁, h. Wei-shan 薇山 and Kuang-wei-tzu 廣微子
D. 1316. The 38th Taost T'ien-shih. Bamboo and dragons. Biography in Yüan-shih. M, p. 464.

Formerly Frank Caro, N. Y. Dragons in clouds. Handscroll, on silk. Signed.

CHANG YÜAN 張遠 t. Mei-yen 梅嚴
From Hua-t'ing, Kiangsu. Active ca. 1320. Landscapes and figures, followed Ma Yüan and Hsia Kuei. H. 5. M, p. 463.

* Shokoku-ji, Kyoto. Winter Landscape with Travellers. Ink on paper. Possibly section of a handscroll, remounted as a hanging scroll. Inscription by the Japanese monk Zekkai Chushin (1336-1405). Fine work of the Yüan period, possibly as attributed; the identification of this by some Japanese scholars as a Korean painting is without basis. See Kokka, 256; Hills 29.
Bijutsu II. A solitary cottage under a pine-tree. Album-leaf. Attributed.
Kawasaki cat. 31. A pavilion under willows by a stream. Attributed.

CHANG YÜEH-HU　張月壺
Active from the end of Sung into the Yüan period. Unrecorded in Chinese sources but mentioned in *Kundaikan Sayuchoki* (No. 36).

Kokka 153 (Ueno collection). Bodhidharma crossing the Yangtse on a reed. Inscribed: Chang Yüeh-hu, the Han-lin Scholar of the Great Sung dynasty.
Ibid. 533 (Baron Dan). Kuan-yin crossing the sea on a lotus petal. Signed: Yüeh-hu.
Daitoku-ji. White-robed Kuan-yin seated on a rock by the water. Attributed. See Shimbi XX; Toyo IX; Suiboku III, 64.
Kawasaki cat. 34. Kuan-yin on a rocky shore looking at the moon in the water. Attributed. See also Choshunkaku 16.
Choshunkaku 17. Kuan-yin on a rock by the water. Attributed.
Muto cat. 22. Kuan-yin seated on a rock by the water; a Deva descending from the air. Attributed.
Osaka catalogue 69. White-robed Kuan-yin by the water. Attributed.
Fujita Museum, Osaka. Kuan-yin with willowbranch. Seal. Ming work?
British Museum, London. Kuan-yin seated on a rock by the water. Attributed. See Ars Asiatica IX, p. 23.

CHAO CH'I　趙淇　t. Yüan-te　元德　, h. P'ing-yüan　平遠　, Tai-ch'u tao-jen　太初道人　, P'ing-ch'u　平初　, Ching-hua-weng　靜華翁
B. 1238, d. 1306. From Ch'ang-sha, Hunan, held an office in Hunan. Painted bamboo. H, 5. I, 53. M, p. 615.

Taipei, Palace Museum (YH20). Examining cranes. Handscroll. Signed. Inscription by Chou Po-ch'i.

CHAO CHUNG　趙衷　t. Yüan-ch'u　原初　, h. Tung-wu yeh-jen 東吳野人
From Wu-chiang. Active in the Yüan period as a doctor and calligrapher. Painted figures in *pai-miao*. M, p. 615.

* Cleveland Museum of Art (67.36). Ink Flowers. Three studies of lily, narcissus, and peony mounted as a handscroll. Inscriptions by the artist, one dated 1361. See TWSY ming-chi 107; Yüan Exh. Cat. 183; Lee Colors of Ink cat. 20.

Peking, Palace Museum. Four landscape studies. Mounted together in a handscroll with paintings by Chang Kuan, Shen Hsüan, and Liu Tzu-yü.

Shen-chou album, 1935. *Chiu-ko t'u:* Illustrations to the Nine Songs of Ch'ü Yüan. Album of 9 leaves, none signed. Long inscription by Chao on last leaf, but sheet is of different size, and may not have belonged with the album originally.

CHAO HSI-YÜAN 趙希遠
A contemporary of Wang Meng, followed his style. I, 54. L, 47. M, p. 615.

Taipei, Palace Museum (YV109). A Fortunate Place among Groves and Mountains. Signed and dated 1349. Poem by Wen Chia. See KK shu-hua chi XXXII; KK ming-hua VI, 23; KK chou-k'an 68. For a similar composition see Cheng Chung of late Ming; the painting is probably of that period.

Metropolitan Museum, N. Y. (13.100.122). Listening to the spring. Album leaf. Attributed.

CHAO HSIU 趙岫 , t. Yün-yen 雲巖 or t. Hsüeh-yen 雪巖
From Wen-chou. Painted birds and flowers in color, ink bamboo. H, 5. *Hua-shih hui-yao,* ch. 3. See the article by Hironobu Kohara in *Kobijutsu,* 30, (June 1970), pp. 95-97.

Kobijutsu 30, 87-88. Wind-blown bamboo and rocks. Hanging scroll, ink on silk. Signed.

CHAO I 趙奕 t. Chung-kuang 仲光 , h. Hsi-chai 西齋
Son of Chao Meng-fu. Painter and calligrapher. See Chao Meng-fu's biography in *Yüan-shih;* also *Hua-shih hui-yao.*

Chung-kuo MHC 39. Landscape with scholars on a terrace looking at paintings. Signed?

CHAO LIN 趙麟 t. Yen-chen 彥徵
D. ca. 1367. Son of Chao Yung. Painted figures and horses. H, 5, p. 1. M, p. 615.

* Crawford Collection, N. Y. A horse and groom. Handscroll, inscribed, signed and dated 1359. Mounted with two other paintings of horses and grooms by Chao Meng-fu and Chao Yung. See Crawford Cat. no. 43; CK shu-hua I, 20; Li-tai jen-wu 36; TWSY ming-chi 97. A similar scroll in the Yale University Art Gallery, former Moore collection; see Yale cat. no. 27.

* Freer Gallery (40.1). Tartar horsemen. Handscroll, ink and gold on paper. Signed and dated 1360. Probably copied after an earlier model; cf. the

painting now in Boston MFA (52.1380) attributed to the Liao painter Li Tsan-hua.

Fujii Yurinkan, Kyoto. Dressing a horse by a stream, after Li Kung-lin. Signed and dated 1365. See Yurintaikan III, 3; Sogen 35; Che-chiang 38.

Taipei, Palace Museum (YV11). A man in a red coat and a horse at the foot of a tree. Signed. See KK ming-hua V, 16; NPM Masterpieces V, 22.

* C. A. Drenowatz, Zurich. *Chuan Lan-t'ing:* Obtaining the Lan-t'ing calligraphy by a trick, after Yen Li-pen. Handscroll. Signed by the artist; colophon by a friend. See Li Chu-tsing, *Asiatische Studien* XXI (1967) pl. 1; W. Speiser et al, *Chinese Art: The Graphic Arts* (1964) col. pl. 15. Another version, ascribed to Chao Meng-fu, in the Metropolitan Museum (25.53) dated 1298; another in the Freer Gallery of Art (10.6) ascribed to Ch'ien Hsüan, see Freer Figure Ptg. cat. 12.

CHAO MENG-FU 趙孟頫 t. Tzu-ang 子昂, h. Sung-hsüeh 松雪 and Ou-po 鷗波 Also called Chao Wu-hsing after his native place in Chekiang. His posthumous titles were Wen-min 文敏 and Wei-kung 魏公 .

B. 1254, d. 1322. A descendant of the first Sung emperor. Summoned in 1286 to service at the Mongol court in Peking. Appointed Secretary of the Board of War in 1316, promoted several times and finally made director of the Han-lin College. Famous calligrapher and painter of horses, figures, landscapes and bamboo. H, 5. I, 53. L, 47. M, p. 614. See also B. Rowland in EWA III, 363-366; and Chu-tsing Li, Autumn Colors and "The Freer Sheep and Goat and Chao Meng-fu's Horse Paintings," Artibus Asiae XXX, 1968.

Taipei, Palace Museum (YV191, chien-mu). Bodhidharma Seated Beneath Trees. Signed, dated 1292. Inscription by Yang Wei-chen. Copy. Cf. the painting of the same subject, YV328, which is sometimes ascribed to Chao but which is listed herein as Anon. Yüan.

Shen-chou 5. A man seated on a ledge by the river. Signed and dated 1293. Poor imitation.

* Taipei, Palace Museum (YH2). *Ch'iao Hua ch'iu-se:* Autumn Colors on the Ch'iao and Hua Mountains. Handscroll, ink and colors on paper. Painted for his friend Chou Mi in 1296. Inscriptions by the painter and Ch'ien-lung; colophons by Tung Ch'i-ch'ang and others. See Ku-kung reproduction scroll, 1933; Three Hundred M 146; CAT 69; CKLTMHC III, 7; KK ming-hua V, 2; NPM Quarterly I, 2; Skira 103; Li Autumn Colors; Barnhart Marriage pl. 7; Hills 12, 14.

* Peking, Palace Museum. A red-coated official on horseback. After a T'ang composition. Short handscroll. Inscription signed and dated 1296; another inscription by the artist dated 1299. Eighteen colophons. Probably genuine, although not of highest quality. See full-size reproduction, in folio of plates, by Wen-wu publishing Co., Peking, 1955: Yüan Chao Meng-fu Jen-chi t'u.

* John M. Crawford collection, N. Y. A horse and groom. Handscroll. Inscribed, signed and dated 1296. Mounted with two other paintings of

horses and grooms by Chao Yung and Chao Lin, both dated 1359. See Crawford Cat. no. 43; CK shu-hua I, 20; Li-tai jen-wu 34; TWSY ming-chi 95. For another work of the same kind, but less convincing, see the scroll in the Yale University Art Gallery, former Moore collection, in the Yale cat., no. 27.

Sogen 31 (Ts'ao Yüan-tu collection). Two men examining a horse. Signed and dated 1298. Poems by Hsien-yü Shu, Wu Chen, Lu Kuang, Shen Chou, Wen Chia and others. Bad imitation.

Metropolitan Museum, N. Y. (25.53). *Chuan Lan-t'ing:* Hsiao I gets the Lan-t'ing manuscript by trickery. After an original picture by Yen Li-pen. Short handscroll. Signed and dated 1298. See the painting of the same subject in the Palace Museum, Taipei, ascribed to Yen Li-pen; also Chao Lin's copy in the Drenowatz Collection.

Taipei, Palace Museum (VA25i). Narcissus. Album leaf. Inscription, signed and dated 1298. Copy. See Suiboku, p. 176, fig. 40.

Cheng Chi, Tokyo. Waiting for the Ferry on the Autumnal River. Signed and dated 1298. Colophon by Tung Ch'i-ch'ang on the mounting.

Shen-chou ta-kuan 2. Playing the ch'in under Wu-t'ung trees. Signed and dated 1299. Poems by Teng Wen-yüan (1258-1328) and Ch'ien-lung.

Yu-cheng album, 1924. *K'u-shu t'u:* Old Tree and Rock. Short handscroll. Not signed, but an accompanying calligraphy by Chao, copying the *K'u-shu fu,* Dessicated Tree Rhymeprose of 630 A.D., is signed and dated 1299. The same? in Bunjinga suihen III, 54. Copy.

Taipei, Palace Museum (VA25k). Leafless trees by a rock. Signed and dated 1299. Poems by Ch'en Lin and K'o Chiu-ssu. See KK shu-hua chi XI; CH mei-shu II; CKLTSHH; Wen-wu chi-ch'eng 57; KK chou-k'an 161; Siren CP VI, 21.

Taipei, Palace Museum (YH34). Two horses and old trees. Handscroll. Signed, dated 1300. Copy? See KK ming-hua V, 4.

* Taipei, Palace Museum. Portrait of Su Shih. Frontispiece to an album of 12 leaves containing Chao's transcription of Su Shih's "Red Cliff," dated 1301. See NPM Masterpieces IV, 25; NPM Bulletin IV, no. 3 (July-August 1969).

A. Stoclet collection, Brussels. Two horses on a riverbank, one drinking. Signed, dated 1301. See London Exh. cat. 1116.

Smith College Museum of Art (1949.12; former Del Drago collection). Wen-chi departing from the Mongol camp. Signed, dated 1301. Good painting of Yüan-Ming date, not by Chao. See London Exh. cat. 1145; Bachhofer, pl. 117. A detail from a similar painting ascribed to Chao—or the same—in Wen-wu 1959/6, p. 32.

* Peking, Palace Museum. *Shui-ts'un t'u:* A Village by the Water. Handscroll, ink on paper. Signed, dated 1302. See CK hua XII, 16; Li Autumn Colors 8; Barnhart Marriage fig. 25; Hills 13, 15-16.

* Taipei, Palace Museum (YH1). *Ch'ung-chiang tieh-chang t'u:* A river scene with high cliffs. Handscroll, ink on paper. Signed, dated 1303. Colophons and

poems by Yü Chi, Wu K'uan, Chou T'ien-ch'iu, Shen Chou, Wang Shih-cheng and others. Close copy? See London Exh. Chinese Cat. 135-139; Three Hundred M., 145; CH mei-shu II; CKLTMHC III, 6; KK chou-k'an 124-127.

I-lin YK 11/1. *Ou-po t'ing:* the Seagull Wave Pavilion (Chao's own studio at Wu-hsing?). Signed, dated 1304. Copy or imitation.

Fujii Yurinkan, Kyoto. Orchids growing by rocks. Handscroll, ink on paper. Signed, dated 1304. Chao's inscription refers, anachronistically, to Wang Yüan-chang or Wang Mien (b. 1335). Ch'ien-lung inscription and seals. Copy. See Yurintaikan I, 53; I-lin YK 65/16.

* Liaoning Provincial Museum. A red-robed foreign monk seated under a tree. Handscroll, signed, dated 1304. Another inscription by the artist dated 1320; colophons by Tung Ch'i-ch'ang and Ch'en Chi-ju. Early copy? or genuine? Liao-ning I, 82-3; Li-tai jen-wu 33; I-yüan to-ying, 1978 no. 3, p. 23.

Metropolitan Museum, N. Y. (1973.121.15). *Chiu-ko T'u:* Illustrations to the Nine Songs of Ch'ü Yüan. Album of 16 leaves. Signed, dated 1305. See Met. Cat. (1973), no. 15; reproduction album, Tokyo, N. D.: *Ta-feng-t'ang ts'ang Chao Wen-min chiu-ko shu-hua-ts'e.* Another set of illustrations, attributed to Chao Meng-fu but later in date, is in the Freer Gallery (03.115); for still another, also late and unrelated to Chao, see Bunjinga suihen III, 47.

Taipei, Palace Museum (YV179, chien-mu). Gazing at the Stream *(Kuan-ch'üan t'u.)* Small hanging scroll, ink and colors on paper. Signed, dated 1309; three seals of the artist. Fine painting; close copy? See Hills 18.

Chung-kuo I, 100. Landscape with houses by the river. Hanging scroll, in the blue-and-green manner. Signed, dated 1309. Much later work. See also CK ming-hua 24.

Li-tai VI (former National Museum, Peking). T'ang, the First Emperor of the Shang Dynasty, Visiting I Yin. Signed, dated 1309. Inscription by Ch'ien Tsai (1299-1394). Ch'ing copy or imitation.

British Museum, London. The Wang-ch'üan villa, after Wang Wei. Signed, dated 1309. Later work. See Ars Asiatica IX, p. 26; Bussagli Chinese Painting pl. 5; Bunjinga suihen I, 28-30.

Siren CP VI, 15. The eight steeds. Handscroll, colors on silk. Signed, dated 1309. Copy or imitation of later date. See also collotype scroll reproduction, Japan, n.d.

Richard Ravenal, N. Y. (1971). Landscape with travelers. Signed, dated 1309. Good painting, but later work, probably by Ku Fu-ch'en of the early Ch'ing.

Taipei, Palace Museum (YV194). A man leading three horses. Signed, dated 1310. Much later work. See Ku-kung IX.

Ibid. (YV192). Two ducks on the shore, signed, dated 1310. Inscription by Yang Wei-chen mounted above; seals of Liang Ch'ing-piao. Copy.

Cheng Chi, Tokyo. Scholar beneath pine. Signed, dated 1310. See Ta-feng t'ang I, 9.

Juncunc Collection, Chicago. A House among trees. Small hanging scroll, ink and light colors on paper. Signed, dated 1310. Inscriptions by Wei Su and Hsü Pen.

I-yüan album, n.d. Orchids, bamboo and rocks. Handscroll. Signed, dated 1311. Copy?

* Peking, Palace Museum. Watering horses in the autumn fields. Handscroll, ink and colors on silk. Signed, dated 1312. Probably genuine, as an archaistic work. See Che-chiang 20; Chung-kuo hua 1959 #6; CK ku-tai 57; Wen-wu 1958, 6, 1; Siren CP VI, 17; Artibus Asiae 30/4 (1968) pl. 13. Another version of the same composition in the Metropolitan Museum, N. Y., said to be after P'ei K'uan.

Fujii Yurinkan, Kyoto. Portraits of Wang Hsi-chih and Wang Hsien-chih, after Chou Wen-chü. Handscroll, signed, dated 1314. Colophons by Yao Shou and others.

Chung-kuo I, 95 (Ti Pao-hsien collection). Verdant hills and red trees: autumn in the mountains. Signed, dated 1315(?). Late Ming? See also Chung-kuo MHC 3.

Chin-shih chia, I, 2. Horse and groom. Short handscroll, signed, dated 1318. Three seals of artist; also Hsiang Yüan-pien, others. Copy.

KK shu-hua chi XLIV. The Abode of the Immortals. Signed "Tzu-ang," dated 1319. Similar in style to Sheng Mou's work; Ming painting. See also Siren CP VI, 20.

Freer Gallery (11.532). Liu Pei and his bodyguard Kuan Yü. Horizontal painting. Signed, dated 1319. Interesting Ming work, not by Chao.

Ibid. (11.487). Tartar groom and horse. Long inscription (T'ien-ma fu), signed, dated 1319. Copy.

Garland II, 9 (former Lo Chia-lun collection). The Lan-t'ing Gathering. Handscroll. Signed, dated 1320.

* C. C. Wang, N. Y. Bare tree and bamboo by a rock. Hanging scroll, ink on silk. Signed, dated 1321. Colophon by Tung Ch'i-ch'ang. See Barnhart Wintry Forests cat. 7; Bunjinga suihen III, 45.

Ibid. Bamboo. Short handscroll. Signed, dated 1321.

Toso 139 (Fang Ching collection). Three figures in a boat near a wooded shore. Short handscroll. Painted together with Kuan Tao-sheng. Signed, dated ping-tzu (1256 or 1336; impossible for Chao Meng-fu). Late imitation.

Shen-chou XIII. Two men examining two horses. Signed, dated 1342. Poem by Kao K'o-kung. Poor imitation. See also Nanga Taisei VII, 10.

Peking, Palace Museum. Washing horses: Seven horses and eight grooms under willow trees. Handscroll. Signed. Later imitation? See Wen-wu 1966, 4, 40; Kokyu hakubutsuin, 33; I-yüan to-ying, 1979 no. 1, with article by Mu I-ch'in, p. 29.

* Ibid. Old tree, bamboo, brambles, and rock. Short handscroll, ink on paper. Signed. Inscription by the artist in which he states that the stone should be depicted in fei-pei ("flying white") brushwork, the trees in ta-chuan ("great seal"), and the bamboo in pa-fen script style. Colophons by K'o Chiu-ssu and other contemporaries. See Shen-chou ta-kuan 13.

Ibid. A woodpecker on a bamboo branch. Short handscroll, slight color on silk. Signed. Yüan painting, but probably not by the master. See KKPWY hua-niao 23.

Ibid. A long bamboo branch bending down. Handscroll, ink on paper. Inscription by the artist. Accompanied by a bamboo painting by Kuan Tao-sheng.

Ibid. Dry tree and some bamboo growing from a rock. Signed. Very dark.

Ibid. Portrait of Tu Fu. Small hanging scroll, ink on paper. Attributed in an inscription by Liu Hung dated 1380. Much damaged and repainted. Probably not by Chao Meng-fu.

* Shanghai Museum. *Tung-t'ing tung-shan t'u:* The East Mountain, an island in the T'ai-hu. Small hanging scroll, ink and colors on silk. Inscription (poem), signed. Originally one of a pair, the other representing the Hsi-shan or West Mountain. See Shang-hai 10; Hills 17; Bunjinga suihen III, 55.

TSYMC hua-hsüan 15, 16, 17. River landscapes. Three album leaves. Attributed. School works, Ming period?

Shanghai Museum. The Hundred Foot Wu-t'ung Tree Pavilion: A gentleman seated in a pavilion under wu t'ung trees, a servant bringing a ch'in. Handscroll, ink and colors on silk. Signed. Colophons by Chou Po-ch'i, Chang Sheng, Ni Tsan, Wang Meng, etc.; tranferred from another version? Fine work, time of Ch'iu Ying? Seals of Liang Ch'ing-piao. See Che-chiang 21; TSYMC hua-hsüan 14; TWSY ming-chi 93.

Taipei, Palace Museum (YV1). A dry old tree and some bamboo by a rock. Signed. Inscriptions by Ni Tsan, dated 1365, and Ch'ou-chai. *Ssu-yin* half-seal. See Three Hundred M., 147; CCAT pl. 106; CKLTMHC III, 10.

* *Note:* See also the painting of an old tree with a bird, bamboo, and rocks, in the Palace Museum, Taipei (SV155). Called "Anonymous Sung," but fine work in style of Chao Meng-fu, probably by him. See NPM Masterpieces I, 16; Hills, 80.

Taipei, Palace Museum (YV2). A bird on a withering lotus leaf, after Huang Ch'üan. Inscription by Tung Ch'i-ch'ang; two poems by Ch'ien-lung. See Three Hundred M., 148; CH mei-shu II; KK ming-hua V, 1; KK chou-k'an 22.

Ibid. (YV3). Kuan-yin with a fishing creel. Seal of artist. Ming work. See Three Hundred M., 149.

Ibid. (YV4). A girl seated on a bench playing the flute. Poems by Sung Lien (1310-1381), Ch'ien-lung, and six of his officials. See KK shu-hua chi XLV.

Ibid. (YV328). Bodhidharma seated on a rock. Seal of the artist in lower right, probably interpolated; catalogued as "Anonymous Yüan," q.v. See CKLTMHC III, 9.

KK shu-hua chi XLIII (not presently in the Taipei Palace Museum?). Bamboo and bare trees by a rock. Signed.

Ku-kung II. Elegant Gathering in the Western Garden. A free verson of Li Kung-lin's famous composition. Signed. Inscription by Yü Chi (1272-1348). Late Ming or Ch'ing work. See also KK chou-k'an 288; Siren

Gardens of China 89; Siren ECP II, 106.

Taipei, Palace Museum (YH3). The Jar-rim Window: the rich Tuan-mu Tz'u visiting his poor friend Yüan Hsien. Handscroll, ink and colors on silk. Seals of the artist; an inscription by him follows the painting. Copy of Ming period. Colophons by Ni Tsan, Ku Ying, Yao Shou, Shen Chou. See KK ming-hua V, 3; NPM Masterpieces III, 29; NPM Masterpieces V, 21.

Ibid. (YH4). Text and Illustrations to the *Hsiao-ching,* Book of Filial Piety. Handscroll. Signed. Copy. See Chung-hua ts'ung-shu reproduction album, Taipei, 1956. Cf. the Li Kung-lin version in the Princeton Art Museum.

* Ibid. (YH22). An old tree, bamboo and rocks. Short handscroll. Signed. Part of collected scroll of Yüan works called Yüan-jen chi-chin. Perhaps genuine, inferior work. See CAT 90a; CH mei-shu II; CKLTMHC III, 11; KK ming-hua V, 5.

* Ibid. (VA7h). A groom leading a horse in the wind. Album leaf. Signed; the signature questionable. See Nanking Exh. cat. 391; KK ming-hua V, 6; NPM Masterpieces I, 17; Li, Freer Sheep and Goat, fig. 11; Hills 8.

Ibid. (VA15o). The Tribute Horse: horse and rider. Album leaf. Attributed. Copy.

* Ibid. (VA25d). Bamboo and trees by a rock. Album leaf, ink on silk. Seals of the painter. See KK shu-hua chi XII; CKLTMHC III, 8; Li, Freer Sheep and Goat, fig. 7; Pageant 263; Hills 84.

Ibid. (VA261). Mountains and River—the Joy of Fishing. Album leaf. Signed. Style of Sheng Mou, by him or close follower.

Ibid. (VA27e). The Pursuit of Leisure. Album leaf. Seal of the artist. Later work.

* Ibid. (VA51a). Sounds of Pines by a Thatched Pavilion. Album leaf; ink and blue and green colors on silk. Seal of the artist; poem by the later Yüan official Yü-wen Kung-liang. Genuine, minor work?

Ch'ing-kung ts'ang 62 (formerly Manchu Household collection). Two Mandarin ducks. Album leaf. Signed. See also Sung-Yüan pao-hui 4/14.

I-lin YK 7/3. An Emaciated Horse, with Tartar Groom and Hound. Inscription, signed. Colophons by Yü Chi and Ni Tsan (dated 1363). Copy?

Shen-chou ta-kuan hsü II. Men departing in a boat. Ming?

Chin-shih shu-hua, 31. Portrait of Lao-tzu, frontispiece to Chao's writing of the *Tao-te ching.* Seal of the artist.

Liu, pl. 28. The top of a slender bamboo. Two characters by the artist; six colophons by contemporaries and later men.

Chung-kuo MHC 2. A groom with a horse. Short handscroll. Reproduction indistinct. See also Chung-kuo I, 99.

Ibid. 4. Yang Kuei-fei dressing her hair with flowers, attended by a eunuch. Copy of earlier work, not by Chao. See also Chung-kuo I, 94.

* Ibid. 22. *Ch'iu-hsing shih-i t'u:* river landscape in autumn, poets assembled in a pavilion on the shore. Short handscroll. Signed. Colophons by Yang Wei-chen and Tung Ch'i-ch'ang. Genuine? or early Ming, cf. Wang Fu? See also Chung-kuo I, 98.

Ibid. 25. A groom feeding a white horse tied to a pole. Short handscroll. Signed. Colophon by Sung Lien (1310-1381). Copy or imitation. See also Chung-kuo I, 97.

Ibid. 39. Five horsemen in a river landscape. Poem, signed. Ming picture, probably based in part on an earlier composition.

Garland II, 8. Sakyamuni seated on a low dais. Artist's inscription and seal.

Tokyo National Museum. Bamboo and rocks. Hanging scroll, ink on silk. Signed: "Sung-hsüeh-chai tso." Interesting work, possibly late Yüan in date. See Tokyo NM Cat. 17.

Muto cat. 27. Portrait of the poet Po Chü-i. Full length, in scholar's dress and with a staff. Attributed. Poem by the Japanese monk Wu-hsüeh.

Kokka 430 (Shimazu collection). Two horses under a tree. Signed. Later work.

Ibid. 435 (Prince Matsukata Collection). Eight horses, four of them with riders. Short handscroll. Signed. Ming work. See also Siren CP VI, 16.

Toyo IX (Nishi Honganji). T'ao Yüan-ming standing under a pine tree on a projecting cliff. Attributed. Good Ming work, unrelated to Chao.

Nanshu ihatsu II. Horsemen by a river in autumn. Signed, poem by the painter.

Suiboku IV, 71 (Nakamura Tomijiro collection). Three old men, probably the fisherman and the elders from the "Peach Blossom Spring" story. Album leaf in the Hikkoen album. Two seals of the artist(?). Yüan-Ming work, unrelated to Chao.

Toso 137 (Huang Chih Collection, 1930). Itinerant tea-vendors, after a composition by Yen Li-pen. Seal of the painter. Ming work? with no relation to Chao. Other versions ascribed to Ch'ien Hsüan (Osaka Catalogue 48) and other artists.

Osaka Municipal Museum. Birds among flowering plants. Handscroll, ink and colors on silk. Signed, with the painter's seal. Later work, unrelated to Chao. See Soraikan II, 30; Osaka Cat. 51.

Ibid. A bamboo branch. Ink on paper. Signed, with the painter's seal. Poems by Wang Meng and Shen Chung. Close copy? See Soraikan II, 31; Osaka Cat. 50.

Fujita Museum, Osaka. Landscape. Signed. Later imitation.

Ibid. Two kings meeting to form an alliance. Signed. Copy.

Ibid. A horse. Signed. Imitation.

Fujii Yurinkan, Kyoto. Scenes from the life of T'ao Yüan-ming. Handscroll, ink on silk. Signed. See Yurintaikan II. Another version in Garland II, 11, inscribed and dated 1298 by the artist. Neither work is by Chao. Other versions in other collections: Cheng chi, Tokyo, dated 1317; Freer Gallery (11.525-6); Denver Art Museum; Ching Yüan Chai Collection, Berkeley (spurious signature of Chao Meng-fu removed; close in style to Yu Ch'iu of the Ming period). See also Doshaku, 19, for a version ascribed to Chu Te-jun.

Ibid. Buddhist figures. Handscroll, ink on paper. Signed, dated 1298. Imitation.

Idemitsu Art Museum, Tokyo. T'ao Yüan-ming. Horizontal hanging scroll, ink and colors on silk. Attributed. Good Ming work.

Inokuma Collection, Yokkaichi. *I-lo-t'ang t'u:* the I-lo Hall. Short handscroll. Title by Wen Cheng-ming; colophons by Ni Tsan, Wang Meng, and others. Imitation of the 17th century.

Yabumoto Kozo, Amagasaki. Scholars gathered on the bank of a river beneath pines. Seals of the artist, interpolated; early Ming painting.

Cheng Chi, Tokyo (former Okura Collection). Chrysanthemums. Handscroll, colors on silk. Seal of the artist. Seals of An Ch'i, Liang Ch'ing-piao, Ch'ien-lung, etc. See Sogen 30.

Ibid. A branch of bamboo. Poem, signed.

Ars Asiatica I, p. 20 (M. Alphons Kann). A Mongol horseman pursuing a galloping horse. Poems by Yang Ch'i and Chang Pi of Ming. Inscribed with the painter's name. Imitation.

Metropolitan Museum, N. Y. (1973.120.5; formerly C. C. Wang). Two pines by the river. Handscroll. Signed. Colophon by the painter. See Chung-kuo I, 96; Siren CP VI, 23; Lee Landscape Painting 28; Garland II, 10; Munich Exh. Cat. 29; Chung-kuo MHC 14; Met Cat. (1973) no. 14; Barnhart Wintry Forests cat. 6; Bunjinga suihen III, 52. A copy in the Cincinnatti Art Museum; see Bunjinga suihen III, 53. For both versions, see also Fu Shen et. al., *Traces of the Brush,* nos. 13-14.

* Princeton University Art Museum (former C. C. Wang). *Yu-yü ch'iu-ho t'u:* Hsieh Yu-yü or Hsieh K'un (280-322) in his Mind Landscape. Handscroll, ink and color on silk. Seal of the artist. Colophons by Chao Yung, Tung Ch'i-ch'ang and others. Done before 1286. See Yüan Exh. Cat. fig. 17, p. 90; NPM Bulletin IV/2, pl. 1; Barnhart Marriage 24; Kodansha CA in West I, 21; Hills 10-11; Bunjinga suihen III, 64.

John Crawford, N. Y. Bridge Pavilion of the Hovering Rainbow. Handscroll. Seal of the artist. Later work, not in his style. See Crawford Cat. 56.

Formerly Frank Caro, N. Y. Orchids growing beside a stone. Signed. Accompanied by a painting of a slender bamboo branch by Kuan Tao-sheng. Ink on paper.

Ferguson, p. 8. Watering a horse. Short handscroll. Signed. Colophon by Sung Lien. Copy?

* Cleveland Art Museum (78.66). River Village: The Pleasures of Fishing. Fan-shaped album leaf, ink and colors on silk. Title, signature and seal of the artist. See Hills pl. 2; Bunjinga suihen III, 66; article by Richard Vinograd in Artibus Asiae XL, 2/3; and article by Sherman Lee in Cleveland Museum Bulletin, Oct. 1979.

Ibid. (63.515). Bamboo and orchids growing from a rock. Handscroll. Signed, done for Shan-fu. 29 colophons by scholars and painters of the Yüan and Ming periods. See TWSY ming-chi 94; Yüan Exh. Cat. 235; Siren CP VI, 22; Lee, Colors of Ink cat. 10; Bunjinga suihen III, 50-51.

C. C. Wang, New York. *Ch'in-hui t'u:* two men seated under trees by the river, one playing the *ch'in.* Hanging scroll, in the blue-green manner. Seal of the artist; inscriptions by Kuo Ch'u-k'ai and Feng Tzu-chen attributing the painting to Chao. Good painting; close copy?

* Freer Gallery (31.4). A goat and a sheep. Inscription by the painter, poem by Ch'ien-lung, and 30 collectors' seals. See Siren CP VI, 19; Kodansha

Freer cat. 47; Chu-tsing Li, The Freer Sheep and Goat; Hills 9; Bunjinga suihen III, 65.

Ibid. (03.115). The Nine Songs. Handscroll. Attributed. Copy.

Ibid. (09.163). Three horsemen riding under trees. Large picture in color. Ming work. See Siren CP in Am. Colls. 153.

Ibid. (08.118). Two horsemen under a tree. Attributed. Later work. See Siren CP in Am. Colls. 124.

Ibid. (31.03). Fifteen horses, three of them with grooms, crossing a river. Handscroll. Signed. Fine Yüan or early Ming work, with interpolated signature. See Siren CP VI, 18.

Museum of Fine Arts, Boston (08.118). Two horsemen under a tree. Work of lesser Yüan master? See La Pittura Cinese, 247.

Ibid. (59.650; former J. D. Ch'en). The Dragon King paying homage to Buddha. Signed; the signature traced from another painting. Yüan-Ming work, by Sheng Mou follower? See Boston MFA Portfolio II, 5; Chink'uei 16.

Juncunc Collection, Chicago. A man in a boat; hills beyond. Seal of the artist.

Ibid. A horse and groom. Album leaf. Seal of the artist.

Various paintings ascribed to him in the Metropolitan Museum, N. Y.: 13.220.4, Judging a horse, handscroll, dated 1305; 13.220.5, the Wangch'üan Villa, see Ferguson p. 51; 13.220.6, Eight horses; 29.100.481, Washing horses in the river, dated 1309; 13.22.20, Arhat; 13.220.99g, Landscape; 13.100.19, Tangut horseman; 29.100.480, the Lan-t'ing Gathering; and a series of album leaves representing a Mongol and a Chinese woman copulating on horseback.

Indianapolis Art Museum (2486). Mongol? with attendants examining tethered horse. Spurious signature of Su Han-ch'en; but the style, and an inscription by Lien Pu, suggest that it was originally intended for Chao Meng-fu; Ming copy after his work?

Musée Guimet, Paris. A man in a house on the shore; visitors arriving by boat. Handscroll. Attributed. Imitation. See La Pittura Cinese, 230.

British Museum, London. The Expert Po-ya Examining a Horse. Handscroll. Attributed. Copy of Yüan composition? See La Pittura Cinese, 238-39.

La Pittura Cinese, 236. Two Horses tethered under a tree. Signed. Copy or imitation.

CHAO MENG-YU　趙孟頔　　, t. Tzu-ch'i　子奇
From Wu-hsing in Chekiang. Elder brother of Chao Meng-fu and Chao Meng-yü. In the Ta-te period (1301-2), at the age of sixty, was professor in Ch'ang-sha. (This information supplied by owner of painting listed below.)

Cheng Chi, Tokyo. Shrimps in a Basket. Outline drawing, ink on silk. Signed; two seals with the artist's names.

CHAO MENG-YÜ　趙孟顓　　t. Tzu-chün　子俊
Younger brother of Chao Meng-fu. Best known for his calligraphy, but also as a painter of figures and birds and flowers. H, 5. M, p. 614.

Taipei, Palace Museum (YV199, Chien-mu). A man in a house; tall trees outside. Signed. Good work by follower of Shen Chou, 16th century.
Cheng Chi, Tokyo. A duck on the bank of a river, beneath a flowering bush. Ink and colors on paper. Signed, dated 1299. Seals and poem of Ch'ienlung.

CHAO TS'ANG-YÜN　趙蒼雲
Cousin of Chao Meng-fu.

* C. C. Wang, N. Y. Illustrations to the story of Liu Ch'en and Juan Chao, who in the year A. D. 72 crossed a stream to pick peaches and met two fairy ladies. Handscroll, ink on paper. Signed. Colophons of the early Ming period.

CHAO YUNG　趙雍　　t. Chung-mu　仲穆
B. ca. 1289, d. ca. 1362. Son of Chao Meng-fu; served as prefect of Hu-chou. Landscapes in the manner of Tung Yüan. Painted figures, horses, bamboo and rocks. H, 5. L, 47. M, p. 614.

Metropolitan Museum, N. Y. (47.135.1). The Mongol Circus: Mongols performing equestrian feats. Handscroll. Signed, dated 1314. Copy?
Shina Kacho Gasatsu 33. Magpies gathering around trees, quails on the ground. Signed, dated 1319. Much later work.
Tenneiji, Takushiyama. Portrait of the Monk Sung-yüan Ch'ung-yo. Signed, dated 1322. See Helmut Brinker's article "Ch'an Portraits...," Archives XXVII, fig. 24-25; Brinker suggests that the inscription and signature may be interpolated.
Taipei, Palace Museum (YV8). Gathering water-chestnuts. Houses under tall pine trees by the river; hills in the distance. Ink and colors on paper. Signed, dated 1342. See CH mei-shu II; CKLTMHC III, 25; KK shu-hua chi 46.
Sogen 33 (M. Harada). Washing the elephant; Buddha seated on a cliff watching. Signed, dated 1334. Late Ming or later work.
Fogg Museum, Cambridge (Hofer Collection). A procession of horsemen. Handscroll. Signed, dated 1343. Copy or imitation.
* Chung-kuo MHC 14. Three horses. Handscroll. Signed, dated 1345. Reproduction indistinct; perhaps genuine. See also Siren CP VI, 27.
* Peking, Palace Museum. A man in a red coat on a black-and white horse. Signed, dated 1347. See I-shu ch'uan-t'ung vol. VIII.
* Freer Gallery (45.32). A groom in a red coat leading a black-and-white horse, after one section of Li Kung-lin's Five Horses scroll. Handscroll. Signed, dated 1347. Inscription by Ch'ien-lung. See Che-chiang 30; Siren CP VI,

27; Kodansha Freer cat. 61; Freer Figure Ptg. Cat. 44.

* John Crawford, N. Y. A Mynah bird on a rock and some bamboo. Signed, dated 1349. See Crawford cat. no 46; Ta-feng-t'ang I, 12; Bunjin gasen I, 12.

* Taipei, Palace Museum (YV10). Horses Pasturing in a wood. Signed, dated 1352. Poems by Liu Jung and Wang Kuo-ch'i. See Three Hundred M., 157; CH mei-shu II; CKLTMHC III, 26; KK ming-hua V, 15; Wen-wu chi-ch'eng 64; Siren CP VI, 26.

* John Crawford, N. Y. A horse and a groom. Handscroll. Signed, dated 1359. Mounted with two other paintings of horses and grooms by Chao Meng-fu and Chao Lin. See Crawford Cat. 43; CK shu-hua I, 20; Li-tai jen-wu 35; TWSY ming-chi 96.

* Peking, Palace Museum. A herd of horses on the meadow. Handscroll, ink and colors on silk. Signed. Odd, minor but genuine work.

Ibid. Fishing in a mountain stream under large pine trees. Small picture mounted together with Wang Mien's Plum Blossoms and Chu Te-jun's Two men in a boat.

* Ibid. A rocky shore with trees; distant mountains; four flying birds. Fan painting. Seal of the artist. See Yüan-jen hua-ts'e II.

* Shanghai Museum. Epidendrum and bamboo by a rock. Signed. See Shanghai 16; TSYMC hua-hsüan 23; Liu 29; Chugoku bijutsu III, p. 35.

* Liaoning Provincial Museum. Bamboo. Handscroll. Signed and inscribed. See Liao-ning I, 85-86.

* Ibid. A man in a boat under a winter moon. Fan. Signed. Genuine, fine work. See Liao-ning I, 84; Sung Yüan shan-shui 14.

Chung-kuo hua 1959/3. Three horses and groom under a tree. Signed.

Taipei, Palace Museum (YV6). Landscape in the manner of Tung Yüan: a gentleman boating on the river, travellers on a bridge, village in the mountains. Ink and colors on silk. Attributed. See KK ming-hua V, 14.

Ibid. (YV7). An auspicious scene in early spring. Signed. Ming painting.

* Ibid. (YV9). A man in a red coat on a white horse under leafy trees. Ink and color on silk. Signed, with one seal. Inscription on the mounting by Tung Ch'i-ch'ang. Poor but probably genuine.

Chung-kuo MHC 32 (former Manchu Household Collection). River landscape with a fisherman on a promontory. Signed. Poems by Yao Chih and Wang Shih-chen (1526-1590). Imitation. See also Chung-kuo I, 103; Ferguson 142; Sung-Yüan pao-hui 4/15; Ch'ing-kung ts'ang 63.

Ta-feng-t'ang IV, 19. Mountain and stream in Autumn; an old man riding on a donkey approaching a smallbridge in the foreground. Signed. Old picture, probably not by Chao, badly retouched.

I-lin 16/1. Three horses and grooms on riverbank beneath pines. Attributed. Seals of Liang Ch'ing-piao, Ch'ien-lung. Reproduction indistinct; possibly genuine.

Ibid. 56/15. Barbarian loading a pack on a camel. Attributed. Album leaf.

Nishi Honganji, Kyoto. Nine egrets by a willow tree in snow. Attributed. Fine Ming painting, unrelated to Chao Yung. See Sogen no kaiga 68; Toso 140; Shimada and Yonezawa pl. 22.

Takeuchi collection, Kyoto. Scholars in a garden examining a painting. Ink and color on silk. Attributed. Somewhat damaged. Old painting, unrelated to Chao Yung.

Sogen Meigashu 58. A monkey on the back of a horse resting on the ground. Album leaf. Attributed. Sung-Yüan work by another artist. See also Hikkoen 55.

Cheng Chi, Tokyo. Han-shan discussing poetry: three monks beneath trees, with an acolyte. Handscroll, ink on silk. Signed. Fifteen of Han-shan's poems copied by the artist, mounted after the painting.

National Museum, Stockholm. Old trees on a rocky shore. Fan painting. Signed. See Siren CP VI, 28.

Suiboku IV, 84. Immortal riding above waves on the back of a tortoise. Attributed.

Metropolitan Museum, N. Y. (13.100.97). Boat landing at a lakeshore. Large fan painting. Attributed. Ming work.

Museum of Fine Arts, Boston (28.355). Portrait of the Ch'an monk Yüan-miao (1238-1295). Biographical inscription at the top. Signed. See Boston MFA Portfolio II, 6; Kodansha CA in West I, 56.

* Mr. and Mrs. A. Dean Perry, Cleveland (former Chang Ts'ung-yü). Secluded Fishing among Stream and Mountains: river landscape with two fishermen in boats. See Yüan Exh. Cat. 229; Sogen p. 34; Lee Landscape Painting 29; Barnhart Marriage fig. 26; Toronto Cat. no. 10; Bunjinga suihen III, 74.

Juncunc Coll., Chicago (formerly Saito). River landscape with tall trees and a boat moored by the rocks. Signed. Poem by Ch'ien-lung. See Toan 9; Kohansha III; Nanshu Ihatsu 4.

Note: See also, under Anonymous Yüan (Figures), the "Tribute Bearers" scroll in the Liaoning Museum, which bears Chao's (interpolated) signature.

CHAO YÜAN　趙原　t. Shan-ch'ang　善長　, h. Tan-lin　丹林
From Suchou. D. after 1373. Landscapes in the style of Tung Yüan. Executed by order of the Hung-wu emperor. N, I, 9. O, 2. M, p. 616. Also biography by Chu-tsing Li in DMB I, 136-138.

T'ien-hui-ko I, 2. Landscape. Signed, dated 1330. Bad imitation.

Freer Gallery (15.29). River landscape. Signed, dated 1334. Good work of early Ch'ing, probably by Ku Fu-ch'en.

Fujii Yurinkan, Kyoto. Buildings in a bamboo grove; two men standing on a bridge. Album leaf. Signed, dated 1361.

* See the Shih-tzu Lin (Lion Grove Garden in Suchou) handscroll listed under Ni Tsan (dated 1373); collaborative work, partly (largely?) by Chao Yüan.

Freer Gallery (09.210). Mountains in snow. Handscroll. Signed, dated *ting-mao,* 1327? or 1387? Ming copy of old composition; see the "Wang Wei" in the same collection (19.124).

* Taipei, Palace Museum (YV121). Pavilion by a stream at the foot of a rocky mountain. Signed. Poems by Yeh Meng-hao, Wang Ming-chi, Chang Chien and two others. See CKLTMHC III, 76; KK ming-hua VI, 34; KK shu-hua chi 29; KK chou-k'an 492.
* Ibid. (YH22). Lu Yü preparing tea. Handscroll. Signed. Part of collected scroll of Yüan works called Yüan-jen chi-chin. See Three Hundred M., 200; CAT 90f (section); CH mei-shu II; CKLTMHC III, 77; KK ming-hua VI, 35; Nanking Exh. Cat. 79; Siren CP VI, 114b; NPM Masterpieces, V, 30; Hills 63.
* Shanghai Museum. A Thatched House at Ho-ch'i: river landscape, a man in a house, a visitor arriving. Signed. Poem by Ku Ying, dated 1363. See Pageant 394; Chugoku bijutsu III, 24.

Garland II, 34. Traveling among streams and mountains. Based on the "Tung Yüan" composition now in the Ogawa Collection, Kyoto. Seals of Keng Chao-chung. See Chu-tsing Li's article "Stages of Development...," NPM Bulletin, IV, 3 (July-August 1969).

Nanzenji, Kyoto (kept at the Kyoto Museum). Bamboo and rocks. Pair of hanging scrolls, ink on dark silk. Title and seals on each, which, however, cannot positively be read as those of Chao Yüan. Attributed. See Toyo IX for one.

* Princeton Art Museum. Steep hills by the river; a villa among trees; visitors arriving. Handscroll, ink on paper. Signed. Seals of Ch'ien-lung. Colophons by Wen Chia (dated 1562) and others. See Summer Mts., 39-41; Bunjinga suihen III, 73. Another version, with the original colophons, owned by J. T. Tai, New York; see Venice Exh. Cat. 789. The Princeton picture is mounted with a painting of bamboo by Shen Hsüan; the copy of that portion is in the Asian Art Museum of S. F.

Honolulu Academy of Arts. Reading in the Summer Mountains, after Tung Yüan. Signed. Colophon by Hsieh K'ung-chao. See Toso 222; Pageant 392; Siren CP VI, 83a.

* Metropolitan Museum, N. Y. (1973.121.8; former C. C. Wang and Chang Ts'ung-yü collections). Saying farewell to friends at Ch'ing-ch'uan. People are departing in a boat on a mountain river, their friends are standing on the shore. Inscription by the painter. See Liu 41; Yüan Exh. Cat. 261; Garland II, 35; Lee Landscape 36; Yün hui chai 49; Met. Cat. (1973) no. 23. The picture exists also in two later imitations; see Wen Fong, "The Problem of Forgeries in Chinese Painting," Artibus Asiae XXV (1962), 95-119.

CH'EN CHEN 陳貞 t. Li-yüan 履元
From Ch'ien-t'ang, Chekiang. Active ca. 1350. Landscapes. L, 54. M, p. 430.

Taipei, Palace Museum (YV114). The study in the white cloud mountains. Signed, dated 1351. Poem by Ch'ien-lung. Late Ming? See KK shu-hua chi IX; KK ming-hua VI, 28; KK chou-k'an 135; NPM Masterpieces V, 28.

CH'EN CHI　　陳基　　h. I-po-sheng　　夷白生
B. 1314, d. 1370.

Cheng Chi, Tokyo. A man crossing a bridge; misty mountains beyond. In the
manner of Mi Fu. Small hanging scroll, ink and light color on paper.
Signed, dated 1368. Ch'ien-lung seals; inscription by Chin Nung on the
mounting.

CH'EN CHIEN-JU　　陳鑑如
From Hangchou. Active ca. 1320. Famous as a portrait painter. H, 5. M, p.
429.

Kokka 487 (Formerly the Prince Li Museum, Seoul). Portrait of Li Ch'i-hsien,
a Korean scholar. Signed. Colophon by Li Ch'i-hsien, dated 1319. See
also Bijutsu Kenkyu I.

CH'EN CHIH　　陳植　　t. Shu-fang　　叔方　　, h. Shen-tu　　慎獨
From Suchou. B. 1293, d. 1362. Landscapes. H, 5. M, p. 430.

Shen-chou ta-kuan 3. Pavilions and trees on a mountain slope in mist. Poem
by the painter. Colophons by Fang Ning, dated 1380, and Ch'en Ju-chih,
dated 1377. See also Ming-pi chi-sheng IV, 2.

CH'EN CHUNG-JEN　　陳仲仁
From Kiangsi. Brother of Ch'en Lin. Active at the beginning of the 14th cen-
tury. Chao Meng-fu esteemed him highly as a painter. Equally skilled in
flowers, birds, figures and landscapes. H, 5. M, p. 429.

Taipei, Palace Museum (VA31g). A house among trees on a river shore.
Album leaf. Signed, dated 1362. Seventeenth century? See Nanking
Exh. Cat. 390.
Ibid. (YV21). The hundred sheep; three children, one dressed as a prince.
Signed. Dull work by hack artist. See KK shu-hua chi XLI; CKLTMHC
III, 15.
Wang-yün-hsien 3/1. Landscape with man in pavilion. Seventeenth century
work, with interpolated inscription.
Sogen 41 (Mr. Eto, Tokyo). Landscape after Chü-jan. Part of a scroll. Attri-
buted. Late Ming work.
Ibid. 42 (Lo Yüan-chüeh collection). Man playing the flute in a boat at the
foot of a high cliff. Seal of the painter. 17th century work.

CH'EN HSÜAN 陳選
Unidentified.

Tientsin Art Museum. Hills by a river; trees on the shore. Inscribed, signed, dated 1357. Five inscriptions by contemporaries. See T'ien-ching I, 6.

CH'EN JU-YEN 陳汝言 t. Wei-yün 惟允 , h. Ch'iu-shui 秋水 .
From Suchou. b. ca. 1331, d. before 1371. Provincial Secretary in Chi-nan, Shantung; executed by order of the Hung-wu emperor. Landscapes in the style of Chao Meng-fu; figures in that of Ma Ho-chih. N, I, 7. O, 2. M, p. 430. Also biog. by T. W. Weng in DMB I, 163-165.

Bunjin gasen I, 3. River landscape with tall trees and high mountains. Signed, dated 1341. Ch'ing work of Orthodox School. See also Toso 221; Chugoku II.
Shen-chou ta-kuan hsü IX. Mountains and rushing stream. Signed, dated 1348.
Nanga taisei XI, 18. A wooded valley in autumn with pavilions on the hillsides. Signed, dated 1348.
* Taipei, Palace Museum (MV5). The Ching River. Colophon by Ni Tsan, dated 1359, in which Ch'en is mentioned as the painter; others by Wang Meng and nine other contemporaries. See KK shu-hua chi XVII; CH mei-shu III; CKLTMHC III, 63.
* Ibid. (VA31f). Illustration to a poem by Meng Chiao: a young man about to leave home; his mother sewing clothes for him. Album leaf. Seal of the artist. Inscription by Ni Tsan, dated 1365. See Nanking Exh. Cat. 390; Hills 71.
* Mr. and Mrs. A. Dean Perry, Cleveland. *Lo-fou shan-ch'iao:* the Woodcutter on Mt. Lo-fou. Landscape in the style of Tung Yüan. Signed, dated 1366. See Yüan Exh. Cat. 265; Lee Landscape 38; Toronto Cat. 8; Siren CP VI, 112; Yün hui chai 51; Lee Colors of Ink cat. 19; Hills 60; Bunjinga suihen III, 85.
* Taipei, Palace Museum (MV6). The Thousand-foot Fall: landscape with a waterfall. Signed, dated 1360. Poems by four contemporaries. Probably a copy after the more convincing version reproduced in Shen-chou ta-kuan XIV. See KK shu-hua chi VII; CH mei-shu III; CKLTMHC III, 64; KK ming-hua VII, 1.
Ibid. (MH1). Tall trees and mountain hut. Short handscroll, ink and light colors on paper; much worn. Attributed to the painter by Kao Shih-ch'i. Minor work of the 17th century.
Art Institute of Chicago (61.222). Landscape. Signed. Poems by Ni Tsan (dated 1371) and others. See Toan 14; Nanshu ihatsu 4; Kokka 622; Archives XVI, p. 104.
* A. Dean Perry Collection, Cleveland. *Hsien-shan t'u:* the land of immortals. Handscroll, ink and color on silk. Colophon by Ni Tsan dated 1371, saying that the artist was already dead by that year. Seals of Hsiang Yüan-pien, Kao Shih-ch'i, Liang Ch'ing-piao. See Yüan Exh. Cat. 264.

CH'EN LI-SHAN　陳立善
From Hai-yen, Chekiang. Served in the Chih-cheng era (1341-1367) as a Censor in Chekiang. Reached great fame as a painter of plum blossoms. I, 54. M, p. 429.

Taipei, Palace Museum (YV104). Slender branches of a blossoming plum-tree. Signed, dated 1451. Two poems by Ming writers. See KK shu-hua chi XVIII; London Exh. Chinese Cat. 169; Mei-shu t'u-chi II; KK chou-k'an 238; Siren LCP 5; KK ming-hua VI, 21; CH mei-shu II.
KK shu-hua chi XXV. Blossoming plum tree and narcissus growing from a rock. Signed, dated 1365. Three poems by Ming writers. See also KK ming-hua mei-chi I, 5.

CH'EN LIN　陳琳　t. Chung-mei　仲美
From Hangchou. Lived ca. 1260-1320. Friend of Chao Meng-fu. Painted landscapes, figures, flowers and birds. H, 5. M, p. 42.

Taipei, Palace Museum (YV206). Chung K'uei standing under leafless trees. Signed, dated 1300. Ming work with interpolated inscription.
* Ibid. (YV22). A duck standing on a river shore. Dated 1301 in a colophon by Ch'iu Yüan, also colophons by Chao Meng-fu and K'o Chiu-ssu. Poem by Ch'ien-lung. See KK shu-hua chi VI; Three Hundred M., 156; CAT 72; Che-chiang 26; CH mei-shu II; CKLTMHC III, 13; KK ming-hua V, 13; KK chou-k'an 182; Nanking Exh. Cat. 69; Wen-wu chi-ch'eng 62; Hills 77.
* Ibid. (VA25h). River landscape with old trees on the rocky shore. Double album leaf, ink and colors on paper. Seal of the painter. Poems by three Yüan writers. See Ku-kung XXIX; CKLTMHC III, 12; Siren CP VI, 29; Hills 22.
Ibid. (YV207, chien-mu). Two sparrows on branch. Signed. Ming work.
* Gems II, 6. A bare tree growing from rocks. Signed. Inscription by Chang Pen (dated 1340) and another man.
Chin-k'uei II, 18 (former J. D. Ch'en collection). Two birds on leafless branches, shadowy bamboo behind. Double album leaf. Signed. Imitation.
Sogen 22 (Chou Chih-ch'eng collection). Two small birds in a leafless tree. Signed. Imitation. See also Pageant 178; I-lin YK 36/3. A similar picture (or the same?) in the collection of Cheng Te-k'un, Cambridge.

CHENG HSI　鄭禧　t. Hsi-chih　熙之　or　禧之
From Suchou. Active ca. 1350. Landscapes after Tung Yüan, bamboo and birds. H, 5. M, p. 640.

Taipei, Palace Museum (YH10). Pavilion among trees at the shore. Handscroll. Signed, dated 1353. Ch'ing work. Many colophons of the

Yüan period, one dated 1348; probably attached originally to the genuine painting. See KK ming-hua V, 43.

CHENG SSU-HSIAO 鄭思肖 t. I-weng 憶翁 , h. So-nan 所南
From Lien-chiang, Fukien. Lived some time in the neighborhood of Suchou. B. 1239, d. 1316. Epidendrums. H, 5. L, 56. M, p. 640. Also biog. by Li Chu-tsing in Sung Biog., 15-23.

* Osaka Municipal Museum. Two epidendrum plants. Short handscroll. Signed, dated 1306. Poem by the painter. See Soraikan II, 19; Yüan Exh. Cat. 236; Genshoku 29/73; Osaka Cat. 46; Hills 1. A copy in the Freer Gallery (33.9): see Siren CP III, 362; Shen-chou 2.
* Yale University Art Gallery (Moore Coll.). Two small epidendrum plants. Poem by the painter; many colophons of various periods. Probably genuine. See Moore Cat. 26.
Kaian Kyo, 1. Bamboo. Handscroll. Inscription, signed. Colophon dated 1372; others by later writers, including Kao Shih-ch'i. Imitation. See also Tokyo NM Cat. 16.

CH'ENG CH'I 程棨 t. I-fu 儀甫 , h. Sui-chai 隨齋
Active second half of the 13th century. A contemporary of the writers Chao Meng-yü and Yao Shih, but not recorded in the dictionaries of painters.

Freer Gallery (54.21). *Keng-tso t'u:* 21 pictures illustrating rice culture forming a long scroll. Each picture is accompanied by a poem written in seal characters. The poems as well as the pictures are copied after earlier originals by Lou Shu of the Kao-tsung reign, 12th century. The name of Liu Sung-nien has been added later. At the beginning is an inscription by Ch'ien-lung, and at the end colophons by Chao Meng-yü, younger brother of Chao Meng-fu, by Yao Shih, a contemporary, and several later writers. See Freer Figure Painting cat. 7.
Ibid. (54.20). *Ts'an-chih t'u:* 24 pictures illustrating Sericulture forming a long scroll. The inscriptions on the pictures and the poems accompanying them are of the same kind as those on the *Keng-tso t'u.* The two scrolls form a pair, and have been reproduced in stone engravings (by order of the Ch'ien-lung emperor in 1769) under the common name: *Keng-chih t'u.* At the beginning are inscriptions by Ch'ien-lung and Chiang P'u and at the end colophons by Chao Meng-yü and later men. See Freer Figure Painting cat. 8.

CH'I-TSUNG 啟宗
Unrecorded. A monk of the White Lotus temple near Suchou. Active ca. 1360.

* Bunjin gasen II, 4 (Wan-yen Ching-hsien Coll.). Portrait of Su Tung-p'o in scholar's dress with a high cap. Colophons by Chang Chien, dated 1366, and by Miao-sheng. See also Chugoku II.

CHIEH-HSI SSU　揭傒斯　t. Man-shih　曼碩
B. 1274, d. 1344. From Lung-hsing, Kiangsi. Han-lin scholar, writer of historical works. Landscapes. L, 60. M, p. 497.

I-shu ts'ung-pien 14. A cow, standing, foreshortened, its head turned toward the viewer. Signed, dated 1341. Painted in a European style, probably not before the 18th century (in spite of colophons purporting to be by Ming writers.)

CH'IEN HSÜAN　錢選　t. Shun-chü　舜舉　, h. Yü-t'an , 玉潭
From Wu-hsing, Chekiang. B. ca. 1235, *chin-shih* 1262, d. after 1301. Painted figures after Li Kung-lin, landscapes after Chao Ling-jang, flowers and birds after Chao Ch'ang. One of the "Eight Talents of Wu-hsing." H, 5. I, 53. L, 18. M. p. 679. See also Richard Edwards, "Ch'ien Hsüan and 'Early Autumn'," Archives VII (1953) 71-83; James Cahill, "Ch'ien Hsüan and His Figure Paintings," Archives XII (1958), 11-29; and Wen Fong, "The Problem of Ch'ien Hsüan," Art Bulletin XLII (Sept. 1960), 174-189.

Taipei, Palace Museum (SV309). Washing the white elephant, after Li Kung-lin. Signed, dated 1273. Late Ming, cf. Ts'ui Tzu-chung; possibly by him. See KK shu-hua chi XXXI.
British Museum, London. A youth in red cloak seated on a white horse holding a large bow. Handscroll. Poem by the painter, dated 1290. Several inscriptions of the Yüan and Ming periods. See Venice Exh. Cat. 784; La Pittura Cinese 228.
Taipei, Palace Museum (VA8f). A flowering plant by a rock, swarming bees. Signed, dated 1303. Colophon by K'o Chiu-ssu. Copy or imitation. See Ku-kung album, 1932: Li-ch'ao hua-fu chi-ts'e 6; London Exh. Chinese Cat. 105.
Ku-kung XXXVIII. A mongol groom holding a horse. Signed, dated 1342, i.e. several decades after the death of Ch'ien Hsüan. Possibly a late copy after a T'ang painting.
* Wen-hua ta-ko-ming chi-chien ch'u-t'u wen-wu (Cultural Objects Unearthed During the Great Cultural Revolution), Peking, 1972, Pl. 135. White lotus flowers and leaves. Handscroll, ink and light (green) color on paper. Inscription, signed, with two seals of the artist. Colophons by Feng Tzu-chen and Chao Yen. Excavated from the tomb of Prince Chu Tan (d. 1389). See also Unearthing China's Past 133; Hills 3.
* Peking, Palace Museum. *Shan-chü t'u:* Dwelling in the Mountains. River landscape in archaic style. Handscroll, ink and colors on paper. Signed. See Shina kaiga shi pl. 67; Siren CP VI, 34; Kokyu hakubutsuin, 32.

Ibid. Eight Flowers. Handscroll, ink and colors on paper. Inscription by Chao Meng-fu. Two of the flowers correspond with the Freer Gallery scroll (17.183) listed below. Copy.

* Shanghai Museum. *Fou-yü shan-chü t'u:* Dwelling in the Fou-yü Mountains. Handscroll, ink and colors on paper. Inscription, signed. Colophons by Chang Yü and Huang Kung-wang (both dated 1348), Yao Shou, and others. Photos in Freer Gallery Study Collection. See Hills 7; Barnhart Marriage 23; article by Chu Wei-heng in Wen-wu, 1978 no. 9, p. 68.

Former National Museum, Peking. Emperor Ming-huang teaching Yang Kuei-fei to play the flute. Handscroll. Colophons and seals of the Yüan period. Copy? See Siren CP VI, 32b; Cahill, Archives XII, fig. 4; Sickman and Soper 110b.

TWSY ming-chi 92. *Hsi-hu ch'in-ch'ü t'u:* the Sung poet Lin Pu gazing at plum branch in a vase; a servant and a crane at left. Handscroll. Inscribed, signed.

CK ku-tai 58 (Peking Palace Museum?). Buildings on an island; people on a bridge. Handscroll. Inscribed, signed. Perhaps genuine; reproduction unclear.

Wen-wu, 1978 no. 6, pl. 6A. A bird perched on a branch of blossoming peach. Poem by the artist, signed. Handscroll, of which other portions depict peonies and blossoming plum. The section reproduced is closely related to, perhaps based on, the Anon. Sung album leaf in Sogen MGS 55. Reproduction unclear.

Taipei, Palace Museum (SV125). Lu T'ung preparing tea on a garden terrace. Seal of the painter. Poem by Ch'ien-lung. Copy? See Ku-kung III; Three Hundred M., 127; KK ming-hua III, 28; Wen-wu chi-ch'eng 54; KK chou-k'an 309.

Ibid. (SV126). The trunk of a tall lichee tree. Signed. Poem by Mo Hsien-chih. Later work. See Ku-kung VIII; Three Hundred M. 129; Nanking Exh. Cat. 50; Wen-wu chi-ch'eng 55; KK chou-k'an 317.

Ibid. (SV127). Egg-plants, melons, turnips, goosefoot and cabbage. Short handscroll. Minor work, perhaps of the period, by lesser artist. See Ku-kung XL; CH mei-shu II.

* Ibid. (SV128). A melon plant with fruits and flowers. Signed, poem by the painter. See KK shu-hua chi, XVI; Three Hundred M., 128; CKLTMHC III, 2; KK chou-k'an 205; Hills 5.

Ibid. (SV313). Blossoming plum in snow, with birds. Ming work, cf. Pien Wen-chin.

* Ibid. (SH24). Waiting for the ferry by a misty river. Inscribed, signed. See KK ming-hua IV, 25.

Ibid. (SH26). Two peony blossoms. Poem, signature, and three seals of the artist. Colophons by Chao Meng-fu, K'o Chiu-ssu, Ni Tsan, etc. Copy. See Three Hundred M. 130; KK ming-hua III, 29.

* Ibid. (SH27). A squirrel on the branch of a peach tree. Handscroll. Seals of the painter. Poem by Ch'ien-lung. See KK shu-hua chi XXVI; London Exh. Chinese Cat. 129; CAT 68; Che-chiang 19; CH mei-shu II;

CKLTMHC III, 1; CKLTSHH: KK ming-hua IV, 26; KK chou-k'an 427; Siren CP VI, 36b; NPM Masterpieces V, 17; Wen Fong article noted above.

Ibid. (SH124). Shih-miao and the calf. Handscroll. Signed. Copy of old work. See other versions ascribed to Chao Meng-fu and Chou Fang.

Ibid. (SH128). The Seven Immortals. Handscroll. Copy after work by him?

Ibid. (SH130). Branches of Lichee. Handscroll. Ming work.

KK shu-hua chi XL. Birds perched on the branches of a blossoming plum tree in snow. Short handscroll. Signed. Ming academic work.

Taipei, Palace Museum (VA3n). A bowl of precious fruit. Album leaf. Attributed. Later work.

Ibid. (VA11q). Thrushes fighting under bamboo. Album leaf. Attributed. Copy of So. Sung work, unrelated to Ch'ien.

Ibid. (VA12v). Song of the autumn bird. Fan. Attributed. Possibly earlier than Ch'ien's time; unrelated to him.

Ibid. (V19q). Two ladies standing by a stone and flowering plants. Album leaf. Attributed. Late Sung work? unrelated to Ch'ien. See CKLTMHC II, 97; NPM Masterpieces III, 27.

Ibid. (VA26p). Camellia branch. Album leaf. Seal of the artist. Copy or early imitation.

Ibid. (VA27g). The Sound of the Waves; the Harmony of the Pines. Fan. Signed. Later copy of Southern Sung work? Unrelated to Ch'ien Hsüan.

Note: Other works in the Palace Museum, Taipei catalogued as Anonymous Sung but stylistically close to Ch'ien Hsüan include SV213; SV224-5; SV338; and VA14i.

KK chou-k'an 20. The Taoist magician Chang Kuo-lao. Short handscroll. Inscription, signed. Reproduction indistinct.

Chin-k'uei II, 13 (former J. D. Ch'en collection). The Tartar King Shih Lo asking the Way of Buddha. After Chao Po-chü. Handscroll. Signed. Four colophons. Copy. Other versions of the composition in the former Abe Collection (Osaka Cat. 47; Soraikan II, 33); the John M. Crawford Jr. Collection, N.Y.; and the Freer Gallery (11.210).

Ibid. I, 1 (former J. D. Ch'en coll.). A bird on the branch of a blossoming fruit tree. Colors on paper. The attribution to Huang Ch'üan is misleading; closer in style and period to Ch'ien Hsüan.

Nanshu ihatsu II (Wang Shih-chieh collection, Taipei). The Red Cliff; river landscape illustrating the poem by Su Shih. Imitation. See also Garland II, 1.

Garland II, 4 (formerly Lo Chia-lun, Taipei). Two mandarin ducks under a hibiscus plant with large flowers. Signed. Imitation.

Chin-k'uei II, 17 (former J. D. Ch'en, Hong Kong). Melon, Lotus Root, Pear and Bamboo shoot. Album Leaf. Attributed.

Garland II, 6. Spring thoughts in a country garden. Five sections each with composition of flowers and insects. Handscroll, ink and colors on paper. Four sections each signed "Hsüan", and with the artist's seal; the last section with inscription and seal. Imitation.

Ta-feng-t'ang IV (C. C. Wang, New York). The tipsy T'ao Yüan-ming asking his two guests to leave. Short handscroll. Inscription by the painter, signed. Ming work?

Shen-chou ta-kuan 7. An eggplant. Short handscroll. Colophons by Ch'ien Po, Chou Hsüan and others. Reproduction indistinct. Another version in the Freer Gallery (15.17). Others: CK ming-hua 20; Laufer 24.

Shen-chou 12. A branch of flowering peach tree. Signed, seal of the artist. Imitation.

Chung-kuo MHC 11 (Lin Po-shou, Taipei). Fisherman returning in wind and rain. Colophon by Yün Shou-p'ing. Early Ming picture.

Toso 142 (Kuan Mien-chün). T'ao Yüan-ming walking, followed by a servant who carries a wine-jar. Handscroll. Signed, three seals of the painter. Copy? See also Chung-kuo MHC 9; Li-tai jen-wu 32.

Ibid. 143 (K. Magoshi). A branch of flowering apple. Poem by the painter, three of his seals. Copy.

Ibid. 144 (E. Takeuchi). Emperor T'ai-tsu of Sung playing football. Handscroll. Copy of older work, not by Ch'ien.

Toyo IX, 101 (Marquis Kuroda). Two birds on a pomegranate branch. Fan. Attributed. Copy of Sung work, with misleading attribution.

Ibid. IX, 100 (Count Sakai). A bird on branch of blossoming plum, watching a bee. Album leaf. Attributed. Fine late Sung work?

Hikkoen 7 (Marquis Kuroda). Children at play under a banana tree by a garden rock. Album leaf. Ming copy of Sung work, misleading attribution.

Kokka 404 (Marquis Asano). A peony flower. Seal of the painter.

Ibid. 418. Yang Kuei-fei asleep. Short handscroll. Attributed. Later work.

Ibid. 482 (Suganuma collection). White plum-blossoms. Album leaf. Seal of the painter.

Ibid. 73. A melon and two grasshoppers. Album leaf. Seal of the painter.

Ibid. 238 (Maruyama collection). A crab and a radish. Seal of the painter.

Fujii Yurinkan, Kyoto. Hung-yai (Chang Yün, the T'ang dynasty Taoist recluse) Moving his Residence. Handscroll, ink on silk. Signed. Colophons by Chu Te-i and others. Close copy of work by Ch'ien Hsüan? See Yurintaikan III, 19; Cahill article in Archives XII, fig. 8. Other versions in Garland II, 5; I-lin YK 38-45.

Ibid. Melons. Album leaf, ink and colors on silk. Inscription, signed. Copy.

Masaki Art Museum. Fruit and autumn insects. Album leaf. Attributed. See Masaki Cat. V.

Nezu Museum, Tokyo. Small bird on a branch of flowering pear. Album leaf. Attributed. Fine work of the period, probably not by Ch'ien. See Nezu Cat. I, 39; London Exh. Cat. 916; Sogen Meigashu 48.

Ibid. Pigeon on a branch of flowering pear. Early copy or imitation. See Nezu Cat. I, 40-41; Rowland, Archives V, fig. 9; Edwards, Archives VII, fig. 8; London Exh. Cat. 919.

Ibid. Shellfish on bamboo leaves. Album leaf. Attributed. Sung-Yüan work. See Nezu Cat. I, 14.

Ibid. Two mynah birds on a pomegranate branch. Attributed. Yüan-Ming work. See Nezu Cat. I, 42.

Kawasaki cat. 6. Huan I (the flute-player of the 4th century) cleaning his nail. Spurious seal of Ch'ien Hsüan. Attributed. Fine work of the period. See also Sogen no kaiga 14; Toyo bijutsu 54; Choshunkaku 5; Genshoku 29/34; Kokka 66; Sogen MGS II, 5.

Sogen MGS 7. Four rats eating through a melon. Album leaf. Seal of the painter. Later, lesser artist. See also Hikkoen 6.

Kawasaki cat. 25. A branch of blossoming apricot. Seal of the painter.

Tokiwayama Foundation, Kamakura (Sugahara Coll.). Cockscomb and insects. Attributed. Work of Yüan period artist of the P'i-ling School. See Chugoku Meiga, II.

Hompo-ji, kept in the Kyoto Nat. Mus. A cockscomb. Signed. Poem by the painter. See Sogen Meigashu; Kokka 163. A close, early copy? Another painting of the same subject with spurious seals of Ch'ien Hsüan, in the Nezu Museum; see Nezu Cat. I, 43.

Tokyo National Museum. Wild ducks. Attributed. Ming painting?

Kyoto National Museum (former Ueno collection). The Seven Sages Crossing the Barrier. Handscroll, ink on paper, in *pai-miao* technique. Poem, signed. Later work.

Yabumoto Kozo, Amagasaki. Two birds on a flowering branch. Ink and colors on paper. Poem with the artist's signature and two seals. Early imitation?

Cheng Chi, Tokyo (former P'u Ju Collection). Three strange men bringing a Tibetan mastiff and its puppy in tribute. According to inscription by the painter, copied after a picture by Yen Li-pen. Seals of the painter. Handscroll. Published as a reproduction scroll by the Jimbun Kagaku Kenkyusho, Kyoto, 1959. See also Siren CP VI, 32a; Garland II, 2.

Ibid. An eggplant. Seal of the artist.

Note: Many other old and interesting paintings preserved in Japan were once loosely ascribed to Ch'ien Hsüan, or bear spurious seals. Examples include the two peony paintings in the Koto-in, Daitokuji, Kyoto (Sogen no kaiga 65-6, etc.); the painting of peonies in a bowl in the Chionin, Kyoto (Ibid. 67); the two paintings of lotuses in the same temple (Toso 74-5); a painting of a basket of flowers in the Hakone Museum; Shina Kacho Gasatsu 36-39, 43, 53, 54; etc.

Freer Gallery (09.230). Blossoming shrubs and plants, birds and butterflies. Handscroll. Signed. Imitation. See Siren CP in Am. Colls. 128.

Ibid. (10.6). Hsiao I getting the Lan-t'ing manuscript from Pien-ts'ai. Handscroll. Seal of the artist; colophon (the *Lan-t'ing hsü*) purporting to be by Wen Cheng-ming. Copy of composition variously attributed; for other versions see under Chao Lin. See Freer Figure Ptg. cat 12.

* Ibid. (17.183). Branches of blossoming magnolia and pear. Two album leaves mounted as a handscroll. Two seals of the painter. Colophons by Ch'eng-ch'in Wang, Chao Meng-fu and others. See Kodansha Freer Cat. 46; Siren CP VI, 36; Edwards, Archives VIII, fig. 9; Sickman and Soper 111; Hills 4. Also see Thomas Lawton's article in Ars Orientalis VIII, 1970, pp. 194-196.

Ibid. (52.25). A lady supervising four servants who are spinning and weaving. Short handscroll. Signed. Copy.

Ibid. (54.10). A branch of blossoming pear. Ink and colors on paper. Seal of the artist. Imitation.

* Ibid. (57.14). Yang Kuei-fei mounting a horse to set off on an outing with the Emperor Hsüan-tsung, who is mounted on a white horse. Eight grooms and four maids attend them. Handscroll, ink and colors on paper. Inscription by the painter. See Skira 100; Siren CP VI, 33; Kodansha Freer Cat. 60; Freer Figure Ptg. cat. 43; Hills 6; Cahill article in Archives XII (1958). Another version in Otto Kummel, *Die Kunst Ostasien*, p. 99, where the subject is given as Chao Chün Leaving China. For other representations of the subject, see the "Chou Wen-chü" scroll in Chung-kuo hua XI, the "Kuo Chung-shu" album leaf in the Taipei Palace Museum, and the anonymous Sung fan painting in the Museum of Fine Arts, Boston (12.896).

Museum of Fine Arts, Boston (11.6146). A dragonfly on a bamboo spray. Seals of the artist. Fine work of the period; the seals probably interpolated. See Siren CP in Am. Colls. 149; BMFA Portfolio II, 4.

Metropolitan Museum, N.Y. Illustration to the *Kuei-ch'ü-lai* or "Homecoming" ode by T'ao Yüan-ming. Signed. Handscroll, ink and colors on paper. Close copy? See Toronto Exh. Cat. 12; Yüan Exh. Cat. 184; Lee Landscape Painting 27, colorplate III.

* Ibid. (1973.120.6; former C. C. Wang). Wang Hsi-chih admiring swimming geese from a pavilion. Handscroll, ink and colors on paper. Poem by the painter. Seals of Yüan and later periods. See Yüan Exh. Cat. 185; Skira 102; Hills pl. 1; Met. Cat. (1973) no. 13; Bunjinga suihen III, 63. Another version in the Palace Museum, Taipei (SH25); see CCAT 103 (section).

* Ibid. (formerly Sir Percival David, London). Branches of blossoming pear. Short handscroll, ink and colors on paper. More than twenty colophons of the Yüan and later periods. See Yüan Exh. Cat. 180; Edwards Archives VII, fig. 6.

Fogg Museum, Cambridge (23.153). Tribute horses with grooms. Handscroll. Attributed. Another version of the composition in the Freer Gallery (15.16) attributed to Han Kan.

Princeton Art Museum (59.1; former Asano collection). A sparrow on an apple branch. Fine painting of the period or slightly earlier, the seal interpolated. See Kokka 390; Archives XIV (1960), p. 74; Wen Fong, "The Problem of Ch'ien Hsüan," Art Bulletin XLII (Sept. 1960), 174-189.

* Cincinnati Art Museum. Two Doves on a branch of a blossoming pear tree. Short handscroll. Inscription by the painter and four of his seals. Colophons and poems by more than twenty connoisseurs of the Yüan and later periods. See Yün hui chai 7; Yüan Exh. Cat. 181; Edwards Archives VII, fig. 7; Unearthing China's Past 122; Bunjinga suihen III, 62.

Cleveland Museum (70.70). Two birds on a flowering branch. No signature or seal; style of Ch'ien Hsüan. See Cleveland *Bulletin*, Feb. 1971, fig. 153.

Detroit Institute of Fine Arts. Early Autumn: insects among grasses and lotus leaves. Handscroll. Signature and seals of the painter. Fine painting, probably of the later 14th or 15th century, unrelated to Ch'ien Hsuan. See Siren CP VI, 37; Asia House Masterpieces II, 40; complete color

reproduction in Mai-mai Sze, The Tao of Painting; Richard Edwards, "Ch'ien Hsüan and 'Early Autumn,'" Archives, VII, (1953).

Chicago Art Institute (former Tuan Fang collection). The washing of the white elephant. Short handscroll. Seal of the painter. Copy. See Kokka 259; Siren CP VI, 31. Other versions in the Freer Gallery (11.163i), Ferguson, 146; Palace Museum, Taipei (SH151, chien-mu); Garland II, 3; Met. Mus., N.Y. (47.18.96).

Frank Caro, N.Y. (1953). Three Vegetables. Handscroll. Inscription by the artist, and by Ch'ien-lung. Copy?

E. Erickson Collection. The parting of Su Wu and Li Ling. Handscroll. Seals of the artist. Old and interesting work, probably not by Ch'ien Hsuan. See BMFEA XXXVI (1964), pl. 5-6.

CHING-CH'U　景初

Uchida Yuji collection, Kanagawa. Fish and aquatic plants. Ink and light color on paper. See Sogen Bijutsu 47; Suiboku III, 95.

CHING-T'ANG　鏡堂
Unidentified. Yüan period.

Kaigo-in, Kyoto. Two portraits of the priest Kokan Shiren (1278-1346). Inscriptions on both by Kokan Shiren, one dated 1343. See Doshaku 48 and 49.

CHOU CHIH　周砥　t. Li-tao 履道　, h. Tung-kao 東皋　and Chü-liu-sheng　菊溜生
Native of Suchou, lived in Wu-hsi. D. 1367. Landscapes, following Wang Meng and Huang Kung-wang. N, I, 8. O, 2. M., p. 245. Also biog. by Chu-tsing Li in DMB I, 265-267.

* Museum of Fine Arts, Boston (56.493). Scenery of I-hsing. Short handscroll. Poem by the painter, signed, dated 1356. Mounted in a handscroll together with Shen Chou's Autumn View of T'ung-kuan dated 1499. See Toronto Exh. 11; BMFA Portfolio II, 16, 18; Archives XI (1957), p. 86.
Osaka Municipal Museum (former Abe collection). Trees on a rocky promontory, mountains beyond. Poem by the painter, dated 1365. See Soraikan I, 26; I-lin YK 28/6; Osaka Cat. 73.

CHOU TUNG-CH'ING　周東卿
Late Sung painter of fish. Friend of the famous scholar-loyalist Wen T'ien-hsiang　文天祥
　, who composed a poem for his Hsiao-Hsiang t'u. Y, p. 144.

* Metropolitan Museum, N.Y. (47.18.10). The Pleasures of Fish. Handscroll, colors on paper. Signed, dated 1291. See Siren Bahr Cat. pl. 12.

CHU SHU-CHUNG　朱叔重
From Lou-tung, Kiangsu. Active ca. 1365. Poet and painter, mainly landscapes. I, 53. M, p. 93.

* Taipei, Palace Museum (YV53). A wooded mountain ridge rising through the mist, in the manner of Kao K'o-kung. Signed, dated 1365. Poem by Ch'ien-lung. See KK shu-hua chi XX; Three Hundred M. 178; CAT 87; CKLTMHC III, 41; KK ming-hua V, 47; Wen-wu chi-ch'eng 71.
 Ibid. (YV52). Willows by a stream in spring. Signed, seal of the artist. Probably the work of Wang Hui of the Ch'ing period. See KK shu-hua chi XXIX; London Exh. Chinese Cat. 164; Three Hundred M. 177; KK chou-k'an 480.

CHU TE-JUN　朱德潤　　t. Tse-min　澤民
B. 1294, d. 1365. From Sui-yang, Honan; lived in K'un-shan, Kiangsu. Painted landscapes in imitation of Kuo Hsi. H, 5. I, 53. L, 8. M, p. 92.

Bunjin gasen I, 12 (Chang Chih-ho collection). A mountain gorge in snow; a man on a donkey crossing a bridge. Signed, dated 1339. Later work.
Kokka 620 (former K. Moriya and Ogiwara Yasunosuke collections). Steep cliffs and bare trees, ink on paper. Signed, dated 1341. Imitation. See also Suiboku II, 60.
John Crawford Jr., N.Y. Hall of Harmony and Joy. Handscroll. Signed, dated 1343. Good Ming work, with interpolated inscription. See Crawford Cat. 54.
Taipei, Palace Museum (YV214, chien-mu). Travelers approaching a temple in a misty valley. Signed, dated 1346. Che School work of 16th century.
Cheng Chi, Tokyo. Landscape in the Kuo Hsi style. Signed, dated 1348. Inscription by Sung Pao-chün.
* Shanghai Museum. Old tree, vines, and moon. Short handscroll, ink on paper. Inscription, signed, dated 1349. Colophon by Wen Cheng-ming dated 1548. Loose, strange, but genuine work.
Seattle Art Museum. River landscape with willows in spring. Signed, dated 1349. Seal of Mu-tsun, i.e. Shang-jui of the Ch'ing period; possibly his work. See Toso 147.
Tokyo National Museum. Mountains in autumn. Signed, dated 1352. Ming academic work with interpolated inscription. See Nanshu ihatsu II; Tokyo N. M. Cat. 36; Bunjinga suihen III, 73.
Taipei, Palace Musem (VA9d). A tall cliff with pines and waterfall. Signed, dated 1353. Later work.
Sogen 39 (Han Te-shou collection). Five scholars assembled around a table in a garden. Signed, dated 1364. Ming picture. See also I-lin YK 40/1.

* Peking, Palace Museum. *Hsiu-yeh hsüan:* the Pavilion of Flowering Fields. Two men are enjoying the view; hills in the background and trees on the shore. Handscroll, ink and light color on paper. Long inscription by the painter, signed, dated 1364 (at 71), and later colophons. See CK hua XV, 12-13; CK ku-tai 62 (section); Wen-wu 1956.1; Chugoku bijutsu III, p. 88-89. A copy of the picture is in the Freer Gallery (50.20); see Archives V (1951), p. 74, and Thomas Lawton's article in Ars Orientalis VIII, 1970, pp. 203-207.

Shen-chou X. A scholar seated under two tall pines. Signed, dated *jen-tzu* year of the Chih-cheng era (which did not exist). Forgery.

* Peking, Palace Museum. Two men in a boat passing a shore on which is a tigerlike rock. A small picture mounted in a handscroll together with Wang Mien's Plum-blossoms and Chao Yung's Fishing in a Mountain Stream. See I-shu ch'uan-t'ung VIII; Siren CP VI, 93.

Taipei, Palace Museum (YV32). Mountains and water in autumn mist. Attributed to the painter in a colophon by Tung Ch'i-ch'ang. Good Yuan or early Ming work in the Kuo Hsi tradition, closer to T'ang Ti than to Chu Te-jun in style. See Ku-kung IV; CKLTMHC III, 100; KK chou-k'an 108.

Ibid. (YV33). Snow-covered mountains and a pavilion on the riverbank. Attributed. Ming academic work. See Ku-kung VII; KK chou-k'an 109.

* Ibid. (YV34). Listening to the Ch'in Beneath Trees: River landscape in mist, three men seated under pines, one playing the ch'in. Signed. Poem by Wang Feng. See KK shu-hua chi XII; London Exh. Chinese Cat. 154; Three Hundred M. 169; CAT 82; CH mei-shu II; CKLTMHC III, 27; KK ming-hua V, 35; Wen-wu chi-ch'eng 67; KK chou-k'an 158; Siren CP VI, 92.

Ibid. (VA13m). Temple on a misty mountain. Album leaf. Attributed. Ming work.

* Ibid. (VA51d). Three men seated under pines by a stream, one playing a ch'in. Fan. Poem by the artist, signed. See KK ming-hua V, 36; Hills 33.

Shen-chou XX. River shore with some sparse trees and buildings. Inscriptions by the painter and by Sung K'o. Ch'ing work.

Chung-kuo MHC 16. A steep riverbank in snow, a man walking over a bridge; other men in a boat and a pavilion on the shore. Signed. Poem by Ch'ien-lung. Later work.

Garland II, 20. The I-lo T'ang: Hall of Pleasure and Harmony. Handscroll, ink on paper. Title and inscription by the artist, signed.

Zenichiro Takeuchi, Tokyo (formerly Manchu Household collection). High mountains and winding waters. Short handscroll. Poems by Tu Mu and Ch'ien-lung. Old imitation? See Sogen 37; Yuan Exh. Cat. 217.

Sogen 38 (formerly Voretsch collection). River landscape; boats on the water, houses on the shore. Handscroll. Attributed? Ming picture? of good quality.

Doshaku, 19. Illustrations to the life of T'ao Yuan-ming. Attributed. One of many versions of the compositions; for others, see Chao Meng-fu, Fujii Yurinkan scroll. See also Suiboku IV, 68-70.

Sogen (large ed.) 19. Wintry hills by the river, with travelers. Fan painting. Seal of the artist. Possibly genuine.
* Chugoku I. A man in a thatched cottage under bare trees by a river; two men in a boat. Short handscroll. Poem by the painter, signed, with a dedication to a man called Te-ch'ang.
* Nanga taisei VIII, 23. A leafless tree and a pine overhanging a river; a fisherman in his boat. Fan. Inscription, signed.

CHU YÜ　朱玉　t. Chün-pi　君璧　.
From K'un-shan, Kiangsu. B. 1293, d. 1365. Boundary paintings and figures. Pupil of Wang Chen-p'eng. I, 54. L, 8. M, p. 93.

Toso 145. (Chu Ch'i-chien collection). The various regions of hell, represented by twelve tiers of figures. Signed. Colophon by Ch'ien-lung.
Art Institute of Chicago (52.8). Street Scenes in Times of Peace: figures representing various trades and occupations. Handscroll. Signed. Colophons of the Ming period. Copy? or heavily repainted? See Venice Exh. Cat. 792; Smith and Weng, 204-7.

CHUANG LIN　莊麟　t. Wen-chao　文昭
A native of Chiang-tung; lived in Peking. Active at the end of the Yüan period. Landscapes. L, 32. See also *Shih-ch'ü sui-pi* 4, 16.

* Taipei, Palace Museum (YH22h). A scholar crossing a bridge toward a house. Handscroll. Signed. Colophon by Tung Ch'i-ch'ang, in which he states that this is the only surviving work by the artist. Part of the collective scroll of Yüan works called Yüan-jen chi-chin. See Nanking Exh. Cat. 79; Three Hundred M. 202; CAT 90h (section); CH mei-shu II; CKLTMHC III, 85; KK ming-hua VI, 37; Siren CP VI, 84b.

CHUNG-MO　仲默　or Tsung-ying　宗瑩
Follower of Hsüeh-chuang. See the article by Teisuke Toda in Bijutsu-shi 65.

* Yabumoto Kozo, Amagasaki (former Matsudaira). Orchids growing from a cliff. Hanging scroll, ink on paper. Signed.
* Yabumoto Soshiro, Tokyo (1965). Bamboo and Rocks. Seal of the artist.

CHUNG-SHAN　仲善
Unidentified. Yüan period.

Yabumoto Kozo, Amagasaki. Sparrows in a tree. Hanging scroll, ink and light colors on paper. Signature and seal of the artist.

FANG CHÜN-JUI　方君瑞

From Wu-chin, Kiangsu. Active early 14th century. Grass and insects, followed the monk Chü-ning. I, 54; M, p. 22.

Kokka 90. Two butterflies and a cabbage plant. Album leaf. Attributed.

FANG TS'UNG-I　方從義　, t. Wu-yü　無隅　, h. Fang-hu　方壺　.

From Kuei-ch'i, Kiangsi. Active ca. 1340-1380. Taoist monk in the Shang-ch'ing temple in Kiangsi. Landscapes. Followed Mi Fu and Kao K'o-kung. H, 5. I, 54. L, 32. M, p. 22. Also biog. by Chu-tsing Li in DMB I, 435-438.

Taipei, Palace Museum (VA2h). River view in mist with a boat; sharply rising rocks on the shore. Album leaf. Signed, dated 1348. Part of the album called *Mo-lin pa-ts'ui.* See Chung-kuo I, 106; Chung-kuo MHC 21; NPM Masterpieces II, 39. A later version of this picture dated 1378 is in the Fujii Yurinkan, Kyoto. Both copies of a lost original?

Bunjin gasen II, 5 (J. D. Ch'en, Hong Kong). A river between high cliffs; a pagoda on a promontory. Signed, dated 1349. Poem and colophon by Wen Cheng-ming. Late imitation. See also Chin-k'uei I, 21.

Kao Yen-yüeh, Hong Kong. River landscape: grassy mountains rising through clouds. Signed, dated 1355.

* Peking, Palace Museum (former Chang Ts'ung-yü collection). Boating Past the Wu-i Mountain: an overhanging cliff, two men in a boat. Signed, dated 1359. Seals of An Ch'i, Pien Yung-yü, etc. See Yün hui chai 53; Ta-feng t'ang I, 17.

Osaka Municipal Museum (Abe collection). A waterfall on a steep mountain; large trees in the foreground. Inscription dated 1360. See Soraikan II, 40; Osaka Cat. 63; Kokka 588; Bijutsu kenkyu 96. Imitation?

Shen-chou ta-kuan 9. A spray of bamboo. Signed, dated 1361. Poem by Huang-fu Lien (1501-1564).

Toso 162 (Ch'en Pao-ch'en collection). Clouds circling around mountains above a river. Signed, dated 1365. Imitation.

* Taipei, Palace Museum (YV111). Divine Mountains and Luminous Woods: a Taoist temple in a gorge. Signed, dated 1365. Poem by Ch'ien-lung. See KK shu-hua chi VIII; Three Hundred M. 196; CAT 89; CKLTMHC III, 8l; KK ming-hua VI, 24; Nanking Exh. Cat. 72; KK chou-k'an 116; Siren CP VI; 61; Hills 59.

* Ogawa collection, Kyoto. *Yün-shan ch'iu-hsing t'u:* River scene in autumn with mists. Signed, dated 1368. See Kokka 348; Pageant 383.

Ku-hua ta-kuan I, 6. Temple on mountain-top. Signed, dated 1369.

N. P. Wong, Hong Kong. Landscape. Handscroll, ink on paper. Signed, dated 1377. Title written by Kao Shih-ch'i. Later work.

Lin Po-shou, Taipei. Landscape. Handscroll, ink on paper. Signed, dated 1377. Painted for a certain Teng Chih-an "on his return to the capital."

* Bunjin gasen I, 12 (former Manchu Household collection). Cloudy mountains. Short handscroll. Signed, dated 1378. Done, according to the artist's

inscription, in his old age, and in the manner of Mi Fu. See also Siren CP VI, 63; Ferguson 138.

* Liu 38. A mountain brook crossed by a bridge. Signed, dated 1379.

Chin-k'uei II, 19 (former J. D. Ch'en, Hong Kong). The I-lu Terrace: a man and servant outside a house. Handscroll, ink and light colors on paper. Signed, dated 1390. Colophon by Wang Shih-min. Ming picture, time of Shen Chou or later.

Shanghai Museum. Mountains in clouds. Handscroll, ink on paper. Signed, dated 1392. See Chugoku bijutsu III, 88-89; Arts of China III, pl. 49.

* Taipei, Palace Museum (YV110). Clouds and snow on the Shan-yin mountains, after Kao K'o-kung. Signed. Damaged and retouched. See KK shu-hua chi V; London Exh. Chinese Cat. 171; CH mei-shu II; CKLTMHC III, 82; KK chou-k'an 180.

* Ibid. (YV112). *Kao-kao t'ing t'u:* pavilion on a steep terrace. Signed, colophon by the artist. See KK shu-hua chi XIV; London Exh. Chinese Cat. 172; CH mei-shu II; CKLTMHC III, 83; CKLTSHH; KK chou-k'an 175; Siren CP VI, 62; NPM Masterpieces I, 27.

* Ibid. (YV298, chien-mu). A pavilion on the rocky shore at the foot of rugged mountains. Signed, dated in the hsin-wei year of the Chih-cheng era (which did not exist). Close copy? See KK shu-hua chi XLIV.

Taipei, Palace Museum (YA4). Album of 12 landscapes. Seals of the artist. Ming work, 16th century?, partly in his tradition.

Ibid. (VA27i). Grass Hut at the Green Cliff. Album leaf. Attributed. Imitation. See KK ming-hua VI, 25.

Ibid. (VA77g). Alone looking at a lofty hill. Fan. Signed. Copy of Liang K'ai composition in the Crawford Collection, with spurious signature. See KK ming-hua VI, 26.

TSYMC hua-hsüan 30. A man in a pavilion looking at misty mountains. Handscroll. Signed. Early imitation?

Garland II, 32. Autumn: a man walking with a staff among convoluted rocks, a misty stream, and pines. Signed, inscription by the artist. Forgery, in the style of K'un-ts'an(!)

Nanga taikan I. Autumn winds over the Five Old Men Peaks. Signed. See also Pageant 381.

Nanshu ihatsu. Pines on strange rocks by a misty river. Signed. Late imitation. See also Shen-chou V.

Sogen 56 (Yang Yin-pei). View over a wide river; a summer retreat and garden on the shore in the foreground. Signed. Odd imitation. See also I-lin YK 37/2.

Chugoku II. Grassy hills on a river shore rising through a layer of clouds. Album leaf. Inscription by the painter. Imitation.

Fujii Yurinkan, Kyoto. Ten immortals. Album leaves mounted in a handscroll ink on paper. Signed, colophon by the artist. Copies of older pictures, not by Fang. See Yurintaikan III, 18.

* Masaki Museum, Osaka. Bamboo in rain. Hanging scroll, ink on paper. Inscription by the artist, signed, four seals.

* Metropolitan Museum, N. Y. (1973.121.4; former C. C. Wang). Landscape with hills in mist. Handscroll. Two seals of the artist. Colophon dated

1447 attributing the picture to Fang. Seals of Cha Shih-piao, Ch'ien-lung, etc. See Yüan Exh. Cat. 268; Met. Cat. (1973) no. 22; Hills 61.

* C. C. Wang, N. Y. Cloudy mountains. Poems by four contemporaries of the artist. In his manner. See Nanshu ihatsu IV; Shen-chou ta-kuan 3.

Ibid. The Lan-t'ing gathering. Handscroll, ink on paper. Title and inscription by the artist. Later work?

Freer Gallery (15.36b). Mountain landscape. Signed. Imitation.

Ibid. (18.8). Landscape with fishermen on the shore. Signature and inscription by Ch'en Shun both spurious; good painting of Ming date.

Boston M. F. A. (15.905). Misty hills. Signed. Imitation.

Paintings ascribed to Fang in the Metropolitan Museum, N. Y.: 13.220.19 (Three Scholars); 13.220.107 (landscape); 47.18.13b and 47.18.14, two versions of the same landscape composition, handscrolls.

Juncunc Collection, Chicago. Misty hills; trees in foreground. Inscription, signed. Hanging scroll, ink on paper.

FANG-YAI 方崖

Mentioned only by Li Jih-hua (cf. I, 54). The following information is contained in the inscriptions on his picture. Lived at the end of the Yüan period in Suchou. Ordained as a priest, a close friend of Ni Tsan. Painted trees, bamboo and stones; following the style of Su Tung-p'o's paintings. M. p. 22.

* Taipei, Palace Museum (YV115). Slender bamboo by a rockery. Seal of the artist. Poem and colophon by Ma Chih dated 1382. See Ku-kung IV; KK ming-jen hua-chu chi 12; Three Hundred M. 197; CCAT 111, B; CH mei-shu II; CKLTMHC III, 75; KK chu-p'u I, 4; KK ming-hua VI, 29; NPM Quarterly I.4, pl. 10; KK chou-k'an 109; KK Bamboo I, 12.

HO CH'ENG 何澄

Native of Peking. B. ca. 1218; d. after 1309. Official in the Yüan court; served as Manager of the Bureau of Painting. Painted figures and horses, followed Li Kung-lin. A different man from the fifteenth century painter of the same name. Listed in *T'u-hui pao-chien* under the name Ho Ta-fu 何大夫 ; otherwise, the above information is contained in colophons on the painting listed below.

* Chi-lin (Kirin) Provincial Museum. Illustrations to T'ao Yüan-ming's "Homecoming Ode." Handscroll, ink on paper. Signed. Colophons by Chang Chung-shou (dated 1309), Chao Meng-fu, K'o Chiu-ssu, Wei Su, Yü Chi, etc. See *Wen-wu,* 1973 no. 8, Pl. 3-5 and pp. 26-29.

HO CHING 郝經 , t. Po-ch'ang 伯常

B. 1223, d. 1275. From Ling-ch'uan, Shansi. Served as an official under the first Yüan emperor; he was sent as an envoy to the Sung capital and was there imprisoned. On his return to Peking he was made a teacher in the Central

College. Equally skilled as painter and calligrapher. Noted in the *Yüan shih* but not in the records of painters. V, p. 857.

Shen-chou ta-kuan 7. A white-headed bird on a slender branch. Unsigned. Six poems by Yüan writers, and an inscription by Wang Chien containing the attribution to Ho Ching.

HSIA SHU-WEN 夏叔文

Unrecorded in standard biographies. Name and native place (Feng-ch'eng) mentioned in Lu Hsin-yüan, *Jang-li kuan kuo-yen lu.* (V.11a.)

Liaoning Provincial Museum. Various birds on a willow bank. Seal of the artist. Yüan work of small interest. See Liaoning I, 96.

HSIA YUNG 夏永 , t. Ming-yüan 明遠 .

Active 14th century. Mentioned in a book called *Hua-chien hsiao-yü* as having represented the Palace of the Prince of Teng and the Yellow Crane Tower by embroidering with human air "as fine as the eyelash of a mosquito." The identification of this man with the Hsia Ming-yüan mentioned in *Kundaikan Sayuchoki,* to whom various academic landscapes in Japan are attributed, is not certain.

* Peking, Palace Museum. Two album leaves: the Yüeh-yang Tower, the Palace of Prince Teng. Inscriptions, seals of the artist.
* Ibid. The Yüeh-yang palace. Fan. Inscribed, signed, dated 1347. See Yüan-jen hua-ts'e II.
* I-lin YK 73/1. A palace by the river; a horseman and other figures in the court-yard. Long inscription, seal of the artist.

Toso 210 (Tokugawa collection). Landscape with palaces, in the manner of Chao Po-chü. Attributed. Ming work.

Nezu Museum, Tokyo. The Hangchou Bore on the Ch'ien-t'ang River; a palace on the shore. Fan-shaped album leaf, ink and color on silk. Attributed. See Kokka 639; Nezu Cat. I, 55-56.

Ibid. The poet Lin Ho-ching on the lakeshore; a crane above the waves, tall peaks beyond. Seal of the artist, probably a Japanese interpolation. The painting is probably early Ming. See Nezu Cat. I, 57.

Ibid. A palace by the river. Album leaf. Attributed. Early ming work. See Nezu Cat. I, 60.

Hikkoen 50-51. Landscapes with buildings. Two album leaves. Attributed. Early Ming works, unrelated to Hsia; cf. Shih Jui.

* Freer Gallery (15.36h-i). The Yüeh-yang palace (or the Yellow Crane tower); the Palace of Prince Teng. Album leaves. Inscribed, with the artist's seal. See TWSY ming-chi 101-102; CK ku-tai 61; Cahill, Album Leaves, pl. XX-XXI; Kodansha Freer Cat. 65. Another version of the first in the Museum of Fine Arts, Boston (29.964).

* Museum of Fine Arts, Boston (29.964). Palace of Prince Teng. Album leaf. Inscription, seal of the artist. See BMFA Portfolio II, 29.
* Fogg Museum, Cambridge (1923.231). Palace by the river. Partly effaced but still legible signature of the artist.
* Ching Yüan Chai collection, Berkeley (former Asano collection). Palace by the river. Small hanging scroll. Signature and seal of the artist. See Yüan Exh. Cat. 203.

C. C. Wang, New York. Two album leaves representing buildings in landscape settings, both signed.

Other paintings that can be provisionally ascribed to Hsia Yung on the basis of style include:

1. Taipei, Palace Museum (YH73). "Anonymous Yüan," the Chien-chang Palace. Short handscroll. See Ku-kung 17.
2. Ibid. (SV56). "Chao Po-chü" A-fang Palace. See K-K shu-hua chi 26.
3. Ibid. (VA5b). "Li Sheng" palace in landscape. Fan painting. See K-K ming-hua I, 19.
4. Shanghai Museum, The Kuang-han Palace. Spurious signature of the Five Dynasties master Wei Hsien. See Shanghai, 27.

HSIEH PO-CH'ENG　　　謝伯誠

From Jen-yang. Friend of Yang Wei-chen (1296-1370). Landscapes in the manner of Tung Yüan. I, 54. M, p. 704.

Bunjin gasen I, 11 (Pao Hsi, Peking). Two men in a pavilion under leafy trees. Signed. Four poems, one of them by the painter. See also Chugoku II.

John Crawford Jr., N. Y. Looking at a waterfall; an old man seated on the riverbank under tall pines. Inscription at the top of the picture by Yang Wei-chen. See Ta-feng-t'ang IV, 24; Crawford Cat. 50.

HSIEH T'ING-CHIH　謝庭芝　　, t. Chung-ho　仲和　, h. Yün-ts'un 雲村

From K'un-shan, Kiangsu. Poet. Painted bamboo, stones, and landscapes. H, 5. I, 53. M, p. 703.

Peking, Palace Museum. Bamboo and rocks. Signed, dated 1345. Genuine work by minor master. See KKPWY hua-niao 27.

HSIEN-YÜ SHU　鮮于樞　, t. Po-chi　伯機　, h. K'un-hsüeh-shih 困學氏　; Chih-an Lao-jen　直案老人　.

B. 1256, d. 1301. From Yü-yang, Hopei. Famous as a calligrapher but little known as a painter. M, p. 688.

Princeton University (Du Bois Morris collection). A river winding between wooded mountains. After a T'ang picture. Poem by the artist, signed "Po-chi" and dated 1303. Ming picture?

HSÜ PEN: Following the division of Siren's Annotated Lists, this artist will appear in the succeeding, Ming volume.

HSÜEH-CHIEH　雪界
Unidentifed.

Peking, Palace Museum. An eagle in a juniper tree. Done with Chang Shun-tzu, whose inscription mentions Hsüeh-chieh; the eagle presumably by Hsüeh-chieh.

HSÜEH-CHIEN　雪澗
A Ch'an monk active towards the end of the Yüan period. Unrecorded except in *Kundaikan Sayuchoki* (no. 112).

Nezu Museum, Tokyo. Manjusri in a mantle of plaited straw. Attributed. Inscription by Hsi-yen dated 1406. Yüan or early Ming painting. See Nezu Cat. I, 48.
Ibid. Manjusri in a mantle of plaited straw. Attributed. See Nezu Cat. I, 35.
Kokka 410 (K. Magoshi). Manjusri (Wen-shu), represented as a youthful monk with a mantle of plaited straw. Attributed. See also Pageant 408.
Former Asano collection. Manjusri as a youth (similar to the picture in the Magoshi collection). Attributed.
Toso 217 (T. Ogura). Manjusri as a youthful monk seated under a tree in a misty landscape. Two seals of the artist(?). See also Pageant 409.
Choshunkaku 56. Manjusri with plaited-rope mantle and scroll. Attributed. Inscription by Chou O (1359-1428).
Fujita Museum, Osaka. Manjusri, represented in the same form as the above pictures. Attributed.
Idemitsu Art Museum, Tokyo. Manjusri with rope mantle. Attributed. Inscription by Ling-yin Lai-fu, Yüan period.
Yabumoto Kozo, Amagasaki. Standing figure of Manjusri in plaited-straw mantle. Attributed.

HSÜEH-CH'UANG　雪窗
See P'U-MING.

HU T'ING-HUI　胡廷暉
From Wu-hsing, Chekiang. Active ca. 1300. Landscapes; highly admired by Chao Meng-fu. I, 53. M, p. 293.

Taipei, Palace Museum (YV28). Immortals meeting on P'eng-lai. Attributed. Ming painting. See CKLTMHC III, 16.

Kokka 462 (Baron Kawasaki). A radish plant. Album leaf. Attributed. Work of the period or slightly later.

HU TSAN 胡瓚 , t. Yüan-t'i 元體 .
From Peking, Hopei. Flowers and bamboo.

Sogen shasei gasen 15. Dog by a garden rock and flowers. Album leaf. Attributed.

HUA TSU-LI 華祖立 , t. T'ang-ch'ing 唐卿 .
Yüan period; fl. ca. 1326. (Information from label on painting listed below.)

* Shanghai Museum (exhibited Fall 1977). *Tao-chia shih-tzu t'u:* Ten Patriarchs of Taoism, Lao-tzu, Chuang-tzu, etc. Painted in 1326. Biographies written by Wu Ping . Handscroll, ink and colors on paper.

HUANG CHIN 黃溍 , t. Chin-ch'ing 晉卿 .
From I-wu, Chekiang. B. 1277, d. 1357. Han-lin scholar, official and lecturer on the classics to the emperor. Recorded in general biographical sources, but not in the books on painters. Followed Huang Kung-wang and Wang Meng. V, p. 1242.

Former Huang Chih collection. Fishing village by a river; terraced high mountains. Inscription, dated 1341.

KK shu-hua chi XVI. The study in the plum-tree garden at the foot of high wooded mountains. Signed, dated 1347. Colophons by the painter and by Li Yung (dated 1454). Imitation?

Formerly Chang Ta-ch'ien coll. Copy of Huang Kung-wang's *Fu-ch'un shan-chü t'u.* Handscroll, ink on paper. Signed.

Freer Gallery (09.215). Hills in mist, in the style of Mi Yu-jen. Short handscroll. Attributed. Fine work, of Yüan date. See Hills, 20.

HUANG KUNG-WANG 黃公望 , t. Tzu-chiu 子久 , h. I-feng 一峯 , Ta-ch'ih 大癡 and Ching-hsi Tao-jen 井西道人 .
From Ch'ang-shu, Kiangsu. B. 1269, d. 1354. Landscapes after Tung Yüan and Chü-jan. The oldest of the "Four Great Masters" of the Yüan period. H, 5. I, 54. L, 31. M, p. 541. See also *Huang Kung-wang yü Wang Meng,* by P'an T'ien-shou and Wang Po-min, published by the Jen-min mei-shu ch'u-pan-she, Shanghai, 1958, in the Chung-kuo hua-chia ts'ung-shu series (HKW/WM); Wen Chao-t'ung, *Huang Kung-wang shih-liao,* Shanghai, 1963.

Earl Morse, N. Y. (formerly C. C. Wang). Landscape. Signed, dated 1333. 17th century work in his style, probably by either Wang Hui or Yün Shou-p'ing. See Morse Cat. *(In Pursuit of Antiquity)* no. 24.

John M. Crawford, Jr., N. Y. Mountain landscape. Signed, dated 1333. Late imitation. See Crawford Cat. 44.

* Ming-jen shu-hua 23. Cloudy mountains and winding river. Signed, dated 1335. Reproduction unclear; possibly genuine.

Shanghai Museum. *Hsien-shan t'u:* sloping hills with rows of trees. Signed, dated 1338. Painted for Cheng Yu; colophon by Ni Tsan dated 1359. Copy. See Gems I, 11; HKW/WM 10; Shang-hai 12; the article by Chuang Shen referred to below (under the Taipei Palace Museum "Nine Pearl Peaks").

Taipei, Palace Museum (YH12). *Fu-ch'un shan-chü t'u:* Dwelling in the Fu-ch'un Mountains. Long handscroll. Inscription, signed, dated 1338. Dedicated to Tzu-ming who may have been intended for the painter Jen Jen-fa (d. 1328). Colophons by Tung Ch'i-ch'ang, Liu Chüeh (1410-1472), Tsou Chih-lin (early 17th century), K'ung O (early 15th century), Shen Te-ch'ien (1673-1769), Ch'ien Ch'en-ch'ün (1686-1774), and a great number of inscriptions by the Ch'ien-lung emperor. Ming? copy after the genuine scroll of 1350, see below. See Ku-kung album, 1935; London Exh. Chinese Cat. 143-147; KK chou-k'an 457-479; Siren CP VI, 64-65; Yüan FGM103.

Agata Collection, Osaka (former Saito collection). A man on a bridge beneath trees. Signed "Ching-hsi Tao-jen," dated 1338. Imitation. See Toan 10; Nanshu ihatsu III.

* Peking Palace Museum. *T'ien-ch'ih shih-pi t'u:* the Stone Cliff at the Pond of Heaven. Inscription, signed "at age 73," i.e. in 1341. Inscription by Liu Kuan dated 1342. Ming copy? See TWSY ming-chi 99; Hills 40. The best among the extant versions of this composition? Other versions: Taipei, Palace Museum (YV610); see KK chou-k'an 10/218; Pageant 333; Siren CP VI, 73; KK shu-hua chi XVII. Freer Gallery (11.308), dated 1342. Fujita Museum, Osaka, dated 1343, a rather free copy of the middle Ming period, ink and light color on silk; see Bunjinga suihen III, 9.

Bunjin gasen II, 4 (former Manchu Household collection). *Chih-lan shih:* the Orchid Studio, at the foot of wooded mountains. Album leaf. Artist's inscription on accompanying leaf dated 1342. Fine work, not by Huang Kung-wang. Colophon by Tung Ch'i-ch'ang. See also Chung-kuo MHC 26; Ch'ing-nei-fu 2; Siren CP VI, 76; Sickman and Soper 115.

Chung-kuo MHC 25 (Ti Pao-hsien). A towering mountain with pines; a pavilion by the river below. Signed, dated 1342. Late Ming work? See also Chung-kuo I, 84.

Freer Gallery (11.308). A view of Lu-shan; mist in the ravine. Inscription, dated 1342. Late copy.

Chin-k'uei 18 (former J. D. Ch'en). Steep grassy mountains overgrown with trees. According to the inscription, painted in 1343 for Yang Cheng (a Taoist) while stopping in a boat at Liang-ch'i. Imitation.

Nanga shusei III, 5 (P'ang Yüan-chi). Mountain village in evening mist. Album leaf. Signed, dated 1343. Imitation. See also Toso 167; Shen-chou ta-kuan 8; Ming-pi chi-sheng III, 2; Siren ECP 117; Pageant 335.

* Peking, Palace Museum. *Ch'i-shan yü-i t'u:* River and Hills Before Rain. Handscroll. Inscription dated 1344, stating that the painting was done "some years earlier." Inscriptions by Wang Kuo-ch'i (father of Wang

Meng) and Ni Tsan (dated 1374). Genuine, important work. See Hills 38-9; also *Wen-wu,* 1973, No. 5, pp. 62-65, with article by Hsü Pang-ta. Two copies of the composition, formerly in the Ch'ing imperial collection, are now in the Liaoning and Tientsin Museums; for the former, see *ibid.* p. 65. Still another copy in the Fujii Yurinkan, Kyoto; see Yurin Taikan, II.

Yu-cheng album, 3rd edition 1923 (formerly Wang Heng-yung coll.). Autumn Mountains Without End. Signed "at age 76," i.e. in 1344. Handscroll. Bottom edge damaged by fire. Late Ming work, possibly by Chao Tso or a follower. Colophons by Ch'eng Cheng-k'uei, Shen Tsung-ching (1714), Wang Ch'en (1771), and Ch'ien Wei-ch'eng (1771). Also in Siren LCP I, 2a; Toso 165; Pageant 341.

Nanga kansho VII, no. 1 (January, 1938), pl. 2 (formerly Sasagawa Rokudo collection). River landscape. Signed, dated 1346. Copy or imitation, probably of the 17th century.

Ta-feng-t'ang I, 11. The Stone Cliff at the Pond of Heaven. Signed "at age 79," i.e. in 1347. Colophons by Tung Ch'i-ch'ang and Ch'en So-yün (dated 1608). Imitation.

Eisei Bunko, Tokyo. Autumn Mountains. Long inscription (poem), signed, dated 1347. Inscription by Chao K'uan dated 1493 mounted above. Early copy. See Bunjinga suihen III, 10.

Kokka 518 (Inokuma collection). *Chiang-shan sheng-lan t'u:* surpassing view over rivers and mountains. Long handscroll. Inscription, signed, dated 1348. Dedicated to Ni Tsan. Good early Ch'ing work, Anhui School.

Nanshu ihatsu III (Former Ueno collection). Mountains in autumn. Signed, dated 1348. Poem by Chou Chu. Good work in the manner of Huang Kung-wang; early Ming? Later?

Chung-kuo MHC 22. The Stone Cliff at the Pond of Heaven. Dated 1348. Late imitation.

Wang Shih-chieh, Taipei. Lowering clouds over streams and mountains. Inscription, signed, dated 1348. Imitation. See Nanking Exh. Cat. 55; Garland II, 15.

Freer Gallery (09.188). Landscape. Signed, dated 1349. Inscription by Chang Yü. Late imitation.

National Museum, Stockholm. *Fou-luan nuan-ts'ui t'u:* Floating Peaks with Warm Verdure. Signed, dated 1349. Copy or imitation. See *Revue des Arts Asiatiques* VII, 3, pl. LXIIa. Other versions of this famous picture probably preserve the composition more accurately; see the one in Hsiao-chung hsien-ta album of copies by Wang Shih-min (?) in the Taipei Palace Museum (MA35h). Leaves l, m, p, and r of that album are also based on Huang Kung-wang compositions.

Freer Gallery (09.246f). Landscape. Signed, dated 1349. Imitation.

* Peking, Palace Museum. The Nine Peaks after Snowfall. Signed, dated 1349. Original? or close copy? See CK hua I, 16; CK ku-tai 64; HKW/WM 11; Wen-wu 1956.1; Siren CP VI, 74; I-shu ch'uan-t'ung VIII, 6; Kokyu hakubutsuin, 177.

Ibid. (former P'ang Yüan-chi). Clearing after snowfall on the river. Handscroll. No signature or seal of the artist(?); attributed. Seals of Hsiang Yüan-pien, An Ch'i, and others. Mounted in the same handscroll as

Hsü Pen's "Rocks in mist after snowfall," and a piece of calligraphy by Chao Meng-fu. Copy or imitation, period and style of Wen Cheng-ming? See Wen-wu 1956.1; photos of the entire scroll in the Freer Gallery study collection.

* Nanking Museum (former P'ang Yüan-chi). *Fu-ch'un ta-ling t'u:* the Fu-ch'un Mountain Range; a winding road along the river. Inscribed, signed. Closely related in style to the Peking "Nine Peaks" of 1349. Original? or early copy? See Sogen 63; HKW/WM 9; I-lin YK 46/1; Nanking Museum Cat. I, 9; also article by Chang Kuang-pin in NPM Quarterly XII no. 2, Winter 1977.

Taipei, Palace Musem (VA10f). Landscape with houses. Signed, dated 1349. Album leaf. 17th-18th century work.

Ibid. (YV229, chien-mu). Tall cliffs and plateaus by a river. Inscription, stating that he painted it in 1349. Early work of Wang Hui?

Sogen 62 (former Manchu Household collection). *Sha-chi t'u:* view over a flat marsh. Short handscroll. Signed. Poems by Jao Chieh and Chang Yü (dated 1349). Close early copy? See also Pageant 337.

Nanking Museum. *Shan-chü t'u:* A house in a mountain valley. Signed, done "at age 81," i.e. in 1349. Early copy? See TSYMC hua-hsüan 19; Nanking Museum Cat. I, 10.

* Taipei, Palace Museum (YH11). *Fu-ch'un shan-chü t'u:* Dwelling in the Fu-ch'un Mountains. Handscroll. Long inscription by the artist, signed, dated 1350; the painting begun three years earlier. Colophons by Shen Chou (1488), Wen P'eng (1570), Wang Ch'ih-teng (1571), Tsou Chih-lin, and Tung Ch'i-ch'ang; long inscription by Liang Shih-cheng, written in 1746 on the order of the Ch'ien-lung emperor. (See the following entry for fragment separately preserved.) See facsimile reproduction by Jurakusha, Tokyo; Three Hundred M. 161; CAT 74 (section); Che-chiang 23-25; CKLTMHC III, 19; HKW/WM 1-8; NPM Quarterly I.2, pl. XX (section); Wen-wu 1958.6.2 (section); 1964.3.20 (two sections from the two versions); Yüan FGM 102; Siren CP VI, 66-72; Skira 110; Hills pl. 5, 41-3; Bunjinga suihen III, 1-3. For a history of the scroll, see Hin-cheung Lovell's article in Ars Orientalis VIII, 1970; also Celia Carrington Riely's article in Archives of Asian Art, XXVIII (1974-75), 57-76; also an article by Hsü Fu-kuan in Ming-pao (August 21, 1974), pp. 14-24; another by Chang Kuang-pin in NPM Quarterly IX/4.

* Che-chiang 25 (Chekiang Provincial Museum, Hangchow). *Fu-ch'un shan-chü t'u;* a section of the fire-damaged first portion of the above scroll which was cut from the original. Considerably restored and repainted. See also Wen-wu 1958, no. 6; Hills 44; Bunjinga suihen III, 8.

* Taipei, Palace Museum (VA 31d). Landscape; house on the shore of a river. Album leaf. Inscribed, dated 1351. Minor, genuine work.

Toso 166 (Inokuma Collection; former Yamamoto Teijiro). Bare mountains and leafless trees in autumn. Signed, dated 1353. 17th century imitation. See also Pageant 336; Daito bijutsu 7.

I-yüan to-ying, 1979 no. 1, p. 16. Jade trees at Tan-yai. No signature or seal of the artist visible; five poems by Yüan writers (?), one of which mentions Huang as the painter. Late copy or imitation.

Taipei, Palace Museum (YV234). Strange peaks at Tung-t'ing. Inscription by

Wen Cheng-ming; perhaps his work; good Ming painting in any case.

* Ibid. (YV230). The Nine Pearl Peaks. Attributed. Three colophons. See CCAT 109; KK ming-hua V, 19; NPM Masterpieces I, 21; Yüan FGM, 101; Bunjinga suihen III, 4; article by Chuang Shen in *Proceedings of the International Symposium on Chinese Painting,* Taipei, 1970, pp. 463-478; another article by Li Lin-ts'an, "Huang Kung-wang's 'Chiu-chu feng-ts'ui' and 'Tieh-yai T'u,'" *National Palace Museum Bulletin,* Vol. VII, No. 6 (Jan.-Feb. 1973), pp. 1-9.

Ibid. (YV233, chien-mu). A Thatched Pavilion by the River. Signed. Close to Shen Chou in style, possibly by him.

Ibid. (YV235, chien-mu). The "Iron Bank," the dwelling of Yang Wei-chen, for whom the painting was done. Inscription by T'ang Ti dated 1350. Copy of Ming period.

Ibid. (YV236, chien-mu). Houses on a mountainside. Signed. Good work of the late Ming period.

Ibid. (YH56, chien-mu). A True View of the Lung-ch'iu Waterfall. Handscroll, signed, dated 1355 (!). Colophon by Sung Lo. Interesting imitation, 17th century?

Ibid. (VA6h). Fishing on the P'an River: two fishermen in boats on the river, old trees and rocky shore. Album leaf. Signed. Imitation, based on a work of Shen Chou.

Ibid. (VA9e). A Taoist temple in the misty mountains. Album leaf. Signed, poem by the artist. Colophon by Ch'ien-lung. Imitation. See KK ming-hua V, 20; KK chou-k'an 16; Wen-wu chi-ch'eng 72.

Ibid. (VA10e). Landscape with a hermit in a grass hut. Album leaf. Signed. Early Ming work? with interpolated signature.

Chin-k'uei 17 (former J. D. Ch'en). Mountains and streams warm and green. Attributed. Late imitation.

Ta-feng-t'ang IV, 17. Cliffs in autumn, a village at their foot. Short handscroll. Inscription by the artist. Imitation.

* Garland II, 14. Autumn clouds over rivers and mountains. Seal of the artist. Original? or fine imitation of later date?

Shen-chou XII. High terraced mountains in layers. Signed. Late imitation.

Toso 168 (Fang Jo). A village in the mountains by the water. Seal of the artist. Poem and colophon by Yang Wei-chen (dated 1365). Imitation.

Nanga taisei XI, 16. Houses on the river shore; wooded hills. Large album leaf? Seal of the artist. Seals of An Ch'i, K'ung Kuang-t'ao, and others. Good Ming-Ch'ing work, with interpolated seal.

Osaka Municipal Museum (Abe collection). Pleasant views of rivers and mountains; terraced mountains with sparse trees, sails on the river, cottages on the shore. Handscroll. Signed, seals of the artist. A skillful imitation. See Soraikan II, 36; reproduction scroll by the Hakubundo Co.; Siren LCP I, 2b; Osaka Cat. 54.

Nanshu ihatsu III. The Iron Cliff: a misty mountain gorge with the cottage of Yang Wei-chen. Signed. Poem by Chao I. Free Ch'ing imitation.

C. C. Wang, N. Y. A pavilion by the river among trees; towering plateaus beyond. Signed. Good early imitation.

Freer Gallery (16.566). Wooded mountains. Signed. Free imitation.

Juncunc Collection, Chicago. Landscape with cliffs and trees, man in boat. Signed. Inscription by Chang Yü. Small hanging scroll, ink on paper. Early imitation.

I-AN 一庵
Unidentified. Active in the early 14th century.

Kogen-ji, Kyogo Prefecture. Portrait of the Priest Chung-feng Ming-pen. Inscribed by the subject. Signed. Brought back by Enkei Soyu, a Japanese disciple of Chung-feng; about 1315. See Yüan Exh. Cat. 197; Kokka 318; Toyo Bijutsu I, 8; Genshoku 29/84; Doshaku, 45 (Two other portraits of the same subject: *ibid.* 46 and 47); Suiboku IV, 104; Hills 65.

JEN JEN-FA 任仁發 , t. Tzu-ming 子明 , h. Yüeh-shan 月山 . B. 1255, d. 1328. From Sung-chiang, Kiangsu. Vice-president of the River Conservation Bureau. Painted horses and landscapes. I, 53. L, 39. M, p. 86.

Toso 153 (Lo Chen-yü). Five horses and three grooms. Handscroll. Signed, dated 1304. Partly the same design as the 1314 Fogg Museum painting.
Fogg Museum, Cambridge (1923.152). Horses and grooms. Short handscroll. Signed, dated 1314. See Siren CP VI, 38; Speiser, Chinese Art III, pl. 14. Partly the same design as the Lo Chen-yü picture above.
* Nelson Gallery, K. C. (former Cheng Chi, Tokyo). *Chiu-ma t'u:* Nine horses with seven grooms. Handscroll. Signed, dated 1324. Parts of the composition correspond with the former Lo Chen-yü scroll noted above, and the Victoria and Albert Museum painting below.
* Peking, Palace Museum (former Shimamura collection). The Taoist sorcerer Chang Kuo-lao before the emperor T'ang Hsüan-tsung creating a small horse. Handscroll. Signed. Colophons by K'ang-li Nao (1295-1345), Wei Su, and Ch'ien-lung. See Siren CP VI, 40-41; Chugoku bijutsu III, no. 10; reproduction folio published by the Palace Museum, Peking. 1962: *Yüan Jen Jen-fa Chang Kuo chien Ming-huang t'u.*
* Ibid. Two horses, one strong and fat, the other lean and tired. According to the inscription by the artist, they symbolize two kinds of officials: the rich and fat (corrupt), and the poor and hard-working. Handscroll, ink and colors on silk. See Siren CP VI, 39; CK hua II, 10; Fourcade 31; Kokyu hakubutsuin, 34; Hills 72; article in Wen Wu, 1965 no. 8.
* Ibid. Two grooms bringing out four horses to their master, who is dressed in a red gown. Handscroll, ink and color on silk. For the first section, see CK ku-tai 59; also Li Chu-tsing's article in Artibus Asiae XXX/4, 1968, pl. 15. The first groom and the horse correspond to the opening of the former Lo Chen-yü scroll of 1504, see above, which may be a copy after this one.
* Shanghai Museum. Two ducks, one swimming in the water; four small birds in a hai-t'ang tree above. Two seals of the artist. See Shanghai 11; TSYMC hua-hsüan 18.
Taipei, Palace Museum (YV44). A *ch'in* player seated on a ledge by a stream.

Poem by the artist, signed. Ming work; another version of the composition in the Stockholm Museum is ascribed to Wen Cheng-ming. See KK shu-hua chi XXVI; Three Hundred M. 172; KK ming-hua V, 41; KK chou-k'an 67.

Ibid. (VA13e). Visiting friends in the autumn grove. Album leaf. Signed. Later work.

Ming-jen shu-hua 8. Two horses, one led by a groom, the other rolling on the grass. Signed. Much later work.

I-yüan chen-shang 9. Tangled trees. Signed.

I-lin YK 115/11. Two birds on a thorny branch by rock with bamboo. Signed. Cf. the "Wet Sparrows" picture in Japan attributed to Mu-ch'i—a copy?

Shinju-an, Kyoto. The layman P'ang and his family. Attributed. See Doshaku, 13.

Toso 150 (Nishiwaki Saisaburo). Emperor Yang-ti of Sui on horseback followed by court ladies in front of a palace. Crude Ming copy of earlier composition.

Ibid. 151-152 (former Count Omura; now Tokyo National Museum). Four hanging scrolls: the Four Accomplishments, Scholars engaged in music, wei-ch'i, painting, and calligraphy. Signed. Yüan-Ming works, probably not by Jen. See also Venice Exh. CAT. 933-6 for all four.

Ibid. 154 (Ogura Tsunekichi). Manjusri; half-length figure in a halo holding a book. Attributed. See also Pageant 310.

Kawasaki Cat. 5. A pair of pictures: a man playing the ch'in in a hall; a bamboo garden in snow and a man in a pavilion. Yüan period, not by Jen Jen-fa. See also Kokka 321; Choshunkaku 28-29; Sogen MGS II, 50-51.

Kokka 453. A branch with two peaches. Seal of the artist, probably a Japanese interpolation. Good Sung-Yüan work. Cf. Sogen MGS III, 58.

Ibid. 636 (Marquis Lanza d'Ajeto; formerly Asano). A caparisoned horse. Album leaf. Attributed. Good Yüan work. See also Venice Exh. Cat. 791.

Toyo, IX (Count Tanaka). Eggplants and Melon. Attributed.

Hikkoen 39. Branches of a bean plant in a bowl. Album leaf. Attributed. See also Sogen MGS III, 6.

Ibid. 38. A high official on horseback before a palace, followed by ladies on foot and men on horseback. Fan painting. Attributed. Not in his style.

Ibid. 37. An arhat seated on a rock; a serpent; a boy hiding his face in the robe of a monk. Early copy of a portion of the scroll by Fan-lung now in the Freer Gallery. Attributed. See Suiboku IV, 80.

Bijutsu XXX. A basket with fruits. Album leaf. Attributed.

The Art Academy (Geijutsu Daigaku), Tokyo. A pair of hanging scrolls representing the Four Accomplishments: playing the ch'in and practising calligraphy; playing chess and practising painting. Badly damaged. Attributed. No relation to Jen. See Toyo IX; Kokka 53, 57; Toso 148-149.

Kokka 412 (former Asano). Two horses and willow trees. Fragment of a handscroll. Attributed.

* Ibid. 403 (Marquis Asano). A horse tied to a post. Seals of the artist.

Ibid. 323 (K. Murakami). A saddled horse. Album leaf. Attributed.

Sogen MGS III, 56. Stalks of rice. Short handscroll? Attributed. Good work of early Yüan? Unrelated to Jen.

Nanga taisei IX, 41. Man on ledge under gnarled trees overlooking river. Signed.

Shimizu Collection, Tokyo. Men pulling boat. Horizontal hanging scroll, ink and colors on silk. Fragment of a handscroll? Attributed. Early Ming?

Yabumoto, Kozo, Amagasaki. Geese, Bamboo, and Reeds. Set of three hanging scrolls, ink on silk. Attributed, 14th-15th cent. works.

* Cleveland Museum of Art (60.181). Three horses and four grooms. Handscroll. Signed. See Yüan Exh. Cat. 188; Archives XV (1961), fig. 7; Sherman Lee and Wai-kam Ho, "Three horses and four grooms," Cleveland Museum Bulletin, XLVII, April 1961, 66-71; Smith and Weng, 194-5.

Nelson Gallery, K. C. (34.195). Three horses and four grooms. Signed.

Indianapolis Museum of Art (56.140). Grazing horse. Attributed. Probably a section of a handscroll, possibly a work of Jen Jen-fa; his style and period.

Victoria and Albert Museum (E. 32-1935). Feeding horses in a moonlit garden. Signed. Fragment from a copy of one of the scrolls listed above. See Ars Asiatica IX, p. 30; London Exh. Cat. 1119; Kodansha CA in West I, 29.

* W. Hochstadter, Hong Kong. Five Princes returning from a drinking party accompanied by three servants, all on horseback. Handscroll, ink and colors on paper. Seal of the artist.

JEN K'ANG-MIN 任康民

Unrecorded in Chinese books, mentioned in *Kundaikan Sayuchoki* (no. 38) among the Yüan painters and said to have executed wall-paintings, besides landscapes and figures.

Shimbi XVI (Count Matsudaira). A peddler, a woman and seven children around his stall. Fan painting. Attributed. See also Artibus Asiae 37/1-2.

Hikkoen 41. Landscape with trees by the river. Album leaf. Attributed. Fragment of Sung-Yüan painting.

JEN PO-WEN 任伯溫

From Sung-chiang, Kiangsu. Active in the 14th century. Grandson of Jen Jen-fa.

Asian Art Museum of San Francisco (B60D100). *Chih-kung t'u:* Tribute bearers. Handscroll. Signed. Another version of the same composition as the handscroll attributed to Han Kan in the Freer Gallery (15.16). See Yüan Exh. Cat. 189, Smith and Weng 193.

JEN TZU-CHAO 任子昭 , also called Jen Hsien 任賢 ? t. Tzu-liang 子良 .

From Sung-chiang, Kiangsu. Active in the 14th century. Son of Jen Jen-fa. Figures and horses. M, p. 86.

Cheng Te-k'un, Cambridge. A running horse without saddle. Album leaf.

Signed, dated 1348. Later work? See Yüan Exh. Cat. 190.

Peking, Palace Museum (exhibited Fall 1977). A red-cloaked man leading a grey horse. Small hanging scroll, ink and colors on silk. Signed: Tzu-liang.

JUNG-YANG 榮陽 or SHIH-CH'ING 時清
Unidentified; Yüan period?

Hikkoen 26. Bamboo growing by a rock. Album leaf. Seals of the artist. Fine work of late 13th or early 14th century?

K'ANG-LI NAO 康里巙 or K'ang Li Nao Nao 康里巙巙, t. Tzu-shan 子山 , h. Cheng-chai shu-sou 正齋恕叟, Shu-sou 恕叟, P'eng-lei-sou 蓬累叟. B. 1295, d. 1345. A Mongol; calligrapher. I. 37.

Taipei, Palace Museum (VA31c). Landscape with scholar. Album leaf. Seal with his name. Ch'ing dynasty work.

KAO JAN-HUI 高然暉
Unrecorded in Chinese books, mentioned in *Kundaikan Sayuchoki* (no. 71). Yüan period. Landscapes. Sometimes, though wrongly, identified with Kao K'o-kung. He may have been a Korean painter. See Bijutsu Kenkyu, no. 13 (1933), and also no. 38, in which a Japanese work called *So Gen gamei roku* 宋元畫名錄 quoting *Wen-fang man-lu* 文房漫錄 gives original family name as Ho 赫 .

Toso 199 (Tokitsugu Takano, formerly T. Ogura). A wooded slope, a herd-boy by the stream and a grazing buffalo. Attributed. Inscription by P'ing-shan Ch'u-lin (1279-1361). See also Bijutsu Kenkyu 13; Sogen meiga 30; Suiboku III, 108.

Konchi-in, Kyoto. Landscapes of Summer and Winter. Two hanging scrolls. Attributed. Korean paintings? or minor Yüan, provincial? See Toyo IX, 102, 103; Toso 197-198; Suiboku III, 110-111; Sogen MGS II, 48-49.

National Museum, Tokyo. Landscapes of Spring and Summer; pair of small hanging scrolls. Attributed. Both with inscriptions by Tu Kuan-tao, an official of the Hung-wu era; probably works of that period. See Toyo IX, 105-106; Min Shin no Kaiga 38-39; Yonezawa, Painting in the Ming Dynasty, 1; Suiboku III, 112-113.

Toyo IX, 104 (Akimoto). Summer mountains with a temple in mist. Attributed. See also Kokka 211; Nanju 3; Bijutsu kenkyu 13.

Homma Sogen, 52. Hills in mist, a temple, a traveler by the river. Attributed. Early Ming, school of Kao K'o-kung? (Same as above?)

Kyoto National Museum. A temple in the mountains. Fragment of handscroll? mounted as hanging scroll. Attributed. Minor Yüan-Ming work.

Fujita Museum, Osaka. A temple among trees. Ink on paper. Attributed (the

box reads "Hao Jan-hui" but presumably Kao Jan-hui is intended).
Note: The painting in Hikkoen 52, once ascribed to him, is now identified as a
work of Kao T'ing-li of the Ming period, q.v. See also Suiboku III, 115.
Also, the painting listed in Anonymous Yüan, landscape section, under
"Kyoto National Museum (Hosomi collection)" is sometimes attributed to
Kao Jan-hui, e.g. in Homma Sogen, 51.

KAO K'O-KUNG　高克恭　　(original name SHIH-AN　士安　) t. Yen-
ching　彦敬　, h. Fang-shan　房山　.
B. 1248, d. 1310. From Ta-t'ung, Shansi. The family had immigrated from
Eastern Turkestan. Appointed by Kublai Khan to an official position and made
President of the Board of Justice. Painted landscapes; followed Mi Fu and Mi
Yu-jen. H, 5. I, 53. L, 20. M, p. 331.

Ta-feng-t'ang I, 10. Hills in mist. Signed, dated 1291. Inscriptions by Yao
 Shih and Chieh-hsi Ssu (1274-1344). Old imitation or copy?
* Taipei, Palace Museum (YV15). Clearing after a spring rain over the moun-
 tains. Colophon by Li K'an dated 1299. See KK shu-hua chi XXXVII;
 CK ku-tai 55; CKLTMHC III, 3; Siren CP VI, 58.
KK shu-hua chi XIII. Mountains rising through spring clouds and morning
 mist. Signed, dated 1300. Ming imitation. See also Siren CP VI, 59.
* Taipei, Palace Museum (YV14). Verdant peaks above the clouds. Colophons
 by Li K'an (dated 1309), Teng Wen-yüan (1258-1328), Wang To (1592-
 1652), and Ch'ien-lung. See Ku-kung XI; Three Hundred M. 152; CAT
 70; CCAT 107; CKLTMHC III, 4; KK ming-hua V, 9; Nanking Exh. Cat.
 52; Wen-wu chi-ch'eng 61; KK chou-k'an 60; Siren CP VI, 57; Hills 19.
Freer Gallery (09.197). Mountains with clouds. Handscroll, ink on paper.
 Signed, dated 1313. Copy.
Siren CP VI, 60 (Hsü Hsiao-p'u, Taipei). White clouds circling grassy hills on
 a river-shore; a man on muleback crossing a mud-bridge. Short
 handscroll. Poem by the artist, dated 1313. Imitation.
Taipei, Palace Museum (YV13). Mist and rain over groves and hills. Signed,
 dated 1333 (!). Poems by Yü Ho (dated 1363), Wu K'uan (dated 1470)
 and Ch'ien-lung. Probably by Lu Yüan of the Ch'ing period. See KK
 shu-hua chi XXXIII; London Exh. Chinese Cat. 142; Wen-wu chi-ch'eng
 59; NPM Masterpieces V, 23.
* Peking, Palace Museum. Bamboo and rock. Signed. Colophon by Chao
 Meng-fu. See KKPWY hua-niao 22.
Shanghai Museum. Spring mountains before rain. Attributed. Early imita-
 tion? See Shanghai 9; Chugoku bijutsu III, no. 7; Bunjinga suihen III, 68.
* Taipei, Palace Museum (YV12). Mountains in rain. Signed. Poem by Ch'ien-
 lung. Early imitation? or genuine work in looser manner? See Ku-kung
 IX; London Exhib. Chinese Cat. 141; Three Hundred M. 153; Wen-wu
 chi-ch'eng 60; KK chou-k'an 59.
* Ibid. (YV16). Autumn colors on mountain peaks. Remains of seal of left mar-
 gin, illegible, may be the artist's. Early work in his style, if not by him.
Ibid. (YV17). Cloudy hills with a waterfall. Signed. Late imitation. See Three
 Hundred M. 154.

Ibid. (VA19p). Rain in the summer mountains. Fan painting. The painting belongs to the tradition of Hsia Kuei; the signature is an interpolation.

Ibid. (VA25e). Mist and rain over streams and mountains. Album leaf. Signed. Interesting work of later date—17th century?

Ibid. (VA35f). Clearing over autumn mountains. Double album leaf. Attributed. Imitation.

Note: The handscroll in the Palace Museum, Taipei (YH17), called "Anonymous Yüan," titled "White Clouds and Green Mountains" is in the style of Kao K'o-kung, and may be his work. See KK shu-hua chi VI; CKLTMHC III, 98; Skira 104. A number of other works close to Kao K'o-kung in style in the same collection: See under Anonymous Yüan, Landscapes.

Ming-pi chi-sheng II. Cloudy mountains. Attributed. Colophon by Wang Chien. Late imitation. See also Nanga Taikan 4.

Garland II, 7. A pair of cranes in front of a cloudy mountain. Inscription by Ch'en Chi-ju mounted above.

Eda Bungado, Tokyo. Landscape in Mi style. Ink on paper. Inscription by Wang Wen-chih ascribing it to the artist. Yüan work.

Sogen 40 (N. Masaki). River landscape with houses and leafy trees. Album leaf. Signed. Poem by the artist. Ming work.

Nanshu ihatsu II. Mist along a mountain ridge by a river; two men in a garden in the foreground. Short handscroll. Ming imitation.

Ibid. II. Evening mist along the river; houses on the shore. Short handscroll. Ming copy or imitation.

La Pittura Cinese 246 (former Del Drago, N.Y.). Misty landscape. Attributed. Early imitation or school work.

Freer Gallery (15.36a). Misty landscape. Album leaf. Signed. Old imitation, or copy?

Art Institute of Chicago (former Saito). Mountain landscape with a man in a pavilion and circling clouds. After Mi Fu. Signed. Imitation. See Toan 8.

Juncunc Collection, Chicago. Landscape. Short handscroll, ink and colors on silk. Signed. Colophon by Lo Chen-yü. Imitation.

K'O CHIU-SSU 柯九思 t. Ching-chung 敬仲 , h. Tan-ch'iu 丹丘
B. 1290, d. 1343. From T'ai-chou, Chekiang. Prominent connoisseur of paintings, calligraphy, and antiquities. He was ordered to examine the imperial collection in the T'ien-li era (1328-1330). Followed Wen T'ung as a painter of bamboo and old trees. H, 5. I, 53. L, 22. M, p. 262. For his dates see Tsung Tien, *K'o Chiu-ssu shih-liao*, Shanghai, 1963, pp. 181-200; some of the works listed below are also reproduced in this book (abbreviated below as K'o Chiu-ssu).

* Peking, Palace Museum. Bamboo by a garden rock. Dated 1338. Poems by Ch'ien-lung. See K'o Chiu-ssu, between pp. 44 and 45.

Garland II, 30 (Chang Ch'ün, Taipei). A branch of a phoenix-tailed bamboo. Signed, dated 1338.

Honolulu Academy of Arts (2218.1). Bamboo. Signed, dated 1340. Colophon by K'ung Kuang-t'ao.

* C. C. Wang, N.Y. A branch of bamboo, after Wen T'ung. Ink on silk. Signed, dated 1343. See Venice Exh. Cat. 786; K'o Chiu-ssu, between p. 44 and 45.

Taipei, Palace Museum (YV212). River landscape. Signed. Colophon by Yo Yü dated 1344. See KK shu-hua chi XXXVIII; K'o Chiu-ssu, between pp. 46 and 47.

Sogen 43 (Lo Chen-yü). A pavilion under leafy trees in autumn. Poem and colophon by the artist. Signed, dated 1345. Much later work.

* Shanghai Museum. A branch of bamboo. Short handscroll, signed. Appended to works ascribed to Su Shih and Wen T'ung, q.v.; K'o's painting is loosely based on Wen's. See Wen-wu, 1965 no. 8, p. 26.

* Ibid. Two branches of bamboo. Signed. See Ming-pi chi-sheng II, 3; Nanking Exh. Cat. 66; Che-chiang 35; Shanghai 26.

Taipei, Palace Museum (YV29). A pavilion built over a stream at the foot of high mountains. Signed. Ming imitation. See KK shu-hua chi XXXV; K'o Chiu-ssu, opposite p. 47.

* Ibid. (YV30). A tall bamboo and a chrysanthemum plant by a rock. Signed. Colophon by Yü Chi (1272-1348); poem by Ch'ien-lung. See KK ming-jen hua-chu chi; Three Hundred M. 180; CAT 79; CH mei-shu II; CKLTSHH; KK chu-p'u I, 2; KK ming-hua V, 48; NPM Quarterly I, 4, pl. 9; Wen-wu chi-ch'eng 63; KK chou-k'an 265; KK bamboo I, 3; Siren CP VI, 54.

Ibid. A bare tree and bamboos by a rock. Signed. 17th century work? See Ku-kung V.

Ibid. (YV31). Bamboo by a stone. Signed. See KK shu-hua chi III; London Exh. Chinese Cat. 155; KK bamboo I, 4.

Ibid. Branches of a blossoming plum tree. Signed. Ming painting. See KK shu-hua chi XXV; KK ming-hua mei-chi I, 3; NPM Quarterly III/3 (Jan. 1969), pl. 1A.

Ibid. (VA27f). The three friends: pine, plum and bamboo. Album leaf. Much later, crude work.

* Ibid. (VA29f). Bamboo growing from a rock. Fan painting. Signed. Poem. See KK chou-k'an VII, 134; CKLTMHC III, 35.

Ibid. (XV213, chien-mu). Kuan-yin on a bank by the water, with bamboo. Signed. Good 15th century painting with interpolated signature.

Garland II, 31 (N. P. Wong, Hong Kong, 1970). Bamboo. According to K'o's inscription, copied after Shih-hsüan, unidentified.

K'o Chiu-ssu, opposite p. 58. Morning colors in an autumn grove. Signed. Reproduction blurred.

Mei-chan t'e-k'an. Bamboo and a bare tree by a rockery. Signed. Reproduction indistinct.

Yu-cheng album, n.d. (ca. 1910). *Chu-p'u:* twenty leaves illustrating the technique of painting bamboo. Attributed. Inscriptions by Hsia Ch'ang; seals of Wen Cheng-ming, Ch'eng Sui, etc.; colophons by Tung Ch'i-ch'ang, Cha Shih-piao, and others.

Sogen 44 (Shao Hou-fu). An old knotted tree, bamboo and epidendrums by a rock. Signed. Imitation.

Mo-chu p'u (Hakubundo album, Osaka, 1929). Eighteen paintings of bamboo. Seals of Hsiang Yüan-pien, Wen Cheng-ming, Ch'ien-lung, etc. Copies or imitations.

* Osaka Municipal Museum (Abe collection). A branch of bamboo. Inscriptions by the painter and by Ch'ien-lung. See Soraikan II, 34; Osaka cat. 67.

* Yabumoto Kozo, Amagasaki. River landscape with fisherman. Fan painting. Seal of the artist. See Bunjinga suihen III, 67; Homma Sogen 49.

Juncunc collection, Chicago. Landscape with trees by a river. Ink on paper. Signed. Imitation.

KU AN 顧安 t. Ting-chih 定之

From Yangchou, Kiangsu. B. ca. 1295, d. ca. 1370. Served as a judge in Ch'üan-chou in the Yüan-t'ung era (1333-1334). Bamboo, followed Hsia Yüeh (of T'ang) and Wen T'ung. H, 5. I, 53. L, 52. M, p. 736.

Chung-kuo MHC 35 (Ti Pao-hsien). A branch of bamboo. Signed, dated 1345. Reproduction unclear. See also Chung-kuo I, 113.

* Shen-chou ta-kuan 4. Bamboo groves along a river. Short handscroll. Signed, dated 1349. Poem by Chang Yü.

* Taipei, Palace Museum (YV45). Bamboo by a rock in wind. Signed, dated 1350. See KK shu-hua chi I; KK ming-jen hua-chu chi; London Exh. Chinese Cat. 159; CH mei-shu II; CKLTMHC III, 71; CKLTSHH; KK ming-hua V, 40; KK chou-k'an 107; KK Bamboo I, 7; Siren CP VI, 53.

* Ibid. (YV46). Bamboo and rock. Signed, dated 1359. See CKLTMHC III, 72; Mei-shu t'u-chi II.

* Ibid. (VA9c). *Ch'üan-shih hsin-huang t'u:* New Bamboo Growing by a Rock. Album leaf. Signed, dated 1365. Inscription by Mo Chin-kung; seal of Ku Ning-yuan (late Ming). See CKLTMHC III, 73; KK ming-hua V, 39; KK Bamboo II, 7; KK chou-k'an 20; Nanking Exh. Cat. 388.

* Ibid. (YV47). Bamboo in the wind. Seals of the artist. See KK ming-hua chi XXXVI; KK ming-jen hua-chu chi; CH mei-shu II; CKLTMHC III, 70; KK Bamboo I, 8.

* Ibid. (YV172). Bamboo (painted by Ku An) and old tree (by Chang Shen); joint work, with an inscription by Yang Wei-chen. More bamboo and a rock added later by Ni Tsan, on separate paper, with an inscription dated 1373. See KK shu-hua chi V; KK ming-jen hua-chu chi; London Exh. Chinese Cat. 161; CH mei-shu II; CKLTMHC III, 74; KK chu-p'u I, 3; KK ming-hua VI, 38; KK chou-k'an 182; KK Bamboo I, 6.

* Ibid. (VA34d). Bamboo in ink. Horizontal album leaf. Several inscriptions, including one by Wang Ta dated 1396.

S. H. Hwa, Taipei (1965). A twisting branch of bamboo. Handscroll, ink on paper. Inscription, with seal of the artist.

* Hsü Shih-hsüeh collection. Bamboo and garden stone. Partly effaced signature. One colophon, by a contemporary, also partly effaced. See CK hua I, 17; TWSY ming-chi 103.

* Kichijo-ji, Komagome (on loan to Tokyo National Museum, 1973). Bamboo and rock, the bamboo done in outline and color. Three seals of the artist, one reading "Ku Ting-chih." See Suiboku IV, 24; Osaka Sogen 5-80; Kokka 996, with article by Toshio Ebine.
* Cincinnati Museum of Art. A single stem of bamboo. Signed. Two inscriptions. See Munich Exh. Cat. 34; Yün hui chai 39.

KU K'UEI 顧逵 or KU TA 顧達 , t. Chou-tao 周道
From Suchou. Active first half of the 14th century. Landscape, figures, portraits. H, 5. I, 53. M, p. 736.

National Museum, Stockholm. Chung K'uei seated under a tall tree. Signed.

KU TE-HUI 顧德輝
See Ku Ying.

KU YING 顧瑛 or KU TE-HUI 顧德輝 , t. Chung-yin 仲瑛 , h. Chin-su tao-jen 金粟道人
B. 1310, d. 1369. From K'un-shan, Kiangsu. Poet and connoisseur. L, 52. M, p. 736. (Note: an unpublished article by Chiang I-han maintains that Ku Ying did not paint at all, and that the first two paintings listed below are by a Ch'ing period painter of the same name, and the third an anonymous Ming work.)

Taipei, Palace Museum (YV95). Two mandarin ducks under reeds and *fu-jung* flowers. Poem by the artist. Colophon by Ch'ien-lung. See Chung-hua wen-wu chi-ch'eng IV, 370; KK shu-hua chi, XXXIII (as a Ch'ing work).
Ibid. (YV96). Poppies. Poem, signed.
Ibid. (VA69). A cabbage plant. Album leaf. Signed, two seals of artist. See KK shu-hua chi XXXIII.

KUAN TAO-SHENG 管道昇 t. Chung-chi 仲姬
From Wu-hsing, Chekiang. B. 1262, d. 1319. Wife of Chao Meng-fu. Calligrapher, painter of bamboo, plum blossoms, epidendrum, and landscapes. H, 5. I, 54. L, 70. M, p. 603. See also the article by Hsi Yü-ch'ing in *Ling-nan hsueh-pao,* v. III, no. 2, April 1934, 181-223; also the article by Ch'en Pao-chen in *Ku-kung chi-k'an (National Palace Museum Quarterly)* XI/4 (Summer 1977), 51-84.

Siren CP VI, 25 (T. Moriya, Kyoto). The purple bamboo retreat; a small landscape. Two inscriptions by the artist, one dated 1296. Later picture. See also Bunjinga suihen III, 56.
Howard Hollis, N.Y. Landscape. Signed, dated 1297. Small hanging scroll, ink on paper. Early imitation?

Princeton Art Museum. Tall bamboo growing by rocks. Hanging scroll, ink on paper. Signed, dated 1297. Ch'ien-lung and other seals.

Fogg Art Museum (1931.11). Lady Su Hui and her rebus. Painting in archaic style, followed by a series of palindrome poems in the style of the Sung period painter and rebus-maker Chu Shu-cheng. Signed, dated 1298. Copy?

Osaka Municipal Museum (Abe collection). Kuan-yin with a fish-basket, after Wu Tao-tzu. Signed, dated 1302. Poem by Chao Meng-fu. Inscription by Chung-feng Ming-pen (1277-1337). Copy of a work in the Yin-t'o-lo manner, with interpolated signature. See Soraikan II, 32; Chung-kuo I, 101; Chung-kuo MHC 19; Speiser Chinese Art III, 46; Suiboku IV, 115; Osaka Cat. 52.

Fujii Yurinkan, Kyoto. Two branches of bamboo. Ink on paper. Signed, dated 1305. Poem by Chao Meng-fu. Imitation. See Yurin taikan II.

* Taipei, Palace Museum (YH22). Bamboo grove along a river-bank. Short handscroll, part of the collected scroll of Yüan works called Yüan-jen chi-chin. Signed, dated 1308. See Three Hundred M. 150; CAT 90b (section); CH mei-shu II; KK ming-hua V, 8.

Museum of Fine Arts, Boston (08.133). Sections of bamboo stalks and branches. Handscroll. Colophon and poem by Kuan Tao-kuo, sister of the painter, dated 1309. Copy or imitation. See Siren CP in AM. Colls. 125.

National Museum, Tokyo (former Tokugawa collection). Sections of bamboo stalks and branches. Long handscroll. Colophon by the artist, dated 1313. Poem by Chao Meng-fu, copied by the painter. Imitation. See Toso 138; Sogen MGS III, 59.

Metropolitan Museum, N.Y. (13.220.99d). Bamboo. Album leaf. Signed, dated 1313. Imitation.

Preetorius collection, Munich. Mountain landscape with a bamboo grove. Ink on silk, much darkened. Poem by the artist, signed, dated 1315.

Pageant 267. An emaciated horse by a pine tree. Signed, dated 1321(!). Imitation of Ming date. See also La Pittura Cinese, 240.

Laufer 25. A bamboo grove on a river shore at the foot of misty mountains. Signed, dated 1322(!). Poems by Chao Meng-fu, dated 1324. Imitation.

Toso 139. Three figures in boat near wooded shore. Painted with Chao Meng-fu, q.v.; dated ping-tzu (1256 or 1326) in his inscription. Ming painting.

* Taipei, Palace Museum (YV5). Slender bamboo by a rock. Seal of the artist. Old imitation? Colophon by Tung Ch'i-ch'ang. See KK shu-hua chi XII; KK ming-jen hua-chu chi; London Exh. Chinese Cat. 140; Three Hundred M. 151; Che-chiang 22; KK ming-hua V, 7; Wen-wu chi-ch'eng 58; KK chou-k'an 156; KK Bamboo I, 2; Siren CP VI, 24b; Kokka 830 (pl. 9) and article by Kawakami Kei, p. 215 ff. See also article by Ch'en Pao-chen noted above.

* Ibid. (YV198, chien-mu). Eggplant. Seals of the artist and of Chao Meng-fu. Work of the period, perhaps genuine.

Peking, Palace Museum. A long branch of bamboo. Handscroll. Accompanies a similar painting by Chao Meng-fu.

N. P. Wong, Hong Kong. Bamboo and rock, the bamboo in the outline technique. Signed.

Chung-kuo MHC 27 (Ti Pao-hsien). Early Snow at Wu-hsing: a river landscape. Signed. Imitation. See also Chung-kuo I, 102.

Ibid. 2. A man in an open pavilion on a river shore among bamboo. Album leaf. Signed. Imitation.

Ogawa collection, Kyoto. Clumps of small bamboos among rocks. Long handscroll, ink on paper. Attributed. Yüan work.

Agata collection, Osaka (former Saito collection). Tufts of epidendrum. Signed. Painting of the period., with interpolated signature? See Toan 7; Kokka 555.

National Museum, Stockholm. The slender bamboos of spring. Album leaf. Poem by the painter. Imitation.

C. C. Wang, N. Y. Bamboo and rock. Attributed to Kuan in an inscription by Chao Meng-fu.

Yale University Art Gallery (formerly Moore coll.). River view with bamboo groves on the rocky shores. Handscroll. Signed. Imitation. See Laufer 26; London Exh. Cat. 1038; Moore Cat. 28.

Freer Gallery (11.501a-l). Album of landscapes with bamboo, ink on silk. Interesting Ming works in her tradition.

Seattle Art Museum. Bamboo growing by garden rock. Signed. Imitation.

Formerly Frank Caro, New York. Bamboo. Handscroll. Inscription composed by Chao Meng-fu and written by the artist. Imitation.

KUNG K'AI 龔開　t. Sheng-yü 聖予 , h. Ts'ui-yen 翠巖
From Huai-yin, Kiangsu. B. 1222, died 1307. Scholar, calligrapher. Landscapes after Mi Fu, figures and horses. H, 5. I, 52. L, 3. M, p. 749. Also biog. by James Cahill in Sung Biog. 64-69.

Li-tai IV (formerly Peking National Museum). Chung K'uei moving his residence. Handscroll. Signed. Seals of Yüan and Ming collectors. Colophons by Ch'ou Yüan (dated 1371) and by later men. Ming?

* Osaka Municipal Museum (Abe Coll.). An emaciated horse. Short handscroll. Poem by the painter mounted after the picture. Colophons by Yang Wei-chen (1296-1370), Ni Tsan, Hsiang Yüan-pien, Kao Shih-ch'i and ten other writers of the Yüan, Ming and Ch'ing periods. See Soraikan I, 18; Yüan Exh. Cat. p. 95, fig. 18; Li Chu-tsing, Artibus Asiae 30/4 (1968) pl. 14; I-lin YK 63/13, 4; Osaka cat. 45; Hills 2.

Toyo IX (T. Namba Coll.). Hilltops and trees in mist, after Mi Fu. Poem by the painter. Signed. Much later, unrelated to Kung. See also Nanju 16.

* Freer Gallery (38.4). *Chung-shan ch'u-yu t'u:* Chung K'uei, the demon queller, escorting his sister to her marriage, with a retinue of demons. Handscroll, ink on paper. Poem and inscription by the artist following the painting and colophons by later writers. See Siren CP III, 323-324; Freer Figure Ptg. cat. 35; Kodansha Freer Cat. 43; Suiboku IV, 118-120.

Ibid. (16.537). A man asleep in a boat near the shore. Inscribed with the painter's name and his seal. Ming work. See Siren CP in Am. Colls. 99; Pageant 280.

Ibid. (19.171). Wen-chi's Return to China. Handscroll. Attributed. See under Anon. Yüan, Figures, below.

Metropolitan Museum, N.Y. (24.44 and 47.18.12). The World of the Magic Pot: Taoist immortals in a landscape. Handscroll, ink on paper. Attributed. Ming work of Che School, perhaps by Cheng Wen-lin (Cheng Tien-hsien). See Los Angeles Exh. Cat. 1948, p. 16. Another section of the same in the Princeton Art Museum; see Rowley, Principles (old ed.), 6; Cahill, *Parting at the Shore,* 62.

Seattle Art Museum. Album of paintings illustrating the manufacture of clay roof tiles. Signature of Kung K'ai and (illegible) date. The paintings, although of good quality, are later (15th-16th century) in date.

KUO MIN　郭敏　t. Po-ta　伯達
Early Yüan dynasty. From Ch'i-hsien, Honan. Landscapes, figures, flowers, and ink bamboo. H, 5. M, p. 398. Hua-shih hui-yao.

* T'ai-shan series III, 9. Spring revels in the palace. Handscroll. Signed, dated 1270 (seventh year of Chih-yuan).

Imai Goichiro coll. auction cat., Tokyo, 1933, no. 17. Bamboo growing by a rock. Seals of the artist.

* Ching Yüan Chai collection, Berkeley. Wind and snow in pines and firs; house in a valley between towering mountains, three men drinking tea. Signed. See Yüan Exh. Cat. 223; Kodansha CA in West, I, 22; Bunjinga suihen II, 48.

Note: Cf. also the pair of paintings of boys and water buffalo in landscapes, formerly attributed to Li Ti, reproduced in Kokka 355; poems, signed *Po-ta,* in same hand as signature on the Ching Yüan Chai painting, above; probably by Kuo Min.

KUO PI　郭畀　t. T'ien-hsi　天錫　, h. T'ui-ssu　退思
From Ching-k'ou, Kiangsu. B. 1280, d. 1335. Landscapes after Mi Fu, bamboo. H, 5. I, 53. L, 60. M, p. 398. See Richard Rudolph, "Kuo Pi, a Yüan Artist and His Diary," Ars Orientalis III, 1959, pp. 175-188. See also Weng T'ung-wen "The Birth and Death Dates of Kuo Pi and Related Matters," *Ta-lu tsa-chih* vol. XXIV no. 7, April 1962, pp. 7-10. Also article by Tsung Tien, *Wen-wu* 1965 no. 8, pp. 36-39, in which he distinguishes this artist from the early Yüan collector-calligrapher Kuo T'ien-hsi, t. Yu-chih　祐之　, h. Pei-shan　北山　, from Chin-ch'eng in Shansi. The two are confused in later Chinese writings, and signatures and seals reflecting this confusion appear on some of the spurious works listed below.

Fujii Yurikan, Kyoto. Mountain landscape in the style of Mi Fu. Handscroll, signed, dated 1327. See Kohansha III. Seal reading *Chin-ch'eng Kuo-shih,*

i.e. mixing Kuo Pi and Kuo T'ien-hsi.

Taipei Palace Museum (YH9). Bamboo grove in snow. Short handscroll, signed. Colophons, the first by Teng Wen-yuan (d. 1328), written for a painting by Kuo Pi, although perhaps not the present work. Fine painting of Yüan date; the signature may be an interpolation. See KK ming-jen hua-chi; KK chou-k'an 122-123; CAT 78; KK Bamboo I, 5; NPM Masterpieces V, 29.

* Formerly Frank Caro, N.Y. (former Chang Ts'ung-yü). A cluster of bamboo branches. Short handscroll, signed. Done in the Chih-hsün era (1330-1333). See Toronto Exh. Cat. 14; Yün hui chai 30.

* Liu 42. Green Mountains and White Clouds, after Mi Fu. Handscroll, signed. Colophons, according to Tsung Tien (see above), by the monks Ch'i-tzu (dated 1333) and Tsu-ying (dated 1337); another by Ni Tsan (dated 1363).

Kokka 412 (former Hayashi and J. D. Ch'en collection). River landscape after rain. Signed, dated 1334. Imitation. See also Chin-k'uei 19; Pageant 307.

Sogen 70 (Chang Hsueh-liang). River landscape with leafy trees and hills rising through clouds. Signed, dated 1337 (after death of artist). Imitation.

Taipei, Palace Museum (YV43). Mountains in mist: illustration to two lines of poem by the fourth century poet Kao Shih-chün. Signed, dated 1339 (after death of artist). Late Ming? See KK shu-hua chi V; London Exh. Chinese Cat. 168; Three Hundred M 174; CH mei-shu II; KK ming-hua V, 42; KK chou-k'an 191; Nanga Taisei IX, 35; Pageant 309.

Ibid. (YV222, chien-mu). Reading the Changes in the Mountains. Signed. 17th century imitation.

Toso 199a (former Chin Shou-shu). River landscape in mist. Handscroll, signed. See also Siren CP VI, 63a.

* Kyoto National Museum (former Ueno collection). Old tree and bamboo. Short handscroll, signed. Colophon perhaps by Wu-wen, the recipient of the painting; another by Weng Fang-kang. See Sogen no Kaiga 79; Toyo bijutsu 76; Yüan Exh. Cat. 226; Genshoku 29, 72; Ueno Exh. Cat. Pl. 2.

Fogg Museum, Cambridge (Hofer collection). Morning Mists Over Rivers and Hills. Handscroll, much damaged and repainted. Attributed to Mi Fu, but a seal reading T'ien-hsi indicates that it may be by Kuo Pi.

KUO TSUNG-MAO　郭宗茂

From Ning-p'o. Active in the 14th century. Flowers and birds. L, 60. V, p. 398.

Chung-kuo MHC 36 (Ti Pao-hsien). Two ducks on the river shore. Attributed. Reproduction indistinct. See also Chung-kuo I, 116.

LAI-AN　賴菴

Probably a priest. Yüan period. Specialized in painting fishes. Recorded in *Kundaikan Sayuchoki* (no. 67).

Kokka 381 (Iwasaki collection). A fish. Short handscroll. Attributed. The seal on the picture reading Na-an is probably a Japanese interpolation. See also Pageant 413.

Ibid. 409 (Marquis Asano). Four fish among weeds. Seal of the artist, probably a Japanese interpolation. See also Pageant 412; Suiboku III, 94.

Hikkoen 21. Three fish. Section of a handscroll. Attributed. Good 14th century work.

Ogawa collection, Kyoto. Fish among weeds. Attributed.

Muto Cat. 21. A pair of pictures, each representing a fish. Attributed.

* Yabumoto Kozo, Amagasaki. Two fish and water-weeds. Horizontal hanging scroll, ink and colors on silk. Attributed. Fine Sung painting.

Choshunkaku 10. Carp. Two horizontal compositions mounted as a pair of hanging scrolls. Attributed.

Cheng Chi, Tokyo. A fish. Hanging scroll, on dark silk. Attributed.

Howard Hollis, N.Y. A fish. Hanging scroll, ink on silk. Attributed.

Fogg Museum (1929.238). A carp. Attributed.

* Nelson Gallery, K.C. A large carp swimming between aquatic plants. Good Yüan work. See Yüan Exh. Cat. 213; Suiboku III, 93; Kodansha Ca in West, II, 70.

LAN-AN CHÜ-SHIH　懶菴居士
For the landscape in the Chicago Art Institute bearing a seal with this name, which may be the artist's, see under Kuo Hsi, Sung.

LENG CH'IEN　冷謙　t. Ch'i-ching　啟敬　, h. Lung-yang-tzu　龍陽子
A semi-legendary Taoist from Wu-ling, Hunan. In the Chih-cheng era (1341-1367) he is said to have been more than 100 years old, but became a court musician in the Hung-wu era (1368-1398). Landscapes in the manner of Li Ssu-hsün. N, I, 10. O, 2. L, 49, I. M, p. 114. Also biog. by T. W. Weng in DMB I. 802-804.

* Taipei Palace Museum (MV1). The P'o-yüeh Mountain. Long inscription by the artist, describing his journey to Po-yueh with Liu Chi, who served as Prime Minister in the Hung-wu era. Signed, dated 1343. Odd, amateurish but possibly genuine work; or close copy? See KK shu-hua chi XLV. NPM Masterpieces V, 31. A late copy in the collection of Chang Ta-ch'ien; see Ta-feng-t'ang I, 19.

Ibid. (MV343, chien-mu). The Po-yüeh Mountain. Colophon by the artist copied from the above picture, with the same date. Early Ch'ing work of Anhui School? See Ku-kung XXVI.

Fujii Yurinkan, Kyoto. Clouds and woods in the purple valley. Signed, dated 1359. Imitation. See Yurin taikan II.

Ch'ing-kung ts'ang (2nd ed.). A thatched house under leafy trees in a river valley. Fan painting. Signed. Ming work with interpolated signature.

Freer Gallery (11.188). Playing Wei-chi in Paradise. Colophon dated in the Yung-lo era (1403-1424). Imitation.

H. C. Weng, New York. Landscape. Handscroll, ink and colors on silk. Attributed.

LI HENG 李亨 t. Ch'ang-shih 日時
Active ca. 1335-1340. Flowers and birds, pupil of Wang Yüan. Unrecorded in biographies of painters. The above information is supplied by Ch'ien Ku in his inscription on this picture.

Bunjin gasen I, 11 (Chin K'ai-fan). Flowering bushes and other plants growing by a rock; insects and frogs. Signed. Colophon by Ch'ien Ku (1508-1572). Poem by Pien Yung-yü (17th century). Chang Ts'ung-yü (article in Wen-wu 1964 no. 3) reattributes the work, probably correctly, to a Ch'ing dynasty painter of the same name. See also Toso 192; Siren CP VI, 115.

LI JUNG-CHIN 李容瑾 t. Kung-yen 公琰
First half of the 14th century. Specialized in boundary painting, followed Wang Chen-p'eng. H, 5. M, p. 197.

* Taipei, Palace Museum (YV48). Imperial palaces of the Han period built on cliffs over a river. Signed. See KK shu-hua chi XXXVI; Three Hundred M. 175; CKLTMHC III, 30; KK ming-hua V, 44.

LI K'AN 李衎 t. Chung-pin 仲賓 , h. Hsi-chai Tao-jen 息齋道人
B. 1245, d. 1320. From Chi-chiu, near Peking. President of the Board of Officials. Painted trees and bamboo. Author of the Chu-p'u 竹譜 , translated (German) by Aschwin Lippe in Ostasiatische Zeitschrift XVIII, 1942-43. H, 5. I, 53. M, p. 196.

J. P. Dubosc (formerly Nakanishi Bunzo, Kyoto and Fujii Yurinkan). Bamboo in a landscape. Handscroll, ink on paper. Signed, dated 1296. Colophons by Kao Shih-ch'i and others.
Chang Pe-chin, Taipei. Outline bamboo. Signed, dated 1300. See T'ien-yin-t'ang I, 8.
* Peking, Palace Museum. Ssu-ch'ing t'u: The Four Purities. Bamboo, Orchids, T'ung trees and Rocks. Handscroll, ink on paper. Inscription by the artist, dated 1307. Colophon by Chou T'ien-ch'iu (1514-1595); seals of Hsiang Yüan-pien and An Ch'i. See Wen-wu, 1956.1 (section). The Nelson Gallery painting listed below was probably originally a portion of the same scroll.
* Nelson Gallery, K.C. (48.16). Two spreading clumps of bamboo; bamboo shoots growing on a slope. Handscroll, ink on paper. Signed, with a dedication to Hsüan-ch'ing (presumably the same as the Yüan-ch'ing to whom the Peking scroll of 1307 is dedicated), whose poem on bamboo is transcribed in the first colophon, by Chao Meng-fu, dated 1308. Another

colophon by Yüan Ming-shan dated 1309. See Yüan Exh. Cat. 242; Siren CP VI, 48-49; Yün hui chai 10; NPM Quarterly I.4, pls. 4-5 (sections). Probably originally a portion of the same scroll as the Peking work, above.

Formerly P'ang Yüan-chi collection. Two branches of bamboo. Signed, dated 1310. See Freer Gallery study photo.

* Metropolitan Museum, N. Y. (1973.120.7; formerly C. C. Wang). Tall bamboo growing by a garden rock. Painted on two separate pieces of silk. Signed, dated 1318. See Yüan Exh. Cat. 241; Met. Cat. (1973) no. 24.

* Nanking Museum. Bamboo growing by a rock. Signed, dated 1319. See Gems I, 9; Nanking Museum Cat. I, 8.

* Japanese Imperial Household collection. Tall bamboo growing by rocks. Signed, dated 1320. See Sogen no kaiga 87; Toyo bijutsu 81.

* Peking, Palace Museum. Tall bamboo and a bare tree growing by rocks. Seal of the artist. See Chung-kuo ku-tai 60; KKPWY hua-niao 21; I-lin YK 74/1; Kokyu hakubutsuin, 175; Bunjinga suihen III, 60.

* Ibid. Tall bamboo growing on a bank. Ink and color on silk. Title *(Mu-yü,* "Bathed in Rain") and two seals of the artist. Seal of An Ch'i. See I-yüan to-ying, 1979 no. 1, p. 15.

Ibid. Bamboo on a cliff in rain. Ink and color on paper.

* Hsieh 98. Tall bamboo and other plants growing among rocks. Done in the *shuang-kou* method, in outline, with colors on silk. Large hanging scroll. Attributed? (No seal or signature visible).

* Taipei, Palace Museum (YV18). A pair of tall pines and brier bushes. Seal of the artist. See KK shu-hua chi XXI; Three Hundred M. 155; CKLTMHC III, 5; KK ming-hua V, 10; Nanking Exh. Cat. 51; KK chou-k'an 291.

* Ibid. (YV19). Four tall stalks of bamboo growing by a stone. Signed. See CCAT 106; Hills 75.

Ibid. (VA33i). Bamboo branch. Fan painting. Seal of the artist. Imitation.

C. C. Wang, N. Y. A branch of bamboo in the outline-and-color style. Signed. See Ta-feng-t'ang IV, 18.

Fujii Yurinkan, Kyoto. Bamboo. Album leaf, painted on silk. Inscription by Yang Kuo-ch'i. Attributed.

Tokuzenji Temple. Bamboo and rocks: pair of hanging scrolls. Seals of the artist. See Osaka Sogen 5-78.

Freer Gallery (19.159). Bamboo growing by a rock, with sparrows. Ink and colors on silk. Old attribution to T'ang Su of Sung; style and perhaps period of Li K'an.

* Indianapolis Museum of Art (60.142). Three dry pines and small bamboo on a rocky shore. Attributed. See Siren CP VI, 50; Yüan Exh. Cat. 224; Barnhart Wintry Forests cat. 8; Bunjinga suihen III, 59.

LI K'ANG　李康　t. Ning-chih　甯之
Native of T'ung-lu, Chekiang. Active ca. 1340-1360. M, p. 198. *Yüan Shih.*

Former Palace Collection(?). Fu-hsi seated on a rock holding brush and paper. Attributed. Ming academic work, cf. Wu Wei. See Nanking Exh. Cat. 76; Che-chiang 42.

LI SHENG 李升　t. Tzu-yün 子雲　, h. Tzu-yün-sheng 紫篔生
From Hao-liang. Active at the end of the Yüan dynasty. Painted bamboo,
rocks, and landscapes. H, 5. M. p. 197.

* Shanghai Museum. Wooded hills by the river, with temples and houses.
 Handscroll. Inscription by artist, signed, dated 1346. See Gems II, 7; CK
 hua I, 18-19; Chugoku bijutsu III, no. 19.
 Taipei, Palace Museum (VA5b). The Yüeh-tang Palace. Fan painting. Attri-
 buted. Long inscription in minute characters. Close in style to the work
 of his contemporary Hsia Yung. See KK ming-hua I, 19.
 National Museum, Stockholm. Mountain landscape. Ink and color on silk.
 Inscription by Fang Ts'ung-i.
* Mr. and Mrs. A. Dean Perry, Cleveland. Buddha's conversion of the Five
 Bhiksu. Handscroll. Signed. See Yüan Exh. Cat. 222; Bunjinga suihen
 III, 83; Liu 11 (as a Five Dynasties work). The Osaka Municipal Museum
 version of the "Ten Views of a Grass-thatched Hut" compositions by Lu
 Hung of the T'ang period (q.v.) is in a very similar style, and may be by
 Li Sheng; see Soraikan II, 26.

LI SHIH-AN 李士安
Yüan follower of Tung Yüan. Active ca. 1341-ca. 1367.

Yüan Exh. Cat. 267 (formerly Chiang Erh-shih collection). Hills by the river.
Handscroll. Signed. See also Chiang Erh-shih II, 6.

LI SHIH-HSING 李士行　　t. Tsun-tao 遵道　.
Son of Li K'an. B. 1283, D. 1328. Painted landscapes, bamboo, and stones.
H, 5. I, 53. M, p. 197.

* Cleveland Museum of Art (70.41). Old trees by a cool spring. Signed, dated
 1326. See Lee Colors of Ink cat. 11; Cleveland Bulletin, Feb. 1971, fig.
 125.
* Former Preetorius collection, Munich. Mountain landscape with bare trees.
 Signed, dated 1326. See Munich Exh. Cat. 10; Goepper Essence pl. 38 (as
 Anon. No. Sung).
 Taipei, Palace Museum (YV20). A twisting pine tree and bamboo growing by a
 stone. Signed. See Ku-kung XI; London Exh. Chinese Cat. 157; CH
 mei-shu II; CKLTMHC III, 24; CKLTSHH; KK ming-hua V, 11.
* Ibid. (YH5). River landscape in late autumn. Handscroll. Seal of the artist.
 Colophons by many Yüan and later writers. Poor but probably genuine
 work. See CH mei-shu II; CKLTMHC III, 23; KK ming-hua V, 12.
* Shanghai Museum. Two intertwined old trees and bamboo growing among
 rocks. Signed. Inscription by the Monk Chih-yüan. See Yün hui chai 13;
 Shanghai 13; Shanghai 15; Chugoku bijutsu III, 42; Bunjinga suihen III,
 61.

* Liaoning Provincial Museum. Tall bamboo growing by stones. Signed. See Liao-ning I, 88.

Peking, Palace Museum. Topped mountains rising above a stream. Signed.

Shen-chou ta-kuan hsü I. Plum tree. Inscription, with artist's seal.

* Fogg Museum, Cambridge. The Guardians of the Valley; two old pines on a river shore. Signed. See Yüan Exh. Cat. 225; Lee Landscape Painting 30; Munich Exh. Cat. 30.

LI T'I 李侗 t. Shih-hung 士弘 , h. Yüan-ch'iao Chen-i 員嶠眞逸
From T'ai-yüan, Shansi. 14th century. Served as a lecturer on the classics to the emperor. Followed Wen T'ung as a bamboo painter. H, 5. I, 53. L, 43. M, p. 197.

Sogen (formerly Lo Chen-yü coll.). Bamboo groves by a rocky shore. Section of a handscroll. Attributed. 17th century?

LI YAO-FU 李堯夫
Unrecorded in Chinese sources; mentioned only in Kundaikan Sayuchoki.

Choshunkaku 36. Tan-hsia meeting Lady Ling-chao. Ink on paper. Attributed. Good Yüan work.

Princeton University Art Museum (former Yabumoto Soshiro, Tokyo). Bodhidharma crossing the river on a reed. Signed. Inscription by I-shan I-ning (1247-1317). See Suiboku III, 42.

Ching Yüan Chai collection, Berkeley. Pei Hsiu paying his respects to Priest Huang-hsieh Hsi-yün. Attributed. Early Yüan period. See Yüan Exh. Cat. 210; Suiboku III, 53; Kodansha CA in West I, 60.

LIANG-CH'ÜAN 艮銓 h. K'o-weng 可翁 , Wu-shih 無事 and Ssu-k'an 思堪
Unrecorded. According to Shimbi XII, he went to Japan in 1299 and died there in 1317. Not to be confused with the Japanese artist Ryozen (name written with the same characters), active in the mid-14th century. See article by W. Speiser in *Sinica,* 1938, p. 254ff.

Shimbi XIII (Baron J. Go, Tokyo). An arhat and his servant standing on a promontory in front of a waterfall; a dragon appears in the clouds. Short handscroll. Seal of the artist(?).

LIN CHÜAN-A 林卷阿 t. Tzu-huan 子奐 , h. Yu-yu-sheng 優遊生
Landscapes, followed Kuo Hsi and Fang Ts'ung-i. K. Li Jih-hua, *Wei-shui-hsüan jih-chi.*

Taipei, Palace Museum (YH22). A broad river view, two men on the bank, two others in a boat. Inscription, signed, dated 1373. Mounted as part of the collected scroll of Yüan works called Yüan-jen chi-chin. See Nanking Exh. Cat. 79; Three Hundred M. 201; CH mei-shu II; CKLTMHC III, 84.

LIU KUAN-TAO 劉貫道 t. Chung-hsien 仲賢

From Chung-shan, Hopei. Active ca. 1270-1300. Painted Buddhist and Taoist figures, portraits and landscapes. He was summoned to paint the portrait of Kublai Khan in 1279. H, 5. I, 53. M, p. 659.

C. C. Wang, N. Y. The founders of the three religions with their disciples under trees. Signed, dated 1280. See Sogen 36.

* Taipei, Palace Museum (YV25). Emperor Kublai Khan and others hunting on horseback. Signed, dated 1280. Genuine? or later painting, with interpolated signature? See Chung-hua wen-wu chi-ch'eng IV, 356; Three Hundred M. 158; CCAT 108; CKLTMHC III, 14; KK ming-hua V, 17; Wen-wu chi-ch'eng 66; Siren CP VI, 42; NPM Masterpieces III, 30 and IV, 33; Smith and Weng, 196-7.

Taipei, Palace Museum (YV24). Two arhats seated under palm trees. Signed, dated 1356(!). Late imitation. See KK shu-hua chi VI; KK chou-k'an 501; Nanking Exh. Cat. 56.

Ibid. (MH3). Seven sages. Handscroll, ink and colors on silk. Signed Liu Chung-hsien, dated 1437(!). Interesting late Ming archaistic work. See CCAT 113.

Ibid. (YV23). Mountains and pavilions in snow by a river. Poem by Ch'ien-lung. Ming picture, cf. Li Tsai etc. See KK shu-hua chi XV; KK chou-k'an 170.

Toso 146a (Kuo Tse-yün). The Taoist immortal Ko Hung moving his residence. Handscroll. Ming work.

Freer Gallery (16.110). Three poets under a pine tree. Late Ming picture. See Siren CP in Am. Colls. 152.

* Nelson Gallery, K. C. (48.5). A man reading on a couch in a garden, attended by two women servants; a screen behind, on which is painted another screen with a landscape. Old attribution to Liu Sung-nien, but a small signature "Kuan-tao" on the left margin, discovered by the modern collector Wu Hu-fan, identifies him as the artist. Colophon by Li Shih-ta dated 1618. See Yüan Exh. Cat. 198; Li-tai jen-wu 29 (section); Siren CP VI, 43; Hills 68-9. A free copy in the Freer Gallery (11.232), early or middle Ming in date, to which is attached a Taoist treatise on "Nourishing the Vital Principle," written in the Yung-cheng era.

Former C. C. Wang, N. Y. Meng-tieh t'u: the Dream of Chuang-tzu. Handscroll, ink and colors on silk. Originally mounted together with the Nelson Gallery picture listed above; but the two are apparently not by the same hand. See Venice Exh. Cat. 787; Garland II, 13.

Juncunc collection, Chicago. Album of 6 fan paintings, palace scenes. Attributed to Liu Kuan-tao by the late collector Wu Hu-fan. Various other paintings in this style could be associated with Liu, or with early Ming

followers of this tradition; see under Li Sung, Sung, for a group of them; also the "Anonymous Sung" painting "Whiling Away the Summer" in Suchou 2, and several fan paintings in Yüan-jen hua-ts'e, 1.

LIU MIN-SHU　劉敏叔
Active in the Yüan period. Probably identical with Liu No　劉訥 t. Min-shu 敏叔 . M, p. 658-659.

* Freer Gallery (16.584). Portraits of three great Sung period Neo-Confucian philosophers: the Ch'eng brothers and Chu Hsi. Title and signature of the artist.

LIU SHAN-SHOU　劉善守
Active in the second half of the 14th century.

Cleveland Museum of Art (71.132). Butterfly and day lilies. Signed. See Ta-feng-t'ang I, 18; Lee Colors of Ink cat. 21.

LIU TZU-YÜ　劉子輿
Active at the end of Yüan and the beginning of the Ming dynasty.

Peking, Palace Museum. Landscape. Handscroll, ink on paper. Mounted together with similar paintings by Chang Kuan, Chao Chung and Shen Hsüan.

LIU YIN　劉因　t. Meng-chi　夢吉
From Yung-ch'eng, Hopei. B. 1249, d. 1293. Better known as a writer and philosopher. Biography in the Yüan Shih.

Osaka Municipal Museum. A fisherman in a boat on the river; trees on the shore. Inscription, signed. Good early Ming work, with interpolated inscription? See Soraikan II, 35; Osaka Cat. 49.
Musée Guimet, Paris (AA217). A mountain river. Seal of the artist.

LIU YÜAN　劉元　or　原
Unrecorded in books on painters. According to the colophon on the following picture, he was among the most famous professional painters in Northern China during the Chin and Yüan dynasties. Known also as a sculptor. Executed wall paintings in temples.

* Cincinnati Museum (1948.79). The Dream of Ssu-ma Yu. Short handscroll. Signed. Long colophon by Chang Ts'ung-yü of the 20th century. See I-shu ch'uan-t'ung VIII, 2; Yün-hui-chai 6; Yüan Exh. Cat. 199; Munich

Exh. Cat. 26.

LO CHIH-CH'UAN 羅稚川

A native of Ling-chiang, Kiangsi. Unrecorded in Chinese biographical works, but mentioned in Wu Ch'i-chen's *Shu-hua chi* (late Ming), p. 98, in Li K'ai-hsien's *Chung-lu hua-p'in,* and in Korean and Japanese record books as a scholar and associate of noted literati of the time.

* Tokyo National Museum. Birds gathering in knotty old trees on a riverbank in winter. Fragment of a handscroll? See Genshoku 29/24; Sekai bijutsu zenshu XIV, 72; Bunjinga suihen III, 80.
* Metropolitan Museum, N. Y. (1973.121.6; former C. C. Wang). Crows in old trees. Seal of the artist. See Met. Cat. (1973), no. 16; Barnhart Wintry Forests cat. 9.
* Cleveland Museum of Art (15.536). Ramblers over a windy stream. Fan painting, ink on silk. Seal of the artist. See China Institute Album Leaves no. 55, ill. p. 59; Yüan Exh. Cat. 215; Lee Scattered Pearls over the Ocean no. 11; Lee Colors of Ink cat. 22; Bunjinga suihen III, 81. See also Cleveland Museum (19.974), Bunjinga Suihen III, 82, also Yüan Exh. Cat. 218, closely related to Lo Chih-ch'uan in style, perhaps his work.

LU KUANG 陸廣 t. Chi-hung 季弘 , h. T'ien-yu 天游

From Suchou. Active during the second quarter of the 14th century; latest recorded work 1359. Painted landscapes. I, 54. M, p. 417. Also biog. by Chu-tsing Li in DMB I, 994-5.

Taipei, Palace Museum (YV105). Towers and pavilions on the mountains of the immortals. Inscribed, signed, dated T'ien-li 4 (1331/1332?). Colophons by Li K'ai (1245-1320), Tung Ch'i-ch'ang, Li Jih-hua and Cha Shih-piao. Poem by Ch'ien-lung. See KK shu-hua chi VIII; KK ming-hua VI, 22; KK chou-k'an 118; Nanking Exh. Cat. 67. Another version in the collection of Cheng Chi, Tokyo.

Ibid. (YV106). The Five Auspicious Plants. Signed. Poem by Liu Chüeh (1410-1472). Late Ming? See KK shu-hua chi XVI; London Exh. Chinese Cat. 163; KK chou-k'an 206.

Shanghai Museum. A man in an open pavilion by a river. Colophon by Wu K'uan (15th century) attributing it to the master. Early Ming work by lesser master? See Gems I, 14; Shanghai 24.

* Chung-kuo MHC 23 (former Manchu Household). Spring in the Tan-t'ai Mountains. Signed. Poems by the artist and Ch'ien-lung. Colophon by Tung Ch'i-ch'ang. See also Chung-kuo I, 92; Chugoku II; Siren CP VI, 138a; Ch'ing-nei-fu 6.

Nanshu ihatsu IV. River landscape. Signed. Poem by Wang Lo-yü. 17th century? See also Shen-chou 6.

* Princeton Art Museum (L215.69, former C. C. Wang and Yamamoto collections). *Tan-t'ai ch'un-hsiao:* Alchemist's Terrace in the Dawn of Spring.

Poem by the artist. See Chung-kuo I, 93; Bunjin gasen I, 2; Yüan Exh. Cat. 263; Siren CP VI, 83b; Chung-kuo MHC 1; Liu 39; Bunjinga suihen III, 75.

* J. T. Tai, N. Y. A pavilion among rocks by a river on a clear autumn day. Poem by the artist. See Toso 160; Siren Later CP I, 6; Munich Exh. Cat. 37.

MA SHIH-CH'ANG 馬世昌
Unidentified. Yüan period?

Taipei, Palace Museum (VA26j-k). Pair of album leaves: Birds on a ginko branch; yellow bird on a cherry branch. Each signed.

MA SHIH-TA 馬世達
Unidentified. Yüan period? From Yen-shan 燕山 , according to his signature on the painting below.

Metropolitan Museum, N. Y. (47.18.22). Cabbage. See Siren, Bahr Cat. pl. XXIV; Priest article in their *Bulletin,* January 1948, p. 10.

MA WAN (also read YÜAN) 馬琬 t. Wen-pi 文璧 , h. Lu-ch'un 魯純 , or Lu-tun 魯鈍
From Nanking. Active ca. 1325-1365. Governor of Wu-chou, Kiangsi in the Hung-wu period. Painted landscapes; followed Tung Yüan and Mi Fu. I, 55. M, p. 339.

Taipei, Palace Museum (YV302, chien-mu). Cottages in the mountains among pines. Signed, dated 1328. 17th century with interpolated inscription. See KK shu-hua chi XXXVIII.

Ibid. (YV301, chien-mu). Rain over Hills and Rivers. Signed, dated 1342. Early Ch'ing, cf. Wang Chien.

Sackler collection, N. Y. (former Chang Ts'ung-yü). River landscape with sailing boats; travelers on the shore. Signed, dated 1343. Inscriptions by Yang Wei-chen and another writer. See Yün hui chai 50; Marilyn and Shen Fu, *Studies in Connoisseurship,* 1; NPM Quarterly VII/3 (Spring 1973), 31-61.

* Taipei, Palace Museum (YV118). High terraced and deeply creviced mountains in snow. Signed, dated 1349. Original? or close copy? *Ssu-yin* half-seal. See KK shu-hua chi X; CKLTMHC III, 78; KK ming-hua VI, 31; KK chou-k'an 127; Siren CP VI, 79.

* Shanghai Museum. *Mu-yün shih-i t'u:* Evening Clouds Arouse Poetic Thoughts. Signed, dated 1349. See I-shu ch'uan-t'ung IX, 1; Shanghai 30; Chugoku bijutsu III, no. 30.

Shen-chou ta-kuan 10. Bidding farewell; boats waiting at the shore. Short handscroll. Signed, dated 1360. Fine work; but of Ming date?

Chung-kuo MHC3 (Ti Pao-hsien). High wooded mountains with cottages in autumn. Signed, dated 1360. Later copy or imitation. See also Chung-kuo I, 105.

Nanshu ihatsu IV. Trees by a stream in mist, a man standing on the shore. Signed, dated 1361. Late Ming work of Suchou school with interpolated inscription.

* Taipei, Palace Museum (YH22). Clearing over spring mountains. Short handscroll. Signed, dated 1366. Part of the collected scroll of Yüan works called Yüan-jen chi-chin. See Nanking Exh. cat. 79; Three Hundred M, 198; CAT 90e; CH mei-shu III; CKLTMHC III, 80; KK ming-hua VI, 30; Hills 62.

Ibid. (YV119). Mountains in autumn with travellers. Attributed to the artist in an inscription by Tung Ch'i-ch'ang. Fine work of the 16th century? See KK shu-hua chi XLIII; CKLTMHC III, 79; KK ming-hua VI, 32.

Ibid. (YV120). An angler in a boat by the shore in autumn. Signed. Colophon by T'ao Tsung-i. Imitation. See KK shu-hua chi I; CH mei-shu III; KK ming-hua VI, 33; Wen-wu chi-ch'eng 79; KK chou-k'an 500; Siren CP VI, 80.

Ibid. (YV304, chien-mu). A Ferry on the River in Spring. Minor 15th century work with interpolated signature?

J. D. Ch'en Cat. 32. Scholar in autumn grove. Inscription, signed. Colophon by Wu Hu-fan. Ch'ing painting.

Ming-pi chi-sheng I (P'ang Yüan-chi). Clouds and mist on a spring morning. Signed. Much later work.

* Kokka 492 (former Manchu Household collection). River landscape with groves of leafy trees. Handscroll. Signed. Seals of Hsiang Yüan-pien, Kao Shih-ch'i, and others; poem by Ch'ien-lung.

Osaka Municipal Museum (Abe collection). Summer mountains before rain, pavilions over the stream. Signed. Ming imitation. See Soraikan II, 42; Nanshu ihatsu IV; Osaka Cat. 64.

Kyuka I. An immortal with a gourd. Signed (at age 69).

Cincinnati Art Museum (1948.83; former Chang Ts'ung-yü). A quiet river at the foot of misty mountains. Signed. Inscription by Tung Ch'i-ch'ang.

Walter Hochstadter, Hong Kong. A river valley with houses and figures. Signed. Good 16th century work of Suchou School, cf. Yu Ch'iu.

* Ching Yüan Chai coll. Travelers on a river shore; hills beyond. No signature or seal, but attributable to Ma Wan on the basis of style. See Bunjinga suihen III, 78.

MAO LUN 毛倫 t. Chung-hsiang 仲庠 . h. Yü-hsien 寓軒
Native of Shao-hsing, Chekiang. Trees and rocks in Li-Kuo tradition; water buffalo in ink. See note by Ebine in Genshoku 29, p. 45, which mentions two other buffalo pictures by him preserved in Japan.

Nezu Museum, Tokyo. Buffalo and herdboy. See Suiboku III, 25; Genshoku 29/23.

Myokoji Temple. Water Buffaloes and herdboy. See Suiboku IV, 121.

Suiboku IV, 16, 122. Grazing water buffalo. Seals of the artist. Inscription above by Chao Meng-fu.

Tokuzenji Temple. Old trees on a bank. See Osaka Sogen 5-79.

MEN WU-KUAN　門無關
See P'u-men.

MENG YÜ-CHIEN　孟玉澗　Original name MENG CHEN　孟珍　t. Chi-sheng 季生　, h. T'ien-tse　天澤
From Wu-ch'eng, Chekiang. Active 14th century. Painted flowers, birds and landscapes in blue and green. H, 5. L, 57. M, p. 225.

Toso 191 (T. Ogura). Two mandarin ducks on a snowy river-bank; bamboo and blossoming plum. Signed, dated 1326. Ming work? See also Suiboku III, appendix 33.

* Taipei, Palace Museum (MV24). Three magpies and spring flowers. The attribution to Pien Wen-chin is mistaken; the style is earlier, and a seal of Meng Yü-chien is in the lower right corner. See Ku-kung VII; NPM Masterpieces I, 30; Hills pl. 8.

* Kokka 251 (Lo Chen-yü). A bird in a loquat tree. Signed. See also Pageant 371.

Moriya collection, Kyoto. Landscape: mountains, bridges and trees. Seal of the artist.

Bijutsu XII. Wooded hills in mist. Short handscroll. Poem by the artist.

Fujita Museum, Osaka. Small bird on paulownia branch. Attributed.

Suiboku. III, 103. Winter landscape with travellers on donkeys. Attributed. Inscription by Tuan-shan Cheng-mien, unidentified. Yüan work, unrelated to him? See also Osaka Sogen 5-33.

* Princeton Art Museum (former Count T. Tokugawa). River landscape with temple buildings, boats and flocking wild geese. Album leaf. Attributed. Good work of the period. See Shimbi XI; Toyo IX; Toso 190.

Ching Yüan Chai collection, Berkeley. Forested shore, with two boats nearby. Horizontal composition. Seal reading "Yü-chien." See Suiboku III, 101.

NI TSAN　倪瓚　t. Yüan-chen　元鎮　, h. Yün-lin　雲林　, Yü 迂　, Ching-ming Chü-shih　淨名居士
From Wu-hsi, Kiangsu. B. 1301, d. 1374. Poet, calligrapher and painter of landscapes. One of the "Four Great Masters" of the Yüan period. H, 5. I, 54. L, 11. M, p. 314. Also biog. by Chu-tsing Li in DMB II, 1090-1093; and by John Ayers in EWA X, 659-661. See also Ni Yün-lin, by Cheng Ping-shan; and *Ni Tsan,* by Cheng Cho-lu, both published in the CKHCTS series, Shanghai, 1958 and 1961; Wang Chi-ch'ien, "The Paintings of Ni Yün-lin," NPM Quarterly I, 3 (Jan. 1967), pp. 15-38.

Freer Gallery (16.547). River landscape with pavilion. Inscription, signed, dated, 1336. Imitation.

* John M. Crawford Jr., N. Y. A man in a pavilion under autumn trees by a river; low hills beyond. Two inscriptions by the artist, the first dated 1339, the second 1354. Four colophons by Wu K'uan and others. Badly damaged and retouched. See Ta-feng-t'ang IV, 21; Crawford Cat. 48; NPM Quarterly I, 3, pls. 1-2; Hills 47; Bunjinga suihen III, 35.

Agata collection, Osaka (former Saito collection). River landscape with tall trees in the left foreground. Poem by the artist, dated 1341. Imitation. See Toan 12.

Nanshu ihatsu IV. Trees by a river in autumn. Poem by the artist, signed, dated 1342. Poem by Shen Chou, colophon by Tung Ch'i-ch'ang. Imitation.

* Garland II, 28 (Wang Shih-chieh, Taipei). Five trees. Inscription by the artist, dated 1342. Inscriptions by Shen Chou and Chan Ching-feng (dated 1591) mounted above.

Hakubundo album, 1918 (Ueno collection). *Yün-lin liu-mo.* Album of six leaves: landscapes, rocks and trees. Inscriptions, signed, two of them dated 1342 and 1343. Seal on last leaf reading "Meng-yang," probably identifying the actual artist as the late Ming master Ch'eng Chia-sui; work of that period in any case.

* *Shui-chu-chü t'u:* The River-Bamboo Dwelling. Hanging scroll, in color. Inscription by the artist dated 1343; others by the monk Liang-ch'i and Wen Cheng-ming; seals of Hsiang Yüan-pien. Genuine work. See *Jen-min hua-pao, 1978, p. 10.*

Freer Gallery (15.26). Spring mists over a riverside pagoda. Poem and colophon by the painter, dated 1344. Late imitation.

* Chung-kuo MHC 37 (P'ang Yüan-chi). *Liu-chün-tzu:* the Six Gentlemen. Six trees on a river shore; low hills in the distance. Colophon by the artist, dated 1345. Poems by Huang Kung-wang and three other writers. Close copy? Or original? See also Chung-kuo I, 89; Toso 179; Bunjin gasen II, 13; Pageant 352; Ni Tsan 1; Ni Yün-lin 1; NPM Quarterly I, 3, pl. 3; Siren CP VI, 94.

C. C. Wang, N. Y. Landscape with leafy trees. Ink on silk, in the manner of Chiang Ts'an. Poem, signed, dated 1346. Painting of the period, with a genuine inscription by Ni Tsan; sometimes ascribed to him, but more likely by Chang Hsün, whose inscription it bears, along with another by Li Tsuan.

Osaka Municipal Museum (Abe collection). River view with scattered trees and a low pavilion. Large album leaf. Poem by the artist, dated 1348. Poems by two other writers. Good work of early Ch'ing period. See Soraikan II, 37; Speiser Chinese Art III, pl. 51; Osaka Cat. 60.

Taipei, Palace Museum (VA7i). Sparse trees and distant mountains. Album leaf, ink on paper. Signed, dated 1349. Ming painting of good quality.

Ibid. (YA3). *Hua-p'u:* studies of rocks, trees, etc. Album of 10 leaves. Inscriptions, one signed, dated 1350. Colophon by Tung Ch'i-ch'ang. Ming works.

Ming-hua sou-ch'i I, 1. River landscape; spare trees on the cliffs. Poem by the artist, dated 1350. Imitation.

Taipei, Palace Museum (YV267, chien-mu). River landscape with leafy trees in the foreground. Inscription by the artist, signed, dated 1351. Colophons by Ch'en Ju-yen, Yang Wei-chen, Yao Shou, etc. Ch'ing period imitation. See KK chou-k'an 176; KK shu-hua chi 13.

* Ch'ing-kung ts'ang 61 (former Manchu Household collection). Two cottages on a hill-slope at the foot of a mountain by a river. Large album leaf. Colophon by the artist, dated 1352. Poem by Hsü Pen. Perhaps genuine, although in uncharacteristic style. See also Bunjin gasen II, 15; Siren CP VI, 96; Pageant 351; Sung-Yüan pao-hui IV, 13; Ch'ing Nei-fu 4; Siren ECP 121.

C. C. Wang, N.Y. (former J. D. Ch'en). Two leafless trees and bamboo growing by stones. Inscription by the artist, dated 1353. Colophons by Wen Cheng-ming and Chang Ta-ch'ien. Seals of Pien Yung-yü, Chu Feng-ch'ing, and others. See NPM Quarterly I, 3, pl. 4; Archives XXX, p. 121, fig. 48.

* Taipei, Palace Museum (YV87). A pavilion under tall trees by a river. Ink on silk. Poem by the artist, dated 1354. Colophon above the picture by Tung Ch'i-ch'ang. See KK shu-hua chi XVII; CKLTMHC III, 61; Ni Tsan 2; Ni Yün-lin 2; NPM Quarterly I, 3, pl. 5; Nanking Exh. Cat. 60; KK chou-k'an 217; NPM Masterpieces I, 25; Yüan FGM 301.

* Shanghai Museum. *Yü-chuang ch'iu-chi:* Clearing in Autumn near a Fishing Lodge. River scene with sparse trees on a promontory, low hills beyond the water. Inscription, signed, dated 1372, stating that the painting was done in 1355. The painting is genuine, but may have been painted in 1372 instead of 1355. See Shanghai 20; Chugoku bijutsu III, 15; Ming-pi chi-sheng V; Mei-chan t'e-k'an; Ni Tsan 4; Hills 49; Bunjinga suihen III, 20-22.

* Ibid. Trees and bamboo growing on a rocky bank. Poem, signed, dated 1357. See Shanghai 21.

Ibid. (former Ti Pao-hsien). Bamboo and trees; a cliff with a waterfall. Poem and colophon by the artist, dated 1360. Good Ming work, cf. Liu Chüeh. See Chung-kuo I, 88; Chung-kuo MHC 30; CK hua I, 20; Ni Tsan 5.

Tokyo National Museum. River landscape; illustration to two lines of a poem by Tu Fu. Colophon by the artist, dated 1361. Good work of much later period. See Nanshu ihatsu IV; Toyo bijutsu IV, 42; Tokyo N. M. Cat. 37.

Taipei, Palace Museum (VA6g). Landscape. Album leaf. Signed, dated 1361. 17th century imitation.

Ibid. (YV173). Looking at the waterfall. According to the inscription, painted with Wang Meng, dated 1361. Colophon by Tung Ch'i-ch'ang. Imitation. See KK shu-hua chi II; KK ming-hua VI, 39; Nanking Exh. Cat. 63; KK chou-k'an 495; Yüan FGM 302.

Ibid. (YV273, chien-mu). A house among trees by the river. Inscription, signed, dated 1361. Inscriptions by Sung K'o and Kao Ch'i. Good Ming imitation.

Bunjin gasen I, 1 (Setsu Gatodo, Tokyo, 1977). River landscape; a pavilion on the shore. Large album leaf? Signed, dated 1362. Heavily repainted, but

possibly genuine; old in any case. See also Toso 178; Ni Yün-lin 3.

Freer Gallery (38.9; former P'ang Yüan-chi). Another version of the same composition as the preceding picture. Signed, dated 1362. Accompanied by a letter written by the artist. Copy. See Bussagli pl. 45.

Metropolitan Museum, N. Y. (18.124.6). River valley with thin pine-trees. Signed, dated 1362. Colophon by Wen P'eng. Late, free imitation.

Wen-wu Magazine, Shanghai, 1933 (copy in Harvard-Yenching Institute). The Ch'ing-pi-ko, Ni's studio. Inscription, signed, dated 1362. Inscription by Liang Chang-chü. Ming imitation?

Taipei, Palace Museum (VA25c). Autumn woods and far mountains. Album leaf. Signed, dated 1362. Imitation.

Ibid. (YH14). *Shui-chu chü:* the Water-Bamboo Dwelling. Houses among bamboo and trees by the river. Handscroll. Inscription, stating that the picture was painted in 1362 for Wang Chung-ho and represents his villa. Another inscription by Yü Ho. Early Ch'ing work, probably by Wang Hui, perhaps based on a Ni Tsan original. A different painting with the same inscription, also a handscroll, owned by J. T. Tai, N. Y.; it is a free copy of the Ni Tsan *An-ch'u chai* composition in the Palace Museum, Taipei (see below). See Kwen Cat. 57.

National Museum, Stockholm. River landscape. Signed, dated 1362. See Nanga shusei III, 4; I-yüan chen-shang 1.

* Taipei, Palace Museum (YV82). Mountains Seen from a River Bank. Poem by the artist, dated 1363. See KK shu-hua chi XIX; London Exh. Chinese Cat. 160; Three Hundred M. 185; CAT 84; CH mei-shu II; CKLTMHC III, 52; CKLTSHH: KK ming-hua VI, 9; NPM Quarterly I, 2, pl. XXXI and I, 3, pl. 7A; Wen-wu chi-ch'eng 82; KK chou-k'an 242; Siren CP VI, 97a; Hills 48; Yüan FGM 304.

* John M. Crawford Jr., N. Y. Wind among the trees on the stream bank. Signed, dated 1363. See Crawford Cat. 49; Shen-chou ta-kuan 13.

Mo-ch'ao pi-chi, II. A house on the shore, leafy trees. Signed, dated 1363. Imitation.

Ling Su-hua 1. River landscape with pavilion. Inscription by the artist, dated 1363. Inscription by Hsü Pen and many other writers. Imitation.

Taipei, Palace Museum (YV91). Fresh bamboo and dry trees at a stone. Poem and inscription by the artist, signed, dated 1363. See Ku-kung XXV; CKLTMHC III, 55; KK ming-hua VI, 11; NPM Quarterly I, 3, pl. 6; Nanking Exh. Cat. 62; KK chou-k'an 270; KK Bamboo II, 8; Yüan FGM 303.

* Peking, Palace Museum (former Kuo Pao-ch'ang). Portrait of Yang Chu-hsi (Yang Chü) in a landscape. The figure by Wang I, the trees and stones by Ni Tsan. Short handscroll. Inscribed, signed, dated 1363. See Sogen 64; CK hua XVIII, 16; Li-tai jen-wu 40; TSYMC hua-hsüan 27; Oriental Art, o.s. vol. III, no. 1 (1950), p. 29.

Garland II, 27. Trees, bamboo, and rock. Inscription dated 1363. Imitation.

Freer Gallery (19.10). Bamboo growing in a landscape. Handscroll. Signed, dated 1363. Good early Ch'ing work.

* TSYMC hua-hsüan 26. Landscape done for Chou Po-ang: trees by a river with distant hills. Poem, signed, dated 1364; a second poem and inscription by

the artist, and two additional colophons. See also Wen-wu 1978 no. 6, pl. 41b.

T'ien-hui-ko I, 1. Winter Poetic Thoughts at the Southern Mooring. River landscape. Inscription, signed, dated 1364. Early imitation?

Ku-hua ta-kuan, 3. Bamboo. Signed, dated 1364. Inscription by Liang Chang-chü. Possibly genuine.

Shen-chou III. River view with bare trees. Inscription by the artist, dated 1364. Poor imitation.

Formerly Frank Caro, N. Y. (former Chang Ts'ung-yü). Landscape seen from the T'ung-lu Pavilion. Signed, dated 1364. Imitation.

Taipei, Palace Museum (YV266, chien-mu). A riverside pavilion, hills beyond. Inscription, dated 1365. Ming imitation.

Garland II, 25 (former Lo Chia-lun, Taipei). Riverside pavilion, mountain colors. Inscription by the artist, dated 1365. Colophon by Sun Ta-ya dated 1382. Early imitation. See also Siren CP VI, 98.

Shen-chou ta-kuan hsü III. Bare trees and bamboo by rocks. Signed, dated 1365. Imitation. See also Nanga taisei I, 25.

Chung-kuo MHC 22. A Wu-t'ung tree with climbing plants; bamboo by a rock. Signed, dated 1365. Odd Ch'ing work.

NPM Quarterly I, 3, pl. 8 (former Wu Hu-fan). Riverside pavilion under trees, hills in the background. Signed, dated 1365. See also Ni Tsan 3; Ni Yün-lin 4.

Juncunc collection, Chicago. The western garden: river scene with low pavilion on foreground bank, mountain with waterfall in background. Poem by the artist, signed, dated 1365. Seals of Ch'ien-lung. See NPM Quarterly I, 3, pl. 7.

I-lin YK 51/1. River bank with trees and pavilion; a waterfall on the opposite shore. Inscription, signed, dated 1365. Copy or old imitation?

Taipei, Palace Museum (YV84). Maple Leaves Falling on the Wu River. Inscribed, signed, dated 1366. Close copy? See NPM Quarterly I, 3, pl. 9; Yüan FGM 305.

* Ibid. (YV81). *Yü-hou K'ung-lin t'u:* A Deserted Grove After Rain. Ink and light colors on paper. Inscription by the painter, signed, dated 1368. Colophons by four contemporaries. Copy? or original, heavily repainted? See Chung-hua wen-wu chi-ch'eng IV, 371; Three Hundred M. 184; CH mei-shu II; CKLTMHC III, 53; KK ming-hua V, 6; NPM Quarterly I, 3, pl. 11; Nanking Exh. Cat. 61; Wen-wu chi-ch'eng 81; KK chou-k'an 250; Siren CP VI, 101; Yüan FGM 306; NPM Bulletin X/5 (1975), cover; Bunjinga suihen III, 25-6; also article by Kao Mu-sen in NPM Quarterly XIII/I.

Ibid. (YV274, chien-mu). Bamboo, trees, and rock. Signed, dated 1368. Ming imitation.

C. C. Wang, N. Y. River landscape, with pavilion and four leafy trees on the shore. Poem by the artist, signed, dated 1368, with a dedication to his friend Shu-kuei. See Cleveland Exh. Cat. 31; Ni Tsan 11; NPM Quarterly I, 3, pl. 10; Archives, XXX; Bunjinga suihen III, 36.

Toso 181 (M. Kato coll). Two leafless trees and young bamboo sprigs. Poem and colophon by the artist, dated 1369. Imitation.

* Taipei, Palace Museum (YV268, chien-mu). High mountains by a river. Signed, dated 1371. Poems by Wang Ju-yü (early 15th century) and Ch'ien-lung. Colophon by Tung Ch'i-ch'ang. Original, somewhat repainted? See CKLTMHC III, 54; Ku-kung V.
* Ibid. (VA31e). A small, sparsely-leafed tree and sprigs of bamboo. Signed, dated 1371. Album leaf. See KK shu-hua chi XL; CKLTMHC III, 57; NPM Quarterly I, 3, pl. 12; Siren CP VI, 100; Hills 83; Yüan FGM 309.

Ibid. (YH15). *Hu-yüeh hsien:* the Moon-pot Study. A low pavilion on a rocky shore, hills beyond. Short handscroll. Signed, dated 1371. Ten colophons, poems, by Yüan writers. Copy or imitation.

* Ibid. (YV92). A branch of bamboo. Poem by the artist, signed, dated 1371. Seven contemporary inscriptions and one apparently later, unsigned. Genuine but minor work. See CKLTMHC III, 56; NPM Quarterly I, 3, pl. 15; KK Bamboo II, 9.
* Formerly Chiang Erh-shih collection. A rocky river shore; a path leading over a bridge to houses by tall cliffs with a waterfall. Ink on silk. Signed, dated 1371. Odd; possibly genuine. See NPM Quarterly I, 3, pl. 13; Parke-Bernet Auction Cat. of Chiang coll., March 1971, no. 12.

Metropolitan Museum, N. Y. (1973.120.8; former C. C. Wang and Chang Ts'ung-yü). Woods and Valleys of Yü-shan. Signed, dated 1371. Colophon by Ch'ien-lung. See Ni Tsan 6; NPM Quarterly I, 3, pl. 14; Siren CP VI, 195 (detail); Yün hui chai 34; Skira 111; Yüan Exh. Cat. 253; Met. Cat. (1973) no. 20; Bunjinga suihen III, 28.

* Taipei, Palace Museum (YVf89). The Jung-hsi Studio. Sparse trees and a low rest-shelter on the shore; hills across the river. Poem and colophon by the artist, dated 1372. See KK shu-hua chi XIII; London Exh. Chinese Cat. 160; Three Hundred M. 186; CH mei-shu II; CKLTMHC III, 58; KK ming-hua VI, 7; NPM Quarterly I, 3, pl. 16; KK chou-k'an 166; Hills 50; Yüan FGM 314; Bunjinga suihen III, 27.

Ibid. (YV269, chien-mu). Landscape with pavilion beneath two trees. Inscription, signed, dated 1372. Early imitation? Yüan FGM 313.

Ibid. (YV272, chien-mu). The Ch'ing-pi-ko, Ni Tsan's studio. Inscription, dated 1372. Good 15th century work, not in Ni Tsan style.

Ibid. (YV372, chien-mu). Dwelling on the River Bank. Inscription, signed, dated 1372. Another inscription by Wang Fu. Good Ming imitation. 16th century?

Garland II, 26 (Huang Chün-pi, Taipei). Autumn trees, distant peaks. Inscription dated 1372. Done for his friend the Ch'an monk Fang-yai. Inscriptions by Shen Chou, Wen Cheng-ming, etc. Old imitation?

Bunjin gasen II, 2 (Kikuchi collection). A low pavilion beneath leafy trees; a river winding into distance. Poem by the artist, signed, dated 1372. Seals of Hsiang Yüan-pien, Ch'ien-lung, etc. Another version in I-shu ts'ung-pien 9. A different picture with the same inscription, less convincing, in NPM Quarterly, I, 3, pl. 17.

KK chou-k'an 71. A river landscape; a house on the near shore. Painted for his friend Chang Yü. Signed, dated 1372. Reproduction indistinct; 17th century?

Taipei, Palace Museum (YV83). Mountain scenery with river lodge. Inscribed, signed, dated 1372. Old imitation? See CAT 85; CCAT 111; KK ming-hua VI, 10; NPM Quarterly I, 3, pl. 18; Yüan FGM 312.

* Chung-kuo MHC 23 (former Manchu Imperial Household collection). A high mountain ridge above a bay. Large album leaf. Poem by the artist, dated 1372. Genuine work in uncharacteristic style? In an album with works of Huang Kung-wang and others, present whereabouts unknown. See also Chugoku II; Bunjin gasen II, 14; Ch'ing Nei-fu 3.

Taipei, Palace Museum (YV85). *Su-lin yüan-yu t'u:* Scattered Trees and Distant Mountains. Signed, dated 1372. Two more inscriptions by the artist, one dated 1374. Late imitation.

* Album published by Yen Kuang Shih, Peking, 1927 (former Manchu Household collection). The Shih-tzu-lin Garden in Suchou. Short handscroll. Inscription by the artist, dated 1373. According to the artist's inscription, done in collaboration with Chao Yüan, who is probably responsible for most of the painting. See also Ni Yün-lin 5-7; Siren CP VI, 102; Ferguson 144 (section).

* Taipei, Palace Museum (YV172). Old tree, rock, and bamboo. Painted with Ku An (q.v.), and Chang Shen; a rock and bamboo added later by Ni Tsan, with an inscription; signed, dated 1373. Inscription by Yang Wei-chen. See KK shu-hua chi V; KK ming-jen hua-chu chi; CH mei-shu II; CKLTMHC III, 74; KK chu-p'u I, 3; KK ming-hua VI, 38; KK chou-k'an 182; KK Bamboo I, 6; Hills 85; Yüan FGM 315.

Ibid. (VA7j). Open river-view. Large album leaf, much repaired. Signed, dated 1373. Imitation.

National Museum, Stockholm. Autumn landscape. Poem by the artist, dated 1374. Poem by Yang Wei-chen. Possibly early 17th century. See La Pittura Cinese, 264.

* Taipei, Palace Museum (YV93). A slender bamboo branch. Inscription by the artist, signed, dated 1374. Colophons by Chang Shen, Wang Ju-yü and Miao-sheng. See Chung-hua wen-wu chi-ch'eng IV, 373; Three Hundred M. 187; CKLTMHC III, 59; KK ming-hua VI, 8; NPM Quarterly I, 3, pl. 19; Wen-wu chi-ch'eng 83; KK Bamboo II, 10; Yüan FGM 317.

Chiang Ku-sun, Taipei (1955). River landscape. An open pavilion under three trees in the foreground, and a mountain with a waterfall on the further shore. Signed, dated 1374.

Peking, Palace Museum (former P'ang Yüan-chi). Stalks of bamboo and a tall Wu-t'ung tree by a garden rock. Inscription by the artist, signed. See CK ku-tai 66; Ni Tsan 8; Ni Yün-lin 10; Wen-wu 1961 VI, 4.

Ibid. (former P'ang Yüan-chi). Pavilion and spare trees in autumn on a river shore; mountains in the distance. Inscription by the artist and a poem to a friend. See Siren CP VI, 94r; Fourcade 8.

* Ibid. Cold Pines by a Remote Stream: a rocky shore with trees, a stream flowing down from a pool; low hills. Long inscription, signed. Good work, probably genuine. See I-shu Ch'uan-t'ung VIII, 8; Ni Tsan 10; Ni Yün-lin 12; Kokyu hakubutsuin, 178.

* Ibid. A slender branch of bamboo. Short handscroll. Inscription by the artist in which he complains of advanced age and a feeble hand. See CK hua II, 8; Ni Tsan 9; Ni Yün-lin 11.

Shanghai Museum. *Wu-sung ch'un-shui t'u.* Mountain landscape with sharp-cut terraces; waterfall; buildings among trees below. Inscription, signed.

Taipei, Palace Museum (YV86). Leafless trees on a rocky shore. Long inscription by the artist. Imitation. See KK shu-hua chi XXIX; KK chou-k'an 484; Pageant 484.

* Ibid. (YV88). *Tz'u-chih shan-fang:* the Pavilion of the Purple Fungus. River landscape. Poem by the artist, signed. Copy? or somewhat repainted original? See Ku-kung XXXV; CKLTMHC III, 60; Ni Tsan 7; Ni Yün-lin 8; NPM Quarterly I, 3, pl. 21; KK chou-k'an 475; Siren CP VI, 99a; Yüan FGM 308.

Ibid. (YV90). Bamboo, stone and dry tree. Signed. Imitation? or original, repainted? See NPM Quarterly I, 3, pl. 24; Yüan FGM 316.

Kk chou-k'an 1. Leafless trees and bamboo growing on big stones. Poem by the artist. Imitation.

Ku-kung XXIII. Tall spare trees by a river; hillocks farther away. Poem by the artist. Poems by K'o Chiu-ssu and Sung K'o. Late imitation. See also KK chou-k'an 199.

Taipei, Palace Museum (YV277). A branch of bamboo. Inscription, signed. Copy? or genuine, minor work? Done for Jih-chang chen-shih. See Yüan FGM 311.

Ibid. (YV275, chien-mu). Autumn Trees by the river. Inscription, signed. Poems by K'o Chiu-ssu, Sung K'o, and Yüan Hua (dtd. 1372). 17th century copy?

* Ibid. (YH22). The An-ch'u Study. Poem by the artist, signed. Part of the collected scroll of Yüan works called Yüan-jen chi-chin. See CAT 90c; CH mei-shu II; CKLTMHC III, 51; KK ming-hua VI, 12; Yüan FGM 307.

* Ibid. (VA25f). Bamboo branch. Album leaf. Inscription, signed. Genuine, minor work. See Yüan FGM 310.

Ibid. (VA27h). Wild rock and cultivated bamboo. Album leaf. Title in his calligraphic style. Good imitation.

Ming-pi chi-sheng III, 5. Bare trees and bamboo by a rock. Poems by the artist and by Chang Yü, Yang Wei-chen and Ch'ien-lung. Colophons by Tan Chung-kuang, Wang Hui and Kao Shih-ch'i.

Shen-chou VII. River landscape with spare trees and a pavilion. Signed. Poor imitation.

Ibid. XI. A tall tree on a rocky shore. Signed. Even worse imitation.

C. C. Wang, N. Y. Two leafless trees and small sprays of bamboo by a rock. Inscription by the artist, signed. Poem by Wen Cheng-ming mounted above. See Ta-feng-t'ang I, 15.

Kokka 651 (Abe Kojiro, Tokyo). Distant view of mountains and rivers. Hanging scroll, ink on paper. Inscribed, signed by the artist. Imitation.

Osaka Municipal Museum (Abe collection). Three trees on a rocky promontory. Poem by the artist. Poems by Ch'ien-lung and three other writers. Early imitation. See Soraikan I, 24; I-lin YK 29/1; Osaka Cat. 61.

Fujii Yurinkan, Kyoto. A thatched hut in the mountains. Ink on paper. Colophon by the artist. Imitation. See Yurintaikan III, 17.

Fujita Museum, Osaka. Landscape. Long handscroll. Signed. Imitation.

Nanshu ihatsu IV (Sasaki collection, Tokyo). The Ch'an Study in the Western Grove. Signed. Interesting work of later period. See also Toso 180; Ni Yün-lin 9; Siren LCP I, 1; Pageant 353.

Shoen (calligraphy magazine) v. IV, no. 3, 1914. Trees and pavilion by a river. Large album leaf. Attributed. Good early imitation.

* Freer Gallery (15.36d). A branch of bamboo. Album leaf. Signed. Similar to the Bamboo picture in the Peking Palace Museum; probably a work of his old age. See NPM Quarterly I, 3, pl. 25 and I, 4, pl. 16; Cahill Album Leaves XVIII.

Ibid. (19.122). *Ch'iu-lin yeh-hsing t'u:* Autumn landscape. Short handscroll. Early imitation. Other paintings purportedly by Ni Tsan, all later imitations, in the same collection.

* Cleveland Museum (78.65, formerly C. C. Wang, N. Y.). An old, mossy tree and new shoots of bamboo growing by a rock. Inscription by the artist, signed. Poems by four contemporaries. See Yüan Exh. Cat. 254; Lee Landscape Painting 34; Munich Exh. Cat. 39; Bunjinga suihen III, 24; Barnhart Wintry Forests cat. 11; NPM Quarterly I, 3, no. 35; Cleveland Museum Bulletin, Jan. 1979.

C. C. Wang, N. Y. Two trees and slender bamboo by a rock. Inscription by the artist, dedicating the picture to Ch'en Wei-yün. Colophons by Ts'ao Shu and Chu Sheng. See Liu 35; NPM Quarterly I, 3, pl. 23; Garland II, 29.

Ibid. Two trees, a tall stone and bamboo around a house on the shore; mountains across the river. Inscription, signed. See NPM Quarterly I, 3, pl. 20; Siren CP VI, 99b.

* Ibid. (former Chang Ts'ung-yü). Five trees on a river shore. Inscription by the artist dedicating the picture to one Shou-tao. See Yün hui chai 35; NPM Quarterly I, 3, pl. 22; Bunjinga suihen III, 23.

PEN-CH'ENG　本誠　t. Tao-yüan　道元　, h. Chüeh-yin　覺隱
A priest from Szechuan. Active ca. 1356. Painted landscape, flowers and birds. I, 54. M, p. 67.

Private collection, Japan. A cabbage plant, a sparrow and swarming insects. Signed, dated 1356.

PIEN LU　邊魯　t. Chih-yü　至愚　, h. Lu-sheng　魯生
From Hsüan-ch'eng, Anhui. Birds and flowers in ink. H, 5; M. p. 720.

* Wen-wu, 1978 no. 6, pl. 4A. A pheasant on a rock, bamboo and thorns. Signed. See also *Jen-min hua-pao*, 1978, 10.

PIEN WU　邊武　t. Po-ching　伯京
From Peking. Active first half of the 14th century. Followed Hsien-yü Shu
(1257-1303) as a calligrapher. Painted flowers, birds, bamboo and stones. H,
5. I, 38, 53. M, p. 720.

* Berlin Museum. Winter landscape with birds gathering in a tree on a rocky pro-
montory. Fan painting, signed. See Shimbi XX; Yüan Exh. Cat. 182;
Berlin Cat. (1970) no. 28.

PIEN TING　邊定
Yüan-Ming period?

* Hsü Po-chiao, Hong Kong (1969). Landscape with figures. Ink and light colors
on paper, much darkened and damaged. Signed. Inscriptions by Hsü Pen
and T'ang Su; colophon above by Wang Wen-chih, dated 1788. Style
derived from Wang Meng.

PO TZU-T'ING　柏子庭
A Buddhist priest from Chia-ting, Kiangsu. According to a painting recorded in
Wu Ch'i-chen shu-hua-chi, signed and dated in 1353 "at age 70," he lived from
1284 until after 1353. Painted stones and flowers. H, 5. I, 54. M, p. 263.
See article by Shujiro Shimada in *Bijutsu Kenkyu*, 180.

* Umezawa Memorial Museum, Tokyo (formerly Prince Konoe). Rocks and
Calami. Poem by the artist, signed. See Nanshu gashu 3; Bijutsu Kenkyu
180; Yüan Exh. Cat. 237; Toyo Bijutsu 79; Sogen no kaiga 81; Kokka
783; Genshoku 29/66.
* Muto collection, Hyogo. A pair of pictures representing old trees and bamboo.
Signed. Inscriptions by four Ch'an monks active in the late Yüan and
early Ming. See Kokka 540; Sogen no kaiga 80; Toyo bijutsu 80;
Genshoku 29/65.
* Kokka 407 (Marquis Asano). An iris growing in the crevice of a stone. Short
handscroll. Signed.
* Yabumoto Kozo, Amagasaki. Grass and rock. Small horizontal picture, ink on
paper. Signed. See Homma Sogen, 75.

PO-YEN PU-HUA　伯顏不花　　t. Ts'ang-yen　蒼岩
A Uigur nobleman, distinguished himself as a military commander in fighting
the rebel Ch'en Yu-liang. D. 1359. Painted dragons and landscapes. H, 5. L,
61. M, p. 112.

Ma Shou-hua, Taipei. Clumps of trees on the rocky shore of a bay enclosed by
steep cliffs. Short handscroll. Signed, dated 1308. See Siren CP VI, 84a;
Garland II, 12.

Taipei, Palace Museum (YV56). Pines and circling clouds in a mountain valley. Signed. Colophon by Chiang Li-kang (15th century); poem by Ch'ien-lung. Later work, with interpolated inscriptions. See KK shu-hua chi IV; KK chou-k'an 105.

P'U-KUANG 溥光 . Family name LI 李 , t. Hsüan-hui 玄暉 , h. Hsüeh-an 雪菴
From Ta-t'ung, Shansi. A priest, served as head of the Dhuta sect and as a professor in the Chao-wen College in the reign of Kublai Khan, who called him Yüan-wu Ta-shih 元悟大師 . Active still in 1312. Landscapes, bamboo and Buddhist figures. H, 5. L, 64. M, p. 556. Article by Pelliot in *T'oung pao* (1922), p. 351.

Princeton Art Museum (formerly Yuji Eda, Tokyo). Snow retreat; landscape with pines, waterfall, and two men. Signed, dated 1310. Middle Ming or later work of Wu School.
Chung-kuo MHC 40. An arhat. Attributed. Colophon dated 1345. One of the series listed under Anonymous Yüan, Buddhist Taoist Subjects, Freer Gallery of Art.
Seikado Foundation, Tokyo (Iwasaki collection). A series of 19 album leaves representing Bodhidharma, Pu-tai, and 17 arhats. Poems by the artist. Brought to Japan in 1654 by the Huang-po (Obaku) priest Yin-yüan. Late Ming works by a Fukienese master? See Kokka 333; Siren ECP II, 88; Genshoku 29/57; Doshaku, 42; Suiboku IV, 22-23; Seikado Kansho III, 5-6.

P'U-MEN 普門 h. Wu-kuan 無關
From Hsin-chou, Kiangsi. A priest. B. 1201, d. 1281. Painted figures. Recorded only in *Kundaikan Sayuchoki* (no. 42).

Shimbi IV (Viscount O. Akimoto). The Taoist Mao Po-tao on a stag speaking to his servant-boy. Short handscroll. Attributed. Good work of the period. See also Kokka 36.
Tokugawa Museum, Nagoya. Triptych: Bodhidharma crossing the Yangtse on a reed (center); a man on an ox and a man on a donkey (sides). Attributed.
Hatakeyama Museum, Tokyo (former Matsudaira). Pu-tai laughing. Attributed. Inscription by the priest Wu-chun Shih-fan. Minor late Sung work. See Shimbi XV; Suiboku III, 51; Genshoku 29/63; Sogen MHS II, 33.
Myoshinji, Tokyo. Bodhidharma. Attributed. Colophon by Mieh-weng Wen-li (1167?-1250?). Centerpiece of triptych of which side pieces are by Li Ch'üeh. See Bijutsu Kenkyu 15; Suiboku III, 49; Boston Zen Cat. 7, where it is called Anonymous 13th century.
Tokyo Art Club auction cat., May 1941. A monk on a donkey; another on an ox. Pair of hanging scrolls. Attributed.

P'U-MING 普明 . Family name Ts'ao 曹, h. Hsüeh-ch'uang 雪窗
From Sung-chiang, Kiangsu. A priest of the Ch'eng-t'ien temple in Suchou.
Active ca. 1340-1350. Specialized in orchids. H, 5. I, 54. L, 64. M, p. 501.
See Shimada article in *Houn* 15 (1935), 49-64; also Chu-tsing Li, "The Oberlin
Orchid and the Problem of P'u-ming," *Archives* XVI, 1962, pp. 49-76.

Bijutsu III. Orchids. Short handscroll. Inscriptions by the priest Ling-feng
(dated 1341) and by Pao-hua Wen-hsin.
* Imperial Household, Tokyo. Orchids and bamboo growing among rocks: set of
four hanging scrolls. Signed, one dated 1343. See Kokka 483, 484; Toso
211-214; Siren CP VI, 116; Toyo bijutsu 77-78; Sogen no kaiga 81-82;
Sogen bijutsu 53; Pageant 398-401; Genshoku 29/75; Hills 79.
* Kumita Shohei, Tokyo (1971). Orchids, bamboo, and rocks: pair of hanging
scrolls, ink on silk. Signed, dated 1345. One reproduced in Suiboku, IV,
126.
* Kokka 687. Orchids. Hanging scroll, ink on silk. Inscription, signed, dated
1345. See article by Yonezawa in Kokka 687, p. 157ff.
Seattle Art Museum. Orchids growing on a rock and jujube branches in wind.
Signed, dated 1345. See Kokka 687; Shina Meiga Senshu II; Yüan Exh.
Cat. 245; Munich Exh. 35.
Oberlin College, Allen Memorial Art Museum (57.12). Orchids and bamboo.
Inscription by a monk named Ling-feng, attributing it to P'u-ming, dated
1348. Japanese copy or imitation. See Chu-tsing Li's article cited above;
Archives XII (1958), p. 82.
* Hikkoen 24 (J. Nakamura). A tuft of orchid. Album leaf. Attributed. Good
work of the kind, possibly genuine.
* Nezu Art Museum, Tokyo. Orchids and bamboo: a pair of paintings. Signed.
See Kokka 630.
* Nagase Takero collection, Tokyo (former Marquis Asano). Orchids and jujube
plants by a rock. Short handscroll. Signed. See Kokka 400; Bijutsu
kenkyu XV; Sogen no kaiga 84; Sogen bijutsu 52.
Kyoto National Museum. Orchids, bamboo and rock. Ink on silk. Signed.
Agata collection, Osaka. Orchids and bamboo growing by rocks. Pair of hang-
ing scrolls, ink on silk. Signed. Inscriptions by the monk Yü-chi Yüeh-
weng. Copies, based on two of the Imperial Household set listed above.
Shinju-an, Kyoto. Orchids. Horizontal hanging scroll. Signed. See Sogen
bijutsu 54.
Muto Coll., Tokyo. Orchids. Signed. Fourteen inscriptions.
Brooklyn Museum (52.50). Orchids and bamboo in wind. Handscroll. Signed.
See Toso 215; Archives VII (1953), fig. 3.
* Cleveland Museum of Art (53.246; former Marquis Asano). Bamboo and
orchids in the wind. Signed. See Kokka 424; NPM Quarterly I, 4, pl. 17;
Yüan Exh. Cat. 244; Venice Exh. Cat. 788; Lee Tea Taste no. 6; Lee
Colors of Ink cat. 16.
* Princeton Art Museum (former Harada Coll.). Orchids, bamboo, and rock.
Short handscroll. Signed. See Kokka, 594.

SA TU-LA 薩都拉 t. T'ien-hsi 天錫 , h. Chih-chai 直齋
B. 1308, d. after 1388. Born of a Mongol family which lived at Yen-men, Shansi. Passed the *chin-shih* degree and became a provincial judge. Poet and calligrapher. See KK shu-hua chi vol. I.

KK shu-hua chi XXXIV. Two birds in a plum-tree. Poem by the artist, dated 1315. See also KK ming-hua mei-chi I, 4.

Taipei, Palace Museum (YV49). The Yen Kuang (Tzu-ling) Cliff, or Fishing Platform (of the Fu-ch'un Mountains) projecting over a river. Poem by the artist, mounted above on separate paper, dated 1339; perhaps an interpolation. 17th century work? See KK shu-hua chi I; Nanking Exh. Cat. 65; KK chou-k'an 495; NPM Masterpieces I, 19.

SHANG CH'I 商琦 t. Te-fu 德符
From Ts'ao-chou, Shantung. Employed as a teacher at the court of the Emperor Ch'eng-tsung (1295-1307), and later on in the imperial library. Painted landscapes and bamboos. H, 5. M, p. 376.

KK shu-hua chi XXVIII. A lotus stream in summer at the foot of cloudy mountains, after Chao Ling-jang. Signed, dated 1314. Poems by Wang Ta and T'ao Chen (end of the 14th century). Good work of slightly later period—early Ming, period of the inscriptions?

Taipei, Palace Museum (YV27). Two crows: one in a blossoming apricot-tree; the other splashing in the water below. Signed, dated 1315. Work of much later period. See KK shu-hua chi VIII; KK chou-k'an 113; NPM Masterpieces V, 24.

Yabumoto Kozo, Amagasaki. Landscape handscroll, after the first half of Hsia Kuei's *Ch'i-shan ch'ing-yüan* scroll. Signed, dated 1327. Two colophons, the first dated 1536. Seals of Hsiang Yüan-pien. Ming work.

Taipei, Palace Museum (YV26). A wanderer approaching a Taoist's hut at the foot of the Sung mountain. Signed, dated 1342. Early Ch'ing work, cf. Yün Shou-p'ing; the inscription interpolated. See Ku-kung XXXVI; KK chou-k'an 487.

* Peking, Palace Museum. Spring mountains. Ink and colors, mostly heavy green, on silk. Handscroll. Signed.

* KK shu-hua chi XXIV. A deep mountain gully; a pavilion built over a stream, in which men are playing chess. Signed.

SHANG CHU 商璹 t. T'ai-yüan 台元 , h. Sung-chai 遜齋
Painted landscapes, in *p'o-mo* 破墨 manner, and rocks. H, 5. L. M, p. 376.

Chang Ta-ch'ien, Hong Kong (1951). Moon over a mountain village. Handscroll. Signed, dated 1342. Later imitation.

SHEN HSÜAN 沈鉉
Active at the end of Yüan and beginning of the Ming dynasty. Followed Huang
Kung-wang in landscape painting. M, p. 144.

Peking, Palace Museum. Landscape. Ink on paper. Mounted together with
similar paintings by Chang Kuan, Chao Chung and Liu Tsu-yü.

SHEN HSÜAN 沈巽 t. Shih-cheng 士偁 , h. Hsüan-weng 巽翁
From Wu-hsing. Late Yüan period. Followed Hu T'ing-hui as a landscapist.
M. p. 144, *Hua-shih hui-yao.*

Princeton Art Museum. Bamboo Growing Beside a River. Short handscroll.
Seal of artist. Mounted with a painting by Chao Yüan. Another version
of the Shen Hsüan picture in the Asian Art Museum of San Francisco
(B60 D118).

SHEN MENG-CHIEN 沈孟堅
Pupil of Ch'ien Hsüan. H, 5. L, 49. M, p. 143.

Hikkoen, 30. Peony and Butterfly. Attributed. Early Ming work?

SHENG CH'ANG-NIEN 盛昌年
Unrecorded. According to the inscription on the following painting, his t. was
Yüan-ling 元齡 , and he was from Wu-lin, Chekiang.

Peking, Palace Museum. Two swallows and a willow tree. Ink on paper.
Inscribed, signed, dated 1352. Inscription by Ts'ai Ch'iu-sheng. See
KKPWY hua-niao 28.

SHENG CHU 盛著 t. Shu-chang 叔彰 From Lin-an, Chekiang. Active
second half 14th century. Nephew of Sheng Mou (act. ca. 1310-1360). Served
in the Academy under Hung-wu; executed on his order. Painted figures,
flowers, and birds. O, II, p. 20. M, p. 389.

Taipei, Palace Museum (VA7k). Man fishing from boat near wooded shore.
Album leaf. Signed (2nd character not certain). See CKLTMHC III, 105
(as Anon. Yüan).
* Metropolitan Museum, N. Y. (1973.121.14; former C. C. Wang). Fishing in
the Autumn River. Fan painting. Seal of the artist. See Yüan Exh. Cat.
234; Met. Cat. (1973), no. 19; China Institute Album Leaves (no. ill).

SHENG HUNG　盛洪　(or SHENG HUNG-FU　盛洪甫), t. Wen-yü 文裕
From Hangchou; lived in Chia-hsing, Chekiang. Father of Sheng Mou.
Painted landscapes, figures and birds. H, 5. M, p. 389.

Ming-pi chi-sheng I, 3. Narcissus plants. Signed, dated 1354. Inscriptions by
　　Ch'en Chi-ju and Ch'ien-lung.

SHENG MOU　盛懋　t. Tzu-chao　子昭
From Chia-hsing, Chekiang. Active ca. 1310-1360. Painted landscapes, figures
and birds. Followed Tung Yüan and Chü-jan as well as later Sung masters. H,
5. M, p. 389.

Chung-kuo MHC 31 (Manchu Household collection). Mountain landscape,
　　after Chang Seng-yu. Album leaf. Signed, dated 1313. See also Chung-
　　kuo I, 120; Ferguson 152.
Taipei, Palace Museum (YV282, chien-mu). A farmstead among trees at the
　　foot of a mountain ridge in snow. Poetic couplet by the artist, dated 1322.
　　Poem by Ch'ien Wei-shan, dated 1364. Late Ming painting. See Ku-kung
　　3.
Ibid. (YV286, chien-mu). Travelers in a Winter Landscape. Signed, dated
　　1342. School work, 15th century.
Metropolitan Museum, N. Y. (47.18.121). Landscape, "in the style of Tzu-
　　mei," i.e. Ch'en Lin, his teacher. Handscroll. Signed, dated 1343. Actu-
　　ally a copy of the Hsia Kuei scroll in the Nelson Gallery, K.C., not by
　　Sheng Mou. See Priest article in their Bulletin, March 1950, pp. 202-3.
* Taipei, Palace Museum (VA32a). A man fishing in a boat under five trees.
　　Album leaf. Inscribed, signed, dated 1344. See KK ming-hua VI, 3;
　　Chung-kuo MHC 38.
J. T. Tai, N. Y. (former Chang Ts'ung-yü). Pleasures of Fishing. Signed,
　　dated 1347. Ming imitation.
Peking, Palace Museum. An old pine growing from a split rock. Ink on paper.
　　Inscription by the painter, dated 1347(?).
Siren CP in Am. Colls. 140 (former Owen F. Roberts, N. Y.). A river valley
　　with clouds; a boat. Signed, dated 1348. 17th century; Nanking School?
* Taipei, Palace Museum (YV285, chien-mu). A man walking on a river shore
　　beneath trees. Signed, dated 1349. Poem signed "Po-ch'eng," probably
　　Hsieh Po-ch'eng. Original or close copy.
Metropolitan Museum, N. Y. (1973.121.13; former C. C. Wang). Solitary
　　fisherman in an autumn forest. Album leaf. Signed, dated 1349. See
　　Yüan Exh. Cat. 233; China Institute Album Leaves no. 50; Met. Cat.
　　(1973), no. 18.
* John M. Crawford, Jr., N. Y. Recluse fishing by autumn trees. Signed, dated
　　1350. Poems by Lin Yung and Wang Fu. See Crawford Cat. 47; Ta-
　　feng-t'ang I, 16.
Chicago Art Institute (54.103). River landscape in autumn with a fishing-boat.
　　Signed, dated 1350. Ming work. See Bunjin gasen I, 5; Nanshu ihatsu
　　IV; Toso 189; Archives IX (1955), fig. 4. Another version with the same

inscription in Chung-kuo MHC 6.

* Peking, Palace Museum. Waiting for the ferry on a river-bank in autumn; men seated under trees. Ink on paper. Signed, dated 1351. Seven inscriptions. See TWSY ming-chi 100. Copies in the Freer Gallery (54.12) and Fujii Yurinkan, Kyoto (Yurintaikan II). (Note: the Peking version may itself be an old copy; not entirely convincing in details of drawing).

* Nanking Museum. A man playing the flute on a river bank under curving trees. Signed, dated 1351. Fine, genuine work. See Li-tai jen-wu 37; Nanking Museum Cat. I, 11.

Kao Yen-yüeh, Honk Kong. River landscape in the style of Wu Chen. Signed, dated 1351. Six inscriptions by contemporaries of the artist.

KK shu-hua chi XVIII. Travellers in cloudy summer mountains. Signed, dated 1362. Late Ming?

Osaka Municipal Museum. Landscape with a man walking with a staff by a low pavilion. Ink on paper. Signed, dated 1362. See Osaka Cat. 57.

Peking, Palace Museum. *Shan-chuang t'u:* A Villa in the Mountains. Large hanging scroll, ink and colors on silk. A man arriving with friends; musicians waiting. Spurious signature of Chao Meng-fu; good work of Sheng Mou school.

Ibid. Fishing from a boat in a clear stream. Fan painting. Seals of the artist. See Yüan-jen hua-ts'e I.

Ibid. A man holding a *ju-i* seated on a promontory watching two flying geese; misty mountains. Fan painting. Seal of the artist. Later imitation. See Yüan-jen hua-ts'e II.

Ibid. Fishing by an autumn grove. Album leaf. Signed. Imitation. See Yüan-jen hua-ts'e I.

* Shanghai Museum. Singing in a boat on the river in autumn. Attributed. Fine work, probably by Sheng. See Gems I, 12; Che-chiang 29; Shang-hai 17; Chugoku bijutsu III, no. VIII; Chung-kuo I, 115; Chung-kuo MHC 34; Hills 25.

TSYMC hua-hsüan 22. A fisherman on the shore beneath bare trees. Attributed. See also Shang-hai 14.

Taipei, Palace Museum (YV97). Boating in the moonlight under pines; a pavilion on the shore. Signed. Poem by Yao Shou (1423-1495). Late Ming painting, cf. Ch'en Kuan, with interpolated inscriptions. See Ku-kung V.

* Ibid. (YV98). A hermit seated under autumn trees; high mountains rising through thick clouds. Signed. See KK shu-hua chi X; London Exh. Chinese Cat. 153; Three Hundred M., 181; CAT 81; CH mei-shu II; CKLTMHC III, 40; KK ming-hua VI, 1; Wen-wu chi-ch'eng 77; KK chou-k'an 126; Siren CP VI, 91.

Ibid. (YV99). A mountain stream, two men in a small boat; leafy trees on the shore, high peaks in the background. Signed. Work of early Ming follower? See KK shu-hua chi XXXVI; CKLTMHC III, 38.

* Ibid. (YV133). Wintry trees. Catalogued as "Anonymous Yüan," but closely in the style of Sheng Mou, probably his work. See KK ming-hua VI, 49; KK shu-hua chi IX; Hills 23.

Ibid. (YV283, chien-mu). A man meeting a Taoist at the gate of his house. Signed. Early Ming work? of good quality.

* Ibid. (YH16). Gentlemen boating on the river in Autumn. Handscroll, ink and colors on paper. Signed. Eight poems by Yüan writers; one, by Wei Chiu-ting, dated 1361. See CAT 80; Skira 109.

Ibid. (VA15p). Lady standing by pine and plum trees. Fan painting. Seal of the artist.

Ibid. (WV18). Cherished Companions: Lute and Crane. Pavilions under pines by a mountain stream. Elements of style relating to both Sheng Mou and Wu Chen; probably by one of them, more likely Wu. See Three Hundred M., 49 (as Chü-jan); CKLTMHC III, 39 (as Sheng Mou).

Ibid. (VA29g). A man making a barrel under two trees. Fan painting. Signed. Imitation. See KK chou-k'an 127; NPM Bulletin VI/1 (1971), p. 3.

Ibid. (VA29h). A man angling in a boat on a quiet lake. Fan painting. Seal of the artist. Copy or early imitation. See KK chou-k'an 126; CKLTMHC III, 37; NPM Masterpieces II, 38.

Ibid. (VA91b). Landscape with a man riding a donkey on a bridge. Fan painting. Attributed. Good early work of school, perhaps by Sheng Mou. See KK ming-hua VI, 2.

* Ibid. (YV368). A summer day in the mountains; river valley with figures and buildings. Attributed. Good work by Sheng Mou or early follower. See KK shu-hua chi XIV; CKLTMHC III, 36.

Ibid. (YV287, chien-mu). Swallow soaring above the river in spring. Signed Tzu-chao. Odd Ming? work with interpolated signature. See KK shu-hua chi XXVIII.

Ibid. XLIV. A scholar with his servant and two cranes under pines. Signed. School work, early Ming?

Chung-kuo MHC 40. Spring colors on the lake: large, colored landscape. Signed(?). Imitation.

Nakamura Katsugoro. Scholars in gardens looking at paintings and writing calligraphy: pair of hanging scrolls, ink and color on silk. Attributed. Early Ming copies of older compositions? See Osaka Sogen 5-112.

Hompoji, Kyoto. Landscapes with figures playing music under trees: pair of large hanging scrolls. Signed. See Sogen bijutsu 21.

* Kokka 213 (K. Beppu). Lin P'u seated under a blossoming plum tree; a servant-boy bringing him tea. Signed. In the Ma Yüan tradition, cf. Sun Chün-tse; very early work by Sheng? See also Homma Sogen 56.

Ibid. 401 (Marquis Asano). The immortal Chang Kuo-lao riding on the donkey through clouds over the sea. Fan painting. Attributed. Fine Sung-Yüan work, probably unrelated to Sheng Mou. See also Doshaku, 20.

Hikkoen 44. River landscape with a fisherman in a boat. Large album leaf. Signed. Imitation.

Nanshu ihatsu IV. A boat in a gorge; a cart travelling on the road over the rocks along the river. Short fragmentary handscroll. Signed. Later work.

Choshunkaku 22. Ch'en Hou-chu and Palace Ladies in a garden. Attributed. Ming work, school of T'ang Yin.

Osaka Municipal Museum (Abe collection). Mountains rising through thick clouds, a man in a pavilion under pines. Fragment(?). Attributed. Early Ming? See Soraikan I, 23; Osaka Cat. 56; Kokka 587.

Shina kacho gasatsu. Four wild geese among reeds. Signed. Ming work.

* Freer Gallery (11.161c). A lake scene with sailing boats. Signature and seal of the artist. See Cahill Album Leaves XIV.

* Nelson Gallery, K. C. Retreat in the Pleasant Summer Hills; a scholar in a pavilion among leafy trees at the foot of high mountains. Two seals of the artist. Inscription above by Tung Ch'i-ch'ang. See Yüan Exh. Cat. 230; Siren CP VI, 90; Speiser Chinese Art III, pl. 16; Kodansha CA in West II, 16; Hills, pl. 3.

Cleveland Museum of Art (63.589). Travelers in autumn mountains. Album leaf. Attributed; partly effaced signature, reading only "Sheng." Good early work of Sheng Mou school. See Munich Exh. Cat. 31; Yüan Exh. Cat. 232; China Institute Album Leaves 49; Lee Colors of Ink cat. 13.

Asian Art Museum of San Francisco (B69D10). Pleasures of Fishing Among Rivers and Mountains. Attributed in a title written by Wu Hu-fan. Good school work.

Ibid. (B69D13). Winter landscape with fisherman. Not attributed to Sheng Mou, but fine work of a follower, 15-16th century.

* Ernest Erickson, N. Y. Landscape with rivers and mountains. Fan painting. See Yüan Exh. Cat. 231; BMFEA XXXVI, (1964), pl. 3-4; Hills 21.

Juncunc collection, Chicago. A man under a pine by a stream. Attributed. Work of close follower.

C. C. Wang, N. Y. Scholar and servant walking by a stream. Large album leaf, badly damaged. Seal of the artist.

Ibid. Fishing on a snowy river. Large hanging scroll, ink and light color on silk. Attributed. Fine work of this school.

Ibid. Landscape with man and servant in boat by wooded shore. Attributed.

Paul Spheeris, Indianapolis. River scene; wood gatherer and fisherman conversing. Fan painting. Two seals of the artist. School work.

British Museum, London. "The Scholar's Paradise." Pair of hanging scrolls, scholars in landscapes. Attributed. Fine work of later date.

Note: Many other works can be associated with Sheng Mou and his followers on the basis of style. These include:

1. Yüan-jen hua-ts'e I and II, various. See under Anonymous Yüan, Landscape.

2. CKLTMHC III, 103; landscape with figures, fan painting.

3. Taipei, Palace Museum: "Sung Ti," (VA19e); "Chao Meng-fu," in KK shu-hua chi 44 (Ming follower of Sheng Mou?); "Anon. Sung," landscape with figures and palace (VA20h); "Mooring on an Autumn Bank," (VA36m); "Mountain Retreat," (VA35h), possibly by Sheng Mou.

4. "Anon. Yüan" Landscape with Crane, Met. Mus., N. Y.; see China Institute Album Leaves no. 52.

5. Freer Gallery of Art (16.137). "Hu Shün-ch'en," Winter landscape with boat on river (early follower of Sheng Mou?). (11.155h). Winter landscape with travelers. See Cahill Album Leaves XV.

6. Boston Museum of Fine Arts (37.115). "Ch'i Chung" (Siren CP III, 311), which bears a *Tzu-chao* seal. Also Anon. Sung album leaf (20.754); early Sheng Mou? or slightly earlier work in same stylistic lineage?

7. C. M. Lewis, Pittsburgh. Landscape, fan painting; attributed to Hsü Tao-ning.

SHIH CHIANG (KANG) 史杠 t. Jou-ming 柔明 , h. Chü-chai Tao-jen 橘齋道人

From Yung-ch'ing, Hopei. First half of the 14th century. Painted figures, landscapes, flowers and birds. H, 5. L, 41. M, p. 77.

Shen-chou ta-kuan hsü VI. Cock and flowers. Inscription by the artist, signed.

Toso 223 (Huang Chün-pi, Taipei). Chung-k'uei and attendant demons on a hunt. Handscroll. Signed. Ming or later work. See also Pageant 290b.

Sogen 77 (J. C. Ferguson). The meeting of Lao-tzu and Confucius. Short handscroll. Ming work. See also Pageant 290a.

SHIH CH'ING 時清 t. (?)Jung-yang 滎陽

Unrecorded. Presumably a Yüan dynasty priest-painter, close in style to T'an Chih-jui.

Hikkoen 26. Bamboo growing among stones. Seals with the above names.

SUN CHÜN-TSE 孫君澤

From Hang-chou, Chekiang. Active at the beginning of the 14th century(?). Painted landscapes with figures and architectural subjects. Followed Ma Yüan and the Academy tradition. H, 5. M, p. 346.

* Tokyo National Museum (formerly Yoshihara collection, Tokyo). Winter landscape, with men in a house looking out over a river. Hanging scroll, ink and touches of color on silk. Signed. See Osaka Municipal Museum, *China and Japan as Seen in Their Art*, 1972, no. 7-20; Tokyo N. M. Cat. 34; Kokka 684; Suiboku II, 16.

Ibid. 110 (formerly Yotoku-in, Daitoku-ji). Autumn landscape: a man seated on a promontory in front of a pavilion overlooking a misty valley, a servant-boy standing behind him with a *ch'in*. Attributed. Good work of the period. See Kokka 191; Shimbi II; Sogen no kaiga 112; Toyo IX, 110; Tokyo N. M. Cat. 33.

* Seikado, Tokyo (former Iwasaki collection). Pair of hanging scrolls: A man on a terrace before a pavilion under a twisting pine; two men in a pavilion under pines. Signed. See Toyo IX, 112-113; Kokka 249; Shimbi XII; Che-chiang 40; Sogen no kaiga 113; Suiboku II, 53-54; Seikado kansho III, 3-4.

Kokka. 282 (Count S. Tokugawa). Men drinking wine on a terrace under pines; high mountains and temples beyond. Attributed. Fine Academy work of 15th century.

Ibid. (Viscount H. Akimoto). Pair of horizontal paintings: Ting Fan, the Filial Son; Lu Chi offering an orange to his mother. Attributed. Fine works of the period or slightly later. See also Pageant 322-3.

Nezu Museum, Tokyo. Pair of hanging scrolls: Garden pavilions with figures, built over a stream. Attributed. Early Ming works. See Toso 187-188; Nezu Cat. I, 53; Suiboku II, 112-113.

* Toyo IX, 111 (Kikuya Kojiro coll, Hagi). Travelers in a gorge; misty trees above. Tall, narrow hanging scroll—section of a screen? Signed. See also Toyo bijutsu (Tokyo National Museum, 1968), no. 630; Suiboku II, 55.

Yabumoto Kozo, Amagasaki. Landscape with a palace, visitors arriving on horseback, plum-trees across the river. Large album leaf?, ink and colors on paper. Seal of the artist.

Eda Bungado, Tokyo. Landscape with buildings and Taoist Immortals. Handscroll, ink and colors on silk. Attributed. 15th century picture?

Musée Guimet, Paris. A house in a bamboo grove. Long inscription by the Yüan priest Li-t'ien. Attributed. Good Yüan or early Ming work. See Ars Asiatica XIV, pl. 7; Lee, *Tea Taste in Japanese Art*, no. 4.

* Ching Yüan Chai collection, Berkeley. A large landscape: a villa beside the river, with tall pines; a visitor approaching across a bridge. Signature partly obliterated but legible. See Kodansha CA in West II, 1; Suiboku II, 15; Hills pl. 4.

Ibid. Summer landscape: a man gazing at lotus on a lake. Attributed. 15th century, cf. Chou Wen-ching.

SUNG K'O　宋克　t. Chung-wen　仲溫　, h. Nan-kung-sheng　南宮生
B. 1327, d. 1387. From Suchou. A poet, one of the "Ten Talents" of the time. Painted bamboo. N, I, 12. O, 7. I, 55, 1. M, p. 127.

* Freer Gallery (38.18). Myriad bamboo growing on hills by a stream. Handscroll. Signed, dated 1369. See Toso 223a; Siren CP VI, 56; Siren LCP I, 7; Kodansha Freer Cat. 48; Kodansha CA in West, II, 73.

Princeton Art Museum. Bamboo and rocks; a small view of a rocky bank. Handscroll. Inscription dated 1370. See Garland II, 37.

Shen P'ing-ch'en, Hong Kong. Bamboo growing by a stone. Signed.

Perry Collection, Cleveland. Landscape with bamboo. Handscroll.

SUNG-T'IEN　松田　. Original name(?) KO SHU-YING　葛叔英　h. Tsui-shan 翠山　Chiao-yin　樵隱　(these names known only from seals on the painting in the Yabumoto collection listed below).
Lived to over 90. Unrecorded in China, excepting a mention in Wu Ch'i-chen's *Shu-hua chi* (p. 239), but mentioned in *Kundaikan Sayuchoki* (no. 114).

Specialized in squirrel paintings; probably not identical with Yung-t'ien 用田 , who also painted squirrels.

Yabumoto Soshiro, Tokyo (1973). Squirrels in an old tree. Ink on paper. Inscribed "at the age of 91"; three seals of the artist. See Suiboku IV, 123.

Yabumoto Kozo, Amagasaki. Two squirrels on a pomegranate branch. Ink on silk. Seal of the artist.

Kokka 522 (Baron Dan). A squirrel on the branch of a chestnut tree. Attributed.

Jinzaburo Takanashi, Kanagawa. Two squirrels on a bamboo stalk. Seal of the artist. See Muto Cat. 26; Kokka 554; Yüan Exh. Cat. 248; Suiboku III, 90.

Moriya coll., Kyoto. Two squirrels on a bare branch. Signed.

Agata coll., Osaka. Squirrel on a bamboo branch. Ink on paper. Attributed.

Kokka 403 (Marquis Asano). Three squirrels on the branch of a pomegranate tree. Seal of the artist. See also Sogen no kaiga 61; Sogen MGS II, 43.

Fujita Museum, Osaka. Squirrels on a vine. Attributed.

TAI SHUN 戴淳 t. Hou-fu 厚夫
From Ch'ien-t'ang, Chekiang. Active ca. 1317. H, 5. M, p. 714.

Taipei, Palace Museum (YV50). The K'uang-lu mountain; a gateway at its foot, a temple at the top. Signed, dated 1318. 17th century, Nanking School, cf. Lü Ch'ien. See KK shu-hua chi XXXV; KK ming-hua V, 45.

T'AI PU-HUA 泰不華 t. Chien-shan 兼善
From T'ai-chou, Chekiang. B. 1304, d. 1352. Son of a Mongol, became naturalized. Minister of the Board of Rites. V, p. 815.

Shen-chou Ta-kuan 9. A tall T'ai-hu stone. Poem and dedication to the Prime Minister, on his 80th birthday, by the artist. Inscription by Feng Kuo-t'ai, dated 1437. See also Chugoku II.

T'AN CHIH-JUI 檀芝瑞
Active in the early 14th century. Unrecorded except in Kundaikan Sayuchoki (no. 81). Painted bamboo. See also the article by Matsushita in Kokka 664, and the two by I. Takuji in Bijutsu Kenkyu 162, 1951, and 169, 1952, on the calligraphy of I-shan I-ning (came to Japan in 1299, died in 1317), who inscribed some of the pictures below.

Kokka 426 (Count T. Shimazu). Bamboo growing on a slope. Good Yüan-Ming work.

* Ibid. 468 (Count S. Tokugawa). Bamboo on a rocky shore by a brook. Album leaf. Poem by Sokei Tsutetsu (ca. 1299-1358), who went to China ca. 1320 and stayed over thirty years. Fine work of the period. See also Toso 204; Pageant 404; Bijutsu 6.

Toyo IX (Magoshi collection). Bamboo and rocks. Album leaf. Poem by I-shan I-ning (1247-1317). Minor work of the period.

Hikkoen 53. Bamboo in mist. Album leaf. Attributed. Good work of period.

* Toso 205 (Marquis Hachisuka). Bamboo growing on the rocky shore of a stream. Fragment of a handscroll? Fine early Yüan work. See also Pageant 405.

* Nezu Museum, Tokyo. Wind-swept bamboo growing in a rockery. Attributed. Inscription by Ch'ing-cho Cheng-ch'eng (1247-1339). Good work of the period. See Sogen Meigashu 54; Kokka 664; Boston Zen Cat. 27; Nezu Cat. I, 27.

* Seikado, Tokyo. Tall bamboo growing on a river bank. Inscription by Ling-yin Lai-fu. See Seikado Kansho, III, 10.

Yuji Eda, Tokyo. Bamboo in mist, rocks. Ink on paper. Inscription by I-shan I-ning (1247-1317). Seal of the artist, probably interpolated. Early painting, but perhaps Japanese.

Kokka 404. Bamboo blowing in the wind. No signature, seal or attribution, but period and style of the artist.

Imai Goichiro coll. auction cat; Tokyo, 1933, no. 29. Bamboo growing by rocks. Attributed.

Tokyo Art Club auction cat., May 1941, no. 6. Bamboo growing by a stone. Attributed.

Yabumoto Soshiro, Tokyo (1965). Bamboo and rock. Attributed; but seal reading K'o-shan 柯山 may be the artist's.

Okazaki collection, Kyoto. Bamboo growing beside a rock. Album leaf, ink on paper. A seal perhaps that of the artist.

Yasuda collection, Kanagawa. Bamboo growing on a rocky knoll. Attributed.

Domoto collection, Kyoto. Bamboo and rocks. Attributed.

Masaki Museum, Osaka. Bamboo and rocks. Attributed. Inscriptions by three men of the early 15th century. See Masaka Cat. VIII. Japanese imitation?

Osaka Municipal Museum. Tall bamboo growing by a slope. Hanging scroll, ink on silk. Attributed. See Osaka Cat. 68.

Freer Gallery (56.22). Bamboo growing in snow beside a stone. Album leaf. Poem by I-shan I-ning. Attributed. See Cahill Album Leaves XIX.

* Ibid. (70.24). Windblown, slender bamboo growing by rocks. Attributed. See Oriental Art N. S. XIII, 2 (Summer 1967), p. 74; Archives XXV (1971-2), p. 97; Hills 74.

* Ching Yüan Chai collection, Berkeley. Tall bamboo growing by a stone. Old attribution to T'an Chih-jui. Good work of early Yüan. See Yüan Exh. Cat. 247; Kodansha CA in West, II, 71.

T'ANG TI 唐棣 t. Tzu-hua 子華

From Wu-hsing, Chekiang. B. ca. 1286, d. ca. 1354. Pupil of Chao Meng-fu,

followed also Kuo Hsi. Executed some wall-paintings in the palaces. H, 5. I, 53. M, p. 326. See the article by Kao Mu-shen in *National Palace Museum Quarterly*, VIII/2 (Winter 1973), 43-56.

* The Brooklyn Museum (on loan from Ernest Erickson, N. Y.). Old trees on the river shore; a man seated on a ledge. Illustration to a poem by Wang Wei. Signed, dated 1323. See Chung-kuo I, 108; Chung-kuo MHC 33; Yüan Exh. Cat. 220; Yün hui chai 32; Suiboku II, 62; Bunjinga suihen III, 69.
* TSYMC hua-hsüan 20. Four gentleman drinking wine on a river bank beneath bare trees. Signed, dated 1334. See also Chung-kuo hua V, 15.
* Taipei, Palace Museum (YV42). Fishermen walking under tall trees along a river-bank. Signed, dated 1338. *Ssu-yin* half-seal. See KK shu-hua chi III; Three Hundred M., 171; CAT 83; Che-chiang 43; CH mei-shu II; CKLTMHC III, 29; KK ming-hua V, 38; Wen-wu chi-ch'eng 78; KK chou-k'an 101; Siren CP VI, 81. Another version, dated 1342, in the Metropolitan Museum, N. Y. (1973.121.5). See Met. Cat. (1973), no. 17; Suiboku II, 61.

Bunjin gasen II, 2, 3, 5 (Chiang Meng-p'in). Cliffs and streams in autumn; travellers on donkeys. Long handscroll. Signed, dated 1341. Ming work.

Ishiguro collection, Kyoto. The Wang-ch'uan Villa, after Wang Wei. Handscroll, ink on silk. Dated 1342. Yüan-Ming work, with interpolated signature.

Shen P'ing-ch'en, Hong Kong. Landscape. Dated 1342.

Shen-chou ta-kuan 16. Autumn mist over the hills, after Yen Su of the Northern Sung period. Signed, dated 1351.

Shanghai Museum. Fishing in a snowy mountain harbour. Signed, dated 1352. See Chung-kua hua X, 13; Shang-hai 18; Chugoku bijutsu III, no. 14; Bunjinga suihen III, 70. Copy? or Ming imitation? Another version, dated to 1349, in I-lin YK 99/9, appears (in poor reproduction) to be earlier and better, perhaps the original.

John M. Crawford, Jr., N. Y. Pavilion of Prince T'eng. Handscroll. Signed, dated 1352.

Sogen 48 (Chang Wen-fu). A quiet day in the mountains; men in the pavilions. Signed, dated 1361. Poem by Chou Chih (14th century). Ming imitation.

Metropolitan Museum, N. Y. River valley with thin pines. Signed, dated 1362. Colophon by Wen P'eng. Imitation.

Bunjin gasen II (Chang Hsi-ts'un). A misty moutain gorge with a pavilion. Signed, dated 1364. Poems by Ch'ien-lung and others.

* Taipei, Palace Museum (YV41). Travelling in autumn mountains, after Kuo Hsi. Signed. See Nanking Exh. Cat. 71; Siren CP VI, 82; NPM Masterpieces I, 18; Hills 31.
* Ibid. (YV220). A boat on a misty stream; pines and a pavilion on the shore. Signed. See Ku-kung VI; CKLTMHC III, 28; Hills 32.

KK shu-hua chi XL. A donkey-rider travelling over snow-covered hills. Short handscroll. Seals of the artist. Poor 16th century work.

Taipei, Palace Museum (VA11r). Fisherman's Delight on the Pure Stream. Album leaf. Signed. Later work.

Ibid. (VA19r). Talking in a boat between misty banks. Album leaf. Seal of the artist.

Ch'ing-kung ts'ang 28 (former Manchu Household collection). Roses, after a Sung painting. Fan-shaped. Signed.

Clark Humanities Museum, Scripps College, California (former Pettus collection). River landscape; a man buying a fish from a fisherman. Inscription by Chao Meng-fu. Good Yüan work in the style of T'ang Ti; possibly by him.

Staatliche Museen, Berlin. River Landscape. Handscroll section mounted as hanging scroll. Attributed. Good work of the period or slightly later. See Yüan Exh. Cat. 219; Berlin Cat. (1970), no. 30.

TAO-MING .
Unidentified; Yüan period?

Fujii Yurinkan, Kyoto. Arhats in a landscape. Handscroll. Section reproduced in Osaka Sogen 5-139.

T'AO FU-CH'U　陶復初　t. Ming-pen 明本 , h. Chieh-hsüan Lao-jen 介軒老人
From T'ien-t'ai, Chekiang. Active first half of the 14th century. Calligrapher. Followed Li K'an as a painter of bamboo. Not to be confused with the priest Chung-feng Ming-pen　中峯明本　(1265-1325). H, 5. M, p. 394.

Taipei, Palace Museum (YV103). A hermit in an autumn grove. Inscribed, signed. Probably a work of Hsiang Te-hsin (1561-1623) whose *tzu* was Fu-ch'u and whose seal is on the painting. See KK ming-hua VI, 5.

Kawasaki Cat. 35. A narcissus plant and a stone. Ink on paper. Attributed. Yüan-Ming work. See also Choshunkaku 46.

T'AO HSÜAN　陶鉉　h. Chü-ts'un　菊邨
From Chin-ling (Nanking). B. Ca. 1280. Poet. Followed Li Ch'eng as a landscape-painter. H, 5. M, p. 394.

Seattle Art Museum (Former Chang Ts'ung-yü). Leafless trees on a low shore. Similar in composition to works of Ni Tsan. Signed, dated 1345. Imitation. See Yün hui chai 48; Toronto Exh. 6.

TENG YÜ　鄧宇　t. Tzu-fang　子方
From Lin-ch'uan, Kiangsi. B. ca. 1300, d. after 1378. A Taoist. In the early Ming served as an official in Nanking, in charge of Taoist affairs; active in Peking in the 1370's. See Chiang I-han's article below for further information.

* Princeton University Museum. Bamboo and rock. See Yüan Exh. Cat. 246; Kodansha CA in West I, 31; see also article by Chiang I-han in NPM Quarterly, VII/4, Summer 1973, pp. 49-86.

TING CH'ING-CH'I 丁清溪

A Taoist monk from the 14th century. Native of Ch'ien-t'ang, Chekiang. Painted Buddhist and Taoist figures after Li Sung, Wang Hui and Ma Lin. Also portraits. M, p. 3.

Cheng Te-k'un, Hong Kong. Manjusri (Wen-shu) seated on a lion. Album leaf. Signed.

TS'AI SHAN 蔡山

Yüan period. Unrecorded except in *Kundaikan Sayuchoki* (no. 120). Perhaps to be identified with Chao Ch'iung 趙璚, from Ts'ai-shan, a mountain near Ya-chou in Szechwan; did paintings of arhats in the manner of Li Kung-lin.

Tokyo National Museum. An arhat with a staff seated on a rock. Signed: Ts'ai-shan. Dedicatory inscription by Ashikaga Tadayoshi (1307-1352). See Shimbi XI; Toyo IX; Yüan Exh. Cat. 196; Sogen bijutsu 98; Kokka 542; Suiboku IV, 99; Doshaku, 67.
Myoshin-ji, Kyoto. Pair of hanging scrolls: an Arhat and a priest watching a man tickle the nose of a sleeping Indian; an Arhat and a priest, two devils kneeling before them. Attributed. Yüan works. See Shimbi XIV.
Tokai-an, Kyoto. Sixteen Arhats. Sixteen hanging scrolls. Attributed. See Doshaku, 68; Kokka 311; Suiboku IV, 97-98. Also Homma Sogen 7 (same series?).

TS'AO CHIH-PO 曹知白 t. Yu-yüan 又元 and Chen-su 貞素, h. Yün-hsi 雲西

From Hua-t'ing, Kiangsu. B. 1272, d. 1355. Served in the Ta-te era (1297-1308) as a district teacher in the K'un-shan district, but resigned in order to devote himself entirely to Taoist studies and painting. Followed Li Ch'eng and Kuo Hsi as a landscape-painter. H, 5. I, 54. L, 21. M, p. 404. See also Chu-tsing Li, "Rocks and Trees and the Art of Ts'ao Chih-po," *Artibus Asiae*, XXIII, 1960, pp. 153-208.

* Peking, Palace Museum. A grove of wintry trees. Album leaf. Inscribed, signed, dated 1325. See Yüan-jen hua-ts'e I.
* Taipei, Palace Museum (YV60). Two tall pines and smaller trees; a stream beyond. Signed, dated 1329. Colophons by Sung Lien (1310-1381), and two others. See KK shu-hua chi VII; London Exh. Chinese Cat. 148; CH mei-shu II; CKLTMHC III, 20; KK ming-hua V, 33; KK chou-k'an 117; Hills 34.

Freer Gallery (09.226). Rocky landscape. Handscroll, ink on paper. Spurious signature, with the date 1341. Early Ch'ing work.

Taipei, Palace Museum (YV58). A pavilion among sparse trees. Signed, dated 1344. Poems by Chang Yü, Ni Tsan, Wang Meng, and three others. Ch'ing work, by Wang Hui? See KK shu-hua chi II; KK ming-hua V, 32; KK chou-k'an 105; NPM Masterpieces I, 20.

National Museum, Stockholm. Bare trees by the river shore. Signed, dated 1349. See Stockholm Cat. (1971), p. 75.

* Taipei, Palace Museum (YV57). Snow-covered hills by a river. Signed. Colophon by Huang Kung-wang, dated 1350. See KK shu-hua chi XV; Three Hundred M., 168; CAT 75; CH mei-shu II; CKLTMHC III, 21; CKLTSHH; KK ming-hua V, 31; Wen-wu chi-ch'eng 68; KK chou-k'an 170; Hills 37.

* Peking, Palace Museum (former P'ang Yüan-chi). Landscape with two pines. Signed, dated 1351 (at age 80). Poems by two contemporaries. See Fourcade 6; Wen-wu 1956, 1.

Taipei, Palace Museum (YV59). Pavilion of the Lofty Pines and White Snow. Dated 1352. Inscriptions by Ni Tsan, Yang Wei-chen and Chang Yü. Late imitation.

Ibid. (YV289, chien-mu). Pine trees by a river. Signed. Inscription by Cha Shih-piao on mounting. Late Ming?

Ibid. (YV291, chien-mu). The Pleasure of a Window by the Pines. Signed. Interesting late Ming work.

Ibid. (YV292, chien-mu). Drinking in the East Garden. Inscription, signed. Good 15th century work.

Ibid. (VA2g). Spare trees growing among rocks by a river. Signed, dated 1362. Part of the album called Mo-lin pa-ts'ui. Impossible date, later picture. See KK chou-k'an 34.

Note: See also the Palace Museum, Taipei (VA5c) fan painting, listed under Li Ch'eng; may bear a signature of Ts'ao Chih-po, and appears to be of this period and school in any case.

Ibid. (VA32b). A hermitage among pines by a river; misty mountain in the background. Signed. Six poems, one of them by Wang Mien, another by Ch'ien-lung. Good painting, but later in date—16th century? See KK shu-hua chi XLII; Chung-kuo I, 114; CKLTMHC III, 22; KK ming-hua V, 34; Nanking Exh. Cat. 244; Siren CP VI, 77; Chung-kuo MHC 34; NPM Masterpieces II, 37.

Ku-kung XXIV. The Twelve Good News Bringers, i.e. Magpies in a Pine-tree. Inscribed with the artist's signature. Later work.

* Shanghai Museum. Landscape with two fisherman in boats on a lake. Signed. Colophon by Ni Tsan dated 1362. Old imitation? or genuine? See Gems I, 13; Chung-kuo shu-hua I, 22; Shang-hai 13; Bunjinga suihen III, 71.

Shen-chou 8. A pine at a waterfall. Signed, dated Chih-cheng *kuei-ch'ou,* a year which did not exist. Imitation. See also Nanga shusei II, 11.

Sogen 52 (Chang Hsüeh-liang). Strange cliffs forming islets in a river; a pavilion in the center. Handscroll. Poem by the artist. 16th-17th century work.

Nanshu ihatsu III. A man with a staff walking in a forest. Colophon by Wang Hui. Later work.

Toso 158 (Ch'en Pao-ch'en). River landscape with bare trees and a man in a boat. Poems by the artist and by Huang Ch'ien. Ming work. See also Siren LCP I, 5.

Ibid. 159 (Chang Ying-hua). Sparse trees on rocky islets in a river. Signed. Poem by Wu K'uan (1435-1504). Imitation.

Nanshu 2 (Yamamoto collection). Two pines and a rock on a river shore; mountains in the distance. Signed. Poem by Shen Chou. Imitation. See also Bunjin gasen I, 3; Nanshu ihatsu III; Toso 157; Chugoku I.

Ts'ao-hui Tung-yün (Shimbi Shoin, 1921). Eight landscape studies. Poems by Tung Ch'i-ch'ang, dated 1632. Imitation.

* Princeton University Art Museum (58.51). Trees growing among rocks. Fan painting. Signed. See Yüan Exh. Cat. 227; China Institute Album Leaves no. 48; Barnhart Wintry Forests cat. 10; Chu-tsing Li, "Rocks and Trees and the Art of Ts'ao Chih-po." Artibus Asiae, XXIII, 1960, pp. 153-208.

C. C. Wang, N. Y. Two pines on the shore. Signed. Inscription by Chang Yü (1275-1348).

Musée Guimet, Paris (MA1890). Pavilion under old pines. Large album leaf. Signed. See Chung-kuo I, 125; Yüan Exh. CAT. 228; Lee Landscape Painting 35; Munich Exh. Cat. 38; Ferguson 148; Ch'ing Nei-fu 7; Chung-kuo MHC 24; Kodansha Guimet, 128.

TSOU FU-LEI 鄒復雷
Poet and painter, active about the middle of the 14th century. Said to have lived as a Taoist hermit. Followed in his plum-blossom paintings Chung-jen. I, 54. M, p. 567.

* Freer Gallery (31.1). The Breath of Spring. A long branch of a blossoming plum-tree. Handscroll. Poem by the artist, dated 1360. Colophon by Yang Wei-chen, dated 1361. See Chung-kuo I, 118; Toso 117b; Siren CP III, 364-65; Chung-kuo MHC 32; Kodansha Freer Cat. 45; Kodansha CA in West I, 30; A. G. Wenley, "A Breath of Spring" by Tsou Fu-lei," Ars Orientalis, vol. II, 1957.

TS'UI YEN-FU 崔彦輔 or TS'UI YEN-HUI 崔彦輝 t. Tsun-hui 遵暉, Yün-lin 雲林
From Ch'ien-t'ang, Chekiang. Active mid-14th cent. A nephew of Chao Meng-fu. I, 54. L, 12. M, p. 388.

Taipei, Palace Museum (YV296). A deeply creviced mountain rising above a river. Signed, dated 1342. Poem by Ch'ien-lung. Seals in the lower left corner of the 17th century artist Ch'eng Sui, who is probably the actual painter of the picture. See KK shu-hua chi XXI.

WANG CHEN-P'ENG 王振鵬 t. P'eng-mei 朋梅. Emperor Jen-tsung (1312-20) bestowed on him the *hao,* Ku-yün Ch'u-shih 孤雲處士, The Hermit of Lonely Clouds.
From Yung-chia, Chekiang. B. ca. 1380, d. ca. 1329. Most prominent as a painter of architectural and other subjects in the fine-line "boundary painting" manner, but painted also figures and landscapes. H, 5. I, 53. M, p. 35. See also Yüan Exh. Cat., note to no. 201.

Chung-kuo I, 110. A toy peddler and a man and woman with their child. Signed, dated 1310. See also TSYMC hua-hsüan 29; Siren CP VI, 47; Chung-kuo MHC 36.

John M. Crawford, Jr., N. Y. The Ta-ming Palace. Handscroll. Signed, dated 1312. Good Ming work, after an original by Wang Chen-p'eng? See Crawford Cat. 53.

* Sogen 46 (Chou Chih-ch'eng coll.). The A-fang Palace. High buildings and trees rising over a misty river. Signed, dated 1321; seal "Imperially Presented to Ku-yün Ch'u-shih." See also Pageant 293.

John M. Crawford, Jr., N. Y. Lichee and marigolds. Inscription, dated 1323. Ming work. See Crawford Cat. 58.

* Metropolitan Museum, N. Y. (66.174). The Dragonboat Regatta on the Chin-ming Lake. Handscroll. Inscribed, dated 1323. According to the artist's inscription, the original of this painting was done for the emperor in 1310. Twelve years later when the emperor's elder sister asked for a similar picture, the artist painted it again, apologizing in the inscription for the poor execution due to his old age. See Met. Mus. *Bulletin,* May 1968; Yüan Exh. Cat. 201; Archives XXI (1968), fig. 29.

Other versions of the composition exist as follows (information based on notes supplied by Karen Brock, who has made a study of these scrolls):
1. Detroit Institute of Arts (64.75). Signed and dated 1323. Copy of the above work, probably done in the late Yüan period. Seals of Hsiang Yüan-pien and others. Unpublished.
2. Taipei, Palace Museum (YH7). Signed and dated 1323. Copy of the Detroit version, late Ming? Inscription by Yüan Chüeh and Liu Chi. *Ssu-yin* half-seal. See Three Hundred M., 160; CAT 73; CH mei-shu II; CKLTMHC III, 18.
3. Ibid. (YH8). Seal of the artist; also *Ssu-yin* half-seal, and seals of Hsiang Yüan-pien and others. Best in quality of the three versions in the Palace Museum. May be a 14th century copy after the lost 1310 original. See Mei-shu t'u-chi, II.
4. Ibid. (YH6). Signed, dated 1310. Ch'ing academic work, incorporating elements of the above earlier versions.
5. Cheng Chi, Tokyo. Signed, dated 1323. Perhaps a copy after the Metropolitan Museum scroll, see above.
6. (A fragment of another scroll of this type, very good in quality but lacking signature and seals, perhaps the work of Wang Chen-p'eng or a close follower, was exhibited at the Peking Palace Museum in Fall, 1977).

* Peking, Palace Museum. Po-ya playing the *ch'in* for his friend. Handscroll. Signed. Genuine, fine work.

Taipei, Palace Museum (VA30c). Palace by the water. Album leaf. Closer to the style of Hsia Yung, perhaps his work.

Ibid. (VA12w). View from the Immortal's Palace. Album leaf. Attributed. Copy?

Ibid. (YV211). The Abode of the Immortals in the Midst of a Misty Sea. (Really a view of Chin-shan in the Yangtze River.) Attributed. Ming, by follower of T'ang Yin. See KK shu-hua chi XXIII.

Nezu Art Museum, Tokyo. Kuan-yin. Attributed. See Doshaku, 7; Suiboku IV, 67.

Ch'ing-kung ts'ang 10 (Manchu Household collection). A man seated on a cliff overlooking a misty gorge. Fan painting. Signed. Ming work.

Chung-kuo I, 111 (Ti Pao-hsien). A hermit under a tree with two attendants receiving peaches from a monkey. Signed. Imitation. See also Chung-kuo MHC 34.

Shen-chou album, N. D. Illustrations to the Life of Confucius. Album of 10 leaves. Each leaf inscribed by Yü Ho (late Yüan); last leaf signed by both. Ming imitations.

Sogen 45. The night revels of Han Hsi-ts'ai. Handscroll. Attributed. Ming copy of Ku Hung-chung's work. See also Pageant 292; Che-chiang 36.

* Museum of Fine Arts, Boston (12.902). *I-mu yü-fo t'u:* Mahaprajapat. Nursing The Infant Buddha. Handscroll. Signed. See BMFA Portfolio II, 9-20; Siren CP in Am Colls. 114; Siren CP VI, 46; Suiboku IV, 66; Kodansha BMFA 97.

Ibid. (12.889). The Imperial Dragon Boat. Fan painting. Attributed. Good work of the period. See Kokka 270; Yüan Exh. Cat. 202; BMFA Portfolio II, 11; Siren CP in Am. Colls. I, 18.

Freer Gallery (11.161e). A peddler with his pack; a mother and two children. Not attributed to him, but in the style associated with him, and Yüan period. See Cahill Album Leaves XXII; Freer Figure Painting cat. 55.

* Indianapolis Museum of Art (60.35; former Chang Ts'ung-yü). Demons attacking the glass bowl containing Hariti's son. Handscroll. Signed. Genuine. Colophon by a monk named Yen-chün dated 1363; others 1389, 1390. Seals of Tuan-fang, Ti Pao-hsien. See Yün Hui Chai 28.

* Nelson Gallery, K. C. A palace on a river bank; misty mountains beyond. Album leaf. Signed.

Metropolitan Museum, N. Y. (13.100.105). Pavilion by a lake. Fan painting. Attributed.

Ibid. (47.18.41). People on the terrace of the Yo-yang Pavilion watching Lü Tung-pin appear in mid-air. Attributed. Ming work.

Staatliche Museen, Berlin. Toy-peddler and children. 15th-16th century Academy work. See Berlin Cat. (1970), no. 31.

* Laufer, 27. The Palace of Prince Teng. Short handscroll. Long inscription by the artist; according to Laufer's notes, executed in the period 1312-1314. Genuine?

Note: Some of the paintings now recognized as works of Hsia Yung, such as "The Palace of Prince Teng" in the Boston M.F.A., were formerly ascribed to Wang Chen-p'eng.

WANG I 王繹 t. Ssu-shan 思善 , h. Ch'ih-chüeh 癡絕
Lived in Hangchou. B. 1333, d. after 1362. Painted portraits and landscapes. Author of an essay on portrait-painting translated by Herbert Franke in *Oriental Art,* vol. III, no. 1 (old series), pp. 27-32. H, 5. I, 54. L, 28. M, p. 36.

Shen-chou 5. High mountains rising along a river, after Tung Yüan. Handscroll. Signed, dated 1362. Ming work, unrelated to Wang I.
* Peking, Palace Museum (former Kuo Pao-ch'ang). Portrait of Yang Chü (Yang Chu-hsi) in a landscape. Figure by Wang I; Trees and stones by Ni Tsan; dated 1363. See Sogen 64; Chung-kuo hua XVIII, 16; Li-tai jen-wu 40; TSYMC hua-hsüan 27; Kokyu hakubutsuin, 179.

WANG KUEI 王珪 t. Chün-chang 君璋 , h. Chung-yang Lao-jen 中陽老人
From K'ai-feng, moved to Ch'ang-shu, Kiangsu, in the Ta-te era (1297-1307). Painted landscapes. I, 54. L, 28. M, p. 36.

Toso 146b (formerly Lo Chen-yü). A hundred buffaloes grazing along the river. Part of a handscroll. Work of a later period.

WANG MENG 王蒙 t. Shu-ming 叔明 , h. Huang-hao Shan-ch'iao 黃鶴山樵;
Huang-hao Shan-jen 黃鶴山人 , Hsiang-kuang Chü-shih 香光居士
From Wu-hsing, Chekiang. B. C. 1308, d. 1385 in prison. Grandson of Chao Meng-fu; one of the "Four Great Masters" of the Yüan period. Painted landscapes. Learned from his grandfather; followed Tung Yüan and Chü-jan. H, 5. I, 54. L, 28. M, p. 36. See also Huang Kung-wang Yü Wang Meng, by P'an T'ien-shou and Wang Po-min, Shanghai 1958, in the CKHCTS series (HKW/WM). Also biog. by Chu-tsing Li in DMB II, 1392-1395; and unpub. dissertation by Richard Vinograd (U. of Calif., 1979).

Taipei, Palace Museum (VA260). Fishing on the pine stream. Album leaf. Signed, dated 1341. Old imitation; fragment?
Garland II, 23 (former Wang Shih-chieh). Clouds and pines on Shao-pai Mountain. Inscription dated 1341. Good 17th-18th century work with interpolated inscription and seals.
Taipei, Palace Museum (YV254, chien-mu). Listening to the Wind in the Pines. Signed, dated 1342. Good late Ming work.
Sogen 57 (Ogawa Coll.). A house in the autumn mountains. Signed, dated 1342. Imitation.
Taipei, Palace Museum (YV77). Tung Shan homestead at the foot of high mountains by the water. Signed, dated 1343. Good Ming imitation, time of Shen Chou? See KK shu-hua-chi XXVII; London Exh. Chinese Cat.

158; KK ming-hua VI, 17; Wen-wu chi-ch'eng 85; KK chou-k'an 405; Yüan FGM 401.

Ibid. (YV240, chien-mu). A house among trees by the river. Signed, dated 1343. Early Ch'ing work, cf. Wang Hui.

Wango H. C. Weng, Lyme, N. H. *Ching-shih ch'ing-yin:* Quiet Room and Clear Music. Signed, dated 1343. Imitation. See Yüan Exh. Cat. 255; Bunjinga suihen III, 44.

Toso 177 (Hsiao Fang-chün). A rock from the Sung Mountains. Colophon by the artist, dated 1343. Two poems by Ch'ien-lung. Copy?

Taipei, Palace Museum (YV76). Pines growing below a cliff; a waterfall. Signed, dated 1344. Imitation. See Three Hundred M., 192; Yüan FGM 402.

Ibid. (YV74). A deep gully between wooded cliffs; two men on the bridge in the foreground. Signed, dated 1344. Poem by Ch'ien-lung. Imitation. See Ku-kung XXIX; Three Hundred M., 190; KK ming-hua VI, 16; Chugoku 2; Yüan FGM 403.

Chugoku II, 5. Reading in Autumn Mountains. Signed, dated 1345. Early and good imitation.

Taipei, Palace Museum (YV262, chien-mu). *Lin-ch'üan ch'ing-ch'ü t'u.* Mountain gully with tall trees. Much damaged. Poem by the artist, dated 1346. Inscription by Wang To. 15th cent. Suchou school work.

Sogen 59. River scene in wind and rain. Signed, dated 1346. See also Che-chiang 33; HKW/WM 14; I-lin YK 35/10.

Wen-hua album, 1922. Parting at Wei-yang. Short handscroll. Signed. Colophons dated 1346. Imitation.

Shen-chou ta-kuan 16. Pavilion on the mountain of the Immortals. Signed, dated 1348. Poems by Ni Tsan and Chang Yü. Reproduction blurred.

Taipei, Palace Museum (YV263, chien-mu). A man in his study in the mountains. Signed, dated 1349. Copy.

Osaka Municipal Museum (former Abe Coll.). A river winding between ridges of wooded mountains. Long handscroll. Signed, dated 1349. Imitation. See Soraikan I, 25; Kokka 556; Shoman; Osaka Cat. 66.

Bunjin gasen II, 3 (Kikuchi Coll.). A hermit's cottage under pines at the foot of high mountains. Signed, dated 1349. Imitation. See also Chugoku II, 8.

Ibid. I, 1 (Tokyo National Museum, formerly Takashima Coll.). Two men in a cottage under pines by a stream in the mountains. Signed, dated 1350. Poem by Shen Chou. Imitation. See also Chugoku II; Tokyo N. M. Cat. 38.

Taipei, Palace Museum (YV72). *Yu-lin ch'ing-i t'u:* Pure Withdrawal in a Secluded Grove. A scholar's abode at the foot of a mountain. Signed, dated 1350. Good 16th century work by Wen Cheng-ming follower.

Kaian Kyo 3 (formerly Takashima, now Tokyo Nat'l Mus.). A waterfall between high mountains; a clump of pines below. Signed, dated 1350. Imitation. See also Chugoku II; Bunjin gasen II, 4.

Nanga shusei I, 3. Steep cliffs with a waterfall; a man in a pavilion by the river. Horizontal picture; or section of a handscroll? Signed, dated 1351. See also Siren CP VI 106.

Kaian Kyo, 2 (formerly Takashima collection, now Tokyo Nat'l Museum). Mountains with waterfall; thatched houses beneath leafy trees. Poem by the artist, dated 1351. Two colophons. Imitation. See also Liu, 34.

Taipei, Palace Museum (YV245, chien-mu). A temple in the mountains; a traveler approaching. Signed, dated 1352. Good late Ming work.

Fujii Yurinkan. Landscape. Ink and light color on silk. Signed and dated 1352. Colophon by Kao Ch'i. Date impossible; Ming work?

Ibid. (YV244, chien-mu). Men beneath pines in a valley. Signed, dated 1353. Good Ming work, close to Wen Cheng-ming.

Ibid. (YV251, chien-mu). A temple in a mountain gorge. Signed, dated 1354. Early copy; a later version is listed below under Toso 172.

* Freer Gallery (59.17). *Hsia-shan yin-chü t'u:* Dwelling in the Summer Mountains. Small painting, on silk. Signed, dated 1354. See Ta-feng-t'ang I, 14; TWSY ming-chi 104; Kodansha Freer Cat. 63; Hills 51; Bunjinga suihen III, 37.

Toan II (Saito Coll.). A retreat among Cassia trees at the foot of high mountains. Long colophon by the artist, dated 1357. Impressive work, but of later period? See also Nanshu ihatsu IV; Kohansha II.

Taipei, Palace Museum. The Ya-i Studio of Ch'en Wei-yün. Signed, dated 1358. Good Ming imitation. See also KK chou-k'an 243; Pageant 345.

Nanshu ihatsu III. A scholar's retreat in the mountains. Signed, dated 1360. Imitation.

Chicago Art Institute. (47.728). Quiet Life in a Wooded Glen. A man in his study under leafy trees at the foot of high mountains. Signed, dated 1361. See Siren CP VI, 103-104; Bunjinga suihen III, 39.

Taipei, Palace Museum (YV173). A man by a mountain stream looking at the waterfall. Painted together with Ni Tsan. Poems and colophons by both artists, Ni Tsan's dated 1361, and by Tung Ch'i-ch'ang. Imitation. See KK shu-hua chi II; KK ming-hua VI, 39; Nanking Exh. Cat. 63; KK chou-k'an 495.

I-shu ts'ung-pien 12. Fishing in the Pine Stream. Signed, dated 1361. Reproduction blurred.

Kuan Po-heng Collection. Wooded mountain ridge; buildings in the gorge and a man seated by the stream under tall pines. Signed, dated 1361.

Taipei, Palace Museum (YV258, chien-mu). *Tung-shu ts'ao-t'ang;* tall cliffs by a river, figures and houses beneath trees. Signed, dated 1361. Late imitation.

I-yüan chen-shang 8. Landscape. Signed, dated 1362. 17th century?

Taipei, Palace Museum (YV80). *Ch'iu-shan hsiao-ssu t'u:* A Temple in the Autumn Mountains. Signed, dated 1362, with a dedication to Tsou Fu-lei. Copy of genuine work? See KK shu-hua chi 46; Yüan FGM 404; Three Hundred M., 195; CH mei-shu II. A later copy in the collection of C. C. Wang, N. Y.

Ibid. (YV241, chien-mu). A house among pines; tall mountains. Signed, dated 1362. Good late Ming imitation.

Ibid. (YV252, chien-mu). Fishing in a boat near a waterfall. Signed, dated 1362. Early Ch'ing work, cf. Wang Hui.

Ibid. (YV255, chien-mu). Landscape of Ching-ch'i. Signed, dated 1364. Interesting late Ming work.

Shen-chou ta-kuan hsü 7. Drinking under the pines. Signed, dated 1364.

Fujii Yurinkan, Kyoto. Landscape. Handscroll, ink and colors on paper. Signed, dated 1364. Late Ming work of good quality; cf. Sung Hsü. See Yurintaikan II, 32.

* Suchou Museum. Bamboo and rock. Poem, signed, dated 1364. See Suchou 3.

* Peking, Palace Museum (exhibited Fall 1977). *Hsia-shan Kao-yin t'u:* Lofty Recluses in Summer Mountains. Hanging scroll, ink and colors on silk. Title, dedication to Yen-ming, dated 1365, signed. Fine genuine work.

Garland II, 22 (Wang Shih-chieh, Taipei). Luxuriant Bamboo, Dense Pines; the study pavilion of a scholar in a pine-grove near a rocky shore. Short handscroll. Inscription by the artist, dated 1365. Good work of later date.

* Shanghai Museum (former Ti Pao-hsien). *Ch'ing-pien yin-chü t'u:* Dwelling in the Ch'ing-pien Mountains. Signed, dated 1366. Colophon by Tung Ch'i-ch'ang. See Chung-kuo I, 85; Nanga shusei I, 2; Toso 169; Chung-kuo MHC 1; Chung-kuo hua I, 20; HKW/WM 12; Shang-hai 22; TSYMC hua-hsüan 25; Chugoku bijutsu III, 17-18; Hills 53-5; Bunjinga suihen III, 31-33. A late, exact copy is in the Princeton Art Museum; see Bunjinga suihen III, 34.

* Shen-chou 5. *Lin-ch'üan ch'ing-chi t'u:* An Elegant Gathering by the Stream in a Pine Grove. Signed, dated 1367. See also Nanga Taisei IX, 83; and Rowley, Principles of Chinese Painting, 2nd ed., 1959, Pl. 24. A copy in Chugoku II and Nanga shusei III, 3; still another, former collection of Chang Ta-ch'ien, later Chiang Er-shih, see Chiang Er-shih II, 8.

Ming-pi chi-sheng III. Bamboo growing by a stream; a scholar seated in contemplation. Signed, dated 1367. Imitation.

* Peking, Palace Museum (former P'ang Yüan-chi). Living in the mountains on a summer day. Signed, dated 1368; painted for Tung Hsüan. Poems by Lin Han and Ch'ien-lung. Genuine? or good early copy? See Toso 175; Ming-pi chi-sheng IV; Che-chiang 32; Fourcade 7; Siren CP VI, 109b; Kokyu hakubutsuin, 180.

Taipei, Palace Museum (YV70). *T'ao-yüan ch'un-hsiao t'u:* Spring Morning in the Peach-grove Temple. A fisherman in a boat. Poem and inscription by the artist, dated 1370. Good middle-Ming painting.

Ibid. (YV246, chien-mu). *Yu-yü-ch'ing t'u.* A man in a house playing a ch'in for another. Signed, dated 1382. Ming? See KK shu-hua chi 47.

* Peking, Palace Museum. *Hsi-chiao ts'ao-t'ang t'u:* A Thatched Cottage in the Western Field. A man in a pavilion under budding trees; view over a river between rocky shores. Signed. See Siren CP VI, 110a.

Ibid. The Lan-tien Village. Water rushes down the hills; a man seated in the pavilion on a terrace. Inscription by the artist. Much repaired.

* Ibid. Ko Hung Moving his Residence. He is seen crossing a bridge, followed by his family; houses above in rocky valley. Title and inscription, signed. Seals of Hsiang Yüan-pien and others. See also Chung-kuo I, 86; Nanga shusei III, 6; CK ku-tai 69; Chung-kuo MHC 7; CK shu-hua I, 23; HKW/WM 18.

* Liaoning Provincial Museum. *T'ai-po-shan t'u:* the Buddhist Temple at Mount T'ai-po. Long landscape handscroll, ink and bright colors on paper, with many figures. Seals of the artist, on separate paper, replacements for seals cut off at the time of Wang Meng's political troubles? Inscriptions by Buddhist monks of the early Ming period, dated from 1388 to 1417; seals of Shen Chou, Hsiang Yüan-pien, Liang Ch'ing-piao, An Ch'i, etc. See Liao-ning I, 92-95; Chugoku bijutsu III, 20.

* Shanghai Museum (former Chou Hung-sun). *Ch'un-shan t'u:* A Scholar's Study in the Spring Mountains. Two pavilions under large pines at the foot of a steep mountain. Long inscription by the artist. See Toso 176; HKW/WM 13; Shang-hai 23; Siren CP VI, 108; Chugoku bijutsu III, no. 16; Bunjinga suihen III, 38.

 TSYMC hua-hsüan, 24. *Tan-shan p'eng-hai t'u:* Cinnabar Hills in the Immortal's Sea. Seascape; a bridge leading to a mountain promontory. Short handscroll, signed. Copy?

* Taipei, Palace Museum (YV69). *Ku-k'ou ch'un-keng t'u:* Plowing in Spring at the Entrance to a Valley. Poems by the artist, by Ch'ien-lung and three other men. Colophon by Tung Ch'i-ch'ang. See KK shu-hua chi XIV; London Exh. Chinese Cat. 159; Three Hundred M., 188; CH mei-shu II; CKLTMHC III, 67; KK ming-hua VI, 14; Wen-wu chi-ch'eng 84; KK chou-k'an 171; Siren CP VI, 109a; Yüan FGM 405; Bunjinga suihen III, 29.

 Ibid. (YV71). A scholar's pavilion by a mountain stream under leafy trees. Signed. Good middle Ming work by Suchou master. See KK shu-hua chi XXXIV; Three Hundred M., 189; CH mei-shu II; CKLTSHH; KK ming-hua VI, 15; Wen-wu chi-ch'eng 86; Siren CP VI, 107; NPM Masterpieces I, 24; Yüan FGM 410.

* Ibid. (YV264, chien-mu). *Hua-ch'i yü-yin t'u:* A Fisherman-Recluse on the Flowery Stream. Poem, signed. Inscription by Shen Meng-lin, dated 1393; another by Shen Liang. See Siren CP VI, 111; CKLTMHC III, 66; NPM Quarterly I, 2 (article by C. C. Wang and Li Lin-ts'an concerning the three versions of this painting), pl. 2; Yüan FGM 407; Hills 52. Two copies of the composition in the same collection: YV73 (pl. 1 in the same article); YV275 (pl. 3 in the same article). A copy of the upper section only preserved as an album leaf in the same collection (VA10d).

* Ibid. (YV75). *Chü-ch'ü lin-wu t'u:* The Forest Grotto at Chü-ch'ü. Signed. See Three Hundred M., 191; KK ming-hua VI, 20; NPM Quarterly I, 2; Yüan FGM 411; pls. 7, 9b; Skira 114; Hills 58; Bunjinga suihen III, 40-41. A later copy of the composition in the same collection (YV253, chien-mu).

* Ibid. (YV78). *Ch'iu-shan ts'ao-t'ang t'u:* Thatched Houses in the Autumn Hills. Signed. See KK shu-hua chi XXXII; Three Hundred M., 193; CAT 88; CCAT 110; CKLTMHC III, 65; KK ming-hua VI, 19; Speiser Chinese Art III, 52; Pageant 346; Yüan FGM 408.

* Ibid. (YV79). *Ch'iu-lin wan-ho t'u:* Autumn Groves and Myriad Valleys. Signed. See Three Hundred M., 194; KK ming-hua VI, 18; Yüan FGM 409.

 Ibid. (YV248, chien-mu). The Chien Pass. Title and signature. Early Ch'ing work, cf. Fa Jo-chen.

Ibid. (YV249, chien-mu). Visiting a Hermit in the Mountains. Inscription, signed. Good late Ming work. Seal of Mo Shih-lung; by him?

Ibid. (YV250, chien-mu). A house in a valley among pines. Title and signature. Ming copy?

* Ibid. (YV256, chien-mu). *Chu-shih liu-ch'uan t'u.* Stalks of bamboo growing by a stream. Poems by the artist, by Yao Kuang-hsiao, and by Wang Hsing; seal of Shen Chi, uncle of Shen Chou. See NPM Bulletin, II.5, p. 8; Yüan FGM 406.

Ibid. (YV257, chien-mu). A man on the shore gazing across the river at a mountainside. Signed. Late Ming work.

* Ibid. (YV259, chien-mu). Enjoying Oneself with Books and Lute. Signed. Original? or early imitation? Early work of good quality.

Ibid. (YV260, chien-mu). Bamboo growing by a rock. Signed. Late Ming, cf. Chan Ching-feng.

Ibid. (YV261, chien-mu). The Lan-hsüeh Studio. Signed. Good Ming work by a follower of Wen Cheng-ming.

* Ibid. (YH71, chien-mu). *Chih-lan-shih t'u:* the Villa of Iris and Orchids. A scholar's study in a valley; potted orchids inside; figures meeting in a cave behind. Handscroll. Title by the artist, signed. Colophons by K'o Chiu-ssu and four other contemporaries. Calligraphy by Wen Chia and Tung Ch'i-ch'ang. See Hills pl. 6. Another version in the collection of J. P. Dubosc, Paris.

Ibid. (YH13). Playing the Yüan. Handscroll. Attributed. Colophons by Wen Cheng-ming and others. Imitation.

Ibid. (MH63). The Depths of the Cassia Flower Hall. Short handscroll. Signed "Hao-shan Lao-ch'iao," intended for Wang Meng. Late imitation.

Ibid. (VA6i). Landscape. Album leaf. Signed. Imitation.

Ibid. (YV74). Misty mountain landscape. Album leaf. Signed. Imitation. See Ku-kung 29; KK chou-k'an I, 3.

Garland II, 21 (Wang Shih-chieh, Taipei; former Ti Pao-hsien). A waterfall in an Autumn Valley. Colophons by Ma Han-chung and Cha Shih-piao. Fine late Ming work, cf. Sung Hsü. See also Siren LCP I, 4; Chung-kuo I, 87; Toso 170; Siren CP VI, 105; Chung-kuo MHC 27; Pageant 344; Nanga shusei XIV, 14; Sickman and Soper 116b.

Chin-k'uei 20 (former J. D. Ch'en). Myriad pines, mountain lodge. Inscription, signed. Late Ming imitation?

HKW/WM 16-17. A gentleman on a promontory watching a high waterfall; a man on a bridge watching rapids, a pagoda in the background. Two album leaves. Imitations.

* Mei-chan T'e-k'an. Bamboo and an old tree by a rock. Signed. Colophon by Yang Wei-chen.

Chin-shih shu-hua, 30. *Wan-sung hsien-kuan t'u:* Taoist temple amid myriad pines. Title, signed. Reproduction indistinct.

Shen-chou ta-kuan hsü 7. High wooded mountains. Signed. Imitation.

Chung-kuo MHC 10. Small pavilions at the foot of lofty mountains; two men on the river-bank. Signed. Good Ming imitation.

N. P. Wong, Hong Kong (former P'ang Yüan-ch'i). Temple in mountains in autumn. Signed. Dedicated to Ch'en Ju-yen.

Ming-pi chi-sheng I, 4. A Temple in the Autumn Mountains. Title and two poems by the artist. Signed. Ming imitation.

Shen-chou ta-kuan hsü 1. *Ch'i-shan kao-i t'u:* a man in his house by the river. Title and signature. Album leaf. Good Ming imitation? See also Nanga taisei XI, 20.

Cheng Chi, Tokyo. *Nan-ts'un ts'ao-t'ang t'u:* the residence of T'ao Tsung-i, Wang's cousin, painted for him. Handscroll. Signed. Colophons by contemporaries.

Toso 172 (former Shen Jui-lin; now private collection, Chicago). A temple in a mountain gorge. Signed. Poem by Ch'ien-lung. See also Sickman and Soper (old ed.), 116a; HKW/WM 15.

Pageant 348 (former Shao Fu-ying). A homestead in the gorge of a steep mountain. Signed. Ming imitation.

Toso 174 (former Shao Fu-ying). A solitary angler in a boat on the stream. Signed. Imitation.

* Chugoku II, 11-12. *Yün-lin Hsiao-yin t'u:* the villa of Ts'ui Yen-hui. A river shore with rounded hills and houses among leafy trees; a fisherman in a boat. Short handscroll. Signed. Long inscriptions by the artist and many others by contemporaries. Seals of An Ch'i, Liang Ch'ing-piao, and others. See also TSWY ming-chi 105-106.

Kokka 441 (Yamamoto collection). Fishermen in two small boats at the foot of a mountain ridge. Album leaf. Signed. Poems by Chang Yü (1333-1385) and four other contemporaries. See also Bunjin gasen I, 2; Nanshu ihatsu IV; Toso 173; Naito 17; Chugoku II; Pageant 347. Close copy or early imitation?

Osaka Cat. 65. Pines in a Misty Valley. Signed. Imitation.

Nanshu ihatsu IV. An old man and a crane in a small boat on a mountain river. Signed. Poem by Ch'ien-lung. Poor forgery.

Chugoku II, 6. Buddhist temples in autumn mountains. Signed. Copy or imitation.

Hayashibara collection, Okayama. Landscape. Signed. Late imitation.

Cheng Te-k'un, Hong Kong. Rocky mountain with waterfalls and tall pines at the lower edge, surrounding the scholar's pavilion. Poem by the artist.

Freer Gallery (16.568). Mountain landscape. Inscription, signed. Interesting imitation of Ming date.

Ibid. (39.59). *I-ch'in-t'ang t'u.* A homestead in a fantastic garden with hollowed rocks; leafy trees and waterfalls by a river along a mountain ridge. Signed, dedicated to a man called Chang Chih. Short handscroll. 17th century imitation.

Ibid. (48.22). Landscape with pavilion. Inscription, signed. Imitation, perhaps by Li Shih-cho of the Ch'ing period.

Ibid. (15.36c). Twin pines by a river. Album leaf. Inscription, signed. Inscriptions by Yang Wei-chen and others. Early copy?

Museum of Fine Arts, Boston (55.618). Scenery of Mount T'ai-po. Handscroll. Seals of the artist. Poem by Shen Chou. Early imitation? Unrelated in composition to the scroll of the same title in the Liaoning Museum (see above). See BMFA Portfolio II, 12-14; Bunjinga suihen III, 49.

* Metropolitan Museum, N. Y. (1973.121.7; formerly C. C. Wang). *Tan-yai ts'ui-ho t'u:* Red Cliffs and Verdant Valleys. A scholar on a river bank with his ch'in; a servant. Small hanging scroll. Long inscription, signed. Minor, probably genuine. See Garland II, 24; Met. Cat. (1973), no. 21.

Ibid. *I-wu Hsüan t'u:* the Single Wu-t'ung Tree Retreat. Ming? imitation. See Bunjinga suihen III, 48.

* Indianapolis Museum of Art (60.50). A scholar's retreat on a rocky promontory at the foot of Mt. Hui. Short handscroll. Inscription, signed. See Yüan Exh. Cat. 256; Yün hui chai 36; Hills 56-7; Bunjinga suihen III, 43.

* Mr. and Mrs. A. Dean Perry, Cleveland. Writing Books under the Pine trees. Double album leaf. Dedicated to Ts'ao Chih-po, so painted before 1355. Signed. See Yüan Exh. Cat. 257; Bunjinga suihen III, 42.

John M. Crawford, Jr., N. Y. *Hsü-chai t'u:* The Sunrise Studio. Short handscroll. Signed. Imitation.

Ibid. Dwelling in the Hills. Signed. See Crawford Cat. 52.

* Ernest Erickson, N. Y. *Hsiu-chu yüan-shan t'u:* Tall bamboo and distant mountains. Inscription by the artist, signed. See Shen-chou ta-kuan VII; BMFEA XXXVI, 1964, pl. 1-2. A copy in the Palace Museum, Taipei (YV243, chien-mu).

* C. C. Wang, N. Y. (former Kuan Mien-chun). *Su-an t'u:* the Su-an Retreat. A villa beneath a towering mountain. Title and signature. See Toso 171; Yüan Exh. Cat. 258; Siren CP VI, 110b; Bunjinga suihen III, frontispiece.

Ibid. Large bending and twisting pines along a steep mountain path; a pavilion below and two men approaching. Signed, dedicated to I-yün Shang-jen. See Bunjinga suihen III, 30.

Ibid. A man in a pavilion over the water, beneath leafy trees. Fan painting. Signed. Inscription by Ch'en Wei-yin. Minor but genuine work?

WANG MIEN 王冕　　t. Yüan-chang 元章　, h. Lao-ts'un 老村　, Chu-shih Shan-nung 煮石山農
From K'uai-chi, Chekiang. B. 1287, d. 1359. Specialized in blossoming plum branches. I, 55, 1. L, 28, 2. M, p. 36. N, I, 5-7. O, 7. See also Hung Jui, *Wang Mien,* Shanghai, 1962 (CKHCTS series); and biog. by Chu-tsing Li in DMB II, 1395-1398.

Princeton University Art Museum (47-46, Morris Collection). Plum branch in mist. Hanging scroll, ink on silk. Inscription (same poem as on Metropolitan Museum Wang Mien, see below) signed and dated 1342. 15th century work?

* Shanghai Museum. A branch of flowering plum. Handscroll. Inscription, dated 1346. Seals of Liang Ch'ing-piao and Ch'ien-lung. See Kokka 526; China Pictorial 1965 no. 6.

Princeton University Art Museum (47-12, Morris Collection). Plum branch. Hanging scroll, ink on paper. Inscription signed and dated 1347. Ch'ien-lung period work. See Rowley, pl. 46B (as "artist unknown").

* Peking, Palace Museum. Bamboo growing on a slope; painted in the *kou-le* (outline) method. Inscription signed and dated 1349. See Chung-kuo hua IX, 12; Wang Mien 3.

Taipei, Palace Museum (YV116). A branch of blossoming plum. Poem by the artist; signed, dated 1353. Poem by T'ang Su. See CH mei-shu II.

* Shanghai Museum. Ink plum blossoms. Five inscriptions by the artist, one signed and dated 1355. Ten colophons on the mounting, by Chu Yün-ming, Wen Cheng-ming, Wang Ch'ung, Hsü Lin, T'ang Yin, Ch'en I, Lu Shen, Hsieh Ch'eng-feng, Hsüeh Chang-hsien and Wang Wei. See Shang-hai 33; Chung-kuo I; Chung-kuo MHC 35; Wang Mien 5; Chugoku bijutsu III, 58.

* Masaki Museum, Osaka. Branches of blossoming plum. Large hanging scroll, ink on paper. Inscription signed, dated 1355. Inscription by Wang Yüan-lu; Ch'ien-lung seals. See Masaki Cat., I, VIII.

Nanga taisei XVI, 30-31. Plum blossoms. Handscroll. Signed, dated 1355. Later work. See also Che-chiang 44 (detail); Chung-hua album, 1926. Colophons also reproduced in Nanga taisei part II, vol. 5, *t'i-pa-chi, I.*

* Toso 193 (Shao Fu-ying). A branch of blossoming plum. Long inscription—a biography of the plum tree—signed, dated 1355. See also Wang Mien 6, Siren CP VI, 118.

Taipei, Palace Museum (YV117). *Nan-chih ch'un-tsao t'u.* A long branch of blossoming plum tree, hanging down in a double curve. Poem by the artist, dated 1357 (the year *ting-ping* should presumably be read *ting-yu,* i.e. 1357). See Three Hundred M., 199, CK li-tai III, 86.

Yabumoto Soshiro, Tokyo. Branch of blossoming plum. Narrow hanging scroll, ink on paper. Long inscription, signed, dated *kuei-ch'ou,* 1313 or 1373, the former unlikely and the latter impossible. Inscription by the Genroku era Japanese tea-master Yoken. Early work, probably not by Wang Mien.

* Peking, Palace Museum. Branch of a blossoming plum. Poem by the artist. Mounted on the same scroll as Chao Yung's Fishing in a Mountain Stream and Chu Te-jun's Two Men in a Boat. See I-shu ch'uan-t'ung 9; Chung-kuo hua II, 9; CK ku-tai 68; KKPWY hua-niao 26; Fourcade 37; Wang Mien 1; Kokyu hakubutsuin 181; Hills 78.

* Taipei, Palace Museum (YH19). Twigs and blossoms of a plum branch. Long inscription. Mounted in a handscroll with a bamboo painting by Wu Chen (dated 1344) under the title *Shuang-ch'ing t'u,* "Two Purities." See KK chou-k'an 118; KK chu-p'u I, 11; NPM Masterpieces I, 22-23.

Ibid. (VA19t). Spring Freshness in the Hidden Valley. Plum blossoms. Album leaf. Signed. Later work?

Kao Yin-yüeh, Hong Kong. Plum blossoms. Signed.

* Siren CP VI, 119 (former Lien Ch'üan, Shanghai). The top of an old plum tree in blossom. See also Siren LCP I, 8; Kokka, 302.

KK ming-jen hua-mei chi I, 6. Branches of blossoming plum. Tall, narrow composition. Three seals, of the artist? Imitation?

Chin-k'uei 22 (former J. D. Ch'en). A hanging curved branch of plum blossom. Poem, signed. Early imitation? See also Wang Mien 2.

Wang Mien 4. An upward-growing branch of blossoming plum. Poem, signed. See also Po-mei chi, 1; Nanga taisei III, 3 (left).

Shimbi XVI. A blossoming plum tree. Part of a handscroll.

Kyoto National Museum (former Ueno collection). Blossoming plum branch. Title, no signature. Attributed. Probably a Yüan work unrelated to Wang Mien. See Ueno Cat. pl. 1.

Fujita Museum, Osaka. Plum blossoms. Handscroll. Signed. Imitation.

* Japanese Imperial Household. A branch of blossoming plum by a rock. Inscription, signed. See Sogen no kaiga 86; Toyo bijutsu 82.

* Metropolitan Museum, N. Y. (1973.126.9; former C. C. Wang). A hanging branch of plum blossoms. Poem by the artist (same as on 1342 Princeton scroll, see above). Writing at the top by Ku Ta-tien. See Yüan Exh. Cat. 250; Met. Cat. (1973), no. 25.

* Cleveland Museum of Art (74.26, former Asano). Branch of blossoming plum by moonlight. Large hanging scroll, ink on silk. Poem by the artist. Seals of the Ch'ien-lung emperor. See Bunjinga suihen III, 89.

Nelson Gallery, Kansas City (51.76). A branch of a plum tree. Hanging scroll, ink on paper. Poem signed "Fu-yüan," perhaps Tsou Fu-yüan, the brother of Tsou Fu-lei. Attributed to "Mr. Wang" or Wang Mien? in Fu-yüan's inscription. Japanese, Muromachi work? See Toso 194; Siren CP VI, 24a; Pageant 385; Cohn 176.

Yale University Art Gallery (1954.40.3; formerly P'ang Yüan-chi). Branch of blossoming plum. Signed. Ming copy? See Yale Cat. 417; Moore Cat. no. 29.

C. C. Wang, N. Y. A branch of plum blossoms. Signed. Ch'ien-lung inscription. See Garland II, 33.

Ching Yüan Chai collection, Berkeley. Hanging branch of plum blossoms. Not attributed, but a work of his time and school.

WANG TI-CHIEN 王迪簡 t. T'ing-chi 庭吉 , h. Chi-yin 畸隱
From Hsin-ch'ang in Chekiang. Yüan period. Painted narcissi. H, 5. M, p. 35.

Peking, Palace Museum. Narcissus Handscroll. Signed?
Nanshu 4 (Prince Konoe). A narcissus plant. Poem by the artist and his seals.

WANG YÜAN 王淵 t. Jo-shui 若水 , h. Tan-hsüan 澹軒
From Hang-chou, Chekiang. B. ca. 1280, d. after 1349. Pupil of Chao Meng-fu. Painted flowers, birds and landscapes. H, 5. I, 53. M, p. 35.

Taipei, Palace Museum (YV37). A traveller in autumnal mountains. Signed, dated 1299. Poem by Ch'ien-lung. Later work. See Three Hundred M., 159; KK ming-hua V, 18.

Peking, Palace Museum. River landscape; trees along the shore bending over the water; two egrets on a stone in the foreground. Handscroll. Signed, dated 1310. Peking National Museum scroll reproduction.

Princeton University Art Museum (47.5). The Pure Serenity of Green Bamboo. Ink and color on silk. Signed, dated 1342.

* Shanghai Museum. Pheasants and other birds, with a rock and bamboo. Signed, dated 1344. See Sogen 49; Che-chiang 34; Chung-kuo hua V, 14; Shang-hai 19; Wen-wu 1957.8.74; Wen-wu 1964.3.17; Chugoku bijutsu III, no. 8.

Fujii Yurinkan (former Yamamoto). A white cock under peony flowers. Signed, dated 1345. Poem by Ch'ien-lung. Imitation. See Yurintaikan II; Toso 155.

Taipei, Palace Museum (YV40). A bird on a peach-tree, and bamboo; ducks sleeping below. Signed, dated 1346. See KK shu-hua chi XXXV; CKLTMHC III, 31.

* Berlin Museum (former C. C. Wang). Bamboo and a blossoming gardenia growing by a rock; two mandarin ducks in the water. Signed, dated 1347. See Yüan Exh. Cat. 239; Berlin Cat. (1970), no. 29.

* Mr. and Mrs. A. Dean Perry, Cleveland (former Chang Ts'ung-yü). Two quail at the foot of a rock; bamboo and dry brambles behind; small birds soaring above. Signed, dated 1347. See Toronto Cat. 7; Yüan Exh. Cat. 240; Siren CP VI, 30; Munich Exh. Cat. 32; Shen-chou ta-kuan 13; Hills 73.

* Indianapolis Museum of Art (60.40). Camelias, bamboo and sparrows. Signed, dated 1347. Poem by Hsü Chin. See Yüan Exh. Cat. 238; Munich Exh. 33.

* Taipei, Palace Museum (YV38). Meeting in the Pine-tree Pavilion: Landscape with a waterside pavilion and a boat beneath pines, other boats on the water beyond. Signed, dated 1347. See NPM Masterpieces V, 26.

C. C. Wang, New York. Peonies. Album leaf. Seal of the artist. Four poems; (written at the top of the painting;) the longest, the *Mu-tan fu* copied by Li Sheng, is dated 1347. Companion to the painting in the Freer Gallery (11.163m). See Ta-feng-t'ang IV.

* Peking, Palace Museum. Pheasant on a rock; a blossoming peach tree and bamboo. Signed, dated 1349. See KKPWY hua-niao 25.

* Ibid. A golden pheasant on a rock; blossoming magnolia, bamboo and other plants. Ink and colors on silk. Signed. See KKPWY hua-niao 24.

* Taipei, Palace Museum (YV39). A hawk chasing a thrush. Signed. Colophons by Ch'en Chi-ju and others. Minor early work of the artist? See London Exh. Chinese Cat. 156; KK chou-k'an 197; CCAT 108; CH ming-hua.

Ku-kung XVI (YV218). Two wild geese among reeds on a shore. Dedicated to a friend by the painter. Ming painting.

Ming-pi chi-sheng V. A hen with five chickens; lilies, bamboo and rocks. Signed. Colophons by Yang Wei-chen and later men. Imitation.

Shen-chou ta-kuan hsü VII. Waterfowl on a flowery bank. Section of a handscroll. Signed.

Mei-chan t'e-k'an. A white cock on a garden rock. Signed. Poem by one "Chu-ch'uan-sheng." Reproduction blurred.

Shen-chou ta-kuan hsü 9. A scholar fishing. Signed. Ming work, with no relation to Wang Yüan.

Toso 156 (Kuo Pao-ch'ang). Two mynah birds on a blossoming plum-tree. Signed. Poem by Ch'ien-lung. Imitation.

Tokyo National Museum. Mandarin Ducks. Attributed. Ming work.

Nezu Museum, Tokyo. Peach-tree and parakeet. Attributed. Ming painting. See Nezu Cat. I, 44; London Exh. Cat. 1120.

* Osaka Municipal Museum (Abe Collection). Sparrows gathering at a tuft of bamboo, two quails on the ground. After Huang Ch'uan's picture of Bamboo and Birds. Signed. Poem by Ch'ien-lung. See Soraikan I, 21; Sogen 50; CK ku-tai 67; Pageant 302; I-lin YK 109/3; Osaka Cat. 58.

Chugoku I. A man reading in a thatched cottage on a river-bank; cloudy mountains on the other side of the river. Short handscroll. Signed, dedicated to a man called Te-ch'ang. Ming work, unrelated to Wang Yüan.

Shina kacho gasatsu. Mandarin ducks on a river and birds in a willow; pheasants on a rockery and mynah-birds in a tree. A pair of pictures. Ming works.

Ibid. Six kinds of chrysanthemums. Signed. Old painting with interpolated signature.

Ibid. Two cranes by a rushing stream. Seal of the artist. Good Ming work, school of Lü Chi.

Ibid. Three white herons on a wintry day. Signed. Imitation.

Shokoku-ji, Kyoto. Pheasants, bamboo and rose-mallows. Attributed. Early Ming? See Shimbi XI; Toyo IX.

Toyo IX (Kuroda collection). Pheasants, bamboo and peonies. Attributed. Ming painting.

Choshunkaku 41-42. Doves and peonies; pheasant and peonies. Pair of hanging scrolls. Attributed.

Hikkoen 56. Two wagtails on a lotus plant. Album leaf. Attributed. Work of the period, probably not by Wang. Cf. Sogen MGS III, 55.

Homma Sogen 55. Two birds on flowering branches. Pair of hanging scrolls, ink and colors on paper. Attributed. Works of the period? or Japanese imitations?

Kokka 56 (Ueno collection). Birds in a flowering tree by a stream; a pheasant on the opposite shore. Attributed.

Ibid. 157 (Marquis Kuroda). A dragonfly on a pea-vine. Album leaf. Attributed. See also Hikkoen 57; Sogen MGS III, 5.

Ibid. 173 (K. Magoshi). A branch of wild camelia. Album leaf. Attributed. See also Sogen MGS III, 4.

Ibid. (Baron Kawasaki). Two pheasants and rose-mallows. Attributed. See also Kawasaki Cat. 21; Choshunkaku 40.

Ibid. 579 (Kato collection). A spring landscape. Fan painting. Attributed. Good Yüan work, probably unrelated to Wang Yüan.

Hosomi Collection, Izumi Otsu (kept at Kyoto National Museum). Birds eating insects among plantain plants. Horizontal painting, ink and colors on paper. Attributed. Fine Yüan work.

Yabumoto Kozo, Amagasaki (1962). Pear flowers. Small picture, ink and light colors on silk. Seal of the artist.

Cleveland Museum of Art (former Inouye). Peonies. Large hanging scroll, ink and colors on silk. Attributed. Yüan or early Ming period, by specialist in this subject; cf. the paintings in the Daitoku-ji loosely attributed to Ch'ien Hsüan.

Freer Gallery (11.163m). A peony. Album leaf. Companion to the painting in the C. C. Wang collection (Ta-feng-t'ang IV) and has inscriptions by the same men.

Ibid. (16.590). A pheasant on a rock. Hanging scroll, ink and colors on silk. Signed. Copy (of Palace Museum, Peking painting listed above?).

* Ibid. (16.523). Doves on a flowering branch. Formerly called "Anon. Sung," but bears a seal of Wang Yüan, and is in his style. See Siren CP in Am. Coll. 49; Siren CP VI, 35.

Ibid. (54.126). A bird on an apricot branch. Seal of the Sung artist Li Chih, but sometimes ascribed to Wang Yüan, and close to his style. See Shimbi XVII; Cahill Album Leaves I.

Museum of Fine Arts, Boston. A small bird on a branch. Ink-painting of later date. The poem is signed by the painter Yo Tai (active in the 16th century).

Fogg Art Museum (1967.29). Landscape. Ink and color on silk. Signed.

Metropolitan Museum, N. Y. (50.157). The Hundred Flowers. Handscroll, ink and colors on silk. Signed. Imitation.

Victoria and Albert Museum, London (F. E. 109-1970). Mynah bird on a flowering branch. Attributed.

WEI CHIU-TING　衞九鼎　　t. Ming-hsüan　明鉉
From T'ien-t'ai, Chekiang. Active ca. 1350-1370. Painted landscapes and boundary (architectural) paintings. Followed Wang Chen-p'eng. H, 5. M, p. 671.

* Bunjin gasen I, 11 (former Manchu Household collection). River landscape; a mountain ridge; temples and minor buildings on the shores. Album leaf. Signed, dated 1352. Poem by Ch'ien-lung. See also Chugoku II; Siren CP VI, 29; Ch'ing-nei-fu 5.

* Taipei, Palace Museum (YV51). The Nymph of the Lo River walking on the waves. Poem by Ni Tsan, dated 1368. See Ku-kung IV; Three Hundred M., 176; Che-chiang 37; CKLTMHC III, 62; KK ming-hua 46; Nanking Exh. Cat. 64; KK chou-k'an 287; NPM Masterpieces II, 31.

WEI-TUAN
Unidentified.

Osaka Sogen 5-67. Grape vines. Seals of the artist?

WEN-CHI　聞極
Unrecorded. Said to have been a Ch'an Buddhist monk active in the late Yüan period.

Satomi collection, Kyoto. Red plum tree in bloom. Signature and seal of the artist. Inscription by Hsien-yün　閑雲

WU CHEN 吳鎮　t. Chung-kuei　仲圭　, h. Mei-hua Tao-jen 梅花道人
From Chia-hsing, Chekiang. B. 1280, d. 1354. One of the "Four Great Masters" of the Yüan period. Prominent as a poet and calligrapher, particularly in *ts'ao-shu* style. As a landscape painter, he followed Chü-jan and in his bamboo paintings Wen T'ung. H, 5. I, 54. L, 7. M, p. 160. See also Cheng Ping-shan, *Wu Chen,* Shanghai, 1958 (CKHCTS series).

* Taipei, Palace Museum (YV66). Juniper trees on the bank of a stream; a landscape beyond. Signed, dated 1328. See KK shu-hua chi IX; London Exh. Chinese Cat. 150; Three Hundred M., 166; CH mei-shu II; CKLTMHC III, 42; KK ming-hua V, 25; Wu Chen 1; KK chou-k'an 127; Siren CP VI, 85; Yüan FGM 201; Bunjinga suihen III, frontispiece.
* Ibid. (YH22). *Chung-shan t'u:* the Central Mountain. A large peak surrounded by smaller ones. Short handscroll. Signed, dated 1336. Mounted in the collected handscroll called Yüan-jen chi-chin. See CAT 90d (section); CH mei-shu II; CKLTMHC III, 47; KK ming-hua V, 29; Hills 27, Yüan FGM 204.

Peking, Palace Museum (former Kao Yen-yüeh). River landscape with fishermen in a boat; hills beyond. Signed, dated 1336. Imitation? See Chung-kuo hua XIV, 14; CK ku-tai 65; Fourcade 5; Kokyu hakubutsuin, 176.

Wu Chen 2. Pine tree by a flowing stream. Poem, signed, dated 1338.

Garland II, 16 (Wang Shih-chieh). Listening to the Rain at the Mountain Window. Mists and rain over streams and mountains. Handscroll. Signed, dated 1338. Imitation.

C. C. Wang, N. Y. A dry tree and some bamboo by a stone. A large ink painting on silk. Inscription by the artist, dated 1338. See Cleveland Exh. Cat. 29; I-shu ch'uan-t'ung VIII, 9.

* Taipei, Palace Museum (YV63). A Solitary Fisherman on the Tung-t'ing Lake. Poem by the artist, dated 1341. Poem by Ch'ien-lung. See KK shu-hua chi XI; London Exh. Cat. 152; Three Hundred M., 163; CH mei-shu II; KK ming-hua V, 22; Wu Chen 4; Wen-wu chi-ch'eng 74; Yüan FGM 205; Bunjinga suihen III, 5.
* Ibid. (YV65). Fisherman: view over a broad river, low hills on the further shore; a scholar and boatman in a boat. Poem by the artist, dated 1342. See KK shu-hua chi XLI; Three Hundred M., 165; CAT 76; CKLTMHC III, 43; KK ming-hua V, 24; Wu Chen 3; Siren CP VI, 89; Speiser Chinese Art III, 50 Hills 26; Yüan FGM 206.

Ibid. (VA9f). Returning in a boat on a mountain stream. In the manner of Chü-jan. Album leaf. Signed, dated 1342. Poem by Ch'ien-lung. Imitation. See Ming-hua lin-lang; KK chou-k'an 32; KK ming-hua V, 28.

* Freer Gallery (37.12). Fishermen, after Ching Hao. Handscroll, ink on paper. Poems by the artist; a long inscription at the end, containing the date 1352 and stating that the painting was done ten years earlier. Colophons and seals of Yao Shou; colophons by others, 15th century and later. See Skira 108; Siren CP VI, 86-87; Siren LCP I, 3; Bunjinga suihen III, 14-15. For another version, see the Shanghai Museum scroll dated 1345.

Ibid. (11.495). A steep rock by the water, two men in a boat. Signed, dated 1342. Sketchy album leaf. Imitation.

S. H. Hwa, Taipei. River landscape with covered bridge. Poem signed, dated 1343. Early imitation?

Toso 186 (Kuan Mien-chün). A bamboo stem and a bamboo shoot. Signed, dated 1343. Imitation. See also Wu Chen 5; Pageant 360.

* Kokka 500 (former Lo Chia-lun, Taipei). *Chia-ho pa-ching:* Eight Views of Chia-ho. Long handscroll. Signed, dated 1344. See also Sogen 60 (section); Che-chiang 27 (section); Wu Chen 6 (section); Garland II, 17; Hills 28.

* Taipei, Palace Museum (YH19). A branch of bamboo. Mounted with a branch of plum-blossom painted by Wang Mien in a handscroll titled "Two Purities." Inscription, signed, dated 1344. See KK chou-k'an 120; KK bamboo I, 11; NPM Masterpieces I, 22-23; KK ming-hua chi II; Yüan FGM 207.

Nanshu I (Prince Konoe). Bamboo by a rock. Poem by the artist, dated 1344.

Ogawa collection, Kyoto. A river valley overshadowed by trees; a man in a boat. Signed, dated 1344. Early imitation?

Toso 185 (Yang Heng). A sailing-boat on the river, a two-storied pavilion among trees in the foreground. Signed, dated 1344. Poem by T'ang Yin. Poor imitation.

Shen-chou album 1908 (former Lo Chen-yü). Pines along a stream. Handscroll, ink on paper. Signed, dated 1344. First colophon dated 1356. Imitation.

* Shanghai Museum (former Wu Hu-fan). Fishermen, after Ching Hao. Handscroll, ink on paper. Inscription, with a dedication to Wu's fellow townsman Wu Kuan. Colophons by Wu Kuan, dated 1345, and others. This and the Freer scroll of 1342 agree generally but not exactly in composition and in the poems inscribed on them; both may be genuine. See Wu Chen 8-9; Commercial Press album, n.d.; Bunjinga suihen III, 16-17.

Toso 184 (Huang Chih). Willows on the low banks of a river below the hills. Colophon by the artist, dated 1345. Copy or imitation. See also Pageant 355.

* Taipei, Palace Museum (YV68). Two slender stalks of bamboo growing by a stone. Inscription by the artist, dated 1347. See KK shu-hua chi II; London Exh. Chinese Cat. 151; KK ming-jen hua-chu chi; Three Hundred M., 167; CH mei-shu II; CKLTMHC III, 49; KK ming-hua V, 27; NPM Quarterly I.4, pl. 6; Wu Chen 7; Wen-wu chi-ch'eng 76; KK chou-k'an 90; KK Bamboo I, 9; Siren CP VI, 51; Hills 81; Yüan FGM 208.

Cleveland Museum of Art (63.259). Thatched pavilion in a clearing; two men seated inside. Handscroll. Inscription, signed, dated 1347. Colophon by Shen Chou. See Yüan Exh. Cat. 252; CK shu-hua I, 21; Chiang Er-shih 2; Lee Colors of Ink Cat. 12; Bunjinga suihen III, 11.

* Liaoning Provincial Museum. Plum blossoms. Handscroll, ink on paper. Long inscription, signed, dated 1348. Originally mounted, together with a similar painting by Wu Kuan, in a single handscroll with the painting ascribed to Hsü Yü-kung, Sung period (q.v.). See Liao-ning 89-90.

Taipei, Palace Museum (YA2). Ink bamboo. Album of 20 leaves. Signed, dated 1348. Copy? or weak, perfunctory, but genuine work?

Wang Fang-yu, Short Hills, N. J. River landscape with houses. Signed, dated 1349.

Juncunc Collection, Chicago. Album of six paintings, all signed, one dated 1349. Imitations.

Garland II, 18 (the late Lo Chia-lun, Taipei). *Yeh-chu-chü t'u:* Living Among Bamboo in the Wilds. Landscape with houses among bamboo. Seals of Ch'ien-lung and others. Mounted in a handscroll with a painting of a branch of bamboo, which is inscribed and dated 1349. Both were painted for T'ao Tsung-i.

* Taipei, Palace Museum (YA1). Bamboo studies. Album of twenty leaves. Poems and colophons by the artist, signed, dated 1350. See Palace Museum album, 1936 (Wu Chen mo-chu p'u); CAT 77 (leaf 8); Che-chiang 28 (leaf 3); CKLTMHC III, 50 (entire); NPM Quarterly I.4, pl. 8 (leaf 3); Nanking Exh. Cat. 57; Siren CP VI, 52; Yüan FGM 210.

* Ibid. (YV67). A slender branch of bamboo. Poem, signed, dated 1350. See KK shu-hua chi VII; KK ming-jen hua-chu chi; CKLTMHC III, 44; KK ming-hua V, 26; KK chou-k'an 112; KK Bamboo I, 10; Yüan FGM 209.

* Freer Gallery (53.85; former Ti Pao-hsien). A windblown branch of bamboo, after Su Shih. Inscribed, signed, dated 1350. See Chung-kuo I, 91; Nanga shusei II, 1; NPM Quarterly I.4, pl. 7; Siren CP VI, 51; Chung-kuo MHC 1; Kodansha Freer Cat. 62; Hills 82; Bunjinga suihen III, 12. See also A. G. Wenley, "'A Spray of Bamboo' by Wu Chen," Archives VIII, 1954, pp. 7-9.

Ta-feng-t'ang IV (former Chang Ta-ch'ien). A branch of Bamboo. Long poem by the artist, dated at the age of 71, i.e. 1350.

C. C. Wang, N. Y. Rock, old tree, and bamboo. Poem, signed, dated 1350. See Garland II, 19.

Taipei, Palace Museum (YV239, chien-mu). Men in a riverside house in a valley among trees. Signed, dated 1352. Ming imitation of some interest.

Peking, Palace Museum. Bamboo branch and stone. Long inscription by the artist.

Ibid. (former P'ang Yüan-chi). A fisherman in his boat among the reeds near the shore; alighting wild geese. Ink on silk. Poem by the artist. Odd, possibly genuine. See Liu 37.

Tientsin Art Museum. Bamboo, rock and tree branch. Inscribed, signed. See T'ien-ching II, 9.

Shanghai Museum. Pine and rock. Inscription, signed. See Shang-hai 14; TSYMC hua-hsüan 21.

Ibid. Two bamboo branches. Long inscription by the artist.

* Taipei, Palace Museum (YV62). *Ch'ing-chiang ch'un-hsiao t'u:* Spring Morning on the Clear River. Signed. Colophon by Tung Ch'i-ch'ang. Genuine, but semi-finished work; sketch for a screen? See Chung-hua wen-wu chi-ch'eng IV, 365; Nanking Exh. Cat. 58; Three Hundred M., 162; CH mei-shu II; CKLTMHC III, 48; CKLTSHH; KK ming-hua V, 21; Wen-wu chi-ch'eng 75; Yüan FGM 202.

* Ibid. (YV64). A lonely fisherman on an autumn river below a steep cliff, in the manner of Chü-jan. Poems by the artist and Ch'ien-lung, signed. See KK shu-hua chi XXIII; Three Hundred M., 164; CKLTMHC III, 45; KK ming-hua V, 23; KK chou-k'an 280; Siren CP VI, 88b, Yüan FGM 203.

Ibid. (VA26n). Old tree, bamboo and rock. Album leaf. Signed. Imitation.

Ibid. (VA31b). Landscape. Album leaf. Signed. Imitation. See KK chouk'an I, 2.

Ibid. (VA10c). Scattered Groves and Far Mountains. Double album leaf. Signed. The date, with the era-name Chih-cheng hand-written and the cyclical date hsü-wu impressed with a seal, is impossible; there was no hsü-wu (1318 or 1378) in the Chih-cheng era (1341-1368). The painting may nonetheless be genuine, and the mistake Wu Chen's.

* See also the Autumn Landscape attributed to Chü-jan in the Palace Museum, Taipei (WV13), which bears a seal of Wu Chen and is probably his work. See Three Hundred M., 45; KK shu-hua chi 43; Nanking Exh. Cat. 12; Wen-wu chi-ch'eng 16; KK ming-hua II, 11; CKLTMHC III, 46; Hills 24. Also another landscape ascribed to Chü-jan in the same collection (WV18) titled "Cherished Companions: Lute and Crane," which is probably by either Sheng Mou or Wu Chen, most likely by Wu. See Three Hundred M., 49; Siren CP VI, 88; KK shu-hua chi 44; CKLTMHC III, 39.

S. H. Hwa, Taipei. Bamboo growing from a cliff. Short handscroll, on silk, damaged. Inscription, signed.

Chiang Er-shih II, 5. River landscape with sailing boats, houses on the shore. Handscroll. Attributed in a title by Hsiang Yüan-pien. Imitation, post-Shen Chou in date.

Nanga shusei III, 7 (former P'ang Yüan-chi and J. D. Ch'en). Mountains after rain, large trees and a cottage. Inscription, signed. Imitation. See also Wu Chen 13; Ming-pi chi-sheng III; Pageant 359.

Toso 183. A house in a valley beneath trees. Poem, signed. Inscription and seals of Ch'ien-lung. Imitation. See also Pageant 354; Shen-chou ta-kuan 8; I-yüan chen-shang 3.

Wu Chen 10-11. Bamboo. Handscroll, in seven sections. Inscriptions, signed.

Shen-chou ta-kuan hsü 3. Two birds asleep on a bough. Poem by Wu K'uan. Imitation.

Chung-kuo I, 90 (Ti Pao-hsien). *Shui-chu yu-chü t'u:* Dwelling in Seclusion with Water and Bamboo. Poem by the artist. Good early 16th century work with interpolated inscription. See also Nanga shusei I, 1; Toso 182; Chung-kuo MHC 5; Pageant 358; Siren ECP 122.

Shen-chou II. An old pine tree. Signed. Imitation.

I-shu ts'ung-pien 23. Bamboo in wind growing in a rockery. Signed. Early Ming work?

Ta-feng-t'ang IV, 20 (Chang Ta-ch'ien). A slender bamboo and orchid by a rock. Long inscription by the artist.

Chugoku II. Village in the mountains; a wanderer approaching on the path below. Poem by the artist. Imitation.

Sogen 61 (P'ang Yüan-chi). Mountain landscape after rain. Poem by the artist, signed. Ming imitation. See also Wu Chen 14; I-lin YK 52/3.

Osaka Municipal Museum (Abe collection). Scenes of boating. Two paintings, fragments of a scroll? Attributed. Fine works by Che School artists of 15th-16th century. See Soraikan I, 22; Siren ECP 123; Osaka Cat. 55.

Nanshu ihatsu III. A dry shrub and some bamboo growing through a garden rock. Signed. Good imitation. See also Toyo bijutsu IV, 40.

Hakubundo album 1917. Rocks and trees. Album of eight sketches, the last in Mi Fu style. Seal of the artist. Ming works of Che School, early 16th century; cf. Li Chu etc. See also Toan 13-15; Toyo bijutsu IV, 41.

Tokyo National Museum. Bamboo growing by rocks. Inscription, signed. See Tokyo N. M. Cat. 35.

Yabumoto Kozo, Amagasaki. Bamboo and Rocks. Handscroll, ink on paper. Signed. Early Ming?

Nanga taisei I, 9-15. Bamboo. Handscroll, ink on silk. Inscriptions by the artist. Reproductions indistinct.

Bunjin gasen II, 1 (Wang Shih-yüan). Two dragon-pines with intertwined stems. Poem by the artist. Imitation. See also Wu Chen 12. A different version in Shen-chou 2.

Nanshu ihatsu III (former Yamamoto Teijiro). Gazing at the Tide. Pavilions and temples in a mountain gorge. Poem by the artist and dedication to Hsü I, who served as a censor about the middle of the century. Bad imitation.

Fujita Museum, Osaka. Bamboo. Signed. Copy or imitation.

Agata collection, Osaka. Bamboo and rocks. Pair of hanging scrolls, ink on silk. Poems, signed. Old imitations.

Museum of Fine Arts, Boston (15.907). Bamboo in wind. Poem by the artist. Fine old painting of later date—15th century? See BMFA Portfolio II, 8; Siren CP in Am. Coll. 119; Siren ECP 124; Bachhofer 113; Cohn Chinese Painting 34; Bunjinga suihen III, 6.

* John M. Crawford, Jr., N. Y. Fisherman in a boat near the shore under overhanging trees. Album leaf. Poem by the artist. See Ta-feng-t'ang I, 13; Crawford Cat. 45; Yüan Exh. Cat. 251; Lee Landscape Painting 32; Bunjinga suihen III, 13.

Ibid. Two pictures of bamboo, with a long inscription, forming a handscroll. Painted in ink on silk. Early imitations or copies. See Crawford Cat. 70.

Formerly Frank Caro, N. Y. (former Chang Ts'ung-yü). A thin bamboo spray growing from a rock. Long inscription by the artist. See Toronto Exh. Cat. 9; Yün hui chai 33; Bunjinga suihen III, 7.

Musée Guimet, Paris. Bamboo. Album leaf. Signed. Imitation. See Petrucci, *Les Peintres Chinois;* Sinica X (1935), pl. 32.

British Museum, London. Rocks and bamboo. Album leaf, ink on silk. See Bussagli Chinese Painting, pl. 48.

WU-CHU-TZU　無住子
Unidentified. Fl. late 13th century.

Tokugawa Art Museum, Nagoya. Monk mending his robe; monk reading sutra by moonlight. Pair of hanging scrolls. Inscriptions by the artist, dated 1295. See Suiboku III, 38-39; Sogen no kaiga 32-33; Kokka 272.

WU KUAN 吳瓘 t. Ying-chih 瑩之
From Chia-hsing, Chekiang. Active ca. 1348. Connoisseur and collector.
Painted ink plum blossoms; imitated Yang Pu-chih. H, 5. M., p. 160.

* Liaoning Provincial Museum. Plum blossoms and bamboo. Handscroll, ink on
 paper. Signed; also an inscription dated 1348. Colophons by Ch'ien-lung
 and others. Originally mounted, together with a similar painting by Wu
 Chen, in a single handscroll with the painting ascribed to Hsü Yü-kung,
 Sung period (q.v.). See Liao-ning I, 91.

WU T'AI-SU 吳太素 t. Hsiu-chang 秀章 h. Sung-chai 松齋
From K'uai-chi, Chekiang. Yüan period. Painted plum-blossums and wrote a
treatise on this subject, *Sung-chai mei-p'u.* L, 7, 1. M, p. 160. See Shimada
Shujiro, "Sosai baifu daiyo," Bunka v. XX no. 2, March 1956, pp. 96-118.

I-lin YK 67/1. Phoenix (?) on garden rock, narcissi at its base. Signed, dated
 1339. Reproduction indistinct; copy or imitation?
* Daisen-ji, Yamanashi. Branches of blossoming plum and pine. Painted on silk,
 much damaged. Two seals of the artist. See Sekai bijutsu zenshu 14, pl.
 77; Sogen no kaiga 85; Hills 76.
* Taikan-en, Niigata. A branch of blossoming plum in snow. Poem and seals of
 the artist. See Bijutsu-shi 18 (1955); Sogen no kaiga 83.
* Yabumoto Kozo, Amagasaki. Branch of blossoming plum. Hanging scroll, ink
 on paper. Three seals of the artist. See Suiboku IV, 125; Bunjinga suihen
 III, 90.

WU T'ING-HUI 吳庭暉
From Wu-hsing, Chekiang. 14th century. Painted landscapes in the blue-and-
green manner; flowers and birds. H, 5. M, p. 160.

Taipei, Palace Museum (YV113). A dragon-boat race on a river below a misty
 temple hill. Attributed. Late Ming work? See Ku-kung SV; London
 Exh. Chinese Cat. 167; KK ming-hua VI, 27; Wen-wu chi-ch'eng 65; KK
 chou-k'an 135.

YANG HUI 楊輝 t. Chung-ho 仲和
Unidentified. Probably active in Hangchou in the late Yüan period.

Seattle Art Museum (CH32/Y17.1). *Sui-han-chih t'u:* Flowering Plum Branch
 in Cold Winter. Three seals of the artist. Inscription by the priest
 Huang-an. See Yüan Exh. Cat. 249; Kodansha CA in West, II, 72.

YANG WEI-CHEN　楊維楨　　t. Lien-fu　廉夫　, h. T'ieh-yai　鐵崖
From Chu-chi, Chekiang. B. 1296, d. 1370. Best known as a calligrapher;
wrote colophons on many pictures by contemporaries. I, 39. Also biog. by
Edward Worthy in DMB, II.

Chung-kuo I, 107 (Ti Pao-hsien). Drinking tea among bare trees by a stream.
　　Poem by the artist, dated 1342. Later work. See also Chung-kuo MHC
　　30.
* Taipei, Palace Museum (YV94). A knotted old pine. Poems by the artist and
　　two of his pupils. Minor, genuine work. See KK shu-hua chi III; Che-
　　chiang 31; CKLTMHC III, 34; KK chou-k'an 110; NPM Masterpieces I,
　　26.
　Ibid. (YV278, chien-mu). "The Iron Flute": a man in a boat playing a flute for
　　a fisherman on the shore. 16th century Che School work.
　KK shu-hua chi XXII. A crowing cock standing below a tree on a rock.
　　Signed. Imitation.
　Suchiku (Oguri collection). Sailing boats on a lake; a temple on the shore.
　　Album leaf. Poem, signed.
　Note: The Anonymous Yüan "Spring Mountains" (YV124), which bears an
　　inscription by Yang, may be his work; see Fu Shen's article in the NPM
　　Bulletin, VIII/4 (Sept.-Oct. 1973).

YAO YEN-CH'ING　姚彥卿　　t.? T'ing-mei　廷美
(Note: The identity of Yao Yen-ch'ing and Yao T'ing-mei is probable but not
positive. See Barnhart's article below.) From Wu-hsing, Chekiang. Active ca.
1360. Landscapes in the manner of Kuo Hsi. H, 5. M, p. 286. See the article
by Richard Barnhart, "Yao Yen-ch'ing, T'ing-mei, of Wu-hsing," *Artibus Asiae*,
XXXIX, 2 (1977), pp. 105-123.

* Cleveland Museum of Art (54.791). *Yu-yü-hsien t'u:* Leisure Enough to Spare.
　　Thatched houses seen between trees on a river bank. Short handscroll.
　　Poem by the artist, signed (Yao T'ing-mei), dated 1360. Long inscription
　　by Yang Wei-chen, dated 1359, mounted after the painting; poems by
　　contemporaries. Seals of Liang Ch'ing-piao (1620-1691) and others. See
　　Yüan Exh. Cat. 260; Lee Landscape Painting 37; Yün hui chai 40;
　　Archives IX (1955), fig. 6; Lee Colors of Ink cat. 17; Kodansha CA in
　　West I, 24; Bunjinga suihen III, 84.
* Peking, Palace Museum. Fisherman on a river in winter. Handscroll. Seals
　　(Yao Yen-ch'ing) of the artist; poem by Ch'ien-lung. See Fourcade 9;
　　Wen-wu 1956/1.
* Museum of Fine Arts, Boston (15.902). Temples in a mountain ravine; rush-
　　ing water and leafless trees. Signed (Yao Yen-ch'ing). See Yüan Exh.
　　Cat. 214; BMFA Portfolio II, 15; Kodansha CA in West 1, 23; Hills 35.

YEN HUI　顏輝　t. Ch'iu-yüeh　秋月
From Chiang-shan, Chekiang. Active late 13th-early 14th century. Painted

Buddhist and Taoist figures, landscapes. H, 5. I, 53. M, p. 710; see also *Hua-chi pu-i* (1299), where it is stated that by the end of the Sung dynasty his works were already popular among gentry families.

Cheng Te-k'un, Hong Kong. Men in boats fishing with cormorants, others drawing in their nets. Handscroll, ink and slight color. Signed, dated 1339. Colophon by Yeh Kung-cho. Ming picture.

* Peking, Palace Museum. The Taoist Immortal Li T'ieh-kuai as a beggar seated on a rock. Ink and color on silk. Signed. Very dark.

Taipei, Palace Museum (YV54). Winter landscape. Yüan An (of the Han dynasty) lying in the snow; the mayor approaching in an ox-cart. Attributed. Ming academic work, early 16th century? cf. Hsü Lin. See KK shu-hua chi IV; London Exh. Chinese Cat. 165; CKLTMHC III, 109 (as anon. Yüan); KK chou-k'an 188.

* Ibid. (YV155). Two monkeys on the branch of a p'i-p'a tree. Signed, but the signature partly missing; may have read "Ch'iu-yüeh." See KK shu-hua chi XXXV; Three Hundred M., 179; CH mei-shu II; CKLTMHC III, 17; KK ming-hua V, 30; Nanking Exh. Cat. 74; Wen-wu chi-ch'eng 70; Siren CP VI, 10a.

Ibid. (YV225, chien-mu). Lao-tzu Riding on Ox. Signed. Ming painting.

Ibid. (YV226-7, chien-mu). Shih-te and Li T'ieh-kuai. Parts of a series? Attributed. School works.

Atami Art Museum, Shizuoka. Chung-li Ch'üan and Lü Tung-pin. Attributed. See Doshaku, 63.

Lin Po-shou, Taipei. *Ts'ui-hsien t'u:* the Drunken Immortal. Handscroll. Signed. Imitation.

T'ien-yin-t'ang I, 10 (Chang Pe-chin, Taipei). Two immortals. Attributed. Ming work.

Kao Yin-yüeh, Hong Kong. A monk seated on a projecting rock; a monkey in a tree above reaches down a ring. Colors on silk. Signed.

* Chion-in, Kyoto. The Taoist Li T'ieh-kuai watching his animus ascending; his companion Liu Hai-chan with the three-legged toad. Pair of hanging scrolls, the former with two seals of the artist. See Toyo IX; Siren CP VI, 9; Toyo bijutsu 10; Kokka 29; Shimbi II; Toso 163-64; Li-tai jen-wu 31; Che-chiang 39; Sogen no kaiga 46; Genshoku 29/85; Doshaku, 50; Hills 66.

* Tokyo National Museum (former Nishi Honganji). Han-shan and Shih-te. Pair of hanging scrolls. Attributed. Yüan works, by him or close follower. See Toyo IX; Kokka 298; Kawasaki Cat. 1; Sogen MGS II, 46-7; Sogen no kaiga 47-48; Choshunkaku 1-2; Genshoku 29/86; Siren CP VI, 10b; Doshaku 51.

Tokuo-in, Kyoto. Sakyamuni triad. Three hanging scrolls. Attributed. See Doshaku 53.

Toyo IX. (Count M. Tanaka). The immortal Chung-li Ch'üan standing on billowing water. Fine school work, early Ming?

* Ibid. (Viscount Koide). Bodhidharma. Inscription by Chung-feng Ming-pen (1263-1325). Fine work of the period.

Kokka 207 (Count Matsudaira). Three Immortals: Liu Hai-chan, Li T'ieh-kuai and Lü Tung-pin. Attributed.

Ibid. 231 (Marquis Inoue). The priest Wen-yen Sewing his mantle; a servant is seated before him. Attributed. Poem by Yün-an.

Ibid. 279 (R. Murayama). Arhat seated under a cliff, attended by a monk; Arhat meditating in a cave. Two pictures from a series of sixteen. 14th century, unrelated to Yen Hui. See also Siren CP VI, 7.

Sogen meigashu 6. A wave; the moon rising behind a mountain. Album leaf. Southern Sung picture? arbitrarily ascribed to Yen Hui. See also Kokka 164; Hikkoen 2.

Nezu Museum, Tokyo. Portrait of the monk Pai-chang, who died in 814 at age 95. Attributed. Inscription by the priest Cheng-yin, active at the end of the 13th century; the painting is of that period but probably not by Yen Hui. See Nezu Cat. I, 36.

Fujita Museum, Osaka. The Ch'an priests Lin-chi and T'e-shan. Seal.

Mitoko Collection, Tokyo. The Eight Immortals. Pair of hanging scrolls. Attributed.

Sogen 65 (Yabumoto Soshiro, Tokyo, 1963). Li T'ieh-kuai and his Animus. Signed.

Eda Bungado, Tokyo. Han-shan and Shih-te. Pair of hanging scrolls. Attributed. Works of early Ming follower? See Doshaku 52.

Ibid. Han-shan. Seal of the artist. Inscription by Takuan Soho (1573-1645). Work of follower.

Kobijutsu 37, 89-90. Red-robed Bodhidharma. Hanging scroll, ink and color on silk. Signed. Inscription by Hui-chi Yüan-hsi (d. 1319). See also Homma Sogen 58.

Yabumoto Kozo, Amagasaki. Li T'ieh-kuai? or Lü Tung-pin. Attributed.

Ibid. Two arhats beneath trees; a deer bringing fungus. Attributed. Good Yüan work.

Choshunkaku 52. An Arhat scratching his back. Attributed. Good Yüan work.

Setsu Gatodo, Tokyo (former Asano). *Chün-hsien t'u:* A Gathering of Taoist Immortals. Album leaf, ink and colors on silk. Attributed. Late Sung painting of fine quality, not connected in style with Yen Hui.

Nelson Gallery, K. C. White-robed Kuan-yin seated on a rock by a waterfall. Good Yüan work, probably unrelated to Yen Hui. See Toyo IX; Kokka 298; Choshunkaku 3; Li-tai jen-wu 30; Yüan Exh. Cat. 207; Lee Tea Taste no. 5; Suiboku IV, 101.

* Cleveland Museum of Art (61.206). The Lantern Night Excursion of Chung K'uei. Handscroll, ink on silk. Signed. Two colophons once attached to the scroll, by Yü Ho (dated 1389) and Wu K'uan (1435-1504), have probably been transferred to a similar scroll owned by the late Yeh Kung-cho. See Yüan Exh. Cat. 206; Munich Exh. Cat. 27; Lee Colors of Ink cat. 14; Cleveland Bulletin XLIX (Feb. 1962), 36-42.

* Ibid. (former J. P. Dubosc and Akaboshi). Branches of plum blossoms by moonlight. Fan painting. Signed. See Archives XXVI (1972-73), fig. 2; ibid. XXXII, 1979, p. 89.

Museum of Fine Arts, Boston (11.4003). The Ch'an monk Niao-k'o seated in meditation in a pine tree. Attributed. Yüan work, probably not by Yen Hui. See BMFA Portfolio II, 7; Siren CP in Am. Coll. 117; Siren ECP II, 100.

J. T. Tai, N. Y. Chung-k'uei with fighting demons and animals. Handscroll, ink on paper. Seal of the artist. Inscription by Ch'en Yung dated 1358; many colophons of the early Ming period. Yüan-Ming work, later than Yen Hui. See Yün hui chai 14-25; CK Ku-tai 56 (section).

See also the painting of Han-shan in Sogen shasei gasen 4, with poem by Cheng-yin, unidentified; there ascribed to Ma Yüan and misidentified as Wen-shu. By follower of Yen Hui, Yüan-Ming period. Also Taipei Palace Museum (SV169), "Anonymous Sung" Immortal Gathering Fungus; and many others. Works by followers of Yen Hui in the Freer Gallery include: 01.241 (Li T'ieh-kuai); 15.12 (Hsia-ma and his Toad); 16.588 ("Fang Ch'un-nien", Immortals Crossing the Sea); 17.426 (Immortals on the Sea); 16.37 (Li T'ieh-kuai).

YEN KENG 顏庚 , t. Ts'un-keng 存畊
Active Southern Sung to early Yüan period?

Tseng Hsien-ch'i, New Hampshire. Night excursion of Chung-k'uei. Handscroll, ink on silk. Signed. Colophon by Wu K'uan dated 1470.

YIN-T'O-LO 因陀羅
Said to be a Chinese transcription of the Indian name Indra. A Ch'an monk said to have been born in Rajgir, Bihar, India. In the 1340s he was abbot of the Kuang-chiao Temple in Kaifeng; also said to have lived for a period in the T'ien-chu temple near Hangchou. Buddhist figures. Mentioned in *Kundaikan Sayuchoki*, no. 109. See also Werner Speiser, "Yin-t'o-lo" in *Sinica* 12 (1937) pp. 155-160; Boston Zen Cat., p. 36; and biog. by Jan Fontein in Sung Biog. 154-157.

* Tokyo National Museum. A pair of pictures representing Han-shan and Shih-te. Attributed. Poem by the monk Tsu-ying. See Kokka 110.

Note: The following six paintings are considered to have been originally parts of a single handscroll; all bear poems by Ch'u-shih Fan-ch'i (1297-1371), probably written in the period 1328-1357. Note, however that Yoshiaki Shimizu, in an unpublished article, offers evidence against their having been parts of a single set.

* Kokka 173 (Ishibashi Kan'ichiro Coll., Tokyo). The Monk from Tan-hsia Burning a Wooden Image of the Buddha. See also Toyo IX; Bijutsu kenkyu 14; Sogen no kaiga 34; Toyo bijutsu 73; Sogen bijutsu 139; Boston Zen Cat. 13; Genshoku 29/61; Doshaku, 25; Suiboku IV, 105; Sogen MHS III, 52.

* Seikado Foundation, Tokyo (Iwasaki Coll.). The Ch'an mank Chih-ch'ang.
 See Sogen no kaiga 35; Genshoku 29/58; Doshaku, 27; Suiboku IV, 106;
 Seikado Kansho III, 7.
* Tokyo National Museum (former Marquis Asano Coll.). Han-shan and Shih-te.
 See also Siren CP III, 350; Sogen no kaiga 37; Sogen bijutsu 136; Kokka
 419; Doshaku, 29; Suiboku IV, 20.
* Nezu Museum, Tokyo. Pu-tai and Chiang-mo-ho. See Sogen no kaiga 36;
 Sogen meigashu 53; Toso 203; Nezu Cat. 18-19; Siren CP III, 353; Toyo
 bijutsu 72; Genshoku 29/60; Doshaku, 26; Suiboku IV, 18.
* Hatakeyama Museum, Tokyo (formerly Marquis Kuroda Coll.). The priest
 Chih-ch'ang speaking to Li Po. See Sogen bijutsu 137; Kokka 201;
 Genshoku 29/59; Speiser Chinese Art III, pl. 45; Doshaku 28; Suiboku
 IV, 19; Sogen MGS III, 51.
* Cleveland Museum of Art (67.211). The second coming of the Fifth Patriarch.
 See Yüan Cat. 208; Archives XXIII, fig. 9; Lee Colors of Ink Cat. 18; Sui-
 boku IV, 114.
 Daitoku-ji (Ryuko-in). The second coming of the Fifth Patriarch. Inscription
 by Fa-ying. See Doshaku 30; Suiboku IV, 21.
 Kokka 35 (Morioka Coll.). Feng-kan with his tiger, Han-shan and Shih-te.
 Signed? Three poems; one of them by the priest Hsin-yüeh who died in
 1274. Later work.
 Nezu Museum, Tokyo. Ch'ao-yang t'u: A Monk Mending His Robe. Seal of
 the artist(?); inscription by the Yüan period priest Wu-ch'an. See Nezu
 Cat. I, 13.
 Ibid. Han-shan. Attributed. Fine Sung-Yüan work. See Nezu Cat. I, 25.
 Tokyo National Museum (formerly Count Date Coll.). A pair of pictures
 representing Han-shan and Shih-te. Each with a poem by Tz'u-chiao. See
 Kokka 223; Shimbi IX; Boston Zen Cat. 14; Suiboku IV, 108-109.
* Suiboku IV, 107. Han-shan. Attributed. Inscription by Fa-yüan. Corresponds
 in composition to the right picture of the above Tokyo National Museum
 pair, but finer and older.
 Fujita Museum, Osaka. Han-shan. Signed. Inscription by Yüeh-chiang
 Cheng-yin.
 Inui Collection. The Ch'an monk Hung-jen. Seal. Inscription by Ch'u-shih
 Fan-ch'i.
* Kokka 310 (Murayama Coll.). Vimalakirti. Signed. Poem by the monk P'u-
 men (Men Wu-kuan). See also Sogen no kaiga 38; Toyo bijutsu 74;
 Sogen bijutsu 141; Suiboku IV, 17; Sogen MGS II, 41.
 Ibid. 392 (formerly Marquis Asano Coll.). Bodhidharma Crossing the Yangtse
 River on a Reed. Signed. Japanese imitation? See also Artibus Asiae
 VIII, 1945, p. 229.
* Sogen MGS I, 51-2 (former Mayeyama Coll., now Nagao). Two pictures
 representing Han-shan and Shih-te. Signed. See also Toso 200-201; Siren
 CP III, 352. A copy of one in the Freer Gallery (18.59).
 Ibid. II, 42 (formerly Kawasaki coll.). Han-shan. Signed. (Same as Fujita
 Museum painting listed above?)
 Toso 202 (S. Kato Coll.). Han-shan and Shih-te. Two pictures mounted in one
 scroll. Imitations.

Kawasaki Cat. 4. The Four Sleepers: Feng-kan with Han-shan, Shih-te, and a tiger. Album leaf. Seals of the painter. Copy or imitation. See also Chushunkaku 7; Sogen MGS II, 40.

Choshunkaku 8. Han-shan. Attributed. Copy or imitation.

Sei Kan Magazine, 1940, no. 5 (private collection, Kyushu). The monk Yang-shan and Prince Hsiao discussing a Ch'an koan.

Sogen bijutsu 143 (Nakamura Gakuryo, Kanagawa). A Zen Patriarch. Inscription by Ts'ung-hsiao. Attributed. Yüan work?

Doshaku, 31. Ch'uan-tzu and Chia-shan. Attributed. See also Suiboku IV, 111.

* Masaki Museum, Osaka. The King of Min doing Homage to the Ch'an Priest Hsüeh-feng; accompanied by a servant and a demon-like attendant. Inscription above with the seal of Ch'u-shih Fan-ch'i (1297-1371). See Suiboku IV, 110, Masaki Cat. VIII; Hills 67.

Nagao Collection (formerly Mayuyama). Han-shan and Shih-te. Pair of hanging scrolls. Attributed.

Setsu Gatodo, Tokyo. Han-shan and Shih-te. A pair of hanging scrolls, ink on paper. Inscriptions by Yü-chi Tsu-ying. See Sogen MGS III, 53-54.

Suiboku IV, 112-113. Han-shan and Shih-te. A pair of hanging scrolls, ink on paper. Inscriptions by Ch'ing-yüan Wen-lin. Attributed. Poor copies.

Ibid., 116. Bodhidharma Crossing the Yangtse River on a Reed. Inscription by Yün-wai Yün-hsiu. Attributed. Probably a work of the period, not by Yin-t'o-lo. See also Osaka Sogen 5-109.

YÜ CHUNG　愚中　. Perhaps to be identified with Yü-chung Chou-chi 愚中周及　(1323-1409).
Founder of the Fo-t'ung-ssu　佛通寺　in An-i　安藝　.

Goto Art Museum, Tokyo. Pu-tai. Inscription by Chien-hsin Lai-fu (1319-1391). See Suiboku III, 66; Doshaku, 35.

YÜ TI-CHIEN　玉迪簡　t. T'ING-CHI　庭吉
Native of Hsin-ch'ang　新昌　in Chekiang. (Information from label on painting below.)

Peking, Palace Museum (exhibited Fall 1977). Narcissus plants. Handscroll, ink on paper. Similar to the work of Chao Meng-chien.

YÜ-WEN KUNG-LIANG　宇文公諒　t. Tzu-chen　子貞
From Ch'eng-tu, Szechuan; moved to Wu-hsing, Chekiang. Chin-shih in 1333 and became a Han-lin member. See note in KK shu-hua chi XXXVIII.

KK shu-hua chi XXXVIII. Wooded mountain landscape, in the manner of Wang Meng. Poem by the artist, dated 1346. Ming work, 16th century?

YÜN-KANG TAO-SHIH　雲岡道士
A Taoist monk; friend of Ni Tsan. See note on the following picture.

Chung-kuo I, 117 (TI Pao-hsien). Two magpies on a rock and some bamboo. Signed "Yün-kang." Poem and a colophon by a writer of the Ming period, dated 1466. Later work. See also Chung-kuo MHC 36.

YUNG-CHUNG　永中
Also known by the signatures Chüeh-chi Yung-chung　絕際永中　　and Huan-chu Yung-chung　幻住永中
A Ch'an monk who for a time resided with the Abbot Chung-feng Ming-pen (1264-1325) at the Huan-chu Temple at P'ing-chiang in Wu-hsien, Kiangsu. Died ca. 1330. See the entry by Ebine Toshiro in Suiboku IV, p. 161.

Cleveland Art Museum (78.47). White-robed Kuan-yin. Signed. Inscription by Chung-feng Ming-pen (1264-1325). See Suiboku IV, 90; Doshaku, 4; Cleveland Museum Bulletin, Jan. 1979; Archives XXXII, 1979, p. 89.

YUNG-T'IEN　用田
The painter is unrecorded in China, but mentioned in *Kundaikan Sayuchoki*. He is not the same person as Sung-t'ien, though both painted squirrels in a similar style.

* Kokka 413 (Yabumoto Kozo, Amagasaki, formerly Marquis Asano). A squirrel on a pine branch, looking upward at pine cones. Attributed. Inscription by a monk named Tzu-yü, unidentified. Good work of the period. See also Homma Sogen 70.
* Ibid. 460. Two squirrels on pine branches. Seal of the artist. See also Kawasaki Cat. 30.
Toso 216 (Makita collection). Two squirrels on the stalk and branch of a bamboo plant. Seal of the artist (Japanese interpolation?). Good work of the period. See also Pageant 411; Siren CP VI, 117.
Kyoto National Museum. Squirrel on an oak branch, eating an acorn. Attributed. Inscription by Ch'u-shih Fan-ch'i (1297-1371). See Pageant 410.
Fujii Collection, Kyoto. Two squirrels in bamboo. Attributed.
Agata Collection, Osaka. Squirrel and bamboo. Ink on paper. No signature or seal; attributed. Good painting of the period.
Yabumoto Kozo, Amagasaki (former Kuroda coll.). Two squirrels in a chestnut tree. Ink on paper. Attributed. Work of period. Similar painting (or same?): Setsu Gatodo, Tokyo.
See also Shina kacho gasatsu 5. Three squirrels in cypress tree. Good painting of early date (Yüan?), of the kind commonly ascribed to Yung-t'ien and Sung-t'ien. Also Eda Bungado, Tokyo. Two squirrels in a chestnut tree.

VII.

Anonymous Yüan Paintings

Buddhist and Taoist Subjects

Nanking Museum. Kuan-yin enthroned, worshippers and lotuses below. Large
 painting on silk in colors. See Gems I, 18; Ku-hua pa-chung.
Taipei, Palace Museum (YV136). Preaching the Avatamsaka Sutra at the Edge
 of the Sea: five hundred arhats at a Hua-yen meeting. Ming temple paint-
 ing. See CKLTMHC III, 89.
Ibid. (YV137a-c). Triptych: Buddha enthroned between two monks; eight
 Bodhisattvas (four in each side piece). Works of the period; the center-
 piece apparently a later replacement. See KK shu-hua chi XXXVII.
Ibid. (YV138). An Indian monk seated on a rock explaining a sutra, flowers
 falling upon him. School of Yen Hui. See KK shu-hua chi XXIII;
 CKLTMHC III, 94; KK ming-hua VI, 51; KK chou-k'an 274.
Ibid. (YV139). Vairocana enthroned.
Ibid. (YV140). Two arhats in conversation by a rockery. Ming work. See KK
 shu-hua chi XXXVI.
Ibid. (YV141a-b). Arhats: pair of hanging scrolls, nine arhats in each. Origi-
 nally side pieces of a triptych? See CKLTMHC III, 92.
Ibid. (YV142). An antelope offering a flower to Lohans. Late Ming, cf. Ts'ui
 Tzu-chung etc.

Ibid. (YV143). Offering the peach of longevity. Good work of the period.

Ibid. (YV312, chien-mu). Han-shan and Shih-te. Ming, follower of Yen Hui.

Ibid. (YV313, chien-mu). Bodhidharma Crossing the River. Late Ming, cf. Ting Yün-p'eng.

Ibid. (YV328). Bodhidharma seated on a rock. Poems by Chang Yü (1277-1348) and four others. Fine work by close follower of Chao Meng-fu (whose seal is in the lower right corner). See KK shu-hua chi XXXVII; Hills pl. 7.

Ibid. (YV331, chien-mu). Liu Hai-chan and His Toad. Ming, follower of Chang Lu.

Ibid. (YV332-349). The eighteen arhats. Set of 18 hanging scrolls. Curious, minor works of post-Yüan date; two of them (YV343 and 345) are from a different set.

Ibid. (YV357, chien-mu). The three Taoist patriarchs *(San Ch'ing)* seated under trees with devotees. Ming academic work? See KK shu-hua chi XXXII; CKLTMHC III, 93.

Ibid. A Taoist fairy with a basket of fungi seated between a lion and a tiger. Curious work of late Ming or early Ch'ing date. See Ku-kung XXXIV; CKLTMHC III, 91.

Ibid. (YH18). Portrait of the immortal Chung-li Ch'üan. Handscroll. Poor Ming or later work.

Chung-kuo I, 122. Bodhidharma meditating in a cave in the snowy mountains. Ming work. See also Chung-kuo MHC 22.

Sogen 80 (S. Yamaoka coll.). Manjusri on the lion. Poem by Yün-chü Chi-an.

Ibid. 85 (P. Inoue coll.). Han-shan and Shih-te by a cliff. School of Yen Hui. See also I-lin YK 31/3.

Daitoku-ji, Kyoto. Kuan-yin by the sea. Large hanging scroll, colors and gold on silk. Old attribution to Wu Tao-tzu. See Sogen Appendix 17; Sogen Bijutsu 85. A copy in the Seikado Foundation, Tokyo. See Seikado Kansho III, 9.

Kokka 126. Manjusri as a youthful monk, in a mantle of plaited straw. Half length. Inscription by the monk Tsu-ming, dated 1353.

Ryuko-in, Kyoto. Five pictures from a series of the Sixteen Arhats. Inscription by I-shan I-ning (1247-1317). See Kokka 286; Siren CP VI, 6.

Kokka 387 (Marquis Asano). Yün-fang and Lü Tung-pin.

Ibid. 526 (Baron Dan). Two paintings from a series of twelve Devas: a guardian King; a Taoist female deity(?).

Ibid. 631 (Muto collection). Seated Kuan-yin.

Ibid. 790 and 798 (Kobayashi collection, Tokyo). A series of the Sixteen Arhats. Eight reproduced in Kokka 790, including a colored detail; details of three others in Kokka 798. See article by Yonezawa in vol. 798. Other versions of the same compositions in the Ryuko-in, see above.

Enkaku-ji, Kanagawa. Sakyamuni with two attendants. See Sogen bijutsu 80.

Gyokurin-in, Kyoto. Sakyamuni seated on lotus pedestal. See Sogen bijutsu 76.

Houn-ji, Ibaragi. Portrait of the priest Kao-feng (1239-1295). Inscriptions by Chüeh-an, K'o-hsiang (1206-1290); dated 1290 and Wang Kang-chung. See Sogen no kaiga 12; Sogen bijutsu 111; Genshoku 29/83; Doshaku, 44.

Tofuku-ji, Kyoto. Vimalakirti. See Genshoku 29/89; Suiboku IV, 81; Doshaku, 6.

Toshunji. Vimalakirti. See Osaka Sogen 5-130.

Masaki Art Museum. Bodhidharma crossing the river on a reed. Inscription, of doubtful authenticity, by Chung-feng Ming-pen (1263-1323). Yüan work. See Suiboku III, 60; Masaki Cat. III.

Suiboku III, 62. White-robed Kuan-yin. Inscription by the late Yüan-early Ming priest Ch'ing-yüan Wen-lin; the painting probably of that date.

Ibid. III, appendix 14. Sakyamuni coming down from the mountains. Inscription, of questionable authenticity, by Chung-feng Ming-pen (1263-1323). Yüan painting?

Nanzen-ji, Kyoto. Manjusri. Inscription, dated 1338, by Ch'ing-cho Cheng-ch'eng (1274-1339), a native of Fukien. See Genshoku 29/88.

Myokoji. Four Guardian Kings, in a series of four pictures. See Suiboku IV, 10, 83.

Goto Art Museum, Tokyo (former Kennin-ji, Kyoto). Ch'an Master riding an ox. Inscription, dated 1324, by Ch'ing-cho Cheng-ch'eng (1274-1339).

Jodoji, Shizuoka Pref. Bodhidharma crossing the Yangtze on a Reed. Ink and light colors on silk. Colophon by I-shan I-ning (1247-1317). See Boston Zen Catalog 22.

Reimeikai Foundation, Tokyo. *Chao-yang* and *Tui-yüeh:* pair of hanging scrolls, ink on paper. Inscription dated 1295. See Sogen no kaiga, 32; Sogen bijutsu 119.

Ibid. The priest Pu-tai. Inscription by Yen-ch'i Kuang-wen (1189-1263). See Sogen bijutsu 118; Sogen no kaiga 28; Kokka 272.

Bujo-ji, Tottori. Seated Kuan-yin and a willow branch. See Sogen bijutsu 86.

Myoshin-ji, Kyoto. Samantabhadra. See Sogen bijutsu 89; Doshaku, 62.

Kaizo-in, Kyoto. The priest Hu-kuan Shih-lien (Kokan Shiren). Inscription by the subject dated 1343. See Sogen bijutsu 109; Doshaku, 48. (Attributed to Ching-t'ang.) Another portrait of the same subject, bearing an undated inscription by him, is also in the Kaizo-in; it too bears a seal of Ching-t'ang. See Doshaku, 49.

Shofuku-ji, Fukuoka. The priests K'ao-feng, Tuan-ai and Chung-feng. Inscription by the priest Wen-k'ang. See Sogen bijutsu 110; Doshaku, 43.

Sogen bijutsu 114 (Nakamura Gakuryo, Kanagawa). The priest Ch'ien-yen Yüan-chang.

Kyoto National Museum. Samantabhadra in a chariot, drawn by an elephant; two grooms leading the animal. Copy of the Anonymous Sung picture in the Shinchogokuji, Kyoto, q.v. See Siren CP VI, 13. Another copy in a private collection, Stockholm.

Ibid. Kuan-yin. Inscription by Yün-wai Yün-hsiu (1242-1324). See Doshaku, 8; Suiboku IV, 92.

Ibid. Arhats with tiger. See Doshaku, 10; Suiboku IV 11, 72.

Tokyo, National Museum. The Tenth Arhat, Panthaka. See Sogen bijutsu 97; Yüan Exh. Cat. 195; Tokyo N. M. Cat. 40.

Ibid. (former Yabumoto Soshiro, Hara and Minera collections). The Four Sleepers: Pu-tai, Han-shan and Shih-te, a tiger. *Pai-miao* manner, ink on paper. Inscriptions written above by P'ang-shih Ju-chih (1268-1357),

Hua-kuo Tzu-wen (1269-1351), and Meng-t'ang T'an-e (1285-1373). See Genshoku 29/64; Doshaku, 11; Suiboku IV, 15.

Ibid. Shou-hsing (god of longevity). See Doshaku, 60; Suiboku IV, 100.

Sogen no kaiga 16 (Maeda Ikutoku-kai, Tokyo). Portrait of Kuan-yin transformed as Ma-lang. Inscriptions by Yung-fu and Shih-yüeh. See also Sogen no bijutsu 87; Suiboku IV, 7, 53.

Nison-in, Kyoto. Sakyamuni Triad. See Yüan Exh. Cat. 194; Sogen bijutsu 87.

Rokuo-in, Kyoto. The Eighteen Arhats. Pair of hanging scrolls. See Doshaku, 22; Teisuke Toda, "Figure Painting and Ch'an-Priest Painting in the Late Yüan," *Proceedings of the International Symposium on Chinese Painting* (Taipei, 1970), Pl. 4; Suiboku IV, 77-78. Another version of the compositions, rendered in *pai-miao,* in the Jobodaiji, Shiga Prefecture; see Doshaku, 23; Suiboku IV, 73-74. Still another version of one in the Heirinji, Saitama Prefecture; see Doshaku, 24; Toda, *op. cit.,* 5; Suiboku IV, 13, 79. Yet another version of the compositions in the Joshoji Temple; see Suiboku IV, 75-76.

Komyoji Temple. Kuan-yin as a Lady of the Ma Family; Kuan-yin with a Fish Basket. Pair of hanging scrolls. See Suiboku IV, 93-94.

Kotoin Temple. Kuan-yin. See Suiboku IV, 91.

Tokugawa Museum, Nagoya. Triptych: Kuan-yin by the water; blossoming plum and bamboo. See Tokugawa, 169.

Ryoko-in, Kyoto. The Four Sleepers. See Doshaku, 12; Suiboku IV, 14.

Tenju-in, Kyoto. Discussion between Ma-tsu and the layman P'ang. Inscription by Ch'ing-cho Cheng-ch'eng (1274-1339). See Doshaku, 15; Suiboku IV, 87.

Nezu Art Museum, Tokyo. The Three Stars: three hermits playing wei-ch'i. See Doshaku, 21.

Senbutsu-ji, Kyoto. Portrait of the priest Chung-feng Ming-pen (1263-1323). Inscription by Chung-feng Ming-pen. See Doshaku, 46. Another, also inscribed by the subject: Homma Sogen 66.

Jisho-in, Kyoto. Portrait of the priest Chung-feng Ming-pen (1263-1323). Inscription by Kuang-yen. See Helmut Brinker, "Ch'an Portraits in a Landscape," *Archives of Asian Art,* XXVII (1973-74), 8-29; Doshaku, 47. For another portrait of the same subject, see under I-an.

Hatakeyama Kinenkan, Tokyo. Lao-tzu going through the Han-ku-kuan barrier. See Doshaku, 61.

Kodai-ji, Kyoto. Sixteen Arhats. 16 hanging scrolls. See Doshaku, 69.

Matsuo-dera, Nara. Amitabha and attendants. See Doshaku, 84.

Doshaku, 3 (private collection, Japan). White-robed Kuan-yin. Inscription by P'ing-shih Ju-chih (1268-1357). See also Suiboku IV, 9.

Ibid., 14. Bodhidharma crossing the Yangtze on a reed. Inscription by Liao-an Ch'ing-yü (1288-1363). See also Kokka 827, Suiboku IV, 86. For related works and a study of the theme, see Chu-tsing Li's article in *Asiatische Studien* XXV, 1971, 49-75.

Ibid., 16. The Eighteen Arhats. Inscription by T'an-fang Shou-chung (1275-1348), dated 1348. See also Suiboku IV, 88; Homma Sogen 59.

Ibid., 17. Han-shan and Shih-te. Pair of hanging scrolls. See also Suiboku IV, 95-96.

Eda Bungado, Tokyo. An Arhat with two attendants; a servant with a sword. Colors on silk. Probably Yüan in date.

Fugendo, Tokyo (1977). Taoist immortals. Left panel of a triptych? Good Taoist temple painting of Yüan date.

Yabumoto Kozo, Amagasaki. White-robed Kuan-yin. Ink and light colors on paper. Inscription above by Chung-feng Ming-pen (1263-1323). See Doshaku, 9; Suiboku IV, 85.

Ibid. Kuan-yin on lotus-petal. Ink on silk. Inscription by I-shan I-ning (1247-1317).

Ibid. Kuan-yin. Inscription by Miao-shen, early Yüan.

Ibid. Manjusri as a youth with rope-wound robe.

Ibid. Sakyamuni Descending from the Mountains. Ink on paper. Inscription by Yüeh-p'o P'u-ming.

Ibid. Shih-te beneath pine, with broom. Inscription by Ju-an, unidentified. See Homma Sogen 69.

Homma Sogen 63. Bodhidharma crossing Yangtze on reed. Attributed to a certain Ch'en Shih-ying; inscription by Yüeh-chiang Cheng-yin.

Ibid. 64. Kuan-yin with Fish Basket. Inscription by Liao-an Ch'ing-yü (1288-1363).

Ibid. 68. Kuan-yin Floating on Lotus Petal. Poem, dated 1302(?), unsigned.

Ibid. 46. Bodhidharma. Inscription by Cho-an Te-kuang dated 1189, but the painting appears to be Yüan in date.

Ibid. 2. Pu-tai with bag under a tree.

Freer Gallery (06.261). A bust portrait of Bodhidharma. See Freer Figure Painting 23.

Ibid. (06.269). The Buddha enthroned and preaching; eight Bodhisattvas. Korean painting? See Siren CP in Am. Coll. 185.

Ibid. (11.313). Deva King. See Kodansha Freer Cat. 64; Kodansha CA in West I, 55; Freer Figure Painting 24; Suiboku IV, 82.

Ibid. (13.65). A Bodhisattva and two attendants. See Siren CP in Am. Coll. 186.

Ibid. (17.334; 18.6; 19.107; 19.163). Four paintings of Arhats, from a series of sixteen. Inscriptions, dated 1345. Others from the series are in the Metropolitan Museum (47.18.103) and the British Museum (two). See also Kokka 337; Chung-kuo MHC 40; Siren CP VI, 8.

Boston Museum of Fine Arts. Lords of the Elements (Heaven, Earth, Water) with their attendants in landscape settings. Taoist temple paintings? See BMFA Portfolio I, 103-105; Siren CP VI, 12.

Ibid. (11.6140). Kuan-yin of P'u-t'o and Shan-ts'ai, crossing the Sea. See BMFA Portfolio II, 23.

Ibid. (11.6142). Buddha expounding the Law, surrounded by Bodhisattvas and Devas. See Siren CP in Am. Coll. 160; Siren CP VI, 14.

Ibid. (05.199). Kuan-yin with the fish-basket. Inscription by Mu-an, dated 1318. See Siren CP in Am. Coll. 129; BMFA Portfolio II, 20; Yüan Exh. Cat. 192.

Ibid. (11.4001). Prajnalosnisa Buddha: the Buddha of Blazing Light and Stellar Deities. See Siren CP in Am. Coll. 159; BMFA Portfolio II, 21.

Ibid. (09.86). Sakyamuni and two Bodhisattvas standing on clouds. See BMFA Portfolio II, 1.

Ibid. (14.71-2; 15.889). Three paintings of Arhats, from a set of sixteen. Yüan or early Ming. For one, see Pratapaditya Pal, *Lamaistic Art,* cat. 25; BMFA Portfolio I, 98.

Nelson Gallery, K. C. The Taoist Immortal Lü Tung-pin. See Yüan Exh. Cat. 191.

Princeton Art Museum. The Ten Kings of Hell. Set of 10 hanging scrolls, ink and color on dark silk. Probably Yüan in date.

Ibid. White-robed Kuan-yin. Inscription by Chi-t'an Tsung-le (d. 1391). See Kobijutsu 22, 111-12; Suiboku IV, 102.

Ibid. Monk reading sutra by moonlight. Inscription by Yü-hsi Ssu-min (before 1332). Hanging scroll, ink on paper.

Cleveland Museum of Art (64.44). Bodhidharma Crossing the Yangtze on a Reed. Inscription by the Yüan priest Liao-an Ch'ing-yü (d. 1363). See Kokka 827; Yüan Exh. Cat. 209; Lee, Tea Taste in Japanese Art, 1963, no. 3; Suiboku III, 59; Kodansha CA in West I, 59; Lee, Colors of Ink cat. 24.

Metropolitan Museum, N. Y. (55.155.1). Han-shan and Shih-te: pair of hanging scrolls, ink and color on silk.

Alice Boney collection, N. Y. Arhat, attendant and two small demons.

National Museum, Stockholm. A Taoist Immortal seated on the ground holding a small gilt casket in his raised hand. Western influenced; late Ming or early Ch'ing? See Siren CP VI, 11.

Louvre, Paris. A Judgement scene: the Sixth King of Hell surrounded by attendants; below, Scene of Torture.

Ars Asiatica I, 17 (Collection Riviere). Portrait of a priest.

Museum für Ostasiatische Kunst, Cologne. The Taoist Immortal Lan Ts'ai-ho. (Formerly identified as the Bodhisattva Wen-shu as a Beggar-Singer.) See Speiser Chinese Art III, pl. 12; Artibus Asiae I (1925), p. 121; Yüan Exh. Cat. 193.

Ars Asiatica I, 4-5 (Collection Goloubew). The Immortal Lü Tung-pin.

Staatliche Museen, Berlin (221). Two Arhats by a waterfall. 13th-14th c. See Berlin Cat. (1970), no. 33.

Ibid. (1962.14). The King of Hell Presiding on the T'ai Mountain. See Yüan Exh. Cat. 204; Berlin Cat. (1970), no. 34.

Figures

Liaoning Provincial Museum. *Li-p'ing t'u:* Emissaries from various countries bringing tribute. A long procession of baggage mules, oxen, camels and men in various garb on horseback. Handscroll, colors on silk. Yüan work, with spurious signature of Chao Yung. See Liaoning I, 99-110.

Peking, Palace Museum. A gentleman on horseback with his retinue in a courtyard watching a cockfight. Fan painting. Early Ming, follower of Liu Kuan-tao? Another version in the Nelson Gallery, K. C., has a signature of Li Sung of the Sung period, q.v. This and the following three pictures

seem to be by the same hand and to belong to a series of palace scenes; all four probably early Ming copies after earlier (late Sung or early Yüan) works. See Yüan-jen hua-ts'e I. Cf. the article by Ellen Laing in *Oriental Art*, N. S. XX/3 (Autumn 1974), figs. 1-4, 7.

Ibid. A man seated on a garden terrace surrounded by six ladies. Fan painting. See above. See Yüan-jen hua-ts'e I.

Ibid. A gentleman and two servants in front of a laden table on a garden terrace. Fan painting. See above. See Yüan-jen hua-ts'e I.

Ibid. A gentleman seated on a chair on a garden terrace surrounded by seven ladies and servants. Fan painting. See above. See Yüan-jen hua-ts'e II.

Ibid. Burning incense on a terrace. Fan painting. Spurious signature of Wei-ch'ih I-seng of the T'ang period. Early Ming, after earlier composition? See Yüan-jen hua-ts'e I.

Tientsin Art Museum. Dancers performing for a barbarian king seated beneath a canopy. Handscroll. Copy of older (Liao?) composition. See T'ien-ching II, 10.

Li-tai jen-wu 39. Elegant Gathering in the Western Garden. Handscroll.

Taipei, Palace Museum (YV144). Wen-chi returning to China. The text of the Eighteen Songs of Wen-chi is written above. Copy of earlier work.

Ibid. (YV146). Shooting wild geese; huntsmen on horseback with camels passing through a valley between snowy hills. Yüan period, by minor follower of Liao-Chin tradition. See KK shu-hua chi XXIX; London Exh. Chinese Cat. 174; CKLTMHC III, 88; KK ming-hua VI, 40; KK chou-k'an 470.

Ibid. (YV147). A tartar on horseback by a river. Ming work. See KK shu-hua chi XLIII; CKLTMHC III, 90.

Ibid. (YV148-151). Four scenes of scholars in gardens, practicing the Four Accomplishments: painting, calligraphy, chess and music. 16th century? See KK shu-hua chi XII (YV150) and XV (YV151), the latter also in KK chou-k'an 177.

Ibid. (YV152). Lady under plum blossoms looking into a mirror. Late Ming work, school of T'ang Yin.

Ibid. (YV153). A bird-merchant with his stand offering his goods to a lady with two children on a garden terrace in spring. Early Ming work of good quality. See KK shu-hua chi XXXIX.

Ibid. (YV154). A boy riding a goat, with small goats frolicking around him. Routine New Year's picture of Ming date. A similar picture in the same collection (YV317, chien-mu).

Ibid. (YV155). "Brotherhood:" four children and a cat cooking at a small table. Routine Ming work.

Ibid. (YV309, chien-mu). Two men under an umbrella crossing a bridge toward a house, where a woman waits for them at the gate. Minor Wu School work, 16th-17th century. See Ku-kung XXI.

Ibid. (YV323, chien-mu). Tartar horsemen in a landscape. Ming copy of older composition.

Ibid. (YV324, chien-mu). Transmitting the Sutra: a monk and a scholar in a garden. Interesting copy of older composition.

Ibid. XXXII. Seven boys performing a New Year's play on the house porch. Ming work.

KK shu-hua chi XVIII. A school for small children; some in the house, others playing in the garden.

Taipei, Palace Museum (YH21). Portrait of Ni Tsan. Handscroll. Inscription by Chang Yü (1277-1348). See Three Hundred M., 205; CAT 86; CH mei-shu II; CKLTMHC III, 110; KK ming-hua VI, 13; NPM Masterpieces IV, 37; Yüan FGM 327; Hills 45-6. A copy by Ch'iu Ying, with an inscription by Wen P'eng dated 1422, in Toso 278. Another copy, late and poor, purportedly by Chao Yüan, in I-yüan chen-shang 5.

Ibid. (VA24d). Lady enjoying the cool breeze; two servants accompanying. Double album leaf. Seals of Chao Meng-fu. See NPM Masterpieces III, 28; NPM Bulletin, vol. IV, No. 3 (July-August 1969), cover.

Ibid. (VA24H). In the Plains: Home from the Hunt. Two figures seated, saddles, and two horses. Album leaf. Copy of earlier work in Liao tradition.

Ibid. (VA25g). Portrait of T'ao Hung-ching. Album leaf. Spurious seals of Chao Meng-fu, intended to attribute the painting to him. Copy? An accompanying inscription by Chang Yü is dated 1344, and is probably genuine. See NPM Masterpieces IV, 10.

Sogen 82 (G. Harada). Chao-chün mounting a horse with the aid of servants to start her journey to Mongolia. Curious work of Ch'ing period.

Yuji Eda, Tokyo. Portrait of Ch'en P'u-hsieh. Life-size standing portrait. Ink and colors on silk. See Doshaku, 59.

Yabumoto Kozo, Amagasaki. Portrait of the Sung philosopher Shao Yung. Ink on paper.

Freer Gallery (11.219). Wen-chi's Return to China. Handscroll in eight sections, ink on silk. Old attribution to "Zhour Poo" (Ts'ao Pu?), T'ang. The poems, originally written at the top, have been effaced. Probably of the Yüan period, but belonging to a stylistic tradition which may be Liao or Chin in origin. Three other scrolls exist that are in the same style but painted on paper, probably later and by a lesser artist: Freer Gallery (19.171), attributed to Kung K'ai; Freer Gallery (18.52), attributed to Li Ch'eng; and a scroll of which one section is reproduced in Toso 196, with the artist given as "Nan-shan ch'iao-yin," a name appearing in one of the seals. These three form a series. For a related picture of a similar subject see the "Anon. Sung" album leaf in the Palace museum, Taipei (VA14j).

Ibid. (17.332). Hsin-p'i tugging at the emperor's robe. See under Wang Wei, T'ang.

Cincinnati Museum of Art (former Chang Ts'ung-yü). Portraits of four scholars: Wu Ching (1219-1333), Yü Chi (1272-1348), Ou-yang Hsüan (1283-1357) and Chieh-hsi Ssu (1274-1344). Handscroll. Colophon by Su Ch'ang-ling, dated 1354. See Yüan Exh. Cat. fig. 14, p. 81; Yün hui chai 54-5.

Art Institute of Chicago (52.9). *Yang P'u i-chü t'u:* Yang P'u moving his Family. Handscroll. See Yüan Exh. Cat. 205; Kodansha CA in West I, 58.

Asian Art Museum of S. F. (B70D3). Portrait of the Duke Feng-kuo (Chao Ting, 1085-1147). See Venice Exh. Cat. 790; I-lin YK 74; Yüan Exh. Cat. 186; *Oriental Art* N. S. XXII/4 (Winter 1976), p. 380.

Palaces and Buildings

Peking Palace Museum (exhibited Fall 1977). Palace by the River. Large hanging scroll, ink and light colors on paper; drawing in detailed *chieh-hua* manner. Ming work?

Shanghai Museum. The Kuang-han Palace. Two characters, "Ch'en (Your Subject) Hsien," intended for a signature of the 10th century master Wei Hsien. Good Yüan work, cf. Wang Chen-p'eng and Hsia Yüng. See Shanghai 27.

Liaoning Provincial Museum. A water-powered mill built over a river in the mountains. See Liao-ning I, 111. Mediocre post-Yüan picture; copy by someone who misunderstood the mechanism.

Ibid. Ladies in pavilions; open river scenery in the background. Album leaf. See Liao-ning I, 113.

Taipei, Palace Museum (YV135). The Palace of Prince Teng. Poem by Ch'ien-lung. See Ku-kung XVIII; KK ming-hua VI, 50; KK chou-k'an 147.

Ibid. (YH73). The Chien-chang Palace of Emperor Han Wu-ti. Handscroll. Fine Yüan work, perhaps by Hsia Yung, q.v. See Ku-kung XVII; CKLTMHC III, 108.

Ibid. (YH72). The Dragon Boat Festival. Palaces on the lakeshore. Handscroll. Fine work of the 16th cent.

Ibid. (YV307). A two-storied pavilion by a broad river. See KK shu-hua chi XXII; London Exh. Chinese Cat. 173; CKLTMHC III, 102.

Metropolitan Museum, N. Y. (13.100.105). A pavilion by a lake. Large fan painting, ink and some color on silk. Related to Wang Chen-p'eng in style.

Ars Asiatica I, 32 (Coll. Goloubew). Palatial pavilions on a high terrace. Album leaf.

Landscapes

Peking, Palace Museum. (These and the following were exhibited Fall 1977.) Travellers in Autumn Mountains. Large hanging scroll in Kuo Hsi manner. Painting of fine quality.

Ibid. Jade Trees and Jasper Peaks. Winter landscape. Ink and colors on paper. Inscriptions by Yao Pi and three other Yüan writers. Colophon by Hua-jan ascribing it to the Sung period. Fine Yüan work, cf. Yao Yen-ch'ing.

Ibid. Leisurely Gazing from a Window by Willows: a man and a servant wth a fan in a house by the water under willows. Fan painting. See Yüan-jen hua-ts'e I.

Ibid. A fisherman selling fish from a boat at a pavilion; snowscape. Fan painting. Work of minor Sheng Mou follower. See Yüan-jen hua-ts'e I.

Ibid. A man walking with a staff, a servant with a *ch'in*. Fan painting. Work of minor follower of Chao Meng-fu. See Yüan-jen hua-ts'e II.

Ibid. Winter scene: an inn in the mountains; travellers arriving. Fan painting. Crude Ming work. See Yüan-jen hua-ts'e II.

Ibid. Early winter scene; houses on a cliff; bare and red-leafed trees. Album leaf. See Yüan-jen hua-ts'e II.

Ibid. A scholar seated by a river inlet under red-leafed trees. Album leaf. Good work by follower of Chao Meng-fu and Sheng Mou in archaistic style. See Yüan-jen hua-ts'e II.

Ibid. Fisherman poling a boat toward a cove, another fisherman in the cove. Fan painting. Good work by Sheng Mou or close follower. See Yüan-jen hua-ts'e II.

Ibid. Buildings along the banks of a mountain stream. Fan painting. Good work by Sheng Mou or close follower. See Yüan-jen hua-ts'e II.

Historical Museum, Peking. Traffic on the bridge. Seal of Wen Cheng-ming, perhaps spurious. See Wen-wu 1962, no. 10, 10.

Liaoning Provncial Museum. Admiring plum blossoms at night: lady leaning on a tree, the moon reflected in a stream. Fan painting. See Liao-ning I, 98.

Ibid. Scholar leaning on a pine-tree. Album leaf. Old attribution to Chao Meng-fu; work of later, lesser Yüan artist. See Liao-ning I, 112; Sung Yüan shan-shui 13.

Ibid. Landscape with travelers (emperor's emissaries?) approaching a hermit's dwelling; the hermit above, with friends. Album leaf. Late Ming, cf. Ch'en Hung-shou. See I-yüan to-ying 1978 no. 3, cover.

Ibid. Summer scene: a man and his servant in a boat among lotus on the shore of a lake; willows and other trees. Handscroll. Yüan work in blue-green maner. See I-yüan to-ying 1978 no. 3, p. 47.

Tientsin Art Museum. Travellers in mountains and on rivers. Fine Yüan work in Kuo Hsi tradition. See I-yüan chi-chin 6.

Taipei, Palace Museum (YV122). Cloudy mountains, after Mi Fu. Poem by Ch'ien-lung. Minor work, Yüan or early Ming, by follower of Kao K'o-kung. See KK shu-hua chi III; Three Hundred M., 203; CAT 71; CKLTMHC III, 107; KK ming-hua VI, 52; Nanking Exh. Cat. 80; KK chou-k'an 247.

Ibid. (YV123). Cloudy mountains, in the style of Mi Fu. By minor follower of Kao K'o-kung, later 14th century? See KK shu-hua chi III; KK ming-hua VI, 53.

Ibid. (YV124). Mountain in spring; a temple at the bottom of a gorge. Poem by Yang Wei-chen. Fanciful work in Kuo Hsi tradition, possibly by Yang Wei-chen, q.v. Another view (Richard Barnhart) attributes it to Yao Yen-ch'ing, q.v. See KK shu-hua chi XI; CKLTMHC III, 99; Hills 36.

Ibid. (YV126). A bamboo pavilion in the green mountains. Late Ming work? An inscription above, on separate paper, is dated 1347.

Ibid. (YV127). Two fishermen in boats; their homes on the promontory; mountains in the background. Ming work, cf. Shih Jui. See Ku-kung XX; KK ming-hua VI, 42; KK chou-k'an 178.

Ibid. (YV128). Homeward bound in wind and rain; a boat with two men steering towards the pavilion on the shore. Middle Ming, cf. Hsieh Shih-ch'en. See KK shu-hua chi XXXI.

Ibid. (YV129). Buying Fish and Purchasing Wine on a Snowy Day. Buildings by a river; snowy mountains. Hard Ming or Ch'ing work. See KK shu-hua chi XIX; KK ming-hua VI, 43; KK chou-k'an 242.

Ibid. (YV130). Tea and conversation in a wintry grove. Hard Ming-Ch'ing work.

Ibid. (YV131). Clearing after Snow on Mount T'ai-hang. Yüan or early Ming painting, after earlier model, by artist in Li T'ang tradition.

Ibid. (YV132). Snow landscape. Hard Ming copy of Sung painting.

Ibid. (YV134). Landscape; figures on a misty path; a man meditating on a ledge above. Interesting 17th century picture in Kuo Hsi tradition.

Ibid. (YV305, chien-mu). Autumn mountains. 15th century follower of Wang Fu.

Ibid. (YV306, chien-mu). Rain over summer mountains. Early 16th cent., cf. Chiang Sung.

Ibid. (YV311, chien-mu). Hunting on the cold plain. Yüan-Ming work in Liao tradition.

Ibid. (YV356, chien-mu). Picking fungus. Interesting 15th cent. work by Tai Chin follower.

Ku-kung XIV. Li Po in a boat enjoying the moon-light. Short handscroll. Seals of K'o Chiu-ssu and Mi Wan-chung. Ming work of Che School, follower of Wu Wei.

Ibid. XXX. Scholars enjoying themselves in a pavilion by a mountain stream. Early Ming Academy work, cf. Shih Jui.

Taipei, Palace Museum (YH17). Blue mountains and white clouds. Houses at the foot of rounded hills. Short handscroll. Poem by Ch'ien-lung. Style of Kao K'o-kung, may be by him. See KK shu-hua chi VI; CKLTMHC III, 98; KK chou-k'an 174; Skira 104.

Ibid. (VA24i). Solitary boat on the misty water; trees and faint hills. Fan painting. Good Yüan or early Ming copy of Southern Sung work, style of Hsia Kuei.

Ibid. (VA33g). Cloudy mountains. Fan painting. Badly damaged and retouched. Work of a follower of Kao K'o-kung.

Ibid. (VA35a). Cloudy mountains; river and hut. Double album leaf. Interesting work by painter of Kao K'o-kung school, late Yüan or early Ming?

Ibid. (VA35b). Tasting Spring Waters: four figures in a forest. Double album leaf. Late Yüan or early Ming work, with elements of Ma Ho-chih and Weng Meng styles.

Ibid. (VA35d). Autumn at the Forest Pavilion. Double album leaf. Yüan-Ming work, in Kuo Hsi tradition.

Ibid. Playing the ch'in and enjoying the view. Fan painting. By Sheng Mou or close follower. See CKLTMHC III, 103.

Ibid. Landscape with five people in a dragon boat. Fan painting. Archaistic Yüan work. See CKLTMHC III, 104.

Ibid. Boat approaching a pavilion on a wooded shore. Double album leaf. Good work by Sheng Mou or close follower. See CKLTMHC III, 106.

Ibid. (VA37t). Figures on a flower terrace enjoying the view of a pavilion in the valley. Fan painting. Work of the 14th century, by follower of Ma Yüan. See KK ming-hua VI, 44.

Ibid. A ferry boat under a cliff. Album leaf. Possibly late Sung Academy work, by Li T'ang follower. See KK ming-hua VI, 45.

Ibid. A boat anchored at the riverside in autumn. Album leaf. By follower of Sheng Mou. See KK ming-hua VI, 47.

T'ien-yin T'ang I, 12 (Chang Pe-chin, Taipei). Fishermen returning along a snowy bay. Hard Ming Che School work.

Chung-kuo I, 123 (Ti Pao-hsien). Fantastic mountains in snow; poet on donkey crossing the bridge. Early Ch'ing academic work. See also Chung-kuo MHC 30.

Kyoto National Museum (Hosomi collection). Wintry forest and returning woodsman. Ink on silk. Colophon by P'ing-shan Ch'u-lin (1279-1361). Spurious seal of Wang Meng. See Kokka 273 and 787; Boston Zen Cat. 18; Suiboku III, 108. Sometimes attributed to Kao Jan-hui.

Sogen 79 (Prince Chichibu). River landscape: two men in a pavilion surrounded by chrysanthemums. Free Ming version of a composition sometimes associated with Chao Ling-jang.

Ibid. 83 (Chin K'ai-fang). Hsiao I and the Lan-t'ing manuscript: landscape with a man on horseback approaching a temple. Ming copy of the composition in the Palace Museum, Taipei, once ascribed to Chü-jan.

Ibid. 84 (Jen Chen-t'ing). Summer Groves at Ch'ung-shan, in the manner of Chü-jan. Title, unsigned. Copy of older work.

Kokka 108. Pavilion on a cliff; a man and his servant walking under overhanging pines. Album leaf. Ming Che School work, cf. Wang E.

Ibid. 260 (former Tuan Fang). Mountains by a river in spring. Short handscroll? Fine work of late Yüan or early Ming.

Tokyo National Museum (formerly Yuji Eda, Tokyo). Rocks and waves. Inscription dated 1351. See Tokyo N. M. Cat. 39.

Yabumoto Kozo, Amagasaki. Landscape with men in a riverside pavilion among bare trees. Old attribution to Liu Sung-nien; fine work of Yüan period, cf. T'ang Ti. See Bunjinga suihen III, 76.

Bunjinga suihen III, 77. *Sui-ch'ao t'u:* the New Year's Holiday. Large river landscape with many buildings and figures: people paying New Year's visits. Work of some academic master of the period.

Ibid. 79. Tall landscape with buildings, two men on a bridge. Odd picture; Korean?

Metropolitan Museum, N. Y. Landscape with pavilion and cranes. Fan painting, ink and color on silk. See China Institute Album Leaves no. 47, ill. p. 57.

Freer Gallery (09.215). Landscape; hills in mist; houses among trees. Handscroll. A fine work in the Mi Yu-jen tradition, early Yüan in date. Related in style to Kao K'o-kung. Old attribution to Huang Chin, q.v. See Hills 20.

Ibid. (15.122). River landscape with mountain peak and pavilions. Old attribution to Li Ch'eng; Yüan or later in date.

Ibid. (19.127). Mountain landscape with temple and travelers, in the tradition of Fan K'uan. Inscription dated 1340; the painting probably slightly earlier in date.

Museum of Fine Arts, Boston (50.1456). Misty landscape in Mi style. See BMFA Portfolio II, 26.

Cleveland Museum of Art (19.974). Carrying a *ch'in* on a visit; landscape in the style of Li Ch'eng-Kuo Hsi school, close in style to Lo Chih-ch'uan. See Yüan Exh. Cat. 218; Lee Colors of Ink cat. 23; Bunjinga suihen III, 82.

Ibid. Two men conversing in a thatched house; bamboo and banana palms outside. Fan painting. See Bunjinga suihen III, p. 117, fig. 9; Cleveland Museum Bulletin, Oct. 1979, p. 284.

Nelson Gallery, K. C. (46.52). River landscape: a mounted traveler and his servant waiting for the ferry. Fan painting. Late Sung or early Yüan work in the Kuo Hsi tradition. Seal of Shen Chou. See China Institute Album Leaves no. 54 (no ill.).

Ibid. (59.23). River landscape, in the style of Yen Tzu-p'ing.

Ibid. (63.19). Composing poetry on a spring outing. Handscroll, ink and light color on silk. See Archives XVIII (1964), p. 79, fig. 35.

Ibid. Fishing in the Chill of Autumn. Style of T'ang Ti, but later—15th cent.? See Yüan Exh. Cat. 221.

Asian Art Museum of San Francisco (B66D1). Towering mountain over a river valley; figures on a bridge below. Tradition of Kuo Hsi, probably Yüan in date. A label in the calligraphy of Tung Ch'i-ch'ang attributes the picture to Fan K'uan, and it was so published in Kokka 584. See also Chinese Treasures from the Avery Brundage Collection, N. Y. 1960, no. 114.

Ibid. (B69D4). Seasonable snow in fishing village. Ink and light colors on silk. Copy of earlier work?

Ibid. (B69D13). Winter landscape. School of Sheng Mou, q.v.

Clark Humanities Museum, Scripps College, California (Pettus collection). River landscape; a man buying fish from a fisherman. Inscription by Chao Meng-fu. Style of T'ang Ti, may be by him.

Ching Yüan Chai collection, Berkeley. Misty landscape. Ink on silk. A painting in the Metropolitan Museum, N. Y., with an old attribution to Wang Hsia of the T'ang period, appears to be by the same hand. Both are sometimes loosely called Korean.

Note: The pair of landscapes in the Tokyo National Museum in the Mi Style, once attributed to Kao Jan-hui, forming a single composition, with inscriptions by Tu Kuan-tao (active at the beginning of Ming), are sometimes dated in the Yüan period. See Minshin no kaiga 38-9; Kokka 685, etc.

Flowers, Birds, and Animals

Peking, Palace Museum. Two peaches on a branch. Album leaf. See Yüan-jen hua-ts'e I.

Liaoning Provincial Museum. A groom holding a horse drinking at a stream. Album leaf. Old attribution to Han Kan. Good Yüan work, after older design? See Liao-ning I, 97.

Ibid. Ducks and birds among flowering plants. See Liao-ning I, 114.

Shanghai Museum. Ducks under a blossoming apricot tree by a stream. Fine work of the period. See Shang-hai 28.

Taipei, Palace Museum (YV156). A herdboy dreaming of a good harvest. Four water buffaoes and three herdboys in a river landscape. Ming work.

Ibid. (YV157). Boy with three goats: New Year's greetings. Ming work.

Ibid. (YV158). Hundred sparrows on plum and bamboo. By a follower of Pien Wen-chin, Ming period. Cf. Pien's picture of the same subject in the same collection (MV27). See CH ming-hua.

Ibid. (YV159). Doves, sparrows and early spring flowers. Poem by Ch'ien-lung. Good Yüan work, close to Wang Yüan in style. See KK shu-hua chi XLIII.

Ibid. (YV160). A cock, a hen and chickens under peonies. Late Ming or Ch'ing. See KK shu-hua chi XXXI.

Ibid. (YV161). Two ducks among peonies. Hard Ming painting. See KK shu-hua chi XXVII; KK chou-k'an 391.

Ibid. (YV162). A white swallow and a willow pool. Minor Ming academic work.

Ibid. (YV163). Birds in bamboo; two pheasants below. Fine painting, probably Southern Sung in date, time and style of Li Ti. See under Anonymous Sung for additional references.

Ibid. (YV164). Ten crows in an old tree. Ming copy of Sung work? See KK shu-hua chi V; CKLTMHC III, 95; Nanking Exh. Cat. 81; KK chou-k'an 214.

Ibid. (YV165). Three herons on the shore and small birds in a plumtree in snow. Hard Ming decorative work. See KK shu-hua chi IV; KK chou-k'an 212.

Ibid. (YV166). Two wild geese under a willow. Interesting Ming academic painting of early 16th century. See Ku-kung XIII; KK chou-k'an 98.

Ibid. (YV167). Three fish and aquatic plants. Minor painting, probably early Ming.

Ibid. (YV168). Two wild geese among reeds; a heron alighting. Good Academy work, early Ming? See KK shu-hua chi II; KK chou-k'an 104.

Ibid. (YV169). Two pheasants, two swallows, two other birds, with rocks and flowering plants. Interesting Ming work.

Ibid. (YV170). Flowers of the fifth month: Peonies, rock, and flowering cassia tree. Ming or Ch'ing work. See KK shu-hua chi XLIV.

Ibid. (YV171). A clump of tall rice stalks. Fine, unusual work of the period. See KK shu-hua chi XI; CKLTMHC III, 96; KK chou-k'an 159.

Ibid. (YV316, chien-mu). Chrysanthemums Growing by a Rock, with Sparrows. Good early Ming painting.

Ibid. (YV359). Six quails by a rock and small birds on stalks of millet. Good painting of the period. See KK shu-hua chi XXI; London Exh. Cat. 175; CKLTMHC III, 101.

KK shu-hua chi XXX. Lotus flowers and bamboo in a vase; fungi in a pot; "Buddha's Hands" and peaches on a plate. Hard 17th century painting.

Ibid. XXVI. Flowers of the New Year's Day in a vase; fruits in a plate and toys. Hard, dull work of later period.

Ku-kung XXII. A branch of autumn hollyhock with two flowers. Good work of the period, probably by an artist of the Ch'ang-chou or P'i-ling School.

KK Ming-hua VI, 46. Two buffaloes and cowherd under autumn trees. Fan painting. Copy of Sung work?

T'ien-yin T'ang I, 11 (Chang Pe-chin, Taipei). Three birds in blossoming plum tree, bamboo and rock. Ming painting.

Garland II, 41. Mandarin ducks in a stream; willows on the shore. Handscroll. Colophons by Chou T'ien-ch'iu (1514-1595) and Chang Feng-i (1527-1613); seals of Hsiang Yüan-pien (1525-1590) and An Ch'i (1683-ca. 1744).

Tokyo National Museum. Grapes and insects. Fine work of the period. See Sogen meiga 32; Sogen no kaiga 88; Genshoku 29/74; Suiboku IV, 124; Sogen MGS III, 57.

Kogakuji, Yamanashi Pref. Bamboo, Blossoming Plum and Orchids. Pair of hanging scrolls. One reproduced in Suiboku IV, 127.

Kyoto National Museum (Hosomi collection, Osaka). Four birds eating insects. Horizontal hanging scroll, ink and colors on paper. Fine work of the period. Loosely attributed to Wang Yüan, q.v.

Ibid. (Koshoji, Uji). Lotus. Ink and colors on silk.

Hompoji. Lotus flowers: a pair of hanging scrolls. See Shimbi IV; Toso 208-209; Siren CP III, 371; Sogen MGS II, 44-45.

Koto-in. Peony flowers: a pair of hanging scrolls. See Sogen meigashu 63-64; Toso 206-207; Sogen Appendix 5-6; Sogen no kaiga 65-66; Siren CP III, 372.

Tokugawa Museum, Nagoya. Peonies and quail. Three hanging scrolls. Yüan period? See Tokugawa 168.

Tokuzen-ji, Kyoto. Bamboo and rocks: pair of hanging scrolls. See Sogen Bijutsu 58.

Sogen bijutsu 62 (Umezawa Hikotaro collection, Tokyo). Branch of blossoming plum. Inscription by Gyokuen Bompo (Japanese, 15th century).

Kokka 381 (Baron Iwasaki). A perch. Handscroll. Good 14th century work.

Ibid. 421. Shrimp on a bamboo leaf.

Ibid. 861. Hanging grape vines. Fine painting by a specialist in this subject, Yüan or early Ming.

Sogen meiga 23 (Keita Goto, Tokyo). Duck.

Sogen 81 (Masaki Coll.). A groom leading an emaciated horse. Copy after Yüan painting? See also Pageant 436.

Suiboku III, 89 (Eda Bungado, Tokyo). Branches and shoots of bamboo, painted in ink on silk. Old attribution to Hui-tsung; good Yüan work.

Eda Bungado, Tokyo. Five birds eating grain. Horizontal painting, ink and colors on silk. Called "Anonymous Sung" but probably Yüan in date.

Sasagawa collection, Osaka. A bird pecking an insect. Album leaf.

Ibid. Four magpies pecking a mantis. Album leaf.

T. Yanagi, Kyoto (1979). Flowers and butterflies. Late Sung or Yüan work of P'i-ling school.

Homma Sogen 71. Herons and lotus.

Boston Museum of Fine Arts (14.64). Hawk and quails in a winter setting. Album leaf.

Freer Gallery (15.5). Eight horses, one with a rider. Handscroll. Odd picture of later date. See Siren CP in Am. Colls. 126.

Ibid. (16.48). A cabbage plant. Seals that may be those of the artist, but unidentified.

Ibid. (70.33). Wintry trees and sheep. Probably Yüan period, after much earlier (10th century?) model. See Kodansha CA in West, I, 25; Meyer Cat. 21.

Cleveland Museum of Art. Peonies. Old attribution to Wang Yüan. See their Bulletin, Feb. 1977, no. 162.

Ching Yüan Chai collection, Berkeley. Bird on a flowering branch. Album leaf mounted as a hanging scroll. A spurious signature of Ts'ui Po was removed.

Ars Asiatica I, 23 (Collect. Doucet). A horse called "White as Frost." Album leaf.

Musée Guimet, Paris. Ink bamboo. Ink on paper. See Pao-hui chi 1.

Indianapolis Museum of Art (55.109). Tribute horse. Color on silk.

Bibliography and Abbreviations

Part I: Sources for Reproductions

Books and series in Chinese:

CCAT: *Chinese Cultural Art Treasures, National Palace Museum Illustrated Handbook,* The National Palace Museum, 2nd edition, Taipei, 1966. The text on painting by Li Lin-ts'an 李霖燦 .

Che-chiang: *Che-chiang ku-tai hua-chia tso-p'in hsüan-chi* 浙江古代畫家作品選集 (Selected works of ancient artists of Chekiang Province), compiled by Wang Po-min 王伯敏 and Huang Yung-ch'üan 黃湧泉, Hangchou, 1958.

Chin-k'uei: Ch'en, J. D., *Chin-k'uei ts'ang-hua chi* 金匱藏畫集 (Chinese Paintings from King Kuei Collection), 2 vols., Kyoto, 1956.

Chin-shih SH: *Chin-shih shu-hua* 金石書畫 , Tung-nan jih-pao, Hangchou, 1935?-1937?, 3 vols. A reissue of nos. 1-72 of the newspaper's supplement of the same title, ed. by Yü Shao-sung 余紹宋, and published Sept. 15, 1934 - Dec. 31, 1936.

Ch'ing-kung ts'ang: *Ch'ing-kung ts'ang Sung Yüan pao-hui* 清宮藏宋元寶繪 (Rare Paintings of the Sung and Yüan Dynasties belonging to the Ch'ing

Imperial Family), 1 vol., n.d., also published as a series of 5 vols., Yu Cheng Book Co., Shanghai.

Chung-kuo: *Chung-kuo ming hua chi*, 中國名畫集 2 vols., preface dated 1909, Yu Cheng Book Co., Shanghai. The same material in 40 parts, issued from 1923. Cross-references given for some, but not all paintings; the 40 indexed as

Chung-kuo MHC. (See the preceding entry.)

Chung-kuo hua: *Chung-kuo hua* 中國畫 (Chinese Painting), Peking, 1957-1960, 21 volumes.

CH mei-shu: *Chung-hua mei-shu t'u-chi*, 中華美術圖集 (Art of China), 3 vols. on painting, Taipei, 1955-1956.

CK shu-hua: Chu Hsing-chai, 朱省齋 ed., *Chung-kuo shu-hua* 中國書畫 (Chinese Painting and Calligraphy), Hong Kong, 1961.

CK ku-tai: *Chung-kuo ku-tai hui-hua hsüan-chi* 中國古代繪畫選集 Peking, 1963.

CK li-tai: *Ku-kung po-wu-yüan so ts'ang Chung-kuo li-tai ming-hua chi*, 故宮博物院所藏歷代名畫集 , 2nd ed., 5 vols., Peking, 1964-1965.

CK li-tai hui-hua: *Chung-kuo li-tai hui-hua*, 中國歷代繪畫, V. 1 (Eastern Chin through Five Dynasties, Peking, Palace Museum, 1978).

CKLT shu-hua: *Chung-kuo li-tai shu-hua hsüan* 中國歷代書畫選 (Selections of Chinese Paintings and Calligraphy), Chung-hua ts'ung-shu wei-yüan-hui, Taipei, n.d.

Gems: *Hua-yüan to-ying* 畫苑掇英 (Gems of Chinese Painting), a selection of paintings from the Shanghai and Nanking Museums, 3 vols., Shanghai, 1955.

I-shu ch'uan-t'ung: *Wei-ta ti i-shu ch'uan-t'ung t'u-lu* 偉大的藝術傳統圖錄 (The Great Heritage of Chinese Art), parts I-XII in 2 vols., compiled by Cheng Chen-to 鄭振鐸, Shanghai, 1951-54.

I-shu ts'ung-pien: *I-shu ts'ung-pien* 藝術叢編, vols. 1-24, Shanghai, 1906-1910.

I-yüan chen-shang: Ch'in Chiung-sun 秦絅孫 ed., *I-yüan chen-shang* 藝苑眞賞, 10 vols., Shanghai, 1914-1920.

I-yüan chi-chin: *I-yüan chi-chin* 藝苑集錦, compiled by the Tientsin Art Museum, Tientsin, 1959.

I-yüan to-ying: *I-yüan to-ying* 藝苑掇英, Shanghai, 1978, nos. 1 and 2; 1979, no. 1.

KK chou-k'an: *Ku-kung chou-k'an* 故宮週刊 (Palace Museum weekly), nos. 1-510, Palace Museum, Peking, 1930-1936.

KK chou-k'an NS: *Ku-kung chou k'an,* new series, 1936-37.

KK chu-p'u: *Ku-kung chu-p'u* 故宮竹譜 (Bamboo paintings in the Palace Museum), National Palace and Central Museums, Taipei, 1962.

KK ming-hua: *Ku-kung ming-hua* 故宮名畫 (Select Chinese Painting in the National Palace Museum), 10 vols., compiled by the Editorial Committee of the National Palace Museum, Taipei, 1966-68.

KK ming-jen hua-chu chi: *Ku-kung ming-jen hua-chu chi* 故宮名人畫竹集, (Bamboo paintings by famous artists in the Palace Museum), 2 vols., Palace Museum, Peking, 1933.

KK ming-jen hua-mei chi: *Ku-kung ming-jen hua-mei chi* 故宮名人畫梅集, (Plum paintings by famous artists in the Palace Museum), Palace Museum, Peking, 1936.

KK ming-shan chi: *Ku-kung ming-shan chi* 故宮名扇集 (Famous fan paintings in the Palace Museum), 8 vols., Palace Museum, Peking, 1932.

KKPWY hua-niao: *Ku-kung po-wu-yüan ts'ang hua-niao-hua hsüan* 故宮博物院藏花鳥畫選, (Selected flower and bird paintings in the Palace Museum), Peking, 1965.

KKPWY ts'ang-hua: *Ku-kung po-wu-yüan ts'ang-hua* 故宮博物院藏畫, (Paintings in the Palace Museum), Vol. II, Sui-T'ang, Peking, 1964.

KK shu-hua chi: *Ku-kung shu-hua chi* 故宮書畫集 (*Calligraphy and Painting in the Palace Museum*), vols. I-XLVII (the last two numbers are exceedingly rare), Palace Museum, Peking, 1930-1936.

Ku-kung: Ku-kung 故宮 (Palace Museum Monthly), vols. I-XLIII, Palace Museum, Peking, 1929-1936.

Kwen Catalogue: *Ku-hua liu-chen* 古畫留眞 (Descriptive Catalogue of Chinese Paintings), compiled by F. S. Kwen, Shanghai, 1916.

Li-ch'ao hua-fu chi-ts'e: *Li-ch'ao hua-fu chi-ts'e* 歷朝畫幅集册, Palace Museum, Peking, 1932.

Li Mo-ch'ao: *Sung-jen hua-ts'e* 宋人畫册 (Album leaves by Sung artists in the Li Mo-ch'ao collection), Shanghai, 1935.

Li-tai: *Li-tai ming-jen shu-hua* 歷代名人書畫 (Paintings by famous artists of successive dynasties), 6 vols., National Museum Peking, 1925.

Li-tai jen-wu: *Li-tai jen-wu-hua hsüan-chi* 歷代人物畫選集 (Selected figure paintings of various dynasties), Shanghai, 1959.

Liang Sung: *Liang Sung ming-hua ts'e* 兩宋名畫册 (Album paintings of the Northern and Southern Sung Dynasties), Peking, 1963.

Liao-ning: *Liao-ning sheng po-wu-kuan ts'ang-hua chi* 遼寧省博物館藏畫集 (A collection of paintings in the Liao-ning Provincial Museum), notes on the paintings by Yang Jen-k'ai 楊仁愷 and Tung Yen-ming 董彥明, Peking, 1962.

Liu: Liu Hai-su 劉海粟 ed., *Chin T'ang Sung Yüan Ming Ch'ing ming-hua pao-chien* 晋唐宋元明清名畫寶鑑, Shen pao kuan, Shanghai, 193-?

London Exh. Chinese Cat.: *Tsan-chia Lun-tun Chung-kuo i-shu kuo-chi chan-lan hui ch'u p'in t'u shuo* 參加倫敦中國藝術國際展覽會出品圖説, (Illustrated Catalogue of Chinese Government Exhibits for the International Exhibition of Chinese Art in London, 1936), Vol. III, Shanghai, 1936.

Mei-chan: *Mei-chan t'e-k'an* 美展特刊 (Catalogue of the National Exhibition of Fine Arts, 1929), 2 vols., 1929.

Ming-hua lin-lang: *Ming-hua lin-lang* 名畫琳瑯, Palace Museum, Peking, 1930.

Ming-hua sou-ch'i: *Ming-hua sou-ch'i* 名畫搜奇, Two vols, Wen-ta Book Co., Shanghai, 1920-23.

Ming-jen shu-hua: *Ming-jen shu-hua* 名人書畫, vols. 1-26, Shanghai, 1920-1925.

Ming-pi chi-sheng: *Ming-pi chi-sheng* 名筆集勝 (Masterpieces of Chinese Painting in the Collection of P'ang Yüan-chi), Vols. I-V, Mo-yüan, Shanghai, 1940.

Mo-ch'ao pi-chi: Li Mo-ch'ao (Hsüan-kung) 李墨巢 (宣龔), ed. *Mo-ch'ao pi-chi ts'ang-ying* 墨巢祕笈藏影, 2 vols., Shanghai, 1935.

Nan-ching: *Nan-ching po-wu-yüan ts'ang hua chi* 南京博物院藏畫集 (A collection of Paintings in the Nanking Museum), 2 vols., Nanking, 1965.

Nanking Exh. Cat.: *Chiao-yü pu ti-erh tz'u ch'üan-kuo mei-shu chan-lan hui chuan chi ti-i chung: Chin T'ang Wu-tai Sung Yüan Ming Ch'ing ming-chia shu-hua chi* 教育部第一次全國美術展覽會專集第一種：晉唐五代宋元明清名家書畫集 (The Famous Chinese Painting and Calligraphy of Tsin, T'ang, Five Dynasties, Sung, Yüan, Ming and Ch'ing Dynasties: A Special Collection of the Second National Exhibition of Chinese Art Under the Auspices of the Ministry of Education, Part One), preface 1937 (year of the exhibition), Commercial Press, 1943.

NPM Bulletin: *The National Palace Museum Bulletin,* Taipei, 1966-, Vols. I-XII (1966-1978) indexed.

NPM Masterpieces I: *Ku-kung ming-hua hsüan-ts'ui* 故宮名畫選萃 (Masterpieces of Chinese Painting in the National Palace Museum), National Palace Museum, Taipei, 1970.

NPM Masterpieces II: *Ku-kung ts'e-yeh hsüan-ts'ui* 故宮冊葉選萃 (Masterpieces of Chinese Album Painting in the National Palace Museum), National Palace Museum, Taipei, 1971.

NPM Masterpieces III: *Ku-kung jen-wu-hua hsüan-ts'ui* 故宮人物畫選萃 (Masterpieces of Chinese Figure Painting in the National Palace Museum), National Palace Museum, Taipei, 1973.

NPM Masterpieces IV: *Ku-kung t'u-hsiang hsüan-ts'ui* 故宮圖像選萃 (Masterpieces of Chinese Portrait Painting in the National Palace Museum), National Palace Museum, Taipei, 1971.

NPM Masterpieces V: *Ku-kung ming-hua hsüan-ts'ui hsü-chi* 故宮名畫選萃續輯 (Masterpieces of Chinese Painting in the National Palace Museum, Supplement), National Palace Museum, Taipei, 1973.

NPM Quarterly: *Ku-kung chi-k'an* 故宮季刊 (The National Palace Museum Quarterly), Taipei, 1966-, Vols. I-XII (1966-1978) indexed.

Pao-yün: *Pao-yün* 寶蘊 , 3 vols., National Museum, Peking, 1930.

Shang-hai: *Shang-hai po-wu-kuan ts'ang hua* 上海博物館藏畫 (Paintings in the Shanghai Museum), Shanghai, 1959.

Shen-chou: *Shen-chou kuo-kuang chi* 神州國光集 , Vols. I-XXI, Shen-chou kuo kuang she, Shanghai, 1908-1912.

Shen-chou ta-kuan: *Shen-chou ta-kuan* 神州大觀 , Vols. I-XVI, Shen-chou kuo-kuang she, Shanghai, 1912-1922.

Shen-chou ta-kuan hsü: *Shen-chou ta-kuan hsü-pien* 神州大觀續編 , 11 vols., Shen-chou kuo-kuang she, Shanghai, 1928-1931.

Su-chou: *Su-chou po-wu-kuan ts'ang-hua chi* 蘇州博物館藏畫集 (A collection of paintings in the Suchou Museum), Wen-wu ch'u-pan she, n.p., 1963.

Sung-hua shih-fu: *Sung-hua shih-fu:* 宋畫十幅 (Ten Sung dynasty paintings), Palace Museum, Peking, n.d.

Sung-jen hua-hsüan: *Sung-jen hua-hsüan* 宋人畫選 (A selection of paintings by Sung dynasty artists), compiled by Hsieh Chih-liu 謝稚柳 , Shanghai, 1958.

Sung-jen hua-ts'e, A: *Sung-jen hua-ts'e* 宋人畫册 (Album paintings by Sung artists), compiled by Cheng Chen-to 鄭振鐸 , Chang Heng 張珩 and Hsü Pang-ta 徐邦達 , Peking, 1957.

Sung-jen hua-ts'e, B: *Sung-jen hua-ts'e* 宋人畫册 (Album paintings by Sung artists), vols. 1-10, Palace Museum, Peking, n.d., vols. 11-19, Wen-wu ch'u-pan she, Peking, 1958-1962.

Sung-tai hua-niao: *Sung-tai hua-niao* 宋人花鳥　　　*960-1279* (Sung dynasty flower and bird paintings), Peking, 1964.

Sung Yüan shan-shui: *Sung Yüan shan-shui chi-ts'e: Liao-ning sheng po-wu-kuan ts'ang-hua chi chih i:* 宋元山水集册：遼寧省博物館藏畫集之一，(A collection of Sung and Yüan dynasty landscape paintings, album leaves, in the Liaoning Provincial Museum), Shenyang, 1960.

T'ai-shan I-IV: *T'ai-shan ts'an-shih-lou ts'ang hua* 泰山殘石樓藏畫, four series of 10 vols. each, ed. by Kao Yung-chih 高邕之, collection of T'ang Chi-sheng 唐吉生, Shanghai, Hsi-leng yin-she, 192(?)-27.

T'ang Sung ming-hui chi-ts'e: *T'ang Sung ming-hui chi-ts'e* 唐宋名繪集册 (Famous album paintings of T'ang and Sung), Yen Kuang Co., Peking, 1927.

T'ang-tai jen-wu: Liu Ling-ts'ang 劉凌滄　　　, *T'ang-tai jen-wu hua* 唐代人物畫 (Figure painting of the T'ang dynasty), Peking, 1958.

Three Hundred M.: *Ku-kung ming-hua san-pai chung* 故宮名畫三百種 (Three Hundred Masterpieces of Chinese Painting in the Palace Museum), selected and compiled by the Editorial Committee of the Joint Board of Directors of the National Palace Museum and the National Central Museum, 6 *ts'e* in 2 *t'ao*, National Palace Museum and National Central Museum, Taichung, 1959.

Three Patriarchs: Ch'en Jen-t'ao 陳仁濤　　　, *Chung-kuo hua-t'an ti nan-tsung san-tsu* 中國畫壇的南宗三祖 (Three Patriarchs of the Southern School in Chinese Paintings), Hong Kong, 1955.

T'ien-ching I and II: *T'ien-ching shih i-shu po-wu-kuan ts'ang-hua chi* 天津市藝術博物館藏畫集，(A collection of paintings in the Tientsin Art Museum), Peking, 1959, *Hsü chi* 續集 (Supplement), Peking, 1963.

T'ien-hui-ko: *T'ien-hui-ko hua-ts'ui* 天繪閣畫粹　　　, 2 vols., Shanghai, 1930.

T'ien-lai-ko: *T'ien-lai-ko chiu-ts'ang Sung-jen hua-ts'e* 天籟閣舊藏宋人畫册 (album paintings by Sung artists, formerly in Hsiang Yüan-pien's collection), Shanghai, 1924.

T'ien-yin t'ang: *T'ien-yin-t'ang ming-hua hsüan* 天隱堂名畫選 (Tien Yin Tang Collection, One Hundred Masterpieces of Chinese Painting), selected and compiled by Tien Yin Tang (Chang Pe-chin 張伯謹　　　), 2 vols. Tokyo, n.p., 1963, 1965.

TWSY ming-chi: *Tang Wu-tai Sung Yüan ming-chi* 唐五代宋元名迹 (Famous relics of the T'ang, Five Dynasties, Sung and Yüan Dynasties), compiled by Hsieh Chih-liu 謝稚柳 Shanghai, 1957.

TSYMC hua-hsüan: *T'ang Sung Yüan Ming Ch'ing hua-hsüan* 唐宋元明清畫選 (Selected paintings of the T'ang, Sung, Yüan, Ming and Ch'ing dynasties), Canton, 1963.

Wang-yün-hsien: *Wang-yün-hsien ming-hua* 望雲軒名畫　　　, (Collection of Ch'en Hsiang-t'ao 陳湘濤　　　), 5 vols., Shanghai, 1922-23.

Wen-wu: *Wen-wu* 文物 (Continuation of *Wen-wu ts'an-k'ao tzu-liao* 文物參考資料), Peking, 1950-, indexed through 1978, no. 3.

Wen-wu chi-ch'eng: *Chung-hua wen-wu chi-ch'eng* 中華文物集成 (Catalogue of Chinese cultural objects in the Chinese national collection), 4 vols., National Museums and Library, Taichung, 1954.

Wen-wu ching-hua: *Wen-wu ching-hua* 文物精華 , 3 vols., Peking, 1959, 1963, 1964.

Yüan FGM: Chang Kuang-pin 張光賓 , *Yüan ssu-ta-chia: Huang Kung-wang, Wu Chen, Ni Tsan, Wang Meng,* 元四大家：黃公望，吳鎮，倪瓚，王蒙, (The Four Great Masters of the Yüan: Huang Kung-wang, Wu Chen, Ni Tsan, Wang Meng), National Palace Museum, Taipei, 1975.

Yüan-jen hua-ts'e: *Yüan-jen hua-ts'e* 元人畫册 , (Album paintings by Yüan artists), 2 vols., Peking, 1959.

Yün-hui-chai: *Yün-hui-chai ts'ang T'ang Sung i-lai ming-hua chi* 韞輝齋藏唐宋以來名畫集, Chang Heng (Ts'ung-yü) 張珩 (總玉) collection, 2 vols., Shanghai, 1948.

Books and series in Japanese:

Bijutsu kenkyu: *Bijutsu kenkyū* 美術研究 (The Journal of Art Studies), Nos. 1-308 (1923-1978) indexed, Institute of Art Research, Tokyo, 1923-.

Bijutsu-shi: *Bijutsu-shi* 美術史 (Journal of the Japan Art History Society), Nos. 1-96 (1950-March 1976) indexed, Tokyo, 1950-.

Bijutsu shuei: *Bijutsu shūei* 美術聚英 , 25 vols., Shimbi Shoin 眞美書院 , Tokyo, 1911-1914.

Bunjin gasen: *Bunjin gasen* 文人畫選 , edited by Omura Seigai 大村西崖 , 2 vols., Tansei-sha, 1921-1922.

Bunjinga suihen II: *Bunjinga suihen* 文人畫粹編 , China, v. II: *Tō Gen, Kyo-Zen* 董源, 巨然, (Tung Yüan and Chü-jan), text by Richard Barnhart, Tokyo, 1977.

Bunjinga Suihen III: *Bunjinga suihen,* China, v. III: *Kō Kōbō, Gei San, Ō Mō, Go Chin* 黃公望, 倪瓚, 王蒙, 吳鎮 (Huang Kung-wang, Ni Tsan, Wang Meng, Wu Chen), text by Wai-kam Ho, Tokyo, 1979.

Chang Ta-ch'ien cat. I: *Taifūdō meiseki* 大風堂名蹟 , 4 vols., Benridō, Kyoto, 1955.

Choshunkaku: *Choshunkaku kanshō* 長春閣鑑賞 , 6 vols. (all references herein are to vol. 4), Kokka-sha, Tokyo, 1944.

Chugoku: *Chūgoku meiga-shū* 中國名畫集 , compiled by Tanaka Kenrō 田中乾郎 from photographs collected by Omura Seigai 大村西崖 , 8 vols., Ryubundo, Tokyo, 1935.

Dai tenrankai: *Tōyō bijutsu dai tenrankai zuroku* 東洋美術大展覽會圖錄, (Illustrated catalogue of an exhibition held in Osaka, 1938), Benridō, Kyoto, 1938.

Doshaku: *Gen-dai dōshaku jimbutsu-ga* 元代道釋人物畫 (Taoist and Buddhist Figure Paintings of the Yüan Dynasty), text by Toshio Ebine, Tokyo National Museum, 1975.

Genshoku 29: Yonezawa Yoshiho 米沢嘉圃 and Nakada Yūjiro 中田勇次郎 , eds., *Genshoku Nihon no bijutsu* 原色日本の美術 , vol. 29, *Shōrai bijutsu* 請来美術 , Tokyo, 1971.

Hikkoen: *Hikkōen* 筆耕園 , album, formerly Marquis Kuroda coll., Shimbi Shoin, Tokyo, 1912.

Hokuga shinden: *Hokuga shinden* 北画薪伝 , 1930.

Homma Sogen: *Sōgen Chūgoku Kaiga-ten* (Exhibition of Sung-Yüan Chinese Paintings). Homma Art Museum, Yamagata, 1979. Selectively indexed.

Kaiankyo: *Kaiankyo rakuji* 槐安居楽事 (Chinese Painting and Calligraphy of the Sung, Yüan, Ming and Ch'ing Periods, Collection of Takashima Kikujiro 高島菊次郎, now given to the Tokyo National Museum), Kyuryudo, Tokyo, 1964.

Kaiga senshu: *Chūgoku kaiga senshū* 中国絵画選集 , Benrido, Kyoto, 1953.

Kawasaki Cat.: Baron Kawasaki coll., sale catalogue, Kobe, 1937.

Kobijutsu: *Kobijutsu* 古美術 , Vols. 1-56 (1963-1978) indexed, Tokyo, 1963-.

Kodansha BMFA: *Sekai no bijutsu,* 世界の美術館, *vol. 15, Boston Bijutsukan: Tōyo,* ボストン美術館：東洋, (Museums of the World, Vol. 15, Museum of Fine Arts, Boston: Oriental), Kodansha, Tokyo, 1968.

Kodansha CA in West: *Chūgoku bijutsu,* 中国美術 *I, II: kaiga* 絵画 (Chinese Art in Western Collections, Painting, vol. I, Suzuki Kei 鈴木敬 and Akiyama Terukazu 秋山光和 , eds., vol. II, Suzuki Kei and Toda Teisuke 戸田禎佑 , eds.), Kodansha, Tokyo, 1973.

Kodansha Freer cat.: *The Freer Gallery of Art, I: China,* Kodansha, Tokyo, 1972.

Kodansha Guimet: *Sekai no bijutsukan,* 世界の美術館 *Vol. 14: Guimet tōyo bijutsukan* ギメ東洋美術館 (Museums of the World, Vol. 14: Musée Guimet), Kodansha, Tokyo, 1968.

Kohansha: *Kōhansha Shina meiga senshū* 考槃社支那名画選集, 3 vols., Bunkado, Kyoto, 1926-1929.

Kokka: *Kokka* 国華 , Nos. 1-1005 (1889-1977) indexed, Tokyo, 1889-.

Kokyu hakubutsuin: *Kokyū hakubutsuin* 故宮博物院 (The Peking Palace Museum), Kodansha, Tokyo, 1975.

Meiga-sen: *Shina meiga sen* 支那名画選 , Geisodō, Kyoto, n. d.

Muto cat. vol. II: *Chōshō seikan* 聴松清鑑 , Muto collection, 1929.

Naito: Naitō Konan 内藤湖南, *Shina kaiga-shi* 支那絵画史, Kobundo, Tokyo, 1938 (the same material in *Bukkyō bijutsu* 仏教美術, nos. 14-17, 1929-1930).

Nanga shusei: *Shina nanga shūsei* 支那南画集成, Tanaka Beihō 田中米舫, ed., 3 vols. of 12 numbers each, Bunsuiken, Tokyo, 1917-1919.

Nanga taikan: *Shina nanga taikan* 支那南画大観, Vols. I-XII, Tokyo, 1926.

Nanga taisei: *Shina nanga taisei* 支那南画大成, 16 vols., supplement in 6 vols., Kobunsha, Tokyo, 1935-1937.

Nanju: *Nanjū meiga-en* 南宗名画苑 , Vols. I-XXV, Shimbi Shoin, Tokyo, 1904-1910.

Nanshu gashu: *Nanshū gashu* 南宗画集 , Saito Shobo, Tokyo, 1918.

Nanshu ihatsu: *Nanshū ihatsu* 南宗衣鉢 , five folios of plates, Hakubundo, Osaka, 1916-1927.

Nezu cat.: *Seizansō seishō* 青山荘清賞 (Illustrated Catalogue of the Nezu Coll., Vol. I: Sung, Yüan, Ming and Ch'ing Dynasties), Tokyo, 1939.

Osaka cat.: *Osaka shiritsu bijutsukan-zo Chugoku kaiga* 大阪市立美術館蔵
中国絵画 (Chinese Paintings in the Collection of the Osaka Munic-
ipal Museum of Art), Asahi Shimbunsha, Tokyo, 1975.

Osaka Sogen: Osaka Municipal Museum, *Sogen no Bijutsu* 宋元の美術 (Arts of
Sung and Yüan Dynasties), exhibition catalog, 1978.

Pageant: *Shina meiga hokan* 支那名画宝鑑 (The Pageant of Chinese Painting),
comp. by Harada Kinjiro 原田謹次郎 Otsuka Kogeisha, Tokyo, 1936.
(Note: since the contents of this work are largely taken from other books,
this volume has been indexed only selectively).

Saido seiganshu: *Saido Seiganshu* 西涧清玩集, Hatta Hyojiro 八田兵次郎 collec-
tion, Kyoto, 1909.

Seikado kansho: *Seikado kansho* 静嘉堂鑑賞, *Vol. 3: Shinaga-bu* 支那画部,
(Chinese Paintings in the Seikado Coll.), Taki Seiichi 滝精一, ed.,
Kokka-sha, Tokyo, 1922.

Seikasha Sogen: *Sogen meigashu* 宋元名画集, Seikasha, Kyoto, 1923.

Shimbi: *Shimbi taikan* 真美大観, Vols. I-XX, Kyoto, 1899-1908.

Shina kacho gasatsu: *Shina kacho gasatsu* 支那花鳥画冊 Benrido, Kyoto, 1926.

Soga: *Soga seika* 宋画精華 (Great Paintings of the Sung Dynasty), Vol. I and
supplement, Gakken, Tokyo, 1975.

Sogen: *Sogen Minshin meiga taikan* 宋元明清名画大観. 2 vols., Tokyo, 1931.

Sogen bijutsu: *Chugoku Sogen bijutsu-ten mokuroku* 中国宋元美術展目録, Tokyo
National Museum, 1961. (Note: most of the same material in *Sogen no
kaiga;* selectively indexed).

Sogen meiga: Matsushita Takaaki 松下隆章 and Suzuki Kei 鈴木敬, eds., *Sogen
meiga* 宋元名画, 3 vols., Jurakusha, Tokyo, 1959-1961 (selectively
indexed).

Sogen MGS: *Sogen meiga-shu* 宋元名画集, 2 vols. and supplementary volume,
n. p., 1930.

Sogen no kaiga: *Sogen no kaiga* 宋元の絵画, comp. by Tokyo National Museum,
Benrido, Kyoto, 1962.

Sogen shasei: *Sogen shasei gasen* 宋元写生画撰, Kyoto, 1932.

Sokenan: *Sokenan kansho* 双軒庵鑑賞 (Matsumoto coll.), Kokka-sha, Tokyo,
1920-1923.

Soraikan: *Soraikan kinsho* 爽籟館欣賞, Pts. I-II, each 3 vols., former Abe Coll.,
Hakubundo, Osaka, 1930-1939.

Strehlneek: *Sutsuraheruneku-shi shozo-hin tenkan* スツラヘルネク氏所蔵品展観,
(Collection of E. A. Strehlneek, auction cat.), n. p., n. d.

Suiboku II: *Suiboku bijutsu taikei,* 水墨美術大系, *Vol. II: Ri To, Ba En, Ka
Kei* , (李唐, 馬遠, 夏珪), (Li T'ang, Ma Yüan, and Hsia
Kuei), Suzuki Kei 鈴木敬, ed., Kodansha, Tokyo, 1974.

Suiboku III: *Suiboku bijutsu taikei,* 水墨美術大系, *Vol. III: Mokkei, Gyokkan*
(牧谿, 玉澗) (Mu-ch'i and Yü-chien), Toda Teisuke 戸田禎佑,
ed., Kodansha, Tokyo, 1973.

Suiboku IV: *Suiboku bijutsu taikei,* 水墨美術大系, *Vol. IV: Ryokai, Indara*
(梁楷, 因陀羅), (Liang K'ai and Yin-t'o-lo), Kawakami Kei
川上涇, Toda Teisuke 戸田禎佑, and Ebine Toshio 海老根聰郎, eds.,
Kodansha, Tokyo, 1975.

Toan: *Tōan-zō shogafu* 董盦蔵書画譜 (former Saitō coll.), 4 vols., Hakubundo, Osaka, 1928.

Tokasha Shina meigashu: *Shina meigashū* 支那名画集, Tokasha, Tokyo, 1922.

Tokugawa: *Tokugawa bijutsukan* 徳川美術館 (Catalogue of the Tokugawa Museum, Nagoya), Tokyo, 1962.

Tokyo N. M. Cat.: *Tokyo Kokuritsu Hakubutsukan zuhan mokuroku:* 東京国立博物館図板目録：中国絵画 *Chugoku kaiga (Illustrated catalogues of Tokyo National Museum: Chinese Paintings). Tokyo, 1979.*

Toso: *Tōso Gemmin meiga taikan* 唐宋元明名画大観, 2 vols., Tokyo, 1929.

Toyo bijutsu: *Tōyō bijutsu* 東洋美術 (Asiatic Art in Japanese Colls.), 2 vols., Asahi shinbunsha, Tokyo. 1967.

Toyo bijutsu taikan: *Tōyō bijutsu taikan* 東洋美術大観, Vols. VII-XII, Shimbi Shoin, Tokyo, 1912.

Ueno Cat.: *Ueno Yūchikusai kishū Chūgoku shoga zuroku* 上野有竹斎蒐集中国書画図録 (An Album of Ueno Yuchikusai Collection of Chinese Paintings and Calligraphies), Kyoto National Museum, 1966.

Yurin taikan: *Yurin taikan* 有鄰大観, 4 vols., Yurinkan, Kyoto, 1929-1942.

Books and series in English:

Archives: *Archives of Asian Art* (formerly published as *Archives of the Chinese Art Society of America* for Vols. I-XIX, 1945-1965), Vols. I-XXXII (1945-1979), indexed.

Ars Orientalis: *Ars Orientalis,* Smithsonian Publication, Freer Gallery of Art and University of Michigan Department of the History of Art, Vols. I-X (1955-1975), indexed.

Artibus Asiae: *Artibus Asiae,* Vols. I-XXXIX (1925-1977) indexed.

Bachhofer: Bachhofer, Ludwig, *A Short History of Chinese Art,* New York, 1946.

Barnhart Marriage: Barnhart, Richard, *Marriage of the Lord of the River: A Lost Landscape by Tung Yüan, Artibus Asiae* Supplementum XXVII, Ascona, 1970.

Berlin Cat. (1970): Ragué, Beatrix von, *Asgewählte Werke Ostasiatische Kunst: Staatliche Museen Preusischer Kulturbesitz,* Museum für Ostasiatische Kunst, Berlin-Dahlem, 1970.

Boston MFA Portfolio I and II: *Boston Museum of Fine Arts, Portfolio of Chinese Paintings in the Museum, Vol. I (Han to Sung Periods),* Kojiro Tomita, ed., Boston, 1933, 2nd enlarged ed., 1938; *vol. II (Yüan to Ch'ing Periods),* Kojiro Tomita and Hsien-chi Tseng, eds., Boston, 1961.

Boston Zen Cat.: Fontein, Jan and Money Hickman, *Zen Painting and Calligraphy,* Catalogue of an exhibition, Nov. 5 - Dec. 20, 1970, Museum of Fine Arts, Boston, 1970.

Cahill Album Leaves: Cahill, James, *Chinese Album Leaves in the Freer Gallery of Art,* Smithsonian Publication No. 4476, Washington, D.C., 1961.

CAT: *Chinese Art Treasures, Chung-hua wen-wu* 中華文物 , a Selected Group of Objects from the Chinese National Palace Museum and the Chinese National Central Museum, Taichung, Taiwan, exhibited in the

United States by the Government of the Republic of China, 1961-1962, Skira, Geneva, 1961.

Chiang Er-shih I: *Ville de Paris Musée Cernuschi: Seize Peintures de Maitres Chinois XIIe - XVIIIe Siècles de la Collection Chiang Er-shih,* catalogue of an exhibition, December 1959 - January 1960, Paris, 1959.

Chiang Er-shih II: *Ville de Paris Musée Cernuschi: Peintures Chinoises et Calligraphies Anciennes VIIIe - XIXe Siècles de la Collection Chiang Er-shih,* catalogue of an exhibition, May-July 1971.

China Institute Album Leaves: *Album Leaves,* The China Institute in America, Catalogue of an exhibition at China House Gallery, March 26 - May 30, 1970, Compiled by C. C. Wang.

Crawford Cat.: Sickman, Laurence, et. al., *Chinese Calligraphy and Paintings in the Collection of John M. Crawford, Jr.,* New York, 1962.

Fourcade: Fourcade, Francois, *Art Treasures of the Peking Museum,* New York, 1965.

Freer Figure Ptg.: Lawton, Thomas, *Freer Gallery of Art Fiftieth Anniversary Exhibition, II: Chinese Figure Painting,* Smithsonian Institution, Washington, D. C., 1973.

Garland: *A Garland of Chinese Paintings,* compiled by Wang Shih-chieh, Na Chih-liang and Chang Wan-li, Vols. I and II indexed, Hong Kong, 1967.

Hills: Cahill, James, *Hills Beyond a River: Chinese Painting of the Yüan Dynasty, 1279-1368,* Tokyo and New York, 1976.

La Pittura Cinese: Giugnanino, Alberto, *La Pittura Cinese,* 2 vols., Istituto Poligrafico della Stato, Rome, 1959.

Laufer: Laufer, Berthold, *T'ang, Sung, and Yüan Paintings Belonging to Various Collections,* Paris and Brussels, 1924.

Lee Colors of Ink: Lee, Sherman E., *The Colors of Ink: Chinese Paintings and Related Ceramics from the Cleveland Museum of Art,* catalogue of an exhibition, January 10 - March 3, 1974, Asia Society, New York, 1974.

Lee Landscape Painting: Lee, Sherman E., *Chinese Landscape Painting,* Cleveland Museum of Art, 1962.

Li Autumn Colors: Li, Chu-tsing, *The Autumn Colors on the Ch'iao and Hua Mountains: A Landscape by Chao Meng-fu,* Artibus Asiae Supplementum XXI, Ascona, 1965.

Ling Su-hua: *Quelques Peintures de Lettrés XIVe - XXe Siècles de la Collection Ling Su-hua,* catalogue of an exhibition, Nov. 1962 - Feb. 1963, Musée Cernuschi, Paris.

Met. Cat. (1973): Fong, Wen and Marilyn Fu, *Sung and Yüan Paintings,* The Metropolitan Museum of Art, New York, 1973.

Meyer Cat.: *Eugene and Agnes E. Meyer Memorial Exhibition,* Smithsonian Institution Freer Gallery of Art, Washington, D. C., 1971.

Munich Exh. Cat.: *1000 Jahre Chinesische Malerei,* Exhibition at Haus der Kunst, Munich, 16 Oct. - 13 Dec. 1959.

Oriental Art: *Oriental Art,* New Series Vols. I-XXIV (1955-1978) indexed.

Rowley: Rowley, George, *Principles of Chinese Painting,* Princeton, 1947.

Shimada and Yonezawa: Shimada Shujirō and Yonezawa Yoshiho, *Painting of Sung and Yüan Dynasties,* Mayuyama and Co., Tokyo, 1952.

Sickman and Soper: Sickman, Laurence and Alexander Soper, *The Art and Architecture of China,* Baltimore, 1956.

Siren Bahr Cat.: Siren, Osvald, *Early Chinese Paintings from A. W. Bahr Collection,* London, 1938.

Siren CP: Siren, Osvald, *Chinese Painting: Leading Masters and Principles,* 7 vols. (III and VI with plates), New York and London, 1956.

Siren CP in Am. Colls.: Siren, Osvald, *Chinese Paintings in American Collections,* 2 vols., Paris and Brussels, 1927-1928.

Siren ECP: Siren, Osvald, *A History of Early Chinese Painting,* 2 vols., The Medici Society, London, 1933.

Siren LCP: Siren, Osvald, *A History of Later Chinese Painting,* 2 vols., The Medici Society, London, 1938.

Skira: Cahill, James, *Chinese Painting,* Geneva, Skira, 1960.

Smith and Weng: Smith, Bradley and Wan-go Weng, *China: A History in Art,* New York, 1972.

Southern Sung Cat.: Cahill, James, *The Art of Southern Sung China,* Asia House, New York, 1962.

Summer Mts.: Fong, Wen, *Summer Mountains: The Timeless Landscape,* The Metropolitan Museum of Art, New York, 1975.

Swann: Swann, Peter, *Chinese Painting,* New York, 1958.

Toronto Cat.: *Loan Exhibition of Chinese Paintings,* The Royal Museum of Archaeology, Toronto, 1956.

Unearthing China's Past: Fontein, Jan and Tung Wu, *Unearthing China's Past,* Boston Museum of Fine Arts, 1973.

Wintry Forests: Barnhart, Richard, *Wintry Forests, Old Trees: Some Landscape Themes in Chinese Painting,* China Institute in America, New York, 1972.

Yale Cat.: Lee, George J., *Selected Far Eastern Art in the Yale University Art Gallery,* New Haven and London, 1970.

Part II: Sources for Bibliographical Information Used in Artist Entries

(Note: Since the same series of sources, identified by the same letter code, will be used in the succeeding Ming and Ch'ing volumes, sources for biographies of artists of these later periods are also listed here.)

A Chang Yen-yüan 張彥遠, *Li-tai ming-hua chi* 歷代名畫記, completed A.D. 847, 10 *chüan, Hua-shih ts'ung-shu* 畫史叢書 punctuated edition, Yü An-lan 于安瀾 general editor, 9 volumes, index, Shanghai, 1963, vol. 1.

B Chu Ching-hsüan 朱景玄, *T'ang-ch'ao ming-hua lu* 唐朝名畫錄, 1 *chüan*, in *Mei-shu ts'ung-shu* 美術叢書 , compiled by Teng Shih 鄧實 and Huang Pin-hung 黃賓虹, 1912-36, reprint of the enlarged edition, Taipei, n.d., vol 8, II/6.

C Huang Hsiu-fu 黃休復, *I-chou ming-hua lu* 益州名畫錄, preface dated 1006, 3 *chüan, Hua-shih ts'ung-shu* edition, Shanghai, 1963, vol. VI.

D Liu Tao-ch'un 劉道醇 , *Sheng-ch'ao ming-hua p'ing* 聖朝名畫評 , 3 *chüan, I-shu shang-chien hsüan-chen* 藝術賞鑑選珍 facsimile reprint of the 1908 edition, Han-hua 漢華 Co., Taipei, 1972.

E Liu Tao-ch'un 劉道醇, *Wu-tai ming-hua pu-i* 五代名畫補遺, preface dated 1060, 1 *chüan, I-shu shang-chien hsüan-chen* facsimile reprint of a Ming edition in the National Central Library, Taipei, 1972.

F Kuo Jo-hsü 郭若虛, *T'u-hua chien-wen chih* 圖畫見聞志, 6 *chüan, Hua-shih ts'ung-shu* edition, Shanghai, 1963, vol. I.

G *Hsüan-ho hua-p'u* 宣和畫譜, preface dated 1120, 20 *chüan, Hua-shih ts'ung-shu* edition, Shanghai, 1963, vol. II.

H Hsia Wen-yen 夏文彥, *T'u-hui pao-chien* 圖繪寶鑑, preface dated 1365, 5 *chüan, Hua-shih ts'ung-shu* edition, Shanghai, 1963, vols. III-IV.

I *P'ei-wen-chai shu hua p'u* 佩文齋書畫譜, 1708, 100 *chüan*, facsimile reprint of original edition, Taipei, 1969.

J Li E 厲鶚, *Nan-Sung yüan-hua lu* 南宋院畫錄, 1721, 8 *chüan*, supplement 1 *chüan, Hua-shih ts'ung-shu* edition, Shanghai, 1963, vol. VII.

K Lu Chün 魯駿, *Sung Yüan i-lai hua-jen hsing-shih lu* 宋元以來畫人姓氏錄, 36 *chüan*, preface dated 1829.

L P'eng Yün-ts'an 彭蘊燦, *Li-tai hua-shih hui-chuan* 歷代畫史彙纂 72 *chüan*, appendix 1 *chüan*, Shanghai, n.d.

M Sun Ta-kung 孫毓公 , *Chung-kuo hua-chia jen-ming ta-tz'u-tien* 中國畫家人名大辭典, Shanghai, 1934.

N Chiang Shao-shu 姜紹書, *Wu-sheng shih-shih* 無聲詩史, 7 *chüan, Hua-shih ts'ung-shu* edition, Shanghai, 1963, vol. IV.

O Hsü Ch'in 徐沁, *Ming-hua lu* 明畫錄, 8 *chüan, Hua-shih ts'ung shu* edition, Shanghai, 1963, vol V.

P Chou Liang-kung 周亮工, *Tu-hua lu* 讀畫錄, 4 *chüan, Hua-shih ts'ung-shu* edition, Shanghai, 1963, vol. IX.

Q Chang Keng 張庚, *Kuo-ch'ao hua-cheng lu* 國朝畫徵錄, 3 *chüan*, supplement 2 *chüan, Hua-shih ts'ung-shu* Shanghai, 1963, vol. V.

R Feng Chin-po 馮金伯, *Kuo-ch'ao hua-shih* 國朝畫識, 17 *chüan,* first edition, 1797, reprint 1923.

S Hu Ching 胡敬, *Kuo-ch'ao yüan-hua lu* 國朝院畫錄, 1816, 2 *chüan, Hua-shih ts'ung-shu* edition, 1963, vol. VIII.

T Chiang Pao-ling 蔣寶齡, *Mo-lin chin-hua* 墨林今話, 18 *chüan,* supplement 1 *chüan,* lithographic edition 1910.

U Ch'in Tsu-yüng 秦祖永, *T'ung-yin lun-hua* 桐陰論畫 7 *chüan* divided into 3 parts, author's preface to first part dated 1864, published 1880.

V *Chung-kuo jen-ming ta-tz'u-tien* 中國人名大辭典 Shanghai, 1921.

X Saitō Ken 斎藤謙, *Shina gaka jimmei jiten* 支那画家人名辞典, 2 vols., supplement 2 vols., Tokyo, 1900.

Y Chu Chu-yü 朱鑄禹 and Li Shih-sun 李石孫, *T'ang Sung hua-chia jen-ming tz'u-tien* 唐宋畫家人名辭典, Peking, 1958.

Sung Biog.: Herbert Franke, ed., *Sung Biographies: Painters.* Weisbaden, 1976 (Münchener Ostasiatische Studien, Band 17.)

EWA: *Encyclopedia of World Art.* New York, McGraw Hill, 1959-1968.

EB: *The New Encyclopedia Britannica: Macropaedia.* Chicago etc., 1979.

DMB: L. Carrington Goodrich, ed., *Dictionary of Ming Biography.* New York, Columbia U. Press, 1976.

Loehr Dtd. Insc.: Max Loehr, "Chinese Paintings with Sung Dated Inscriptions," *Ars Orientalis* IV, 1961, pp. 219-284.

Note: For information on the "Ssu-yin half-seal," noted in many entries, see Chiang Chao-shen's article in NPM Quarterly v. X no. 4, Summer 1977, English summary pp. 9-10, Chinese text p. 16.)